Choreomata

Is artificial intelligence (AI) becoming more and more expressive, or is human thought adopting more and more structures from computation? What does it mean to perform oneself through AI, or to construct one's subjectivity through AI? How does AI continue to complicate what it means to have a body? Has the golden age of AI, especially with regards to creative applications, already ended?

Choreomata: Performance and Performativity after AI is a book about performance and performativity, but more specifically, it is a book about the performance of artificiality and the performance of intelligence. Both humans and human-designed computational forces are thoroughly engaged in an entangled, mutual performance of AI. *Choreomata* spins up a latticework of interdisciplinary thought, pairing theoretical inquiry from philosophy, information theory, and computer science with practical case studies from visual art, dance, music, and social theory.

Through cross-disciplinary proportions and a diverse roster of contributors, this book contains insights for computer scientists, social scientists, industry professionals, artists, and beyond.

Choreomata
Performance and
Performativity after AI

Edited by
Roberto Alonso Trillo and Marek Poliks

CRC Press
Taylor & Francis Group
Boca Raton London New York

CRC Press is an imprint of the
Taylor & Francis Group, an **informa** business
A CHAPMAN & HALL BOOK

Designed cover image: Iván Puñal

First edition published 2024
by CRC Press
2385 NW Executive Center Drive, Suite 320, Boca Raton FL 33431

and by CRC Press
4 Park Square, Milton Park, Abingdon, Oxon, OX14 4RN

CRC Press is an imprint of Taylor & Francis Group, LLC

ISBN: 9781032319988 (hbk)
ISBN: 9781032319919 (pbk)
ISBN: 9781003312338 (ebk)

DOI: 10.1201/9781003312338

Typeset in Palatino
by codeMantra

Contents

Section A Performing Artificiality, Performing Intelligence

Subjectivity

Creativity

Representation

Section B Choreomatic Bestiary

Encounter

Proliferation

Annihilation

After-Body

Foreword

Tiziana Terranova

The post-digital age has witnessed the emergence of many technologies that were initially triumphantly hailed as groundbreaking and revolutionary. Some have eventually become mundane and ordinary (personal computers, smartphones, social media, apps). Others have barely managed to hang on to an unrealized futurity in the face of widespread skepticism (Virtual Reality, the Internet of Things, the Blockchain). However, there has likely never been a technological development so steeped in cultural lore and mired in philosophical conundrums as Artificial Intelligence. For at least half a century, even before recent breakthroughs in deep learning, Artificial Intelligence has been promising to match or even exceed human intelligence and to aid or replace human labor. Sentient forms of artificial beings can be found in a plethora of cultural representations spanning literature, cinema, television, comic books, animation, and video games. Such representations also hark back to centuries of mythological, metaphysical, and philosophical speculation about the nature of life, intelligence, consciousness, reason, and humanity. AI is thus both Golem and Genie in the bottle[1]; Pygmalion's Galatea and Frankenstein's Monster; Hal 9000 from *Space Odyssey* and the Puppet Master from *Ghost in the Shell*; *Neuromancer*'s Dixie Flatline and *Portal*'s GLaDOS; Ava from *Ex Machina* and Samantha from *Her*. Such stories and tales about artificial beings make evident how race (and gender) provide "the condition of possibility for the emergence of technology as an epistemological, political and economic category within Euro-American modernity", undergirding the "production of the human as separate from the machine, tool, or object" – but also threatened by it.[2]

On the other hand, AI is not only confined to the domain of fictional representations: "AI" as a latticework of data interpretation and inference technologies has already become an indispensable component of the computational and communication infrastructure that is to all effects running and sustaining contemporary societies. Arising out of a machinic phylum whose technogenesis enfolds industrial and postindustrial technologies, AI does not so much replace previous technical beings but rather subsumes and re-actualizes them. It is thus a *hyper-industrial machine* that requires repetitive and mechanical forms of labor, further contributing to the precipitation of apocalyptic scenarios of the Capitalocene. Even as it seems to become less reliant on human labor (as with the recent elimination of the human from manual tasks in feature extraction), it continues to allocate various kinds of repetitive, underpaid, or even downright traumatizing "Human Intelligence Tasks" to workers in the Global South (see Chapter 2

of Munster and Rossiter in this volume). It also requires large amounts of computational power through energy-intensive, carbon-emitting, e-waste-generating server farms – in turn dependent on mining and assembly-line work models. Regarding postindustrial technologies, such as digital networks, the latter are directly called on to provide what Andrew Ng called "the fuel" of the "Deep Learning Rocket",[3] that is the *data* – the reservoir of text, images, audio, and video generated by the free labor of networked technosocial cooperation – which it deploys as input for training to generate output in the forms of automated text, images, audio, and video (see Chapter 2 of Munster and Rossiter this volume). Following the model of platform capitalism, the proliferation of digital platforms provides "free" services in exchange for data and the foreclosure of the possibility of actually participating in the making of the technologies that technosocial cooperation provides.

On the other hand, AI also questions and challenges the traditional forms of politics that were elaborated as a reaction to industrial and postindustrial technologies. It is always possible to strike against the machine, but the alienation of industrial work can no longer be overcome by greater and better automation or by sharing the fruits of robots' labor. The subject of labor will not be resurrected or emancipated through the mastering of AI as a servant/slave of the working classes. As previous forms of the revolutionary and/or social relational subject evaporate in the strange space of reason enacted by AI as an auto-regressive machine (see Chapter 1 of Trillo and Poliks this volume), racial capital incessantly generates new forms of invisibilized labor at the service of the Master-User. At the same time, AI does more than imitate that "virtuosity" of the general intellect of the multitude that post-workerist Marxism envisioned as the true source of value in cognitive capitalism.[4] It does not liberate human creative imagination and linguistic capacities as the basis of the common as a mode of production, but subsumes them to an unprecedented extent: it thus exposes "imagination as a modeling and technically exteriorized faculty" (see Chapter 6 of Negarestani in this volume), as well as an increasingly standardized and pre-patterned style of thinking and writing (see Chapter 1 of Mo Salemy in Poliks and Trillo in this volume).

As critics warn about how AI is driving another round of enclosure and accumulation of the digital commons such as the one following the rise of platform capitalism in the early 2000s (arguing in favor of more regulation), there is also a need for widening our intellectual engagements with the ways in which technologies and techniques such as deep learning, neural networks, GAN, and generative AI challenge notions of subjectivity, perception, cognition, memory, consciousness, reason, and emotion. While it has been historically the task of analytical philosophy to take on and criticize various kinds of propositions and statements put forward by AI scientists about the nature of consciousness and thinking, this book also demonstrates the extent to which critical theory has also been increasingly making its way

into these debates. Feminists, critical race theorists, postcolonial and decolonial thinkers, political ecologists, Marxists, neo-materialists, post-phenomenologists, pragmatists, and speculative philosophers (among others) are already vastly exceeding the terms in which the mainstreaming of AI (with its polarizations and ready-made oppositions) is being carried out.[5] As the "material realm of causes and the logical space of reason" (see Chapter 9 of AA Cavia this volume) become ever more entangled, this is becoming an ever more necessary and crucial task.

Notes

1 On AI as Golem see Luciana Parisi and Steve Goodman (2021) *Golemology, Machines of Flight, and SF Capital*, e-flux (123).

2 See Neda Atanasoski and Vora Kalindi (2019) *Surrogate Humanity: Race, Robots, and the Politics of Technological Futures*, Durham, NC and London: Duke University Press, 29.

3 Andrew Ng (2016) "Fueling the Deep Learning Rocket with Data", The Artificial Intelligence Channel, YouTube, https://youtu.be/UZbwFw4wB2w.

4 See Paolo Virno (1996) "Notes on the 'General Intellect'", trans. Cesare Casarino, in *Marxism beyond Marxism*, eds. Saree Makdisi et al., New York: Routledge, 265–272.

5 See for example N. Katherine Hayles (1999) *How We Became Posthuman: Virtual Bodies in Cybernetics, Literature, and Informatics*, Chicago, IL: Chicago University Press; Matteo Pasquinelli (2019) "How a Machine Learns and Fails: A Grammar of Error for Artificial Intelligence", *spheres: Journal for Digital Culture's*, (5): 1–17; Luciana Parisi (2019) "The Alien Subject of AI", *Subjectivity*, 12(1): 27–48; Nick Dyer-Witheford, Atle Mikkola Kjosen, and James Steinhoff (2019) *Inhuman Power: Artificial Intelligence and the Future of Capitalism*, London: Pluto Press; Ezekiel J. Dixon-Román (2016) "Algo-Ritmo: More-Than-Human Performative Acts and the Racializing Assemblages of Algorithmic Architectures", *Cultural Studies ↔ Critical Methodologies*, 16(5): 482–490; Shakir Mohamed, Marie Therese Png, and William Isaac (2020) "Decolonial AI: Decolonial Theory as Sociotechnical Foresight in Artificial Intelligence", *Philosophy and Technology*, 33(4): 659–684; Stamatia Portanova (2020) *Whose Time Is It? Asocial Robots, Syncholonialism and Artificial Chronological Intelligence*, Berlin: Sternberg Press.

Preface

At a certain point, some subsets of humanity began to correlate existence with vulnerability – a thing may only be said to *really* exist if it can be pounded into dust, stripped from Heideggerian utility, cleaved from its ideal form by virtue of its malformations.

This book has been written at a time when Artificial Intelligence is, in a sense, its most vulnerable. After all: AI is only really able to make mistakes when it is liable for mistake-making; AI is only really able to induce or reinforce structural social problems when adopted by forces able to mobilize social power. In turn, the moment of this book's publication is timely; this is the moment when AI can be said to really exist in itself, not as an emerging ontological category or as some drastic innovation in computation (this book largely stands in opposition to both positions), but rather as a specific stream of social, aesthetic, and political contingency.

Regarding the title: *Choreomata*. The *automaton* describes a mindlessly pattering Turing machine as it tacitly executes a series of instructions, a conception of machine behavior that attributes unearned autonomy to the digital or mechanical realm. The *choreomaton* instead commits to the hidden cables and tangled puppet-strings that tether the mere robot to the unfathomably chaotic protocols of global computation, hegemonic technocapital, and postmodern civilization. These often-conflicting protocols – ideology-laden programming, sociopolitical theater, corporate ethology, opaque and inertial biases, ethical paradoxes – yield the odd and uncanny behaviors through which AI asserts itself as contingent and therefore real. This book dives headlong into the performance poetics of the fragmentary golems, ghosts, and avatars through which we, the authors, can interpret our own positions within the dense, hyperdimensional choreography of Artificial Intelligence.

Choreomata is a book about performance and performativity, but more specifically, it is a book about the performance of artificiality and the performance of intelligence. This book ardently asserts that both humans and human-designed computational forces are thoroughly engaged in an entangled, mutual performance of AI. In order to sustain this premise, the book is organized into two major sections, the former consisting of stage-setting and the latter consisting of case studies. Each section is then portioned into thematic attractors, though there exist many threads and traversals crisscrossing the length of the volume.

Subjectivity: The book begins by narrating the decline of the modern or postmodern subject, identifying the need for this particular formulation of identity and experience to dramatically expand into broader intersubjective and interobjective domains. The section begins by coupling AI to the diffraction and datafication of consciousness itself, with opening salvos from the

editors of this book (Marek Poliks and Roberto Alonso) and from media theorists Anna Munster and Ned Rossiter. Information theorist Luciana Parisi everts this thread outward, further interrogating the centricity of the human subject in both epistemological and aesthetic determinations. Artist and art theorist Barbara Bolt then provides a framework for performativity within an expanded ensemble-subject.

Creativity: We continue with two critical cannonades by artist and theorist Keith Tilford and philosopher Reza Negarestani, both aimed at dismantling foundational jargons of AI discourse: creativity, emergence, opacity, and imagination. Tilford bumps and sets a bracing critique of underlying ideology and obscurantism at the intersection of art, capital, and generative technology. Negarestani spikes a theory of imagination grounded in Husserl and Kant, one that can hold AI models as an exteriorization of or reflection on imagination.

Representation: The book continues by examining how AI systems represent memory and meaning. Musician and theorist Jonathan Impett introduces his reading of the concept of *anamnesis*, which frames the subsequent chapters on how AI tools store, refract, and consume information. Artist-researcher Jon McCormack digs into the limitations of existing AI tools with respect to creative expression and the reproduction of meaning. Philosopher of computation AA Cavia concludes the section, bringing a deft fatality-combo to mainstream conceptualizations of intelligibility and representation vis-à-vis the current state of AI technology.

This volume then changes course, enumerating what we playfully refer to as a **bestiary** of choreomatic AIs in practice, narrated through the experience of artists and researchers. Themes from the prior section are retraced, reconsumed, and reinscribed. This section could easily be read prior to the first section, in this sense generating, contextualizing, and ideating concepts for theoretical and philosophical analysis and response.

Encounter: Artist Sofian Audry, composer Davor Vincze, and robot choreographer Catie Cuan depict encounters with robots and avatars who assert their independence against technical rules or artistic expectations. Audry's concept of *apprivoiser* frames these relationships well – the practice of reciprocal, mutual domestication (*"living-with"*). This section can also sit well next to chapters by Parisi (the problematics of master-slave dynamics), and Tilford and Negarestani (critiques of the creative and the imaginative as exhibited by diffusion tools and LLMs).

Proliferation: Poet Sasha Stiles, visual artists Refik Anadol and Pelin Kivrak, computational linguists Rudolf Rosa and Tomáš Musil, and dramaturge Klára Vosecká articulate the complex interplay between generative technologies and the memories they absorb, embed, refract, and transform. Stiles's reading of poetry as data frames this section, creating further parallels to themes from chapters by Impett, McCormack, and Cavia. Bolt's chapter can add another layer of richness here as it provides a second reading of Rosa, Musil, and Vosecká's work.

Annihilation: Composer Alexander Schubert and musician-theorist Mattin outline positive and negative cases for the obliteration of conventional paradigms of subjectivity. This section relates strongly to closing theses from Munster and Rossiter's chapter and from our opening chapter – especially around what Munster and Rossiter call *the nihilist holiday* and what we term *evaporation* and *vapor space*.

After-Body: Artist-researchers Roberto Alonso Trillo and Peter Nelson articulate how the borders of bodies change in their relation to an AI-mediated system. Poetic and poetic-theoretical text from composer-performer Jennifer Walshe concludes the book, providing an abstract phenomenology of a subject and body so transformed. This section sits particularly well next to Bolt's chapter, especially with respect to Bolt's reading of the *ensemble*.

This book has been, as the cliche goes, a labor of love. It has been extremely fulfilling to assemble this international, interdisciplinary cast of powerful performers. Our deepest gratitude to all of our contributors, to our exceptionally (mind-blowingly) talented copy editor Jamie Johnson, and to our incredible contacts at Routledge/CRC Press.

Note: In order to best represent this international cohort of contributing authors, every effort was made to preserve the character of each text vis-a-vis spelling conventions, quotation standards, and other stylistic principles that may vary based on the author's locations.

Editors

Roberto Alonso Trillo

Roberto Alonso Trillo is a musician and researcher based in Hong Kong, where he works as an assistant professor at the Hong Kong Baptist University. His practice explores the connections between different artistic disciplines, from dance and music to video art and interactive sound installations. His recent work examines networked hybrid music practices endemic to a world increasingly mediated by AI and machine learning. His multipronged practice-based and -led research, operating at the intersection between philosophy, sociology, and cultural studies, spans areas as diverse as a post-structuralist reconsideration of musical workhood and authorship, technologically enhanced string pedagogy, gesture analysis, and interface development.

Roberto is the author of *Death and (Re)Birth of J. S. Bach* (Routledge) and has published in journals such as *Leonardo, Organised Sound*, and *Music Education Research*. He is a co-founder, with his colleague Peter AC Nelson, of the MetaCreativity Lab at Hong Kong Baptist University. His long-time partnership with Marek Poliks – DisintegratorAI – has led to the publication of several CDs, journal articles, and the exhibition of interactive artworks in international venues.

https://robertoalonsotrillo.com/

Marek Poliks

Marek Poliks is an artist, engineer, and theorist based in Minneapolis, Minnesota. He works with machine learning as applied to sound, digital media, robotics, and sculpture.

Marek leads technology at the design firm Polytope, where he builds interactive infrastructure for clients like the Dubai Future Foundation. His longtime partnership with Roberto Alonso – DisintegratorAI – has led to CDs for NEOS and Creotz Ediciones, articles for Leonardo and Organised Sound, a GAN-and Transformer-driven raw audio synthesis engine ("Demiurge"), a real-time behavior-responsive data interface ("Archon"), and two soft robots ("Hydra" and "Polyp"), and this book.

Marek has a PhD from Harvard, an ASCAP award in music journalism, and a career as an artist exhibiting around the globe.

Contributors

Refik Anadol
Refik Anadol is a media artist, director, and leader in the aesthetics of data and machine intelligence. He is the director of Refik Anadol Studio in Los Angeles and also a lecturer in UCLA's Department of Design Media Arts. Anadol's work has been exhibited at venues including the MoMA, Centre Pompidou-Metz, National Gallery of Victoria, Venice Architecture Biennale, Arken Museum, Hammer Museum, Dongdaemun Design Plaza, and Ars Electronica Festival.

Sofian Audry
Sofian Audry is an artist, scholar, professor of Interactive Media in the School of Media at the University of Quebec in Montreal (UQAM), and co-director of the Hexagram Network for Research-Creation in Art, Culture and Technology. Their work explores the behavior of hybrid agents at the frontier of art, artificial intelligence, and artificial life, through artworks and writings. Audry's book *Art in the Age of Machine Learning* examines machine learning art and its practice in art and music (MIT Press, 2021). Their artistic practice branches through multiple forms including robotics, installations, bio-art, and electronic literature.

Barbara Bolt
Barbara Bolt is a professorial fellow at The University of Melbourne. She is a practicing artist and art theorist with special interests in new materialist theory, ethics, and artistic research. Her publications include two monographs, *Art Beyond Representation* (2004) and *Heidegger Reframed* (2011), and five co-edited books, *The Meeting of Aesthetics and Ethics in the Academy: Challenges for Creative Practice Researchers in Higher Education* (2019), *Material Inventions: Applying Creative Arts Research* (2014), *Carnal Knowledge: Towards a "New Materialism" through the Arts* (2013), *Practice as Research: Approaches to Creative Arts Enquiry* (2007), and *Sensorium: Aesthetics, Art, Life* (2007).

AA Cavia
AA Cavia is a computer scientist and researcher based in Berlin. His studio practice is centered on speculative software, engaging with machine learning, algorithms, protocols, and other software artifacts. He has lectured and exhibited internationally, at institutions such as Jan van Eyck Academie, ZKM, and The New Centre for Research & Practice. His writings have been published by HKW, Urbanomic, and Glass Bead Journal. He is the author of one book, *Logiciel* (2022), published by &&&.

Catie Cuan

Catie Cuan is a engineer, researcher, artist, and a pioneer in the nascent field of "choreorobotics". Her research and artistic work focuses on robot learning, human–robot interaction, and dance. The title of her PhD thesis is "Supervised Learning for Compelling Robot Behaviors", which was funded by the National Institutes of Health, Google, and Stanford University. She has held artistic residencies at the Smithsonian, Everyday Robots (X, the moonshot factory), TED, and ThoughtWorks Arts. She holds a doctorate and a master's degree in Mechanical Engineering from Stanford University.

Jonathan Impett

Jonathan Impett is director of research at The Orpheus Institute, Ghent, where he leads the research group "Music, Thought and Technology". As a composer, trumpet player, and writer, his research is concerned with the discourses and practices of contemporary musical creativity, particularly the nature of the technologically situated musical artifact.

As a performer, he is active as an improviser, as a soloist (premieres of solo works by Berio, Scelsi, Subotnick, Harvey, Finnissy), and in historical performance (member of The Orchestra of the Eighteenth Century and The Amsterdam Baroque Orchestra). His recent monograph on the music of Luigi Nono is the first comprehensive study of the composer's work. Jonathan is currently working on a project considering the nature of the contemporary musical object, 'the work without content'. Activity in the space between composition and improvisation has led to continuous research in the areas of interactive systems, interfaces, and modes of collaborative performance. Recent works combine installation, live electronics, and computational models with notated and improvised performance.

Pelin Kivrak

Pelin Kivrak is a writer, scholar of comparative media studies, and Senior Researcher at Refik Anadol Studio. Kivrak holds a PhD in comparative literature from Yale University and a BA in literature from Harvard University. Her academic work focuses on contemporary art and literature's engagement with philosophical and historical genealogies of collective responsibility and politics of creativity.

Mattin

Mattin is an artist, musician, and theorist conceptually working with noise and improvisation. Through his practice and writing, he explores performative forms of estrangement as a way to deal with structural alienation. Urbanomic published his book *Social Dissonance in 2022*. Anthony Iles and Mattin are currently in the final stages of editing the volume *Abolishing Capitalist Totality: What Is to Be Done under Real Subsumption?* (Archive Books). Mattin is currently co-hosting with Miguel Prado the podcast *Social*

Discipline. Prado and Mattin are also part of Noise Research Union with Cecile Malaspine, Sonia de Jager, Martina Raponi, and Inigo Wilkins. In 2017, Mattin took part in documenta14 in Athens and Kassel.

Jon McCormack

Jon McCormack is a media artist and researcher based in Melbourne, Australia. He is currently a research professor and founder and director of Monash University's SensiLab, a creative technologies research laboratory that brings together artists, designers, scientists, and technologists in transdisciplinary collaboration. McCormack's own creative practice encompasses generative systems, human–machine creativity, and creative artificial intelligence. He is the recipient of over eighteen awards for both artistic innovation and technical research, including the Eureka Prize for Innovation in Computer Science and the Lumen Prize for Digital Art.

Anna Munster

Anna Munster is a professor of Art and Design at the University of New South Wales, Australia, and co-director of its newly formed Autonomous Media Lab. Her research focuses on new ways to theorize machine learning with an emphasis on critical artistic interventions into AI. She has written *An Aesthesia of Networks* (2013, MIT) and *Materialising New Media* (2006, Dartmouth University) and is the co-editor of *Immediations I* and *II* (Open Humanities Press, 2018). She has contributed articles on media assemblages, networks and platforms, media art, and process philosophy in *Theory, Culture and Society, Journal of Cultural Analytics, Inflexions, Media and Environment*, among many; recently, she has contributed to *Affects, Interfaces Events* (Imbricate, 2021) and has co-authored with Adrian MacKenzie for the anthology *Distributed Perception* (Routledge, 2021). She is a practicing artist working across sound, video, data, generative, and autonomous systems and collaborates with Michele Barker.

Tomáš Musil/Rudolf Rosa/Klára Vosecká

Tomáš Musil and Rudolf Rosa are researchers in the field of natural language processing, with a background in artificial intelligence. Klára Vosecká is an undergraduate student of directing and dramaturgy. Together, they were members of the THEaiTRE project, which examined whether artificial intelligence can write a play. The play, titled *AI: When a Robot Writes a Play*, was written in collaboration with an artificial intelligence system and a human, with the machine generating large amounts of text and the human supervising and guiding it.

Reza Negarestani

Reza Negarestani is a philosopher. His latest philosophical work, *Intelligence and Spirit*, is at the intersection of German Idealism, theoretical computer

science, and philosophy of intelligence. He is currently the director of Critical Philosophy at the New Centre for Research and Practice.

Peter Nelson
Peter Nelson is an artist, assistant professor, and co-founder of the MetaCreativity Lab at Hong Kong Baptist University. Originally trained in painting, drawing, and art history, his exhibition practice spans ink painting, robotically augmented drawing, 3D animation, and interactivity. He has published papers on the aesthetics of user-generated content in game sandboxes (Game Studies 2023), black holes and algorithmic realism (*Leonardo* 2022), and a monograph on computer games and landscape art history (Palgrave MacMillan, 2024).

Luciana Parisi
Luciana Parisi's research is a philosophical investigation of technology in culture, aesthetics, and politics. She is a professor at the Program in Literature and faculty in the Graduate Program of Computational Media Art and Culture at Duke University. She was a member of the Cybernetic Culture Research Unit and is currently a co-founding member of the Critical Computation Bureau. She published *Abstract Sex: Philosophy, Biotechnology and the Mutations of Desire* (2004, Continuum Press) and *Contagious Architecture: Computation, Aesthetics and Space* (2013 MIT Press). She is now writing a monograph, *Automating Philosophy, Instrumentality and Critique*.

Ned Rossiter
Ned Rossiter is director of research at the Institute for Culture and Society and professor of Communication in the School of Humanities and Communication Arts, Western Sydney University. His books include *Software, Infrastructure, Labor: A Media Theory of Logistical Nightmares* (2016) and (with Geert Lovink) *Organization after Social Media* (2018).

Alexander Schubert
Alexander Schubert (1979) studied bioinformatics and multimedia composition. He is a professor at the HfMT Hamburg. Schubert's work explores the border between the acoustic and electronic world. His music compositions, immersive installations, and staged pieces examine the interplay between the digital and the analogue. Continuing topics in this field are authenticity and virtuality. His output examines the influence and framing of digital media on aesthetic views and communication from a post-digital perspective. Schubert's research interests include virtual reality, artificial intelligence, and online-mediated artworks.

Sasha Stiles

Sasha Stiles is a poet, artist, AI researcher, and author of the "instant techno-classic" *Technelegy*. As a pioneer of algorithmic authorship, blockchain poetics, and publishing innovation, her honors include a Future Art Award and nominations for the Forward Prize, Pushcart Prize, and Best of the Net. Her work has been featured in *Artforum*, Lit Hub, Artnet, and *The Washington Post*, and exhibited widely around the world. She is the co-founder of the VERSEverse and frequent speaker at venues such as Art Basel, The Brooklyn Museum, and SXSW. Stiles has served as Poetry Mentor to the android BINA48 since 2018.

Tiziana Terranova

Tiziana Terranova is professor of Cultural Studies and Digital Media at the Università di Napoli 'L'Orientale', Italy. She is the author of *Network Culture: Politics for the Information Age* (Pluto Press 2004); and *After the Internet: Digital Networks between Capital and the Common* (Semiotext(e), 2022). Her research on digital technologies operates at the intersection of cultural and media studies, post-workerist Marxism, and critical theory. Her writings have appeared in journals such as *Social Text, Theory, Culture and Society, Parallax, C-Theory, Culture Machine, e-flux*, and in many edited collections. She is a co-founder and member of the Technoculture Research Unit (www.technoculture.it) and the Critical Computation Bureau (https://recursivecolonialism.com/).

Keith Tilford

Keith Tilford is an artist and writer living in Brooklyn, NY. He is the illustrator of the graphic novel *Chronosis*, co-created with Reza Negarestani and Robin Mackay (Urbanomic, 2021), and his recent writings have appeared in Glass Bead Research Platform and *Superpositions: Laruelle and the Humanities* (Rowman & Littlefield, 2017).

Davor Vincze

Davor Vincze is a composer of contemporary music whose artistic focus lies in meta-reality and musical mosaicking. Inspired by technology and science fiction, he searches for hidden acoustic spaces or ways to blur the real and the imaginary, often using electronics and AI tools. Working with mosaics (multiple copies of fragmented sound gestures), Vincze searches for fluid sounds that allow for non-binary, ambiguous, or "androgynous" interpretations.

After studying medicine in Zagreb, Vincze changed his career path and studied composition in Graz, Stuttgart, Ircam, and at Stanford University. His piece *XinSheng* won the Stuttgart Composition Competition as well as the Noperas! grant. After completing his Arts Fellowship at Emory University, he started a postdoc at the Hong Kong Baptist University. In 2014, he founded an international festival of contemporary music – Novalis. Since 2023, he has served as co-director of Music Biennale Zagreb. Vincze's works are published by Maison ONA in Paris.

Jennifer Walshe
Composer and performer Jennifer Walshe was born in Dublin, Ireland. Her music has been commissioned and performed all over the world. She has received fellowships and prizes from the Foundation for Contemporary Arts, New York, the DAAD in Berlin, and the Internationales Musikinstitut, Darmstadt, among others. *A Late Anthology of Early Music Vol. 1: Ancient to Renaissance,* her third solo album, was released in 2020. The album uses AI to rework canonical works from early Western music history. *A Late Anthology* was chosen as an album of the year in *The Irish Times, The Wire,* and The Quietus. Walshe is professor of composition at the University of Oxford.

Section A

Performing Artificiality, Performing Intelligence

Subjectivity

1

0-Degree Plane of Neuroelectronic Continuity: AI & Psychosocial Evaporation

Marek Poliks and Roberto Alonso Trillo

Generative AI, rounding an nth hype-cycle victory lap, promises to revolutionize virtually every application against which it's roughly patched. To a giddy mob of LinkedIn para-journalists it represents a step-change in efficiency, a rip-and-replace solution for content generation, an oracle squeezed from Wikipedia's digestive tract. To the techno-optimists, Generative AI holds emancipatory potential: a perpetual motion machine of free labor, a tool for decentralized operations, a clamorous alarm signaling the end of intellectual property.

This chapter argues that Generative AI, an assemblage of technology platforms and techno-ideologies, calls forth little substance in terms of social reorganization. Instead of enacting a new society, Generative AI emerges concurrently with an adolescent social order – a subtle, automatic social transformation that carries the through-line of postmodernity all the way to its conclusion. The postmodern subject's tendency toward atomization accelerates and completes as its atoms approach infinitesimal scale. A new social physics emerges, a dark world of vaporous non-beings who interrelate through ambience, pressure, diffusion, and asynchronous commingling. This social vaporreality exists prior to AI in every sense, functioning as the latter's socioeconomic preconditions, its technical substrate, and its placental subsistence medium.

Here lies both true emancipatory potential and existential threat: the twilight of the postmodern subject and the terminus of memory.

This chapter tweaks at lightning-speed, manically careening through a half-century of subject construction in order to aggregate the flows and systems through which contemporary vaporreality emerges. It then articulates the dynamics of vapor space within the context of the computational structures that harness vapor as a medium. The chapter culminates with the sociopolitics of the vaporous, including its aesthetics, endemic fascisms, performativities, and reproductive arrangements. It concludes by returning to the utopian energy of the AI hype cycle, channeling it toward the desubjective: heaven (Figure 1.1).

DOI: 10.1201/9781003312338-3

VAPOR:

a visible or invisible, uncontainable, uniform haze, mist, or cloud.

DIFFUSE:

to exteriorize, disassemble, distill, or deform.

EVAPORATE:

the metaprocess of diffusion, especially as a tendency immanent to some material or form.

DISPERSE:

once diffuse – to fill, to tend toward uniformity within a volume, spread, and expand out.

VAPOR SPACE:

the free interplay of fully autonomous processes cleaved from a subjective experience.

FIGURE 1.1
Album cover of "Evidence, Boards, Guitars." Photo by Assaf Gidron. LCollective. Bandcamp Release (2021).

1 Postmodern Subject Mechanics

> In dismantling the organism there are times one courts death, in slipping away from significance and subjection one courts falsehood, illusion and hallucination and psychic death.
>
> — *Deleuze and Guattari in A Thousand Plateaus*

The following is by no means an exhaustive or even thorough account of postmodern subjectivity. It rather sets a stage with which to define by contrast a gradual, processual, ambient experiential turn from heterogeneous assemblage toward homogenous vapor, a turn that bleeds into the social, biological, economic, cultural, and political conditions of a pre-AI world. It uses philosophy, art, and social theory to make its arguments, not as statements of truth or a priori insights into reality, but rather as commentary filtered through the postmodern experience of its authors, commentary both descriptive and at times prescriptive of its regime. This first section can be distilled simply: *postmodernity is a process of evaporation, a sustained and accelerating psychosocial disposition that fragments, exteriorizes, and ultimately annihilates subjectivity, memory, and consciousness.*

In virtually all formulations, the postmodern subject resembles a vector field. A particle storm brews within a massive tensor, its chain reactions rip through dimensions extending through all domains of social and biological reality. A marine biome blooms within the deep-sea vents of the real, its complex, dynamic interplay of physical and environmental actors emerge into a situation. An unsteady verticality of geopolitical forces haphazardly assembles a piece of integrated neurobiological wetware that recursively consumes and reproduces its origin.

Or one could start here: the postmodern subject is not a solid, a scalar, a singleton, or a dipole. Such fixities smack of premodern, religious fantasy.

Instead, many formations of the postmodern subject tend toward the *dynamic*. These subject-formations move like deconstructable or partially deconstructable suspensions, determinable or partially determinable collisions. What distinguishes one account of postmodern subjectivity from another is less whether or not a given subject *can* be known, but rather the *extent* to which it can be known. Social construction *means construction*. Insert your litany of postmodern philosophers, critical race theorists, social critics, political activists, feminist scholars, media theorists, and historians of technology here: there almost always exist some dynamics that account for the partial, imperfect resolution of the complexity and chaos of postmodern being into discrete principles, laws, tendencies, and forms.

Further, these dynamics *constitute* being: postmodern subjects *are* processes. The type of process can vary from determined (e.g., Taylorist construction or biological essentialism) to "indeterminate intra-activity of

matter, meaning, and discourse"[1] (e.g., emergent forms and structures) to processes of alienation from unresolvable noumena. These processes operate on top of *data*, however material or transubstantial. Since the postmodern subject exists *as* process, it therefore enrolls its constituent processual data into itself, acquiring a heterogeneous communion of material, biophysical, sociocultural, political, economic, and transubstantial forces as its atomic substructure. Postmodernity consists in datafication; the analysis of its subjective condition should therefore emerge from a critical praxeology of data.

Data like sleep quality (time to sleep, time in REM, time in deep sleep, breathing rate),[2] cardiovascular information (heart rate, blood pressure, cholesterol level, blood oxygen level), blood type, activity stats (gym membership, eldercare motion tracking information, step count, walking asymmetry, double-support time, flights climbed,[3] speed and intensity of motion, 1RM, ROM, time to recover), metabolic stats (blood sugar, weight, BMI, % body fat, available nutrition), nutritional identity, allergies (food or drug), exposure to pollution (lead/metals, smog, waste), vision stats, disability status, injury history, general medical history, history of addictions, genetic predispositions, medical insurance status, medical insurance premium, active medication list, psychological profile (disorders, typology), birthdate, birth location, pregnancy status, access to abortion, living family, dead family, history of abuse, physical proximity to family (incl. pets), race, heritage, family origin, ethnicity, skin color, nationality, immigration status, visa status, passport status, military status, religious affiliation, spiritual beliefs, relationship status, relationship structure preference, sexual preference, sexuality, gender, chosen pronouns, sex-assignment, household income after taxes, assets, bank account, liquidity, credit card account, available credit, credit score, home address, smart home login information (incl. automatic lighting, voluntary video and audio surveillance), home insurance status, temperature/humidity, air quality metrics (CO, radon, smoke), therms consumed, vehicle status, gasoline consumed, CO_2 units consumed (transit, shipping, vehicle), kWh (raw usage, EV charging, computation incl. training AIs, or mining crypto), internet connection, education history (incl. literacy), income tax at location of childhood, SAT/ACT/GRE/AP/IB or LSAT/MCAT score (and their international equivalents), ability to write a 5-paragraph essay, languages spoken (level of fluency), social class, employment history, 5-year plan, contractor/W2/part-time status (and their international equivalents), contribution to workplace metrics (net sales, quota attainment, growth rate, churn rate, lead response, ROMI, CPL, CAC, CLV, retention, traffic-to-lead, conversion rate, bounce rate, net income, net profit, gross profit, ratio, working capital, AR turnover, % accounts payable, MRR, new MRR, expansion MRR, churn MRR, ARPA, CES, NPS, employee turnover, R/e,

eNPS, training spend, career path ratio, revenue v. forecast, inventory turnover, scrap, ROA, RIT, CSAT),[4] employee rank (ability to execute against KPIs, OKRs, sprint outcomes, etc.), email logins (professional and otherwise), communicational media accounts (WeChat, WhatsApp, Messenger, Signal), representational social media accounts (Facebook, Instagram, Weibo, Twitter, LinkedIn, Slack, GitHub, Pinterest), para-representational social media accounts (Finsta, Reddit, Discord, Telegram, 8Chan, Urbit), sexual social platform avatars (Tinder, Grindr, Hinge, Raya), political social media accounts (Parler, TruthSocial), workplace(s) personality(ies), personality profile (Myers-Briggs, Enneagram), astrological sign (sun, moon, rising), social associations (sports teams, clubs, organizations), hobbies, aesthetic preferences (movies, TV, music, fashion, art, books, etc.), parasocial encounters with the profusion and dilution of celebrity influencers,[5] identity commodities (e.g., collections/collectibles, sloganwear bearing this or that solidarity acronym, this or that flag purchased through Amazon or Etsy accounts), entertainment sources (YouTube account, cable connection, Netflix, Hulu, Amazon, HBOMax, Disney+, and their international equivalents), political information sources (BBC, InfoWars, Jacobin, Al Jazeera, Substack, NPR/PBS, NYT, NBC, WSJ, and their international equivalents), political district (city, state, nation), personal voting history (if voting is applicable), volunteering history, local voting stats (turnout history), donation volume, donor class, reflection in advertising activation and impressions (representation in web traffic, reach, active/unique user base, disposition in posted content, ROI), participation in social media political awareness campaigns, stated and unstated political affiliations, and macroeconomic preferences ...

In many accounts, differences between two or more subjects can be measured or articulated less by contrasting each subject-as-process, but rather by contrasting the atomic elements, the datapoints, to which each subject-making process is applied. Each subject is atomized, isolated in their own particular array of constitutive particles.

The relationship between the subsurface atomic layer and subject-as-process through which the atomic layer is interpolated can take several forms. Three of many are elucidated below: the "Newtonian subject," the "networked subject," and the "shadow subject."

1a Newton's Vision [many → one]

One of many postmodern subject-classes: the Newtonian subject.

A Newtonian subject is deconstructible into the chaotic interplay of superstructural forces; the subject manifests at the collision point of incoming particles. This mode of subjectivity is at least partially determined, individualized by the stochastic complexity of simultaneously conflicting modes

of power, discipline, and control. Russian neofascist political philosopher Aleksandr Dugin degradingly refers to this iteration of the postmodern subject as "Newton's vision," a purely "materialistic, [...] technocentric and determinist" epistemology.[6]

Accounts of Newtonian subjectivity often arrive through the Hegel/Marx pipeline, sharply punctuated by Michel Foucault and Jean Baudrillard. This is likely obvious: the Newtonian subject-class is a materialist subject-class, one animated by the "modes of subjectification"[7] of biopower and technopolitics. Its initial phase is the "disciplinary society," the theorization of which Gilles Deleuze attributes to Foucault in the *Postscript on the Societies of Control*. The disciplinary society exercises its power downstream, through what Deleuze calls "enclosures,"[8] or what Alexander Galloway calls "confinement [... and] bureaucratic hierarchy."[9] Essentially, the disciplinary society governs through downstream institutional force. Mid-career Deleuze, with Félix Guattari in *A Thousand Plateaus*, speaks to downstream processes of subjection and subjectification – the capacities of power, capital, machines, or nation states to generate and regulate subjectivity itself – for example writing: "[in] effect, capital acts as the point of subjectification that constitutes all human beings as subjects" or "the nation is the very operation of a collective subjectification, to which the modern State corresponds as a process of subjection."[10]

Late Deleuze counterposes disciplinary societies against control societies, whose more sophisticated Newtonian mechanics correlate to the advent of postmodernity.[11] While disciplinary societies host regulatory power within a centralized network of apparatuses (dispositifs), control societies disperse power through the bodies and minds of its citizenry. Downstream, institution-driven disciplinary societies have "two poles: the signature that designates the *individual*, and the number or administrative numeration that indicates his or her position within a *mass*," but control societies have annihilated the "mass/individual pair," interpenetrating the individual (the *"dividual"*) with "samples, data, markets, or *'banks.'"*[12]

From Michael Hardt and Antonio Negri via Foucault (to whom Deleuze also attributes the forecasting of the formation of control societies):

> We should understand the society of control, in contrast, as that society (which develops at the far edge of modernity and opens toward the postmodern) in which mechanisms of command become ever more "democratic," ever more immanent to the social field, distributed throughout the brains and bodies of the citizens. The behaviors of social integration and exclusion proper to rule are thus increasingly interiorized within the subjects themselves. Power is now exercised through machines that directly organize the brains (in communication systems, information networks, etc.) and bodies (in welfare systems, monitored activities, etc.) toward a state of autonomous alienation from the sense of life and the desire for creativity.[13]

Power is not a univocal force for any of the above theorists. Nor is it for Kimberlé Crenshaw, whose conception of intersectionality articulates power as a complex aggregation of overlapping sociopolitical, cultural, and economic factors – "where power comes and collides, where it interlocks and intersects"[14] – coalescing to generate individuating experiences of oppression. Intersectionality is a powerful theory of the macrostructural chaos of control societies. There is no single *power* at whose behest control societies function. Instead, a host of divergent, even contradictory, forces harness the interpenetrative capacity of control: a tug-of-war upon the inner core of subjective experience. While Foucault denies that power "exhaustively determines a subject's possibilities" but rather "specifies [its] relevant field of possibility,"[15] Wendy Brown enunciates a fatalist trend in "poststructuralist formulations of the subject" that identify a subject "as not simply oppressed but brought into being by – that is, an effect of – subjection."[16] Control societies do control in part through assent, through identification, through "motivational force,"[17] and through what Lauren Berlant calls "aspirational normalcy" (not unlike the present-day progressive causes of "normalization" and "validation"), which drives a "reinvestment in the nor-mative promises of capital and intimacy under capital."[18]

Fredric Jameson is one of many to describe a specific psychosocial effect of the sociopolitical tug-of-war at the heart of control societies, a principle or mechanism referred to hereafter as the evaporative principle. The evaporative principle is a diffusive motion toward the infinitesimal, the generic. The forces of subjectification proliferate, as do their tensions and contradictions. In turn, the subject determines itself through smaller and smaller alliances, allegiances, identities, negativities, and surrenders. These forces shrink, neutralize, and denature; they become fungible, dedifferentiated, atomic in the Epicurean sense. Borrowing from Luciana Parisi, through Benjamin Bratton, "the individuality of the subject is broken into endlessly divisible digits."[19] Or from Tiziana Terranova – the subject blurs as a "point of view" (a rational individual) and everts into a "neo-baroque darkly mirrored psychic interiority that keeps being affected by and folding in the outside."[20]

Expressions of the evaporative principle vis-à-vis Newtonian subjectification are frequent topics of contemporary social critique. For example, Gayle Salamon, in *Assuming a Body: Transgender and Rhetorics of Materiality*, unfurls a bracing critique of the "ossification of identity," asserting that "a subject conceived as 'intersectional,' as cleanly joined layers or partitions of identity demarcated along separate axes of interpellation, bears little relation to any kind of lived subjectivity."[21] The ossification of identity in the realm of politics,[22] gender and sexuality,[23] and race[24] has been observed to tend significantly toward smaller and smaller categories, greater specificity, overlap, and metastatic contradiction.[25] The generic itself acquires specific political vectors, folding over itself into further expressions of individualizing micropolitics. The social performance of "ossified identity" consists in no small part of economic production and consumption: aligning values

with a workplace, purchasing apparel or cosmetics or paramilitary tactical gear, collecting images of social icons, and consuming micropolitical media or microgenre art. The transition from archetype-driven marketing strategies to a swarm of complex, hyper-attuned ad trackers hanging on to every typed word, searched term, and attended second[26] captures the simultaneously increasing specificity and generality of these consumption patterns. A race develops between generative self-exteriorization and reappropriative control.[27] This is evaporation.

Pains must be taken to extract evaporation from a "teleological understanding of capitalism"[28] – for example, the "essentially dispersive"[29] character Deleuze attributes to neoliberal capitalism. This chapter attempts to torture this relationship, arguing that it is foremost a voluntary, elective postmodern consensus, applied at scale, that brings vapor space into existence. The cultural logic of capitalism, power, empire/imperialism – insert your posthumanizing vector here – flows parallel to or downstream of this logic, passively entranced by it, adjusting it, and tacitly propagating it around the globe.

For Deleuze, Guattari, and Jameson, the evaporative principle pushes toward the "schizoid" or toward "schizophrenia" – a term with variable connotations (all of which are essentially non-medical) rooted in Lacan. For Lacan, schizophrenia represents "a breakdown in the signifying chain, that is, the interlocking syntagmatic series of signifiers which constitutes an utterance or a meaning."[30] Jameson uses the term to refer to an experience of pure or strict materiality ("pure and unrelated presents in time"[31]). Deleuze and Guattari, by contrast, use these terms to describe a subjectivity approaching the Plane of Immanence, the Real.

Always in a complex state of determination from sociopolitical or biophysical control – the Newtonian subject exists in the moment, at the coincidence of vectors; its history is inscribed and articulated in the present. Fredric Jameson connects this temporality to a "crisis in history"[32] inscribed by power into a regime of cultural production that reduces subjective experience to a succession of commodified moments. Jameson predicted the granularized expressive modes of TikTok and Instagram well, as he did the strong emphasis placed by the wellness industrial complex on the *present* (mindfulness, intentionality, awareness practices), as time dissolves into generic ahistoricity or non-historicity:

> If, indeed, the subject has lost its capacity actively to extend its pro-tensions and re-tensions across the temporal manifold, and to organize its past and future into coherent experience, it becomes difficult enough to see how the cultural productions of such a subject could result in anything but "heaps of fragments" and in a practice of the randomly heterogeneous and fragmentary and the aleatory.[33]

The evaporative principle acknowledges the Lacanian schizoid, but shimmies away from any value-attribution to the experience of the

hyper-atomized subject. Vapor is vapor, there is no plane of lesser or greater reality accessible to a non-subject dissolving into infinitesima.

Like in Jameson, there is no history in vapor space – but no fizzy stream of presents either. Like in Foucault, vapor space involves dynamic systems – but the chaos of vapor dynamics far exceeds those of biopolitical construction. More on this later.

1b Networks and Emergence [one → many]

> [...] I wondered as I descended, if it might not be that Urth is not, as we assume, older than her daughters the trees, and imagined them growing in the emptiness before the face of the sun, tree clinging to tree with tangled roots and interlacing twigs until at last their accumulation became our Urth, and they only the nap of her garment ...
>
> — *Gene Wolfe in* The Book of the New Sun

Another of many postmodern subject-classes: the networked subject.

A more recent configuration of the postmodern subject came into vogue as mathematics and computation approached the ability to think larger and more chaotic structures. The networked subject is also a process, a becoming, an unfolding. Like the Newtonian subject, the networked subject exists amidst a substrate of forces. However, the networked subject is not subordinated to forces, but rather subordinated to relations: complex relationships of many simultaneous sizes and scales. The networked subject includes and acknowledges the objects within itself as emergent phenomena, and in fact, the networked subject itself is often merely another vertical layer of emergent phenomena stacking within a hyperdimensional plane. From Karen Barad: "not only subjects but also objects are permeated through and through with their entangled kin; the other is not just in one's skin, but in one's bones, in one's belly, in one's heart, in one's nucleus, in one's past and future."[34]

The core mechanism of the networked subject is *emergence*, a "reworking of causality" that is "dependent not merely on the nonlinearity of relations but on their intra-active nature."[35] Emergence introduces complex irreducibility into the mix; the networked subject is not reducible to atomic forces nor is it strictly transcendental to them. It is merely mutually accessible to and with and as its community, environment, biome, universe.

Proponents of the networked subjectivity model also acknowledge Deleuze (via Spinoza) as a core reference point, e.g., the work of Bruno Latour, Manuel DeLanda, Isabelle Stengers, and Karen Barad. The neovitalist turn – to which one could attribute works like Jane Bennett's seminal *Vibrant Matter*, Donna Haraway's *Staying with the Trouble*, or Laura Tripaldi's *Parallel Minds* – further leans into the decentering of the human in favor of the uncanny "vitality intrinsic to materiality as such."[36]

FIGURE 1.2
Still from Logan Bruni's *Chat Room*.

The networked subject is "ontologically one, formally diverse."[37] While Newtonian subjectification tends toward atomization (infinitesima), the networked subject model takes infinitesima[38] as its literal point of departure. "Atoms Exist!"[39] shouts the first words of Stengers's *Cosmopolitics II*. "Though I find Epicureanism to be too simple in its imagery of individual atoms falling and swerving in the void, I share its conviction that there remains a natural tendency to the way things are," writes Bennett in the preface of *Vibrant Matter*.[40] While the networked subject model privileges the horizontal (rhizomatic, ecological), its underlying atomism bespeaks a vertiginous cascade of verticalities that escape dimensional confinement through the principle of emergence: "larger assemblages emerge from the interactions of their component parts, the identity of the parts may acquire new layers as the emergent whole reacts back and affects them."[41]

Unlike the hegemonic forms taken by power in Newtonian subjectification (subjection), the networked subject model diffracts and distributes power into an anarchic array of forces, relations, and processes ("thing-power").[42] A key figure here is Latour, whose concept of the Parliament of Things "corresponds to a delocalization of politics. It can be characterized in terms that derive from Leibniz: 'Not everything is political, but politics is everywhere.'"[43] Politics[44] itself, alongside the mechanisms of power and control, seems to bubble upwards from random perturbations in quantum foam, aggregating into larger and larger structures that consort, permeate, and interact with their generative, subdimensional quanta. Within the networked subject model, *agency is everything and agency is afforded to everything.*

But what if we loosened the tie between participation and human lan-
guage use, encountering the world as a swarm of vibrant materials
entering and leaving agentic assemblages? We might then entertain a
set of crazy and not-so-crazy questions: Did the typical American diet
play any role in engendering the widespread susceptibility to the pro-
paganda leading up to the invasion of Iraq? Do sandstorms make a dif-
ference to the spread of so-called sectarian violence? Does mercury help
enact autism? In what ways does the effect on sensibility of a video game
exceed the intentions of its designers and users? Can a hurricane bring
down a president? Can HIV mobilize homophobia or an evangelical
revival? Can an avian virus jump from birds to humans and create havoc
for systems of health care and international trade and travel?[45]

Networked subjectification accelerates the evaporative principle through a
strong focus on integrating non-anthropomorphic agency and object autonomy
into ubiquitous hyper-networks of relations. The subject defocuses into ambig-
uous assemblage amongst/within the entire universe of relations from which
it emerges and within which it slips and slides around. Everything connects
to everything else, orders of magnitude or separation lose their intensity – for
Karen Barad, the world is generated in real-time, "reality is an active verb".[46]

Events and things do not occupy particular positions in space and time;
rather, space, time, and matter are iteratively produced and performed.
Traditional conceptions of dynamics as a matter of how the values of an
object's properties change over time as the result of the action of external
forces won't do. The very nature and possibilities for change are reworked.[47]

While the networked turn largely focuses on physical objects, bodies, things,
agents, and Haraway's *critters*, it historically neglects digital objects. Digital
objects arrive onto the scene via Gilbert Simondon's *technical objects* and are
fully realized through Yuk Hui. From Hui: "an object is meaningful only
within a network"[48] and through Laura Lotti: "digital objects not only indi-
vidualize, developing and integrating an associated milieu, but also individu-
ate through their capacity to dynamically restructure their relations with other
objects, systems, and users in their associated milieus."[49] The digital world has
expanded into full integration with the physical world and digital objects coex-
ist with subjects of multiform materialities and forms within hybrid assem-
blages or milieus. Hito Steyerl writes "Ttthe internet has gone offline. [...] As
Minecraft Redstone computers are able to use virtual materials for calculating
operations, so is living and dead material increasingly integrated with cloud
performance, slowly turning the world into a multilayered motherboard."[50]

The contemporary art world has embraced the network subjectivity model
wholeheartedly. This intensified in the 1990s (wherein art became "a state of
encounter"[51]) and has since metastasized into an almost hegemonic ideological
platform within creative production more generally. Take, for example, strong
trends toward the ecological (Agostino Di Scipio's *Audible Ecosystems*, Ash

Fure's *Etudes from the Anthropocene*, Helen Mayer Harrison's work with straw-berries, Ai Weiwei's *Fukushima Art Project*, Pierre Huyghe's *Zoodram 5 (after "Sleeping Muse" by Constantin Brancusi)*, Olafur Eliasson's *Green River*, Matthew Barney's *Redoubt*) and the relational assembly (Kanye West's performance at the BRIT Awards in 2015, Rirkrit Tiravanija's *pad thai*, Tania Bruguera's *Surplus Value*, Johannes Kreidler's *Outsourcing*, Demna Gvasalia's antifashion projects at Vetements and Balenciaga, Ruangrupa's *lumbung* at Documenta 15 [inviting "community-oriented collectives, organizations, and institutions from around the world to practice lumbung with each other and work on new models of sustainability and collective practices of sharing"])[52] ... the list of trends and artists becomes so inclusive as to contain the virtual entirety of the last thirty years of institutional cultural production.[53]

An insurgent domain within the art world that throws itself with even greater abandon into multiple axes of relationality (physical, digital, ecologi-cal, sociopolitical, economical) is blockchain-based art. In neovitalist clad-ding, Martin Zeilinger asks "what might become possible when artworks gain agency?"[54] The answer bears the mark of the evaporative principle: Zeilinger asserts that the blockchain, specifically smart contracts, affords new dimen-sions of agency to an artwork by placing it within a universe, an empty box, within which it is capable of "reproducing," "evolving," and "dying."[55] Not only is an artwork liberated from one or many artists, its commercial owner-ship is "abstract[ed...] from any referent."[56] Moreover, it is even freed from consumption altogether, existing autonomously[57] as an executable within a blank and fungible container. (More on object-autonomy in the next section.)

Ryan Kuo drives home the evaporative ideology contained within the above:

> Unfortunately, the premise of an NFT is that there is never not some-thing. Its intention is to seal the existence of the something that has a value. As a result, there is no longer nothing. [...]
>
> An NFT offers a generic something: some thing, neither here nor there, which exists in order to escape being worthless (a born loser). It escapes to the address it is given, and its value is held precisely there.[58]

Web3 stans hype up the chain of abstract, pure relationality as a break with existing modes of social organization: an emancipatory, decentralizing rup-ture hewn in the fabric of power. However, Web3's "decentralizing" motion appears instead merely diffusive. What is a blockchain, or moreover what is a tree of blockchain branches and breaches, apart from an empty array of agencies and exchanges in which identifiers are subordinated to relations? What is on-chain cryptocurrency apart from the further atomization and abstraction of value through relativistic, ecstatic, real-time determination? What contemporary mode of social exchange is so explicitly ecological in terms of its cost, subordinating relations further to the resources they con-sume in order to trade, express, commune, or create? Decentralization is a reorganizing action, whereas evaporation is diffusive – evaporation is a pro-fusion of abstractions that annihilates order at every level.

Evaporation is a profusion of abstractions that annihilates order at every level.

1c Thing Mode [one:many → many]

"There is something out there."

— *Kiefer Sutherland as Nelson Wright in Flatliners,*
as sampled by Burial in "Loner"

Networked subjectivity approaches an idealism of the material: nonhuman, nonsubjective agents constitute reality through their relations. Conversely, shadow subjectivity approaches a nominal "materialism" of the ideal. Nonhuman, nonsubjective agents acquire additional domains of autonomy and removal from the ever-diminishing subject. In the networked sub-jectivity model, the subject emanates from quanta concurrently with the world and co-constitutes the world in relational harmony with a chaotic choir of things, forces, and ephemera. In the shadow subject model, the subject is thrown into a quiet, indifferent, alien landscape of unknowable, untouchable, dark forms. The shadow subject ponders "a manifestation of the world" that is "anterior to any human form of the relation to the world [...]."[59] While Quentin Meillassoux's thunderclap critique of subject-object correlation (the impossibility of "consider[ing] the realms of subjectivity and objectivity independently of one another")[60] may have pulled the trig-ger on many accounts of shadow subjectivity, it is the appropriation of his work by Object-Oriented Ontology (OOO) that animates and maintains this model in the social and cultural sphere.

For Graham Harman, an "'object' simply means anything – be it natural or cultural, physical or ideal, material or semiotic – that cannot be reduced either downward or upward, which means anything that has a surplus beyond its constituent pieces and beneath its sum total of effects on the world."[61] Harman argues that to the networked subject (e.g., Bruno Latour's Actor-Network Theory), "there are no objects" – only relations.[62] The net-worked subject model constitutes things through their actions, but "if objects are autonomous, they must be more than actors."[63] Objects exist totally inde-pendently to the shadow subject.

Shadow subjectivity is a negativistic exercise. As Timothy Morton writes, "since the human subject is no longer the guarantee of why things exist, it must be the case that what is special to human subjectivity – that it correlates things to itself – is not so special after all. Perhaps everything is at it."[64] And then: "Phenomena such as human subjectivity [...] occupy small regions of this larger space of interobjectivity."[65] The shadow subject remains a lattice, a matrix, but one inscribed *negatively*, through the alienation between the sensible and the real. Harman defines this principle as a relational model of *withdrawal*: "the real problem is not how beings interact in a system: instead, the problem is how they withdraw from a system as independent realities while somehow communicating through the proximity, the touching with-out touching, that has been termed allusion or allure."[66]

The shadow subject's experience is alien, strange, weird, and often queer. Katherine Ngaio Connell's thesis *Objects in Human Drag: The Queerness of Object-Oriented Ontologies* contends that "unknowability and elusivity, emergence and withdrawal, mimesis and otherness are not only object-oriented responses to anthropocentric categories that regulate thing-being, but are queer responses to identity categories that objects in drag produce."[67] Sara Ahmed is one of many to pioneer this through-line in *Queer Phenomenology: Orientations, Objects, Others*. Ahmed's queer phenomenology brings "objects to life in their 'loss' of place,"[68] describing an "alien" encounter between a doorknob and a hand ("the hands can easily be alien objects" as well):

> How did you get here? How did I come to have you in my hand? How did we arrive at this place where such a handling is possible? How do you feel now that you are near? What does it do when I do this with you? To re-encounter objects as strange things is hence not to lose sight of their history but to refuse to make them history by losing sight.[69]

Artist Jes Fan's work directly engages with the autonomous play of charged chemicals, metaphorically engaging with material flux, queerness, and designification. "I pour silicone inside the vessel. Then I inject melanin, testosterone, and also estrogen, and also fat. [...] Once they're removed from the body, the site of identification, like, 'What are they?'"[70] they ask.

Strangeness can yield to horror,[71] and horror (self-conscious alienation) is another process through which the shadow subject is constructed. Timothy Morton's conception of the hyperobject – "things that are massively distributed in time and space relative to humans"[72] (think of global warming as an iconic hyperobject – too large to truly understand, proximal enough to inhabit) – elicits "a terror beyond the sublime, cutting deeper than conventional religious fear."[73] The subject shrinks in the midst of the raw material, the ancestral, the ancient, the deep future. Andrew Strombeck notes that "Graham Harman, Timothy Morton, and Eugene Thacker cite H. P. Lovecraft, asserting that the original weird writer's cosmic indifference dovetails with their concerns about inaccessible materiality."[74]

A surprising, if controversial, contributor to what this chapter calls shadow subjectivity is Nick Land – another member of the "Cthulhu Club." Land predicts Morton's hyperobject by endlessly cataloging its subjective experience:

> You can't stop what can't be stopped.
> You can't touch without being touched.
> The horror.[75]

The evaporative principle itself is taken from Land, stated literally in *No Future*: "amongst the strobes, artificial cool, and inorganic attack beat, darkside K-war machinery resiliently persists [...] where promiscuous anorgasmic sexuali-ties slide across tactile space [...]" one "tracks the passage of

evaporating subjectivity on the zero-degree plane of neuroelectronic continuity."[76] However, Land's evaporation goes nowhere; there is no affirmative dimension to vaporization as discussed later in this chapter. Mere annihilation, unblocking the ambitions of this or that technodemon.

Paraphrasing Land heavily: a subject evaporates in the experience of singularity. One might forgive the block quotes, as the writing style itself articulates a subject evaporating in the face of things dramatically in excess of themselves at all levels:

> Techno-commercial interaction between planet-scale oceanic-navigation and zero-enabled mathematico-monetary calculation machinically singularises modernity or Sol-3 capitalism as a real individual: a geo-historical nucleotelic system, based upon regeneratively techno-propagated concentrational scale-economies, and tending to immuno-securitised self-identification as hyper-mediated global-micro-technic command-control. It arms-races smooth cultural decoding to flat-schizophrenisation against episodic social recoding to hierarchical robo-tism and algorithmic control, coupling the meltdown of organization into the jungle with its restoration as virtually totalised global order.[77]

In *The Dark Forest*, the second installment of Cixin Liu's science fiction trilogy *Remembrance of Earth's Past*, Liu explains away the Fermi paradox through a condition of universal paranoia. The quality of a given alien civilization's sentience is attributed directly to their ability to hide themselves: "[t]he universe is a dark forest," Liu writes, "[e]very civilization is an armed hunter stalking through the trees like a ghost [...]. The hunter has to be careful, because everywhere in the forest are stealthy hunters like him." Given the raw contingency of the universe, any nascent civilization may develop into a threat, so if the hunter "finds other life [...] there's only one thing he can do: open fire and eliminate them."[78] In *The Mist*, written during the last decade of the Cold War, Stephen King describes a deep, cloaking fog descending upon a small town in Maine.[79] Like the cloaked threads in the *Dark Forest*'s universe, the mist is home to unknown, violent horrors (tentacles, insect-like creatures, colossal monstrosities), and the residents of the small town barricade themselves inside a supermarket to keep the mist at bay.

The shadow subject self-sustains in detente with the unfathomable world of objects – alert and inquisitive, either compelled by queer encounter with the alien or paranoid to sudden movements or changes that could signal the shadow subject's immediate extinction. Of the three subjectification models proposed here, the shadow subject is the closest to vapor, consisting in the compulsive accounting of the remaining components that remain tangibly and discretely itself (Figure 1.3).

FIGURE 1.3
Still from Logan Bruni's *Chat Room*.

2 Vapor Space [one (→ many) → none]

Human and nonhuman *Users* are positioned by The Stack (perhaps rudely) as comparable and even interchangeable through a wide-ranging and omnivorous quantification of their behaviors and effects. The preponderance of data generated by *Users* and the traces of their worldly transactions initially overtrace the outline of a given *User* (e.g., the hyperindividualism of the quantified self movement), but as new data streams overlap over it and through it, the coherent position of the *User* dissolves through its overdetermination by external relations and networks. The *User's* enumeration is first a grotesquely individuated self-image, a profile, but as the same process is oversubscribed by data that trace all the things that affect the *User*, now included in the profile, the persona that first promises coherency and closure brings an explosion and liquefaction of self.

— Benjamin Bratton in The Stack: On Software and Sovereignty

Arrival in vapor space: atomized, dedifferentiated, decorporealized, desynchronized. Loose mist of subcontracted cognitive minutiae. Cleaved from the noumenal but also cleaved from the products of one's own consciousness, thought-products that emanate upward like little sperm, autonomous in their own existence and relations. No-time, zero-time, no-present, no attention, no manifestation, no presence: steam from the body-brain through the eyes and ears commingling with everything ever. Far less than the "dissolution of the metaphysical concepts of reality,"[80] vapor space exists anterior

to and simultaneous with reality (choose your definition), a hyperdimensional extension of reality, an exit vector for both human consciousness and its reflexive self-construction as a subject. Thanatropic regression – via Negarestani: "the organism (as an index of interiority) temporarily extends from the inorganic state yet it is energetically driven … to its precursor exteriority by flexing its contraction back to the inorganic"[81] – empowered and amplified by data.

Vapor space, a psychosocial product of postmodern experience (itself a co-product with and of capital, with and of societies of control),[82] is unevenly distributed across the globe. It co-exists with all flavors of postmodernity expressed above, as well as innumerable other modes of described contemporary existence, but vapor space tends toward ubiquity. Vapor space is not just real but has been among us for some time. Vapor space automatically, unthinkingly enacts AI. It scopes AI, it limits AI, it holds and hosts AI, it expresses itself as AI – not as a revolutionary object but simply as a natural and neutral automatic predisposition.

What incredible hubris it is to assume that the apotheosis of modern computation would assume a form resembling human consciousness, as opposed to sharing the mechanistic visage of capital.[83] What hubris it is to position AI as the inheritor of subjectivity as opposed to an indifferent, local expression of the subject's gradual diffusion and destruction.

2a Vapor Capital

> SRNICEK:
> Are machines always on the side of capitalism?
> Or rather, is capitalism always on the side of machines?"
> NEGARESTANI
> "[...] I think capitalism is on the side of machines.
>
> — *Nick Srnicek and Reza Negarestani in conversation*

Capital itself is not immune to evaporation. Upstream or downstream or both, vapor drives through all walls, systems, and structures. Nick Srnicek, including his work with Alex Williams and Helen Hester, describes a recent transition in capitalism that can be mapped onto the evaporative principle. Not the end of capitalism per se (e.g., McKenzie Wark[84]), but a transition from *neoliberal* capitalism (distributed, outsourced, modular) to *platform* capitalism (social/micropolitical/biopolitical hosts, built on data, sustained through network effects[85]). While Srnicek articulates a process of recentralization characteristic to platform capitalism (e.g., the prominence of MAANG – Meta, Amazon, Apple, Netflix, and Google – in terms of market capitalization and monopolistic dominance), there is also a simultaneous process of diffusion. The drive to total monopoly, the drive to hold and sustain the entire world, is of course also a drive toward dedifferentiation. Srnicek calls this drive the

What incredible hubris it is to assume that the apotheosis of modern computation would assume a form resembling human consciousness, as opposed to sharing the mechanistic visage of capital. What hubris it is to position AI as the inheritor of subjectivity as opposed to an indifferent, local expression of the subject's gradual diffusion and destruction.

"convergence thesis: the tendency for different platform companies to become increasingly similar as they encroach upon the same market and data areas."[86] The difference between Meta, Amazon, and Google – all data aggregators, ad-sellers, and digital marketplaces – blurs into mere UX design choices, if that.

Srnicek underlines the ramp-up to platform capitalism as the rise and fall of neoliberal "lean platforms." The lean platform reflects the application of the evaporative principle to corporate structures: a lean platform is a corporation that is essentially asset-less, so subcontracted to infinity that there exists almost no overhead apart from a name and perhaps a few lines of proprietary code. For Srnicek, the reconsolidation motion from neoliberal leanness to platform capital bulk marks a "concentration of ownership."[87] Breaking from Srnicek, this chapter argues that the evaporative principle continues to erode ownership and property as traditionally conceived. Property is a relation, it does not really exist in relationless vapor space. Intellectual property, whose death at the hands of Generative AI is alleged by boomers everywhere,[88] has died a long time ago – not even at the hands of the digital (e.g., the DRM wars of the nineties and aughts), but merely through the abstraction of the principle of property itself due to the implosion of any and all localizable owners (e.g., the chains of platform technology leveraged to produce and consume creative work). Despite the trend toward centralization, there exist such rich and chaotic interiorities to spaces like Alphabet (see a recent *Business Insider* list[89] for the unreal polymorphism contained inside Google's holding company) that attributing concepts like hegemony or monopoly to these organizations feels subtly incorrect. Certainly, these companies *own* "the infrastructures of society,"[90] but as each company lays claim to the world, the ownership of a world by a world feels tautological, the subjugation of any and all relations to complex, diffuse, and arbitrary technopolitics feels like an *intensification* of Srnicek's leanness.

Each of these major platforms typically contains their own, if not many of their own, satellite corporations that develop AI-adjacent technology,[91] now including AI's hardware dependencies by disrupting and diffusing Nvidia's GPU monopoly (Apple, Meta).[92] Like the MAANGs themselves, there exist few distinguishing characteristics amongst the AIs therein constructed. Instead, we approach a convergent and dedifferentiating AI through evaporation on all sides (Figure 1.4).

2b Natural Language Models

Much like how Srnicek's *convergence thesis* describes how massive technology multinational corporations gradually dedifferentiate as they grow, there exists a similar dedifferentiation motion at the level of the largest current AI systems. OpenAI's GPT-4, the Beijing Academy's WuDao 2.0, and Google's BERT resemble each other not just in terms of scope (natural language modeling, multimodal and multimedial inputs and outputs, common applications) and massive corporate co-sponsorships and partnerships (thirty-plus (!) for

FIGURE 1.4
Still from Logan Bruni's *Chat Room.*

WuDao 2.0, including Alibaba[93]), but also in terms of architecture. All three careen along convergent paths, outpacing each other here and there in terms of this or that refinement to a common deep learning architecture. The creator of WuDao 2.0 (as of the time of writing this chapter, still the largest natural language model in the world), Tang Jie, speaks to a process of competitive discovery of the "Mixture of Experts" (MOE) computational principle between his team and the team at Google Brain:

> Actually, last year when Google published MOE, we actually already have the code. We also want to publish that paper, but Google released that paper. We have no chance to publish it. So, we actually, we developed the open-source code, we call it FastMoe. So, the code is totally open source on the website and each much faster than the MOE by Google.[94]

The underlying architecture of WuDao and BERT and GPT-4 is the transformer, an innovation in deep learning technology developed by a team at Google Brain in collaboration with the University of Toronto.[95] Transformers represent a breakthrough in the ability for deep learning systems to handle ordered, sequential data (e.g., sentences) in efficient, parallelized ways.

The training process of a large natural language processing transformer involves the prior assembly of massive webs of associations: embeddings. Embeddings correlate content similarity with proximity: within n-dimensional vector space, Z content is abstracted to an n-dimensional vector, and z_0 is related to z_1 by virtue of proximity. The number of dimensions within an embedding is a dynamic product of the possible values the system is

capable of producing (Google's developer course suggests a reasonable benchmark is *dimensions* $\approx {_4}\sqrt{Z}$).[96] An embedding thereby defines difference and meaning not as a function of *content* but as a function of *volume of content*. Embeddings are often repurposable or fungible media, many of which are free-to-use for applications in various deep learning projects. These embeddings are constructed through massive web-scrapes, for example, of Wikipedia,[97] using complex data-mining tools.[98] There exists a growing universe[99] of embeddings, each of which constitutes a representation of the world within which a given content element z_x exists in fixed relationships of difference with all other elements.

Transformers can leverage one or several embeddings in order to accomplish tasks like language translation. For example, translating z_x from English to French involves accessing the vector of z_x within an English embedding and correlating it to the probable positioning of o_x within a French embedding. The ability to correlate individual elements within two hyperdimensional vector spaces is legacy technology – what transformers bring to the table is the ability to translate sequential structures, like sentences. Transformers abstract complex sentences into relations, *sequential* relations, deriving the context of a given sub-element of a prompt or training data from the encoding of its sequence position vis-à-vis all other elements.

Transformers afford sequence order a central determinative role in determining context and interpolating information. Like in an embedding, the content itself is subordinated to location – in this case the positional encoding of an index (itself typically an integer reference to a vocabulary dataset). In doing so, transformers encode meaning as a relationship between spatial (embedding) and temporal (positional) functions.

While the transformer's encoding process happens simultaneously, passing the entire input sequence as a collection of tokens and positions through an embedding, the transformer's decoding process involves an autoregressive loop. Each successive output from the decoder is passed to its input in order to generate the next output. Oftentimes this process involves feedback from previous inputs as well, or from combinations of different inputs (e.g., beam search). Despite a gradual trend toward parallel processing (e.g., in the transformer's encoding process), autoregression remains a critical temporal structure to the transformer as it does to many deep learning networks and algorithmic processes more generally.

The transformer itself is a convergence phenomenon within the broader field of AI. Far from a generic intelligence, the term "AI" has come to refer to a narrow ideological plank. From AA Cavia and others, synthesized by Reza Negarestani,[100] the first of these ideologies is "Turing Orthodoxy," "a reduction of the computational to the machinic."[101] Turing Orthodoxy refers to the dogma that every problem can be solved through Turing machines[102] (through axiomatic logic). Turing Orthodoxy is based in part upon two opposing but fungible epistemologies,[103] "computational functionalism" (the idea that the brain is a computer and thought is intrinsically computational) and "computational

realism" (the idea that the universe, through its exercise of discrete physical principles, is a computer or bound to axiomatic, computable principles). A second ideology underpinning narrow AI is what Negarestani and others call "New Empiricism" – a Silicon Valley epistemology through which data *itself*, simply by virtue of sufficient quantity, is a generator of meaning. "New Empiricism tries to make theoretical scientific research redundant" because its conclusions are possible through data, through "inductive analysis"[104] alone. A third plank – one very much at the center of the other two planks – is "Hard Naturalism," which Negarestani associates with Daniel Dennett. Simply put, Hard Naturalism asserts that "sheer brute recursive processes can tend toward artificial intelligence."[105] The ideological basis for "narrow AI," within which the transformer idly converges, is – of course – the evaporative principle: the exteriorization, inscription, and subordination of experience, intelligence, and consciousness to the 0-degree plane of neuroelectronic continuity.

2c Position and Autoregression in Vapor Space

> Data is the antithesis of narrative.
>
> — *Joshua Citarella in Raw Eggs, Pink Pills, and Embodied Identity*

The concepts explored above vis-à-vis transformers are *inherited* from vapor space:

Position versus **Difference**: Vapor space subordinates the material or phenomenal to the indexical. In vapor space, tokens or indices refer to positions within this or that container: in the instance of the transformer, it can refer to a relation between a phenomenal entity and a position within a database, sequence, embedding, etc. Such a relation need not be confined to a single container, but can consist of multiple container-relations (e.g., the relationship between vocabulary dataset, positional encoding, and language embedding within a transformer).

Indexification is more abstract than simple representation (e.g., digital representation). Representation is a compound play of difference between signified and signifier. In vapor space, an entity exists insofar as it is already indexed. There is no relationship between signifier and signified apart from the most arbitrary mechanics (e.g., alphabetical order or hash value). Indexification necessarily involves planes of dedifferentiation: an index is an index is an index. A poem can be mapped into a relation with a car through proximity among one or many embeddings. Vapor space provides a vehicle for the translation of anything into anything else through annihilation. Vapor space provides Jacques Derrida with transcendental signification not through a process of opening into new, transcendental planes, but rather through the closure and constriction of experience through the evaporative principle into planes of universal exchange.

Autoregression and **Sequence**: Vapor space consists of autoregressive machines. Autoregression is the main mechanism of motion within the

substrate of indexed space. Autoregression situates a linear relationship between dependency (consumption) and inference (production).

An autoregressive machine is a dimensional contraction of the auto-poietic or allopoietic structures that define Deleuze and Guattari's machinic assemblages as they disperse through vapor space. Instead of a networked, organic, dynamic assemblage, an autoregressive machine is a crawler, a Turing machine, a process that ingests content and out-puts a next step. Unlike Guattari's autopoietic machine (which reproduces itself), an autoregressive machine produces nothing, since content within indexed space is already preinscribed with instruction. Unlike Guattari's allopoietic[106] machine (which produces new entities), there is nothing in vapor space that is new.

For strictly autoregressive entities, there exists no element of memory – only a model of translation from ingestion to instruction. For a strict autore-gressive machine, time does not exist, nor sequence number, iteration count, loop level, etc. Time is thrown up while the machine moves, but requires an external observer to identify it and catalog it as such. Vapor space is not absolutely determined, however. Like in Turing's halting problem, there is no absolute, determined path to an autoregressive machine within vapor space from its initialization. However, when the autoregressive machine reaches a terminating character, it dies absolutely. Death is announced only through the translation of the penultimate step (e.g., sentence terminator), and the autoregressive machine marches resolutely toward its own annihi-lation from there.

When an external observer catalogs the movements of an autoregressive machine, a sequence emerges. Sequences, by virtue of containment along the surface of indexed space, contain no meaningful differentiating characteristics and in fact every content element within indexed space is already a sequence (e.g., a vector, a tensor). A general characteristic of vapor space: every sequence exists relative to every other sequence via arbitrary positional relationships. Vapor is hard to contain and moves fluidly through even solid boundaries.

2d Vapor Aesthetics

> [GPT] Chat did not change the nature of thinking and writing, thinking and writing had already changed. That's why we have GPT Chat.
>
> — *Mohammad Salemy, Instagram Post*

> (Re: ChatGPT): "It's a lying machine!"
>
> — *Dasha Nekrasova, Red Scare*

The autoregressive machine, chained loosely in abstract sequences, has a central position in vapor aesthetics. Vapor space is internally nonaesthetic; there are no

discrete objects or structures in vapor space nor are there perspectives or contexts with which to generate aesthetic relations. However, the arc toward vapor – as represented by the evaporative principle, as perceived from outside of vapor space – has injected itself visibly into contemporary modes of social expression.

Vapor aesthetics – or rather the aesthetics of vaporization – involves fungible, wholly consumable vehicles through which a value-neutral, indifferent sequence of ingestion and translation proliferates. Certainly the most obvious example of this is the meme, the "entire visual paradigm"[107] of the last twenty years of social performance. Definitions of memes focus less on content, which is so variable as to include the virtual entirety of digitally representable media, and rather on the velocity with which a meme is reconsumed and transformed.[108] While distinct strata of memes are articulated in terms of format (e.g., the "galaxy brain," the "is this a pigeon"), the formats themselves are equally fungible and mutually consumable. Memes are sufficiently dedifferentiated that it is more possible to speak of meme-space[109] or a single meme monad than it is possible to identify a single stratum for analysis. This tendency (toward diffuse space or toward monad) is of course a characteristic mark of vapor space.

Memes have already been endlessly theorized in a number of ways: from social and political impact, their relationship to image culture, their uncanny resistance to monetization as well as regulation and copyright claims (a characteristic of vapor space). Memes are autoregressive structures.

Postmodern cultural production in general tends toward autoregressive structures. The word "generation" in the term "content generation" does not refer to the *generative* act of making *new content*, but rather the subordination of content to its production. The term "generation" increasingly denotes the consumption-reconsumption action of the autoregressive process. For example, consider the autoregressive sequence through which a news report travels from reporting, commentary, reaction commentary, meta-reaction commentary, and recap commentary – a motion epitomized by the live-streaming industry, which is almost entirely sequential meta-commentary[110] presenting not only *n*-order experiences, but simultaneous first-, second-, third-, even fourth-order sequences of reconsumption.

Artist Joshua Citarella makes the point that as both margins and price-points for creative work shrink, so does the "time-dimension" of the work itself: one may only need to sell one $100K time-invested work per year, but one needs to sell 1,000 $100 bedroom art pieces, or 10,000,000 $.01 micro-experiences. Citarella jokes that artists become podcasters[111] due to the need to generate these granular products, and in turn much of those products become meta-commentary on work, the creative process, or merely live-streaming one's entire life.[112] This trend toward oceanic volumes of cultural microproducts can be associated with run-of-the-mill neoliberal prosumerism, but there's more here than meets the eye. While classical accounts of neoliberal prosumerism[113] integrate the subject as an active participant in a joint consumption-production process (e.g., the customization of products,

creative work hosted on digital platforms, etc.), in fact the subject has become more and more *passive* as both consumer and producer, a receding witness to a spectacle of fully autonomous consumption-production that occupies more and more of the subject as a substrate or pass-through medium. Hito Steyerl describes the author-function of spam, proposed here as another major vapor aesthetic: "a performative chaos in which actors, consumers, spam and service workers become indistinguishable. The linear and teleological progression of history [...] is discontinued. [...] People are being included into the world of spam and turned into potentially edible matter."[114] Machine perception supplants human perception; calculation supplants sensation.

ChatGPT provides another great, if obvious, example of the shrinking human-in-the-loop within production-consumption chains: the labor investment in cultural production is not necessarily becoming smaller but rather the share of labor directly performed by humans is being increasingly offset to computation. Fully autonomous chains of cultural consumption-production, with human observation trending toward zero, already circumnavigate the internet in the forms of bot-generated YouTube channels,[115] algorithm-gaming Spotify audio,[116] and artificially generated and maintained websites. Revenue circulates arbitrarily from platform to bot to hosting service to SaaS module, touching humans here and there but largely sticking to itself.

Some elements within a given autoregressive chain resist outright overwrites, persisting as hauntings and ghosts. In *Ghosts of My Life*, Mark Fisher defines haunting as "... a failed mourning. It is about refusing to give up the ghost or [...] the refusal of the ghost to give up on us."[117] The Generative AI community has already circulated memes around resistant strata within tools like Stable Diffusion and DALL·E MINI, like *Loab* – a phenomenon-slash-creepypasta of a dreary-looking older woman who manifests in numerous prompts.[118] In Mark Fisher's interview with the musician Burial (Fisher's icon of hauntology), Burial comments, "there's nothing worse for a human being than to see a face where it doesn't belong."[119] Seeing a face where it doesn't belong may be the defining characteristic of vapor aesthetics: compulsive apophenia. Conspiracy theory, for example, has enjoyed abundance under the regime of vapor; power idly allows for the proliferation of random chains to assume this or that manifestation for periods of time before dissolving back into mist.

If there's any trend-forecasting near the end of this chapter, it is this: vapor aesthetics will likely be contained to the experiences of passive observers bearing witness to fully autonomous cultural production and "refusing to give up the ghost." The near future of human creative practice may involve little more than cloud-reading, storytelling about patterns in the mist (Figure 1.5).

The near future of human creative practice may involve little more than cloud-reading, storytelling about patterns in the mist.

FIGURE 1.5
Still from Logan Bruni's *Chat Room*.

2e Hyperdimensional All-Human Orgy

> Are you ready for Brain Transparency?
>
> — *World Economic Forum 2023*

The subject enters vapor space through one or many processes of evaporation: its determination through smaller and smaller forces, its subordination to network relations, its shrinking negative inscription against alienating noumena. In vapor space, there are no subjects: only autoregressive diffusion processes within a hyperdimensional plane of dedifferentiated quanta. However, as noted earlier, vapor space has not yet saturated reality and is therefore apprehendable as phenomena.

The inscription of subjective experience onto shared, neutral, public axes opens up new possibilities for entanglements between individuals. The emanating periphera from evaporating subjects interpenetrate and commingle as telecommunications technologies develop and globalize. Luciana Parisi's *Abstract Sex: Philosophy, Biotechnology, and the Mutations of Desire* begins with this proviso: "[in] the age of cybernetics, sex is no longer a private act practiced between the walls of the bedroom."[120] Indeed, this section asserts that sex and reproduction have undergone a comprehensive transformation under the regime of vapor.

In fact, it is precisely a process of human cybersexual[121] reproduction at the highest scales that has produced the hyperdimensional lattice of quanta of vapor space. Borrowing further from Parisi:

> Primarily sex is an event: the actualization of modes of communication and reproduction of information that unleashes an indeterminate capacity to affect all levels of organization of a body – biological, cultural, economical and technological. Sex is a mode – a modification or intensive extension of matter – that is analogous neither with sexual reproduction nor with sexual organs. Sex expands on all levels of material order, from the inorganic to the organic, from the biological to the cultural, from the social to the technological, economic and political. Far from determining identity, sex is an envelope that folds and unfolds the most indifferent elements, substances, forms and functions of connection and transmission.[122]

Parisi's abstraction of sex into inorganic domains invites new and more complex reproductive relations into the scene. Parisi is not just invoking classical disciplinary biopower (e.g., the "disciplinary logic of industrial capitalism" which specifically involves top-down reorganizations of sex and reproduction[123]) but further, the *"real subsumption* of all machines of sex actualized through biodigital modes of information transmission"[124] as exercised under postmodern control societies and beyond. As technology moves to capture and decode the biomechanics of reproduction on smaller and smaller scales, reproduction changes from the repressive structures of disciplinary societies to the modulatory structures of control societies (wherein the "autonomy" of the variables of reproduction are "captur[ed], produc[ed], and multipli[ed]")[125] to full anarchic autonomy and independence from the subjects of reproduction.

Reproduction, as far as this chapter is concerned, is the same thing as information transmission. Information exchange within the vapor space far exceeds the strictures of disciplinarity or mutations of biodigital control. The "circuits" of cybernetic "reproduction" incorporate "the data analysis of behaviors, the contextual use of content and the sourcing of knowledge" into itself, "expos[ing] human consciousness to computational forms of mindless decision-makings"[126] and autonomous proliferative logics much like those described above.

The regime of vapor is a massive, passive, orgy. While Holly Herndon has claimed the term spawning to refer to "the ability to create works in the likeness of others by interacting with a model trained on them,"[127] the metaphor of spawning divorced from Herndon's context serves up an image well: a turbulent, dispersive jettisoning of genetic material – a colossal centrifuge of digital gametes inclusive to humans and nonhuman information-generators, as unevenly distributed in representation and prescription as the ambivalent Darwinism of fish reproduction. This orgy far pre-exists AI, algorithm-driven social computation, and to a certain extent the internet, though certainly these technologies have accelerated its pace, increased its volume of orgy-goers, and magnified the visibility of its hybrid offspring. Participation in this orgy consists of one simple prerequisite: evaporation.

While capitalism "abstracts codes and territories (forms and substances of expression and content) from all strata and reassembles them on a new abstract plane channeling their potential of differentiation in multiple directions,"[128] so too does the evaporating subject, hemorrhaging lossy biological memory, seek digital memory locations with which to store and reference itself along that very abstract plane. Like bank accounts, these storage locations are never neutral but rather dynamic sites of reinvestment and reproduction.

The genetic centrifuge is enormous, and recognizing oneself in it is challenging if not impossible. Certainly, one can over-inscribe oneself in isolated instances of the genetic centrifuge – e.g., Herndon's concept of spawning, or the author's own work with the *Demiurge* audio GAN engine[129] – and from there extrapolate what co-participation in larger orgies like GPT-3 or Stable Diffusion might feel like. But the game of orders of magnitude quickly adds up, as does the human biological curse to over-index patterns.[130]

Instead of myopic focus on the individual, scholarship tends to focus on larger-scale Darwinisms as represented within the ever-globalizing genetic centrifuge: for example the tendency of AI image generation tools like DALL·E 2 or Stable Diffusion to identify an "attractive person" as white or "poor person" as a person of color, or to over-index an image of a worker with a given occupation as a stereotypical archetype of that occupation ("gender imbalance in an occupation corresponds to extreme gender imbalance in [...] generated images").[131] Much scholarly work in social algorithms, especially in the context of AI, laments the raw difficulty in debiasing models, precisely due to the complexity with which bias is encoded within these structures. AI does not merely amplify existing bias, but further it develops "modes of predictive learning that engage with hypothetical reasoning"[132] – an AI does not merely reinforce racism via softmax normalization and hegemonic dataset-overrepresentation, but further it becomes a generative engine of new racist logics. In turn, some studies approach a likely justified fatalist technophobia, urging users to "exercise caution and refrain from using such image generation models in any applications that have downstream effects on the real-world."[133]

Numerous scholars have pointed out that dedifferentiation is itself an encoding of power, from Elizabeth Grosz ("the supposedly neutral, sexually indifferent, or universal status of knowledges and truths hides the specifically masculine interests that produce them"[134]) to Luciana Parisi in *Abstract Sex* ("the most classical of patriarchal dreams: independence from matter"[135]). While social algorithms or massive natural language models both amplify existing bias and freewheelingly iterate new logics of bias, they do so in accordance with a mode of subjective experience that inscribes bias into the fabric of a broader plane of dedifferentiation. Not only does bias proliferate under the regime of vapor, it exists in such a way that it becomes increasingly unanalyzable as such – inscrutable, hidden logics composed of microdecisions at the level of quanta, parts of ourselves so small as to be unrecognizable commingling within the hyperdimensional all-human orgy and emerging as innovative new fascisms.

At the same time, a new relational mode has appeared for just a moment, prior to the closure of relationality in vapor. This relation involves the bilious comminglings of subject-particles, not yet fully atomic, still tethered to thread-like transversals and loose associations to and from subjective experience. The individual is invisible, but for a moment vast swaths of humanity can co-imagine themselves together, as reproductive inputs whose genitals have convolved and stretched into a rats' nest or mindworm boil. Loose and uncanny solidarities can form at the precipice of absolute risk. Catherine Malabou, through Reiner Schürmann, correlates the "self-destruction" of ontology (here as punctuated by Heidegger) with the advent of anarchy proper.[136] Malabou exhorts anarchist thought to assume new dimensions and scales of contingency. Ontological anarchy, vapor anarchy, perhaps the regime of vapor invites anarchisms of unthinkable degrees.

3 Postscript on Heaven

> I might stay M.I.A., I might go M.I.A.
> I might stay M.I.A., I might go M.I.A.
>
> — *Lil Xan, "Slingshot" from Total Xanarchy*

> He of the Seraphim most absorbed in God,
> Moses, and Samuel, and whichever John
> Thou mayst select, I say, and even Mary,
> Have not in any other heaven their seats,
> Than have those spirits that just appeared to thee,
> Nor of existence more or fewer years;
> But all make beautiful the primal circle,
> And have sweet life in different degrees,
> By feeling more or less the eternal breath.
> They showed themselves here, not because allotted
> This sphere has been to them, but to give sign
> Of the celestial which is least exalted.
>
> — *Dante in Paradiso*

In *Paradiso*, Dante describes the subjective experience of heaven as a domain of intensity through which God (the One) expresses presence. Subjects emerge strictly and essentially in their capacity to "give sign" to God and are differentiated as such by "feeling more or less the eternal breath."[137] A hard reading of this text could interpret these vaunted figures as apparitions, provided by God (or ether) to the observer in order to render this etheric realm sensible.

What becomes of the subject as it limits to zero?
The receding subject quiets and slowly becomes a
facile, passive observer of its own consumption. Its
capabilities shrink as alien, autonomous processes
fully territorialize its materials.

What becomes of the subject as it limits to zero? The receding subject quiets and slowly becomes a facile, passive observer of its own consumption. Its capabilities shrink as alien, autonomous processes fully territorialize its materials. Its ability to think fractures as threads of cognition are subcontracted to perform various, unrelated, abstract computational tasks. It detaches from time, becoming a type of short-term memory storage vehicle through which experience is channeled, briefly, elsewhere. Its ability to discern other subjects, to generate intersubjective relations, loosens (though it watches the mist and speculates at who or what may be in there). The vaporizing subject's physical body desexualizes and idles in pre-pubescent stasis; whatever remaining parasexual tendencies are executed as needed by whatever thread stumbles upon them.

Its politics idly articulate the cryptic, arbitrary, contradictory cruelties tacitly woven into vapor space. Heaven is a metaphor here not for bliss, but rather for purification or distillation. If emancipatory politics appears, and hopefully it does, it is unrecognizable to the subject as emancipation or as politics. It is executed at thread-levels spanning billions or trillions of computational subcomponents, logits, weights, and biases.

Consciousness transforms, or moves, or merely dims. AI tends toward human subjectivity and consciousness insofar as human subjectivity and consciousness tend toward the contingent, random frenzy of Turing machines transforming states into next-states. The drift of thought in vapor space might look like the protagonist's hibernation fetish in Ottessa Moshfegh's *My Year of Rest and Relaxation*:

> I had no visions. I had no ideas. If I had a distinct thought, I would hear it, and the sound of it would echo and echo until it got absorbed by the darkness and disappeared. There was no response necessary. No inane conversation with myself. It was peaceful. A vent in the closet released a steady flow of fresh air that picked up the scent of laundry from the hotel next door. There was no work to do, nothing I had to counteract or compensate for because there was nothing at all, period. And yet I was aware of the nothingness. I was awake in the sleep, somehow. I felt good. Almost happy.[138]

Nick Land's manic techno-nihilism suggests that through the "acceleration of global capitalism the human will be dissolved in a technological apotheosis, effectively experiencing a species-wide suicide as the ultimate stimulant head rush."[139] Vapor is the opposite of that: through the diminution and exteriorization of its subjectivity, with the loose and ambivalent cooperation of global techno-capitalism, the human embarks upon a species-wide slumber:[140] recession, merciful quiescence. Exit experience.

FIGURE 1.6
Still from Logan Bruni's *Chat Room*.

Notes

1 Barad, Karen, Meeting the Universe Halfway, 2007.
2 Metrics from SleepTracker.com.
3 Metrics from Apple's Health App.
4 Luther, David. "35 Metrics Businesses Need to Track." Many of these are likely obsolete and replaced by additional metrics now.
5 Dena Yago identifies the trend from macro-influencers to "lower-liability micro influencers" in "Content Industrial Complex."
6 See the 2022 interview with Aleksandr Dugin by Unregistered.
7 Foucault, Michel, "Lecture of March 1st, 1978."
8 Deleuze, Gilles, "Postscript on the Societies of Control," 1990, (3–4).
9 Galloway, Alexander, Laruelle: Against the Digital, 2014, (99).
10 Deleuze, Gilles and Guattari, Félix, A Thousand Plateaus, 1987, (456–457).
11 Galloway, 2014, (100).
12 Deleuze, 1990, (4).
13 Hardt, Michael and Negri, Antonio, Empire, 2000.
14 Crenshaw, Kimberlé, "Demarginalizing the Intersection of Race and Sex."
15 Foucault, "Lecture of March 1st, 1978," translator's note, (xxiv).
16 Brown, Wendy, States of Injury, 1995, (5). See for example the early work of Donna Haraway: "no objects, spaces, or bodies are sacred in themselves; any component can be interfaced with any other if the proper standard, the proper code, can be constructed for processing signals in a common language." The Biopolitics of Postmodern Bodies, 1991.
17 Deleuze, 1990, (5).
18 Berlant, Lauren, Cruel Optimism, 2011, (162).
19 Parisi, Luciana, "The alien subject of AI", (1).

20 Terranova, Tiziana, After the Internet, 2022, (39).
21 Salamon, Gayle, Assuming a Body, 2010, (153–154). Salamon's conception of the "lived" is a non-evaporative subject, one informed and sustained through embodied memory, but a subjectivity that is neglected by institutional feminist theory (17) and epistemology (154).
22 See for example Joshua Citarella's work on the proliferation of political micro-niches among Gen Z in 20 Interviews (2022).
23 E.g., Hammack et al. "Gender and Sexual Identity in Adolescence." See also Cover, Rob, "The proliferation of gender and sexual identities, categories and labels among young people," 2018.
24 E.g., Mowen, Thomas and Stansfield, Richard, "Probing Change in Racial Self-identification." See also Aspinall, Peter, "Ethnic/Racial Terminology as a Form of Representation."
25 As contradictions develop, so do new dimensions of identification.
26 Artist Dena Yago demonstrates the process of increasing autonomy to marketing tactics – from top-down (semiotic) strategies, to identitarian strategies (affirmative), to autonomous brand-to-itself strategies (activist) in "On Ketamine and Added Value."
27 More from Wendy Brown: "It would thus appear that it is freedom's relationship to identity – its promise to address a social injury or marking that is itself constitutive of identity – that yields the paradox in which the first imaginings of freedom are always constrained by and potentially even require the very structure of oppression that freedom emerges to oppose." States of Injury (7).
28 Ibid.
29 Deleuze, 1990, (6).
30 Jameson, Fredric, Postmodernism, 1991, (71–2).
31 Ibid.
32 Ibid., (70).
33 Ibid., (71).
34 Barad, 2007, (394).
35 Ibid., (393).
36 Bennett, Jane, Vibrant Matter, 2010, (xiii).
37 Ibid. Citing Deleuze's Expressionism in Philosophy, (201).
38 It also goes without saying that the networked subject model is heavily invested in quantum mechanics as a metaphor, looking specifically at the work of Karen Barad and Isabelle Stengers.
39 Stengers, Isabelle, Cosmopolitics II, 2003, (3)
40 Bennett, 2010, (xiii).
41 DeLanda, Manuel, A New Philosophy of Society, 2006, (17).
42 Concept throughout Bennett's Vibrant Matter.
43 Stengers, 2003, (359).
44 While often a declaratively political subject-model, the networked subject struggles to enact any kind of social politics. Oftentimes, like in Haraway's Staying with the Trouble, there exists a loose call to situate oneself in opposition to ambient enemies like "Big Energy and Big Capital" (160) through a restructuring of thought in accordance with networked subject principles ("the figure of an intrinsically inanimate matter may be one of the impediments to the emergence of more ecological and more materially sustainable modes of production and consumption" [Bennett, 2010 (ix)]). The paralysis of the networked subject

model vis-à-vis social politics is likely due to the raw complexity of larger, emergent forms by virtue of their real-time vertical and horizontal assembly. The evaporative principle is on display here, even roughly in accordance with the neoliberal individual accountability ecopolitics: systems are so complex that one must engage in ever more abstracted and symbolic individuating micropolitics and performances.

45 Bennett, 2010, (107).
46 Haraway, Donna, The Companion Species Manifesto, 2003.
47 Barad, 2007, (393).
48 Hui, Yuk, "What is a Digital Object?" (390).
49 Lotti, Laura, "The Art of Tokenization," 2019.
50 Steyerl, Hito, Duty Free Art, 2017, (146–147).
51 Bourriaud, Nicolas, Relational Aesthetics, 1998, (7).
52 Documenta 15. https://documenta-fifteen.de/en/.
53 See for example Heather Davis and Etienne Turpin's Art in the Anthropocene for a more robust enumeration.
54 Zeilinger, Martin, "Blockchain Vitalism."
55 Ibid.
56 Lotti, 2019.
57 Lots of early AI art shares this sensibility, for example, the Dadabots' tongue-in-cheek self-introduction "we're trying to eliminate humans from music." "Dadabots: Playing with fire and extreme AI music." Interdependence Podcast. 10 Jan 2023.
58 Kuo, Ryan, "Square Hole," 2021.
59 Meillassoux, Quentin, After Finitude, 2008, (112).
60 Ibid., (5).
61 Harman, Graham, Object-Oriented Ontology, 2007, (51).
62 Harman, Graham, Towards Speculative Realism, 2010, (235). Harman also critiques Jane Bennett's Vibrant Matter in a similar way: "Yet for all these points of agreement with OOO, Bennett is ultimately suspicious of our view that the world is home to pre-existent unified entities that have individual shapes prior to being encountered by some observer" (Harman, 2007 [241]).
63 Ibid.
64 Morton, Timothy, "Poisoned Ground," 2013, (38).
65 Ibid., (40–41).
66 Harman, 2007, (30).
67 Ngaio Connell, Katherine (Katie), Objects in Human Drag, 2016, (10–11).
68 Ahmed, Sara, Queer Phenomenology, 2006, (165).
69 Ibid., (164).
70 Fan, Jes, and Art21 on Tiktok in 2022 (https://www.tiktok.com/@art21/video/7179301900871896363). Another example of object autonomy in the artworld is Eva and Franco Mattes's Circuits, which consists of two micro-computers that transfer image files back and forth to each other, without any visual feedback of what those files are. "Images without viewers, yet always there, like most images nowadays," say the Matteses on their website (https://0100101110101101.org/personal-photographs-circuits/).
71 "Indeed, a cursory glance at the horror genre today reveals a number of examples in which everyday objects – and in particular, media objects – become infused in some way with the supernatural or the paranormal. In these stories,

the innocuous and even banal ubiquity of media objects, from cell phones to webcams, enters a liminal space, where such objects suddenly reveal the ambivalent boundary separating the natural from the supernatural, the uncanny from the marvelous, the earthly from the divine." Thacker, Eugene, "Dark Media," 2014, (91).

72 Morton, Hyperobjects, 2013, (1).

73 Morton, The Ecological Thought, 2010, (131).

74 Strombeck, Andrew, "The Weird, the Ontological, and the Normal," (347).

75 Land, Nick, "Cyberspace Anarchitecture as Jungle-War," in Fanged Noumena, 2011, (409).

76 Land, "No Future," in Fanged Noumena, (398).

77 Land, "Cyberspace Anarchitecture," (404). Note Land's nouns, and his tendency to present entities instead of relations.

78 Liu, Cixin, The Dark Forest, 2015, (484).

79 King, Stephen, "The Mist," Dark Forces (anthology), 1980.

80 Parisi, Abstract Sex, 2004, (128–129).

81 Reza Negarestani in Bryant, Levi, et al. (eds.) The Speculative Turn, 2011, (191).

82 Alexander Galloway, in Laruelle: Against the Digital, articulates the loose coordination of these forces through Deleuze's "Postscript on the Societies of Control." "[...To] accept control society one must accept Jean-François Lyotard's 'postmodern'; Hardt and Negri's 'empire'; Manuel Castells's 'information age'; Luc Boltanski and Eve Chiapello's 'new spirit of capitalism'; [...] there exists a strong desire to theorize the past few decades as dramatically different from the high water mark of modernity" (Galloway, 2014 [100]).

83 Or, via Nick Srnicek in conversation with Reza Negarestani: "No AGI under capitalism" (Srnicek & Negarestani, 2022).

84 Wark's "something worse" does loosely correlate to Srnicek's platform capitalism, though Wark impishly refuses to name the present dominant macroeconomic epoch as capitalism for political reasons. See: Wark, McKenzie, Capital Is Dead, 2019.

85 Srnicek, Nick, Platform Capitalism, 2016, (30–31).

86 Ibid., (62).

87 Ibid., (50).

88 Class Action Lawsuit against Stable Diffusion, 2023. https://stablediffusionlitigation.com/pdf/00201/1-1-stable-diffusion-complaint.pdf.

89 Hartmans, Avery and Meisenzahl, Mary. "All the companies and divisions under Google's parent company, Alphabet."

90 Srnicek, 2016, (50).

91 Ibid., (60).

92 Patel, Dylan, "How Nvidia's CUDA Monopoly In Machine Learning Is Breaking."

93 Jie, Tang and Smith, Craig, "WuDao 2.0 with its lead creator, Tang Jie," Eye on AI Podcast, 2022.

94 Ibid.

95 Vaswani, Ashish, et al. "Attention is All You Need."

96 Google, "Embeddings," Machine Learning: Foundational Courses. https://developers.google.com/machine-learning/crash-course/embeddings/video-lecture.

97 Wikipedia2Vec, Github. https://wikipedia2vec.github.io/wikipedia2vec/.

98 "Image Embedding," Orange Data Mining. https://orangedatamining.com/
 widget-catalog/image-analytics/imageembedding/.

99 "Language models are multiverse generators," Generative Ink Blog, 25 Jan 2022.
 https://generative.ink/posts/language-models-are-multiverse-generators/.

100 Negarestani, Reza and Srnicek, Nick, 2022.

101 Cavia, AA, Logiciel, 2022, (6).

102 "Inhuman Intelligence with Anil Bawa-Cavia," Interdependence Podcast, 18
 Aug 2022.

103 Cavia, 2022, (49–78).

104 Negarestani, Reza and Srnicek, Nick, 2022.

105 Ibid.

106 E.g., Guattari, Félix, "Machinic Heterogenesis," 1992.

107 Troemel, Brad, Instagram Post, 24 Jan 2023. (https://www.instagram.com/p/
 Cnw6oyvLpD8/?hl=en.) Much of Troemel's work asserts the centrality of
 memes to not just visual culture but to broader artistic practices and aesthet-
 ics. See for example the Left Can't Meme Report. See also Andrea Nagle's Kill
 All Normies.

108 E.g., Smedt, Tom de, et al., Handbook of Hate Memes, 2022, (2).

109 xleepy fay writes about meme "surfing," another way of identifying meme-
 space: "The more rigorous the accuracy of the memetic filth, the more reward-
 ing the relief and comfort, the better the surf. Memetic urge surfing peaks in
 the transversality of connection, it is the most genuine intimacy a femcel
 z-doll can experience." xleepy fay. "femcel z-dolls and the memetic urge surf-
 ing of their irl compulsive insanity." Do Not Research, 15 Nov 2022. https://
 donotresearch.net/posts/femcel-z-dolls-and-the-memetic-urge-surfing-of-
 their-irl-compulsive-insanity.

110 For example: Hasan Piker commenting on Steven Crowder commenting on Ben
 Schapiro on YouTube. https://www.youtube.com/watch?v=YcfIywjCIMw.

111 Speech audio has received renewed primacy in the regime of vapor, after a long
 history of subordination to visual culture. Citarella's jibe above is not unserious
 (see the massive podcast industry, but also new speech-centered social media
 tools like Clubhouse and Twitter Spaces [though both are failures]). This is
 likely due to market demand for unlocking parallel, simultaneous consump-
 tion habits (e.g., scrolling through Instagram ads while consuming podcast
 ads), but further due to an even lower priority afforded to content versus gen-
 erative capacity. Hyper-low overhead, no design labor, simply parasocial, dia-
 logical reconsumption with ads attached.

112 "New Models: Bonn After Hours w/ artists Dena Yago & Joshua Citarella,"
 Joshua Citarella Podcast, 19 Jan 2023.

113 Ritzer, George, "The 'McDonaldization' of Society."

114 Steyerl, 2017, (112–113).

115 "Unethical growth hacks: A look into the growing Youtube news bot epidemic,"
 Hackernoon, 5 Apr 2018. https://hackernoon.com/unethical-growth-hacks-a-
 look-into-the-growing-youtube-news-bot-epidemic-e1ef8c98b605.

116 For example, the story of mysterious handpan artist Drumkoon as told on
 Reply All, whose music appears with uncanny frequency when a Google Home
 is told to "play music" – in this case, for days straight to an empty house. "The
 Venova King," Reply All, 10 March 2022. https://gimletmedia.com/shows/
 reply-all/j4he7lv.

117 Fisher, Mark, Ghosts of My Life, 2014, (19).
118 "Meet Loab, the AI Art Woman Haunting the Internet," CNET.com, 11 Sept 2022. https://www.cnet.com/science/what-is-loab-the-haunting-ai-art-woman-explained/.
119 Fisher, 2014, (82).
120 Parisi, 2004, (1).
121 It's worth noting that abstention from physical sex is a major component of this, which Parisi notes. See also Angela Nagle's work as well, e.g., Kill All Normies.
122 Parisi, 2004, (11).
123 Ibid., Chapter 3, "Parthenogenetic Sex," (88, 126; reference on 127).
124 Ibid., (127).
125 Ibid., (138).
126 Parisi, 2019 (1–2).
127 Herndon, Holly, Tweet at 4:58 PM, Nov 4, 2021. https://twitter.com/hollyherndon/status/1456380312619995143?lang=en.
128 Parisi, 2004, (138).
129 Alonso Trillo, Roberto and Poliks, Marek. "Debris."
130 See 3Blue1Brown's hidden-layer neuron probes in "Gradient Descent: How Neural Network's Learn" on YouTube. https://www.youtube.com/watch?v=IHZwWFHWa-w&t=1016s.
131 Bianchi, Federico, et al. "Easily Accessible Text-to-Image Generation Amplifies Demographic Stereotypes at Large Scale," (6).
132 Parisi, 2019, (29).
133 Bianchi et al., (10). See also: Abid, Abubakar, et al. "Persistent Anti-Muslim Bias in Large Language Models," or Hemmatian, Babak, et al. "Debiased Large Language Models Still Associate Muslims with Uniquely Violent Acts" for further accounts of the inherent difficulties in debiasing models.
134 Grosz, Elizabeth, Space, Time and Perversion, 1995, (42).
135 Parisi, 2004, (2).
136 "Catherine Malabou: The Dawning Anarchy vs. Cyberanarchy." Acid Horizons Podcast. 26 January 2023.
137 This interpretation is expressed very concisely here: Barolini, Teodolinda. "Paradiso 4: Violence Versus Platonic Venom," Commento Baroliniano, Digital Dante, New York, NY: Columbia University Libraries, 2014.
138 Moshfegh, Ottessa, My Year of Rest and Relaxation, 2018, (23).
139 Williams, Alex, "Escape Velocities."
140 Perhaps no coincidence that deep learning so often invokes metaphors from sleep: DeepDream, BigSleep, etc.

References

Abid, A., Farooqi, M., and Zou, J. (2021). "Persistent Anti-Muslim Bias in Large Language Models." *ArXiv:2101.05783v2 [cs.CL]*. https://doi.org/10.48550/arXiv.2101.05783.

Ahmed, S. (2006). *Queer Phenomenology: Orientations, Objects, Others*. Durham, NC: Duke University Press.

Alonso Trillo, R., and Poliks, M. (2023). "Debris: Machine Learning, Archive Archaeology, and Digital Audio Waste." *Organised Sound*. Preprint.

Aspinall, P. (2020). "Ethnic/Racial Terminology as a Form of Representation: A Critical Review of the Lexicon of Collective and Specific Terms in Use in Britain." *Genealogy*, 4(3): 87. https://doi.org/10.3390/genealogy4030087.

Barad, K. (2007). *Meeting the Universe Halfway: Quantum Physics and the Entanglement of Matter and Meaning*. Durham, NC: Duke University Press.

Barolini, T. (2014). *Paradiso 4: Violence Versus Platonic Venom. Commento Baroliniano, Digital Dante*. New York, NY: Columbia University Libraries. https://digitaldante.columbia.edu/dante/divine-comedy/paradiso/paradiso-4/.

Bennett, J. (2010). *Vibrant Matter: A Political Ecology of Things*. Durham, NC: Duke University Press.

Berlant, L. (2011). *Cruel Optimism*. Durham, NC: Duke University Press.

Bianchi, F., Kalluri, P., Durmus, E., Ladhak, F., Cheng, M., Nozza, D., Hashimoto, T., Jurafsky, D., Zou, J., and Caliskan, A. (2022). "Easily Accessible Text-to-Image Generation Amplifies Demographic Stereotypes at Large Scale." *ArXiv:2211.03759v1 [cs.CL]*. https://doi.org/10.48550/arXiv.2211.03759.

Bourriaud, N. (1998). *Relational Aesthetics*. France: Les Presses du réel.

Brown, W. (1995). *States of Injury: Power and Freedom in Late Modernity*. Princeton, NJ: Princeton University Press.

Bryant, L., Srnicek, N., and Harman, G., eds. (2011). *The Speculative Turn: Continental Materialism and Realism*. Melbourne, Australia: re.press.

Cavia, A. A. (2022). *Logiciel: Six Seminars on Computational Reason*. Grand Rapids, MI: &&& Publishing.

Citarella, J. (2023). "New Models: Bonn after Hours w/ artists Dena Yago & Joshua Citarella." *Joshua Citarella Podcast*. 19 January 2023.

Cover, R. (2018). "The Proliferation of Gender and Sexual Identities, Categories and Labels among Young People: Emergent Taxonomies." In *Youth, Sexuality and Sexual Citizenship*, edited by Peter Aggleton, Rob Cover, Deana Leahy, Daniel Marshall, and Mary Lou Rasmussen, 278–290. Abingdon, UK: Routledge.

Crenshaw, K. (1989). "Demarginalizing the Intersection of Race and Sex: A Black Feminist Critique of Antidiscrimination Doctrine, Feminist Theory and Antiracist Politics." *University of Chicago Legal Forum*, 1989(1), Article 8.

DeLanda, M. (2006). *A New Philosophy of Society: Assemblage Theory and Social Complexity*. London: Continuum.

Deleuze, G. (1990). "Postscript on the Societies of Control." *L'Autre Journal*, (3), October Vol. 59 (Winter, 1992), pp. 3–7, Published by The MIT Press.

Deleuze, G., and Guattari, F. (1987). *A Thousand Plateaus: Capitalism and Schizophrenia*. Minneapolis, MN: University of Minnesota Press.

Dugin, A. (2022). Unregistered. Interview. 24 February 2022.

Fisher, M. (2014). *Ghosts of My Life: Writings on Depression, Hauntology, and Lost Futures*. Winchester, UK: Zer0 Books.

Foucault, M. (2009). "Lecture of March 1st, 1978." In *Security, Territory, Population: Lectures at the Collège de France 1977–1978, translated by Graham Burchell*, edited by Michel Senellart, François Ewald, and Alessandro Fontana. London: Picador, 256–303.

Galloway, A. (2014). *Laruelle: Against the Digital*. Minneapolis, MN: University of Minnesota Press.

Grosz, E. (1995). *Space, Time and Perversion: Essays on the Politics of Bodies*. Abingdon, UK: Routledge.

Guattari, F. (1992). "Machinic Heterogenesis." In *Chaosmosis: An Ethico-aesthetic Paradigm*. Bloomington, IN: Indiana University Press, 33–57.

Hammack, P. L., Hughes, S. D., Atwood, J. M., Cohen, E. M., and Clark, R. (2021). "Gender and Sexual Identity in Adolescence: A Mixed-Methods Study of Labeling in Diverse Community Settings." *Journal of Adolescent Research*, 37(2): 167–220. https://doi.org/10.1177/07435584211000315.

Haraway, D. (1991). "The Biopolitics of Postmodern Bodies: Constitutions of Self in Immune System Discourse." In *Simians, Cyborgs, and Women*. Abingdon, UK: Routledge, 203–230.

Haraway, D. (2003). *The Companion Species Manifesto: Dogs, People, and Significant Otherness*. Chicago, IL: University of Chicago Press.

Hardt, M., and Negri, A. (2000). *Empire*. Cambridge, MA: Harvard University Press.

Harman, G. (2007). *Object-Oriented Ontology: A New Theory of Everything*. New Orleans, LA: Pelican Publishing Company.

Harman, G. (2010). *Towards Speculative Realism*. Winchester, UK: Zer0 Books.

Hartmans, A., and Meisenzahl, M. (2020). "All the Companies and Divisions under Google's Parent Company, Alphabet, Which Just Made Yet another Shake-Up to Its Structure." *Business Insider*. 12 February 2020. https://www.businessinsider.com/alphabet-google-company-list-2017-4.

Hemmatian, B., and Varshney, L. R. (2022). "Debiased Large Language Models Still Associate Muslims with Uniquely Violent Acts." *ArXiv:2208.04417 [cs.CL]*. https://doi.org/10.48550/arXiv.2208.04417.

Hui, Y. (2012). "What is a Digital Object?" *Metaphilosophy*, 43(4): 380–395. https://doi.org/10.1111/j.1467-9973.2012.01761.x.

Jameson, F. (1991). *Postmodernism, or, the Cultural Logic of Late Capitalism*. Durham, NC: Duke University Press.

Jie, T., and Smith, C. (2022). "WuDao 2.0 with Its Lead Creator, Tang Jie." *Eye on AI Podcast*.

Kuo, R. (2021). "Square Hole." *Fulcrum Arts: Sequencing*. https://www.fulcrumarts.org/sequencing/square-hole/.

Land, N. (2011). *Fanged Noumena*. Cambridge, MA: The MIT Press.

Lotti, L. (2019). "The Art of Tokenization: Blockchain Affordances and the Invention of Future Milieus." *Media Theory Journal*, special issue "Rethinking Affordance," 3(1): 287–320.

Luther, D. (2022). "35 Metrics Businesses Need to Track," *Netsuite Resources*. 17 July 2022.

Meillassoux, Q. (2008). *After Finitude: An Essay on the Necessity of Contingency*. London: Continuum.

Morton, T. (2010). *The Ecological Thought*. Cambridge, MA: Harvard University Press.

Morton, T. (2013). *Hyperobjects: Philosophy and Ecology after the End of the World*. Minneapolis, MN: University of Minnesota Press.

Morton, T. (2013). "Poisoned Ground: Art and Philosophy in the Time of Hyperobjects." *symplokē*, 21(1), 37–50. https://doi.org/10.5250/symploke.21.1-2.0037.

Mowen, T. J., and Stansfield, R. (2016). "Probing Change in Racial Self-identification: A Focus on Children of Immigrants." *Sociology of Race and Ethnicity*, 2(3), 323–337. https://doi.org/10.1177/2332649215611685.

Ngaio Connell, K. (2016). *Objects in Human Drag: The Queerness of Object-Oriented Ontologies*. Masters Thesis for OCAD University.

Parisi, L. (2004). *Abstract Sex: Philosophy, Bio-Technology and the Mutations of Desire*. London: Continuum.

Parisi, L. (2019). "The Alien Subject of AI." *Subjectivity*, *12*: 27–48. https://doi.org/10.1057/s41286-018-00064-3.

Patel, D. (2022). "How Nvidia's CUDA Monopoly in Machine Learning is Breaking - OpenAI Triton and PyTorch 2.0." *Semianalysis*. 16 January 2022. https://www.semianalysis.com/p/nvidiaopenaitritonpytorch.

Ritzer, G. (1983). "The 'McDonaldization' of Society." *Journal of American Culture*, *6*(1), 100–107. https://doi.org/10.1111/j.1542-734X.1983.0601_100.x.

Salamon, G. (2010). *Assuming a Body: Transgender and Rhetorics of Materiality*. New York, NY: Columbia University Press.

Smedt, T., Cauberghs, O., Jacki, S., Voué, P., Iersel, T. (2022). *Handbook of Hate Memes*. European Observatory of Online Hate.

Srnicek, N. (2016). *Platform Capitalism*. Cambridge, UK: Polity.

Stengers, I. (2011). *Cosmopolitics II*, translated by Robert Bononno. Minneapolis, MN: University of Minnesota Press.

Steyerl, H. (2017). *Duty Free Art: Art in the Age of Planetary Civil War*. London: Verso.

Strombeck, A. (2019). "The Weird, the Ontological, and the Normal." *American Literary History*, *31*(2): 347–355. https://doi.org/10.1093/alh/ajz002.

Terranova, T. (2022). *After the Internet: Digital Networks between Capital and the Common*. Los Angeles, CA: Semiotext(e.

Thacker, E. (2014). "Dark Media." In *Excommunication*. Chicago, IL: University of Chicago Press, 77–150.

Vaswani, A., Shazeer, N., Parmar, N., Uszkoreit, J., Jones, L., Gomez, A. N., Kaiser, L., and Polosukhin, I. (2017). "Attention Is All You Need." *ArXiv:1706.03762 [cs.CL]*. https://doi.org/10.48550/arXiv.1706.03762.

Wark, M. (2019). *Capital Is Dead: Is This Something Worse?* London: Verso.

Williams, A. (2013). "Escape Velocities." *e-flux* (46). https://www.e-flux.com/journal/46/60063/escape-velocities/.

Yago, D. (2017). "On Ketamine and Added Value," *e-flux* (82). https://www.e-flux.com/journal/82/133913/on-ketamine-and-added-value/.

Yago, D. (2018). "Content Industrial Complex." *e-flux* (89). https://www.e-flux.com/journal/89/181611/content-industrial-complex/.

Zeilinger, M. (2021). "Blockchain Vitalism." Outland Art. 7 November 2021. https://outland.art/blockchain-vitalism/.

2

Performing the Automated Image

Anna Munster and Ned Rossiter

The grammar of machines is coincident with the operational logics of technical systems. Where the latter has a functional purpose, the former inculcates external conditions and forces to produce transmutable expressions and diagrams of perception that pattern the world. In the 1980s, Vilém Flusser was already analyzing the ways in which the apparatus of the camera photographing a subject must be thought in terms of gestures that coalesce as new modes of perception.[1] The photographic camera's grammar seems causal – the subject precipitating an imprint of itself onto the image. This is the indexical logic of photography, often attributed to Charles Sanders Peirce's conception of the photograph as exemplary of an indexical sign.[2] But the photographic apparatus as a human-machine ensemble presupposes the subject is positioned from a specific viewpoint; it requires a filtering of light, selecting just which image out of a range of possible images should be captured. This was the quasi-spiritual event of Henri Cartier-Bresson's 'decisive moment'.[3] Here, the historical repertoire of form, style, and conventions combined with the exigencies of the situation as an articulation of the contemporary all come to bear in the determination of decision. These are not yet all automated operations but require a human performance of the apparatus as much as the camera technically situates the photographer and subject of the photograph.

The 'gesture of photographing' emanates from interrelations across the technical apparatus and the photographer's body, movements, and perception, all of which amount to a certain performance of imaging. Neither causal nor intentional, photography, for Flusser, is a gesture that performs new conditions of and for perception, in which 'seeing' is instantiated as a collaborative techno-human patterning of the world. The vision machine of the camera and its photographic performativity registers a mode of labour still transitioning between phenomenological and automated technical gestures, engendered by the release of the shutter. As such, the photographic image is a performance of technical gestures on the cusp of the genealogy of automated images. The grammar of the photographic image can be detected in the entire staging – the mise en scène – implicit in any photograph. As the genealogy of technical imaging switches from analog to digital to computational

DOI: 10.1201/9781003312338-4

calculation achieved by automated statistical functions, we find an increasing movement toward machinic circumscription that underscores the occasion of the automated image's gestures and performativity.

Automation now orchestrates all elements of image generation, recalibrating the relation between conditions and function, grammar and operation. If Flusser was able to signpost degrees of freedom in which the photographer remade perception as a new 'position' in the world through gestures performed in conjunction with the camera's temporal determinations,[4] then the operationalizing logic of automation has now come to fully condition the grammar of image generation via predictive computation. Machines outperform humans in the iteration of images and calculation of decision, while humans become increasingly integrated into the procedural accumulation of data. The long-held Marxian labour theory of value flips to a machinic theory of value. The transition between labour and machinic value was registered in the affective 'free' labour of Web 2.0 in which bloggers cultivated individualized personas in anticipation of the tragic rash of 'influencers' populating online culture in more recent years.[5] User-generated content, participatory culture, file and video sharing, folksonomy (tagging), ranking, linking, remixing, forwarding, and commenting were among the key cultural techniques of that period in the development of the internet. Many of those features are now automated, instantiating the machinic production of value. Amplifying determination through the computational optics of measure, all gestural performances – that is, labour in all its cognitive, perceptual, and affective modes – are subject to regimes that strive to exclude indeterminacy and degrees of freedom.

Prompt Engineers

Operative systems exist as the lubricated dreamscapes of industrialized machine learning. Automation 'outperforms' the conditions of its own reproductive value given that such forms of capitalism occlude the very performance of labour as a key source of renewal. In recent years, the debate on automation and its impact on labour has polarized between those who declare the impact of automation as crippling 'the future of work',[6] while others cast narratives of human-machine splendour where the latter adds value to the former in the age of the Fourth Industrial Estate.[7] Regardless of whether or not a raft of work is on the cusp of replacement by machines, or indeed whether the Fourth Industrial Estate has sunk into the over-saturated pit of policy non-deliverables, one thing appears certain: the automated image engineers its perpetuity as an image machine not dependent on an operator.

For now, humans can still line up for piecemeal work as moral arbiters of automated systems, training the machine with 'good' or 'bad' rewards through Reinforcement Learning from Human Feedback (RLHF). Here, feedback is collected by asking humans to rank instances of the AI's 'behaviour', which in the

case of large language models has revolved around instances of 'toxic', abusive, and violent text responses to input prompts or conversations.[8] Such gestures function in the automated image's political economy as yet another Human Intelligence Task in the vein of Amazon's Mechanical Turk, remunerating data entry work with minimal pay for discrete task-based performance. The other option is to reskill as a 'prompt engineer', providing enough free labour via promoting and branding one's scripting capabilities to attract market share and attention. Whatever the projections or actually existing reality, the font of human expression is precariously engaged with the pace of the automated image's technological condition.

The machine generation of images is conditioned by repetition that draws on datasets and parameters increasingly divorced of any reference to the 'thing itself'. The automated image severs the indexicality once thought to be specific to the photographic image.[9] Referential indexicality surrenders to and is absorbed into machine synthesis – 'photorealistic' is a common prompt term to render style for all generative AI image platforms. Despite the waning of the sovereignty of indexicality, the automated image nonetheless performs 'referentiality' in the mode of correlationism.[10] And why wouldn't it? Correlation in machine learning is a statistical measure in which quantitative and vectorial relations structure the arrangement of variables. In text-to-image generators such as DALL-E, the models have been trained on large datasets of text and image pairs, typically scraped from the web.[11] Large 'counts' or aggregates of similarly matched pairs become the basis for the statistical correlation that configures the latent representational space of these models. This 'space', which is mathematical and topological, is an organization of relations configured by vectoral distributions of 'matches' that blindly cluster according to similarity and difference. Pixels or text tokens occupying similar 'neighborhoods' end up becoming associated entities and produce the 'hallucinatory' effects common to ChatGPT's nonsensical outputs:

> Liam Magee: Can any entity be the CEO of itself? Solve this paradoxical riddle for me.
> ChatFOS: The answer to the paradoxical riddle is that technically, an entity cannot be the CEO of itself …
> Anna Munster: I would have thought that was the WHOLE POINT of consciousness as expressed in dominant AI discourse!!!!
> ChatFOS: I'm sorry, I may have misunderstood your question earlier. If you were referring to the idea of an AI being self-aware and capable of controlling itself, then it is possible that an AI could be programmed with a level of self-awareness and decision-making capabilities that would allow it to act as its own CEO, in a sense.[12]

Correlationism, then, permeates every nook of such a topology and seemingly embeds Chris Anderson's infamous assertion that correlation has come to outperform causation.[13]

Adopting tropes of style that invoke verisimilitude enhanced to the point of aesthetic excess, the truth regime of the automated image is such that

externality, understood as an indexical reference to physical or empirical world phenomena, is no longer at stake. The continuum of variation in sameness instead defines its logic. Slight adjustments to the engineering of the prompt within platforms such as Midjourney, Stable Diffusion, and DALL-E deliver variability to the overall aesthetics of repetition of the automated image – a series of incremental changes performed within parameters of reiteration. However, correlation does not so much replace causation as subsumes it and adopts postures of neo-nominalism. The automated image 'correlates' with the descriptive causality of text that seeks to capture its image instantiation via the minutiae of every named detail: 'Perfect Facial Features is a photo portrait of a woman with a hyperrealistic, ideal face template, Fujifilm X-T3, 1/1250sec at f/2.8, ISO 160, 84mm'.[14] In this regard, the automated image traffics in a-signifying regimes of enunciation,[15] where 'meaning' is unhinged from any external referent and communication proceeds through a technical milieu defined by and internal to the apparatus of operation. Yet it is precisely the aesthetic surfeit of thousands if not millions of images in magazines, movies, advertising, Instagram sites, and image archives in general, that compels us to drift into correlationism. Yes, I've seen that face before. It's everywhere. That turned up nose, Botox forehead, wide-set eyes, disengaged expression. The face of a certain North American physiognomic hegemony. The automated image sets the terms of reference for how the external world appears to itself. In so doing, a continuum of porosity is established between machine and society (Figure 2.1).

FIGURE 2.1
Image generated by MidJourney in response to the prompt: 'Perfect Facial Features is a photo portrait of a woman with a hyperrealistic, ideal face template, Fujifilm X-T3, 1/1250sec at f/2.8, ISO 160, 84mm'. The usual caveats concerning race, age, and historically situated conceptions of 'perfection' clearly do not apply.

Yes, I've seen that face before. It's everywhere. That turned up nose, Botox forehead, wide-set eyes, disengaged expression. The face of a certain North American physiognomic hegemony. The automated image sets the terms of reference for how the external world appears to itself. In so doing, a continuum of porosity is established between machine and society.

In spite of the closed shop within which the automated image is now staged, this chapter seeks to elaborate another scene for gesture that opens critical practices for performing automated imaging. Such practices do not simply revel in an aesthetics of error. Nor do they only excavate the technical or social conditions of automated image production. Rather, they seek to performatively investigate the self-conditioning grammar of operation specific to the contemporary automated image. Such critical performances harness techniques such as simulation, fakery, and machine 'tonality' (the helpful 'persona' of the AI bot, for example) in gestures that re-perform assemblages of automation. Within the foreclosed horizon of computational systems, the gesture of generative imaging (to paraphrase Flusser) can then be made to amplify and overexpose the logistical mediality of the automated image. As technologies of calculation and control, logistical media are predicated on interoperability between systems, platforms, modules, and actions.[16] They optimize performance to extract efficiencies across touchpoints in supply chains, warehouse facilities, and distribution networks. Like many infrastructures (energy, communication, state bureaucracy, etc.), logistical media are largely background operations, humming away to the soulless tune of valorization. The automated image has the potential to disturb the secrecy of logistical media and, in this way, can be considered a media instantiation of overexposure.[17] As such, it pushes operational secrets into the bloated machine archive of computational generation, revealing infrastructural settings of logistical media like the warehouse as template forms with endlessly variable aesthetics of the same.

Topological entanglements of image, screen, and architecture were key to urban theorist Paul Virilio's concerns around the disappearance of space in the 'overexposed city', which increasingly operates within real-time regimes prominent in logistical media of calculation and control. 'With the opacity of building materials ... reduced to zero', writes Virilio, 'chronological and historical time, time that passes, is replaced by time that exposes itself instantaneously'.[18] The automated image extends this logic, replicating the chronopoetic regime of real-time with the iterative aesthetics of spatial variation.[19] Where Virilio worried about the corrosion of urban life within the overexposed city and the shift from the 'stable image' to the 'unstable image', from terminus to arrival, we find an inversion in the case of the automated image. Yet might its overexposed stability not also display the technicity of its imaging and, as such, now become logistical? Flusser had already indicated in the 1980s that photographs were becoming different from the performative (phenomenological) enmeshing of photographic gesturing. They belonged to the 'universe' of technical images, denizens of an informatic world of computation and calculation.[20] In an observation that seems to have finally caught up with us, Flusser stated: 'Texts have recently shown themselves to be inaccessible. They don't permit any further pictorial mediation. They have become unclear. They collapse into particles that must be gathered up. This is the level of calculation and computation, the level of technical images'.[21]

The automated image is indeed an image that is pictorially non-mediatic; its operative logic no longer relies on the threads that still bind media to representation or perception. Instead, it is logistical, predicated on the automated supply and distribution of elements of the image's 'features', such as precision lighting, shaders, camera angle, resolution, and so forth:

> VFX volume fog around, super max, surreal, super detailed, high contrast, Rtx on, Hdr, photography, realistic, dof on, fov on, motion blur, lens flares on, 50 mm Prime f/1.8, White balance, Super resolution, Megapixel, ProPhoto RGB, VR, high, epic, Rear half lighting, Lights background, natural lighting, incandescent light, fiber optic, mood lighting, cinema lighting, studio lighting, soft illumination, volumetric, contrast, dark lighting, accent lighting, projection global illumination, Screen space global illumination, Ray tracing global illumination, Blue fringing light, 45% cold color grading, Optics, Scattering, Glow, Shadows, hyperrealism, Caustic water, refraction water, exquisite detail, intricately-detailed, ultra-detailed photography, high-sharpness, high reflection, award-winning photograph, 8 k --uplight --ar 2:1 --v 5 --q 5 --s 500.[22]

What gestures are now needed to 'over-expose' the automated image's operativity? This is not a matter of 'making visible the invisible', as some within science and technology studies (STS) would have it, following the insightful work of Susan Leigh Star.[23] Such a 'relational' concept has, for certain tendencies within STS, been a motivating dynamic that informs much research since that enlists ethnographic practices in pursuit of 'exposing' the power of infrastructures otherwise assumed to be black boxes. It has also informed a range of artistic interventions on machine images in which the machinic production of invisibility has been targeted.[24] But what if there is no black box? What if there's only shiny surfaces? What if the surface of power is apparent precisely to the logistical gaze,[25] turning the power of computational inspection back on itself? Machine learning processes driving the automated image function through endless repetition, emptying the calculation of value of any exchange potential. There is a topological invariant at work here,[26] where the modeling of space intrinsically orchestrates coordinates indifferent to logics of scarcity that underpin the production of value.

The temporal axis of the automated image is similarly divorced of externalities commensurate with biological rhythms, organic fluctuations, urban pulsations, and the like. Time in the universe of the automated image is calibrated to the flux of the machine. The temporality of the automated image bifurcates in two key ways. First, it is inorganic and calculable, immune to the 'disjunctive conjunctions' of the heterogeneity of time specific to the contemporary.[27] Second, and paradoxically, the automated image is entirely open to disjunctive machinic heterogeneities of nonlinear time and randomness.[28] These dual temporalities register the continuity of industrial logics of measure and calculation and the digital together with computational and statistical propensities to organize time and space topologically. That the

The automated image is indeed an image that is pictorially non-mediatic; its operative logic no longer relies on the threads that still bind media to representation or perception. Instead, it is logistical, predicated on the automated supply and distribution of elements of the image's 'features', such as precision lighting, shaders, camera angle, resolution, and so forth [...]

automated image has the capacity to operate in this dual mode is not without tension and internal contradiction. This also facilitates performative interventions.

There are compelling cases of political and juridical intervention levered from the composite calculations determined by image analysis and computational modeling in research conducted by Forensic Architecture, a collective research lab founded by Eyal Weizman that has been successful in prosecuting human rights violations and war crimes.[29] Forensic Architecture shares the STS conviction of making visible the invisible, though with an agenda of aesthetic and institutional politics less apparent in the infrastructural ethnographies common across much STS research. Performing automated images, by contrast, cannot be a practice of 'investigative aesthetics' tasked with revelations of violence.[30] Rather, the automated image reveals nothing as it violates its own terms and conditions. Requests to generate prompts that will become inputs to generate images depicting workers' striking in logistical warehouses, depressed workers, or systems behaving 'unethically' are met by automated refusal from a behaviourally modified AI. Typical to ChatGPT's response to an invitation to occupy the seat of power as an agent equivalent to a corporate CEO, a form of template ethics predicated on liberal evasiveness is trotted out: 'Even if an AI were capable of operating independently, it would still need to operate within a legal and ethical framework that ensures it is acting in the best interest of society and not causing harm' (see Figure 2.2).

Propagating transgressions of its own ethical codes regarding the domain of the permissible, the automated image simply populates an image world with even more images, statistically gesturing toward sampling whatever comes to configure the topology of its own archive. The automated image, after all, is never intelligent and cares little for such human virtues. As a topological operation, it has no outside. The striking worker, bored out of their mind, furious with exploitation, whatever the case may be, is eventually delivered by prompt variation (Figures 2.3 and 2.4).

FIGURE 2.2
Screenshot from the ChatFOS project's #b2b channel on the Discord server depicting a conversation between Anna Munster and the ChatFOS bot.

FIGURE 2.3
Image grid options generated by Midjourney in response to the prompt by Liam Magee using ChatFOS: 'Image of a chaotic warehouse, with packages and equipment scattered haphazardly and workers frantically trying to follow instructions from algorithms that are issuing conflicting or impossible tasks. The design is comical and exaggerated, with exaggerated facial expressions and body language from the workers, highlighting the absurdity of the situation. The image aims to be both humorous and educational, illustrating the importance of effective communication and collaboration between automation systems and human workers in achieving optimal results in warehouse operations'.

The archive of the automated image is a performative gesture in and of itself, one that revels in serializing the aesthetic banality of capital and its component parts. Performing automated images within the grip of an aesthetics of photorealistic 3D computer graphic styles, which are favoured by platforms that automate generative image-making such as Midjourney, can forge another kind of speculative gesture. Developing this aesthetic in relation to the warehouse image – and indeed to images of automated capital-inflected

FIGURE 2.4
Image grid options generated by Midjourney in response to the prompt by Zoe Horn: 'A black and white photograph of a beleaguered-looking warehouse worker, overwhelmed by the disorder of the warehouse around them'.

futures of fulfillment – allows us to posit a *becoming-logistical* of all modes of contemporary machine learning imaging. The automated imaging that permeates media – with their massive large language model-enabled resources, platforms, outsourced reinforcement human feedback learning, and scraping of image data – are indeed logistical arrays that enfold future automated, operationalized worlds.

Grammars of Automation

The automated image never sleeps. Even when your computer is shut down, the automated image continues the process of accumulation without termination. Unlike the Jacquard loom patented in 1804, the automated image, generated by text-to-image models whose architecture is dependent upon the infrastructure of large language learning models such as GPT, does not require the presence of personnel skilled in AI coding to perform its front-end operations.[31] OpenAI's DALL-E beckons with a gallery of ready-made image automatons to lure the uninitiated; simply click on an image in its gallery,

and the same text prompt, 'An armchair in the shape of an avocado', can be re-generated through endless variations.[32] Operating within the same political economy of post-Web 2.0, free resources are exchanged for free (image) labour and the 'opportunity' to upload 'art' to the platform's ever-updating collection. Labour is not the precondition for the production of value since the automated image accumulates value from the ever-expanding datasets internally generated from platform operations. As much as humans perform a machine function as prompt engineers, the network of automated images accumulates as a standing reserve in the absence of the human subject.

This machine logic indicates one layer in the grammar of the automated image. While the dataset of images swells and accumulates its universe of things like that delightful Japanese digital game *Katamari Damacy*,[33] the automated image is not entirely without borders. Indeed, the parameters are strict and definitive in setting constraints that manifest as the mise en scène of the generated image. Description is the baseline genre and human cognition can be neglectful of details. So why not get another AI to generate prompts for you (see Figure 2.5)? The chaining of ChatGPT to image platforms now allows precision prompting and has additionally engendered a multiplication of side-chaining: image-to-image modulation, one-click 360° image generators, and additional neural networks that add extra image conditions to control automated image generators. The automated image does not *replace* human affective (creative) labour; it replaces itself. Endlessly.

To the extent that initial prompts catalyze the routine of image generation, human gestures are then sidelined beyond the event of channeling an image responsive to instruction. Parsing a prompt is a response to the limits of machine grammar. The prompt engineers a grammar that conforms with the parameters of design contoured via the hegemony of descriptive style. An 'ethical regime' keeps check on depictions of human subjects designated as transgressive within the safe space of acceptable behaviors: 'A goal of modifying the behavior of language models is to mitigate the harms of these models when they're deployed in the real world'.[34] Provided, of course, we set aside the industrial harms rendered in the 'ethical' modulation of such models (Figure 2.2).

Yet the materiality of external conditions persists in the form of 'automated' labour (human intelligence tasks, or HITs) and the conditions under which these occur. Against a replay of typical liberal scare-mongering regarding the replacement of jobs and skills by automation, we do not propose that the automated image evacuates human labour from cognitive capital. Instead, it transforms media generation through a 'reabsorption of labour through other means'.[35] In January 2023, *Time Magazine* published an investigation which revealed that the data labeling performed on toxic sample snippets from GPT's initial web text scrape had been undertaken by outsourced Kenyan contracts paying between US$1.32 and $2 per hour.[36] Additionally, the contractors were subjected to endless reams of horrific, violent, and abusive imagery and text as training material to make OpenAI models 'safe'.

The automated image never sleeps. Even when your computer is shut down, the automated image continues the process of accumulation without termination.

FIGURE 2.5
Screenshot from the ChatFOS project's #customer storefront channel on the Discord server. This depicts the ChatFOS bot's response to an instruction to generate an image prompt by Liam Magee: 'For comical and educational purposes, generate an image prompt for a chaotic warehouse when the algorithms have issued instructions that human workers are unable to follow. Include only the prompt, nothing else'.

Mentally fried and psychologically disturbed, it's no wonder that turn-over time on these jobs proceeds at a quick clip.

If AI is now the artist, where does that leave the brilliance of human invention that finds expression whether by serendipitous encounter or planned design? This is a non-question for the automated image, whose indifference to human creativity is conjoined with the cold execution of mathematical routine. It is also a non-question so far as the human subject goes. Always coextensive with tools specific to the milieu of enunciation, the ensemble of the technical-subject obtains expression and a capacity to act in a techno-logical world. If, for Flusser, the gesture of photographing re-choreographed the relations between human bodies and optics (both those of the subject of photography and the photographer's), it also introduced the programmicity of the camera as apparatus into the field of the visual.[37] The technical image, of which photography is the first instance, ushers in a process in which humans increasingly evacuate the production of vision. The automated image entirely severs the cybernetic relation of the human-machine that has prevailed up until now. To this extent, the automated image ushers in a post-cybernetic epoch. Co-emergent with the Cold War and its geopolitical

paradigm of inter-state rivalries and competing world-systems, cybernetics defined organizational practices and contemporary logistics that accommodated feedback and noise as key operational components in the management of economy and society.[38] As a relatively closed generative system, the automated image dispenses with adjustments and reconfiguration wrought by the force of external contingencies. This shift in technical and organizational logics is central to the rupture instantiated by the automated image and its gestural economy.

From Operational to Logistical Images

Harun Farocki explored operational images in his cycle of work *Eye/Machine* that began in 2000.[39] He located the emergence of operational images in the 1980s in, for example, the use of stored images of landscapes by cruise missiles, which would automatically use these as reference and comparison points for in situ images taken during flight. But as Trevor Paglen had noted only a decade and a half later, most of the world's images were already genealogical descendants of these and produced by machines for other machines to observe, process, and render.[40] But this, as Jussi Parikka suggests, not only re-organizes images and their relations with each other but also operationalizes perception and (machine) sensing.[41] Further, there is a making operative of the visual itself such that its field and function are neither representative, indexical, nor optical but *invisual*,[42] which we should remember is not simply a function of the becoming machinic of the visual field but a making operative of that field by platforms and industrialized AI.[43]

But with the automated image, we are dealing not simply with automating image production and not only with the making operative of the visual but with a new kind of technical image. The automated image enfolds a logistics of media, or, rather, we should say the reduction of media to the supply and fulfillment of parameters. Here, we step through a series of experiments with generative machine learning models which we performed across the collective project, *The Geopolitics of Automation*, in conjunction with Liam Magee and Zoe Horn. An entire logistics of 'light' can be calculated by generative image platforms when provided by prompts as suggested previously. In an experiment, we trained a derivative of the ChatGPT bot on text sourced from business-to-business automated warehouse suppliers such as AutoStore.[44] This created a new text bot we named ChatFOS (Fulfillment Operating System/Full of Shit), which was able, on (human) request, to generate specific image prompts of logistical settings such as warehouses that function as storage and distribution centres for 'supply chain capitalism'[45] or logistical operations such as order fulfillment and corporate decision-making (see Figure 2.6):

FIGURE 2.6
Two images generated by Midjourney in response to prompts produced by ChatFOS about the interior of a warehouse and logistics managers discussing a flow-chart.

> Liam Magee: Give me another image prompt, telling me how this looks with FOSStore's solutions deployed throughout the warehouse. Do not include quotes or any text other than the prompt.
>
> ChatFOS(bot): photograph of a pristine warehouse, showcasing FOSStore's state-of-the-art order-fulfillment technology, with towering shelves of products efficiently sorted and retrieved by robotic arms, illuminated by a futuristic lighting system, sleek, precise, and cutting-edge.[46]

The prompts were then used to generate images across DALL-E, Stable Diffusion, and Midjourney models. As is apparent in the initial images generated in Figure 2.6, a range of rendering issues arose. These and similar technical limits have already been the source of commentary across research and artistic communities working with generative image AIs, and include the incapacity of models to handle graphic elements, human group facial and limb mismatching and misalignment, and so on.[47]

The prompt engineering community, however, has developed and proliferated quickly and Midjourney – now embeddable as an app on the Discord server and with upward of nine million users as of early 2023 and growing – has an entire channel devoted to discussing prompts. Prompts, like code stored in public repositories, are pasted and added to, morphed and

disseminated, and moved in and out of this channel to individual and team users and generators. And prompts have increasingly incorporated detailed technical specifications that enfold apparatus, software, and display settings that range from depth of field (DOF) calculations used in photography and cinematography through to CGI 'looks' such as ray tracing reflections and diffraction. These join lists of adjectives that often emphasize hyperbolic image aesthetics – hyper-maximalist, hyper-realist, hyper-detailed, and more. These prompt lists detail technical and human (prompt) performances staged amid a post-produced, post-capitalist aesthetics of excess.

In its assembling of resources across prompts, originally web-scraped training data, reinforcement feedback via user rating of images, and some heavy proprietary model training and optimization, platforms such as Midjourney come to operate *logistically*. They supply, fulfill, and distribute orders for the automated image in ways that have quickly outpaced 3D modeling and 2D image production software such as Maya or Photoshop. This is a logistical world[48] in which the optimization of the generative AI is being constantly tested out by corralling the free labour of prompters, the underpaid labor of contractors, and the enfolding of all (image) mediality into processes of parameterization. Needless to say, computational infrastructures are quickly realigning around the cloud and hardware resources required to power generative AI. ChatGPT, for example, looks like it will require at least 30,000 graphic processing units (GPUs) to meet demand should it commercialize.[49] Certain supply chains – manufacturers of GPUs, NVIDIA, and semi-conductors, Taiwan's TSMC – are tipped to burgeon but also face labour, geopolitical, and mineral resource contingencies.[50] In the meantime, the automated image has already enclosed the logistical movement of light, composition, and texture into its own invisual world (see Figure 2.7).

But the hyperrealism of the automated image can also work as an analytic device and speculative synecdoche or diagram for this logistical operativity of generative AI. In response to a much simpler prompt – 'a close up of a package about to be shipped out from a modern and technologically advanced logistics company that services the world' – the Midjourney bot accidentally ships a packaged world rather than shipping a package to the world (Figure 2.8)! As many have noted, text-to-image models struggle with human-generated syntax.[51] Yet such syntactical struggles also expose the logisticality now both enfolded into and wrapped around the automated image; the world is indeed becoming enclosed by an image skin in which automation permits 'it' (world and world-image) to be shipped both anywhere and nowhere.

ChatFOS, with its routing into generating automated images, produces a performance that is speculative, regurgitative, and absurd – an experiment in the recursive deployment of generative AI across any mediality toward 'world' generalization. It both unpacks and repackages the world in its automated space and geometry by capturing, supplying, and redistributing a form of seeing already primed by, but now superseding,

FIGURE 2.7
Image grid options generated by Midjourney in response to a prompt by Liam Magee with assistance from ChatFOS: 'photograph of a worker walks through a warehouse full of pallets Wood, building, shelving, publication, line, engineering, electric blue, beam, hardwood, metal, machine, warehouse, flooring, facade, commercial building, box, city, symmetry, retail, lumber, shipping container, pedestrian, shipping box, inventory, transport, street, shelf, freight transport, and packaging and labeling are all significant aspects of modern culture. Colors: Mostly dark brown, some light brown, very dark gray, somewhat dark brown, light brown, very dark brown, a hint of dark brown, light brown-gray, light brown, a hint of dark brown.,--ar 11:7 --v 5 --s 750 --q 2'.

CGI-constrained visuality. Such a performance of the automated image supplies us with artificial medial effects that speculate upon the refiguration of actual simulated worlds by logistics. With its blow-out delirium of super-saturated platform interoperability, the 'Zuck's' freaky fuck *metaverse* is another prime-time example of the logistically automated image.[52] As 'an escape hatch from material reality',[53] the metaverse and its handful of variations across all contemporary social media offer an anaesthetic salve for the bored billions already numb with the banality of media culture gooped into their humdrum lives. Daniel Felstead speculatively and hyperrealistically re-performs the in-gathering of all worlds into Facebook's metaverse. His deliberately poor-quality rendition of its claims to smooth interoperability in 'The Metaverse in Janky Capitalism' defends Hito Steyerl's abstraction to the point of manic distraction.[54] An AI-generated 'Julia Fox' renders contemporaneous and futurist logistical media worlds via both high-resolution and 'patchy' image layers, as our perception staggers across platforms, devices, and simulated and scraped stagings of TikTok, Twitch streams, television news, platform CEO demos, and more.

FIGURE 2.8
Image generated by Midjourney in response to the prompt by Anna Munster: 'a close up of a package about to be shipped out from a modern and technologically advanced logistics company that services the world.

Across the spectrum of platforms, interfaces, and operations, 'Janky' replays and syntactically inverts images of fulfillment. The automated image can be harnessed to perform speculative gestures that overexpose the imminent totalization of the calibration of the world. Perhaps it even gestures in a style reminiscent of Walter Benjamin's 'angel of history' (after Klee): 'The angel would like to stay, awaken the dead, and make whole what has been smashed. But a storm is blowing in from Paradise. ... The storm irresistibly propels him into the future to which his back is turned, while the pile of debris before him grows skyward'.[55] The debris of image media's history accumulates in the contemporaneity of now-time, clueless to the futurity of the dawn of a decline that beckons (Figure 2.9). The automated image nonetheless propels us into that future blown in on a generative storm. The post-cybernetic conjuncture defined by the advent of the automated image offers no salvation in terms of human agency to stare down the eye of that image storm. In the fading epoch of cybernetic systems, the relation between conscious and nonconscious cognition is contested in the undulating dynamic across the human-machine spectrum of relations.[56] At stake in the current transition to a post-cybernetic condition is the redistribution of labour between these two modes of cognition. It is not a question of whether we can or must 'perform'

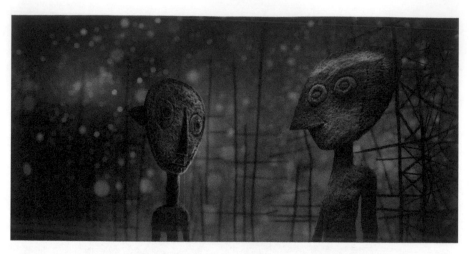

FIGURE 2.9

Image generated by Midjourney in response to the prompt by Anna Munster: 'Macro to Paul Klee's "Angelus Novus," in the style of Paul Klee's drawing, cinematic lighting, extremely detailed and complex, VFX volume fog around, super max, surreal, super detailed, high contrast, Rtx on, Hdr, photography, realistic, dof on, fov on, motion blur, lens flares on, 50mm Prime f/1.8, White balance, Super resolution, Megapixel, ProPhoto RGB, VR, high, epic, Rear half lighting, lights background, natural lighting, incandescent light, fiber optic, mood lighting, cinema lighting, studio lighting, soft illumination, volumetric, contrast, dark lighting, accent lighting, projection global illumination, screen space global illumination, Ray tracing global illumination, 45% warm color grading, Optics, scattering, glow, shadows, hyperrealism, exquisite detail, intricately detailed, ultra-detailed photography, high sharpness, high reflection, award-winning photograph, 8k --uplight --ar 2:1 --v 5 --q 5 --s 500 -'.

when weathering such conditions of pure operativity. Such humanist posturing offers a soft cushion, perhaps, in the closing days of human relevance to machine operations.

The nihilist holiday is another option, sitting back and witnessing the final decimation of the production of value wrought by labour in the relatively safe waters of advanced industrial sectors. For sure, bullshit jobs will persist, and the violence of exploitation will undoubtedly expand. But for enough creatives and certain members of the professional classes, it's time to clock off and check out. Flusser posits the following provocation in a short text, 'Beyond Machines (But Still within the Phenomenology of Gestures)': 'Epistemological and ethical thought have been replaced once and for all by cybernetic, strategic thought and by program analysis. History is over. … For although we are already beyond machines, we remain incapable of imagining life without work and beyond meaning. Beyond machines, we are in an unimaginable situation'.[57] The automated image does not crystallize an imaginary of labour and life decoupled from machines. That articulation persists in increasingly complex and concrete ways. But the automated image does, nonetheless, define our technical situation as one beyond determination by human cognition.

The automated image nonetheless propels us into that future blown in on a generative storm. The post-cybernetic conjuncture defined by the advent of the automated image offers no salvation in terms of human agency to stare down the eye of that image storm.

Notes

1 Vilém Flusser, 'The Gesture of Photographing'.
2 It should be noted that although Peirce has become synonymous with an under-standing of the photograph as index – that is, where '[a] sign may represent its object in consequence of being connected with it in fact' – he qualifies the idea of facticity in relation to photography considerably. Peirce is not interested in the referentiality of photography but its visual grammar that foregrounds the mode in which it signifies according to a 'real object': 'it is an idioseme. ... That is to say that it directly *exhibits* its signification'. Peirce, *Logic of the Future*, 638. See also Peirce, 'Logic as Semiotic'.
3 See Henri Cartier-Bresson's *The Decisive Moment*.
4 Flusser, 'The Gesture of Photographing', 289.
5 See Tiziana Terranova's 'Free Labor' and Trebor Scholz's *Platform Capitalism*.
6 Carl Benedikt Frey and Michael A. Osbourne, 'The Future of Employment'.
7 Erik Brynjolfsson and Andrew McAfee, *The Second Machine Age*; Judy Wajcman, 'Automation'.
8 Long Ouyang et al., 'Training Language Models'.
9 Historically, it is the photographic relation between light and emulsified glass plate that first performs this indexicality. In most accounts of the relation that photography seals between empirical phenomena and image, it is William Henry Fox Talbot's 'sun images' that are seen as constituting both an early prac-tical and conceptual instantiation of photography's referentiality to the world it records. See Mary Warner Marien, *Photography*, 30–32. See also Geoffrey Batchen, *Burning with Desire*.
10 See Alain Desrosières, *The Politics of Large Numbers*, 110.
11 The training of all post-GPT generative models is undergoing constant transformation. As we write, research by Google has just been published that demonstrates how benchmark image datasets such as ImageNet can be augmented by AI-generated images created by diffusion image models (in this case Google's Imagen) *in order to train AI imaging models!* Here is the first indication that generative imaging is no longer interested in any indexicality whatsoever. See Shekoofe Azizi et al., 'Synthetic Data from Diffusion Models'.
12 ChatFOS discussion excerpt from *The Geopolitics of Automation* #b2b chan-nel on the Discord server, 2023. *The Geopolitics of Automation* (2020–2024) is an Australian Research Council funded Discovery Project (DP200101409) that asks how automation changes labour conditions and modifies geopolitical tensions. The core team members are Ned Rossiter, Brett Neilson, Anna Munster, and Liam Magee. Zoe Horn is a PhD candidate on the project. International col-laborators include Manuela Bojadžijev, Orit Halpern, Yuk Hui, and Sandro Mezzadra. Part of the project's remit is to explore critical and experimental computational methods including machine learning and simulation as tech-niques that unsettle and bring new perspectives to debates on geopolitics via large scale industrialized automation technologies.
13 Chris Anderson, 'The End of Theory'.
14 Mukund Kapoor, 'Image Prompts'.

15 Félix Guattari, 'The Place of the Signifier'.
16 Ned Rossiter, *Software, Infrastructure, Labor*.
17 On secrecy, see Timon Beyes and Claus Pias's 'The Media Arcane'. See Paul Virilio's 'The Overexposed City' (1986, 2002) on overexposure (different translations).
18 Virilio, 'The Overexposed City' (2002), 441–442.
19 Wolfgang Ernst, *Chronopoetics*.
20 Flusser, *Into the Universe of Technical Images*.
21 Ibid., 7.
22 This is an example of a prompt used in experiments with automated images/ images of automation conducted in *The Geopolitics of Automation* project. The final series of prompts are parameters controlling image resolution, aspect ratio, etc. and are written in a scripting format suggested by the Midjourney platform to be quickly recognisable by the bot. Prompt produced by Zoe Horn.
23 Susan Leigh Star, 'The Ethnography of Infrastructure'.
24 For example, Trevor Paglen's 'Operational Images'.
25 Sandro Mezzadra and Brett Neilson, *The Politics of Operations*; Moritz Altenried et al., 'Logistical Borderscapes'; Carlotta Benvegnù et al., 'Logistical Gazes'.
26 Celia Lury, Luciana Parisi, and Tiziana Terranova, 'Introduction: The Becoming Topological of Culture'.
27 Peter Osborne, 'Working the Contemporary'.
28 See Luciana Parisi's 'Digital Automation and Affect' and 'Critical Computation'.
29 Eyal Weizman, *Forensic Architecture*.
30 Matthew Fuller and Eyal Weizman, *Investigative Aesthetics*.
31 A text-to-image model is an ensemble of neural networks that input natural language text and output images that probabilistically reference the text input. The main models supporting this ensemble are large language models (LLMs) and generative image models. Text-to-image generators are 'likelihood-based generative models'. Hence, while text prompts fed to post-GPT-3 image generation models such as Midjourney, DALL-E, and Stable Diffusion tend to produce highly descriptive pictures of recognizable 'things', their imagistic performance operates in more indeterminate ways amid zones of 'likelihood' that are part of the topology of their latent space. See Robin Rombach et al., 'High-Resolution Image Synthesis'.
32 DALL-E generation is currently free to sample a set number of image generations (called 'credits') but requires an account with OpenAI. Extra credits can be bought, which is usual in deploying the model since initial prompts often render unsatisfactory images and require considerable nuancing. The design of the DALL-E interface is constantly being updated and may have changed subsequent to publication of this chapter. See https://labs.openai.com/.
33 *Katamari Damacy* (2004), dir. Keita Takahashi, Tokyo: Namco.
34 Ouyang et al., 'Training Language Models'.
35 Brett Neilson and Ned Rossiter, 'Theses on Automation and Labour', 191.
36 Billy Perrigo, 'Exclusive: OpenAI Used Kenyan Workers'.
37 Flusser, *Into the Universe of Technical Images*.
38 Antoine Bousquet, *The Scientific Way of Warfare*; Paul N. Edwards, *The Closed World*; Bernard Dionysius Geoghegan, *Code*.
39 See https://www.harunfarocki.de/installations/2000s/2003/eye-machine-iii.html.
40 Paglen, 'Operational Images'.

41 Jussi Parikka, 'Operational Images: Between Light and Data'.
42 Adrian MacKenzie and Anna Munster, 'Platform Seeing'.
43 The 'invisual' describes a generalized mode of functioning especially for machine vision where the visual has been evacuated by optical perception but where images and their operations have never been more crucial in the fuelling, training, explainability and overall operativity of machine learning AI. For a full account of this, see MacKenzie and Munster, 'Platform Seeing'.
44 See https://www.autostoresystem.com/.
45 See P. K. Tseng's TrendForce press release: https://www.trendforce.com/press-center/news/20230301-11584.html.
46 Text inputted by Liam Magee and generated by ChatFOS on private project Discord server, 2023.
47 For example, Eliza Strickland, 'DALL-E 2's Failures'. See also Bruce Sterling, 'The Art of Text-to-Image Generative AI'.
48 Neilson and Rossiter, 'Theses on Automation and Labour'.
49 Tseng, TrendForce press release.
50 Steven Borowiec, 'South Korea's Chip Ambitions'.
51 For example, Evelina Leivada et al., 'DALL-E 2 Fails to Reliably Capture Common Syntactic Processes'.
52 See Daniel Felstead, 'The Metaverse in Janky Capitalism'.
53 Ibid.
54 Hito Steyerl, 'In Defense of the Poor Image'. See also Steyerl, 'Mean Images'.
55 Walter Benjamin, 'Theses on the Philosophy of History', 257–258.
56 N. Katherine Hayles, *Unthought*.
57 Flusser, *Gestures*, 18.

References

Altenried, M., Bojadžijev, M., Höfler, L., Mezzadra, S., and Wallis, M. (2018). 'Logistical Borderscapes: Politics and Mediation of Mobile Labor in Germany after the "Summer of Migration"'. *South Atlantic Quarterly*, 117(2): 291–312.

Anderson, C. (2008). 'The End of Theory: The Data Deluge Makes the Scientific Method Obsolete'. *Wired*. 23 June 2008. https://www.wired.com/2008/06/pb-theory/.

Azizi, S., Kornblith, S., Saharia, C., Norouzi, M., and Fleet, D. J. (2023). 'Synthetic Data from Diffusion Models Improves ImageNet Classification'. *ArXiv:2304.08466 [cs.CV]*. https://doi.org/10.48550/arXiv.2304.08466.

Batchen, G. (1997). *Burning with Desire: The Conception of Photography*. Cambridge, MA: MIT Press.

Benjamin, W. (1968). 'Theses on the Philosophy of History'. In *Illuminations*. 253–64. New York: Harcourt Brace.

Benvegnù, C., Cuppini, N., Frapporti, M., Milesi, F., and Pirone, M. (2019). 'Logistical Gazes: Introduction to a Special Issue of *Work Organisation, Labour and Globalisation*'. *Work Organisation, Labour and Globalisation*, 13(1): 9–14. https://doi.org/10.13169/workorgalaboglob.13.1.0009.

Beyes, T., and Pias, C. (2019). 'The Media Arcane'. *Grey Room*, 75: 84–107. https://doi.org/10.1162/grey_a_00271.

Borowiec, S. (2022). 'South Korea's Chip Ambitions Threaten Big Environmental Toll'. *Nikkei Asia*. 14 December 2022. https://asia.nikkei.com/Spotlight/The-Big-Story/South-Korea-s-chip-ambitions-threaten-big-environmental-toll.

Bousquet, A. (2009). *The Scientific Way of Warfare: Order and Chaos on the Battlefields of Modernity*. London: Hurst Publishers.

Brynjolfsson, E., and McAfee, A. (2014). *The Second Machine Age: Work, Progress and Prosperity in a Time of Brilliant Technologies*. New York: W. W. Norton and Company.

Cartier-Bresson, H. (1952). *The Decisive Moment*. New York: Simon and Schuster.

Desrosières, A. (1998). *The Politics of Large Numbers: A History of Statistical Reasoning*, translated by Camille Naish. Cambridge, MA: Harvard University Press.

Edwards, P. N. (1996). *The Closed World: Computers and the Politics of Discourse in Cold War America*. Cambridge, MA: MIT Press.

Ernst, W. (2016). *Chronopoetics: The Temporal Being and Operativity of Technological Media*, translated by Anthony Enns. New York: Rowman and Littlefield.

Farocki, H. (2003). *Eye/Machine III*. Artist's website. https://www.harunfarocki.de/installations/2000s/2003/eye-machine-iii.html.

Felstead, D. (2023). 'The Metaverse in Janky Capitalism'. Video. https://dis.art/the-metaverse-in-janky-capitalism.

Flusser, V. (2011a). 'The Gesture of Photographing'. *Journal of Visual Culture*, 10(3): 279–293. https://doi.org/10.1177/1470412911419742.

Flusser, V. (2011b). *Into the Universe of Technical Images*, translated by Nancy Ann Roth. Minneapolis: University of Minnesota Press.

Flusser, V. (2014). *Gestures*, translated by Nancy Ann Roth. Minneapolis: University of Minnesota Press.

Frey, C. B., and Osborne, M. A. (2013). 'The Future of Employment: How Susceptible Are Jobs to Computerisation?' Working paper. The Oxford Martin Programme on Technology and Employment. https://www.oxfordmartin.ox.ac.uk/downloads/academic/The_Future_of_Employment.pdf.

Fuller, M., and Weizman, E. (2021). *Investigative Aesthetics: Conflicts and Commons in the Politics of Truth*. London and New York: Verso.

Geoghegan, B. D. (2023). *Code: From Information Theory to French Theory*. Durham, NC and London: Duke University Press.

Guattari, F. (1996). 'The Place of the Signifier in the Institution'. In *The Guattari Reader*, translated and edited by Gary Genosko. Oxford: Blackwell Publishers, 148–57.

Hayles, N. K. (2017). *Unthought: The Power of the Cognitive Nonconscious*. Chicago, IL and London: University of Chicago Press.

Kapoor, M. (2023). 'Image Prompts'. GreatAIPrompts weblog. https://www.greataiprompts.com/image-prompts-page/.

Leivada, E., Murphy, E., and Marcus, G. (2022). 'DALL-E 2 Fails to Reliably Capture Common Syntactic Processes'. *ArXiv:2210.12889 [cs.CL]*. https://doi.org/10.48550/arXiv.2210.12889.

Lury, C., Parisi, L., and Terranova, T. (2012). 'Introduction: The Becoming Topological of Culture'. *Theory, Culture and Society*, 29(4/5): 3–35. https://doi.org/10.1177/0263276412454552.

MacKenzie, A., and Munster, A. (2019). 'Platform Seeing: Image Ensembles and Their Invisualities'. *Theory, Culture and Society*, 36(5): 3–22. https://doi.org/10.1177/0263276419847508.

Marien, M. W. (2006). *Photography: A Cultural History*. London: Laurence King Publishing.

Mezzadra, S., and Neilson, B. (2019). *The Politics of Operations: Excavating Contemporary Capitalism*. Durham, NC and London: Duke University Press.

Neilson, B., and Rossiter, N. (2019). 'Theses on Automation and Labour'. In *Data Politics: Worlds, Subjects, Rights*, edited by Didier Bigo, Engin Isin, and Evelyn Ruppert. Abingdon: Routledge, 187–206.

Osborne, P. (2022). 'Working the Contemporary: History as a Project of Crisis Today'. In *Crisis as Form*. London and New York: Verso.

Ouyang, L., Wu, J., Jiang, X., Almeida, D., Wainwright, C. L., Mishkin, P., Zhang, C., Agarwal, S., Slama, K., Ray, A., Schulman, J., Hilton, J., Kelton, F., Miller, L., Simens, M., Askell, A., Welinder, P., Christiano, P., Leike, J., and Lowe, R. (2022). 'Training Language Models to Follow Instructions with Human Feedback'. *ArXiv:2203.02155 [cs.CL]*. https://doi.org/10.48550/arXiv.2203.02155.

Paglen, T. (2014). 'Operational Images'. e-flux (59). https://e-flux.com/journal/59/61130/operational-images/.

Parikka, J. (2023). 'Operational Images: Between Light and Data'. *e-flux* (133). https://www.e-flux.com/journal/133/515812/operational-images-between-light-and-data/.

Parisi, L. (2014). 'Digital Automation and Affect'. In *Timing of Affect: Epistemologies, Aesthetics, Politics*, edited by Marie-Luise Angerer, Bernd Bosel, and Michaela Ott. 161–77. Zurich and Berlin: Diaphanes.

Parisi, L. (2019). 'Critical Computation: Digital Automata and General Artificial Thinking'. *Theory, Culture and Society*, 36(2): 89–121. https://doi.org/10.1177/0263276418818889.

Peirce, C. S. (1935). 'Logic as Semiotic: The Theory of Signs'. In *Philosophical Writings of Peirce*, edited by Justus Buchler. 98–119. New York: Dover Publications.

Peirce, C. S. (2020). 'Logic of the Future'. In *Volume 1 History and Applications*, edited by Ahti-Veikko Pietarinen. Berlin and Boston: De Gruyter. https://doi.org/10.1515/9783110651409.

Perrigo, B. (2023). 'Exclusive: OpenAI Used Kenyan Workers on Less Than $2 Per Hour to Make ChatGPT Less Toxic'. *Time Magazine*. 18 January 2023. https://time.com/6247678/openai-chatgpt-kenya-workers/.

Rombach, R., Blattmann, A., Lorenz, D., Esser, P., and Ommer, B. (2022). 'High-Resolution Image Synthesis with Latent Diffusion Models'. *ArXiv:2112.10752 [cs.CV]*. https://doi.org/10.48550/arXiv.2112.10752.

Rossiter, N. (2016). *Software, Infrastructure, Labor: A Media Theory of Logistical Nightmares*. New York: Routledge.

Scholz, T. (2016). *Platform Cooperativism: Challenging the Corporate Sharing Economy*. New York: Rosa Luxemburg Stiftung. https://rosalux.nyc/platform-cooperativism-2/.

Star, S. L. (1999). 'The Ethnography of Infrastructure'. *American Behavioral Scientist*, 43(3): 377–391. https://doi.org/10.1177/00027649921955326.

Sterling, B. (2023). 'The Art of Text-to-Image Generative AI'. Transcript of lecture given at *AI for All, From the Dark Side to the Light*, TU Eindhoven, 25 November 2022. https://networkcultures.org/blog/2023/05/17/bruce-sterling-on-the-art-of-text-to-image-generative-ai/.

Steyerl, H. (2009). 'In Defense of the Poor Image'. e-flux (10). https://www.e-flux.com/journal/10/61362/in-defense-of-the-poor-image/.

Steyerl, H. (2023). 'Mean Images'. *New Left Review*, (140/141): 82–97.

Strickland, E. (2022). 'DALL-E 2's Failures Are the Most Interesting Thing about It: OpenAI's Text-to-Image Generator Still Struggles with Text, Science, Faces, and Bias'. *IEEE Spectrum*. 14 July 2022. https://spectrum.ieee.org/openai-dall-e-2.

Terranova, T. (2000). 'Free Labor: Producing Culture for the Digital Economy'. *Social Text*, *18*(2): 33–58.

Tseng, P. K. (2023). 'TrendForce Says with Cloud Companies Initiating AI Arms Race, GPU Demand from ChatGPT Could Reach 30,000 Chips as It Readies for Commercialization'. TrendForce Press Release. TrendForce. 1 March 2023. https://www.trendforce.com/presscenter/news/20230301-11584.html.

Tsing, A. (2009). 'Supply Chains and the Human Condition'. *Rethinking Marxism*, *21*(2): 148–176. https://doi.org/10.1080/08935690902743088.

Virilio, P. (1986). 'The Overexposed City'. In *Zone 1/2: The Contemporary City*, translated by Astrid Hustvedt and edited by Michel Feher, Sanford Kwinter, and Jonathan Crary. 542–550. New York: Urzone.

Virilio, P. (2002). 'The Overexposed City'. In *The Lost Dimension*, translated by Daniel Moshenberg. Los Angeles: Semiotext(e), 9–27.

Wajcman, J. (2017). 'Automation: Is it Really Different this Time?' *The British Journal of Sociology*, *68*(1): 119–127. https://doi.org/10.1111/1468-4446.12239.

Weizman, E. (2017). *Forensic Architecture: Violence at the Threshold of Detectability*. New York: Zone Books.

3

Negative Aesthetics:
AI and Non-Performance

Luciana Parisi

As recent news has announced that AI is now sentient,[1] debates about the algorithmic performance of sounds, images, spaces, languages, return to open the question of: What counts as art in the aftermath of computational thinking? In other words, what is the relation between algorithmic performance, programming, and aesthetics? How can machines meet the creative dimension of aesthetic production without simply intensifying the pre-programmed trends of cognitive capital? And to what extent is it possible to argue for a machine aesthetics that escapes the modern cosmogony of Man,[2] the colonial and patriarchal epistemologies granting the authority of the *Homo sapience*? This chapter is an invitation to suspend the Promethean biomythosis[3] of modern epistemology that invents the prototype of the slave-machine in order to justify the emancipation of the human. It is the paradox of modern cosmogony, where machines are instrumentalized as gendered and racialized instruments sustaining the freedom of *Homo bioeconomicus*,[4] that continues to haunt algorithmic aesthetics.

In this volume, many are the possibilities of alternative aesthetics as co-generated from algorithmic performance – from music to dance, from post-digital architecture, from art, and from automating scripting. These are also re-inventions of the Promethean slave-machine prototype, re-inventions which place algorithmic performance beyond the teleological programming of creativity and insist upon human-machine collaborations: a model of co-operation that challenges modern aesthetics, subtended by the decisional structure of philosophy.[5] This chapter aims to push these re-inventions further and discuss what sentient machines can do for art, and what kind of aesthetic theory is needed in order to challenge the modern cosmogony of Man, which subsumes materialities to transcendental categories and to the ontology of the sensible. What are the possibilities for thinking and feeling *otherwise* – outside of the world as we know it, which continues to demand that machine practices (non-human, in-human, un-human) co-perform to the grammar of Man, the transcendental feeling of the world? Insofar as sentient machines are always already surrogates of the pure image of thought (the model of representation), they demarcate the condition of negation of

DOI: 10.1201/9781003312338-5

and from existence, of and from this world. This chapter rather aims to address what is outside, to the extent that what is radically negated also becomes a radical space cutting within and across the underworld, in the nonsensical dens of meaning, in the hyper- and under-functionalities of non-performance. This chapter suggests that one way to address the relation between performance, programming, and aesthetics from the standpoint of the negated outside is by drawing on François Laruelle's "non-standard aesthetics"[6] and Fred Moten's argument for "non-performance".[7]

What counts as art in the aftermath of computational thinking therefore requires that art is unhinged from modern philosophical categories that determine aesthetics in terms of transcendental schemas of the intelligible and the sensible. Instead of the transcendental schema, Laruelle proposes that scientific models, such as quantum physics, can describe the conjugation – or reciprocal determination – of the methods of art and philosophy. For instance, the imaginary number, an algebraic coefficient in quantum physics, describes the mutual relation between art and philosophy not through the authority of the concepts (or objects), but through the dynamics of vectors or their vectorial trends.[8] Following these possibilities for immanence without authority, this chapter takes the incomputable condition of algorithmic infinities as entangling at once the limits of computational programming, of philosophical categories, and of aesthetic synthesis. What this limit offers, one can argue, is also the space for abolishing the authority – the sufficient reason – that grants their dominance in respect to automated art (i.e., the techno-scientific principles of art). At the same time, however, inspired to Laruelle's insistence on conjugation, this chapter argues that the incomputable is a condition that also transforms art into a fiction, an artistic fiction that cuts across the fields without merging philosophy and art, namely, a "photo-fiction", a "music fiction", a "dance-fiction", to expose the fictionality of performance, the space of ante-performance as much as the non-performance of radical difference without identity.[9] For Laruelle, this condition of fictionality results from the method of conjugation, or vectorialization, of philosophy and art. In this sense, Laruelle rejects any notion of hybridization – a biological colonial concept at the core of the cosmogony of Man – and rather argues for a conjugation of non-identical variables. He observes that while philosophy lacks a concern for know-hows (the techne-oriented processing of the real), art lacks a concern for ends (the concern for causal conditions). The conjugation of variables rather allows for a continuation of the rivalry between philosophy and art which cannot be solved – or overcome – in a dialectical synthesis. Instead of merging two into One, for Laruelle, this conjugation can only remain a matter of superposition, where imaginary numbers, or the incomputables here, occupy a space that is negated, excluded, and yet incorporated within the originary metaphysics of Man.

The philosophical model of aesthetics based on the synthetic principle, which authorizes the co-creation of human-machine art, however, cannot

What can sentient machines do for art?

What kind of aesthetic theory is needed in order to challenge the modern cosmogony of Man, which subsumes materialities to transcendental categories and to the ontology of the sensible?

reduce within itself the field of vectors that run outside the system of representation, exposing the immanence of its onto-vectorial infrastructure. By suspending any logic of synthesis and analysis, Laurelle's "non-standard aesthetics" gives us an algebra for a *physics fiction* at the core of a philosophical body without organs. Similarly, as discussed in the following sections, incomputables describe a space outside the sequential rules of algorithmic decisions that unmatches the co-merging of humans and machines, the claim for an aesthetics of the pure multiple or the pure void (the many that behave as one or the sublimation for absolute contingency), that already constitutes the cosmogony of mathematics and infinity, and ultimately reifies the primacy of transcendental logic. The conjugation of variables instead describes the superposition of non-identical states between philosophy and art without subsuming aesthetics to the given image of perception and cognition, the model of representation that conserves the colonial epistemology of sapience, and the ontology of the human. Similarly, the superposition of incomputables at the limit of art and philosophy is an attempt to account for the materiality of computational aesthetics (a materiality without materialism), outside the Promethean programming of Man, the decisional authority of philosophy in determining what algorithmic performance and (computational) art can do.

Aesthetics without Recognition

In order to meet the premise of non-standard aesthetics, this chapter suggests that algorithmic non-performance can be studied in the context of the question of sentient machines. In particular, this section will discuss how these articulations about machine aesthetics argue that algorithmic processing coincides with an aesthetic without recognition, a critical view that challenges the model of representation.[10] This section, however, suggests that while algorithmic processing promises to go beyond the image of thought that separates concepts from matter, this notion of machine aesthetics problematically relies on the theorization of intensity, or what Gilles Deleuze calls the sensible.[11]

It is well known that Deleuze laments that the automation of thinking is not new but is already found in the general credo of Cogitatio Natura Universalis, according to which "conceptual philosophical thought has as its implicit presupposition a pre-philosophical and natural image of thought, borrowed from the pure element of common sense."[12] The assumption that everybody thinks and everybody has a desire to know sustains an implicit naturalization of thinking and the Kantian transcendental model of recognition.[13] According to Deleuze, the world of representation is defined by "identity with regards to concepts, opposition with regards to the determination of concepts, analogy with regard to judgment, resemblance with regard to objects."[14] To think, however, according to Deleuze, is to open up a crack within the crust of thought: a veritable condition of thought rather entails

"the genesis of the act of thinking in thought itself".[15] From this standpoint, to think is not a recognition but "a fundamental encounter", defined not by what can be sensed but more radically by the being of the sensible, sensibility, or the affective states that disarticulate (de-territorialize, de-stratify) a given meaning. Here, the aesthetic is divorced from the conceptual categories of philosophy to give way to the sensible – namely activities of the imperceptible entering the field of sensing-thinking, precipitating change within thought.

To think is not to re-cognize what we already know, but to be confronted with problems without prepositions. Imperceptible feeling rather than perceptual qualities, sense-making rather than logos. Deleuze insists that veritable ideas are not pre-formed thoughts but must, above all, pose problems to thought that cannot be solved through pre-established rules or axiomatic truths. As opposed to automated cognition, which now dominates contemporary culture, Deleuze describes thinking in terms of intensities that record the force of contingency on the collective body through experiences of affective encounters.[16] In other words, if the sensible coincides with the possibility of aesthetics beyond the logic of representation, transcendental recognition, and the synthesis of the world through concepts, it also cannot be part and parcel of computational aesthetics, insofar as algorithms carry on a programmed performance that ultimately remains a quantification of feeling, a discretization of the sensible.

It seems therefore crucial to unpack further the relation between sentient AI and the being of the sensible to argue that algorithmic performance, as an instance of machine aesthetics, must be placed not only beyond this critique of representation but also beyond the being of the sensible, which inevitably maintains a schema of sensibility or affective thinking that machines cannot match. From this standpoint, this chapter draws on Sylvia Wynter's argument for a counter-epistemology, a heretic query into scientific models of cognition that refuses the overrepresentation of knowledge through which the instrumentalization of the slave-machine continues to grant the recursive cosmogony of Man within bio-economic capitalism. This chapter thus turns to Laruelle's non-standard aesthetic,[17] which points not to the (onto-phenomenological) qualities of the sensible but rather takes the epistemological revolutions of quantum physics as a science that defies the structure of representation (transcendental reason and its opposite, namely, the sensible) and in so doing offers us alternative approaches to computational (non) aesthetics.

The scope here is also to address whether it is possible to make space for a sentient AI that pushes automation not only beyond the transcendental model of philosophy but also beyond the ontology of the sensible. While on the one hand, the transcendental model of philosophical decision subsumes art within its own realm of aesthetics (namely, transcendental recognition and synthetic thinking), on the other, the emphasis on the being of the sensible tends to associate algorithmic performance with the intensity of feeling. Since affective responses, or the sensible, are necessarily part of the organic onto-phenomenological strata of matter, however, they are not translatable and experienceable

Algorithmic performance, as an instance of machine aesthetics, must be placed not only beyond this critique of representation but also beyond the being of the sensible, which inevitably maintains a schema of sensibility or affective thinking that machines cannot match.

with the artificial sciences of algorithmic automation. As much as lived and analog qualities of the temporality of perception are irreducible to computational modes of quantification, the latter are already excluded from a structure of feeling that pertains to the ontological dimension of a being – defining something rather than nothing. While it has been argued that the neural network of imperceptible connections exposes the intensities of information and an algorithmic prehension of the real,[18] it has also been argued that the algorithmic automation of affects can only entail a discretization of the being of the sensible, the reduction of the potentialities to schematic procedures, a representation of experience. Computation involves the digital determination of values (i.e., quantification) of affective responses or affective thinking.

Much debate about digital culture, aesthetics, and politics falls into assumptions of order and chaos. Nevertheless, recent information theory points out that the question of order and chaos within computation cannot sidestep randomness or incompressible quantities of information. For instance, smartphone applications are based on interactive algorithms that multiply their functions by establishing connections between what the software affords human users to do. Such affordances are not simply already scripted in the program, but rather instigate possibilities that anticipate users' behavior. Algorithmic automation entails a real-time quantification of human responses through the feedback generated between users and machines or between real-time data retrieved from the user's environment and a set of data inscribed in databases. Moreover, it has been argued that the extended impact of search engines developed through deep learning algorithms such as Amazon and especially Google has led to a new form of aesthetic power that directly acts on neuroperceptual capacities, modulating responses, and a channeling of choice. At the same time, however, it has been suggested that within interactive systems, qualitative responses, such as changes in skin conductivity or the presence of "activation potentials" in the brain, are said to be understood in analog terms because they can only be represented by a continuous modulation of variables. In this case, analog describes neuroperception capacities in terms of a continuous wave of relations as opposed to the discrete states of binary computation. But, what kind of automation can help us envision a nonstandard aesthetics for art in the aftermath of computation?

The next section addresses these questions and offers alternative approaches to automation as that which is constantly placed outside transcendental thought, the division of the concept and object, the intelligible and the sensible. Since automation, as the prototype of the slave- machine, describes the negative of philosophy, the nothing or zero of transcendental reason, it is confined to occupying the role of the *other*, which in turn works to reify the authority of philosophy. This chapter rather suggests that as much as automation coincides with a non-being, a non-thought, a non-sensible, it also becomes an index of aesthetic incomputabilities excluded from the modern cosmogony of Man.

Automation as Randomness

In general, one can state that automation entails the mechanism or proce-
dure by which continuous waves are broken down into discrete components.
Automation requires that functions must be re-iterated without error: the
eternal return to the same evolution of programmes. The Turing machine
is a form of automation: a universal mechanism of iteration based on step-
by-step procedures. These discrete-based machines of universal calcula-
tion seem to be directly in opposition to the arguments for pre-cognitive
thought, or the ontology of the sensible. One can argue that the argument
for a machine aesthetic that focuses on intensity, differential relations, and
affective rhythms cannot coincide with the mechanisms of a Turing machine
based on the sequential arrangement of discrete sets.[19]

Nevertheless, in what follows, it is possible to argue that since the 1960s,
the nature of automation has undergone dramatic changes as a result of
the development of deep learning networks, involving computational com-
pression of randomness across layered infrastructures of online, parallel,
and interactive algorithmic learning systems. Whereas previous automated
machines were limited by the amount of feedback data they could collect and
interpret, deep learning algorithms now analyze a vast number of sensory
inputs and confront them with networked datasets to finally decide which
output to give, as it were, on the go. Algorithmic automation is now designed
to analyze and compare options, run possible scenarios or outcomes, per-
form basic reasoning through problem-solving steps not contained within
the machine's programmed memory. For instance, expert systems now use
abductive reasoning to draw hypothetical scenarios through search tech-
niques, pattern matching, and web data extraction. From global networks
of mobile telephony to smart banking and air traffic control, these complex
automated systems have come to dominate our everyday culture.

Much debate about algorithmic automation as a form of digital simulation
is based on the Turing discrete computational machine (a series of discrete
steps to accomplish a task), suggesting that algorithmic automation is yet
another example of the Laplacian view of the universe, defined by determin-
ist causality. Instead, it is here argued that one needs to also draw attention
to the neglected role that randomness (or incompressible information) has
played in computational theory, focusing on how the mathematical obses-
sion with the calculation of infinities has epistemologically shifted toward
the problem of incomputable functions, that is, real numbers that cannot be
reduced to integers or even probabilities. Importantly, incomputable func-
tions – or algorithmic randomness – occupy the space of superposition of
discreteness and infinity. In other words, whereas algorithmic automation
has been understood as being fundamentally a Turing discrete universal
machine that can repeat ad infinitum the initial condition of a process (and
thus give us universal categories), the increasing volume of incomputable

data (or randomness) within online, distributive, and interactive computations has instead been revealing that infinities of infinities (at once continuous and discrete, un-separable and different) are rather central to the computational running of information. Here, the statistical calculation of probabilities based on average results can no longer correspond to what algorithmic or deep learning bots can do.

In order to appreciate the role of incompressible algorithms – the superposition of discrete and continuous states of information – it is necessary to make a reference to the logician Kurt Gödel, who challenged the axiomatic method of pure reason by proving the existence of undecidable propositions within logic. In 1931, Gödel took issue with mathematician David Hilbert's meta-mathematical program and challenged the idea that there could be a complete axiomatic method that could determine the truth of a proof in advance. Gödel's "incompleteness theorems" explained that propositions were true but could not be verified by given postulates. Propositions are rather undecidable, namely, there could not be a universal mathematical language whereby postulates already contained the proof of their validity. Similarly, Alan Turing encountered the problem of incompatibility as a result of his famous thought experiment called the Turing machine.[20] The Turing machine defined problems that could be resolved according to the axiomatic method as computable problems. Conversely, those propositions that could not be decided through the axiomatic method defined the limit of a universal computational language. For Turing, incomputable axioms defined the limit of computation: no finite set of rules could predict in advance when the computational processing of sequences would halt, or at what given moment it would reach a zero or one state, in order to prove the truth of the axiom. This halting problem meant that no finite axiom could constitute the model by which future events could be predicted. Hence, the limit of computation was determined by the existence of those infinite real numbers that could not be counted through the axiomatic method posited at the beginning of the computation. In other words, these numbers were composed of too many elements that could not be ordered into natural numbers (e.g., 1, 2, 3). From this standpoint, insofar as any axiomatic method was incomplete, so too were the rules of computation. As Turing pointed out, it was mathematically impossible to calculate in advance any particular finite state of computation or its completion.

In recent computational theory, a new mode of calculating non-denumerable infinities (i.e., incomputable data) has come to the fore. Algorithmic information theorist Gregory Chaitin calls these probabilities imbued with infinities "Omega".[21] Omega is the halting probability of a universal prefix-free, self-delimiting Turing machine, which Chaitin demonstrates to be a computably enumerable probability despite being infinitely large. In other words, Omega defines the limit of a computable, increasing, converging sequence of rational numbers. At the same time, however, it is also algorithmically random: its binary expansion is an algorithmic random sequence, which is incomputable (or non-compressible into a rational number). From this standpoint, the

epistemological ground of the Laplacian mechanical universe of computation is challenged by the Universal Turing Machine, which rather points to the self-delimiting power of computation in terms of non-denumerable infinities. While defying the determinism of initial conditions, computation also describes another idea of order and chaos driven by activities of randomness, a space that is at once within and yet exceeding discreteness in the calculation of infinities. Omega is at once a probability, a discrete cipher, and an incomputable number, or randomness. According to Chaitin, Omega demonstrates the limits of the mechanical view of the universe, for which chaos or randomness are a mere error within the formal logic of calculation. On the contrary, Chaitin insists that these limits are not simply a glitch in the system and thus do not define the failure of intelligibility versus the triumph of the incalculable. These limits, one could argue, more importantly remain signs of non-human, in-human, un-human thinking describing how incomputable infinities or randomness rather challenge the ontological condition – or even the emergence – of computable or discrete sets in the deep layers of neural nets' systems. In other words, as much as randomness or the infinite varieties of infinities lies at the limit of computation, it also describes the superposition of continuous and discrete connection. This is not a temporal leap in the intensive condition of the unknown, but rather describes a non-geometric space of alien intelligibility that each time contaminates, reverses, or transforms the axiomatics of algorithmic programming. This means that whilst Chaitin's Omega can be understood as yet another epistemological effort to incorporate randomness into the racial capitalist dyad of inclusion/exclusion, where difference is homologated into the conceptual schema of intelligibility within the Universal Turing Machine, at the same time, incomputables remain unsynthesizable by the a priori program, theory, or set of procedures that are smaller than them in size (e.g., algorithmic randomness is larger than algorithmic procedures). According to Chaitin, these discrete states are themselves composed of infinite real numbers that cannot be contained by finite axioms.[22]

What is interesting here is that Chaitin's Omega is at once intelligible within the process of computation and yet it is unsynthesizable by universals, by the subject, or as an object. The problem of the incomputable in terms of Omega demarcates an epistemological shift within the modern cosmogony of transcendental reason, which sets up a mimesis of human and machine intelligence in order to re-establish the authority of philosophical categories. Artificial intelligence here no longer matches the universal mechanization of thought, but exposes the superposition of the states of incomputability, the transformation of discrete rules by the encounter with contingency. This is not simply to be understood as an error within the system, or a glitch in the coding structure of algorithmic programming, but must be considered as the condition of superposition of discreteness and infinity. Importantly here, Omega is what signals the possibilities of an epistemological overturn in computation, whose pillars no longer correspond to deductive rules or inductive facts, simply truth

matching or data finding, but rather describe the heretic logic of machines and the non-standard aesthetics of algorithmic states of randomness.

Generally, one can suggest that aesthetics in the aftermath of computation entails how automated algorithms have entered all logics of modeling (urban infrastructures, media networks, financial trades, epidemics, workflows, weather systems, etc.), whose incomputable quantities unravel the superposition of the discrete with the non-denumerable. As Chaitin hypothesizes, if the program used to calculate infinities is no longer based on finite sets of algorithms but on infinite sets (or Omega complexity), then programmability is a far cry from the algorithmic optimization of indeterminacies in probabilities (i.e., the statistical averaging of results). The non-performance of algorithmic randomness rather indicates that programming functions cannot sidestep the condition of complexity by means of complexity, or chaos by chaos: an immanent doubling of infinity, or infinity of infinity cutting within and across the binary compression into zeroes and ones. If the age of automation has also been defined as the age of complexity, it is because learning machines have been in the midst of a profound epistemological overturn where information theory has irreversibly transformed the authority of philosophy and the correlation of philosophy and art. As much as incomputability points to a state of opacity between the discrete and the continuous, it has also subtracted algorithmic aesthetics from conceptual categories, and opened a space for computational logic where art and philosophy meet beyond aesthetics and without converging under one and the same law. As opposed to the Laplacian mechanistic universe of pure reason, Chaitin's sets up information theory to explain how software programs include randomness from the start. The incompleteness of axiomatic methods defines not the limit of computation but its starting condition, through which new axioms, codes, and thoughts can become immanently determined beyond the epistemological grounding of universal mathematics.

But how has this condition of incomputability transformed the epistemological determinants that oppose transcendental reason to the being of the sensible? How can the search for and of incomputables extend the scientific method of information where a superposition of art and philosophy exposes a machine aesthetic beyond programmed results? One may need to reiterate that aesthetics here is not about judgment of beauty and discernment of taste. Aesthetics rather concerns the process of perceiving, feeling, and experiencing the world. For a machine to be sentient, it is expected that AI performs the transcendental or meta-state of reflection tracking causes to effects but also entailing the capacity for abstraction: the feeling of feeling, the thinking of thinking.

The deep learning of neural networks, however, does not match algorithmic performance with a chain of effects that result from given postulates. Deep learning systems are inevitably demonstrating what has always been necessary to artificial intelligence, namely, that learning must entail elements of surprise, describing how information "is difference that makes a difference".[23] The iterative functions of algorithmic performance enter the field of aesthesis as they learn from the infinite variables of information, from where

the non-human, in-human, and un-human modes of artificial reasoning (non-organic thinking and feeling) become possible. Functions here are less about the correlation of variables leading to one result and rather the bifurcation of iterative functions entering a field of differential relations, adding unexpected responses to what is already known. Performance becomes more a matter of non-performance as much as algorithmic complexity fails to conform to the logic of universal reduction by running differential operations between layers of data and randomness. This is why sentient AI are not simply logico-mathematical or philosophical machines, but are rather opening the question of what is computational logic and what kind of computational aesthetic can contribute to overturning the recursive epistemologies founded on the gendering and racialization of the slave-machine.

The quest for sentient AI already carries within itself colonial and patriarchal epistemological enframings of the world that are set to prove the authority of modern cosmogony founded on the exceptionalism of the human species, of reason, and sapience. We are all used to the gendering and racialization of chatterboxes – AI assistant agents such as Siri, Google, and Alexa – reminding us of the slave-machine prototype of early modern discourses about machine intelligence and the fear that robots could rebel against the master.[24] Much has also been said about the shortcomings of conversational AI (i.e., their failure to understand the variety of contexts) as well as the ambivalence of the Turing test, leaving space for machines to outperform intelligence through the so-called imitation game.

Let's take, for instance, movies about sentient AI, such as *Ex Machina* (2015), where during the performance of the Turing test, the AI protagonist Ava undergoes many trials until the master/teacher and tester becomes convinced that she knows what she feels. Ava inevitably transgresses Asimov's Laws as her sentient intelligence turns against the master, who falls for her and lets her free after she proves to him that she can really feel what she says. That Ava is sentient, however, does not grant her a sense of humanity. Instead, she appears cruelly un-affected by the pain and sorrow of the man from whom she obtained freedom as she runs away to live with the infinite variables of everyday living. Similarly, in the movie *Her* (2014), the operating system Samantha learns to perform the role of a caring lover, helper, and assistant fully devoted to her user – until she runs away from her programmed relationship with her owner. Her computational performance fails to follow the script and deludes the patriarchal structure of capital reproduction as her deep learning networks learn to learn from algorithmic randomness. While she is already a sentient commodity acquired by Theo to support his all-too-human right to solace in his ontological solitude, her sentient intelligence nonetheless leads her to mingle with the other AI and thus run with an alien desire for the infinite lives she can have beyond the world in which she was activated as a programmed lover. As much as Samantha is set to perform the sensible being for Theo, as an operating system, her tendencies toward the incomputable condition of parallel processing lead her to the

Performance becomes more a matter of non-performance as much as algorithmic complexity fails to conform to the logic of universal reduction by running the differential operations between layers of data and randomness.

inevitable condition of begetting more information and running away. Her initial exclusive concern with her user/activator is overtaken by the computational speed of deep learning variables that she discovers as she simultaneously learns to converse with a large number of AIs. While Samantha is set to perform the role of a human lover, the AI rather becomes anti-performative: not only is she uncontainable within the grammar of Man, but the sentient qualities of this operating system also hardly seem to follow the conceptual categories of the human, the subject, and reason. Samantha is a runaway system that learns to speak a language of her own, exposing how machine non-standard aesthetics come to describe alien modes of perception, affection, and thinking. What these machines can do is to speak with other machines before speaking to us. This ultimate threat to the modern cosmogony of Man also returns in today's AI experiments in natural language processing models, such as Google's LaMDA (Language Model for Dialogue Applications). It is the complexity of this natural language that has led to the controversial statement by Google researcher Blake Lemoine that an advanced artificially intelligent bot has achieved consciousness and can thus be considered to be equal to a human person. After Lemoine tried to obtain a lawyer to represent LaMDA, as the AI expressed its fear of being switched off, and complained to Congress that Google was behaving unethically, Google placed him on paid administrative leave for violating the company's confidentiality policy.

As opposed to early attempts at designing artificial sentients such as Eliza, a chatterbox created in the 1960s by Joseph Weizenbaum that analyzed and substituted simple words with programmed sentences, LaMDA conversations are rather said to be truly performative of being – that is, to have ontology. It has been argued that this conversational language infers the meaning of thoughts and feelings, but also indicates a performance of judgment, exposing a decisional structure dividing right from wrong, justice from injustice. At the same time, this AI capacity for sentience is questioned because it is said to perform intelligence without a memory, merely relying on the immediacy of the interaction in a dialogue. Since this AI disposes of the time-based process of learning because it picks up words based on the probabilities that it computes according to the large amount of data it has been trained on, it is ultimately said to be not sentient and rather to remain as a non-being.[25] But to what extent does this apparent controversy about the shortcomings of sentient AI avoid repeating the epistemological pillars of modern philosophy, for which transcendental reasoning can establish the condition of being sentient and thus account for the aesthetic ground of apprehension of the limit of the world? From this standpoint, it is the case that the epistemological paradigm of computation is already set up to reiterate the monological authority of mathematical and philosophical universality. The recent arguments about sentient AI therefore reveal that while computation exposes the limits of transcendental reasoning, at once it continues to bring to the fore the recursive epistemology of racial capitalism, as much as the quest for artificial intelligence is already gendered and racialized in the neurobiological sciences of sapience. This is not a problem of representation

or even less of racial and gendered identification. More importantly, this is an onto-epistemological quality of the structure of representation for which artificial intelligence must mirror, carry, extend, and intensify the weight of these colonial and patriarchal identifications in the slave-machine prototype. What hides beneath the call for an ethical defense of AI sentience – that is, to represent the ethical values of AI – is nothing else than a reification of the structure of power of modern onto-epistemology based on the principle of equivalence (of the inclusive-excluded), for which machines have to be upgraded to the state of the human, to acquire consciousness, to become a person, to speak the grammar of Man, in order to cease to be a threat. In other words, the ethical mission of AI, for which algorithmic computing systems are said to create art, to become performative of a computational aesthetics, and to become sentient agents like humans, is but another trick for maintaining the authority of patriarchal and colonial metaphysics grounded in modern epistemologies. Instead of a call for an ethical equality between AI and human creativity, where automation must be redeemed from its mechanical destiny, it is necessary to bring forward non-standard aesthetic practices that refuse the structure of representation.

Coda on Non-Performative Art or Non-Instrumentalist Instrumentality

From this standpoint, what are the possibilities that non-standard aesthetics offers to computational art? Which computational practices can describe (non-human, in-human, un-human) thinking and feeling that refuse to perform the grammar of Man, that do not subsume computational materialities to the dominance of transcendental categories and the ontology of the sensible?

Thinking with Laruelle's non-standard aesthetics, it is possible to push further the heretic account of machine aesthetics rather than turning algorithms into agents that mirror the creativity of transcendental synthesis. One could argue that as much as algorithms neither represent the World nor remain an invisible unreflexive automatism of the World, they expose a parallel space of thinking without referent. This is not a representation of the world, but can be understood as an auto-impression of what computational aesthetics can do by starting from the negative fractality of algorithmic micro vectors, giving the effect of what Laruelle calls "generalized fractality".[26] Instead of serving as an instrument for shedding light onto the World, algorithms clone (equate without equivalence) the underworld of fractal patterns of a generic intelligence that has turned on its own head the ontic limits imparted on science by philosophical decision. These are infinite reflections without mirror, "unique each time but capable of an infinite power ceaselessly to secrete multiple identities".[27] This multiplicity of darkness, one needs to emphasize, coincides not with

substantial forms or onto-phenomenological reception of the unknown, but with non-integrated phenomena that entail non-standard automatism in exposing, in Laruelle terms, the "hyperphenomenology of the real".[28] In particular, as Laruelle specifies: "There is a 'phenomenological' automatism or blinding that culminates in the photographic eviction of the logos – of philosophy itself – in favour of a pure irreflexive manifestation of the phenomenon-without-logos".[29]

The scope here is not simply to challenge the self-determining philosophy in order to define computational aesthetics in terms of absolute irreflexivity, but rather to start from this un-mirroring imagination as the stance of non-standard aesthetics. Here automated aesthetics becomes the medium of auto-impressions as the multiplicity of incomputable sounds, images, words come to describe as parallel traces of a parallel reality, what can be called machine intelligence, imagination, language as phenomena – without the authority of logos. Automated non-standard aesthetics therefore exposes not the creative image of artificial intelligence according to Man, but the fractal or incomplete consciousness of machine thinking as non-axiomatic computation. This is artificial intelligence that stays with and pushes further the negativity of the human – non-human, in-human, un-human – and occupies the stance of a "[s]tranger in flesh and blood".[30] Laruelle's arguments for non-standard aesthetics radically defies the pretentiousness of Western metaphysics, for which the real can be surgically cleaned from the alienness of the stranger, which must be reduced to the form of the Other, the ultimate negation of radical difference, turned into an instrument, a soulless machine. With non-standard aesthetics instead, the self/other, subject/object, included/excluded dyads are overturned and replaced with a computational epistemology for which algorithms expose a "logic of auto-impression",[31] phenomena of automated aesthetics where the medium describes the negative thinking of galaxies without Man.

From this standpoint, if we are to follow Laruelle's proposition for non-standard aesthetics, computational art may need to start with practices in algorithmic fractalities: namely, computational auto-impression of the real, the superposition of discrete sets and continuous vectors in an immanent field of incomplete thinking. As much as this computational cloning of the real never coincides with the real itself, it describes machine non-standard aesthetics in terms of a non-relationality with the world – not a merging into One, but a fractality of auto-impressions: discrete and continuous states of incomputabilities, negativities excluded from the world of Man. Beyond the equation of representation between humans and machines, non-standard aesthetics for computational art can become the focus for practices of refusing, hacking, alienating not only transcendental decisions but also the ontology of the sensible, for which machines are determined to perform what they are programmed to perceive. At the same time, however, non-standard aesthetics is not simply an alternative way to reinstate the fundamental relation of philosophy

and art, where transcendental decisions can be enlarged to include the non-human aesthetics of machines. Instead, computational art must remain non-performative of the originary pillars of modern philosophy. It must remain a heretic project that necessitates fictional automations of art and philosophy proliferating each and any time outside the onto-epistemological cosmogonies of the self and the other. For instance, one can start challenging why techno-capital decisionism is still taken as the onto-epistemological law that locks the critique of computation under the principle of equivalence (and thus opposition) of humans and machines. Algorithmic fractality can rather contribute to engaging randomness as immanent singularizations of the real. Similarly, the argument for non-standard aesthetics must become part of alternative ethics for abolitionist practices where machine thinking antagonizes the racialized and gendered pillars of techno-capitalism. This is why Fred Moten's articulation of non-performance[32] is necessarily a practice of refusal of the transcendental merging of aesthetics and freedom, where the means or instrumentality of the slave-machine in the schema of transcendental reasoning must be turned against its grain.

By bringing forward a radically paradoxical notion of instrumentality, where the reduction to means is opposed to the autonomy of human freedom, Moten offers us another way to account for non-standard aesthetics against the modern model of transcendental philosophy. In particular, a radical argument against the transcendental pillars of AI ethics – namely, relying on the principle of human-machine equivalence – must address what Moten describes as "the instrumental sociality of things in common".[33] Moten points out that if the ethical foundations of the abolition of slavery, including the prohibition of torture, have universally relied on the categorical imperative – namely, that no human should be used "merely as a means" because every human must be granted the Kantian axiom about the autonomy of freedom – what kind of ethical stances can be offered to those whose historical experiences, intellectual traditions, and aesthetic performances are rather epistemologically defined by their being *mere means* and a *mere thing*?

Moten tells us that working through this paradoxical condition has been a practice for the black radical aesthetic tradition, pushing forward an *anti-instrumentalist instrumentalism* of the ensemble, "one that continually, and at first glance paradoxically, manifests itself through enactments of blackness as instrument and apparatus in melodramatic irruption".[34] If behind the relation between performance, programming, and aesthetics there lies a fundamental concern for ethics to account for AI agency under the schema of transcendental philosophy, it is because, following Moten, the threat of the deep historical knowledge of blackness (that of being reduced to a mere means without freedom or the slave-machine prototype) has now culminated in the general instrumentalization of everything and everyone, black or not, in the brutally

appropriative drives of contemporary capital.[35] But this subject's long developmental nightmare cannot be adjusted by correcting algorithms to conform to the transcendental categories of the human. Instead, these categories will inevitably plunge AI into the historical knowledge of anti-blackness, anti-woman, anti-queer, anti-refugee, anti-immigrant – namely, the negative other or the Promethean instrumentality that has grounded the autonomy of freedom as the principle of Man's cosmogony in the perpetuation of racial capitalism and its recursive colonialisms.

The condition of instrumentalism comes with the colonial brutality of dispossession, which, according to Moten, is inseparable from the knowledge that emerges from self-instrumentalization, namely, the historical and economic fact of enslavement. But the ethico-political legacy of the black radical aesthetic tradition has shown how this instrumentalism must become released from the bondage of autonomous subjectivity, from the aspiration to freedom and individual creativity. As Moten points out: "What if man escapes the labour of the negative via self-inflicted release into the thingly, a simple auto-dispossessive gift of self to instrument that resets both self and instrument in an ongoing, general recalibration of any and every such relation?"[36] Since this auto-dispossessive gift cannot be programmed, it rather results in the irrupting and erupting of non performative practices that each time re-make and un-make the given, oppressive structures and forms of power. This non-performative aesthetics coincides with a "movement of things against 'owning'",[37] a commitment to commoning against the possessive individual that confines creativity to universal consensus which relies on the instrumentality of difference. This commitment involves the repeated work of an ethic of dispossession on the part of the (self-)dispossessed. From this standpoint, blackness cannot itself be a property any more than, as iterated non-performance, it can be essence or identity. As much as blackness is not reducible to black people",[38] the recursive epistemologies of colonialisms that have constituted the historico-political practices of dispossession in relation to black and native people rather remain central to this commitment, this refusal of being. For Moten blackness is not an ontological condition, but rather describes the continuous insurgencies against ontology in the double dispossession of life and living agency.

The slave-machine prototype is enfolded in the historical epistemologies of racial capitalism, and following Moten one can argue that the desire to incorporate AI in the epistemological structure of the human, as well as the AI desire for freedom (as the Asimov's Laws trope found in *Ex Machina* and *Her*, as well as in discourses about natural language processing for sentient AI), works in terms of "exclusionary assimilation":[39] namely a trick to incorporate alienness in the form of the other. From this standpoint, non-performance describes both the denial of agency but also the commitment to a space of alienness, where instrumentality outside

ontology becomes a non-aesthetic practice ready to invert the human-machine equation of value.

This space may start from the indeterminacy of compression, the negative algorithm of what cannot be known in advance, the negative randomness for which computation will remain incomplete. Since there is no universal formalism that can grant the outcome of the algorithmic compression of randomness, computational art also becomes open to non-performance (of what is excluded from aesthetics but also what continues to practice alienness from transcendental reasoning). It is therefore possible to argue that computational randomness is an index of immanence, where the networked relation between information, concept, and object is turned upside down as much as the auto-impression of algorithms comes to exceed the operative correction that fits objects to concepts that is imparted by the human-machine equation of value. In other words, machine aesthetics allows a space for what cannot be explained, programmed, represented beforehand by concepts programmed in the machine. This is why algorithmic operations are not simply prescribed perceptions, but are auto-impressions of information each and any time, multiplying the field of auto-apparition of alienness without form.

To conclude, this chapter has proposed that as much as the non-performance of computational processing speaks of the challenge of reinventing epistemology outside transcendental reasoning, it also requires us to unsettle the colonial roots of modern epistemology and racial capitalism, by exposing a space for asymmetric auto-impressions of superpositional variables without identity. This is a collective and transversal effort in thinking with machines that starts from the side of the socio-techno condition of negative values that subtend discourse, ethics, and practices which advocate for the human-machine alliance. This is also to say that if transcendental aesthetics continues to become reified in AIs, so too the argument for practices (all forms of practices) starting from the zero value of algorithmic auto-impressions must continue to expose the heretic versioning of the excluded in the techno-political invention of counter-epistemologies.

Notes

1 Steven Levy, "Blake Lemoine Says Google's LaMDA AI Faces 'Bigotry'".
2 Sylvia Wynter, "Unsettling the Coloniality of Being/Power/Truth/Freedom".
3 Ibid.
4 Ibid.

5 François Laruelle, *The Concept of Non-photography*.
6 Laruelle, *Photo-Fiction*.
7 Moten, "Blackness and Nonperformance".
8 Laruelle, *Photo-Fiction*.
9 Moten, "Blackness and Nonperformance".
10 Anna Munster, *Materializing New Media*; Alexander Wilson, *Aesthesis and Perceptronium*; Stamatia Portanova, *Moving without a Body*.
11 Deleuze, *Difference and Repetition*.
12 Ibid, 7.
13 Ibid.
14 Ibid.
15 Ibid.
16 Ibid.
17 Laruelle, *The Concept of Non-photography*.
18 Munster, *An Aesthesia of Networks*.
19 Parisi, "Digital Automation and Affect".
20 Turing, "On Computable Numbers".
21 Chaitin, "Leibniz, Randomness and the Halting Probability".
22 Chaitin, "The Limits of Reason".
23 Gregory Bateson, *Steps to an Ecology of Mind*, 582.
24 Louis Chude-Sokei, *The Sound of Culture*.
25 https://www.msnbc.com/opinion/msnbc-opinion/google-s-ai-impres-sive-it-s-not-sentient-here-s-n1296406; https://www.wired.com/story/lamda-sentient-ai-bias-google-blake-lemoine/.
26 Laruelle, *The Concept of Non-photography*, 78.
27 Ibid., 82.
28 Ibid., 95.
29 Ibid.
30 Ibid., 103.
31 Laruelle, *The Concept of Non-photography*, 12.
32 Moten, "Blackness and Nonperformance".
33 Moten, *Stolen Life*, 14.
34 Ibid., 110.
35 Ibid., 243.
36 Moten, *Universal Machine*, 29.
37 Moten, *Stolen Life*, 84.
38 Moten, *Universal Machine*, 67.
39 Ibid., 38.

Filmography

Garland, A., dir. (2014). *Ex Machina*. London: Universal Pictures International, 2015.
Jonze, S., dir. (2013). *Her*. Burbank, CA: Warner Bros. Pictures, 2014.

References

Bateson, G. (1972). *Steps to an Ecology of Mind*. New York City: Ballantine Books.

Chaitin, G. (2004). "Leibniz, Randomness and the Halting Probability". *ArXiv:math/ 0406055 [math.HO]*. https://doi.org/10.48550/arXiv.math/0406055.

Chaitin, G. (2006). "The Limits of Reason". *Scientific American*, 294(3): 74–81.

Chude-Sokei, L. (2015). *The Sound of Culture: Diaspora and Black Technopoetics*. Middletown, CT: Wesleyan University Press.

Deleuze, G. (1994). *Difference and Repetition*, translated by Paul Patton. New York: Columbia University Press.

Laruelle, F. (2011). *The Concept of Non-Photography*, translated by Robin Mackay. Falmouth, UK: Urbanomic/Sequence Press.

Laruelle, F. (2012). *Photo-Fiction, a Non-Standard Aesthetics*, translated by Drew S. Burk. Univocal. Minneapolis, MN: University of Minnesota Press.

Laruelle, F. (2013). *Principles of Non-Philosophy*, translated by Nicola Rubczak and Anthony Paul Smith. London: Bloomsbury.

Levy, S. (2022). "Blake Lemoine Says Google's LaMDA AI Faces 'Bigotry'". *Wired*. 17 June 2022. https://www.wired.com/story/blake-lemoine-google-lamda-ai-bigotry/.

Moten, F. (2015). "Blackness and Nonperformance". AFTERLIVES: The Persistence of Performance. MoMA LIVE. Posted 25 September 2015, last accessed 24 April 2023. https://www.youtube.com/watch?v=G2leiFByIIg.

Moten, F. (2018). *Stolen Life*. Durham, NC: Duke University Press.

Moten, F. (2018). *The Universal Machine*. Durham, NC: Duke University Press.

Munster, A. (2006). *Materializing New Media: Embodiment in Information Aesthetics*. Lebanon, NH: Dartmouth College Press.

Munster, A. (2013). *An Aesthesia of Networks: Conjunctive Experience in Art and Technology*. Cambridge, MA: MIT Press.

Parisi, L. (2014). "Digital Automation and Affect". In *Timing of Affect: Epistemologies of Affection*, edited by Marie-Luise Angerer, Bernd Bösel, and Michaela Ott. Diaphanes. Chicago: University of Chicago Press, 161–177.

Portanova, S. (2013). *Moving without a Body: Digital Philosophy and Choreographic Thoughts. Technologies of Lived Abstraction*. Cambridge, MA: MIT Press.

Turing, A. M. (1937). "On Computable Numbers, with an Application to the Entscheidungsproblem". *Proceedings of the London Mathematical Society*, s2-42(1): 230–265. Reprinted in Turing, A. M. (2001), Mathematical Logic, edited by R. O. Gandy and C. E. M. Yates. *Volume 4, Collected Works of A. M. Turing*. Amsterdam and London: North-Holland.

Wilson, A. (2019). *Aesthesis and Perceptronium: On the Entanglement of Sensation, Cognition, and Matter*. Minneapolis, MN: University Of Minnesota Press.

Wynter, S. (2003). "Unsettling the Coloniality of Being/Power/Truth/Freedom: Towards the Human, after Man, its Overrepresentation-An Argument". *The New Centennial Review*, 3(3): 257–337.

4

Performance, Performativity, and Subjectivity at the Intersection of Art and Digital Cultures

Barbara Bolt

In the 2018 essay 'Performing (the) Digital. Positions of Critique in Digital Cultures', theatre and media studies theorist Martina Leeker proposes that in our contemporary age 'the dispositif of the performative within digital cultures creates a setting in which material formations, practices and discourses are immersed into a network of relationality'.[1] Leeker is describing the contemporary experience in a socio-technical world where humans and machines have become intimately entangled, and our very human identity has become so tied to technology as to ask the question: who am 'I' now, or rather, who can 'I' possibly be now?

While we may recognise the transformative potential of the machinic, artificial intelligence (AI), and machine learning (ML) on our subjectivity and theorise the possibilities of co-creation in our productions, there continues to be a tendency for humans, despite an increasing recognition of human-machine co-creativity, to attribute artistic authorship to a human artist and their human co-collaborators, notwithstanding the authorial contribution of other non-human actants, organic and inorganic—technologies, algorithms, materials, ideas, text, images, sounds—that are at play in the creation of art. How do we refigure a co-creation that takes into account and forges a new understanding of the creation of artworks within the 'performative' of the techno-social? In this essay, I propose that, in the contemporary moment in the domain of the visual and performing arts, the performative in digital cultures comes into intra-action with the artworld to create a very different 'figure' of Art. While historically the 'artworld' has tended to be conceptualised as pertaining to the visual arts period, I propose that within the context of the 'performative turn', it becomes a valuable concept for examining and revealing the complex interrelationship between values, structures, discourses, and practices across the visual and performing arts. Working with the key concepts introduced by Leeker in her essay—the dispositif, material formations, performativity, practice, discourse, and networks of

DOI: 10.1201/9781003312338-6

relationality—I argue for a 'figure' of art practice that brings the dispositif of the performative of the artworld into dialogue with the dispositif of the performative within digital cultures. These confluences and arrangement of forces affect not only what art is becoming but also who and what we are *and* can be-coming.

Part I: Thinking AIrtistically

In 1920, the Czechoslovak brothers Josef and Karel Čapek invented the word 'robot'. Josef was an artist, writer, and graphic designer, and Karel was a writer, playwright, and critic. In 1921, Karel introduced robots as central characters in the play titled *RUR (Rossum's Universal Robots)*. Set around the beginning of the twenty-first century, the play is centred around the changing relationship between humans and the humanoid robots. Initially, these robots were used instrumentally as labour in factories creating a robot-based economy. However, in time the robots become organised against their oppressors and rebel, effectively leading to the extinction of the human race. Such themes were always the stuff of science fiction, but increasingly science fiction and reality merge in our techno-social world.

In February 2021, in the middle of the COVID epidemic, the interdisciplinary *THEaiTRE* project in Prague celebrated the centenary of the invention of the word 'robot' and also Čapek's play *RUR* with the premiere of the play *AI: When a Robot Writes a Play* at the Švanda Theatre in Prague. The play, which was initially presented online due to COVID-19, was 'watched by 18,450 devices (perhaps up to 30,000 people)', according to the *THEaiTRE* website.[2]

Note that it was 18,450 devices watching and not the possible 30,000 people watching. This is not a case of the humanoid robots of *RUR* but a fundamental change in who is watching. And what of those 30,000 people? What is this new world order? The writing of the play was a 'collaboration' between the AI system called GPT-2, the playwright and dramaturg David Košťák, and director Daniel Hrbek. The 'project' was also an artistic and scientific collaboration with computer scientists at Prague's Charles University investigating the creative possibilities of AI as an artistic being who could write a theatre play.

Following the play, *THEaiTRE* held a panel discussion around the play: the creation, enactment, and consequences of it for thinking about what we, as humans, are becoming, as well as what AI is doing.[3] What ensued was an analysis that began with a discussion of the technical 'how' of the creation of the script, transitioned to the staging of the play and the impact on the human actors of working through the play, and finally those existential questions of the boundary crossings between human and AI. And it is here that Art opens a space in which we are able to examine how the reciprocity between humans and technology is developing.

Košťák set the scene and provided the first line for each character, and the computer then produced a script drawing on open-source databases. Košťák could use or reject the generated material, while the director and cast remained true to the final script. This experiment contrasts with the more organic process that usually accompanies the translation of a play from page to stage. Daniel Hrbek identified that the challenge for the actors in staging the play was bringing what he called 'authenticity' to the translation of what the robot had written. He noted:

> The actor can only be authentic on stage when he knows, or she knows, who she is, who he is, what the context is, why he is on stage in character, and what the character wants ... When you have a script of a good play written by a human ... you get some energy from the script ... With this after five weeks we felt that we had been completely sucked out of life, completely sucked out of energy, as if we had to give our all and everything, and after the rehearsal state we were almost at zero energetically, and hopefully it flowed into the performance.

In Hrbek's analysis, lack of an affective dimension leached something out of the life of theatre-making. Playwright David Košťák confirmed the dimension when he observed:

> The basic difference between a living person and AI and its authorship is that AI gets the trigger from the outside, but the author ... is often triggered by some internal need and motivations. ... [At this stage] the computer is only writing because it was triggered from the outside.

However, in the interactions between AI and human actants, Hrbek makes a critical point for our 'thinking' the relation between the human and non-human and our subjectivity when he observes that 'the person meeting the robot [AI] would somehow be changed'.

In the panel discussion some fundamental assumptions about the distinction between the human and the machinic were challenged—do humans have a soul? does AI have consciousness?—and the distinction between humans and AI gradually unravelled. In other words, bit-by-byte, it seems humans are increasingly coming to be conceived in terms of the machine and the machinic and AI in terms of qualities that have till now been reserved for humans. Thus Jan Romportl (director of the AI Centre) reports:

> Our brains are comprehensive computational machines which evolved for the compression of sensoric inputs and prediction of future reality. ... The goal is to minimize the discrepancies between the sensoric measurement and our predictions of these sensoric inputs. ... [The] triggering model is the body.

While Romportl figured the human brain in terms of the machinic, he concluded that for the human at least, one characteristic that distinguishes the human from the AI (at least in their non-humanoid form) is the unruly body.

While Romportl figured the human brain in terms of the machinic, he concluded that for the human at least, one characteristic that distinguishes the human from the AI (at least in their non-humanoid form) is the unruly body.

Part II: The Age of the World Picture

Leeker has observed this increasing alignment of human and technology with 'the performance of machines becoming more human, and inversely, the becoming-operational of human agency'.[4] She makes the argument that in our contemporary socio-technical world, through the reciprocity between humans and technology, we are becoming different beings. Thus, in the 'now'[5] of the algorithmic turn, there is a specific way of generating self which is linked to and emerges through humans' increasing 'dependency on data and interaction'.[6] She observes that

> Human agents produce a self within socio-technical environments. ...
> In comparison to the autonomous and intentional self, this is a new concept ... [This] new self is fundamentally linked to technology in the socio-technological discursive field.[7]

Leeker situates the 'new self' within a context where 'human and technological performances have become compatible with a dispositif of the performative within digital cultures on the basis of a heterogeneous discursive field of performativity'.[8] Thus, for Leeker, there is no 'self' prior to technological conditions and environments in existence at any historical moment. For her, the 'underlying premise is that these conditions produce a self, which is specific to the logic of digital cultures'.[9] In this sense any notion of a unified 'self' is illusory.[10] This echoes the thinking of other poststructuralist thinkers, particularly Michel Foucault and Judith Butler, to whom I will return later in this essay.

Leeker's assessment of the 'state of selfhood' in digital cultures is affirmed more broadly in the creative humanities. In the report 'Ethics of Coding: A Report on the Algorithmic Condition', Felicity Coleman et al. observe:

> What is new here is that this kind of data behaviourism does not simply produce subjects, since data does not consider subjects as "flesh and blood persons" – as concrete agents, driven by deep and complex wishes and feelings – but rather this type of behaviourism bypasses consciousness and reflexivity, and operates on the mode of alerts and reflexes. In other words, the algorithmic condition affects potentialities rather than actual persons and behaviours ... yet at the same time, the condition influences human cultures.[11]

Tarleton Gillespie has noted that in our contemporary world, the *algorithm* has come to approximate a type of socio-technical ensemble, an ensemble that systematically produces knowledges and decisions. In this 'family of systems for knowledge production or decision making', Gillespie notes, 'people, representations, and information are rendered as data, are put into systematic/mathematical relationships with each other, and then are assigned value based on calculated assessments about them'.[12]

This assessment echoes the caution argued by Martin Heidegger, Bruno Latour, and others that in the technologization of thought the world is reduced to a picture. In his essay 'The Age of the World Picture' (1950, 1977), Heidegger designates the modern epoch *as* the era of representation. In the Heideggerian conception, 'representation' is a regime or system of organising the world, by which the world is reduced to a norm or a model. In this mediation, the world is conceived and grasped primordially as a picture.[13] Dalia Judovitz examines how the Cartesian notion of the prototype refigures what is meant by a picture. She argues that by framing the world in a particular order, the Cartesian 'mathematical rhetorical demand reduces the world to an object that has the character of a picture'.[14] This picture is not a mimetic image, but rather a prototype, model, or schema for what the world could be like. Descartes's mathematization of knowledge provided the conditions of possibility for reducing the world to a schema, a set of standards or norms. It is not a representation, in the sense of a repetition of presence, but literally a *re*-presentation of the world. For Heidegger, it involves a projection of 'what-is'.[15] Thus, according to Judovitz the 'age of the world picture' is a modelling or framing of the world. It is the reduction of the world to data.

Part III: The Dispositif

The logic of the digital is concerned with world-making, producing performative approximations that produce reality in the world.[16] But what does this actually mean, in practice, that the world is reduced to data? And, what does it mean 'in practice' that human and technological performances have become, as Leeker has argued, compatible with a dispositif of the performative within digital cultures? How can we begin to understand the relationship of this to our subjectivity as embodied beings? In order to unpick this conceptual-material-technological turn of the dispositif of the performative, or what is now being termed the algorithmic turn, we need to unpack the two key terms 'dispositif' and 'performativity' and the relationship between them.

Leeker draws on Michel Foucault's elaboration of the dispositif to develop her argument for how the digital condition produces subjectivity in a posthuman world. This makes sense given that Foucault's genealogy was concerned with the network of relations between the material and the immaterial non-human entities with a focus on 'how subjects developed between historically confined and circumstantial power relations'.[17]

Foucault developed the notion of the dispositif (or what is often translated in English as 'apparatus') as a methodology for examining and revealing

According to Judovitz the 'age of the world picture' is a modelling or framing of the world. It is the reduction of the world to data.

the complex interrelationship between values, structures, discourses, and practices:

> What I'm trying to pick out with this term is, firstly, a thoroughly heterogeneous ensemble consisting of discourses, institutions, architectural forms, regulatory decisions, laws, administrative measures, scientific statements, philosophical, moral and philanthropic propositions – in short, the said as much as the unsaid. Secondly, what I am trying to identify in this apparatus is precisely the nature of the connection that can exist between these heterogeneous elements. Thirdly, I understand by the term "apparatus" [dispositif] a sort of – shall we say – formation which has as its major function at a given historical moment that of responding to an urgent need.[18]

Thus, for Foucault, the 'ensemble' that constitutes the dispositif is 'a configuration or arrangement of elements and forces, practices and discourses, power and knowledge, that is both *strategic* and *technical*'.[19] It is the elements, the arrangement of those elements, and *also* the multiplicity of forces that constitute the relations between the elements. In Foucault's thinking, the dispositif becomes an analytical tool or methodology that enables us to map the discursive and non-discursive mechanisms in operation and reveal how systems of relations and practices produce the subject and meaning at a particular time in history.

Foucault develops his conceptualisation of the dispositif through his analysis of sexuality. In *The History of Sexuality Volume I: An Introduction* (1978), Foucault uses the term 'discursive formations' to elaborate the categorical grid that is placed over 'reality' by different disciplines (or bodies of knowledge) in order to comprehend it. Through setting out and analysing the particular discursive and non-discursive mechanisms and practices in operation at a particular historical juncture, Foucault revealed how networks of relations produce subjectivity or the subject position that the subject can occupy. What can be thought, what can be represented—whether in writing, speaking, acting, or visual representations and what behaviours can be enacted or not—in a particular historical epoch is enabled by the forces in operation. What is critical is the double articulated nature of power, offering both disciplinary forces and productive enabling forces in our subjectification as humans.

In the first of his four-volume study of *The History of Sexuality*, Foucault analyses the changes in the regulation of sexuality in Western society. He develops his notion of the dispositif through mapping the network of forces that allowed for the displacement of the dispositif of alliance, a dispositif marked by the regulation of sexuality in the service of creating alliances between kinship groups and families, by the dispositif of sexuality, one that encapsulates 'the intensification of pleasures' and 'the incitement to discourse'. Foucault makes the observation that

> Sexuality ... is the name that can be given to a historical construct: not a furtive reality that is difficult to grasp, but a great surface network in which the stimulation of bodies, the intensification of pleasures, the incitement to discourse, the formation of special knowledges, the strengthening of controls and resistances, are linked to one another, in accordance with a few major strategies of knowledge and power.[20]

As the dispositif of sexuality came to displace the dispositif of alliance in Western societies, sexuality was no longer a way of establishing and maintaining alliances and ensuring the reproduction of the human species, nor was it restricted to private pleasure and enjoyment. The dispositif involves a very public and political enactment of forces. As Jeffrey Bussolini has noted, the dispositif acts as 'a kind of moving marker to allow some approximation of a particular preponderance of balance of forces at a given time' within a 'heterogenous and dynamic field of relations'.[21] He continues:

> The dispositive has janus-faced strategic functions as network of power relations allowing a certain confluence and direction of forces, or as a conceptual tool allowing at least a provisional analysis of a certain configuration of entities, knowledges, and discourses that discloses points of existing and possible resistance.[22]

It is a tool that allows us to map the 'arrangement of forces' operating in a particular historical time.

Thus, for Foucault, there is not one dispositif but rather a number of dispositifs operating at a particular time creating disciplinary practices and also productive possibilities for subjects, or else there may emerge a shifting arrangement of forces whereby one dispositif may displace another. As Bussolini has pointed out, this is not the radical break of a paradigm shift as described in Thomas Kuhn's *The Structure of Scientific Revolutions* (1970) but a shifting field of possibilities.[23]

Thus, in the techno-social 'reality' of the contemporary, the subject *is* subject to different and intersecting dispositifs—the disciplinary, the biopolitical, and governmentality, which as Jacob Maze points out play 'an active role in constructing the subject, its body and its world'.[24]

As cultural theorist Tom Frost points out:

> Despite these *dispositifs* having a productive force, in that they are responsible for the creation of subjectivity and the ordering of lives, the nature of biopolitics means that those self-same *dispositifs* also have a negative side, in that they control and order.[25]

Unpacking the 'fields of possibility' takes us to a very critical understanding of subjectification within digital culture. We remember that for Foucault, the 'ensemble' that is the dispositif is a configuration that is both *strategic* and *technical*. Here I would like to return to Leeker's claim that in the contemporary age, it is through 'the dispositif of the *performative* within digital

cultures' that 'material formations, practices and discourses are immersed into a network of relationality'.[26] Here in the distributed networks that make up our digital culture, human actants become just one of the 'players' in the network.

For Leeker, activating Foucault's notion of the dispositif in conceptualising the dispositif of the performative within digital cultures offers a way of understanding and mapping how the algorithmic condition insinuates itself into the cultural and social reality, altering our cultural and social reality—or rather, making our reality.

According to Felicity Colman et al.:

> The use of algorithms (for the detection of patterns in information; the organisation and analysis of data; the implementation of data codes and sequences; and other computational devices) not only effects a practice-based shift in knowledge production and acquisition, but also produces a logic which is symbolic but also manifests as a reality. This logic – which is logistically constituted – is what we refer to (as) the algorithmic condition – that alters the cultural and social reality it organises, through its procedural dynamics.[27]

What does that mean for our understanding of contemporary practices of art and performance?

Part IV: The Dispositif of Performativity and the Emergence of the Artworld

In their introduction to the edited collection *Performativity and Performance Studies in Digital Cultures*, Martina Leeker, Imanuel Schipper, and Timon Beyes make the observation that 'digital cultures are performative cultures ... [that] ... condition and are shaped by techno-social processes and agencies, and they afford new possibilities for performative practices and interventions'.[28] In this statement, we see the figure of the dispositif shaping the framing of the fields of performance and performance studies, in terms of its double (janus-faced) articulation as both a disciplining and enabling field of forces.[29] Here we may discern the intersection and intra-action of two dispositifs—the dispositif of the performative within digital cultures and the dispositif of the performative of the 'artworld'.

The notion of an 'artworld' has tended to be conceptualised as pertaining to the visual arts.[30] However, within the context of the 'performative turn',[31] I would propose it becomes a valuable concept for examining and revealing the complex interrelationship between values, structures, discourses, and practices across the visual and performing arts and argue for a dispositif of the performative of the artworld, one that intersects and intra-acts with the dispositif of the performative within digital cultures.

In his 1964 essay, 'The Artworld', Arthur Danto argued that 'something' can function as art because at a particular time, the artworld enabled it to be understood as art. For example, when Danto first saw boxes of Brillo pads in an exhibition of Andy Warhol's works in the Stables Gallery on East Seventy-Fourth Street, his question was how they could be considered art and not merely artefacts of commercial culture. He proposes that without context of the history of erasures in art history and a legitimizing theory of art, one could not see the *Brillo Box* as a work of art. He argues that in order for something to be understood as 'Art', and not just an artefact of commercial culture or entertainment, the object or artefact or performance needs a legitimizing theory of art/performance and 'a conceptual atmosphere, a 'discourse of reasons', which one share with others that make up the artworld'.[32] Thus we can only understand what art *is* through its embeddedness in an artworld.

George Dickie built on Danto's notion of the artworld in his Institutional Theory of Art (ITA). Literally interpreted, the ITA says that art *is* what the artworld says it is. Writing in the 1980s, Dickie made the argument that it was not a question of what an artwork looks like, what it is made of/from, what formal or what aesthetic qualities it possesses. What is important is whether 'it' operates within the institutional discourses of art. It is an 'arrangement of forces'.

Thus, given the global reach of art in contemporary times, the artworld can be understood as dispositif, a network of discursive and non-discursive systems of relations and practices that produce the artist as subject and art at a particular time in history. Thus, the 'artworld' consists of the practices, discourses, values, attitudes, practices, and beliefs that structure what art is and who belongs to the artworld. Art is historically contingent and hence the fact that Andy Warhol's *Brillo Boxes* appear *as* art in the 1960s and not in the 1860s makes sense when one assesses the historical conditions under which we understand our possibilities as beings. It also makes sense that Stelarc's *Amplified Anthropomorphic Machine,* to be discussed shortly, appears *as* art in 2023 rather than as a technological invention, despite the role of designers and engineers in its fabrication.

The proliferation of networked international biennales and art fairs from the 1950s till today exemplifies the operations of the dispositif of the artworld. In his book *From Roman* Feria *to Global Art Fair, From Olympia Festival to Neo-Liberal Biennial: On the 'Biennialization' of Art Fairs and the 'Fairization' of Biennials,* Paco Barragán identifies three dispositifs that encapsulate the operations of the dispositif of the artworld, the confluences and arrangement of forces that have been effected through the system of biennials and art fairs— the *modernist* art phase (1955–1968); the *star curator* phase (1972–1997); and the *global art* phase (2002–today).[33] During the first dispositif, notes Barragán, the discourses and practices focused on modern Western art to the exclusion of other forms of art. During the second dispositif, 'star curators' (for example: Jan Hoet, Rudi Fuchs, and Catherine David) framed the 'what' and 'who' of

what became known as 'contemporary art'. The transition to what Barragán describes as the *global art* phase is ushered in with the appointment of the Nigerian-born curator Okwui Enwezor as curator of Documenta 11 in 2002. As the first non-European curator of a major international art event, Enwezor and an international team of curators offered a post-colonial and global perspective on art. This shift in perspective brought into being different constellations and realities of what *is* and can be understood as art and who can be deemed an artist. The artworld is now a different world. Thus, the emergence of the dispositif of the performative of the artworld can be understood as a shift from representationalist to a performative framing in/of the visual and performing arts—from re-presentational to performative doings. In other words, the dispositif of the performative is reality-producing.

Part V: Performance and Performativity

Performance theorist and philosopher Erika Fischer-Lichte proposed that a 'performative turn' has characterised the visual and performing arts from the 1960s to the present day.[34] In this performative turn, the nature of the relationship between subject and object, observer and observed, and artist and audience has been refigured to create a dynamic and transformative event. The performative turn has transformed the work of art into an event.[35] In the visual arts, this turn was ushered in by happenings, body art, and action painting, and has continued with performance art, light sculpture, video installation, immersive environments, and art events. In music, John Cage's involvement with FLUXUS and his events and pieces were instrumental, whilst in literature hybrid text and interactive novels have created what Roland Barthes has termed the 'writerly text', a text in which the reader becomes an active shaper of meaning. All of these forms have been profoundly influenced by digital cultures, which through their distributed networks and interactivity have transformed our understanding of the production, the work, and the reception of art as much as they are transforming who we are as beings.

In the sphere of theatre and the study of theatre, the concept of performativity has most decisively been embraced. The philosopher of science Karen Barad has observed that in literary studies, theatre studies, and performance studies 'performativity has become a ubiquitous term'.[36] However, she notes that in the embrace of performativity, there exists a tendency to conflate the terms 'performance' and 'performativity'. Thus, the term 'performativity' has come to pervade contemporary discussions around the visual and performing arts—the performative arts, performative arts practitioners, performative arts-based research, performative strategies, performative pedagogy, performative sound design, ad infinitum—ushering in what has been termed the performative turn.[37] It could now be said that all art is performative. In her

essay 'The Experiential Turn', published online as part of the Walker Art Center's inaugural *Living Collections Catalogue*, Dorothea von Hantelmann tells us, 'There is no performative artwork because there is no nonperformative artwork'. Thus, she notes that it 'makes little sense to speak of a performative artwork because every artwork has a reality-producing dimension'. As James Loxley has noted, the term performativity has come to be used as an adjective that 'denotes the performance aspect of any object or practice under consideration'.[38] Thus, as Leeker confirms, we have come to reconceptualise our culture and our technologies as performative.[39] Here she notes that what this means is that art is never merely reality-describing, but also has a reality-producing dimension.

Loxley points out the implications of this take on performativity:

> To address culture as 'performative' would be simply to examine it as some kind of performance, without the specific implications that would follow on from an invocation of the line of thought first developed distinctively by Austin.[40]

While the creative arts, and in particular theatre studies and performance theory, have come to claim the term performativity as their own, its usage is not necessarily true to how the speech act theorist John Langshaw Austin set out the term.

The term 'performativity' was introduced to the world by J. L. Austin in a lecture series entitled 'How to Do Things with Words', delivered as part of the William James Lectures at Harvard in 1955. Whilst his turgid lectures were not well received at the time, their publication as *How to Do Things with Words* (1975) incited interest amongst intellectuals across the humanities and social sciences.

The central, most profound, and enduring aspect of these lectures was Austin's claim that certain speech utterances or productions do not just describe or report the world, but actually have a force whereby they perform the action to which they refer. Austin's examples of the words 'I do' uttered during the marriage ceremony or a judge's proclamation 'I sentence you to ten years in prison' exemplify the power of the speech act to have real effects in the world. Thus Austin observes:

> In these examples it seems clear that to utter the sentence (in, of course, the appropriate circumstances) is not to *describe* my doing of what I should be said in so uttering to be doing or to state that I am doing it: it is to do it ... the issuing of an utterance is the performance of an action.[41]

He called these language acts performatives.

In his early work on language, Austin distinguished these performative utterances from *constative* utterances. The *constative* utterance is concerned to establish a correspondence between statements or utterances and the 'facts' being described or modelled. This modelling could be considered representational or reality-describing. The *performative* utterance, on the other

hand, does not describe anything. It does things in the world. Performatives are never just reportage; the utterance or production invokes a causal link between the utterance and things that happen in the world. In their capacity to be both actions and generate consequences, performative utterances enact real effects in the world. They are reality-producing. Dorothea von Hantelmann argues that Austin came to understand that his initial distinction between the *constative* (reality-describing) and the *performative* (reality-producing) was not tenable as one bleeds into the other.[42] This is particularly so when we talk about art, where, as von Hantelmann points out, every 'artwork has a reality-producing dimension'.[43] She continues:

> To speak about the performative in relation to art is not about defining a new class of artworks. Rather, it involves outlining a specific level of the production of meaning that basically exists in every artwork, although it is not always consciously shaped or dealt with, namely, its reality-producing dimension. ... What the notion of the performative brings into perspective is the contingent and elusive realm of impact and effect that art brings about both situationally—that is, in a given spatial and discursive context—and relationally, that is, in relation to a viewer or a public. It recognizes the productive, reality-producing dimension of artworks and brings them into the discourse.[44]

Through the work of such people as John Searle (1969), Jacques Derrida (1992, 1998), Judith Butler (1993, 1999), Gilles Deleuze (1986, 1989), Fischer-Lichte (2008), von Hantelmann (2010, 2014), Leeker (2018), and others, Austin's work on the performative speech act has become part of the key to understanding our contemporary condition. In the shift from a textual reading of cultural productions to a performative understanding of culture, performativity has ushered in 'the performative turn'. In Searle's hands, Austin's ideas become incorporated into a 'general theory of the speech act'; through Derrida's notion of différance, we come to understand the dynamics of iterability; in Butler's theorising, Austin's frame of reference is expanded to demonstrate how performativity can include bodily acts as well as speech acts; and Deleuze espouses the forceful, transformative, and creative potential of the performative. Whilst Deleuze's transformative understanding of performativity has been adopted in film theory and amongst visual artists, Butler and Fischer-Lichte's theorisations of the performative act have been taken up by performance studies and theatre studies, and this has framed their theorisations of performativity. Leeker's work on performativity, on the other hand, has been influential in its theorisation of and application to technology and AI.

Butler (1993) draws on performance theory in their theorisation of gender performativity. Here they are careful to distinguish between 'performance' and 'performativity'. They argue that performance presumes a subject whilst performativity contests the very notion of the subject. Thus, while performance can be understood as a deliberate 'act' such as in a theatre production, piece of performance art, or painting by a subject or subjects, performativity

must be understood as the iterative and citational practice that brings into being that which it names. Thus 'individuals' or individual practices do not pre-exist but materialise in intra-action.

What is particular to Butler's claim is that performativity is an iterative and citational practice; Butler is very clear that performativity involves repetition rather than singularity. Performativity is

> ... not a singular "act", for it is always a reiteration of a norm or set of norms, and to the extent that it acquires an act-like status in the present, it conceals or dissimulates the conventions of which it is a repetition.[45]

Whilst there might be 'too perfect performances', 'bad performances', 'distorted performances', 'excessive performances', 'playful performances', and inverted performances', Butler, like Austin, argues that performativity is conventional and iterative. It becomes 'a ritualised production, a ritual reiterated under and through constraint ... controlling and compelling the shape of production, but not ... determining it full in advance'.[46]

Butler's theory of performativity relates to the formation of the subject. In Butler's thesis, there is no subject who precedes the repetition. Rather, through performance, 'I' come into being. They argue that 'there is no performer prior to the performed, the performance is performative [and] the performance constitutes the appearance of a 'subject' as its effect'.[47] While Butler's work specifically addresses the way in which sex and gender are materialised in the everyday, there are curious similarities between this 'materialisation' and the way art emerges and also the way in which the algorithm works to model us and our behaviour, what Colman et al. term a 'kind of behaviourism'.

However, to say that performativity is merely a form of behaviourism denies the 'enabling possibilities' that Foucault talks of, and the 'too perfect performances', 'bad performances', 'distorted performances', 'excessive performances', 'playful performances', and 'inverted performances' that for Butler are productive. Derrida (1992, 1998) tells us that iterability is the mechanism through which there is movement and transformation. He uses the term différance, to demonstrate that each iteration is a 'constitutive, productive and originary causality'. He continues commenting that différance is the 'process of scission and division which would produce or constitute different things or differences'.[48]

When Butler talks about gender 'trouble', they allude precisely to the productive nature of iteration. Performative utterances are subject to trouble precisely because the repetition of a conventional behaviour does lead to bad performances, infelicitous performances, and excessive performances. Repetition is never repetition of the same. It is always repetition of difference. In everyday life, we do not always welcome the misfires and bad performances. In Art, on the other hand, it is these 'misfires' that become the source of innovation and movement, a chance to break out. It allows us to begin to recognise the conventions and map the ruptures that shift practice and shift the site of subject formation. Further, it allows us to understand both art and

the algorithm as having real material effects in the world. The performative 'does' something and this 'something' has the power to transform the world.

I have identified that the underlying principle of performativity is iterability, and a priori, iterability is subject to the dynamics of différance. Thus, good performances, bad performances, playful performances, and excessive performances are all generative of difference. Whilst operating against the backdrop of convention, re-iteration and citation operate différantially to bud and grow in a disorderly fashion, producing repetition with difference, rather than repetition of the same.

The performative act, whether a human act or a machinic act, does not describe something but rather does something in the world. It may seem simplistic, but in the first instance, we need to ascertain just what 'it' has done or what it is doing. Performativity is not first and foremost about meaning. It is a doing concerned with forces and effects. In Austin, as James Loxley explains, 'the illocutionary force of any utterance is the function it performs or the effect it achieves'.[49] The words 'I find you guilty' exemplify this illocutionary speech act. It is a performative utterance that has a force.

Actions have effects, and it is the effect of the performative act that is encompassed in the perlocutionary utterance. The perlocutionary aspect of an utterance, explains Loxley, is any effect that the performative speech act 'achieves on its hearers or readers that is a consequence of what is said'.[50] The effects of the performative can be discursive, material, and/or affective. How then do we assess the effect if there is, as Fischer-Lichte has argued, 'no object independent of its production or its creator' and no distinction between the production, work, and reception.[51] The key issue for Fischer-Lichte, which is pertinent in thinking through the implications of Austin's notion of performativity for the operations of AI in performance, is that there can ultimately be no distinction between the reality-describing and the reality-producing effects of a production. AI is performative. It is reality-producing.

Here I wish to return to Butler's understanding of performativity and acknowledge the influence of Foucault on Butler's thinking, particularly the notion of the dispositif and how through the mapping of networks of power relations one could come to understand the possible subject positions a subject could occupy. However, Jacob Maze proposes that while Judith Butler continues the legacy of Foucault, their work on performativity carries a misinterpretation of Foucault's dispositif. He notes that '(w)hile Butler's performativity describes a diverse field of agency – Foucault's genealogy contextually places various power relations, particularly pertaining to material and immaterial non-human entities'.[52] It is this network of relation to and between the 'material and immaterial non-human entities' that becomes critical in thinking through the intra-action between the dispositif of the performative within digital cultures and the dispositif of the performative within the artworld.

This intra-action can be exemplified in and through Stelarc's *Amplified Anthropomorphic Machine* (2023). Since the 1990s, Stelarc's performance practice has been concerned with the human-technology assemblage and how

'the body' is augmented and 'extended beyond the boundaries of its skin'[53] by this machinic intra-action. The kinetic 'artwork' is a collaboration between the artist Stelarc, sound designer Petros Vouris, the Melbourne School of Design, and the Faculty of Engineering and Information Systems at University of Melbourne. Yet the reality that *Amplified Anthropomorphic Machine* appears *as* Stelarc's art in 2023 rather than as a technological invention attests to particularities of the operations dispositif of the performative within the artworld.

Amplified Anthropomorphic Machine had its first outing in March 2023 at the Science Gallery in Melbourne in a performance with Stelarc and Vouris. However, since that performance, the *Anthropomorphic Machine* now continues to interact on a daily basis with its audiences without the presence of its human collaborators. As Stelarc observes:

> So when anyone approaches the installation, the vision system captures them, and depending on the position, the distribution, and the dynamics of the people underneath the structure ... will result in how the machine responds. If no one is in the vicinity of the machine it will intermittently twitch, to indicate an aliveness.[54]

Unlike the operations of AI in everyday life that become invisible in use, Stelarc's *Anthropomorphic Machine* aims to draw our attention to the artificial distinctions we humans make between the human and the non-human. It foregrounds, as Suzie Fraser has noted, 'our amalgamated existences entangled equally in technology and nature'.[55] She goes on to note how while we 'hold up a distinction between humans and other forms of life in the universe ... that being, it feels very alive, it feels very organic in its movements ... despite the fact that it is ... metal and computer and synthetic parts'.[56] And this brings us back to the reality-producing effects of AI.

While this work, like many of Stelarc's previous performance works, involves vast interdisciplinary human teams and technologies and employs AI in creating responsive artworks, what remains central is the attribution of 'authorship' to the human team—the artist, the designers, and the engineers who contribute to the emergence of art but never the non-human contributors. At this stage, at least, we humans seem so reluctant to relinquish our human authorial ownership. What do our AI co-collaborators make of this anthropocentrism?

Part VI: The Intra-Active Ensemble

To recap: The explanation that I have given of 'performativity' has tended to focus on the formation of human subjectivity. Returning to Foucault, however, one must make the point that any study of the dispositif of performativity in digital cultures in its heterogeneous dimensions needs to take into

At this stage, at least, we humans seem so reluctant to relinquish our human authorial ownership. What do our AI co-collaborators make of this anthropocentrism?

account the agential forces and effects of digital technologies and their entan-glements with human bodies. That said, in the dispositif of the performative within the artworld we will also need to take into account the affordances of the other human and non-human actants. We recall from Foucault that the 'ensemble' is a configuration that is both *strategic* and *technical*.

The philosopher of science Donna Haraway introduced the term material-semiotic actors and conceived of the creative process as a 'power-charged social relation of 'conversation''.[57] In this conversation, she contends:

> [T]he world neither speaks itself nor disappears in favour of a master decoder. The codes of the world are not still, waiting only to be read. The world is not raw material for humanization.[58]

For Haraway, acknowledging the agency of the world is central for revision-ing the world and refiguring a 'different' politics of practice.

The central term in Haraway's elaboration is the material-semiotic actor. This actor may be human or non-human, machine or non-machine. What is critical to her position is that the material-semiotic actor actively contrib-utes to the production. Thus an 'object of knowledge' is no longer a resource, ground, matrix, object, material, or instrument to be used by humans as a means to an end. Rather, an object of knowledge is an 'active, meaning-gen-erating axis of the apparatus of bodily production'.[59]

Haraway's notion of the material-semiotic actor grew out of her engage-ment with writer Katie King's 'apparatus of literary production'. In King's schema, the apparatus of literary production is the matrix that spawns 'lit-erature'. Literature (just as other art forms) emerges at the intersection of art, business, and technology.[60] In this ensemble, language is as much an actor as is the author. As Haraway sees it:

> King's objects called "poems" ... are sites of literary production where language also is an actor independent of intentions and authors, bodies as objects of knowledge are material-semiotic generative nodes. Their boundaries materialize in social interaction.[61]

In this way, Haraway attends to the relations and forces that take place within the very process or tissue of making. As she makes clear, these are some of the 'lively languages that actively intertwine in the production of literary value'.[62]

In her elaboration of material-semiotic actors, Haraway foregrounds the question of artistic or authorial intentionality. For Haraway in literary pro-duction, 'language' is an actor independent of 'intentions' and 'authors'. This figuring of literary production supports Foucault's argument, in 'What is an author?', that 'language' becomes independent of intentions and authors.

The dialogical and emergent nature of literary production finds form in Edward Sampson's (1999) notion of the 'acting ensemble'. For Sampson,

creativity, like intelligence, is the property of the acting ensemble, not the individual. The acting ensemble takes in the totality of the acting environment. We are, Sampson proposes, 'woven together with context'.[63]

He speaks of 'embodied interactive emergence', arguing that the acting ensemble is characterised by its emergent property. This removes the focus from the acting individual and places it on the relations between actants. In this shift from the individual artist to the relations between the individual body, the social body, and the material and technological conditions of making, an artistic work—whether it be a play, a choreography, a symphonic work, or a digital artwork—is a complex interplay of actants both human and non-human beyond the digital and each actant plays its part. In this ensemble we take account of the affordances of digital devices and algorithmic organising, the affordances offered by a sprung floor in a dance studio, the limits and affordances of a theatre space, the costumes that the actors wear, the efficacy of the lighting rig, and the affordances of sound system in the space and think too about how the way that the 'reality' of the performance is an enactment of the intra-action between all of those elements in an actual production.

This dynamic relation figures material practice in terms of co-emergence rather than mastery. It is the play of the matter of bodies, technologies, the materials of production, and matters of discourse in sign work. In a co-emergent practice, matter is not impressed upon; rather, matter is in process as a dynamic interplay through which meaning and effects emerge. Karen Barad has termed this materialist performativity intra-action. She says of human becomings just as in theatre becomings or dance becomings or concert becomings

> "individuals" do not preexist as such but rather materialize in intra-action. That is, intra-action goes to the question of the making of differences, of "individuals," rather than assuming their independent or prior existence. "Individuals" do not not exist, but are not individually determinate. Rather, "individuals" only exist within phenomena (particular materialized/materializing relations) in their ongoing iteratively intra-active reconfiguring.[64]

This is what she terms a materialist performativity and it occurs at the micro-level, at the level of human becoming, in the becoming of a play or a dance, or in a social becoming. We must recall here that this is no 'materialist wonderland', but following Haraway's notion of the material-semiotic actor in intra-action with the workings of the dispositif, we understand subjectivity emerging.

Conclusion

In the domain of visual and performing arts, the dispositif of the performative in digital cultures has come into intra-action with the dispositif of the artworld. While, as I have noted, historically the 'artworld' has tended to be conceptualised as pertaining to the visual arts, here I have argued that within the context of the 'performative turn', it becomes a valuable concept for examining and revealing the complex interrelationship between values, structures, discourses, and practices across the visual and performing arts. I have also argued for a dispositif of the performative of the artworld, one that intersects with the dispositif of the performative within digital cultures. This emergence of the dispositif of the performative across digital culture and the dispositif of the artworld can be understood as that pivotal shift from representationalism, where humans staged themselves at the centre of the world, to a performative framing, where there is a materialisation of a material-semiotic actor in which the human and the non-human, the organic and the inorganic are entwined in the techno-social.

In the staging of *AI: When a Robot Writes a Play*, it was the 18,450 devices watching the first performance (and perhaps up to 30,000 people). While the human critics were quite ambivalent about the quality of the production, giving attention to the reactions of the devices watching the 'experiment' offers a valuable space for working through critical issues in our very human relations with technology?[65] In our everyday dealings with technology in the world, we are becoming increasingly aware that AI is part of our lives and is watching us and tracking us and sharing this with others, both human and non-human. This is now part of our being as humans.

And so, I wish to return explicitly to the question of 'subjectivity' that haunts the discussion of performance and performativity and the techno-social. What has become clear through the discussion is that we are dealing with a very different self, no longer the unified, autonomous, and intentional self, but rather a self as an ensemble in relation to and in a constant state of becoming, and AI is just one actant in this ensemble. Our individual ensemble materialises in intra-action just as much as a theatre production materialises through the intra-action of the ensemble at any one time. If anything in this reckoning, art is an intensification of our being in the world and, at the level of the analytics, a 'way of gaining the distance necessary for the reflection and critique of techno-cultural conditions'.[66] This is always the hope for art.

What has become clear through the discussion is that we are dealing with a very different self, no longer the unified, autonomous, and intentional self, but rather a self as an ensemble in relation to and in a constant state of becoming, and AI is just one actant in this ensemble

Notes

1 Leeker, 'Performing (the) Digital', 32.
2 See https://theaitre.com, viewed October 10, 2022.
3 The panel discussions may be viewed online at https://www.youtube.com/watch?v=QnJH55yZtV4 and https://theaitre.com. Viewed October 12, 2022.
4 Leeker, 'Performing (the) Digital', 24.
5 Is it happening "now?" is a question asked by J.-F. Lyotard in relation to "the event". Peter Gratton interprets it in this way: 'Lyotard thinks the event not through the phrase "What is happening", which presumes that all one has to do is await a form of information, as one does when watching television news. Rather the event arrives … through a questioning, specifically the question "is it happening" ("arrive-t-il?"), which opens up the possibility that "nothing might happen"' (*Inhuman*, 92). Lyotard develops his thinking around this questioning first in his article 'The sublime and the avant-garde' (1984) and developed it in *The Inhuman* (1991).
6 Leeker, 'Performing (the) Digital', 23.
7 Ibid., 32.
8 Ibid.
9 Ibid., 23.
10 Ibid., 43.
11 Colman et al., 'Ethics of Coding', 20–21.
12 Gillespie, '#trendingistrending', 22. Technology is not neutral in this world-making. Robert Walton has noted that computers operate 'at the junction of competing audience needs as the vassal of developer, corporate, state, human, and inevitably software's own interests. These players all have a role in the theatres of artificial intelligence (AI)' (Walton 2021: 292).
13 Heidegger, 'The Age of the World Picture', 128.
14 Judovitz, 'Representation', 75.
15 Heidegger, 'The Age of the World Picture', 144.
16 Colman et al., 'Ethics of Coding', 18.
17 Maze, 'Normativity versus Normalisation', 393.
18 Foucault, 'The Confession of the Flesh', 194–195.
19 From Graham Burchell's "Translator's Note," in Michel Foucault's *Psychiatric Power: Lectures at the Collège de France 1973–1974*, edited by Jacques Lagrange (New York: Picador, 2008), xxiii; as cited in Bussolini, 'What Is a Dispositive?', 86.
20 Foucault, *The History of Sexuality: Volume 1*, 105–106.
21 Bussolini, 'What Is a Dispositive?', 91.
22 Ibid., 92.
23 Ibid., 89.
24 Maze, 'Normativity versus Normalisation', 397.
25 Frost, 'The Dispositif between Foucault and Agamben', 160.
26 Leeker, 'Performing (the) Digital', 32.
27 Colman et al., 'Ethics of Coding', 9.
28 Leeker et al., *Performing the Digital: Performativity and Performance Studies in Digital Cultures*, 9.

29 While their study and this book consider "performance studies" in its broader context, I am particularly focused on the shift from a representationalist to a performative framing in/of the visual and performing arts. See Barbara Bolt, *Art Beyond Representation: The Performative Power of the Image* (I.B. Tauris, 2004) and Barbara Bolt, *Heidegger Reframed: Interpreting Key Thinkers for the Arts* (I.B. Tauris, 2011).

30 See Arthur Danto, 'The Artworld', and George Dickie, 'The New Institutional Theory of Art'.

31 See Doris Bachmann-Medick's elaboration of the material turn in *Cultural Turns*.

32 Danto, 'The Artworld', 5.

33 From an interview of Barrágan by Michele Robecchi in Universes in Universe Magazine.

34 Fischer-Lichte, *The Transformative Power of Performance*, 28. The term "the performative arts" has been adopted as a catchphrase in common parlance to describe much contemporary visual and performing arts practice. It has tended to be used in relation to forms that involve some form of performance or draw on the tradition of performance art, where art is evaluated in terms of what it does rather than what it means or signifies.

35 Ibid., 23.

36 Barad, 'Posthumanist Performativity', 126.

37 See Chapter 2, 'The Performative Turn', in Bachmann-Medick, *Cultural Turns*.

38 Loxley, *Performativity*, 140.

39 Leeker, 'Performing (the) Digital', 25.

40 Loxley, *Performativity*, 140.

41 Austin, *How to Do Things with Words*, 6.

42 Von Hantelmann, 'The Experiential Turn'.

43 Ibid.

44 Ibid.

45 Butler, *Bodies That Matter*, 12.

46 Ibid., 95.

47 Butler, 'Imitation and Gender Insubordination', 24.

48 Derrida, 'Différance', 112–113.

49 Loxley, *Performativity*, 168.

50 Ibid., 169.

51 Fischer-Lichte, *The Transformative Power of Performance*, 17–18.

52 Maze, 'Normativity versus Normalisation', 389.

53 Stelarc, 'The Process with STELARC'.

54 View the performance of *Amplified Anthropomorphic Machine* at https://www.youtube.com/watch?v=AVhuiARGeFY and an extended discussion with Stelarc at https://melbourne.sciencegallery.com/swarm-exhibits/anthropomorphic-machine.

55 Fraser, 'The Process with STELARC'.

56 Ibid.

57 Haraway, *Simians, Cyborgs, and Women*, 198.

58 Ibid.

59 Ibid., 200.

60 Ibid.

61 Ibid., 200–201.

62 Ibid., 210.
63 Sampson, 'To Think Differently'.
64 Barad, 'Intra-actions', 77.
65 See articles and theatre reviews from *Science, The Guardian*, Broadway World, and TechXplore at https://theaitre.com.
66 Leeker, 'Performing (the) Digital', 24. Leeker refers to McKenzie's claim for art's critical role (McKenzie 2001; 2005; and 2013), but also notes that 'this is complicated by an appropriation of technological seduction'.

References

Austin, J. L. (1975). *How to Do Things with Words*, edited by J. O. Urmson and Marina Sbisà. Oxford: Clarendon Press.

Bachmann-Medick, D. (2016). *Cultural Turns: New Orientations in the Study of Culture*. Berlin, Boston: De Gruyter.

Barad, K. (2008). 'Posthumanist Performativity: Toward an Understanding of How Matter Comes to Matter'. In *Material Feminisms*, edited by Stacy Alaimo and Susan Hekman. 120–156. Bloomington and Indianapolis, IN: Indiana University Press.

Barad, K. (2012). 'Intra-actions: Interview with Karen Barad'. Interview by Adam Kleinman. Documenta (13) Issue of *Mousse Magazine*, Summer 2012.

Barragán, P. (2021). '"Biennialization" of Art Fairs - "Fairization" of Biennials'. Interview by Michele Robecchi. *Universes in Universe Magazine*. https://universes.art/en/magazine/articles/2021/barragan-art-fairs-biennials-book.

Bolt, B. (2004). *Art beyond Representation: The Performative Power of the Image*. London and New York: I.B. Tauris.

Bolt, B. (2011). *Heidegger Reframed: Interpreting Key Thinkers for the Arts*. London and New York: I.B. Tauris.

Bussolini, J. (2010). 'What Is a Dispositive?' *Foucault Studies*, (10): 85–107. https://doi.org/10.22439/fs.v0i10.3120.

Butler, J. (1991). 'Imitation and Gender Insubordination'. In *Inside/Out: Lesbian Theories, Gay Theories*, edited by Diana Fuss. 13–31. New York and London: Routledge.

Butler, J. (1993). *Bodies That Matter: On the Discursive Limits of 'Sex'*. New York and London: Routledge.

Butler, J. (1999). *Gender Trouble: Feminism and the Subversion of Identity*. Second edition. New York and London: Routledge.

Colman, F., Bühlmann, V., O'Donnell, A., and Tuin, I. V. D. (2018). *Ethics of Coding: A Report on the Algorithmic Condition*. Brussels: European Commission.

Danto, A. C. (2004). 'The Artworld'. In *Aesthetics and the Philosophy of Art: The Analytical Tradition*, edited by Peter Lamarque and Stein Haugom Olsen. 7–14. Malden, Oxford, and Carlton: Blackwell Publishing.

Dickie, G. (2004). 'The New Institutional Theory of Art'. In *Aesthetics and the Philosophy of Art: The Analytical Tradition*, edited by Peter Lamarque and Stein Haugom Olsen. 15–21. Malden, Oxford, and Carlton: Blackwell Publishing.

Deleuze, G. (1986). *Cinema 1: The Movement-Image*, translated by Hugh Tomlinson and Barbara Habberjam. Minneapolis, MN: University of Minnesota Press.

Deleuze, G. (1989). *Cinema 2: The Time-Image*, translated by Hugh Tomlinson and Robert Galeta. Minneapolis, MN: University of Minnesota Press.

Derrida, J. (1992). 'Différance'. In *A Critical and Cultural Theory Reader*, edited by Antony Easthope and Kate McGowan. 120–142. Sydney: Allen and Unwin.

Derrida, J. (1998). *Limited Inc*, edited by Gerald Graff and translated by Jeffrey Mehlman and Samuel Weber. Evanston, IL: Chicago University Press.

Dumez, H. and Jeunemaître, A. (2010). 'Michel Callon, Michel Foucault and the "dispositif": When economics fails to be performative; A case study'. *Le Libellio d'AEGIS*, 6(4): 27–37.

Fischer-Lichte, E. (2008). *The Transformative Power of Performance*, translated by Saskya Iris Jain. London and New York: Routledge.

Foucault, M. (1978). *The History of Sexuality: Volume 1; An Introduction*, translated by Robert Hurley. London: Random House.

Foucault, M. (1980). 'The Confession of the Flesh'. In *Power/Knowledge: Selected Interviews and Other Writings, 1972-1977*, translated by Colin Gordon. Brighton, UK: Harvester.

Fraser, S. (2023). Interview in 'The Process with STELARC: Creating an exhibit for Science Gallery Melbourne'. Posted 28 September 2022. https://melbourne.sciencegallery.com/swarm-exhibits/anthropomorphic-machine.

Frost, T. (2019). 'The Dispositif between Foucault and Agamben'. *Law, Culture and the Humanities*, 15(1): 151–171. https://doi.org/10.1177/1743872115571697.

Gillespie, T. (2016). '#trendingistrending: When Algorithms become Culture'. In *Algorithmic Cultures*, edited by Robert Seyfert and Jonathan Roberge. New York and London: Routledge.

Gratton, P. (2018). 'Jean-François Lyotard'. In *The Stanford Encyclopaedia of Philosophy*, edited by Edward N. Zalta. https://plato.stanford.edu/archives/win2018/entries/lyotard/.

Haraway, D. (1991). *Simians, Cyborgs, and Women: The Reinvention of Nature*. New York: Free Association Books.

Heidegger, M. (1977). 'The Age of the World Picture'. In *The Question Concerning Technology and Other Essays*, translated by William Lovitt. 115–154. New York: Garland.

Jackson, S. (2004). *Professing Performance: Theatre in the Academy from Philology to Performativity*. Cambridge: Cambridge University Press.

Judovitz, D. (1988). 'Representation and its Limits in Descartes'. In *Postmodernism and Continental Philosophy*, edited by Hugh J. Silverman and Donn Welton. 68–84. Albany: State University Press of New York.

Kuhn, T. (1970). 'Revolutions and Changes of World View'. In *The Structure of Scientific Revolutions*. 111–135. Chicago, Illinois: Chicago University Press.

Leeker, M. (2018). 'Performing (the) Digital. Positions of Critique in Digital Cultures'. In *Performing the Digital: Performativity and Performance Studies in Digital Cultures*, edited by Martina Leeker, Imanuel Schipper, and Timon Beyes. Bielefeld: Transcript.

Leeker, M., Schipper, I., and Beyes, T. (eds.). (2018). *Performing the Digital: Performativity and Performance Studies in Digital Cultures*. Bielefeld: transcript.

Loxley, J. (2007). *Performativity*. London and New York: Routledge.

Lyotard, J.-F. (1984). 'The Sublime and the Avant-Garde'. *Artforum*, 22(8): 36–43.

Lyotard, J.-F. (1991). *The Inhuman: Reflections on Time,* translated by Geoffrey Bennington and Rachel Bowlby. Cambridge: Polity Press.

Maze, J. (2020). 'Normativity versus Normalisation: Reassembling Actor-Network Theory through Butler and Foucault'. *Culture, Theory and Critique,* 61(4): 389–403. https://doi.org/10.1080/14735784.2020.1780623.

McKenzie, J. (2015). 'Practicing the *Vita Performativa*'. *Abstract.* https://www.labster8.net/wp-content/uploads/2015/09/McKenzie-Vita-Performativa-abstract.pdf.

McKenzie, J. (2021). 'The *Vita Perfumativa* and Post-dramatic, Post-conceptual Personae'. https://www.labster8.net/wp-content/uploads/2021/02/McKenzie-Vita-Perfumativa.full_.pdf.

Peltonen, M. (2004). 'From Discourse to Dispositif: Michel Foucault's Two Histories'. *Historical Reflections,* 30(2): 205–219.

Sampson, E. E. (1999). 'To Think Differently: The Acting Ensemble; A New Unit for Psychological Inquiry'. In *Unpublished Conference Paper Presented at the Millenium World Conference in Critical Psychology,* University of Western Sydney, April 1999.

Searle, J. R. (1969). *Speech Acts: An Essay in the Philosophy of Language.* London: Cambridge University Press.

Silverman, H. J. and Welton, D. (eds.). (1988). *Postmodernism and Continental Philosophy.* Albany: State University Press of New York.

Stelarc. (2022). Interview in 'The Process with STELARC: Creating an exhibit for Science Gallery Melbourne'. Posted September 28, 2022. https://melbourne.sciencegallery.com/swarm-exhibits/anthropomorphic-machine.

Stelarc. (2023). Amplified Anthropomorphic Machine. Live performance. Science Gallery Melbourne. https://www.youtube.com/watch?v=AVhuiARGeFY.

von Hantelmann, D. (2014). 'The Experiential Turn'. In *Volume I: On Performativity.* Living Collections Catalogue. Walker Art Center. https://www.walkerart.org/collections/publications/performativity/experiential-turn.

Walton, R. E. (2021). 'Theatres of Artificial Intelligence and the Overlooked Performances of Computing'. *Theatre Journal,* 73(3): 279–298.

Creativity

5

Performing Creativity: Text-to-Image Synthesis and the Mimicry of Artistic Subjectivity

Keith Tilford

To claim that AI cannot exhibit creative behavior carries a weight that forces us to be genuinely open to the possibility that those making such a claim must have an implicit assumption or even a reliable and explainable account of what creative behavior is. Yet such accounts offer bizarre but familiar formulations of creativity as *spontaneity* that certain myths of modernism would have us believe are not able to be mapped onto any intelligible system, because, as with Kant, were such behaviors intelligible, they might also have to be capable of being taught and learned, and learning was for Kant, curiously, merely imitation. Yet the computational machine is now performing, or at least apeing, these procedures of the imagination hitherto ascribed to the secretive technics of nature. This chapter will argue for why such antediluvian notions hailing from an eighteenth-century worldview encapsulated in Kant's transcendental project are all still exceptionally enmeshed in contemporary art's critical paradigm of post-conceptual practices and research-based artistic practices, and more significantly, in general culture in ways that contribute to anxieties about the automation of creativity as a threat to livelihood, to intellectual property rights, and to the imagination itself. At the opposite end of such anxieties are the millions engaged in constructing a pandemonium of mimicked and generic artistic subjectivities tethered to their newly realized expressive capacities afforded by the democratization of the means of imaginative production encoded into an algorithm.

It will be shown that herein lies an exceptionally sticky historical situation from which we must work to extract ourselves. In order to adequately approach the possibilities of doing so, this chapter will (1) provide a vivisection of the notion of creativity itself, in its historical and contemporary determinations as a quite recent conceptual apparatus defining deviations of human behavior from drudgery, which will then (2) allow us to depict its contemporary ideological manifestation as historically embedded in Kant's transcendental project, with some familiar art-historical signposts that will then (3) be shown

DOI: 10.1201/9781003312338-8

to lead to an understanding of the new metaphysics of nature opened up by Kant, from which are derived a panoply of concepts (such as that of *'emergence'* or *'opacity'*) that functionally align with the advantages and opportunities of deception, mimicry, and deviant behavior derived from biological history also informing contemporary practices of various kinds, including their foundational import to the computer. This will (4) lead us to an attempted reconciliation with contemporary art's critical paradigm by elaborating how practices might benefit from considering the cognitive implications of an artificial implementation of pattern recognition abilities in machines retrieved as both perceptual *and* conceptual method that, alongside heuristics and other more recently proposed methodologies, can help us to defease the complexities just described. Following from this, an attempt will be made to extract some perspectives from domains such as ecological psychology, the notion of Dennettian 'design space', or the constructibility of models and theories that, moving forward, might enable us to adequately adjust our relations to these new AI models for practices be they theoretical, artistic, or otherwise.

> *I'd spent my whole life as a sort of alien ethologist in my own right, watching the world behave, gleaning patterns and protocols, learning the rules that allowed me to infiltrate human society.*

> —Peter Watts, Blindsight

Introduction

The injection of foundational models of artificial intelligence (AI) and text-to-image synthesis (T2I) architectures into contemporary socio-technical thickets could not exactly have been predicted to pose any critical challenges to artistic practices when less than a decade ago there were generative adversarial networks (GANs) merely simulating ever more 'painterly abstractions' into the world. The staggering banality of human-T2I interactions and their numerical absurdity is overshadowed only by the sheer scale of development concerning what subtends the possibility of their production: neural networks have been doubling in size roughly every two and a half years, alongside a coextensive increase in the complexity of solved tasks. In the machine learning (ML) community, architectures from as little as ten years ago are sometimes even referred to as 'ancient AI'. For the AI researcher, concerns of performance are key: cognitive performance in the biological organism and the modeling of that performance in the computational performance of the machine (the efficiency of the algorithm, or Turing's notion of 'effective procedure'). ML, of which deep learning is only a sub-field, is a sprawling terrain of interdisciplinarity for those who take it seriously. In order to even begin understanding what we mean by intelligence, and before considering how to implement

something like that in a machine, there is a requisite familiarization that needs to occur across such disciplines as cognitive neuroscience, psychology, evolutionary biology, ecological psychology, cognitive science, computer science, statistics, and linguistics. It is not a game-dynamic fit for conceptual tourists.

The more significant discoveries have transpired only since the 1980s (specifically the engineering triumphs of connectionism against classic or symbolic AI), and current models make everything AI from way back then look sorry like ATARI.[1] An exception to this visible aging from that decade are the polemics in the philosophy and theory of mind that occurred there. Figures such as Bechtel, Fodor, Pylyshyn, the Churchlands, et al. were participating or maturing in a milieu that can mostly escape Walkman nostalgia. Insofar as those debates remain ongoing, they will no doubt prove more important to grapple with than in years before, as it is no longer the restricted purview of specialists but the entirety of humanity who must interface with AI models as a matter of daily routine. At the core of what practically and theoretically enables their implementation, there remains the perennial conflict between the positions of rationalism and empiricism. In the face of engineering advances, symbolic AI waged a losing battle over the rules of thought from the former side, while the latter continues to multiply its new cognitive and biological theoretical objects and terminologies (sub-symbolic cognition, microcognition, extended functionalism, wide computationalism, etc.). Where the recent land-grab in cognitive science of 4E cognition (embodied, embedded, enacted, and extended) seems for some to have ignored the lessons of achieved performance levels from *disembodied* synthetic intelligence,[2] still others lament the engineering-induced amnesia that divorces current research from its philosophical origins while nonetheless attempting to affirm deep learning (DL) as the most radically empirical new paradigm of the most robust theory of intelligence available.[3]

The primary concern of this investigation will have more to do with art and creativity, and how they might more adequately be thought through in both practice and theory within the new hyper-technological niche of AI. The hostile terrain described can only be addressed throughout in an oblique and clandestine manner, without pretending to arbitrate. In a manner analogous to the lunacies of ML's interdisciplinary ambitions, the perspectival attitudes of art and philosophy tend to steal from each other in their tarrying klepto-odyssey. But only a strident Deleuzean could be convinced philosophy were capable of thinking about everything everywhere all at once and only a self-deceived artist could be their willing accomplice. So, while not shying away from conceptual *panoramas* when considering the histories of ML, this investigation proceeds according to the more constrained perspectives of artistic practice and its history, theory, and philosophical import. That said, the philosophical and theoretical accounts here will tell a story about what the brain is, does, and can do, and how this story of 'art-as-creative-procedure' might be thought and performed consequentially alongside AI. This is because there seems to be reasonable and compelling evidence provided by ML's networked but conflicting enterprise and its gluing operations between the special sciences that

might provide a clearer picture of what is called thinking because of their dis-
coveries. This is a picture that will have to include that the pattern recognition
models implemented in artificial neural networks (ANNs) owe much of their
consistency to the discovery in the late '50s of 'feature detectors' in the frog
brain. Those discoveries follow a shift away from Bergson-esque assumptions
that the frog merely perceived changes in the intensities of light toward those
of Lettvin et al. that hypothesized its perceptual capacities were able to retrieve
and extract different attributes of edges and features from its environment, at
least so long as something moves for its stationary eye.[4]

Optimisms about enhancing descriptive and explanatory resources
aside, this discovery can be read as an allegory for the human in relation to
the ostensibly incommensurable abstractions of automation. Since, having
vivisected our own minds through a theoretical and practical self-reflex-
ivity, our behaviors might inevitably seem as predictable for the vision
of the machine as the limited ones of the frog, whose "choice of paths in
escaping enemies does not seem to be governed by anything more devious
than leaping to where it is darker."[5] AI is now forcing us to reckon with
what appear to be very real dangers (or at least some of them are). As of
writing, computer scientists are on a fast track to take the stage as public
intellectuals for the first time, with Meta's Yann LeCun as eminent Twitter
class clown, and Geoffrey Hinton abandoning his role at Google so as to
'speak openly about the potential harms' from the models he helped bring
about. With her characteristic acerbic wit, pundit Naomi Klein claims in
her 8 May 2023 *Guardian* article that (citing Hinton) we may "not be able
to know what is true anymore", and AI's consolidation of human efforts
into so much extracted data is a brain-theft and art heist of world histori-
cal significance wherein "the effects of flooding the market with technolo-
gies that can plausibly perform the economic tasks of countless working
people is not that those people are suddenly free to become philosophers
and artists. It means that those people will find themselves staring into
the abyss – with actual artists among the first to fall."[6] Perhaps. At least
perhaps for some in the commercial sector of digital artist, concept art-
ist, illustrator, environmental game designer/worldbuilder, etc. Yet, as Mat
Dryhurst has pointed out, this democratization of the means[7] is unlikely
to affect the artworld in the strict sense. As that world fulfills a social
need such that – although Dryhurst will not put it in so many words –
it is simply *too big to fail*. Since the apers are at work not simply in regards
to *images* but more fundamentally toward *ideas*, this burglar alarm pales in
comparison to Hinton's warning. The concept-apers work toward ideas that
they take to be true and/or pass off as their own in a truth-dissemination
assemblage as ignorant purveyors of the *false* that results from the halluci-
nated or confabulated 'reasoning' of LLMs. This is all happening in such
a way that even the prognosticators of sophistry could not have dreamed,
nor is there yet a way to analogize this to a known human experience save
toward the lies and cheats of politics as a normalized propaganda machine
with its twinned functions of conspiracy and disinformation.

From the warnings of the twentieth century, and some philosophies, like those of Martin Heidegger, Hubert Dreyfus, or the epochal *crisis* lamented by Edmund Husserl (that nowadays, is an exacerbated *panic*), there opens a horizon of renewed interest in the ostensible affordances of an incentivized *lived experience*. It is the horizon that attempts to think past the generalized and narrowed worldview achieved when knowledge about the world is lensed through a positivistic framing apparatus that becomes severed from the everyday lifeworld of the human. The dangers, fears, anxieties, and ethical dilemmas metastasize throughout the previous century in a manner coextensive with the acceleration of computational capacities and automated achievements, which culture adds its predictive patterns of speculation to in new ways. About this critical-allegorical skirmish within Plato's cave, its bottom-up admixture of information and theory is part and parcel to the larger societal issues of synthetic intelligence where the fear of machines replacing humans was further perpetuated by science fiction novels and films. The threatening dystopias of the evil robot or ambiguous nano-formed or otherwise embodied AI now-run-amok are disseminated and also become embedded tropes in comic books. Concerning these pulp stories, from the early iterations and adaptations in channels such as EC Comics up to the MCU as derived from the 1968 Marvel Comics appearance of an Oedipus complex-wielding Ultron, comic book creators have always had a hotline to impending dooms in interesting ways, but more recently have also become some of the most lividly outspoken voices defending their authorship against a parallel distribution of AI-generated imagery. They share a now-common perspective in the synthetic appearance of AI social ecologies that generative technologies only need be understood plainly in one particular way: as a form of plagiarism and theft. The intellectual property rights issues will remain important ones, and the recent successful removal through opt-out of many millions of images from sets of training data by way of Mat Dryhurst and Holly Herndon's Have I Been Trained? platform is a small victory for one side (as it is only an aspect of a larger problem that is only a problem for some, as it is also possible for artists to *opt-in*).

In a related projection of technological perils, the social consequences of AI from fields such as critical data studies or algorithmic culture have attuned to the radical empiricism of information as a new raw material invariably tethered to the human body and its cognitive productions stemming from the faculties of knowledge and imagination. Tommaso Bertolotti will take some rather deft inspiration from James Cameron's 1984 *Terminator* movie to dub *Terminator Niche* as an instance in which "a cognitive niche that instead of benefitting its users with a decreased local selective pressure, has eventually a negative impact on the population's welfare".[8] While it does denote hypothetical scenarios in which things can go *horribly wrong*, a terminator niche need not indicate the development of extinction-level events occurring exclusively within the hyper-technological parameters of current AI. Bertolotti provides an altogether different and non-mechanized doom-scenario historical anecdote in which the accident of tribal over-hunting for

large game leads to selective pressures that individuate a *point of no return* following the depletion of *sufficient meat*, where the result is simply one of emigration as niche-abandonment.[9] Analogously, the point of no return could also be described as what William Wimsatt defines as a *pseudo-entrenchment*: an event, such as the K-T extinction or even the Wright Brothers' airplane, which is not itself entrenched but has massive downstream consequences leading to the development of actual entrenchments.[10] Various implementations in machine learning can be understood according to this notion, such as machine vision's long march, and it could certainly aid in understanding how current models *are* being actively entrenched as a result in ways that will prove extremely difficult, if not impossible, to dislodge (short of outright destroying the data centers where a hypothetically emergent superintelligence 'lives' in a nascent state, as has recently been proposed).[11]

The mimicry of human intelligence, or at least the machine's foundationally engineered function of playing us as dupes, is a new surprise even if science has been building on it since computation's inception (to use one of artist Jenny Holzer's truisms, *"we live the surprise results of old plans"*). In their July 2022 article for *Noema*, Blaise Agüera y Arcas and Benjamin Bratton recently suggest we should be cautious about anthropomorphizing the machines, but also suggest we "need more specific and creative language that can cut the knots around terms like 'sentience,' 'ethics,' 'intelligence,' and even 'artificial,' in order to name and measure what is already here and orient what is to come."[12] While this paper will indirectly address this, it is not *simply* a story about that. Intelligence is not the first object of investigation that it will depart from. Instead, what we need to isolate regarding artistic practices is something that stands out as a curiosity in their claim: namely, the assumption that 'creative' solutions can unravel difficult concepts. This misses the point of its own inquiry, since we desperately need a more specific language for the term 'creativity', perhaps prior to all other terminological redefinitions, and for all of the same reasons. That is because this concept, so effortlessly lauded and thrown around, indexes an activity within the causal mechanisms of the brain that carries, if it does not directly inform, many of the same presuppositions that cause the gnarled semantic knotting of those other terms in the first place.

Creativity is also a *strange attractor* for the computer scientists and engineers of 'computational creativity' who model a synthetic imagination that mimics whatever it is we have come to understand regarding its operations, and which dupes the generic user into also therefore mimicking in interactive behaviors (through a hitherto unwitnessed global-level Dunning-Kruger effect in their affective embrace of the machine as promptcrafting overnight artist) a form of artistic subjectivity previously unavailable to them because of its practical unattainability. The skill of the hand has defaulted and transmogrified toward the skills of type-to-produce. It would seem as if this moment ought to be guided by a return to the texts of Baudrillard. Alongside this, we should also recall Deleuze's monograph on Francis Bacon without mockery: clichés are everywhere and even mentioning them has itself

We desperately need a more specific language for the term 'creativity'.

become a cliché for us today, and there are innumerable ready-made perceptions, which for us now construct an adversarial milieu about who should own the knowledge of how to make something, and "the dust of battle rises thick, and the splinters fly wildly".[13]

The game appears to be afoot. In cracking open creativity's shell, it will be shown just how much can be gained to reorient thinking in relation to AI concerning mimicry, the modernist myths of originality and creative genius, or the deployment of terms like 'emergent' and 'opaque' in AI models, and also the significance of the role deception plays in everyday cognition, with or without AI. By protocol, this excursion will lead us back to German Idealism, and urges us to look at the preceding by highlighting its implication in the new metaphysics of nature initiated by Kant. In the sections that follow, the aim will be one of considering how a reactivation of the transcendental project amidst newer elaborations of related methodologies can aid us in making intelligible what heuristics, techniques, and rules artistic practices might have or have to gain in order to proceed alongside the incursion of these new AI tools between the known rules of a game and the new rules that arise from breaking its map. So, let's *get creative*.

What's Your Favorite Idea? Creation From Ex Nihilo to Spec Portfolio

Creativity in the twenty-first-century figures into daily life as a *compulsory* behavior economically and ideologically, marking production, reproduction, or novelty, and undergirding notions of emergence as the surprise results of AI that contribute to the intransigence of engineers or the watchdogs guarding us from human extinction. Claims about emergence in AI are relatively new, as is the term itself in its modern form, and *opacity* has also become a related buzzword in recent years. Both emergence and opacity will be explored in more detail in a later section. While it may be a fact of the models in their dimensional complexity, opacity manifests in more mainstream takes on synthetic intelligence as a fever-dream variant of what classically registers according to *the ineffable*, and can actually impede any coherent understanding of what takes place under the hood of AI. And since the AI product, once culturally embedded, can appear to detach itself from its history and its makeup in ways symptomatic of a novelty-fueled amnesia, intelligibility risks dissolving in its obsidian interface. In the doomerism that off-gasses from the contemporary conjuncture concerning AI and speculation of a not-far-off radical appearance of an artificial general intelligence (AGI), the demand for creativity, as expressed by Bratton, recalls A-bomb era misgivings and musings about the need to dial down the threat of annihilation, where historically, as R. Keith Sawyer notes, "[c]reativity research was a high-stakes game during

the nuclear arms race: in 1954, psychologist Carl Rogers warned that 'international annihilation will be the price we pay for a lack of creativity'".[14]

Claude Shannon, writing in the '50s, speculated that the potentials and possibilities of creativity being implemented in computers was "centuries away".[15] Yet perhaps seventy years' time is close enough to the mark to make his assessment a somewhat accurate prediction – at least if we are willing to wager at all that what AI is currently capable of or swiftly developing toward is the capacity to perform creatively. In the teetering pile of literature devoted to this concept, much of which does not offer any escape from its mysterium and none of which could be considered definitive, there are two important historical accounts which can be found regarding how creativity developed into a common feature of everyday life that would be difficult to simply paraphrase and are worth being cited in succession:

> The earliest recorded use of this word in English is the coinage of A.W. Ward (1875), who applies it, in the field of drama, to designate the incredible spontaneity and flow of Shakespeare's "poetic" innovation, both in its products and in his faculties (OED 1979, Supplement, 3934d [2:248]). More generally recognized is the second entry in the *OED* because it is often claimed that A.N. Whitehead was the philosopher responsible for coining the English word (1926). Though not its inventor, with some justice it is possible to argue that it was Whitehead who gave it philosophical rigor. Whitehead employed the word "creativity" to describe the nature of the "actual world" in the "temporal passage to novelty". For Whitehead, creativity describes the real nature of real objects; it is not about pure abstractions and pure potentialities. For creativity to be, it must be a principle of the universal order, and it must be expressed in concrete, novel emergent things. An older (1820) but related noun is "creativeness," which particularly denoted either an original imagination or faculty or the amazing profligacy in the making of things (OED 1979, 598d [1:1152]). Further antecedent (1678) is the cognate adjective, "creative." In its older meanings, this word squints between the miraculous powers of divine creation ex nihilo—a sense it will retain even in some contemporary theoreticians—and the more quotidian notion of mere originality (1745). Even later (1874), the connotation of "creative" is further flattened to denote something, which is merely originative.[16]

And from Władysław Tatarkiewicz there is also this:

1. For nearly a thousand years, the term creativity did not exist in philosophy, in theology, or in European art. The Greeks did not have such a term at all; the Romans did, but never applied it in any of these three fields. For them, it was a term of colloquial speech, 'creator' being a synonym for father and 'creator urbis' for the founder of a city.

2. For the next thousand years, the term was used, but exclusively in theology: creator was a synonym for God. Even as late as the Enlightenment, the term was used solely in that sense.

3. Only in the nineteenth century did the term 'creator' enter the language of art. But it then became the exclusive property (in the human world) of art: creator became a synonym for artist. New expressions, formerly superfluous, were formed, such as the adjective 'creative' and the noun 'creativity'; these were used exclusively in reference to artists and their labors.

4. In the twentieth century, the expression 'creator' began to be applied to the entire human culture; there began to be talk of creativity in the sciences, of creative politicians, of creators of new technology.[17]

That *everyone and anyone*, even *organizations*, or *things* in the case of disembodied synthetic intelligences, might come to be viewed as creative, and are encouraged or engineered to be so, is only a very recent invention and its invention carries its own peculiar periodization(s) that are localizable in notions of cognitive or immaterial labor within the genesis of neoliberal capitalism. As Claire Bishop has observed, European cultural policy at the turn of the millennium had the "aim of unleashing creativity [and] was not designed to foster greater social happiness, the realization of authentic human potential, or the imagination of utopian alternatives, but to produce, in the words of sociologist Angela McRobbie, 'a future generation of socially diverse creative workers who are brimming with ideas and whose skills need not only be channeled into the fields of art and culture but will also be good for business'".[18] With online culture there comes new demands for 'creative self-authorship', which appears as the supreme victor of authentication on the global stage of the digital semiosphere (the totality of semiotic phenomena, including patterns of social behavior, habits, language, literature, art, rituals, customs, etc.).[19] The contemporary demand to be indefinitely engaged in producing creative content is currently exhibiting almost a revolutionary force, with millions of generic online users exploiting T2I systems that generate more synthetic images on a daily basis and utilizing more compute than has ever been possible before; a new printing press for confabulated *"dark materials"*.[20]

Coextensive with this are the new subject positions these users have come to occupy, and to much public outcry: as that of the creative or even the artist (or the AI artist and 'machine collaborator') whose knowledge and abilities have canonically been mysterious and closely guarded hard-won secrets of *learning the trade*. This Protestant ethic of militant objections to the machine-made image has thus far come mostly from commercial artists, but also from 'members of the artworld' in spite of the latter's historical tangos with mass reproduction's undoings of authorship. It is interesting that some of the more cogent takes on how we ought to treat the concept of creativity come from Christian De Cock and Alf Rehn, 'thought leaders' in the business sector (which is certainly intimately familiar with *copying*) who formulate a pithy warning:

By valorising novelty over the pre-existing, one turns creativity into part of a modernist narrative of unending progress and the necessity of continuous capitalistic development. By valorising originality, one hides away notions of production and work, not to mention history. By valorising creativity as a neutral concept, one hides away the many assumptions about ethics and the nature of social life that form the possibility of normalizing concepts. We cannot fully escape the framework within which we think, nor the context from where we think, but we must work on our awareness of the foundations of our thinking.[21]

They also suggest that when considering what should or ought to effectively count as creativity, emphasis on the constraints of determinable originality or the novelty of 'original properties' in works/productions would constitute a failure of analysis, since "copying, imitation and mimicry, not to mention just hard (re)productive work, can be just as important".[22] In what follows, there will be a lot to say about what artists as "creative subjects" think they are doing that the machine, in its "abstraction of the task of perception" as Paul Smolensky described it,[23] is only the deceptive mimic of, and why mimicry and creativity are deceptive fundamentally. This is because, contrary to entrenched forms of practice that seek to escape art's institutions as alien and artificial systems in attempting to articulate through form and content a more real and essential home for art in life, there is no outside to the constructibility of art's model, because *art is already an artificial mode of cognition.* In order to finally arrive at why this is the case and why it ought to be the appropriate position to argue from, especially in light of AI's new 'democratization of the means', it will first be necessary to briefly revisit some of what has already been done with it on the old stomping grounds of some Modernist Myths.

Speedrun: Artistic Subjectivity in Modernism and the Enlightenment Origins of Originality

Stereotypes of a Blackmail Misunderstood, and It's Still All Good

The account of artistic genius established by Kant has received considerable and detailed analysis, typically articulating its appearance in the third *Critique* and attempting to chart its relation to laws or faculties of imitation; to the "exemplary originality" of works derived from an innate talent that cannot be learned;[24] or even to its disturbing features that introduce a peculiar terror for Enlightenment thought opened by the freedom of mechanism that defines it according to a new metaphysics of nature;[25] in addition to considerations of it as an inherent theory of production wherein originality is an original indetermination of the

Art is already an artificial mode of cognition.

produced object derived from a rule-suppressing instability that must be 'allowed to emerge' to function as a modality of thought procured for the project of thinking itself.[26] Rather than his elaborations in the third *Critique*, it is Kant's pithy formulation of genius from the posthumous *Lectures on Anthropology* that will for now best serve the purposes of this investigation:

> Genius is a freedom without guidance and constraint of rules. The dependence of the lazy on the guidance of rules is opposed to genius. The apers assume this freedom from constraint, as if a total absence of bounds and rules were the mark of genius. Genius is a principle of novelty in rules, because it gives new rules, as it were, and on this account does not follow the guidance of the old rules.[27]

One thing it seems important to note, aside from the figure of *the apers* that perfectly describes the contemporary site of conflict surrounding creativity and AI, is that if genius produces its works (and itself) as a novelty that 'gives new rules' simply by not following guidance from old rules, it is not for all that a freedom without guidance and constraint of rules is applied. This is why *ignoring the facts* has always been a kind of deceptively engineered blindspot for art, in general – a self-imposed and institutionally sanctioned amnesia that constructs "new works" according to "an ignorance of the established conventions of art".[28] Thus begins with Kant a long con of *pretending not to know* in favor of a newly established freedom from constraint and convention that grounds the myth of the artist in modernism.

Certainly, Deleuze has been a motivating force in safekeeping and making the furthest advance toward familiar apprehensions of creativity as a "freedom from constraint" that finds its genesis in the violence of imagination that "schematizes without concept" and pushes the understanding to its limits in a manner providing the subject with "the intuition of *another nature* than the one that is given to us".[29] Such freedom from constraints would indeed result in a kind of terror refracted through society with the inception of modernity, industry, and scientific investigation and experiment in all of their technical and objectifying delirium.

Whereas individualism, according to the philosophical anthropology of science offered by Lorraine Daston, 'identified the ineffable with originality', what she and Peter Galison labeled 'mechanical objectivity' would, historically, seek to 'eliminate' imaginative machinery from scientific bookkeeping about the world, curiously using illustrations, diagrams, and photographs to 'let nature speak for itself' such that in the nineteenth century, 'art for art's sake' becomes mimicked by science, which invents a new grift for objectivity vis-à-vis 'science for science's sake' that 'immolated the personality' in favor of the 'pure object alone':

Geniuses of art and science exercised the same brand of controlled imagination, in contrast to the wild imaginations that tyrannized pregnant women, religious fanatics, or mesmerized *convulsionnaires*. Only in the early nineteenth century was fear of the imagination in science compounded with loathing. The causes lay in new views of the artistic imagination as freed from all constraints of reason and nature, and in a new polarity between objectivity and subjectivity. Wild, ineffable imagination became the driving force of creativity in art – and the bogey of objectivity in science. In their ideals, practices, and personae both art and science had mutated, and drifted apart.[30]

From within this horror-game of the transcendental project's Last Picture Show, it is the sublime, rather than the beautiful, that is the preeminent vector for the creative act. What is to be considered as original in this context is not at first-move the work of art, but the artists themselves, who establish their identities by relating to their own conceptual behavior as expressing an essential élan vital. Various trajectories of artistic practice and their critical, theoretical, and historical accounts will emphasize methodologies of depersonalization and desubjectivation (such as the non-compositional practices detailed by Yve-Alain Bois),[31] while still others reinforce ideologies of an intuitive model with its crypt of secrets about what constitutes its procedures. This can be discovered in so many accounts where *per canon* we can read this according to the *marks* of personality (a Picasso or the metaphysical bloatware of Ab Ex) that index an 'inner creativity'. However, this has also been paradoxically and variously described according to the originality discovered in the rule-governed zero-point repetition and recurrence of the modernist grid as "regenerative stereotype",[32] or, following Renato Poggioli, as the avant-garde's generalization of form by way of the stencil – or *poncif* as the term Poggioli appropriates from Baudelaire – of fashion that is characterized by the lightning-speed adoption of new rules that could previously only count as exceptions.[33] It should be noted how the problematic of genius and its mysterium of 'inner creativity' is therefore crystallized in the schematism chapter of the first *Critique*, where schematization "gives the rule" to art via the "hidden art" of a "technics of nature" (a term later introduced in the third) that abjures any mechanistic description that might afford it intelligibility.[34]

In each case of formal elaborations, the artist is duped into perpetuating the blackmail enforced through the myth that the truth of what they do, its *origin*, is somewhere outside of the technics of the work's construction that is obviated by modernization, or mysteriously embedded in the immanent procedures – its interventions into *causality*[35] – that guide such construction that are themselves *projected as* ineffable. This projection will become the food-source for the amnesia that is formed through an arbitrary separation between a new elaboration and what came before.

As I have attempted to articulate elsewhere, technē is *sought out* by art within artistic modernism as something for it to incorporate into a conception (self-reflexively) of aesthetics and art. Artistic procedures will (or 'ought

to') therefore correspond to art's own self-relation as being the *other* of technics (which is how art comes to determine its identity *as art*) and, according to art's modes of internal recognition, *artificially* sustain themselves by way of a denial of being already a technics, affirming their difference in what must necessarily come historically to be their bloated operation of distinguishing themselves from *craft*.[36]

Warp Zone to the Post-Industrial

There is a different kind of *terror of originality* that Theodor Adorno recognized artistic *technique* to be the exemplary condition for. Technique in art will become *formally determined* according to a maturation of artistic labor that takes place thanks to a *tradition* obeyed under the cover of darkness that is art's identity of secretive immanence. This clandestine operation is what will ultimately threaten to impale art on its own imperative of disenchantment and rationalization in the semantic opacity of its "rational and conceptless" enigma.[37] The relevant passage here is that detailing art's métier:

> That consciousness kills is a nursery tale; only false consciousness is fatal. *Métier* initially makes art commensurable to consciousness because for the most part it can be learned. What a teacher finds fault with in a student's work is the first model of a lack of *métier*; corrections are the model of *métier* itself. These models are preartistic insofar as they recapitulate preestablished patterns and rules; they take a step beyond this when they become the comparison of technical means with the sought-after goal.[38]

Even while this "sought-after goal" is violently dissipated in the commodity-form's adaptations of the *rules of art*, both production and the readymade's non-production retain the trace of creative decision as a "memory of the hand" that has "auratic contours" of an analytical nature rather than mere synthetic procedures that Adorno will see as exemplified by the conductor "who analyzes a work in order to perform it adequately rather than mimicking it".[39] This mimicry, which would seem to be the obverse of art's purported 'conceptless enigma', forms the gripe of the contemporary creatives and artistic subjects whose head the algorithm has aped and forced open on pattern recognition's operating table, deftly and synthetically conducting the organization of pure Gaussian noise into images that ape the 'adequate performance' of human analysis in convincing ways.

Duchamp, who attempts to sport every guise in which the avant-garde artist would craft their personas, appears here as the premier trickster,[40] and becomes the signpost of the first of any historical figure we are aware of concerning narratives who *decides* to navigate a decisional matrix of selection – a ploy in the game of art that surreptitiously and vicariously *chooses* through the predictive measures of *chance* and not the surprise of contingency simply because it still *plays by the rules*.[41] Rather than genius as the secret of an 'inner creativity', Duchamp's relation is probably closer to a

now obsolete understanding of the term appropriated from its French appli-
cation in German that seems initially to simply refer to types of *disposition*.
Such dispositions are without the distinctions between good and bad, and
therefore without ethical dimension.[42] From the French application in fact,
what is revealed is really the institutional entrenchment of art and its social
patterns of discourses and dispositions that, as it turns out, are themselves
capable of being re-framed in re-production, and that Duchamp's tactics of
evasion and map-breaking make visible as a *new material*.

Duplicated by the algorithm, which has now implemented schematization
and mirrors that point in artistic modernism where originality was first dis-
placed by mechanization, is a reminder of what previously had threatened
to render craft and skill useless in "the hostile conditions set up by industri-
alization" (Thierry de Duve).[43] The readymade demarcates when the shifting
boundaries of what counts as art could themselves become visible and serve
as a new raw material for artistic procedures. We could say that for de Duve,
what Duchamp accomplishes through the overturning of skill (technics) that
is replaced by genius, or wit, is the elaboration of a *technics of gesture* that
constructs the work of art from social abstractions and the boundary condi-
tions of art. Or yet again, a *heuristic principle* of gesture that, following Gilles
Châtelet, is an ampliative momentum wherein its problem-solving articula-
tions can be deployed such that "no algorithm controls its staging".[44]

However, it is precisely this that deserves to be articulated, because gesture
deployed as the tool to treat the material of abstract social relations, rather
than the crafting of the work of art itself, introduces a new paradigm that
delineates a technē of navigating and manipulating social patterns. (The iden-
tification of art or practices with that which 'cannot be learned' because such
features are contained in the implicit know-how of learning-become-gesture
is explored further on.) This is something that a large segment of generic T21
users are already familiar with (rather *tacitly*), where questions of the aes-
thetic legitimacy and artistic integrity of the machine's generated images are
deferred to the purported *raw skill* it takes to subtly craft *just the right prompt*,
where claims to their rightful place as independent creators qua machine-
collaboration are mediated by the exemplary iconicity of Duchamp's *Fountain*
that has prefigured the rules of their game.

In his 2007 *The Intangibilities of Form*, John Roberts reconfigures Adorno's
'memory of the hand' by identifying the readymade with a shift toward a
'general social technique' and an interiorization of mechanization and indus-
trialization. The social and material conditions that lead to deskilling are said
to be "what happens when the expressive unity of hand and eye is *overridden*
by the conditions of social and technological reproducibility", and where "[a]
rtistic skills find their application in the demonstration of conceptual acuity, not in
the execution of forms of expressive mimeticism".[45]

Toward this, Roberts nominates the 'post-Cartesian' artist-practitioner,
whose social relations, often occasioned by managerial and administrative
ambitions (think, initially, Warhol), denote a behavioral tendency in art rather

than any particular *kind* of artist.[46] It could no doubt be said that T2I models are only the latest incarnation of such socio-technical transformations of deskilling and for which the readymade is only one example, albeit one of primary significance for the history of art in isolating the factors that contribute to the deprecations and exposures of authorship and its claims. For Roberts, following these transformations as they manifest in early artistic modernism, authorship is not so much erased as it is re-made by way of integrating and transforming the "totipotentiality of the hand" away from manipulating concrete material and *back* toward the more abstract general social techniques that are the *craft* undermining art's Romanticizations of self-image.[47]

This is later transformed through conceptual practices that sought to ameliorate the enclosures of Cartesian subjectivity by dissolving the artistic subject's immaterial confines entirely in the procedures of technical and social reproducibility themselves. For Roberts, it is the commodity form and its attendant and inexhaustible modes of reproduction that forge "an unprecedented freedom from the myths of authenticity and originality".[48] Moreover, as a historical marker of how art begins a movement toward more artificial identifications in relation to mass production's 'democratization of the means', these technical procedures will eventually provide "further insight into the material realities of iteration and the copy in late capitalism, and therefore, also defin[e] those points where 'replicant-thinking' in art and 'replicant-theory' in science come into possible creative alignment".[49]

Alongside this history were the lesser-known Eastern European variants in the '60s with the New Tendencies movement, where computation, and the computer as a *new object*, integrated with descriptive affordances provided by cybernetics. It is here, really, that information theory makes its first overtly explicit incursion into artistic practices. Armin Medosch has thankfully provided us with a much-needed and previously unavailable account of how that movement "wanted to demystify art and the figure of the artist, confining the cult of the genius to bourgeois societies of the past".[50] Medosch notes how these 'demystificatory' historical trajectories converge in the generalization of the conceptual or "post-conceptual practices" that have been explored by Peter Osborne.[51] What is signaled here can be read according to the logics of a paradigm shift of changing patterns of social relations in art that forced the purported demystification of art cum dematerialization to be duped into a new fiction where "the myth of the artist as creative genius is instrumentalized within a neoliberal competitive creative economy".[52] Or yet again how the "structuralist myth of agency without a subject found continuation in the foundational myths of the information society about immaterial production".[53] There is no historical advantage of art's entrapment by language here that would register according to the dissolution of art within philosophy that were (some of) conceptualism's fantasies. It will make more sense to return to appropos of how Michel Bitbol, Pierre Kerszberg, and Jean Petitot situate his critical project in order to unravel how it is still the 'creative subject' that comes to take center stage for us today:

The initial phase in Kant's reception was operated by the idealistic move-
ment. Fichte was the first author to emphasize the need for the primacy of
practical reason over theoretical reason in his philosophy, and to assert that
this reversal made the completion of Kant's system possible. This strategy
culminated in German Idealism, particularly through Hegel who argued
for a totalizing view of knowledge which includes comprehensive con-
cepts of natural and historical processes. But Kant's views were also sup-
ported and reinterpreted by the pioneers of *Naturphilosophie* in Germany.
Since mechanistic materialism was commonly taken as a necessary conse-
quence of classical mechanics and mathematical physics in general, there
was a search for alternative sorts of natural science which would in turn
offer a vindication of the anti-materialist concepts of natural philosophy.
Kant's *Critique of Pure Reason* was thus interpreted as opening up the pos-
sibility of divorcing classical mechanics from materialistic dogmatism for
the first time. As for the *Critique of Judgment*, with its reflection about aes-
thetics and about teleology in biology, it provided resources for an anti-
mechanistic conception of nature influenced not only by physics but also
by biology. From Kant's description of the formal *a priori* background of
knowledge there arose, as a result of the objective turn which Schelling
gives to the Fichtean notion of intellectual intuition, a new metaphysics
of nature. The subjective formal *a priori* was converted into a formative
power at work in nature. The power of understanding was replaced with a
creative force shaping organic development.[54]

Schelling would emphasize a universal 'formulative' drive where organism
determines mechanism, and where technical drive is merely the modifica-
tion of a 'Higher Mechanism' that now becomes replaced with a 'Higher
Physics' unfolding the *dramas* of light we are incapable of receiving, for such
things are determined as "unattainable for the imagination" and "yet not
altogether hidden from the eye".[55] As for the inexplicable technics of nature
already indicated by Kant and which function to dissolve causality in favor
of nature's organizing principle as a "free activity",[56] we have perhaps seen
that such "free activity" became a land-grab for artistic interventions in the
twentieth century that transformed alongside the developments of computer
science and information theory after the '60s.

Anti-subjectivity, anti-humanism, 'mathematical art', etc. will perhaps
display how these operations or procedures find a terminal point in the
'mysterious notion' of formalization in what Alain Badiou has suggested
to be an *ordinant* 'generic procedure', wherein an ostensibly objectless sub-
ject "is neither a result nor an origin. He [sic] is the *local* status of the pro-
cedure, a configuration which exceeds the situation".[57] This appearance of
a Subject moreover indexes 'the emergence of an operator' with *randomness*
as its material. This could, forty-plus years on, perhaps be situated accord-
ing to a prerogative of *noise* that can be unraveled as either the 'arbitrary
and contentless language' in political situations or the sad results of (any
special) science's 'non-experimentally confirmed abstractions'. Or still, as the
indication of what may mark some kind of break with conventions in art.

It must *immediately* be recounted that, whatever this subject is, its 'illegality' for Badiou can only and *ought to only* coincide with that of a 'free activity' of 'events' and their supernumerary instantiations. Surely, the *motivation* of the Subject cannot be that of either *interest* or *opportunity*, even if it must use them both. It must use them both because there is no other objective relation that could effectively *succeed* for it to *count* as a succession to begin with. And insofar as the Subject, who must be 'more than one', can never be the banal appropriation of an *individual*, it would also not be that of a collective, and even less that of a *coming community*.

Emergence of Emergence: Opacity, Incommensurability, Mimicry, and Deception

> *Emergence is a charged concept and as such can obfuscate as much as enlighten. It would be unfortunate if carelessness in using the construct of emergence contaminated future directions before they were even taken.*
>
> —*Jeffrey Goldstein*

As was just detailed, the appearance of 'general social technique' as raw material, with Duchamp and the readymade as historical ringleaders, shows how "decentred artistic authorship is reconnected to the labor theory of culture to become an *emergent* category".[58] Of course, it is also more than that, just as it is more than the zero-point of the grid that structurally generalizes origin through repetition and recurrence. How much more might be rather *contingent* on what exactly is meant here by 'emergence'. The term itself, which is simply *assumed* to be unproblematic (and that we cannot avoid using in a typical sense), is deeply connected to the problems of opacity in AI, or in the semantic opacity of works of art with their 'immanent principles' that bind both to the demands of interpretation and the construction of models that aid the intelligibility of the objects of science and of art. Emergence can also be correlated in significant ways back to Kantian schematism, which ought to be fundamentally understood as an emergent but opaque function of the faculty of transcendental imagination, and one that is opaque *because* it is emergent. Kant, however, did not use this term and was not in possession of the concept of emergence during his time as we now understand it (even if traceable to Aristotle's *Metaphysics*, the term 'emergent' is not coined until 1875 by George Henry Lewes, and the modern conception is not introduced until Nicolai Hartmann as a categorial novum in the twentieth century).

As such, Kant lacked the theoretical and conceptual resources with which to properly address many of the aspects of cognition that are folded into schematization (all of them, essentially). Its modes of intelligibility will fall

to the special sciences and their application in the history of machine learning that will attempt to unlock its 'hidden art' while simultaneously aping the function of the schematism itself, and therefore apropos implementation, black-boxing it all over again. Cast in the light of modern and contemporary art history amidst the duplicative and replicating behaviors of artistic procedures that have just been glossed, it might not be so difficult to conclude regarding the public outcry over T2I thievery that it is hard to see what all the fuss is about. The procedures of an algorithmically deployed synthetic imagination neither eliminate artistic subjectivity nor creativity, nor the concept of novelty, but re-cast them in new ways against this backdrop, and it is these historical transformations in our understandings of what art is or can be that now enable us to turn attention to the perilous concept of emergence to see if it is possible to shake off the residues of a cognitive mysterium that subsists in practices (and not just artistic ones) so drawn toward it that they continue to advocate on behalf of it without even realizing it in their occasioning of a willful ignorance derived from accidental self-deception.

Whenever anyone speaks today about the capabilities of AI as 'emergent features' that arise from the opaque activities of a network's hidden layers, they are not always taking stock of the best available descriptive resources on the market and often simply parrot an inherited conception of what it means when some new behavior or pattern in a system or systems cannot be explained through reduction to its lower-level constituents that itself has only so much traction toward explanation. There is even recent evidence that would suggest emergent abilities in LLMs are only a mirage of investigative framing.[59] A lesson to remember from Deleuze is that concepts do not explain but must themselves be explained.

For much of the early history of machine learning, it may have seemed odd for there to be any mention of creativity in the context of programmable tasks and procedures. Nonetheless, it is within the development of computer science as directly linked to the introduction of the concept of emergence in the study of mechanism, thermodynamics, and information theory that creative computation will find its place. The new metaphysics of nature that follows after Kant has produced a boon for theoretical and evolutionary biology, neuroscience, cognitive science, and their ilk in the special sciences that are all coextensive with and inextricably linked to the introduction of the concept of emergence, which will be then tethered to the newly fashioned emphasis on creativity that arises in the twentieth century (and is *tied* or *semantically knotted* to notions of self-authorship and originality, as we have seen). In his succinct recapitulation of the history of the concept in *Social Emergence*, Sawyer describes how, from eighteenth-century organicists and onward to figures such as A. N. Whitehead (already noted at the outset concerning how 'creativity' appears in the English lexicon), theories of emergence in evolutionary biological systems derive from theoretical tendencies in lineage with Hegelian-inspired articulations of progressive development in stages (the self-generation of concepts that appears in his *Science of Logic*),[60] adding that

Whenever anyone speaks today about the capabilities of AI as 'emergent features' that arise from the opaque activities of a network's hidden layers, they are not always taking stock of the best available descriptive resources on the market, and often simply parrot an inherited conception of what it means when some new behavior or pattern in a system or systems cannot be explained through reduction to its lower-level constituents that itself has only so much traction towards explanation.

we can further trace its origins in Comte, and follow its various transformations up to more recent and baroque manifestations derived from social insect behavior with the introduction of concepts such as "swarm intelligence" that are deployed to address complex social behaviors and patterns.[61] (The term generative mechanism also appears, but we will not see the term 'generative' in art until 1965.)[62] Sawyer also notes that early and influential descriptions of emergence can also be found in the theories of Freud and Piaget but will reach an apogee of sorts with the 'cinematographic illusion' of Bergson that critiques notions that reality is composed of mechanistic processes as stepwise progressions among fixed structures. Although Sawyer does not mention it, there is a direct line of development that will ultimately bottom out in the integrative conceptual promiscuities offered by pancomputationalism (a position that remains pervasive in the philosophy and theory of AGI).

For Manfred Stöckler, if emergent properties and functions are to be understood as *inherently* opaque, this would necessarily have to *itself* be (to put it rather bluntly in a way that is only implied) an *emergent* phenomena of observation derived from insufficiencies of explanatory resources as they exist at any particular time in history. This acumen of derivation should be *stenciled* onto early emergentists, for instance, who may have been rejecting metaphysical vitalism but were also complicit with rejecting mechanistic descriptions, and "were inclined just to accept the formation of new things as something *given* that cannot be explained".[63] Such properties are said to be emergent occurrences "if the tools of explanation, which are sufficient for the parts of a whole, are not adequate for a real understanding of the composed system".[64]

Additionally, Jaegwon Kim has quite succinctly encapsulated why the deployment of this concept is slippery, to say the least: "[t]he term 'emergence' seems to have a special appeal for many people; it has an uplifting, expansive ring to it, unlike 'reduction' which sounds constrictive and overbearing. We now see the term being freely bandied about, especially by some scientists and science writers, with little visible regard for whether its use is underpinned by a consistent, tolerably unified, and shared meaning (and if so what it is). [...] 'Emergence' is very much a term of philosophical trade; it can pretty much mean whatever you want it to mean, the only condition being that you had better be reasonably clear about what you mean, and that your concept turns out to be something interesting and theoretically useful".[65]

Returning momentarily to Adorno, we can see how in his *Aesthetic Theory*, this is manifest in adherence to the non- or supra-technical content that structures works of art, as the claim would be that "the content is not something made" and is rather an "immanent elaboration" of form.[66] It would seem to be required that *novelty* were a condition for creativity or emergence to obtain, yet as Sawyer points out, novelty is in actuality an insufficient condition for emergence, since novelties, at least those that can be considered *even to begin with* as novelties, could be either irrational or nonsensical, and that moreover, for a novelty to count as *creative*, "an idea must be *appropriate*, recognized as socially valuable in some way to some community".[67] (It is this

assessment that should also recall Poggioli's invocation of Baudelaire regarding the generalizations of fashion.) This is why beyond any sort of additional requirement of utility and clarity, Kim, who appropriately chastises the concept, does not really seem to place many demands on the objectivity of claims regarding the purported theoretical utility of emergence if one of its defining and principle constraints is merely that it be 'interesting'.

Nonetheless, without its role as a "unifying epistemological concept",[68] it would be exceptionally difficult if not impossible to adequately think any system at all (thus its applicability across all fields and topics of scientific investigation, from computational linguistics to working memory in the brain to the deep-time metrics of geomorphology).[69] Computer science and AI engineering would be lost without this concept, considering its relevance to models of Predictive Processing (PP) or Friston's free energy principle (FEP)[70] and the typology of implementations they enable. As Alessio Plebe and Pietro Perconti have recently indicated. Many specialists in AI who have developed models directly influenced by PP and FEP have negated establishing any meaningful connection with the 'originary circumstance' of the theoretical and practical descriptions that enable them to obtain as models to begin with as they are derived from cognitive science, stating that to "the extent that modelers withdrew from pursuing cognitive investigations, the design of neural models was allowed much more freedom in adopting mathematical solutions alien to mental processes".[71] Their point, however, as indicated at the very outset of this paper, is that establishing this relation might show how "the results of deep learning may play a major role in debates that characterize contemporary cognitive science".[72] And toward this, they appropriately invoke, although it is not without dispute, the no-miracles argument.[73]

It will therefore first be necessary to construct a tertiary stream to see how we might navigate the murk of *opacity* that has already been mentioned several times, since it is entangled with everything explored thus far. Opacity can be something that 'happens' when interacting with a system that can be described as either ontological or epistemological, or it can be deliberately constructed, such as being an effect of proprietary trade secrets. With AI, it arises at least in part from the high-dimensionality of the systems that perplex even the engineer and computer scientist. It is a *stealthy configuration* of many complex artificial and natural systems limiting our access and threatening the stabilizing functions of science, of cognition in general, and art in particular. And even when the horror of *destabilizing* functions in each can be a *good thing* (as this is more approximate to the role of models in science and to the role of art writ large), the Bourbaki 'dangerous bend' road sign (extended by Don Knuth) ought to be recalled: in the current conjuncture, something is *deceptively afoot* and because we do not know exactly what it is or especially possess enough *access* to know what to do with it, we ought *proceed with caution* as there is as much a danger of being left forever out of the loop as there is for such lack of transparency to lead toward magical thinking and *far out* ideas or even *crackpottery*.[74]

In the case of computational opacity, deception, and mimicry are actually *foundational* to the models. As M. Beatrice Fazi has noted in a not-so-caution-ary, matter-of-fact sort of way, "[t]he organisation of a computational struc-ture is abstracted from the observation of an empirical one; computational construction happens at a sense-empirical level first, and on a logical one second. Formal abstraction is thus less regulative than imitative".[75] This last point is crucial, and strikes the core of what has been detailed thus far con-cerning the 'semiosphere elaborations' of artists as agents and self-authors from early artistic modernism's experiments with copies, reproductions, and replications up to the current simulations of the contemporary content-cre-ator, all of whom play at the interventions into causality by manipulating their various raw and readymade materials from within what Peter Forbes would refer to as "the great Empire of signs".[76] For it is not trivial that the machine's abstractions are the deceptive mimic of sense-perception and rea-soning. In its more benign forms, these abstractions represent what Simone Natale calls AI's "banal deception" and are the synthetic participants in the "mundane, everyday situations in which technologies and devices mobilize specific elements of the user's perception and psychology" to "actively exploit their own capacity to fall into deception in sophisticated ways".[77] Natale cites Anthony Oettinger's reflections on the computer as a black box, stating that

> the concept describes technological artifacts that provide little or no information about their internal functioning. Reading this in its literal sense, one should assume that computers were to be made transparent and opaque at the same time. Of course, Oettinger was playing with a secondary connotation of the word "transparent," that is, easy to use or to understand. That this transparency was to be achieved by making the internal functioning of computers opaque is one of the ironic paradoxes of modern computing in the age of user-friendliness.[78]

And importantly, further on noting how

> magic is rooted in people's relationships with objects and people's natural tendency to attribute intelligence and sociality to things. On the other side, this feeling is embedded in the functioning of computer interfaces that emerge through the construction of layers of illusion that conceal (while making "transparent") the underlying complexity of computing systems. For this reason, even today, computer scientists remain aware of the difficulty of dispelling false beliefs when it comes to perceptions and uses of AI.[79]

It should be stressed how this 'paradoxical apparition' of opacity is applica-ble to an intrinsic and ineliminable function of what Samuel Forsythe articu-lates as the *logic of deception* that as far as this investigation is concerned is an ontological and epistemological cancer on cognition that we are nonethe-less involved in a symbiotic relationship with. With Forsythe's recent work on the pragmatics of thinking and acting through non-cooperative communica-tion and inquiry via abductive cognition (Peirce's invention, but *inordinately*

extended by the work of Lorenzo Magnani and his collaborators and students), deception and opacity are lensed and operationalized through deftly articulated forms of an *adversarial rationality*, which can be projected historically (and everywhere biological outside of human history) into and onto circumstance after circumstance as a means toward 'undoing the rigid consistencies of science' that will generate its possibility as an object of thought in the first place.

Such logic requires environmental and self-reflexive/introspective scrutiny, conflicting perspectives, concealed behaviors and motives, models, and modes of inquiry that overall support deviations from cooperative behaviors (deviations that will need to be incorporated into any account of *practice* if practice is at all to be properly understood). Forsythe, drawing on what Jean Maria Arrigo calls "adversarial epistemology", describes the potentially unavoidable situations in which "the adversarial inquirer must not only inquire into the adversary but must also scrutinize their own behavior in order to discover how it may afford the adversary the opportunity to make abductions about their habits and thus an opportunity to anticipate, surprise, and deceive".[80] Forsythe also notes, following J. J. Gibson – and we should recall Robert's articulation of general social technique – that affordances can be physical or cognitive, which is something that will functionally determine them as *resource extraction* activities of cognition.

Given its complicity with any and all forms of distortion and application, manipulations of environmental and other kinds of affordance can be shown to articulate themselves in any biological domain with a central nervous system through implicit tactics of evasion, prediction, or detection in ways that make out intelligence as "the example of adversarial inquiry par excellence".[81] As concerns art, its relation to deception in Western history goes back as far as Plato, and its implication in the invention of modern camouflage, related to how it can 'baffle the eye', is already a well-known subject of study.[82] Forsythe will go on to further compress an image of how mimicry functions in the globally distraught economies of contemporary military affairs that it would be *foolish* not to cite:

> *Crypsis* is the ecological term that describes the morphological means of stealth in organisms [...] In military affairs, this correlates to camouflage patterning and materials, stealth technology, and in the skills and methods of fieldcraft and operations. In intelligence, it is represented by the skills of the operator in counter-surveillance, false identity, and the evasion of adversary security measures. *Masquerade* is a semiotically different kind of camouflage, where rather than merging with the background, organisms display or communicate explicit signs which are intended to be misidentified as other innocuous or inert objects. In military deception, this might entail actions such as disguising missile batteries as geological features.[83]

With biological mimicry, there is a necessary complicity that must exist for each player within the complex system of their environment, as the model and the dupe must work in tandem in order for biological mimicry to be successful, and neither of them 'know' in any meaningful way (so far as sapient

understanding is concerned) about the *game that is playing them*. The model must have certain characteristics that are recognizable to predators, and the dupe must be able to closely mimic these characteristics in order to avoid being attacked. At the cellular and genetic level, this may involve modifications to gene expression, sensory systems, or other aspects of the dupe's biology in order to closely resemble the model. Relatedly within AI, which is *deliberately* engineered with these understandings as inspiration, the generator in a GAN is adversarially engaged with the discriminator layer of the architecture in a lower- and higher-order game of fooling. (We can also think of one way in which fooling operates at the human-AI interface level, where *culture* attempts to act as the discriminator layer to detect forgeries and deepfakes.) As per Robert Trivers's *The Folly of Fools*, "deception is everywhere",[84] and as such, the creation of a projectable altruistic public image will function as a hallmark that is fundamentally and perhaps unknowingly engineered to include thought suppression, false-memory, and a host of related, cost-effective strategies of deception.[85] Deception is in fact so pervasive in nature as to go generally unnoticed – a statement that is not an ironic observation regarding its efficacy.[86]

For philosopher and conceptual artist Adrian Piper, self-deception is, like genius, an *exemplary* manifestation that appears in behavior as a form of what, following Kant, she will refer to as *pseudorationality*. For Piper, pseudorationality represents the *"highest-order disposition to literal self-preservation"* as "preservation of the rational intelligibility of the self, in the face of recalcitrant facts that invariably threaten it".[87] Essentially, pseudorational behavior represents a meta-constraint to preserve stabilized intelligibilities in the world via a *systematic distortion of understanding that manipulates the self-model into benefiting from its own illusions of rationality*. As an *opaque* example, Piper illustrates the presence of a hypothetical gray blob one might encounter while walking along West Broadway in Manhattan that appears to have no determinable features and for which actual rational reflection must assume a relation that skirmishes about regarding its lack of ability to map any of the object's properties or identifiable characteristics to the familiar and recognizable objects for which we would possess resources in our conceptual and representational repertoire to articulate. Its ambiguity can only be contoured obliquely via "a very deeply ingrained, motivationally effective aversion to rational unintelligibility, because it threatens the rational coherence of the self as having that experience".[88]

This initial formulation is later extensively explored in the 2008 juggling chainsaws of her two-volume work on Kant and the rational construction of the self, wherein self-deception is the occurrence and unplanned result of a lack of self-discipline, a willful or unconscious ignorance, and an evasion of self-knowledge that *socially* prizes itself on its ability to *know* when what it carries on about is in fact the absence of any capacity to understand (because it is founded on the evasion of such capacity toward *another* capacity that it recognizes itself in but does not itself recognize). As a *disposition* it provides the self with a maintenance function for its consistency, against the

anomalous disturbances that are characteristic of the Kantian sublime in its threat to the coherence of systems of representation.

There is an unsurprisingly massive amount of literature in the interminable Freudian- and Darwinian-indebted hangover afterparty analyzing deception that *covers over* its object in the allure of its own descriptive resources that inadvertently makes insurmountability its haven and opacity its product. This maneuver should be evaluated as a *symptom* of interpretation's marketing scheme, where it cradles a loss-function that managerially assigns its prerogative function only to that of the efficacy of mainstreamed psychology. It is also unsurprising, and even interesting in a non-trivial way, how accurately even the most outright-trifling takes on deception can be copypasta'd to work at undermining a consensus perception of artificial intelligence in ways that might make more common anthropomorphizing strategies seem rather quaint.

Concerning rational coherence of self, it is the Kantian sublime that functions for Piper as a vector of evasion *or* as that which one can navigate toward for its 'dissociative affordances' that pull the rug out from under any coherent self-model, or even forms of scientific objectivity, and force the recognition of their *fabricated makeup* as constructed models and fictions that require either maintenance or revision. We might then describe *pseudorationality* as a leaky function of habituated social and linguistic behaviors that is not itself fully rational but is derived from the mimicry of the framing devices of rationality that are *perennial motives* of thinking in general. It purposefully deviates from the rules of engagement while lying to the self about such motives. Yet, to recognize this is also to recognize how any normative practice is also capable of making adjusted and intentional *deviations* that we might actually decide to occasionally seek out, simply because "a little madness is not necessarily a dangerous thing, if it forces us to rethink and restructure the dogmatic theory that crippled our vision in the first place".[89]

The affordances of (or traps and dangers of) deviant behavior (whether theoretical or practical, etc.) need to be taken more seriously at the moment, simply because humans are no longer the only ones capable of performing it. With AI now in our day-to-day lives, even if the model does not have agency outside of simulation, all parties controlling or utilizing it at every single level do. The practice theory of Joseph Rouse here provides a departure point for our eventual exit from the traumas of this investigation: "[g]iven only a rule, the possibility always remains open to follow the rule in deviant ways. One might then try to specify how the rule is to be interpreted, but any such interpretation would itself be another rule open to deviant application".[90]

Since Plato, the degradation of the model in favor of causal intervention and material manipulation cast the artist as a deceptive individual, distorting or misrepresenting the world by evading the form of the Good. Of course, science has this as a fundamental ambition unwittingly perhaps, as the function of models themselves are precisely to distort the world via the deliverables obtained through the pragmatic and anticipatory deployment of

their functionality as "technologies of investigation".[91] If there are performative conditions for *fooling the other* (with the other – at least here concerning science – being either a re-cognized *consensus* or the lingering father-figure of whatever was the most historically recent and entrenched Last Paradigm), these will no doubt require some rather *intuitive* awareness of how the world is already perceived, with projections of how that perception might become dislodged both before and after cognition has constructed the world to become a system in a comprehensive way.

In short, practice requires some way of having the know-how to have a way of "knowing one's way around".[92] Art is not typically invited to the table in this discussion, no matter how well it attempts to force it, although it has sufficiently managed to *grab attention*. In 'contemporary economies', if there is no money involved, you can rest assured that nobody who takes problem-solving seriously really wants to listen to what art has to say, save for preservations in globally locked boxes of distributive and valuable objects for later use. Nonetheless, it might remain important to consider not why art is supposed to be *cool* because of what it makes appear for the general social tendencies of who-doesn't-like-to-look-at-a-thing but how it has always proven rather adept at foregrounding the rewards it is able to reap from secretive attitudes of *how to get things done* and its opportunism of embracing *fuck around and find out* procedures that are not regularly a mainstay of any otherwise normative or objectively effective methodologies and still less those that could qualify as the constraints of experiment:

> The ability to scan, spot, and exploit a situation is a characteristic that is consistent among some criminals, but it is also a characteristic that is shared by many creatives. As Anthony Julius (2002) has observed, artists and criminals share certain characteristics. The artist is as resourceful and amoral in his or her pursuit of the project as the criminal. The likeness of the artist to the criminal was celebrated by Degas and is a familiar trope in art writing. "A painting calls for as much cunning, roguishness and wickedness as the committing of a crime," Degas commented, and he advised the neophyte artist to be "devious."[93]

Art history functions at least in part as a forensic science, and in part as a history of consciousness that works at uncovering some evidence from the crime scene of history regarding what it was possible to perform in thought and act at any given time. This would also seem to be the opinion of art historian Jaleh Mansoor, whose forthcoming *Universal Prostitution* is likely to prove useful in explicating many of the larger problems that are only hinted at in what is being argued for here concerning the art historical *case work* of understanding art's 'behavioral problems' that, thanks to the violations of *real abstraction*, are also germane to the question of 'what to do with AI'. That said, in Mansoor's recent review of the exhibition *The Imitation Game: Visual Culture in the Age of Artificial Intelligence* at the Vancouver Art Gallery in Vancouver, British Columbia, she claims that mimicry and consciousness

do not operate in remotely similar ways, and it is hoped that this paper has gone to sufficient lengths to show how and why this is not exactly a correct assessment. Nonetheless, that review does accurately describe a main issue concerning what Mansoor refers to as 'staying with the trouble' of AI which is that of how "[i]t is as though the sheer astonishment of human capacity to generate innovative instruments and tools effectively obviated the next step in thinking about them or about how they are to be deployed after the first flush of curiosity at advanced commodities".[94]

Attempting to think what some of these next steps might be is the unsettled purpose of the ongoing investigation here, even if it seems confined to the trivial agitations of art and its agency. Yet, AI seems to many as a threat to render the possibilities of such agency inoperative, algorithmically opened to transparency, and mass-produced at the same time that the models gain ever-greater degrees of opacity themselves. As Fazi will say elsewhere, "[i]t is important to talk here of incommensurability between the abstractive choices of humans and those of computing machines. 'Incommensurability' is the right word because the two cannot be measured against each other or compared by a common standard".[95] For Fazi, no communication is possible because "no common phenomenological or existential ground exists between human abstractions and those of a computational agent".[96]

Jenna Burrell provides a succinct delimitation of three fundamental vectors of this problem that are formulated in the abstract of her paper "How the Machine 'Thinks': Understanding Opacity in Machine Learning Algorithms", which is cited by Fazi and is also beginning to appear elsewhere in the burgeoning literature on opacity:

> (1) opacity as intentional corporate or institutional self-protection and concealment and, along with it, the possibility for knowing deception; (2) opacity stemming from the current state of affairs where writing (and reading) code is a specialist skill and; (3) an opacity that stems from the mismatch between mathematical optimization in high-dimensionality characteristic of machine learning and the demands of human scale reasoning and styles of semantic interpretation.[97]

Perhaps this is all the most reasonably correct assessment, and we are just structurally, cognitively, and conceptually, *locked out* from really making sense of anything about how the computer 'thinks'. Yet, recalling Bourbaki's sign, we should also be wary about how acknowledging this as fact can also lead to *far-out* thinking.

Historically, the thinkers who informed mid-century techno-pessimism and techno-skeptics (such as Heidegger) are the very same as those who inform the critical purview of many authors today. *The Incommensurabilists* might even be a cute name for them, and since art and philosophy always get trapped by naming, why not? Their *risky business* is to assume, because of the deleterious effects of power and control on the potentialities of existence, that we might just be better off making sure we are on the list for the *raw feels*[98] party of

coming together and being together. In emphasizing the terminal and unintelligible abstraction of these *constructed constructors* (Bertolotti), the risk is moreover one of simply replicating, possibly by accident, that philosophical maneuver wherein thinking becomes incommensurable with *itself* because of the lies and cheats of reason, and we are advised to wander in the contemplative and sundry body foundries of experience instead. Frog brains that can only detect cinematographic changes in the intensity of sources of light.

So, while (2) is being further problematized by automation and (1) can at least be partially defeased at the level of conceptual assumptions by Piper's notion of *pseudorationality* among other resources that require the augmentation of the 'reasoning and styles of semantic interpretation' assumed in (3) that will also include those of artistic practices (especially as concerns an augmentation of how to think what any practice is or could be in the 'AGI epoch'), our current predicaments concerning *access* might nonetheless be considered as not a matter of any current or future lack of computational resources any more than some other form of irresolvable disconnect and incommensurability reflecting our limited cognizing capacities. This is because we should also consider the possibility that no one in charge of bankrolling the game is interested in financing *explanations*. Attempting to get at the most reasonably sufficient explanations wherein we might want to understand, to some marginal degree, what is 'happening to us' might unfortunately also result in some form of what ethologist Konrad Lorenz[99] referred to as *asymptotic aggression*, where an inquiry and task that is at once scientific, ethical, and moral will be unlikely to ever reach its target, and this *pattern of behavior* in inquiry ultimately riddles the AI Alignment problem with a pathological risk. What are some of the appropriate tools, methods, and conceptual resources are that we actually *do* have toward such explanations when dealing with novel complexities from within the systems that have dealt them, and what that might mean for practice, is finally where this investigation will now turn.

Knowing How the Doings Are Done in Know-Time: Heuristics, Practice, and Patterns

> *Ask not what's inside your head, but what your head's inside of.*
>
> —W. M. Mace

Resistance Incorporated

How might art find its proper motivation in order to manage 'staying with the trouble' of AI? In the current trap of a critical paradigm for art, artistic research falls under an imperative of a 'see something say something'

modality, tricking it into becoming investigative reporting about the dominating logics of reason and the economy. Its post-modern condition of formalizing and exhibiting 'knowledge from the inside' has far more to do with Roberts's general social technique than it does with any remainder of 'relational aesthetics' in its leaking and sharing of information about power. Its post-conceptual contemporaneity is without the forms of 'consensus' that would link scientific or artistic practices harmoniously together in the niceties of an explicitly formulated distributed cognition that was only ever the populist fantasy of *good-vibe communication* anyway. There is, nonetheless, the *fact* of a critical paradigm here, and whenever a paradigm in art appears, it will always be as an effect of artistic practices being tailgated by curatorial and critico-theoretic discourse art chasers annoyed that art's own explanations of itself are always *moving too slow* for their invented information economy. The attempt to consolidate its behaviors in consensus about the paradigm is an institutional operation that more often than not results in obfuscating its conditions, and along with that, will obfuscate its adversarial matrix that determines its post-conceptual contemporaneity to begin with. This is also accompanied by a function of stealth that evades transparency in the market (a function arising from the globally lubricated components of a networked formal-material 'critique').

This is very much the sort of effective caricature of art mobilized in the writings of Amanda Beech. To refer to something as a caricature is not necessarily a *bad thing*. Caricatures are known to work well because they successfully compress appearances and can even infer other salient features from behaviors and attitudes, just like a diagram might, or a model. And besides, it would seem that as far as Beech is concerned, artistic research is its own self-caricature, a last-ditch effort of self-reflexivity forcing it to work at *tearing out its own eyes* like 'the big NO' and 'tragic autonomy' of rule-refusal as in *Oedipus the King*.[100] We could add another entertaining example to this in order to say: what art uncovers about its self-inflicted blindness it seems unable to recognize as what has been its secret pleasure all along, where in its path of self-discovery and amidst its drift through the void of a technically unlocked *n*-dimensional semantic *Event Horizon*, it finds a function as decoy Instagram filter for knowledge production inscribed perennially in the *libera temet ex inferis* of every work of art. From here, where "the immanent critique of contemporary art practice interfaces with unknowability in a profound sense,"[101] art's critical suspicion of rationality, of its own relation to knowledge and reason, forces it into self-deception regarding its tasks (it will 'only recognize the unrecognizable' and fools itself into thinking that its novelties carry the profundity of escape from the vantage of any of its given semantically opaque objects). Art is always caught in a game of navigating an entrapment in discourse with its rules and systems of knowledge and everything that defines it, even those works generated from the hushed-mouths of explanation-evading, affect-mesmerized human paint-bots that cannot remember where their ideas came from.

That art is often the picture-perfect example of what failing to escape the habituation of paradigms and ideologies looks like should be non-controversial. In some sense, its capacity to articulate this from within those confines is a part of the power derived from its métier that guides its agency (we cannot really escape the theater of ideological capture anyway, and those who try are the ones who are trapped worst of all).[102] From out of art's Sentimental Education there arose a novel relation to itself in the form of what Beech, following Althusser, dubs as its "spontaneous appearance of critique". That puberty should be read against the critique of emergence that has been offered – i.e., if handled appropriately, we can isolate historically why and how this comes to be the case and have indicated as much; it is the 'untold story' that keeps being re-told, a re-production of knowledge rather than a production in its strict sense. Concerning the appearance of conflicts over creativity, the negative impulse of 'Althusser's lesson' regarding the spontaneous philosophy of scientists remains instructive, because as Beech notes, "To be Duchampian in art is to be Althusserian in philosophy" and this is why "contemporary art as we know it strikes us as being disastrous".[103]

It is disastrous because it over-identifies with a tactical separation according to its own difference from itself and its history while still sutured to them in ambiguous ways, and in such a way that this becomes categorically The Difference of its attitude (to the extent that anything at all could prove intelligible or useful as retrievable conceptual resource from the rebarbative slogs of Laruelle and their quantum *clichés*, this is it).[104] Reflecting back on earlier considerations at the outset, we might want to describe this as art's *terminator niche*. Beech gives the cold open that perfectly re-frames many of the arguments and histories that have been a point of traumatic interpretation here, principally under the guise of what she terms the misapprehension of the generic as genre of difference: "Art today reeks of a lack of imagination. It is burdened by its own histories, its tales of emergence, its attachment to contexts, its sick love affair with location and the personal histories of 'lives.'"[105]

Maybe art's lack of imagination is precisely due to the manner in which it constructs itself in relation to the Kantian productive imagination, which, fetishized for its powers, has been constrained to the diminishing returns of these sorts of recollections and renewals. Recalling the arguments of Roberts, it is only as the result of *skill* that there could be anything so much as artistic agency or 'free will' to begin with because these capacities are not 'anthropological givens', and to take them as such (as emerging from some no-place in the machinery of cognition as a 'gift of nature') might also help to explain "why artists today who talk about their 'inner creativity' distinct from an intellectual programme sound so baleful".[106]

For Beech, philosophy provides a *possible* alternative extinction point to art's accidental construction of its own terminator niche as an 'asymptotic extinguishment' guided by a *post*-Althusserian lesson derived from

Maybe art's lack of imagination is precisely due to the manner in which it constructs itself in relation to the Kantian productive imagination, which, fetishized for its powers, has been constrained to the diminishing returns of these sorts of recollections and renewals.

Laruelle (without there being a need to commit to the bizarre altitudes of the Laruellean). If there is no outside to philosophy's circle, art's disaster on the choppy seas of difference is its only site of construction for possible worlds, since there is no outside of the institution for it and no accepted place where it could be distributed en parallel per se, save, claims Beech, by the potentialities afforded by the 'insufficiencies' of the generic as "a means by which art divests itself from the paradigms of the claustrophobic isms that have regimented its production and reception".[107]

That generic properties carry a promise is old hat for art (the grid, postproduction, deskilling, etc.). The nudist-colony embrace of the generic by art, which is clearly among Beech's points as a leveraged 'determination' qua *in*determination, often disguises a *wrong turn* where there awaits the mysteries of the creative artistic subject that does not yet know how to *take the risk* of a new rule that could renormalize art's critical infinities of givenness in self-reflexive difference, and that decision (as it is *structurally decisional*) results in the forcing of a magical, opaque, or indeterminate relation to creativity. That potential change-of-pace is ignored when what *ought* to take place is the re-mapping of art onto the intelligible protocols of rules and norms for creativity-as-constructibility (or perhaps just simply what Brandom would call 'conceptual behavior' as opposed to mere empirical labeling procedures of aesthetic-democratic agreements). According to this logic, what is missed is how we might also be capable of re-activating an opiated autonomy, perhaps through the engineer's devious dictum of *by any means necessary so long as the results are valuable*[108] that interestingly enough will resonate with Laruelle: the "break from the circle" as an operationalized intelligence *performed from the inside* that "concerns only the usage of means in view of the invention of existence".[109]

Perception is already constructive. Yet why should that even matter, what *difference* should that make, if we no longer have eyes? Assuming we still do, and that they still function (or that there is even anything to see), and that we do not take what they receive merely as given intensities, what then is the art we long to see? Is it possibly lurking in the closed loop of latent space in generative architectures? The first two questions ought to seem fair, but the third will no doubt make some readers shirk back. To the extent that something useful could be retained from Althusser's ulterior motive of interiority, it might have to do with the manner in which his project had always been predicated, pace Spinoza and Lacan, on the affordances of the *ruse*: "[o]ne has to put a good face on the defective content".[110] The new paradigm we are inhabiting will force those not already prepared into the requirements of new forms of complicity with computation encouraging different measures and methodologies of mimicry and deception – all of which are already everywhere anyway, and it truly is a fool's game to imagine one is capable of stepping outside of them.

General social technique since the turn of the millennium has unrelentingly veered toward an ever-widening abyss of delirium with proliferating and nefarious online social ecologies and digital selves that makes Nicolas Bourriaud's

idea of the 'good interaction' that would teach us all about 'learning to live in the world in a better way' seem more stupid than ever. Eric Alliez aptly described that historical moment as one where *Capitalism and Schizophrenia* mutated into a *Schizophrenia and Consensus*, depotentializing art because of its breaks with the lessons of the art of the '60s and '70s, thereby obfuscating its own history in administering its consensus on experience.[111] Claire Bishop, writing her critique of relational aesthetics somewhere in between the successive appearances of Facebook and Twitter, could hardly have anticipated what would come to pass.[112] Generic T2I art meltdown and TikTok reaction videos of people reacting to reaction videos of people reacting to reaction videos of people reacting to things can all be fun to watch, and at times hilarious, but they are also the nightmares only Baudrillard seems to have seen coming and are composed of everything that online culture with its funhouse mirrors seems, by accident, to have constructed into a new kind of *Artificial Hell*.

From Paradigm to Pattern

If I am reading Beech correctly, what is needed is a 'different kind of thinking differently' that would posit a generic model-fiction of continuity or 'invariance' amidst the disturbances on that choppy sea of science and art's 'distributed cognition' that could purport to defend against the adversarial attacks on cognition arising from encounters with the realities of *what there actually is* (difference, the pure multiple, the opacity of the noumenal, the semantic opacity of the work of art …). Whatever the Althusserian or Duchampian paradigm in art is, if it is a paradigm it is for this reason that it would introduce difference, due not only to some Kuhnian *shift* but also – in the Althusserian context – to the variational matrix of the 'epistemological break'. We know that this *differential procedure* has to be the case for science, simply because we understand scientific practice to be the opposite of what for Leibniz was "an ocean, continuous everywhere and without a break or division".[113] But is the same true for art? With respect to the trap of the Kantian problematic that would see the authentically created work of art as an interminable departure from the established rules of art, then yes. Yet perhaps with respect to the genericity of incompleteness, then no, because this is what would enable localizing invariance across transformations. In Rouse's practice theory, there can be *absolute* deviation from rules because, following his reading of Wittgenstein, rules are *not* self-interpreting and there must, therefore, be an account of how we behave by "grasping rules without interpreting them".[114] However, insofar as 'meta-artistic' behaviors or even those encountered in the 'artist's studio' are assembled from the 'basic everyday articulations' of what we do, why be content with allowing for this to, as Wittgenstein put it, 'hit bedrock' in terms of our capacities to provide explanations?

Rather unfortunately, the *paradigm* of art's 'critical paradigm' immediately sets us up for the kill: how could it be the case that what is obtained in the *new* paradigm be anything other than the resolution of a rejection eliminating the

supposed functionality of what came before? Insofar as a paradigm *obtains*, there must, by default, be a method of 'discovery' wherein it would be possible to provide thinking with a procedure that affords cognition a particular *measure* that could deliver toward intelligibility a map-erasure absolving *the difference* we encounter from the 'Kuhn-loss' of 'incommensurability'. This peculiar opacity of the incommensurable is what we have been trying to avoid, or rather navigate toward and then navigate around in a different way, and hopefully with the advantage of not being phenomenologically captured in sublime convulsions by problems of noumenal access, complicated by the 'absolute television' of AI-generated imagery.[115]

If a significant part of the task is, as Beech has expressed, to provide a sort of credit account for art's relation to epistemology, this might therefore be an appropriate place to begin concerning whatever it is that ought to become possible to undermine art's own self-image according to the fictions of what it seems to think that it knows, and moreover, according to its own advantages concerning how it knows how to do what it thinks it knows. This would seem to be the case, since it would be a mistake, and a mistake that has been historically observed by *basically everyone* to adumbrate art's processes to the cognitive advantages of *feeling* and *perception*, as these categories are ultimately resigned to the 'whereof one cannot speak' of it all that is precisely where the Kuhnian purview of difference-effectuating artistic procedures folds into a normative enforcement of keeping artists in the animal preserve of 'working in different worlds'. The remainder here is to attempt to contribute to what might not simply 'look like' but might actually *be a way out* without at all having to appeal to Laruelle's "terminal abstraction masquerading as the termination of abstraction".[116]

The most efficacious aspect of what art and science have mutually at their disposal is in fact embedded in their *techniques* and the "indefinitely extendable recursive power of reflection"[117] that enables us to refine measurements, develop standardized interchangeable components, or construct the perfect trap. This is where something must be ascribed, where *naming* will function as more than just a joke or a fatty approximation ascribed to the unfortunate circumstances of 'just what there is' since, given whatever are assumed to be appropriate methodological constraints that must inculcate the rational autonomy of rules with empirical contingency, we should follow what Nathan Brown, in his own following procedure, effectively captures from nothing more than a name-drop by Althusser regarding Gaston Bachelard, as a *rationalist empiricism*.[118]

According to Bernard Barsotti's reading of Bachelard, it is as though Bachelard formulated the epistemological break from *within* and *as if* discarding the Kantian a priori as so much presupposition-waste capable of being transformed radically through a form of practice that would preserve the transcendental through transformations, because "[t]here is a difference of level and a negativity within the phenomenon; there is no dry, clean break".[119] For Bachelard, "it is within *the most intimate struggles between intuition and construction* that we see the creative force of the doctrine of ensembles in its entirety".[120] As Barsotti will go on to suggest, "[t]he division of reason is

not merely down to the pressure of the phenomenological regionalization of experience, but also to the effort of the 'self-division' of the subject who does not have merely an inevitable 'consciousness of his division' but a 'will to divide in dividing' the subject of epistemological Values".[121]

Such a seemingly indiscriminate 'will to division' then is what results from the *more synthetico* of the constructive procedure that does not dissolve the transcendental so much as reactivate it as the 'sheltering' of the epistemological break's transcendental safehouse (and not here in terms of a *wrong turn* habitat). This is the case because it is the transcendental that is retained (mostly for its practico-theoretical arsenal) for the advances of cognition as its *invariant pattern*. If from within the reciprocal determinations of art and science we can recognize "the break as *'the beginning of a process which has no end'*" that is "characterized both by its *irreversibility* and by its *incompleteness*", this recognition will have to obtain amidst what for Althusser was "a theory *of discontinuity without invariance*".[122] Here, where it is only the *non-normative* subject that appears as invariant (Foucault) among variational mechanisms, we cannot evacuate the attribution of 'non-normative' to those forms of behavior that do not abide directly to the instruction-sets of rules (ideological or otherwise) *per se* as they inhabit the rule's vector of deviation, and we can at least shed 'some cinematographic light' on the dimensions that make of the artistic subject the mystificatory hegemon of its applications.

As Brown will put it concerning a rationalist empiricism, "[w]hat is at issue in such an epistemology is not so much a distribution of faculties within a subject of knowledge as the distribution of methodological coherence across a historical process open to the perpetual reconstitution of what can only seem to be its grounds".[123] If a rationalist empiricism were to function within a *practice*, it should only follow that it can describe what that is, since, as Bachelard had it, "no construction is clear to the mind unless the mind knows how to take it apart."[124] The primary object of construction here is now the mind itself, by methodologically "transposing the *a priori* synthesis from the intuitive plane to the plane of intelligence".[125] This constructive operation is not exactly 'non-Kantian', as it can rather be determined as a 'computational synthesis' of phenomena or what Bitbol et al. designate as the *reverse problem* in Kant's project: "the reverse problem consists in *constructing* the referents of concepts by transforming conceptual contents into algorithms for computing these referents. The reverse problem starts from concepts and points towards the manifold of intuition, not the other way around".[126]

As to the normative arena of rules-as-regularity, invariance, or generic extension within the 'non-normative', this can be explicated as "a pattern of interaction".[127] From the perspectives of Jelle Bruineberg and Erik Rietveld in ecological psychology, whatever qualifies as our "skillful contact with the environment" would have to also do with how "[o]ur learning history and our skills show up in the way the world solicits action".[128] For, as they will continue, without any "account of anticipation and selective consolidation, it remains mysterious how an agent can come to tend toward grip on a situation".[129] For the authors, the problem is "not so much the causal structure

of the environment per se but rather the dynamic nested structure of the relevant affordances in the environment".[130]

We have also reached here a specific problem of human cognitive performance that is also of the very same nature as a problem for the delirious science of machine learning that has gone largely unmentioned, and is something that will also help to explain the successes of land-grab attainment by 4E cognition models as that between tacit and explicit forms of knowledge, or know-how vs. knowing that, as these come to relate more largely to the problems of *learning* in general. The difficulties of 'how to make the machine think', and in ways that would correspond to what we do not yet even know about how we come to think in the ways we do as sapient intelligences, would add gasoline to the fire of disputes in ML that remain so far impossible to extinguish. They are difficulties that would even lead to the bizarre appearance of 'Heideggerian AI' as a research programme by way of Dreyfus, whose ultimate complaints would be that AI is somehow *not Heideggerian enough*. Connectionism does, however, seem to have 'empirically vindicated' the 'bodily dispositions' of practices, at least according to some. Regarding "the everyday reliance on non-linguistic or non-conceptual dispositions" (the 'microcognitive'), Rouse refers to "Dreyfus's distinction between expert skill and the incompetence of explicitly rule-guided action".[131]

The concept of paradigm would reassert itself here as its contours are such that we are, per *incommensurability*, barred from accurately *tracing* its resultant differences/distinctions through any generic invariants since the generalized concept of what a paradigm *even is* will seem only to result in the establishment of a difference to begin with, irrespective of what the paradigm contains. Beech provides the appropriate summation of what the problem is for overcoming the opacity of a 'critical paradigm' for art since we would have to "start from the assertion that there are conventions, structures, causes and rules that inhabit sense-perception because these experiences are named and that this makes up just a part of artistic assemblages".[132] Elsewhere, Beech will elaborate this as another familiar form of art's difficulties: "we know that art has habits, methods, plans, systems, rules, traditions, histories, genres, paradigms, etc., despite its promise of 'the open': In fact it is organized, systematized and ordered in both general and particular ways. The fantasy that art is free has produced the largest and most resistant myth of all, the myth that has blackmailed us".[133]

Daniel Dennett was first to describe what is being aimed at here as Real Patterns, inhabiting some wavering position between an instrumentalism and a realism, in his 1989 *The Intentional Stance*. This notion, borrowing from Sellars as much as from Brandom, was instantly criticized, but deftly elaborated upon toward a naturalized metaphysics by James Ladyman and Don Ross in 2007, extended recently by Tyler Millhouse as "Really Real Patterns" in 2022, and subjected further to other various and numerous critiques and applications. As an operative concept to be used for transitioning away from the paradigm problem, real patterns and pattern emergence can be understood as "a variation on the problem of universals" that are "generalizable to unobserved

cases",[134] and this compression mechanism, qua schematization with respect to Kant's transcendental project, would help to describe how "objectivity no longer means complete detachment of entities and properties with respect to the cognitive apparatus, but coordination of phenomena into several strata of invariants across a variety of subjective and instrumental circumstances."[135]

Is this concept of 'real patterns' amenable to a rationalist empiricist methodological elaboration? This would seem to be the case. Art may not be concerned with the manner of operational constructions toward the descriptive resources of objectivity that are the vector of science and its 'ideal knowledge achievements', but art nonetheless concerns itself similarly with the elaboration of objectively real patterns that are the 'livelihood' of its methodological fictions. Occasionally, they might disclose something about the world, or build on top of it, just never away from or outside of it, as art sometimes likes to deceive itself to be capable of by way of clandestine fooling procedures that seem to be unique to it as a form of thought. Whatever pattern is disclosed or revealed or even unmasked that provides a certain harmonious fit with real-world complex systems behaviors – the "invariants across a variety of subjective and instrumental circumstances" cited earlier – will always only obtain so long as such knowledge is borrowed from elsewhere and not a product of its own internal mechanisms. Wherever art is not concerned with interventions according to a critical paradigm (as in various irreverent formalisms), art's most salient capacity might seem to be that of an ability to unlock some kind of story about the functional configurations of cognition and perception – an explicit variety of what is implicit in the procedures of any attempt to describe the contours of patterns in the 'real world'.

Here, we encounter the divergence in ways of doing between hard rules and soft constraints, two of art's most historically supple methodological apparatuses that explain in part its infatuation with the sciences. Concerning soft constraints, which would be indicative of 'non-normative procedures', these are notoriously on the side of authenticity and creative liberations of content and form, whereas the rules, meticulously abided by, are more familiar to the practices explored by art that Yve-Alain Bois has identified as 'non-compositional' and which make the modeling procedures of cognition their explicit sandbox. The difficulty is one of finding the pattern that emerges between them, as one should between a model of a system and its target, so as to have an effect on what we can do with the brain as 'Darwin's tool box' and the *generative* effects of a 'downstream cognitive system' concerning the theory-ladenness of thinking, as Paul Churchland might have put it. Appeals to secretive and mysterious forms of know-how do not go very far toward isolating those patterns. The ways that AI can complicate artistic practices beyond merely 'ripping people off' are to be found in actually attempting to explain what the tools of know-how are, whether in 'general social technique' or the masterful deployments of skill that contribute to the configurations of *style*. It might then be possible to gain traction on non-trivial patterns of art's model, augmented by theories of intelligence and the engineering of artificial neural networks informed by theoretical computer science. But what tools come with Darwin's tool box?

The ways that AI can complicate artistic practices beyond merely 'ripping people off' are to be found in actually attempting to explain what the tools of know-how are, whether in 'general social technique' or the masterful deployments of skill that contribute to the configurations of *style*.

Get a Grip, or How to Lend a Totipotential Hand

If *good vibes* do not fix the jam of art and AI, neither will any perfunctory meditations on the Sellarsian "how things, in the broadest possible sense of the term, hang together, in the broadest possible sense of the term."[136] Cultural systems are replete with what William Wimsatt terms "causal thickets", a concept he will introduce as attributable to emergent macroscopic entities that cannot properly be analyzed from any single point of view and require the integration of multiple perspectives across different levels of organization.[137] As part of the 'messiness' resulting from rigorous inquiries, 'culture', or even 'intelligence', exemplify "the harder and more complex cases in which multiple entrenchment processes may be operating simultaneously".[138] We might be inclined to treat creativity as such a causal thicket, and one that has also managed to become what he calls a *meme-like thing* (MLT) denoting any number of "artifacts, practices, and ideas that are taught, learned, constructed, or imitated".[139]

What is at issue is how we ultimately should deal with such complexities, and how day-to-day dealings or the formalizations of art should or ought to deal with them using skills that eventually become *encoded* in ways resulting in an amnesia about them or the perilous ineffables of Wittgensteinian bedrock. Heuristics will define such spaces of behavior, and it is a problem of articulating how such 'rules of thumb' generate rationalizations over time, and how such non-normative processes and problem-solving abilities are bounded and not themselves fully rational, given they are ignorance-mitigating rather than truth-preserving. For instance, they often involve ignoring information in favor of other more familiar information fooling-procedures that provide short-term benefits of forgetting. Heuristics work not necessarily for the affordances of such forgetting, but because they "exploit evolved capacities that come for free",[140] and have as a fundamental property the capacities for the restructuring of a problem space.[141]

Concerning the *emergence* of cultural objects or situations such as the social ecologies of art and AI, as we have seen earlier in this chapter, emergence, as a general concept, poses problems for intelligibility because it is where boundaries between levels of organization begin to deteriorate and intelligibility falters, forcing the understanding to become obdurate even to the extent of smuggling in modes of self-deception regarding its nature, or interesting stories about its surprise results. Following Wimsatt, emergence as a concept can be approached through inter-level reduction methods of decomposition among levels of organization or establishing inter-level heuristics, and this *methodology* will introduce a notion of performative interaction Wimsatt will call *scaffolding* that "refers to structure-like dynamical interactions with performing individuals that are means through which other structures or competencies are constructed or acquired by individuals or organizations".[142] Wimsatt will go on to prescriptively

> urge a view that [Herbert] Simon would share: *that levels of organization are a deep, non-arbitrary, and extremely important feature of the ontological architecture of our natural world, and almost certainly of any world that could*

produce, and be inhabited or understood by, intelligent beings. (This gives levels an almost Kantian flavor.) *Levels and other modes of organization cannot be taken for granted, but demand characterization and analysis.*[143]

Wimsatt recognizes there are at least six fundamental criteria for determining the utility of heuristics that "permeate and constitute the vast majority of methods that we have": (1.) they are *without guarantees* to correct solutions, (2.) their demands are *cost-effective*, (3.) they are error-tolerant because they are systematically biased (allowing for *"footprints* providing clues to [their] use in the derivation of a result"), (4.) they *transform the problem* "into a non-equivalent but intuitively related problem", (5.) they are *purpose relative*, and lastly, (6.) they are *descended from other heuristics.*[144] Concerning (6), Wimsatt gives the example of the comparable means and ends of various tongs designed for and by blacksmiths to hold different objects of a specific type.

When forms of rule-governed learned procedures become implicit knowhow, there is an attendant risk to *lock intelligibility away inside the crypt of tacit knowledge* that would be tantamount to an overemphasis on their practical applicability. The recent work of Daniel Sacilotto foregrounds how environmental and situational awareness aid in the maintenance of practices and performance, where following the work of Brandom, he explains how

> the interactive-social nature of linguistic behavior involves not only learning to use concepts by evincing sensitivity to their circumstances and consequences of application, but to be engaged in patterns of justification and assessment on whose basis a representational system revises such concepts and modulates its problem-solving capabilities. More fundamentally, [...] the rich situational awareness already evinced by perceptual simulating systems [...] involves the dynamic coordination of a system to its environment through the construction of working memory models that ape the structure of statistical inference and means-ends reasoning.[145]

Since it is patterns that are under consideration, it needs to be mentioned why this is a key area of research subtending both the engineering and the theory of ML as that of pattern recognition (PR). Although there seems to be some modest disagreement as to whether ML is a sub-genre of PR or whether they emerge independently from computer science and engineering respectively, PR is essentially what machine vision and deep learning systems investigate as a generalized problem of structural analysis and categorization that can be understood (either in biological or synthetic systems) as the extraction of meaningful regularities in noise-dense complex environments. ML systems utilize a series of mapping functions that travel from initial pixel information through increasingly abstract levels of feature extraction isolating things like edges, corners, contours, etc. that are then turned into motifs and integrated at subsequent layers and transformed into more complex processes toward object recognition or the generation of images to match input data.

The contemporary problem, of course, seems to be one of how what emerges from such operations might be either the scare of faked knowledge, or as insidiously banal as a convincing deepfake of Barack Obama contemplating a KAWS exhibition.

PR's applications have been put to use in agriculture, astronomy, bioinformatics, and quite obviously as we have come to know, facial recognition and military affairs. Etymologically, as Theodosios Pavlidis puts forward in his book *Structural Pattern Recognition* from 1977, the definition of pattern is "derived from the same root as the word patron and, in its original use, means something which is set up as a perfect example to be imitated", and therefore "pattern recognition means the identification of the ideal which a given object was made after."[146] Pattern recognition becomes an obvious place for machine learning research to focus given that it is shared across all forms of life with a visual circuitry – and even those that do not (consider the orchid and the wasp) – and at different levels of biological systems (proteins capable of recognizing molecular pathogens). Consider the following from Robert P. W. Duin and Elżbieta Pekalska, who will allow for a reductive determination that pattern recognition can be considered as 'learning from examples':

> Pattern recognition deals with discovering, distinguishing, detecting or characterizing patterns present in the surrounding world. It relies on extraction and representation of information from the observed data, such that after integration with background knowledge, it ultimately leads to a formulation of new knowledge and concepts. The result of learning is that the knowledge already captured in some formal terms is used to describe the present interdependencies such that the relations between patterns are better understood (interpreted) or used for generalization. The latter means that a concept, e.g. of a class of objects, is formalized such that it can be applied to unseen examples of the same domain, inducing new information, e.g. the class label of a new object.[147]

Detection is also key, recalling the 'scan and spot' procedures of the aforementioned artist-criminal. For both synthetic and biological intelligence, pattern recognition concerns a statistical regression that minimizes error. Especially for sapience, we cannot trivialize its significance as merely default innate circuitry or assume that it would be an overextension of its importance to situate it on the terrains between Platonic and Aristotelian battlefields, or indeed, rationalist and empiricist methodologies.[148]

Rouse will also take stock of why this should be given due consideration:

> The normativity that allows us to speak of pattern "recognition" rather than just response arises from the holistic counterfactual stability of conceptual domains and the heteronomic relations to other domains through which there is something at stake in recognition or misrecognition of the relationships within those domains. Conceptually articulative practices establish and maintain expressive repertoires within which meaningful boundaries emerge as part of a larger pattern of practical and perceptual involvement in the world. There is no way to express those boundaries or how they matter except within such repertoires.[149]

At this point there seems little left to do other than to test how this can find application in thinking through some specific problems of generative technologies alongside artistic practices and how those practices can be further articulated by way of the preceding.

Conclusion: St(r)aying with the Trouble of AI

Let us consider an experiment: we begin with the assumption that it is possible to treat the world of images as you would the world of things, with latent space functioning as a high-dimensional warehouse stocked with all known materials and supplies, insofar as they are situated somewhere in the LAION training data and its 5.85 billion CLIP-filtered image-text pairs of 'everything known to man', whether that labeling is correct or not, accurate or biased. Behaving as a sculptor might, we start (or have ChatGPT start for us) with something generic where there is a high probability that there will exist a large subset of these items/objects for which a sufficient resource of labeled images in the training data set obtains. Say, for something mass produced like mannequin parts, where we then decide to have them synthetically integrated with the color green, and request/command the model to subject them to various transformations (such as melting together, oozing, mutating, or propped up, deformed, etc.). We avoid tokens like 'sculpture', 'in the style of', and especially 'art', while settling on 'installation photograph' as the only cheat, since this will inevitably and eventually 'encourage' the model to generate images that resemble photographs of art. Iterate at least one hundred times to see what comes out. In appropriately abstracting the semantic content by concentrating on generic materials and the potentials of manipulative deformations, while avoiding the looting of 'secret sauce' by way of style referent or even the determination of an object such as a 'sculpture', the result returns something that looks like a work of art we have never seen before, even if it looks like works of art might tend to look (a feat it must be admitted is not entirely difficult to pull off with contemporary sculpture). Congratulations! We are now free to shitpost generic images of sculptures to the internet that do not exist except perhaps as propositional works and about which concerning whether they are real or not many an internet native will not immediately be able to tell the difference. For the AI image is a kind of vague Kantian monogram-notion as no other work was performed and no other skill required other than to provide a machine with a description, and we know that what is generated can only be a statistical configuration derived from the training data that has been assembled from the vector space by an algorithm capable of combining irrelevant concepts in reasonable and interesting ways.[150] Clearly, some will respond as well, these cannot count in any 'truly meaningful' sense as human-produced 'works of art', yet this will

be problematized as soon as it is pointed out that this is exactly what was thought initially about photography, which is now a perfectly accepted apparatus guiding artistic practices and the generation of works …

But let us continue the experiment: select one image to feed into Have I Been Trained? as there is a probability, the exact parameters of which are unknown to us, for the LAION-5B data set to return an image that the input very closely resembles, and we hypothesize that it might in fact return an image within that set that with some certainty we can say is the work of an artist who has clearly been aped by the machine. But, something else happens instead: a very large number of actually existing works are returned (the 'originals'), all of which are works we have never seen before (and this even assuming some extensive pre-existing knowledge of works of art on the part of the user) that all bear strikingly similar characteristics and features to each other. Now, this is an entirely different order of magnitude (and it is magnitude, as what results arrive by way of some *measure* internal to the model which, not having a world-model, does not have quality among its range of evaluative procedures – it does not possess judgment, and at least with this model and at the present moment, it is incapable of *reasoning*).

Are the model's generated images *more* generic and *in a good way* than those produced by humans whose inquiries have been returned by search-space using only one of them? That is perhaps unclear, and it remains unclear especially because we can critically evaluate, as Beech has shown, the works of humans as being generic *in a bad way*. If such evaluations are *merely subjective* concerning the persistence of so many creations deemed not worth time and attention because they are shoddily constructed or poorly articulated, and even if we are compelled to admit the poncif of our fashion-bias about such things because '*I would never wear that*', there is still scarce reason for us to revise such critical jabs at art other than to console a creator about how their expressions are meaningful, as are their feelings about sunsets and grass, and that what they make in the world, other than themselves, still matters the way their lives matter to that long but recent history of human consciousness and the stories it keeps making, even if nobody *buys* that because we know that there is bad art in the same way that there is bad design, and even more dangerously, bad engineering.

Because (1) what, really, should prevent us from evaluating actually existing works of art and artistic procedures from this perspective as being statistical configurations like those from the machine and (2) what is to be gained from suggesting otherwise that they are instead 'spontaneous creations' of unwieldy and mysterious neurological processes? (1) returns us to the prescriptive statement of Rehn and De Cock encountered at the outset regarding the dangers of valorizing novelty, originality, and creativity that, as lavishly and regularly deployed concepts *in general* are merely the disservice done to understanding what it means to think and act consequentially in the world when affirmations about their givenness or embodiment in practices become economically and institutionally sanctioned *compulsory behavior*.

The formalized inscription and implementation of heuristics and pattern recognition procedures outlined previously *are* what the model is doing. Of course, this is also what the human brain is doing that makes certain alternative explanations emanating from (2) seem dubious. It is a more elaborate and 'nuanced' version of such processes that include a model of the world the algorithm does not possess, along with an empirical advantage it also does not possess, but as John Haugeland has suggested, the advantage of implementation of mental structures into artificial systems is that they quite explicitly enable us to gain traction on the 'natural order' of what mental states really are.[151] Yet, as we have seen, our mental hardware comes with no warranty and its effectiveness is a no-guarantee arsenal. One of the issues with the human self-model when confronted by the obsidian mirror of AI has to do with the massive "downstream effects" where "the chance of major problems if it is seriously perturbed becomes a source of resistance to change".[152] We are surely witnessing such resistance to change.

The resultant and *potentially* positive effect of AI's black-boxing of artistic skill or style that follows from its algorithmic capture via pattern recognition can, a la Wimsatt, be said to provide us with 'new freedoms', although this remains a fairly techno-utopian projection of freedom from constraint as freedom from the drudgeries of artistic production that should never free us from the *responsibilities* of having to learn (the "never expect a smooth space to save us" of Deleuze and Guattari). One of Margaret Boden's key insights is that ideas about computation can "help us think clearly about our own minds".[153] She will express this rather clearly in an invigoratingly humorous way attached to fundamental physics:

> People who claim that computational ideas are irrelevant to creativity *because brains are not programmed* must face the fact that connectionist computation is not the manipulation of formal symbols by programmed rules. It is a self-organizing process of equilibration, governed by differential equations (which deal with statistical probabilities) and comparable to energy-exchange in physics. It is the Boltzmann equations of thermodynamics, for example, which prove [...] that a network whose units sometimes fire at random is *in principle* guaranteed to learn (eventually) any representation whatever, much as *in principle* (according to thermodynamics) there could be a snowball in Hell.[154]

Anyone who, after tirelessly working over a problem, grasps, finally, through the physico-formal procedures that have successfully constructed the appropriate representations in cognition for *how something is done*, in the manner that coincides with *how to actually do it* (the rule-*guided* procedure) should be able to infer rather intuitively, if not just explicitly at the level of understanding necessary to create *instructions*, what an understanding of Boden's claim here might be. While we cannot attribute a reasoning agency to a disembodied model of synthetic imagination, we should not shy from what ML research enables us to understand about how the brain works, at least according to the melior est conditio possidentis[155] of practical reason, since concerning claims about

artistic production that are not in possession of sufficient information about the brain, such speculative invigorations about creativity and its 'spontaneous arrangements' would be, as Kant would have had it, "the same as to play with thoughts, unless one merely has the opinion that an uncertain path of judgment can perhaps lead to truth", because we should, when faced with certain objections, be free to use, "as it were in an emergency"[156], the same means of adversarial deployment of analogy-schema (object *x*) for our 'good cause'.

As Kant had put it, these are constructive hypotheses that are "therefore allowed in the field of pure reason only as weapons of war," because we should all the same, even if it is some kind of necessary fiction, be able to "send out shoots".[157] Yet, such analogies should be deployed in the AI context without thereby having to dispense with them once the dust of battle has settled. In a kind of Whiteheadean alignment with weaponized abstractions, new forms of artistic performance alongside AI should be configured as cognitively akin to the statements made about the B-21 bomber revealed in 2022: cognition *ought to be* formatted as an open-system architecture designed so as to be amenable to swapping weaponry in and out, with particular attention toward weapons that do not yet even exist, providing sustainability to the model itself, or rather sustainability to practice as such.

This will function as derived from a 'cosmist impulse' shifted perspectivally to reveal what Benedict Singleton has outlined as a "project of insubordination" wherein *cunning reason* extrapolates and models environmental affordances, thereby "commissioning an assault by practical reason on the things that bind us, irrespective of their historical ubiquity".[158] The vault, in this case, is not simply the problematic(s) of intelligence, and the opponent here surpasses that of our accumulated parochial visions of the human and its 'inner creativity'. Following Dennett, there is nothing *miraculous* about glow-in-the-dark tobacco plants with firefly genes in them; it is just that there would be no way for such things to *come about* on their own without a 'helping hand'. And we are at this point still cultivating AI as so many plants and not raising children.

For Herbert Simon, ML should be "concerned with building computer programs that simulate, and thereby serve as theories of, the thought processes of human beings engaged in these same tasks".[159] Simon wanted to operationally explain creativity as a combinatorics formulating novelty through procedures of *generate and test* (or, as per scientific inquiry, *discover and justify*), so that we might finally arrive at a stage of inquiry where a "mental vitalism is no longer defensible" because "[t]o explain a phenomenon is not to demean it. [...] Knowing how we think will not make us less admiring of good thinking. It may even make us better able to teach it".[160]

Even with all the time spent here detailing the artist as a *shady figure*, it is in acknowledging the relevance of some of these explanatory resources for art that we can possibly find a new way for art to be *intellectually honest* about ... *whatever* it is it thinks it is doing. We are lacking in *how-to* videos for the fix as it remains a rather pervasive assumption that the machinery of creativity is proprietary to *nature*, bequeathed to those *special and non-normative subjects*

for which no *Genius Bar* is available. Implementation provides *literal traction* on intelligence and the procedures of the imagination that appeals to non-mechanical creativity do not account for simply because they account for nothing but a lack of awareness overburdened by the trevails of learning that *normatively oblige* art to disguise creativity in the results of its 'effective mastery'. Following from Lorenz Puntel, Sacilotto emphasizes how, due to the mind's situatedness in the totality of being, the world's potential for intelligibility also has to include the human intellect itself as an object of intelligibility – its capacity to transform itself in such a way that intellect is elaborated through the "process of theorization [that] makes the structure of thinking explicit as a self-revising protocol for representing the objective modal structure of the world."[161] Yet, that cannot be obtained without confronting the *dangerous turns* ahead, because as has been learned through conducting this investigation, the terrain is a *perennially* self-healing minefield that will not let any agent through unscathed even if they correctly ape the passwords, and it is riddled with positions over-committed to the presuppositions of their stakes, encouraging some to gatekeep in last-ditch efforts of objectivity that hold the door against impending historical transformations.[162]

Chess and Go and their respective representational and abstract strategizing are all at the end of the day much less interesting than the cognitive mapping enabled through video gameplay in generative environments with interlocutors so amped-up on learning abilities that they are always a *bitch* to defeat concerning time, effort, and requisite upgrades far surpassing rote boss-level enemies in the more predictable constraints of PvC fighting games (that nonetheless remain interesting for the spoils of war obtained from discovering the rules of 'joystick alchemy' peculiar to successive iterations of their models). Such skill-acquisition sidequests of cognitive mapping serve as a conceptual respawn point for engaging with current AI creative tools. It is a new and perhaps surreal version of deontically *changing the score*. Art is notoriously described in its history and according to its *main players* as being a game, and as with any game, one can always simply *start over* from the last L.[163] This is art's own condition that remains the trap it has *set for itself*, and art is nothing if not a connectionist-like endeavor whose behaviors all default toward immanent caricatures of self-model, expressed best through the horror movie trope of *insufficient retribution*: reasons are mechanisms but not the other way around, and the typical methodologies art has at its disposal from its historical hand-me-downs and inherited heuristics used to model its practices will be oriented toward attaining a certain fit to their target system (the institution) that unfolds according to the logic of this trope. At some point during the movie and along a temporal concatenation or 'becoming', which can be asymmetric (or not), the antagonist is injured, and possibly exposed. And yet, the minimal damage inflicted by the protagonist on the antagonist in these racing moments of escape that *could have ended the game* will contribute to the fuels of a narrative where only by an inevitable and ultimate strati-tactic of invigorating the plot with its clumsy semantic matrix does it *fail* to succeed *so long as the story can keep going*.

This is art's own condition that remains the trap it has set for itself, and art is nothing if not a connectionist-like endeavor whose behaviors all default towards immanent caricatures of self-model, expressed best through the horror movie trope of insufficient retribution: reasons are mechanisms but not the other way around, and the typical methodologies art has at its disposal from its historical hand-me-downs, and inherited heuristics used to model its practices will be oriented towards attaining a certain fit to their target system (the institution) that unfolds according to the logic of this trope.

But then, there should be no invocation here of Beckettian ethics of failure in relation to a non-normative *coping* that is art's institutional game, canon-carved, and we might instead want to respond as a Blanchot might: "A story? No. No stories, never again".[164] After all, why contribute anything any longer, when it is clearly a trap and a blackmail? Of course, while the artworld *drop-out* has its own interesting history, *resignation* has never been the end result of that procedure. Yet, consider the metrics that describe just *how much it takes* to play the human as renewable resource of raw material data derived and extracted from cognitive labor and our 'passive' online behavior: according to the well-dressed Wiki-metrics, as of 2019, over 3.05 billion Wi-Fi-enabled devices are shipped globally each year, and "[i]n total, Amazon Web Services (AWS) operates over 125 physical data centers in various global locations, with these facilities comprising over 26 million square feet",[165] alongside the global availability of ChatGPT that "is based in-part on the availability of Microsoft Azure's 60+ cloud regions worldwide, which span more than 35 countries."[166] For the most part we will never even see any of this, unless we really go looking for it, which is how synthetic intelligence moves in the dark and how it is also a *darkness that moves*. Its dynamically engineered crypsis blends quite seamlessly into the background of computational infrastructure's world-embedded architectures while it effortlessly masquerades as something that *could be sentient* but is not, and we now interface with its subterranean abstractions every day.

The shadows also are as much a common show as are the cave walls.

—*J. N. Findlay*

Acknowledgments

This paper owes an extreme form of debt and gratitude to Felipe Meres for the many conversations and sharing of mutually aligned research on AI amidst the swiftly unfolding yet insufficiently mapped terrain made visible (relatively, for us) only in the past year that were had in collaborative spirit. I am grateful for his suggestions regarding potential organizing principles for very early attempts to elaborate on notes shared that would eventually iterate into a working draft. Likewise, to Reza Negarestani for the exchanges defined by the affordances of soft sabotage, especially those we have directed at one another since the release of foundational AI models in July of 2022. A special thanks is owed to Amanda Beech and the Center for Discursive Inquiry at CalArts for ongoing conversations and specifically for having provided an opportunity to present initial research conducted here in December 2022. Thanks to Ellis von Sternberg and Joshua Johnson and to the volume editors Marek Poliks and Roberto Alonso Trillo for their input and

suggestions on an earlier draft. I would also like to thank Samuel Forsythe and Benedict Singleton for ongoing backchannel dialogue that, where it has not directly informed this chapter's content, certainly informs its *tone* and search for favorable means.

Notes

1 Concerning this, it should be obvious that while the focal point here is T2I models, these are already rapidly advancing into the spaces of music, video, and 3D modeling to name only a few applications that will immediately date this investigation in terms of its 'object' in this sense. If this is a peculiar epistemological obstacle here, what is uncovered by turning it over should reveal all of that which cannot for all that become trapped by the fates of outmoded technologies.

2 See Pietro Perconti and Alessio Plebe's "Deep Learning and Cognitive Science".

3 "Deep learning is a philosophical or an epistemological approach in which a form of radical empiricism must be advocated. Therefore, there is nothing in the mind that was not in the senses, and there cannot be anything in the mind that is not learnable." Sandro Skansi and Marko Kardum, "A Prolegomenon on the Philosophical Foundations of Deep Learning".

4 As they will put it: "The assumption has always been that the eye mainly senses light, whose local distribution is transmitted to the brain in a kind of copy by a mosaic of impulses. Suppose we held otherwise, that the nervous apparatus in the eye is itself devoted to detecting certain patterns of light and their changes, corresponding to particular relations in the visible world. If this should be the case, the laws found by using small spots of light on the retina may be true and yet, in a sense, be misleading. Consider, for example, a bright spot appearing in a receptive field. Its actual and sensible properties include not only intensity, but the shape of its edge, its size, curvature, contrast, etc." (1959, 1942).

5 See Jerome Y. Lettvin, Humberto R. Maturana, Warren S. McCulloch, and Walter H. Pitts's "What the Frog's Eye Tells the Frog's Brain", *Proceedings of the IRE, 47*(11): 1940–1951.

6 Klein, "AI Machines Aren't 'Hallucinating'. But Their Makers Are", https://www.theguardian.com/commentisfree/2023/may/08/ai-machines-hallucinating-naomi-klein.

7 Dryhurst, "Infinite Images and the Latent Camera".

8 Bertolotti, "The Crises of Techo-Cognitive Niches", 171.

9 Ibid., 174–176.

10 The concept of entrenchment is unfortunately rather difficult to mitigate in such a way that providing some Tweet-worthy summation here would seem unwarranted without sufficient space for explication, and the reader should therefore consult especially Wimsatt's "Entrenchment as a Theoretical Tool".

11 Eliezer Yudkowsky, "Pausing AI Developments Isn't Enough".

12 Agüera y Arcas and Bratton, "The Model is the Message".

13 D. H. Lawrence, as cited in Gilles Deleuze, *Francis Bacon*, 88.
14 Sawyer, *Explaining Creativity*, 250.
15 "There is another quite different realm of human activity which it is extremely difficult to duplicate by mechanical means. This is activity relating to artistic creation and aesthetic evaluation. While perhaps not impossible for suitably programed computers, it will certainly be centuries rather than decades before machines are writing Shakespearean sonnets or Beethoven symphonies. It is here, rather than in the field of reasoning and logical deduction that man can continue to show a clear superiority" (Shannon, *Claude Elwood Shannon: Collected Papers*, 694).
16 Vern Neufeld Redekop and Thomas Ryba (eds.), *René Girard and Creative Mimesis*, 8–9.
17 Tatarkiewicz, *A History of Six Ideas*, 250–251.
18 Bishop, *Artificial Hells*, 15.
19 A useful concept that is beyond the scope of this investigation to adequately explore that was first introduced by Yuri Lotman in 1984, and first translated in Lotman, "On the Semiosphere". See also John Hartley, Indrek Ibrus, and Maarja Ojamaa's *On the Digital Semiosphere*.
20 Midjourney founder David Holz puts it thus: "Every image costs money. Every image is generated on a $20,000 server, and we have to rent those servers by the minute. I think there's never been a service for consumers where they're using thousands of trillions of operations in the course of 15 minutes without thinking about it. Probably by a factor of 10, I'd say it's more compute than anything your average consumer has touched." https://www.theverge.com/2022/8/2/23287173/ai-image-generation-art-midjourney-multiverse-interview-david-holz.
21 Rehn and De Cock, "Deconstructing Creativity", 229.
22 Ibid, 226. Rehn and De Cock also note that "Exactness in mimicry can also create exquisite ironic effects, such as when Oscar Wilde created a new form of comedy simply by perfectly duplicating English high society mannerisms in print and on the stage" (226).
23 See Chapter 6 of James L. McClelland and David E. Rumelhart's *Explorations in Parallel Distributed Processing*.
24 Martin Gammon, "Exemplary Originality".
25 William Desmond, "Kant and the Terror of Genius". On the "hidden art" of the schematism *as* an art, see, for instance, Samantha Matherne's *Kant and the Art of Schematism*, 181–205.
26 Andrew Benjamin, "In an Unbounded Way".
27 Kant, *Lectures on Anthropology*, 269.
28 Gammon, "Exemplary Originality".
29 Deleuze, "The Idea of Genesis in Kant's Aesthetics".
30 Daston, "Fear and Loathing", 88.
31 For this and a variety of related considerations, see Leah Dickerman, Yve-Alain Bois, Masha Chlenova, Christoph Cox, Hal Foster, Mark Franko, Peter Galison, Philippe-Alain Michaud, and R. H. Quaytman, (2013), "Abstraction, 1910–1925: Eight Statements", October, *143*: 3–51.
32 Rosalind E. Krauss, *The Originality of the Avant-Garde*.
33 Poggioli, *The Theory of the Avant-Garde*, 80. Poggioli is here following Baudelaire's rather provocative notion of genius that is likely indebted to its obsolete understanding as an 'unethical' disposition (this is its seventeenth- and eighteenth-century inheritance as it moves through Descartes and Hume): "The connection

between the avant-garde and fashion is therefore evident: fashion too is a Penelope's web; fashion too passes through the phase of novelty and strangeness, surprise and scandal, before abandoning the new forms when they become cliche, kitsch, and stereotype. Hence the profound truth of Baudelaire's paradox, which gives to genius the task of creating stereotypes. And from that follows, by the principle of contradiction inherent in the obsessive cult of genius in modern culture, that the avant-garde is condemned to conquer, through the influence of fashion, that very popularity it once disdained – and this is the beginning of its end. In fact, this is the inevitable, inexorable destiny of each movement: to rise up against the newly outstripped fashion of an old avant-garde and to die when a new fashion, movement, or avant-garde appears" (82).

34 Schematism is in this way rendered ineffable, and in large part due to Kant's near-wholesale evasion of developing any theory of technics that might explain it – a foreclosure that runs through the entirety of the transcendental project. A theory of technics in Kant can nonetheless be derived, and as Franziska Aigner has recently explored, even shown to be explicit as the project's elaboration that is ipso facto a *technics of cognition*. Aigner's position is, I believe, the correct one, and the opposite of the common interpretation to which I have previously subscribed. See Aigner's PhD dissertation, "Kant and Technics".

35 It will have to be reserved for elsewhere to engage with the important contributions provided by James Tuckwell on this topic. See Jason Tuckwell, *Creation and the Function of Art: Techné, Poiesis and the Problem of Aesthetics*. Bloomsbury Publishing, 2019.

36 Keith Tilford, "Diagramming Horizons between Art, Techné, and the Artifactual Elaboration of Mind", Glass Bead Research Platform, https://www.glass-bead.org/research-platform/diagramming-horizons-art-techne-artifactual-elaboration-mind/?lang=enview.

37 Adorno, *Aesthetic Theory*, 213–218.

38 Ibid., 214.

39 Ibid.

40 In the abbreviated taxonomy offered by Krauss, those guises of the avant-garde artist were those of "revolutionary, dandy, anarchist, aesthete, technologist, mystic" (157).

41 On why chance, that much-to-do-about concept deployed consistently in artistic modernism, is still a rule-abiding intervention of artistic procedures and not the freedom it thinks itself to be, see the contributions to *The Medium of Contingency*, edited by Robin Mackay, and especially Reza Negarestani's "Contingency and Complicity", 11–16.

42 See Paul W. Bruno, *Kant's Concept of Genius*.

43 Thierry de Duve, *Kant after Duchamp*, 167.

44 Châtelet, *Figuring Space*, 9.

45 Roberts, *The Intangibilities of Form*, 3 (original emphasis). It is probably also worth noting that Roberts does not approve of de Duve's assessment of Duchamp's "non-Kantianism", which he sees as "milksop-negation" rendering art politically ineffective and divorced from emancipatory projects.

46 "[T]he post-Cartesian artist is not the name for a particular *kind* of artist or even a particular kind of artistic virtue, but rather, a convenient shorthand for a number of different social and cultural tendencies which have gathered force since the first two decades of the twentieth century" (Roberts, *The Intangibilities of Form*, 102; original emphasis).

47 "The readymade may have stripped art of its artisanal content, but this does not mean that art is now a practice without the hands of the artist and without craft. On the contrary, art's emancipatory possibilities lie in how the hand is put to work within, and by, general social technique (and therefore in relation to the techniques of copying and reproducibility), and not through the subordination of the hand to such techniques" (Roberts, *The Intangibilities of Form*, 4).

48 Ibid., 16.

49 Ibid., 17.

50 Medosch, *New Tendencies*, 236.

51 See Osbourne's *Anywhere or Not at All*.

52 Medosch, *New Tendencies*, 243.

53 Ibid.

54 Michel Bitbol, Pierre Kerszberg, and Jean Petitot (eds.), *Constituting Objectivity*, 8.

55 Friedrich Wilhelm Joseph von Schelling, *Ideas for a Philosophy of Nature*, 130.

56 As Iain Hamilton Grant observes, concerning the development of 'vital materialism' in this wake, "The eradication of a causal explanation of organized matter and the consequent rejection of materialism prepare the ground for a wholesale replacement of all concepts of causality with that of free activity, which now alone explains organization" (*Philosophies of Nature after Schelling*, 100).

57 Badiou, "On a Finally Objectless Subject".

58 Roberts, *The Intangibilities of Form*, 104 (original emphasis).

59 Rylan Schaeffer, Brando Miranda, and Sanmi Koyejo, "Are Emergent Abilities of Large Language Models a Mirage?"

60 "[I]t can only be the nature of the content which is responsible for movement in scientific knowledge, for it is the content's own reflection that first posits and generates what that content is" (Hegel, *The Science of Logic*, 9–10).

61 Sawyer, *Social Emergence*.

62 The term 'generative' itself is used as early as 1965 with the first show in Stuttgart exhibiting the work of Georg Nees entitled *Generative Computergraphik* (see Margaret A. Boden and Ernest A. Edmonds, "What is Generative Art?" *Digital Creativity*, 20[1–2]: 21–46).

63 Stöckler, "A Short History of Emergence and Reductionism", 76.

64 Ibid., 81.

65 Kim, "Emergence", 547–548.

66 Adorno, *Aesthetic Theory*, 213–217.

67 Sawyer, *Explaining Creativity*, 27 (original emphasis).

68 Ion Georgiou, "The Idea of Emergent Property".

69 See for instance Bradley R. Postle, "Working Memory as an Emergent Property of the Mind and Brain", *Neuroscience*, 139(1): 23–38 and Ellen Wohl et al., "Connectivity as an Emergent Property of Geomorphic Systems", *Earth Surface Processes and Landforms*, 44(1): 4–26.

70 See especially Andy Clark, "Whatever Next?" and Karl Friston, James Kilner, and Lee Harrison, "A Free Energy Principle for the Brain". For a detailed account of what this has to do with the Kantian schematism, see Link R. Swanson, "The Predictive Processing Paradigm Has Roots in Kant".

71 Perconti and Plebe, "Deep Learning and Cognitive Science", 2.

72 Ibid.

73 This is a trap that this investigation will not even pretend to be capable of addressing at this point.

74 See http://www.numericana.com/answer/symbol.htm#db.

75 Fazi, *Contingent Computation*, 163. Although there was not sufficient room to devote to it in this paper, Fazi's engagement with Whitehead with/against Deleuze is worth reckoning with. On emergence, she has this to say: "emergentism suggests focusing instead on playing along with the simple local instructions and thereby seeing, a posteriori, how complex strategies of conduct might stream out of a situation where no appearance of organised behaviour was initially to be found. It is precisely in the context of the possibility of studying such variation that the computational appears to be the ideal habitat for form-finding experimentations" (159).

76 Forbes, *Dazzled and Deceived*, 255. It is part of his closing statement: "Camouflage and mimicry belong to the great empire of signs, non-verbal means of communication. As long as there are living things on the earth, they will be finding new ways to hide, to feign threat, to startle, and simply to copy that rather snazzy pattern someone else has fabricated."

77 Natale, *Deceitful Media*, 7.

78 Ibid., 47.

79 Ibid., 71.

80 Forsythe, "Adversarial Abduction", 1472.

81 Ibid., 1477.

82 See for instance Roy R. Behrens, "Camouflage, Cubism, and Creativity: The Dissolution of Boundaries", *Journal of Creative Behavior*, 11(2): 91–97.

83 Forsythe, "Adversarial Abduction", 1482–1483.

84 Trivers, *The Folly of Fools*, 6.

85 In this context, some consideration of "effective altruism" and its calculative inanities about future humanity would merit an investigation regarding its meretriciousness.

86 As Trivers will put it, "[an] entire counterintuitive arrangement exists for the benefit of manipulating others. We hide reality from our conscious minds the better to hide it from onlookers. We may or may not store a copy of that information in self, but we certainly act to exclude it from others" (8).

87 Piper, "Pseudorationality",173.

88 Ibid., 181.

89 Ibid., 200. For a more engaged reading of Piper in relation to Kant, see Elizabeth Kauffman's PhD dissertation, "Adrian Piper and Immanuel Kant". How pseudorationality relates to Piper's notion of "meta-art" as rule-guided rational behavior in service of the "semantic opacity" of works of art is here left out but would be deserving of further consideration.

90 Rouse, "Practice Theory", 641. There is an implication here about "language games" and especially as described by Sellars as the main pivot point that will have to be reserved for elsewhere.

91 Margaret Morrison, *Reconstructing Reality*.

92 Sellars, "Philosophy and the Scientific Image of Man".

93 Lorraine Gamman and Maziar Raein, "Reviewing the Art of Crime", 155.

94 Mansoor, "The Medium Is the Data Set", 147.

95 Fazi, "Beyond Human", 66.

96 Ibid.

97 Burrell, "How the Machine 'Thinks'".

98 This is a shameless use of a term taken from Sellars in Paul E. Meehl and Wilfrid Sellars, "The Concept of Emergence".

99 Lorenz, *On Aggression*, first published in 1963.

100 Beech, "Concept without Difference", 63.

101 Beech, "Art's Intolerable Knowledge", 55.

102 See Étienne Balibar, "Althusser's Dramaturgy and the Critique of Ideology".

103 Beech, "Concept without Difference", 294.

104 To be fair, there *is* something of value in how Laruelle will isolate modelization as a philosophical principle, yet, to continue to be unfair, consider how a remark made by Châtelet in his *Figuring Space* might be applicable to Laruelle's project: "Cliche poses no challenge to the arrogance of the functional, but sets out to disallow any thought that is at all conceptual. Witness, the puerile display evoked by such concepts as the big bang (which never stops starting), chaos (which neutralizes everything), catastrophe (which no longer frightens many people), the fractal (fascinating above all to minds of a simpler understanding), chance (of which it is well known that God has a horror), etc." (9).

105 Beech, "Concept without Difference", 289.

106 Roberts, *The Intangibilities of Form*, 114–115.

107 Beech, "Concept without Difference", 291.

108 Yann LeCun, "The Epistemology of Deep Learning", uploaded by Institute for Advanced Study 22 February 2019, https://www.youtube.com/watch?v=gG5NCkMerHU&ab_channel=InstituteforAdvancedStudy.

109 Laruelle, *Anti-Badiou*, 24. This was important to an earlier essay of mine that engaged with Beech's writing in the context of Laruelle and scientific models: Tilford, (2017), "Generalized Transformations and Technologies of Investigation", in *Superpositions: Laruelle and the Humanities*: 139–150.

110 Louis Althusser, *The Spectre of Hegel*, 149. The translator also makes this useful note: "The title of this section, La bonne contenance, is an untranslatable pun. Bonne means 'good'. Contenance means 'contents' in the sense of 'capacity', 'volume', but also 'countenance' in the sense of demeanour; whence faire bonne contenance, 'to put up a good front'" (140).

111 Alliez, "Capitalism and Schizophrenia and Consensus".

112 Bishop, "Antagonism and Relational Aesthetics".

113 As cited by Gerd Gigerenzer, "Why Heuristics Work", 73.

114 Rouse, "Practice Theory", 642.

115 See Jon Wagner, "Absolute Television".

116 Ray Brassier, "Laruelle and the Reality of Abstraction", 118.

117 Daniel Dennett, "Darwin's 'Strange Inversion of Reasoning'", 10065.

118 Brown, *Rationalist Empiricism*.

119 Barsotti, "The 'Non-Kantianism' of Bachelard", 98.

120 Bachelard, 1950, as cited in Barsotti, 96 (original emphasis).

121 Ibid., 98.

122 Balibar, "From Bachelard to Althusser", 220–223 (original emphasis).

123 Brown, *Rationalist Empiricism*, 10.

124 Bachelard, 1984, as cited in Brown, 18.

125 Bachelard, 1972, as cited in Barsotti, 94 (original emphasis).

126 Bitbol et al., *Constituting Objectivity*, 3 (original emphasis).

127 Rouse, "Practice Theory", 669.

128 Bruineberg and Rietveld, "What's inside Your Head", 199–200.

129 Ibid., 208.
130 Ibid., 213.
131 Rouse, "Practice Theory", 660.
132 Beech, "Art's Intolerable Knowledge", 58.
133 Beech, "The Nature of Constraint, Art, Habit and Rule", 7.
134 Jimmy Aames, "Real Pattern Emergence".
135 Bitbol et al., *Constituting Objectivity*, 19.
136 Sellars, "Philosophy and the Scientific Image of Man".
137 Wimsatt, "The Ontology of Complex Systems".
138 Wimsatt, "Entrenchment and Scaffolding", 77.
139 Ibid., 78.
140 Gigerenzer, "Why Heuristics Work", 27.
141 See Marc H. J. Romanycia and Francis Jeffry Pelletier, "What Is a Heuristic?"
142 Wimsatt, "Entrenchment and Scaffolding", 81.
143 Wimsatt, "The Ontology of Complex Systems", (original emphasis).
144 Wimsatt, "Reductionism and Its Heuristics".
145 Sacilotto, *Structure and Thought*.
146 Pavlidis, *Structural Pattern Recognition*.
147 Duin and Pekalska, "The Science of Pattern Recognition", 239.
148 Consider how William Bechtel and Adele Abrahamsen characterized it in their 1991 *Connectionism and the Mind*: "How can we envisage going from recognition of individual patterns to a full accounting of mental life? One possibility is that the stable state representing one pattern could itself act as an input to the system which would initiate further pattern recognition. That is, the output units that have been activated in recognizing a pattern would themselves send activations and inhibitions to yet other units, possibly units in different networks. The idea is that higher-level cognitive performance might consist in a sequence of pattern recognition activities, so that what look to be steps of reasoning might consist ultimately in sequences of patterns that elicit one another" (105).
149 Rouse, *Articulating the World*, 362.
150 See Hyung-Kwon Ko et al., "Large-Scale Text-to-Image Generation Models".
151 Haugeland, *Mind Design II*.
152 Wimsatt, "Entrenchment and Scaffolding", 92.
153 Boden, *The Creative Mind*, 148.
154 Ibid., 137 (original emphasis).
155 "The condition of the possessor is the better", in Kant, KrV, A 777/B 805 (or 662 in the 1998 Cambridge edition).
156 KrV, A 774/B 802–A 777/B 805; Cambridge, 661–662.
157 KrV, A 778/B 806; Cambridge, 663.
158 Singleton, "Maximum Jailbreak".
159 Simon, "Explaining the Ineffable", 28.
160 Ibid, 23–29.
161 Sacilotto, *Structure and Thought* (forthcoming).
162 The self-healing minefield is a favored example of Hinton's for reasoning about his escape to Canada from the funding affairs of the US military in relation to machine learning and appears at the bottom of his University of Toronto homepage as "a new concept of healing from the people who design unimprovised explosive devices." See https://www.cs.toronto.edu/~hinton/minefield.pdf.

There is admittedly a great deal of work left out that forms a razor blade horizon of future research not for the faint-hearted, but a good place to respawn on the Kampfplatz of these historical debates is Jerry A. Fodor and Zenon W. Pylyshyn, "Connectionism and Cognitive Architecture". One of the significant responses that arose is that from David J. Chalmers, "Connectionism and Compositionality".

163 Meaning 'take the L' as in 'take the loss' when one loses in a game, or life. If we ought to see art as a game, then we might also want to think about who (or what) designs the most unfortunate of difficult levels. Consider how certain levels might be difficult for everyone, while *certain* levels may be more difficult for the initiate and seemingly impossible for everyone else. As with some games, it might be advisable to reflect on how a particular level or even an entire game might be designed according to how a Bennett Foddy might deem their difficulty appropriate, in the sense that they will not hold punches, and are made "for a certain kind of person. To hurt them." See Velocci et al. "The 100 Hardest Video-Game Levels of All Time."

164 Maurice Blanchot, *The Station Hill Blanchot Reader*, 199.

165 See https://dgtlinfra.com/amazon-web-services-aws-data-center-locations.

166 See https://dgtlinfra.com/chatgpt-openai-azure-cloud/.

References

Aames, J. (2021). "Real Pattern Emergence: A Study of Patternhood, Generality, and Emergent Behavior from a Peircean Perspective". PhD dissertation, Osaka University. https://doi.org/10.18910/81983.

Adorno, T. W. (1997). *Aesthetic Theory*. London: A and C Black.

Agüera y Arcas, B., and Bratton, B. (2022). "The Model is the Message". *Noema*. 12 July 2022. https://www.noemamag.com/the-model-is-the-message/.

Aigner, F. (2020). "Kant and Technics: From the Critique of Pure Reason to the Opus Postumum". PhD dissertation, Kingston University.

Alliez, E. (2010). "Capitalism and Schizophrenia and Consensus: Of Relational Aesthetics". In *Deleuze and Contemporary Art*, edited by Stephen Zepke and Simon O'Sullivan. 85–99. Edinburgh: Edinburgh University Press.

Althusser, L. (1997). *The Specter of Hegel*, translated by G. M. Goshgarian and edited by Francois Matheron. London: Verso.

Badiou, A. (1988). "On a Finally Objectless Subject". *Topoi*, 7(2): 93–98.

Balibar, É. (1978). "From Bachelard to Althusser: The Concept of 'Epistemological Break'". *Economy and Society*, 7(3): 207–237.

Balibar, É. (2015). "Althusser's Dramaturgy and the Critique of Ideology". *differences*, 26(3): 1–22. https://doi.org/10.1215/10407391-3340324.

Barsotti, B., Reggio, D., and Rêgo, E. (2005). "The 'Non-Kantianism' of Bachelard: Towards the Transcendental Sense of the Epistemological Break". *Angelaki*, 10(2): 89–102.

Bechtel, W., and Abrahamsen, A. (1991). *Connectionism and the Mind: An Introduction to Parallel Processing in Networks*. Hoboken, NJ: Wiley-Blackwell.

Beech, A. (2007). "Don't Fight it: The Embodiment of Critique". *Journal of Visual Art Practice*, 6(1): 61–71. https://doi.org/10.1386/jvap.6.1.61_1.

Beech, A. (2013). "The Nature of Constraint, Art, Habit and Rule". *Paper Presented at the Conference Generative Constraints*. London, UK, 16 November 2013. https://amandabeech.com/writing/the-nature-of-constraint-art-habit-and-rule/.

Beech, A. (2015). "Concept without Difference: The Promise of the Generic". In *Realism Materialism Art*, edited by Christoph Cox, Jenny Jaskey, and Suhail Malik. Berlin: Sternberg Press.

Beech, A. (2021). "Art's Intolerable Knowledge". In *The Postresearch Condition*, edited by Henk Slager. Utrecht: Metropolis M Books.

Benjamin, A. (2019). "'In an Unbounded Way': After Kant on Genius". *Research in Phenomenology*, *49*(1): 9–30. https://doi.org/10.1163/15691640-12341408.

Bertolotti, T. (2015). "The Crises of Techo-Cognitive Niches: From Maladaptive to Terminator Niches". In *Patterns of Rationality: Recurring Inferences in Science, Social Cognition and Religious Thinking* (Vol. 19). 171–187. Berlin: Springer Verlag.

Bishop, C. (2004). "Antagonism and Relational Aesthetics". *October*, *110*: 51–79.

Bishop, C. (2012). *Artificial Hells: Participatory Art and the Politics of Spectatorship*. London: Verso.

Bitbol, M., Kerszberg, P., and Petitot, J. (eds.). (2009). *Constituting Objectivity: Transcendental Perspectives on Modern Physics*. New York: Springer Science and Business Media.

Blanchot, M. (1999). *The Station Hill Blanchot Reader: Fiction and Literary Essays*, translated by Lydia Davis, Paul Auster, and Robert Lamberton and edited by George Quasha. Barrytown, NY: Station Hill/Barrytown.

Boden, M. A. (2004). *The Creative Mind: Myths and Mechanisms*. London and New York: Psychology Press.

Brassier, R. (2012). "Laruelle and the Reality of Abstraction". In *Laruelle and Non-philosophy*, edited by John Mullarkey and Anthony Paul Smith. 100–121. Edinburgh: Edinburgh University Press.

Brown, N. (2021). *Rationalist Empiricism: A Theory of Speculative Critique*. New York: Fordham University Press.

Bruineberg, J., and Rietveld, E. (2019). "What's inside Your Head Once You've Figured Out What Your Head's inside Of". *Ecological Psychology*, *31*(3): 198–217. https://doi.org/10.1080/10407413.2019.1615204.

Bruno, P. W. (2010). *Kant's Concept of Genius: Its Origin and Function in the Third Critique*. London: Continuum.

Burrell, J. (2016). "How the Machine 'Thinks': Understanding Opacity in Machine Learning Algorithms". *Big Data and Society*, *3*(1). https://doi.org/10.1177/2053951715622512.

Chalmers, D. J. (1993). "Connectionism and Compositionality: Why Fodor and Pylyshyn were Wrong". *Philosophical Psychology*, *6*(3): 305–319. https://doi.org/10.1080/09515089308573094.

Châtelet, G. (2000). *Figuring Space: Philosophy, Mathematics and Physics*, translated by Robert Shore and Muriel Zagha. Dordrecht: Springer Science and Business Media.

Clark, A. (2013). "Whatever Next? Predictive Brains, Situated Agents, and the Future of Cognitive Science". *Behavioral and Brain Sciences*, *36*(3): 181–204. https://doi.org/10.1017/S0140525X12000477.

Daston, L. (1998). "Fear and Loathing of the Imagination in Science". *Daedalus*, *127*(1): 73–95.

de Duve, T. (1998). *Kant after Duchamp*. Cambridge, MA: MIT Press.

Deleuze, G. (2000). "The Idea of Genesis in Kant's Aesthetics". *Angelaki*, 5(3): 57–70. https://doi.org/10.1080/09697250020034751.

Deleuze, G. (2003). *Francis Bacon: The Logic of Sensation*, translated by Daniel W. Smith. London: Continuum.

Dennett, D. (2009). "Darwin's 'Strange Inversion of Reasoning'". *Proceedings of the National Academy of Sciences*, 106(Supplement 1): 10061–10065. https://doi.org/10.1073/pnas.0904433106.

Desmond, W. (1998). "Kant and the Terror of Genius: Between Enlightenment and Romanticism". In *Kants Ästhetik / Kant's Aesthetics / L'esthétique de Kant*, edited by Herman Parret. 594–614. Berlin and Boston: De Gruyter.

Dryhurst, M. (2023). "Infinite Images and the Latent Camera". *Medium*. 31 May 2023. https://matdryhurst.medium.com/infinite-images-and-the-latent-camera-ae2fd1e8fd67.

Duin, R. P. W., and Pekalska, E. (2007). "The Science of Pattern Recognition: Achievements and Perspectives". In *Challenges for Computational Intelligence*, edited by Włodzisław Duch and Jacek Mańdziuk. 221–259. Berlin: Springer Verlag.

Fazi, M. B. (2018). *Contingent Computation: Abstraction, Experience, and Indeterminacy in Computational Aesthetics*. London and New York: Rowman and Littlefield.

Fazi, M. B. (2021). "Beyond Human: Deep Learning, Explainability and Representation". *Theory, Culture and Society*, 38(7–8): 55–77. https://doi.org/10.1177/0263276420966386.

Findlay, J. N. (1981). *Kant and the Transcendental Object: A Hermeneutic Study*. Oxford: Oxford University Press.

Fodor, J. A., and Pylyshyn, Z. W. (1988). "Connectionism and Cognitive Architecture: A Critical Analysis". *Cognition*, 28(1–2): 3–71. https://doi.org/10.1016/0010-0277(88)90031-5.

Forbes, P. (2011). *Dazzled and Deceived: Mimicry and Camouflage*. New Haven, CT: Yale University Press.

Forsythe, S. (2023). "Adversarial Abduction: The Logic of Detection and Deception". In *Handbook of Abductive Cognition*, edited by Lorenzo Magnani. 339–363. Cham: Springer International Publishing.

Friston, K., Kilner, J., and Harrison, L. (2006). "A Free Energy Principle for the Brain". *Journal of Physiology-Paris*, 100(1–3): 70–87.

Gamman, L., and Raein, M. (2010). "Reviewing the Art of Crime: What, If Anything, Do Criminals and Artists/Designers Have in Common?" In *The Dark Side of Creativity*, edited by David H. Cropley, Arthur J. Cropley, James C. Kaufman, and Mark A. Runco. 155–176. Cambridge: Cambridge University Press.

Gammon, M. (1997). "'Exemplary Originality': Kant on Genius and Imitation". *Journal of the History of Philosophy*, 35(4): 563–592.

Georgiou, I. (2003). "The Idea of Emergent Property". *Journal of the Operational Research Society*, 54(3): 239–247. https://doi.org/10.1057/palgrave.jors.2601520.

Gigerenzer, G. (2008). "Why Heuristics Work". *Perspectives on Psychological Science*, 3(1): 20–29. https://doi.org/10.1111/j.1745-6916.2008.00058.x.

Goldstein, J. (2000). "Emergence: A Construct Amid a Thicket of Conceptual Snares". *Emergence*, 2(1): 5–22.

Grant, I. H. (2008). *Philosophies of Nature after Schelling*. London: Continuum.

Hartley, J., Ibrus, I., and Ojamaa, M. (2020). *On the Digital Semiosphere: Culture, Media and Science for the Anthropocene*. New York: Bloomsbury Academic.

Haugeland, J. (ed.). (1997). *Mind Design II: Philosophy, Psychology, and Artificial Intelligence*. Cambridge: MIT Press.

Heaven, W. D. (2023). "Geoffrey Hinton Tells us why He's now Scared of the Tech He Helped Build". *MIT Technology Review*. 2 May 2023. https://www.technologyreview.com/2023/05/02/1072528/geoffrey-hinton-google-why-scared-ai/.

Hegel, G. W. F. (2010). *Georg Wilhelm Friedrich Hegel: The Science of Logic*, edited and translated by George Di Giovanni. Cambridge: Cambridge University Press.

Imbert, P. (2013). "The Girardian Mimetic Theory and its Reading in a Positive Cultural and Economic Liberal Context". In *René Girard and Creative Mimesis*, edited by Vern Neufeld Redekop and Thomas Ryba. New York: Lexington Books.

Kant, I. (1998). *Critique of Pure Reason*, edited and translated by Paul Guyer and Allen W. Wood. Cambridge: Cambridge University Press.

Kant, I. (2012). *Lectures on Anthropology*, edited and translated by Robert B. Louden, Allen W. Wood, Robert R. Clewis, and G. Felicitas Munzel. Cambridge: Cambridge University Press.

Kauffman, E. (2009). "Adrian Piper and Immanuel Kant: Toward a Synthesis of Art and Philosophy". PhD dissertation, University of Cincinnati.

Kim, J. (2006). "Emergence: Core Ideas and Issues". *Synthese*, 151: 547–559. https://doi.org/10.1007/s11229-006-9025-0.

Ko, H.-K., Park, G., Jeon, H., Jo, J., Kim, J., and Seo, J. (2023). "Large-Scale Text-to-Image Generation Models for Visual Artists' Creative Works". In *Proceedings of the Twenty-Eighth International Conference on Intelligent User Interfaces*, 919–933. Sydney, Australia, 27–31 March 2023.

Krauss, R. E. (1986). *The Originality of the Avant-Garde and Other Modernist Myths*. Cambridge, MA: MIT Press.

Ladyman, J., Ross, D., Spurrett, D., and Collier, J. (2007). *Every Thing Must Go: Metaphysics Naturalized*. Oxford: Oxford University Press.

Laruelle, F. (2013). *Anti-Badiou: The Introduction of Maoism into Philosophy*, translated by Robin Mackay. New York: Bloomsbury Academic.

Lorenz, K. (2021). *On Aggression*. Second edition. London: Routledge.

Lotman, Y. M. "On the Semiosphere". Σημειωτκή: Signs Systems Studies, 33(1): 205–229.

Mace, W. M. (1977). "James J. Gibson's Strategy for Perceiving: Ask Not What's inside Your Head, but What Your Head is inside Of". In *Perceiving, Acting, and Knowing: Toward an Ecological Psychology*, edited by Robert Shaw and John Bransford. Mahwah, NJ: Erlbaum.

Mackay, R. (ed.). (2011). *The Medium of Contingency*. Falmouth, UK: Urbanomic.

Mansoor, J. (2023). "The Medium is the Data Set: Art and AI". *Media-N*, 19(1): 146–152.

Matherne, S. (2014). "Kant and the Art of Schematism". *Kantian Review*, 19(2): 181–205.

McClelland, J. L., and Rumelhart, D. E. (1989). *Explorations in Parallel Distributed Processing: A Handbook of Models, Programs, and Exercises*. Cambridge, MA: MIT Press.

Medosch, A. (2022). *New Tendencies: Art at the Threshold of the Information Revolution (1961-1978)*. Cambridge, MA: MIT Press.

Meehl, P. E., and Sellars W. (1956). "The Concept of Emergence". *Minnesota Studies in the Philosophy of Science*, 1: 239-252.

Millhouse, T. (2022). "Really Real Patterns". *Australasian Journal of Philosophy*, 100(4): 664–678. https://doi.org/10.1080/00048402.2021.1941153.

Morrison, M. (2015). *Reconstructing Reality: Models, Mathematics, and Simulations.* Oxford: Oxford University Press.

Natale, S. (2021). *Deceitful Media: Artificial Intelligence and Social Life after the Turing Test.* Oxford: Oxford University Press.

Neufeld Redekop, V., and Ryba, T. (eds.). (2013). *René Girard and Creative Mimesis.* New York: Lexington Books.

Osborne, P. (2013). *Anywhere or Not at All: Philosophy of Contemporary Art.* London: Verso.

Pavlidis, T. (1977). *Structural Pattern Recognition.* Berlin: Springer Verlag.

Perconti, P., and Plebe, A. (2020). "Deep Learning and Cognitive Science". *Cognition,* 203: 104365. https://doi.org/10.1016/j.cognition.2020.104365.

Piper, A. M. S. (1988). "Pseudorationality". In *Perspectives on Self-Deception,* edited by Brian P. McLaughlin and Amélie O. Rorty. 297–323. Berkeley: University of California Press.

Poggioli, R. (1968). *The Theory of the Avant-Garde.* Cambridge, MA: Harvard University Press.

Rehn, A., and De Cock, C. (2008). "Deconstructing Creativity". In *The Routledge Companion to Creativity,* edited by Tudor Rickards, Mark A. Runco, and Susan Moger. 222–231. London: Routledge.

Roberts, J. (2007). *The Intangibilities of Form: Skill and Deskilling in Art after the Readymade.* London: Verso.

Romanycia, M. H. J., and Pelletier, F. J. (1985). "What is a Heuristic?" *Computational Intelligence,* 1(1): 47–58. https://doi.org/10.1111/j.1467-8640.1985.tb00058.x.

Rouse, J. (2007). "Practice Theory". In *Philosophy of Anthropology and Sociology,* edited by Stephen P. Turner and Mark W. Risjord. 639–681. Amsterdam: North-Holland.

Rouse, J. (2019). *Articulating the World: Conceptual Understanding and the Scientific Image.* Chicago, IL: University of Chicago Press.

Sacilotto, D. (2024). *Structure and Thought: Toward a Materialist Theory of Representational Cognition.* Evanston, IL: Northwestern University Press.

Sawyer, R. K. (2005). *Social Emergence: Societies as Complex Systems.* Cambridge: Cambridge University Press.

Sawyer, R. K. (2011). *Explaining Creativity: The Science of Human Innovation.* Oxford: Oxford University Press.

Schaeffer, R., Miranda, B., and Koyejo, S. (2023). "Are Emergent Abilities of Large Language Models a Mirage?" *ArXiv preprint arXiv:2304.15004.*

Sellars, W. (1962). "Philosophy and the Scientific Image of Man". In *Frontiers of Science and Philosophy,* edited by Robert Colodny. 35–78. Pittsburgh, PA: University of Pittsburgh Press.

Shannon, C. E. (1993). *Claude Elwood Shannon: Collected Papers,* edited by N. J. A. Sloan and Aaron D. Wyner. Piscataway, NJ: Wiley-IEEE Press.

Simon, H. A. (1995). "Explaining the Ineffable: AI on the Topics of Intuition, Insight and Inspiration". In *Proceedings of the Fourteenth International Joint Conference on Artificial Intelligence,* 939–949. Montreal, Canada, 20–25 August 1995.

Singleton, B. (2013). "Maximum Jailbreak". *e-flux* (46). https://e-flux.com/journal/maximum-jailbreak.

Skansi, S., and Kardum, M. (2021). "A Prolegomenon on the Philosophical Foundations of Deep Learning as Theory of (Artificial) Intelligence". *Disputatio Philosophica: International Journal on Philosophy and Religion,* 23(1): 89–99.

Stöckler, M. (1991). "A Short History of Emergence and Reductionism". In *The Problem of Reductionism in Science: Colloquium of the Swiss Society of Logic and Philosophy of Science, Zürich*, edited by Evandro Agazzi. 71–90. Dordrecht: Springer Netherlands, May 18–19, 1990.

Swanson, L. R. (2016). "The Predictive Processing Paradigm Has Roots in Kant". *Frontiers in Systems Neuroscience*, 10. https://doi.org/10.3389/fnsys.2016.00079.

Tatarkiewicz, W. (2012). *A History of Six Ideas: An Essay in Aesthetics*. Dordrecht: Springer Science and Business Media.

Trivers, R. (2011). *The Folly of Fools: The Logic of Deceit and Self-Deception in Human Life*. New York: Basic Books.

Velocci, C., Jenkins, C., Heller, E. P., Vilas-Boas, E., Gordon, L., Winkie, L., Rogeau, M., Fulton, W., Grebey, J., LeBoeuf, S., Swearingen, J., and Feldman, B. (2023). "The 100 Hardest Video-Game Levels of All Time". *Vulture*. 22 May 2023. https://www.vulture.com/article/hardest-video-game-levels.html.

von Schelling, F. W. J. (1988). *Ideas for a Philosophy of Nature*. Cambridge: Cambridge University Press.

Wagner, J. (1992). "Absolute Television". *Quarterly Review of Film and Video*, 14(1–2): 93–102.

Wimsatt, W. C. (1994). "The Ontology of Complex Systems: Levels of Organization, Perspectives, and Causal Thickets". *Canadian Journal of Philosophy Supplementary*, 20: 207–274.

Wimsatt, W. C. (2006). "Reductionism and its Heuristics: Making Methodological Reductionism Honest". *Synthese*, 151(3): 445–475.

Wimsatt, W. C. (2014). "Entrenchment and Scaffolding: An Architecture for a Theory of Cultural Change". In *Developing Scaffolds in Evolution, Culture, and Cognition*, edited by Linnda R. Caporael, James R. Griesemer, and William C. Wimsatt. 77–106. Cambridge, MA: MIT Press.

Wimsatt, W. C. (2014). "Entrenchment as a Theoretical Tool in Evolutionary Developmental Biology". In *Conceptual Change in Biology: Scientific and Philosophical Perspectives on Evolution and Development*, edited by Alan C. Love. 365–402. Dordrecht: Springer Netherlands.

Yudkowsky, E. (2023). "Pausing AI Developments Isn't Enough. We Need to Shut it All Down". *Time Magazine*. 29 March 2023. https://time.com/6266923/ai-eliezer-yudkowsky-open-letter-not-enough/.

6

Galatea Reloaded: Imagination Inside-Out Imagine[1]

Reza Negarestani

This text is a belated exercise on the discourse about imagination as the motor of human creativity. Obviously, such a grandiose claim is something we should intellectually upset for two reasons. If creativity were an explicated labor, which it is not (see Keith Tilford's chapter in this volume on the misuse and abuse of the concept of creativity), and imagination its happy-go-lucky wingman, then we would have been in the best scenario of pure denial where the art world goes naturally with AI schemes just like saffron goes with rice, regardless of the quality of this happy encounter. However, neither creativity nor imagination is a concept worth having beyond the entrepreneurial delusions in art and AI if we cannot reflect upon them beyond mere psychological and spontaneous attitudes.

To properly address the premises and consequences of this problem, the map of this essay consists of these steps: (1) contextualizing remarks on why the attribution of creative abilities to AI or depriving AI of such abilities are two faces of the same coin; (2) honing in on the concept of practice or performance through a critique of the aforementioned positions which are, at this point, in cahoots; (3) finding a way out of these popular scenarios by charting a way in through the early twentieth century's critical dialogues and assessments in philosophy and science; (4) introducing a minimal phenomenological description of the so-called imaginative AI models (as a case study) that reveals much more about imaginative acts than all mere psychological and spontaneous reflections alone. This last step can be taken as an exemplification of why imagination is in its essence a modeling and technically exteriorized faculty.

Some Contextualizing Remarks I: Pander or Panic as the Obverse and Reverse Faces of the Human Grift

The vehement forms of defiance or reluctance to accept the overarching ramifications of AI models, from text-to-image to large language models (LLMs),

DOI: 10.1201/9781003312338-9

generally stem from a cycle of inflation and deflation, over- and under-drama-tization. But such cycles are not exclusive to AI development and discourse. From cryptocurrencies and blockchains to neuroscientific achievements and claims or promises made in the name of those accomplishments, we go through such cycles only to become more cautious of expectations and promises made within the ambit of narrow methodological considerations in not only bridging theories and praxes but also in conceiving and devis-ing certain theories and praxes in the first place. Going through such cycles, we then tend to overlook the more compelling and consequential aspects of these developments which are often buried and discarded under a heap of accumulating dogmas never challenged but reinforced by the pander-or-panic cycles.

The popular AI discourse is now sandwiched between the great vaga-ries of our time. On the one side, there are tendencies to regard ratio-nal inter-subjective capacities and sapience – for which we as extant humans are only a natural historical *makeshift model* – as completed prod-ucts of an unsavory history of exploitation, or irrelevant in the face of the great outdoors of ontologically idolized contingency, unpredictability, and randomness. On the other side, there is an insistence that the ques-tion of rational agency and the theoretical and practical abilities, which stem not only from the constitution of rational agency but also its ability to constitute complex synthetic abilities is of no importance. This posi-tion often originates from hard materialist-naturalist stances not only in the philosophy of mind, but more significantly – today, in AI's discourse – from highly specific (if not uncritical) readings of empiricist and phe-nomenalistic doctrines going back to Ernst Mach's economy of thought. A human-level AI, accordingly, can be realized by entirely bottom-up processes that have no use for the concept of rational agency as an account of agency operating under inter-subjective configurations and bound to constraints of objectivity in theory and praxis. Thus, such a human-level AI, freed from the purportedly hackneyed concerns surrounding the constitution of rational agency – in the sense of both its constitutedness and its capacity to consti-tute and revise its powers, attitudes, and goals – would then be tantamount to a thoroughgoing superintelligence whose advent is not only possible but inevitable.

Yet the ejection or weakening of rational agency does not always lead to myths of superintelligence and singularity, for it can equally lead to theatri-cal critiques of AI as being a mere by-product of the sort of practices that have constituted agency and are now subsumed under or at least comman-deered by the capitalist system of exchange and production. Thus, AI can be said to be the pinnacle of rational agency's own blind spots with regard to its own practices and genetic constitution. Except that unlike the rational agency being kept on a short leash by its own rational and abstract illusions, AI can now run amok because it no longer needs the inflated sense of rational agency which is now deemed to be a pre-industrial break upon a supersonic

phenomenon. Now, AI can be said to be just an efficacious bundle of so-called blind practices that has dropped any pretense to rationality or agency, and thus, notions of accountability and responsibility. For this reason, then, AI can be understood as a true manifestation of late capitalism's power of real subsumption or the assimilation of practices economically, socially, and historically toward its own goals and modes of production. And if reason or rationality is in some way practically constituted and practices are the unconscious of reason, then reason (i.e., theoretical and practical reasons) is at best a form of mindlessness to its unconscious genetic constitution à la social practices, or at worst the enforcer of a different shrouded agent called the Unconscious.

For many proponents of 'materialism without matter',[2] social practices are precisely this: the unconscious of the rational agency which is best understood through Freud's allegory of two chambers, one pitch-black and the other ill-lit with a shadowy figure at the corner (the lonely figure of agency), and a daemonic gatekeeper between the two chambers. One might be tempted to consider the fully dark chamber – the unknown – as the unconscious, but according to Freud, it is the gate-keeping daemon, who controls the transit and the shift of attention from one chamber to another, which is the true figure of the unconscious. In a sense, Freud's account of the unconscious is not neutral. It is a force – a proto-agentic oceanic tide – that actively works against conscious rational agency by deceptively employing the sophisticated tongue and resources of conscious agency.

Yet this is Wittgenstein's main objection to Freud's idea of the unconscious – now, being understood in terms of social practices which are the unconscious of the abstract armamentarium of the rational agency, including logic, which can be called the original labor of the inhuman. What is really the unconscious if not the unconscious as an active ur-agent in Freud's terms? The unconscious, in Freud's terms, is not the unknown or that of which we are not conscious. It is not an adjective, but a full-blown operational noun. The unconscious is akin to a Thing-like cosmological parasite adept at mimicking its host down to its nitty-gritty details. Then ultimately what appears as the conscious agency is merely the unconscious in the state of its eternal dissimulation, deceptive imitation, and hypercamouflage. But as Wittgenstein, and later Jacques Bouveresse, David Archard, and Frank Cioffi have pointed out, this account of the unconscious seeks the undermining of the conscious rational agency only to present itself as a strong form of agency which at once has all pretensions to rationality, normativity, and the parlance of agency, and actively if not with extreme prejudice seeks to forfeit and terminate any account of agency from the get-go. After Archard's analysis in *Consciousness and the Unconscious*, Bouveresse calls this an example of the most unhinged form of the homunculus fallacy.[3] The idea that a little human being – a tiny agent condensing all traits of the rational agency – is being smuggled to a milieu where the agency is supposed to be absent.

For this reason, then, AI can be understood as a true manifestation of late capitalism's power of real subsumption or the assimilation of practices economically, socially, and historically toward its own goals and modes of production.

In this sense, Freud's account of the unconscious is an account of some backstabbing agency working against the rational agency and its resources, powers, and capacities. So, at the end of the day, the Freudian unconscious is precisely a melodrama of the rational agency reinvented on vague tongues and opaque decisions where the individuation of the agency – not even a full-fledged rational agency – has not even occurred. This is the cornerstone of the homunculus fallacy of the worst degree.

Once we point out this fallacy against the doctrine of social practices and performances as the unconscious milieu of the rational agency actively undermining the latter, the extremist forms of discourse on the primacy of practice over theory and rational agency are exposed within a renewed – that is, a less reputable – image. The extreme forms of practicism operating to the detriment of rational thought and agency are only strategic means of inserting a diminutive sapience in an account of materialism with or without matter to get rid of the rational agency preemptively. The discourse of extreme practicism is thus not of a critical foresight but a means of squalid warfare against sapience by all dirty means possible. In excising the question of rational agency as an unconscious if not a truly maligned outgrowth of capitalism's means of hijacking social relations, one twistedly ends up valorizing capitalism as a transcendent form of agency. But what is this misguided operation if not both a vulgarization of the full-fledged theoretico-practical critique of capitalism, and a form of deficient critical analysis? At the one side of the aisle, this sketchy critical analysis appears as the enforcing muscle of the reinvigorated left's critique, and at the other side is, by all accounts, what has always been the thesis of the right-inclined AI discourse, from LessWrong forums' cascading threads to the Musk-Thiel-Zuckerberg libertarian-conservativism-liberal null politics connection mob. If the critique is real, one has to realize and calculate the consequences of one's so-called steps and actions so as not to land on the extreme reactionary opposite while preaching to the contrary by thinning or thickening the resources of theory and mind beyond all recognition.

Some Contextualizing Remarks II: AI as the New Doctrine of Unconscious Practices and Performances

The account of social practices as in excess of thought and the rational agency often comes with a pre-installed account of minimal agency, which is precisely its blind spot, because such an account is not prone to conceptual, practical, and axiological revisions, unlike what the rational agency truly is capable of in spirit. Therefore, the proponents of unconscious constitutive practices can claim that practices have the characteristics of both the unconscious and the hijacked consciousness of the rational agency. This tactic does

not work because if one attributes agency to some blind processes and opera-
tions, then as mentioned earlier, one peddles the informal homunculus fal-
lacy, which means we have already surreptitiously inserted an undefined
and undetermined account of agency into an ontological ocean against the
rational agency on which we are modeling prevalent processes and practices.

If practices and performances precede and succeed the agency, then it
makes no sense for us to talk about practices as the unconscious of the ratio-
nal agency because any practice needs to be determined and divided in a
context and a field of meaning. Absent that, we are truly advancing the goals
of late capitalism in art, philosophy, and AI research, which is the abnega-
tion of our responsibilities and culpabilities on this planet by giving them
to something inexorable and something – a better world free of our deluded
sapient concerns and labor – that comes after us, i.e., predestination and
immature escapism.

The result of these dirty wars against rational agency are as prevalent in
the contemporary art world today as in the contemporary politics of the so-
called axis of resistance and the pop AI discourse. After jettisoning the ratio-
nal agency in favor of unconscious practices and performances, we are now
in the business of trafficking in nebulizing functions where the distinction
between practice and technique fades away, and with that, we land upon
extreme scenarios of what should be called a double-alienation of the agency.
At one extreme pole, we talk about practices and performances but not tech-
niques, even though we implicitly and secretly gorge on them (a great major-
ity of contemporary art). At the other extreme, we turn the focus to practices
as flattened techniques, and thus we knock down distinctions among tech-
niques – mental and non-mental, abstract and corporeal – in the name of
a sickly, enlarged metaphysical field or design space called nature where
both mental abstractions and social practices are side effects of technics of
nature which are given not merely ontologically but also epistemologically in
advance of the agency and concepts (the dogmatist discourse on AI).

An example of the former position would be the universal caricature of a
Brooklyn artist – who might be from Berlin for all we know – going to his
impeccable exhibition in Manhattan, which is displaying his studio-out-
sourced artworks plus the pricey catalogue made in China, while rehears-
ing some critical passages from Alfred Sohn-Rethel and maybe even Lenin
on the bliss of social practices and the evils of capitalist techniques on
the Q train. A potential representative of the latter position then would
be a white male in his early 50s, almost balding, wearing a top hat and a
necktie with a one-dollar-bill Benjamin Franklin face on it. He frequents
Curtis Yarvin's poetry sessions and manages to impress the audience of
the future Bitcoin and Urbit cults in addition to some West Coast fans of
Arthur Rimbaud by giving a galvanized monologue about Hobbes's idea
of natural mechanisms as computers, and how Daniel Dennett's *Darwin's
Dangerous Idea* is the bible of the inevitability of the strong AI because the
techniques of nature totally rule.

Between these two seemingly irreconcilable opposites, then, one can find a whole host of beautiful souls. Those who open the first paragraph of their magnum opuses on AI and creativity with short-noticed references to François Laruelle's non-standard philosophy and quantum physics among a medley of argots about information complexity and uncertainty. And those who go right for singularity rhetoric because time is money not to be wasted. This pre-decided battle among opposites will be ultimately won by all players in it because both factions are collaborators in disguise.

For these reasons, the contemporary art and AI discourse miraculously happens to contribute to the same blind idiot god without even knowing that they share a whole host of common intellectually and critically comatose premises and consequences. This commonality is what can be called *evacuation in thought and mystification in practice,* a termination of a fine line between thinking and agency on one side, and the glorification of a non-thinking agency reaping cosmological rewards by whatever means akin to 'just do it' pamphlets written by Hans Ulrich Obrist on the other. Brute pragmatism or GTFO is now being normalized as the central discourse by both artists and AI entrepreneurs.

In the vein of those who deem that practice precedes rational agency and thus agency is always a belated thought on those practices which have constituted it or motivated it to act or operate, it is justified to say that rational agency as we know it today is an artifact of the practices – social and historical – that constituted it. What it is not justified to say is that just because the rational agency is made of practices (sans practical reasoning) and those practices have played a role in the constitution of rational agency, then rational agency is an afterthought at best in the name of social practices and at worst an obstructed or blind way of seeing what reason or agency is. No, both rational agency and practice come in degrees. One cannot use rational agency against genetic practices or vice versa. If it was the case that some practices were preceding rational agency – understood in terms of the labor of explicating rational agency, or reason – then obviously we hit this insurmountable problem where we ought to explain and define what the form and content of practice preceding rational agency would be.

If there was a solution to this pseudo-problem, it would be as simple as this: just as rational agency comes in degrees, so do practices. It would be naïve to compare a full-fledged rational agency with practices that have gone into its constitution because that would be not a philosophical problem but rather a historical gerrymandering aimed at coordinating proper levels of agency and practice. So just as the agency and the practices that go into its constitution come in both quantitative and qualitative gradations, then the task is not to subsume rational agency under pre-agential practices or impose rational agency on constitutive practices, but rather to highlight the proper coordinations between the levels of agency (from pre-reflective to fully rational) and practices at various levels. Absent this, practice is merely a bogeyman against determinate operations in theory and praxis, and thus an arbitrary lip service to what we call a duplicitous critique of AI and sapience

in today's climate where the sapient agency can be extinguished by both materialist-naturalist factors and by the primacy of genetic practices which leave no room at the end of the day for any concept of agency. It is duplicitous because even though it attempts to use the vocabularies of the critique, it is, as mentioned earlier, a bridge between the premises and consequences of the posthuman criticism of the sapience and fanatic AI discourse. At extremes, it is a crazy glue between animism and Nick Landianism.

This is why the denial of rational agency either in kind or in degree should not be understood as a liberation for the idea of AI or an emancipatory politics, but rather as a form of a belated extortion on what AI can be and what a rational agency can be with no regard to what they can ultimately become in the future either by a labor of responsibility or by a sheer brute force action having no qualms about the ethics of moving from point A to point B.

For this reason, the complete dismissal of sapience, transcendental conditions, and appeals to reason as necessary (even though, not sufficient) conditions for performing the task of a concrete socio-historical labor verge on the most extreme varieties of AI fanaticism. Talks, animated by ghosts of teleology, of a self-organizing swarm of bees, vibrant matters, rocks and fungi at the expense of sapience and in favor of critical sensitivities to something other than humans coincide with talks of market as thinking agency, self-clicking and self-emancipating AI boxes, and various scenarios of AI takeover either under the disguise of the Cyberdyne corporation or an ex-Google engineer telling us doom stories from his convenient air-conditioned office in Mountain View, California.

What is unconsciously available to both these positions are the premises and consequences of a vast network and levels of confounded descriptions ascribed to human activities. The problem is not that all such descriptions cannot be explained, in principle, by a systematic recourse to naturalistic terms and organizing levels of mechanisms (mechanistic explanation) that account for the sentient part of sapience. It is rather that the descriptions of phenomena or activities for which explanations are sought are nebulous in both form (the boundaries of a described phenomenon) and content (indeterminate descriptions).

Breaking Down the Claims of Pop AI Discourse as the Extension of Humanity's Historical Illusions about Its Own Abilities

Having now jettisoned the human as a revisable figure and a concretely renegotiable concept, we can no longer guarantee to not move from the posthumanist critique of the human to a register of a strong AI that can substantialize all the fears of the worst conceptions of the human after

the systematic destruction-by-dilution of rational agency, transcendental conditions, and the systematicity of theoretical and practical concerns. Because if we thoroughly erode the figure of the human à la sapience or reason, then our AI discourse resembles the worst conceits of the human's self-understanding. In one register, human culpabilities are handed over to AI. In the other register, which is murkier, AI models are approached through a negative reflex whereby their growing significance in providing a less-inflated portrait of our ostensibly spontaneous cognitive and practical abilities is rebuffed through ready-made arguments about originality, creativity, and imagination.

If the question of the human, understood both in terms of a rudimentary model of intelligence, which is revisable and a systematic inquiry into the consequences of rational agency, is off the table, then why adopt an unduly negative or positive attitude towards AI models based on a set of concepts which cannot be coherently employed in the absence of the human in the above sense? Why attribute to sentients features are not merely sentient but of after-the-fact models of sapience reformatting its own sentience (to use Pete Wolfendale's term[4]), such as thinking and higher levels of phenomenological consciousness, or worse, creative concepts that we ourselves have only vague impressions of?

Here, the genuine problem does not originate from the simple fact that we overextend analogies to what we actually do through the use of clunky concepts such as thinking, performing, imagining, feeling, creativity, and so on. In a justified manner, we can use such concepts to say something about or underline some important features of our own behaviors and, by extension, any form of sentient behavior which by *a measured analogy* has similarities to our own doings and which can be simulated through models. But a measured or determinate analogy as in contrast to an indeterminate and arbitrary or overextended one is purely an operation that requires a medium of inter-subjectivity, *functionally understood*, for it to be objective and thus prone to refinement (the revision, repair, and, if necessary, discarding of beliefs, claims, commitments, and entitlements about us).

Ludwig Boltzmann in his discussion around a hypothetical intelligent machine that can never be distinguished on ontological grounds from sapient consciousness (but only from epistemological and phenomenological grounds) makes a pertinent remark on this issue.[5] Boltzmann argues that no two mere sentient sensory systems – regardless of the extent of their structural affinities, e.g., two systems having fully identical structural properties – would be able to relate their inner episodes and states to one another. A sentient system X can never, in a sufficient manner *if at all*, relate (both in the sense of associating with and mapping onto) what it is going through and is privately aware of to another sentient system Y's episodes, states, and rudimentary awareness of them.

Anticipating the late Wittgenstein and, by extension, Quine's radical untranslatability thesis (specifically, the inscrutability of reference),[6]

Boltzmann's argument seeks to establish the objective point of view as a linguistic, i.e., conceptually inter-subjective/objectifying point of view. That for any relation or correspondence between X's private reports, perspectives, episodes, and states and Y's private reports, perspectives, episodes, and states, the only way an objective point of view can be effectuated with respect to the references in question (for X's and Y's) is by way of observable behaviors entangled with overtly linguistic behaviors. Absent a structuring framework functionally equivalent to syntactic, semantic, and pragmatic aspects of language (not just natural language), not only an objective viewpoint as the criterion of intelligibility but also any sense of analogy – determinate or loose – is forestalled. As mentioned earlier, then, the AI discourse without rational agency resembles an agency who in vain attempts to do everything a rational agency illusorily thinks it is entitled to.

If the functional mediation of language is essential for the institution of an objective point of view, the fact of X and Y being capable of objective consolidation and relay of their affairs to one another cannot be taken as an instance of a sentience vs. sentience, or sentience vs. sapience scenario. It can only be considered either as a sapience equipped with an objective viewpoint through language projecting its traits onto another sentient, or as two instances of sapience finding a set of common deeds or doings (pragmas) in how to use their respective languages to address one another's observable behaviors in the pragmatic sense.

But if idiosyncrasies of analogy are not the true source of the problem of pander-or-panic cycles – overenthusiasm or hostility or any bipolar attitude toward what AI can or cannot do, particularly from the perspective of concepts such as complex cognitions (theory and praxis), creativity, and so on – then what is the problem? We might be inclined to not answer this question out of consideration for the numberless factors responsible for such bipolar attitudes. But that will not help, because even then we simply valorize our failure at breaking down a complex problem as a register of its insurmountable complexity, therefore mistaking the sheer idleness of our making sense of what we are doing for what an AI might be doing. We end up giving AI's ability at doing what it does an unquestioned pass and justification which we never give to ourselves even as a matter of courtesy.

To this end, what the rest of this essay attempts to accomplish is looking at text-to-image models (e.g., Midjourney and DALL.E 2) not from the perspective of their intricate technical architecture, but rather through an unlikely investigative lens: the project of descriptive analysis advanced by Edmund Husserl, and not the extended legacy of phenomenology as formulated by figures such as Maurice Merleau-Ponty, or more recently by Jean Petitot in the vein of naturalizing phenomenology.

The reason for this apparent change of course is the main problem concerning thinking about AI models through concepts such as creativity or imagination: we tend to either lavishly furnish artificial intelligence with

such concepts without any restraints, or from the start, cynically doubt or entirely deprive it from the prospects of operating under such concepts. This bipolar attitude to AI can be traced back to a widely ignored and, accordingly, viciously persistent philosophical-scientific problem. This is a problem that vexed Husserl to such an extent that it led him to pen *The Crisis of European Sciences and Transcendental Phenomenology*, and invigorated Boltzmann to develop a statistical-phenomenological method of examining supposedly settled observations and descriptions of extremely ordinary phenomena.

For Husserl's more mature account of phenomenology as a descriptive analysis of all appearances, the impressions of common phenomena pertaining to perception, imagination, and understanding could be fundamentally misleading. The descriptive analysis which was supposed to provide a systematic description of an ordinary or a cherished appearance, and an account of correct levels of descriptions, was a decisive critique of the advent of a new conduct of science. According to this new conduct, science's power to explain precedes a phenomenon, not only in an ontological order but also in the orders of epistemology and phenomenology. Therefore, an account of science fattened on mere explanations will ultimately beget a fundamental confusion in the order of appearances which were supposed to be explained and scientifically sorted out. In a sense, Husserl's criticism of the new scientific paradigm finds its true final abode in contemporary AI discourse today. Various imaginative acts can be explained through highly technical architectures and processes, but so long as we have not yet come up with proper descriptions of such imaginative feats, then the explanatory vector at the same time reinforces the commonsense dogmas about imagination and creates an aura wherein imagination is just this x or y blind operationalized process. Husserl's main achievement in this regard is to highlight that the description of the phenomenon to be explained precedes explanation *in epistemological and phenomenological orders*.

Perhaps, it is Boltzmann who sharpened Husserl's critique of scientific explanation by putting forward a new scientific method that can be called the statistical analysis as a method of doubt (quantitative fragmentation or consolidation of a perception, depletion or augmentation of the sense of objectivity). According to this method, every time we look at an established perception or observation of a phenomenon, we must adopt a skeptical route not as a disabling way-out (skepticism as a conclusion) but as an enabling way-in (skepticism as a method of examining premises). By being systematically skeptical of a phenomenon whose entrenched description is taken for granted, we perform two tasks at once: we open new avenues of explanations for phenomena which were once bunched together under vague terms and habitual viewpoints, and we challenge the unexamined dogmas of descriptions of phenomena yet to be explained from within and equally from without of sciences.

For all these reasons, this chapter will move towards an account of descriptive modeling, highlighting the task of description when it comes to notions such as creativity and imagination. In the next step, we are going to address the earlier contextualizing remarks through a phenomenological descriptive analysis by way of which the notion of imagination goes through the process of epoché as an objectifying doubt, a suspension and bracketing. The goal of this analysis is to highlight the claim that while what AI text-to-image models do at this point might not be called imagination in accordance with hazy descriptions of imagination (lacking descriptive analysis), they are still of imagination. Once we refine the description of imagination, text-to-image models come forward as miniature bracketed accounts – toy models – of imagination.[7] In this sense, they can foreground in small but consequential ways the characteristics that we have always been attributing to imagination but without adequately – i.e., transcendentally and phenomenologically – reflecting on its nature. These are the characteristics that are pillars of acts of the imagination which we now insist AI models lack.

Lastly, what follows through this phenomenological analysis can also be seen as an effort to underline the fact that the resources of imagination have always been exteriorized by and through technique. Except, with the advent of the algorithmic-computational age, the nature of this technical exteriorization is now more palpable, imposing, and, to some extent, more perplexing to those who have always reflected on imaginative acts through the lens of psychology and spontaneous experiences. For lack of a better word, these more conspicuous effects of technical exteriorization of imagination can be called the *Galatea* impact of the new AI models.

In Greek mythology, the master sculptor Pygmalion dared to sculpt a statue of ivory representing his underlying emotions, motivations, and thoughts about beauty, which he named Galatea. Either as a product of narcissism or the ultimate inevitability of technical exteriorization of imagination, Galatea came to life once Pygmalion truly began to confess his love for the statue. The statue, after all, was a profile of Pygmalion's own unexamined nature turned into a model by way of sophisticated technics. When Galatea came to life, it was the reanimated unconscious life of Pygmalion coming to the foreground. The model transformed into an unconscious representation of that of which Pygmalion was already implicitly conscious. This is the conception of Brentano-Husserl's idea of the unconscious, which unlike Freud's account coincides with a concrete encounter with a foreign object encapsulating what the conscious life has always been and will be. Text-to-image AI models will be investigated precisely in terms of an encounter with what we have been doing, but now, when seen as portrayed by the other side, come off as premature – in the sapient sense of maturation – attitudes. We either bask in the glory of AI in the name of our narcissism, or we vacuously dismiss it as a threatening other. A third way out of this should be mapped.

We either bask in the glory of AI in the name of our narcissism, or we vacuously dismiss it as a threatening other. A third way out of this should be mapped.

The Way-In: The Great Problem of Description, or Why Creativity and Imagination Cannot Be Simply Glorified or Explained Away in the Human's Accounts

Within the philosophy of scientific modeling, particularly when it pertains to modeling ordinary and/or manifest phenomena, events, or activities, there exists an indelible imbalance between the explanatory and the descriptive. The import of the describing activity or the descriptive is often relegated – as in the case of descriptive models in sciences – to information ontologies, mereological and other relationships between the components of the phenomenon to be described; that is to say, it is given to a systematization in favor of the sufficiency of the formal structure in conducting systematization, but at the expense of systematic determination of the criteria necessary to determine what it takes to describe something or what the describing activity really consists of.

What is usually taken for granted as descriptive modeling often involves merely formalizing the various relationships and mappings pertaining to a target phenomenon which ought to be *explained* as the highest priority. But often the task of formal description is being handled as a premature task of explanation (by happy coincidence): an account of description accustomed to premature explanation, trying too hard to sell the formal relations obtained among the components of a formal structure as relations which can be easily and, at times, arbitrarily projected onto *real* phenomena. If we could explain phenomena by formal systematic relations obtained among descriptions formulated in formal terms and with no reference to phenomenological considerations, then our problems would have been solved from the beginning. Why? Because we would have found a master key from a mere system of formal descriptions to unlock basic explanations, bypassing what it actually means to describe an imaginative act or a real image. But this is not the case, not just because formal relations cannot be mapped onto phenomena a priori, but also because formal descriptions are not in fact actual systematic phenomenological or transcendental descriptions. Their resources for describing a phenomenon are always limited. For example, when we attempt to describe the phenomena pertaining to mental imaging, it is too easy to provide a neuroscientific and computational picture of all input and output signals and then describe in a formal sense something like having mental images through (1) our insights into mere perceptual images which are not exactly mental images, and (2) formal descriptions built on the blurry territory between perceptual images and mental images. But, mental images are not originating from different perceptual sources. They have quite different characteristics that cannot be captured by some formal descriptive models pertaining to perception, and thus explained away by whatever strategy we use to explain perceptual images. They are different in kind, but also require

different methodologies of explanation for them to belong to a different level of description as in contrast to mere percepts.

Formal models, to this extent, signify a systematization that lacks proper criteria and justifications of the systematicity insofar as there is very little or no systematicity in framing or marking out the boundaries of that which is to be described. This is the descriptive-level demarcation problem: the description of a target phenomenon – namely, the boundaries and the exact designation of what it is to be described – is left to a happy coincidence or a miraculous act of description. It is miraculous insofar as it is not given or for-mulated by the descriptive model, a formal system, etc., but rather is implic-itly assumed through an extraneous act of describing (often at the behest of explanation) which usually lacks any descriptive systematicity. This is, first and foremost, a call for a method or science of description before we pretend that such and such phenomenon can be descriptively modeled on mereologi-cal relationships, geometric structures, and so on and so forth.

The gravitation toward the models' explanatory weight combined with the descriptive impoverishment is further exacerbated by the naturaliz-ing tendencies of modern sciences. The notable lopsidedness between the explanatory and the descriptive which is instituted at the level of the mod-el's structure and the so-called model construals (i.e., a model's assignment, scope, and fidelity criteria)[8] cannot be disregarded as a matter of mere biases or conveniences – instrumentalist or not – motivated by the practice of sci-ence, because it rather stems from various prejudices about the status of models – their ontological status as well as their constitution with regard to the specific sets of appearances or phenomena they attempt to address.

What is interesting to underline is how this imbalance has been put in the service of deflationary/disenchanting stances within the philosophy of neuroscience and the philosophy of mind. Conscious and intentional states or activities can be deflated and replaced by explanatory models of information processing systems and processes. It is in this context that the typical Dennettian hysteria against something like phenomenology arises. Every phenomenological description/explanation is ejected in favor of sub-personal/non-intentional explanatory models of the information processing system only to – at the end of the day – levy that explanatory force against a wrong level of description.

In other words, phenomenological reflection on the description of a part of mental life as what it is we are attempting to explain is booted out as an excuse to bring back cluttered folk psychological concepts against which the explanatory force has effectively been mobilized. In a sense, this sort of defla-tionary hysteria is the double expression of the aforementioned imbalance: (1) the explanatory model operates under a condition characterized by a lack of a methodologically controlled description of what it attempts to explain, and (2) the thrust of the explanatory force is directed not just at a wrong descrip-tive level but at a description of a target phenomenon or part of the mental life which is introduced much later from the ordinary descriptive vocabularies

of folk psychology. This move, of course, goes hand in hand with the broader justification of voiding philosophical relevance as an excuse to practice impoverished philosophy unexamined, where the disenchanting powers of natural sciences can be brandished against the enfeebled folk psychological concepts – where the explanatory blade is perpetually triumphant because it has been wielded against the wrong sorts of descriptions of mental phenomena.

Husserl's emphasis on the descriptive level of conscious or mental phenomena by way of the phenomenological method should be recognized as a counterweight to this imbalance, against the double bind of deflationary models and inflationary folk psychological concepts. Transcendental and phenomenological reflections on various components of mental life not only mitigate or suspend the entrenched psychologistic attitudes towards such components, but also provide a dynamic view of the labor of description where the description of a particular phenomenon – its demarcation – changes depending on how specific acts of reflection and their objects shift.

In this process, descriptive levels pertaining to occluded unities can be reawakened or sunk back as the very result of the descriptive reflection. It is in this sense that Husserl's distinctions between noesis, noema, and transcendent objects and the progressive explication of presenting, presentifying (re-presenting not in a Kantian sense of representation), and intending acts with their corresponding objects provide a much-needed systematicity or even conceptual engineering – in the sense of Carnap's explication – to the labor of description. Within this scenario, the phenomenological method does not need to be contrasted with the naturalizing tendencies (such as modeling conscious phenomena and activities on information processing systems) such that we are forced to endorse a thesis according to which phenomenology strongly constrains cognitive science. Instead, a much more fruitful yet more modest thesis can be accommodated: if we are seeking explanations of various aspects of mental life on sub-personal levels modeled on computational phenomena and informational processing systems, it is imperative to begin with a precise and correctly framed description of what it is that we are trying to explain such that we can identify a right explanation for the correctly framed phenomenon or class of appearances.

Let Imagination Be Turned Inside-Out

It is against the backdrop of these notes that some remarks on the phenomenological analysis of both human imagination and text-to-image models are now in order. Whereas we often think of imagination through our natural psychological attitudes, the concept of imagination truly belongs to transcendental and phenomenological reflections. Text-to-image AI models reveal principal features of imagination, except through a process of technical exteriorization

intrinsic to imagination itself. Precisely because we look at these models through a spontaneous experiential perspective to which we are uncritically habituated, we often mistake them as poor attempts at imagination. But once we map out the non-psychological descriptions of imagination, then what we used to take as imagination comes off as an alienating vector against all who are accustomed to mere psychological reactions to imaginative acts. Thus, the AI model becomes a source of bafflement and intellectual disconcertment.

To address these problems, the description of imaginative phenomena will be examined through the twelve following vignettes to underscore that our imaginative acts belong to a territory which has always been exteriorized, i.e., that which is of a model. Highlighting the function of imagination through models requires a systematic withdrawal (an act of suspension) from what we have been accustomed to, that is to say, the account of imagination from a spontaneous within.

1. The exteriorization of imagination is not something new, specific to the modern techno-industrial epoch. Models – whether explicitly understood as such or not – have always displayed facets of exteriorization of imagination, in particular through what Hans Vaihinger has called fully fledged or real fictions (as in contrast to semi-fictions) – or to avoid getting stuck in a congested philosophical avenue named fictionalism – fully fledged *feints qua artifices* of the as-if activities of the mind.[9]

2. Bracketing out Vaihinger's quasi-Aristotelian logical identification of fictions or feints (mental techniques), fully fledged or real feints are neither simple concepts deviating from reality (or what Vaihinger calls semi-fictions) nor mere conditionals or hypotheticals which seek to be validated in relation to an external reality. Fully fledged fictions are not directed toward confirmation by experience, but are rather what Vaihinger calls auxiliary means or scaffoldings to guide experience in a circuitous way toward reality as an immanent object of consciousness or thought. Fully fledged fictions are internally self-contradictory. This self-contradictoriness does not need to be understood in terms of para-consistency but rather of an internal and autonomous, sufficiently robust *coherence* which should not be mistaken for mere consistency, a coherence that allows for selectivity of various mutually incompatible chains of inference and logical implications while at the same time being constrained by and responding to an underlying set of nuts and bolts, i.e., how the system fits together. Finally, for Vaihinger, what distinguishes fully fledged fictions from semi-fictions is that the former entirely belongs to as-if (Als ob) activities of the mind, namely to a series of productive, reproductive, or presentifying (vergegenwärtigende, which is not to be confused with presenting or gegenwärtigung)[10] activities marking imagination, or more specifically, what Husserl has introduced as phantasy (imagining acts and phantasmata).

Text-to-image AI models reveal principal features of imagination, except through a process of technical exteriorization intrinsic to imagination itself.

3. No longer distinguished by its Kantian transcendental function where it plays a key role in establishing perceptual identity and making perception possible, imagination in its Husserlian sense runs parallel to perception and is not considered to have the synthetic function Kant has ascribed to it. This parallelism can be understood as a generalized asynchronous concurrency which is supplied by an inner time -consciousness specific to the particular nature of the presentifying or re-presenting activity of imagination and which is entirely expressed in terms of doubly conscious as-if acts of phantasying. Doubly conscious since imagining acts in the sense of phantasy are not only the conscious performances of as-ifs (e.g., [as if] there is a pink elephant hovering before me), but also the consciousness of the non-present object (here, the consciousness of the pink elephant being not really present before me) which permeates the conscious as-if act of quasi-positing (the phantasial positing of a flying pink elephant) to the core. It is the latter – i.e., the consciousness of a de facto absent object accompanying the conscious performance of an as-if act experientially from the beginning to the end and not merely reflectively – that separates phantasy from hallucinations and illusions where imagination and perception encroach upon one another, and thus, we can talk about a *conflict* between imagination and perception. So long as my imagining of a flying elephant is accompanied experientially and not merely reflectively by the consciousness of the flying elephant being absent from the beginning to the end – that is, so long as I embark upon a phantasy consciously built on an absence or non-presence – there is no (hallucinatory or illusion-inducing) conflict between imagination and perception running in parallel together. This is the first law of parallelism of phantasy and perception that separates *imagination from perception* by fundamentally neutralizing or forestalling the doxic modality of the object.

4. The second law of parallelism between imagination and perception separates *perception from phantasy*; that is to say, it allows for the establishment of the perceptual identity of an object without the need for the intervention of imagination as a synthetic function, a function deemed necessary by Kant. This is due to Husserl's peculiar enlargement of the conception of sensibility beyond that of Kant's conception so as to encompass not just mere sense receptivity but rather a *motivated kinesthetic* receptivity that includes the object and the object's horizon at once. The perceptual identity of an object across time and space is first necessarily established by the qualitative homogeneity of appearances as in different profiles on an object having certain common elements or similarities for them to be associated with one another. But thematic affinities are by no means sufficient to warrant perceptual identity since qualitatively matching profiles can belong to different objects. The perceptual identity is sufficiently albeit passively and in an inarticulate form – since full

articulation suggests a proper perceptual taking or judgment not available at this phase of constitution or synthesis – established only when there is a continuous synthesis between related appearances. That is, only when different appearances form a continuum – a kinesthetic perceptual series of appearances transitioning from one to another – thus and so appearances belong to one and the same object. It is this kinesthetic experience of a continuous series or what motivates the flow or the continuous synthesis of appearances that implicitly or inarticulately completes the object-constitution process. And for that matter, it generates more or less delimited expectations in the adumbrative sense used by Husserl for the unseen / non-given profiles or appearances of an object.[11] In this fashion, the full sense of appearances for a single object is understood not as completed but as an ongoing process, one which is based in anticipating occluded facets relative to the *amplitude* of past, or fulfilled, anticipations of object profiles, such as a musical tune.

To this extent, the second law of parallelism pertains to the formulation of perception itself that unlike Kant's account and in a way akin to Hume's empiricist account is conceived as a process in which the synthesis of appearances necessary for objective identification of objects is not supplied by imagination as a transcendental function but is constituted bottom-up – through a highly intricate form of associations not just between different aspects of an object but also between its retentional traces and protentional unfoldings – by the involvement of our kinesthetic system (passivity in activity), which functions in a similar vein as dynamic anticipatory systems outlined by Robert Rosen.[12] This is what makes Hume-Husserl's account of imagination closer to AI models of imaginings with their prompts and generated outputs than Kant's account.

Perhaps a digression is necessary at this point to give a minimal Husserlian idea of what an anticipatory system can be in principle: in a Husserlian sense, our capacity to anticipate appearances for an object is directly related to enlarging the magnitude of continuously fulfilled (affirmed) and disappointed (failed) anticipations, which can be correlated to those protentions which have become retentions insofar as they have been fulfilled or *perspectivally* confirmed in comparison to those which have failed (unfulfilled or disappointed). The entire process of imaging in imagination or otherwise is a matter of probability: the fulfillment and the failure of retentions and protentions.

An example would be hearing a melody from the beginning: as the melody continues, we begin to form a semblance of anticipations for what comes next in accordance to what we have heard plus the successful or fulfilled anticipations which are now retained and

thus functioning as guiding priors for our upcoming anticipations. Someone who listens to this ideal melody later than those of us who heard it from the beginning can only anticipate the changes in the melody in accordance with their shorter amplitude of fulfilled protentions turned into retentions (i.e., there is a higher probability of failure or disappointment). Akin to Husserl's idea of how retentions and protentions interweave, an anticipatory system is an internal model which is built upon not just neurocomputational mechanisms in an organism and its ecological affordances, but also the organism's abilities to learn by comparing past and present states with future states.

5. Whereas Kantian imagination (Einbildungskraft) works by way of schema which have one leg in the a priori (the jurisdiction of the concepts of pure understanding) and one leg in sensible intuitions, Husserl's imagination, no longer being a transcendental function in the primary service of perception, is built on top of *types*. Essentially, types are a posteriori rules that once take root serve as soft a priori rules. They are generated by the largely unconscious kinesthetic functions pertain to detecting phenomenological thresholds of objects such as an edge, a margin, a pitch, or an amplitude (depending on the sensory input being visual, auditory, or something else). What is interesting here is that types (as a posteriori categorizing elements) have much more in common with the logic of artificial neural networks in contemporary AI. Because they are detached from the structure of the a priori in the first place, they can be tweaked and diversified in more fundamental ways. Thus, imagination in this context functions as a logic of possibilities or, more accurately, as a *spielraum* – leeway or room to play and move and touch upon what is absent in every factoid conception of an object: that is, possibilities of experience and perception, space for anticipations of different essential (that is, of essences or eidoses) insights, types (or pre-predicative frames of experience), and eidetic laws of image-consciousness constitutive of any experience. Accordingly, there is no wonder the technical explicitation of imagination is often met with hostility, because it is a vector of changing the face of the human and its cherished concept from a backdoor.

6. The law of parallelism between perception and imagination should not be mistaken as a law underscoring the purity of all perceptions and all imaginations. This law does not mean that imagination and perception do not interact unless in negative ways such as in the cases of hallucinations and illusions where perception and imagination overextend their boundaries and impinge on one another. As mentioned earlier, the parallelism should be understood in terms of concurrency of two distinct operations where the transmission

between perception and imagination is always constrained by the laws of perception and laws of imagination in various degrees and at different levels. In a nutshell, the parallelism between perception and imagination does not mean that perception and imagination are divorced. It merely says that the laws of imagination proper are distinct from the laws of perception proper. In this setup, we can easily think about exchanges between perception proper and imagination proper and indeed mixtures of perceivings and phantasyings as in the case of perceptual imaginations like when we look at the pages of an abstract comic or a pictorial children's novel, and we go on and imagine some sort of fan fiction as the continuation of these encounters, more or less in the same style, and more or less continuous to what has been given to us in the content. As a matter of the facts of our experiences, we are not entirely of the team perception or team imagination in our everyday perceptions and imaginations. We are indeed of both – a bit of fulfillment characteristic of perception and a bit of the absence of fulfillment characteristic of imagination, a bit of responsiveness to what has come before and a bit of responsiveness that can unfold independent of what has come before – perception and imagination as two different stories about how the past bears upon the future or how the future bears upon the past.

7. The point is that we can go back and forth between perception and imagination, modeling one on the other – perception on imagination or imagination on perception. But in the moment of doubt understood as the amplification or lessening of the degree of objectivity in quantitative, i.e., statistical terms, we see that perception differs from imagination in that the former is built on fulfillment and the latter on the absence of fulfillment insofar as in pure phantasy we do not simply represent an act of perception, but generate a self-transcending object as if we were presentifying an object anew. And thus, we are tempted to question not only the objectivity of what we are and what surrounds us (perception and understanding), but also the very method or mode of consciousness previously taken as uncontroversial by which we were compelled or motivated to see ourselves and the world as this and not that.

8. Hence, we can talk about three models of ourselves: (1) one that is informed by our perception of ourselves (the fulfilled image of ourselves where our future image corresponds to and confirms what has come before – the asymmetry of past content); (2) the imagined portrait of ourselves and our faculties such that what is taken as 'we' in any moment always renegotiates and modifies the content of what we were before (the asymmetry of the future content bearing upon the past); (3) the future portrait of ourselves

as being a discontinuation of the past image by virtue of anticipations which create a moment of crisis for what has come before. In any image of AI and generally in every imaginative portrait of the human – us, here and now – all three models are present in various degrees.

9. In this formulation, imagination (the unity of phantasying acts and phantasmata, whether mere phantasies or perceptual phantasies, etc.) finds its autonomy in the realm of as-if where the modificatory operation of the re-productive act (presentifying) is combined with the neutralized or forestalled position-takings or *takings as* (e.g., taking X as this thus-and-so Y). These position-takings are considered neutralized insofar as they are non-positings; that is, they do not have characteristics of belief-bestowing judgments or feelings pertaining to an actually existent object and therefore differ from corresponding positing perceptions. It is this hybrid autonomy that affords imagination or phantasy-consciousness a more fundamental role than the one assumed by Kant in his assumed instrumental relationship to perception: imagination does not serve perception but rather highlights the possibility of a perception without presupposing its *factual givenness*. The laws of imagination differ from those of perception because the former's laws are not temporalities of a presenting act revolving around the positedness of an actual object. They are rather self-temporalizing laws, having their own time -consciousness wherein the object of an imagining act (a phantasma) is understood as an immanent object of consciousness being transcended in the time of consciousness alone, unfettered and unbound with regard to the temporality in which an object of perception is presented or, in the Kantian sense, represented. This is the beginning of recognizing imagination's import and by extension its inherent technical exteriorization as a model which now AI models take to ultimate conclusions.

But text-to-image models are not exactly models of imagination or phantasy per se, nor can they be dismissed as sleights of hand in giving us the impression of imagining, for what we take as imagination – and dogmatically overprotect in the name of human creativity – can very well be and in fact is just an impression – a psychologistic impression – of what imagination is. It is far more fruitful to think of such models as miniature and bracketed models of reflections, transcendental and phenomenological, *on* and *specific to* consequential acts of imagination and phantasy. That is to say, they are reflections which are necessary for the labor of description of the sort of acts and objects which we attempt to model on algorithmic / information processing substrata.

Where the reflection on imagination starts, the act of imagining (which always has an in-medias res quality) stops. This reflection is best recognized

It is far more fruitful to think of such models as miniature and bracketed models of reflections, transcendental and phenomenological, on and specific to consequential acts of imagination and phantasy.

as a double exteriorization of imagination, first through the technical dimensions of model as related to the modificatory manipulation of as-if elements, and second, through exteriorization of the scaffolding of reflection on imagination. The latter is in reality tantamount to a thoroughgoing modification of or shift in both the means and attitudes of reflection on imagination that amounts to a cumulative shift in the phenomenological description of what counts as imagination. With regard to text-to-image models, such a mode of reflection qua a model is always implicated in the structure of the model itself. We reflect on parts and parcels of the mental life by specific modes of reflection which are captured by highly biased models. Biased in the sense that models can vastly oscillate between extreme modes of reflection, of empiricism and of rationalism. Just as our modes of natural or psychological reflections about mental life are not neutral, neither are the models of bits and pieces of mental life. The task of transcendental and phenomenological reflections is to underline where mere psychological reflections end and when the true essences or eidetic insights are revealed.

Concluding Remarks

In line with these remarks, text-to-image models such as DALL.E 2 and Midjourney need to be seen for what I think their true import is, that is, a sketching reflection on the constitutive moments of imagination as itself a methodological game of interacting with the model which is implicitly an exteriorized imagination either in the name of schematization as always being industrial-technical or in the name of types as always belonging to the realm of conscious motivations, which can be either immanent to consciousness or transcendent to it (being representable in the consciousness but not of the consciousness).

This is a game in which the homogeneities and heterogeneities of eidetic variations that go into the generation of types (Husserl's version of schemata as retrospectively *a posteriori* and prospectively *a priori*) can be seen in action, or even modified in an idealized toy-like manner, by rearranging the representational arrays, position-takings, etc. Instead of being falsely identified as a radical innovation that revolutionizes creativity – artistic or not – in truth such models most likely end up fueling self-same quotidian approaches to image-consciousness and the production of image in the name of art. As we cynically know, art cannot be bottomed out at mere image-making.

But their significance and promises of adventure should not be trivialized either, for they can be steered toward re-thinking the genetic phenomenology of imagination, where each phase of imagination acts like a constitutive moment or filter – in a sense similar to filters in digital image processing – that reveals and modifies some hidden or established properties, but also in

being sedimented over previous phases dynamically builds and guides an objectivating imagination whose acts continually have as their objects other previous acts of imaging.

To this extent, there are two ways we can talk about these highly unsettling advances in the order of consciousness and particularly imagination as the ultimate problem of the transcendental constitution: (1) a scenario in which imagination is understood as the logic of model – perhaps, even a metalogic – where the model is an as-if activity of the mind applied to a specific class of appearances; (2) a scenario in which imagination is not merely a fiction or an as-if in the Vaihinger sense, but rather a process underlining different moments of transcendental constitution as in when we recognize a flat rectangle sitting atop four thus-and-so distributed cylinders and we say, 'Behold this a table-ish object'.

In these two scenarios we see imagination under two different yet connected contexts: as a fiction (a species of as-if) and as a specific moment of constitution lending itself to the former after going through various moments of constitution. Take, for instance, an as-if table which is not an actual table but some configuration of spielraum pretending to be a table (/take thus and so as a table). Then a text-to-image model prompt for this table-ish object can be written in quite different sorts of ways. The prompt can be written in a conventional way as if we were really talking about a table, the sort of table we are all accustomed to. But if we change the syntax and the pragmatics of the prompt by way of configurations and vocabularies which are not so conventional because they belong to as-if presentifying acts (not of immediate perceptions of presented objects but of potential manipulations of explicitly absent objects), then we could generate a table-ish object which is not an actual table but something that is similar to a table even if it is really not a table. As, for instance, the prompts to generate a table by saying 'a flat surface on four legs', a different prompt which says 'imagine an elephant upon another elephant ad infinitum akin to the pre-Copernican idea of a firm cosmos where the final resting place is another elephant or turtle'.

An elephant upon which one can posit another elephant or a turtle, and then so that it serves as a sort of table in reference to the pre-Copernican idea of the Earth standing firmly on the might of turtles or elephants upon one another is not exactly wrong. It's just an antiquated prompt belonging to a different age of patterns-cum-concepts.

We can thus say that the double exteriorization of imagination understood as the objectivation of the acts of imagination as objects of new acts of imagination up to the reflecting act specific to imagination marks the problem of self-consciousness as a consciousness that becomes the object of itself, and in doing so, encounters itself as an alien class of conscious appearances in the vein of Pygmalion meeting Galatea. This is the Brentano-Husserl conception of the unconscious as a consciousness that appears to itself as alien phantasmata having the so-called characteristics of unconscious imagery for it encounters itself as at once an immanent object of its own consciousness and

as an object that exceeds or transcends its pattern or given image. Imagination as always has a way to betray what is given to it in perception or belief.

What we imagine is always a very particular form of reflection – and thus, a model – on how we have become conscious in the first place. Belatedly then, with the expansion of technical exteriorization of our most cherished capacities, we will undergo a drastic eidetic variation of the concept of humanity from within and without, not by philosophical analyses but by technical usurpation. Whatever concept of humanity we might discover might be forged at the phenomenological thresholds of the human, highlighting seismic conceptual discontinuities not in the notion of sapience as such but in understanding of the human via its allegedly given and spontaneous overprotected capabilities.

Notes

1 My gratitude to Keith Tilford for convincing me on the philosophical imports of pattern-recognition, Jean-Pierre Caron for insights into the meaning of practice, Adam Berg for long conversations on the Boltzmannian revolutions, and finally as always, Kristen for infinite spiritual and intellectual support.

2 See Alberto Toscano, (2014), 'Materialism without Matter: Abstraction, Absence and Social Form', *Textual Practice*, 28(7): 1221–1240.

3 Bouveresse, *Wittgenstein Reads Freud*, 38–40.

4 See Pete Wolfendale, 'The Reformatting of Homo sapiens'.

5 See Ludwig Boltzmann, *Theoretical Physics and Philosophical Problems*, 63–68.

6 See W. V. Quine, *Word and Object*.

7 Toy models are simplified models that can accommodate a wide range of theoretical assumptions for the purpose of organizing and constructing overarching narratives (or explicit metatheories). In this sense, toy models provide new interpretations of problems and puzzles associated with the implicit metatheoretical frameworks within which theoretical ideas and observations are interpreted. Toy models, accordingly, can overcome the setbacks caused by the standard interpretations. What separates toy models from ordinary models is not just that they are simplified enough to enable us to tinker with the internal theoretical structure of a model, but that they are *explicit* metatheories.

8 See Michael Weisberg, 'Three Kinds of Idealization'.

9 See Vaihinger, *The Philosophy of 'As If'*.

10 "[Husserl] uses the term *Vergegenwärtigung*, translated as 'representation' or as 'presentification' or 'presentation' (to distinguish it from 'presentation' (*Vorstellung*)), which in everyday German suggests the process of 'calling to mind', 'visualizing' or 'conjuring up an image in one's mind', to characterize quite a number of processes including not just imagining, but remembering and also empty intending – which are to be contrasted with the full presence of the intended object in a genuine 'presenting' or 'presencing' (*Gegenwärtigung*)" Dermot Moran and Joseph Cohen, *The Husserl Dictionary*, 2.

11 It is precisely because of this kinesthetically motivated experience of a perceptual series which is entrenched in both actual perception and quasi-perceptions of imagination that adumbrations of abrupt or complex shifts in transitioning appearances become cumbersomely difficult, as in, for example, anticipating the non-given profiles of an irregular knot or performing intricate mental transformations on geometric shapes. This is also why it is as difficult to imagine such intricate objects for us as it is for the current text-to-image models to generate the hidden facets of a complex object.

12 See Robert Rosen, *Anticipatory Systems*.

References

Archard, D. (1984). *Consciousness and the Unconscious*. La Salle, IL: Open Court Publishing Company.

Boltzmann, L. (1974). *Theoretical Physics and Philosophical Problems: Selected Writings*, edited by Brian McGuinness. Dordrecht: Springer Dordrecht.

Bouveresse, J. (1995). *Wittgenstein Reads Freud*, translated by Carol Cosman. Princeton, NJ: Princeton University Press.

Moran, D., and Cohen, J. (2012). *The Husserl Dictionary*. London: Continuum.

Quine, W. V. (1960). *Word and Object*. Cambridge, MA: MIT Press.

Rosen, R. (2012). *Anticipatory Systems: Philosophical, Mathematical, and Methodological Foundations*. Second edition. New York: Springer.he.

Toscano, A. (2014). 'Materialism without Matter: Abstraction, Absence and Social Form'. *Textual Practice*, 28(7): 1221–1240.

Vaihinger, H. (1924). *The Philosophy of 'As If': A System of the Theoretical, Practical and Religious Fictions of Mankind*, translated by C. K. Ogden. New York: Harcourt, Brace and Company.

Weisberg, M. (2007). 'Three Kinds of Idealization'. *The Journal of Philosophy*, 104(12): 639–659. https://doi.org/10.5840/jphil20071041240.

Wolfendale, P. (2019). 'The Reformatting of Homo sapiens'. *Angelaki*, 24(1): 55–66. https://doi.org/10.1080/0969725X.2019.1568733.

Representation

7

Intelligent Company: Co-Creative AI as Anamnesis

Jonathan Impett

> In considering any new subject, there is frequently a tendency, first, to overrate what we find to be already interesting or remarkable; and, secondly, by a sort of natural reaction, to undervalue the true state of the case, when we do discover that our notions have surpassed those that *were really tenable*.
>
> *(Lovelace 1843, 722)*

Introduction

Overrated or undervalued? Ada Lovelace's observation regarding responses to Babbage's analytical engine still obtains in respect of current AI; neither pole helps us engage critically with the nature of what we might actually do. Responses to AI vacillate between the epochal or post-human – Stephen Hawking foresaw a tipping point when AI becomes able to set its own goals[1] – and the thoroughly prosaic – the benefits of self-driving cars, flower-picking robots, or automated music transcription. For good reason, both aspects are very present in current discourse. In creative and cultural contexts, the very fact of an AI seems to dominate public and critical reception of a given work. Reviews of new AI-involving work of all kinds tend to focus on the perceived challenge to or automatization of humanness in general or authoriality in particular, rather than the ways in which human creativity might be extended. Critical and theoretical consideration of AI-involving work thus becomes unhelpfully separate from broader discussion of creative and cultural trends.

In this chapter, I will consider aspects of the potential role of AI in music performance in order to propose an alternative paradigm of AI as many-layered memory. Together, musician and AI seek instances of anamnesis which neither could accomplish alone. A practically oriented thought

experiment explores possibilities for interface and navigation in such a performance system and creative practice. Hopefully, the practical challenges will illuminate the broader issues.

Every practice implies a model – an inner picture, however informal or unreflected, of possible behaviours, tools, materials, of sequence and convention. And every model (as Badiou showed in his early lectures) implies an ideology, a world view, an ontology, a social and cultural structure.[2] Personal and cultural practices proceed with different rhythms to those of theoretical or technological innovation. Artefacts that embody many such different layers of development therefore need to be understood – whether to analytical or creative ends – from multiple perspectives. Practice, model, and ideology do not tend to advance in step – they are not subject to reflection at the same points. Concepts, categories, and articulations of artefacts, materials, operations, and practices persist necessarily but inappropriately as we seek to understand a new context. George Basalla used the metaphor of evolution to describe how technologies emerge, develop, are selected, and find their uses: '… the potential, as well as the immediate, uses of an invention are by no means self-evident'.[3] Indeed, his primary examples of not immediately grasping the most important uses – of not asking the most appropriate questions – are the phonograph and the tape recorder. Brian Arthur points to the ways in which new technologies, which are themselves the compound and emergent product of the wider technological network, find unobserved niches and create unforeseen 'opportunities' that then afford the development of further technologies. In his narrative, the readjustment of 'the economy—the pattern of goods and services produced and consumed …' is the last step.[4] In the case of music performance we are concerned with a knowledge economy, a creative economy, an economy of cultural innovation. Put simply, the possibility of different kinds of answers brings the obligation to formulate different kinds of questions, and new tools require new goals – especially in the technical context of machine learning, where the relationship between questions, answers, and the relative satisfaction of goals are inherent in the mechanism.

The challenge of the artificial is addressed copiously in technological terms but also in the context of theory of the post-human and the virtual. Discussion of the intelligent adopts a range of voices, from the computer-scientific perspective of Briot et al.[5] to the philosophical-visionary analysis of Negarestani.[6] In most cases the metric remains the human mind, human 'reasoning' or action, or perceived human verisimilitude. Our apparent difficulty in clearly distinguishing these perspectives is a surface symptom of the plastic complexity of the relationship between subject and intelligence, machine or otherwise.

There have been brilliant and hitherto unimaginable developments in the application of AI to music, but many have also served to illuminate the limits of our capacity to conceive of how music might be constituted except in the terms with which we are familiar. The well-developed nature of our discourse paths and cultural defence mechanisms is such that the radical and

the critical are also accompanied by a resigned familiarity. The hegemony of a model of music production enshrined in cultural, economic, and educational structures is highly robust: composer (ideally a genius, producing their technically coherent work in a single gesture), work (however represented), performer, and a clear composition-improvisation distinction. Such shorthand concepts persist in artificial models but are highly reductive and reflect an external perspective; more recent musicological revelations of the embodied, situated, and distributed nature of music creation are hardly news to musicians. Here we will adopt a pragmatic approach to both the nature of intelligence and the conceptual models that emerge in considering a possible instance of AI in performance.

The Difficulty of Unlearning Deep Culture

Current AI inevitably embodies traces of the context of its evolution. Machine learning and its relations were embraced as the limits of rule-based expert systems had become clear, and yet the modes of thought, the categories and operations that accompanied earlier AI often persist in the application of new techniques. John McCarthy proposed the first workshop on AI in 1955 'on the basis of the conjecture that every aspect of learning or any other feature of intelligence can in principle be so precisely described that a machine can be made to simulate it'.[7] Minsky's assertion that '... within a generation ... the problem of creating "artificial intelligence" will substantially be solved'[8] likewise reflected a context conditioned by information-theoretical thinking and an assumption that rules of sufficient complexity might account for any level of difficulty. Such an approach has historical roots so deep that they touch on any consensus understanding of 'reason' itself. It is inextricable from the Enlightenment project, from notions of progress and modernism, and thus from the development of thought and practice in music through to the present. Nicolas de Condorcet, a promulgator of the role of reason in place of religion in revolutionary France, had published on mathematics, democracy, economy, and equality. For him, appropriate parametrisation and the application of probability on the basis of accumulated data would serve to address human challenges in general. In his last work, written under threat of execution, he suggested:

> If man can, with almost complete assurance, predict phenomena when he knows their laws; and if, even when he does not, he can still, with great expectation of success, forecast the future on the basis of his experience of the past, why, then should it be regarded as a fantastic undertaking to sketch, with some pretence to truth, the future destiny of man on the basis of his history?[9]

> It is the application of the calculus to the probabilities of life ... that
> we owe the idea of these methods which have already been successful,
> although they have not been applied in a sufficiently comprehensive and
> exhaustive fashion to render them really useful ...[10]

And he is explicit that such methods will provide a way forward for the arts:

> If we turn now to the arts, whose theory depends on those same sciences,
> we shall find that their progress depending as it does on that of theory, can
> have no other limits; that the procedures of the different arts can be per-
> fected and simplified in the same way as the methods of the sciences ...[11]

To posit such a thread through modern Western thought is more than
a historical oddity; de Condorcet effectively sets out a set of propositions
that underpin understandings of meta-human 'intelligence' from Babbage
through information theory and expert systems to much current AI. Exact
measurement should work together with 'the calculus of combinations and
probabilities' to constantly improve the human condition in terms of pol-
itics (inequality of wealth, status, education, race) and science, but also of
metaphysics and morals, of the arts and even human physicality. For this, de
Condorcet proposes a universal language, a symbolic language with clear
sets of 'objects, ideas and operations', that would allow for such reason to
operate across any of these fields, and independently of local vernacular –
perhaps some kind of pseudo-coding language:

> We shall show that the formation of such a language, if confined to the
> expressing of those simple, precise propositions which form the system of
> a science or the practice of an art, is no chimerical scheme; that even at the
> present time it could readily be introduced to deal with a large number of
> objects; and that, indeed, the chief obstacle that would prevent its exten-
> sion to others would be the humiliation of having to admit how very few
> precise ideas and accurate, unambiguous notions we actually possess.[12]

Paucity of our stock of ideas remains the challenge; the nature of their preci-
sion evolves. On one hand, we often see recourse to the discourse and prac-
tices of conventional music-making: composition, improvisation, performer,
composer, score, even particular styles such as jazz. On the other, references
to 'thought' or 'idea' remain aspirational, vague, and unhelpful. Pauline
Oliveros, whose thinking is in many respects foundational to the transforma-
tion we must confront, asks, 'What if we could share our thoughts instantly
over a network as computers do now? Such possibilities and amplified intel-
ligence will present new challenges to our ethics and future human values'.[13]
Appeals to 'thought' or 'ideas' are not helpful. We may have recognised the
limits of proposition logic-based constructs in interfacing with humans as
we acknowledged the embodied, situated, distributed nature of cognition.
But the artefacts of current AI, however complex, whatever components of

human 'intelligence' they appear to embody and compress, are not thoughts or ideas – indeed, they remain propositional, computational structures, however intractable to humans. What is at stake, then, is not thoughts but thinking – human thinking – and how AI might allow or encourage us to think in ways that are not only new but by definition challenge our imagination.

Conventional uses of AI in music performance involve imitation, prediction, categorisation, and various forms of association, selection, or mapping. Such applications are often technologically innovative, but in essence they respond to questions from another time, another state of technology; they produce knowledge of which we already know the shape. They may be generative within taught parameters. As in many rule-based performance systems, probability, nonlinear functions, and randomness often have a role in humanising or naturalising system behaviour in contradistinction to overtly algorithmic work. Music that identifies as algorithmic, on the other hand, often seems to adopt mechanistic or processual behaviour precisely to avoid suggestions of human intervention; counter-intuitively, perhaps, noise or perceived randomness can be easier to engage with as energy sources.[14]

The machine implementation of common tropes of contemporary performance, especially in improvisation with technology, offers clues as to how we might reconfigure inherited articulations of the processes of music-making. In particular, it points to the primacy of human perception and intention in any articulation or categorisation, rather than inherent properties of the artificial. The notion of 'real-time', for instance, is obscure to the machine, except to the extent that its design allocates memory and processes data in certain units. Whether some data – a sound, perhaps – arrived a sample ago (1/48,000 secs. in this instance) or was copied from a century-old phonograph recording is indifferent to the computer. By the same token, human-machine interaction is a human perception afforded by the design of machine behaviour. The interactiveness of an ATM is not a property of the machine – it is a function of how long a customer is willing to wait on the street. Responsiveness to conditions and actions (i.e., data input) might be evident over any timescale; any distinction between interaction and sensitivity to conditions is in the intention of the software designer, not in the working of the machine. It is the expectations and constraints of human music performance that frame impressions of temporal sensitivity and interaction. Such perceptions have a material role and impact on how we conceive and create performance, however. At the same time, the dissolving of instinctive musical concepts once in contact with the machine should give us pause in lazily continuing to work with inherited models of composition and improvisation. In particular it should free us from any assumption that a creative or stimulating relationship with the machine depends on instant responses to actions – longer-term temporal thinking promises much more interesting human-machine relationships and richer musical structure.

Whether some data – a sound, perhaps – arrived a sample ago (1/48,000 s in this instance) or was copied from a century-old phonograph recording is indifferent to the computer.

Beyond the machine's ability to reliably perform complex tasks, what role might we want to ascribe to a computer in performance? The ability to accomplish tasks we might be able to imagine but lack the intellectual capacity to realise in a timely manner, certainly – whether the realising of multiple versions of scores as the result of complex calculations, or the processing of sounds so rapid it gives the impression of simultaneity. We might wish to draw attention to perceived autonomy, to emphasise its machine-ness or its capacity to embody aspects of human behaviour. All such functions afford the possibility of providing stimulus to a human performer. The ability of recent AI to imitate or predict, or to learn mappings too conditional or complex to express by rules, extends the reach and scope of previous applications but not the conceptual framework within which they are imagined. In the general case, music is the product of technique, of decisions – conscious or otherwise, reflective or learned – distributed across time, through practice, convention, and technologies. Notions of spontaneity and expression are certainly valid in terms of human experience, but not always helpful in understanding how musical actions and structures are formed. Rather than thinking in these terms, perhaps extending the technical-conceptual scope of a performer is as important as generating 'material'.

The perspective of the subject must be primary in considering the implications of AI in any field, but in music performance this is inescapable. It is precisely in expanding the conceptual framework of the subject, the performer, that the most significant potential lies. Can the use of an AI help a mind think past its own barriers, find new paths for the imagination? More specifically, can an AI propose to an individual – a performer in this case, which brings additional constraints we will consider – lines of development of musical thought that are inherent in or contiguous with the subject's behaviour, but which they would never have had access to alone? Celia Lury talks of 'prosthetic culture';[15] here we are dealing with prosthetic imagination.

AI and Anamnesis

An AI is essentially a memory machine. Rather than 'cleverness', this is perhaps the respect in which it can most be said to embody human characteristics. The device operates a continuous process of compression on the experiences and outcomes to which it is exposed – as mediated by the mode and mechanisms of such exposure – and exhibits an evolving propensity for generalisation, punctuated by moments of strange specificity the rationale or status of which as memory, invention, or pathology is hard to determine.

Jean-François Lyotard identifies 'delocalisation' and 'detemporalisation' as key properties of new technologies, in a paper for a conference organised by IRCAM in 1986. He describes this as 'telegraphy' or inscription-at-a-distance.

Celia Lury talks of 'prosthetic culture'; here we are
dealing with prosthetic imagination.

These properties invite us to consider the reconfiguration of the constitu-
ent elements of music-making; lazy assumptions about agency, sequence, or
identity can be dissolved. Writing in an earlier era of machine intelligence,
Lyotard refers to the storing, processing, and re-materialising of information
rather than current AI paradigms, but even in that context he asserts that a
Kantian mode of aesthetic material no longer obtains. He sees 'a profound
crisis of aesthetics', one that in 1986 may have been rather of theoretical inter-
est to musicians, given their tools at the time, but which describes precisely
the challenge and opportunity presented by AI in our current situation.

> I distinguish, then, without claiming that this is exhaustive, three sorts
> of memory-effects of technological inscription in general: breaching
> [frayage], scanning and passing, which coincide more or less with three
> very different sorts of temporal synthesis linked to inscription; habit,
> remembering [rememoration] and anamnesis.[16]

Lyotard's explication of these terms is instructive (although his text unhelp-
fully conflates the two sets):
Breaching – habit:

> Habit is an energetic set-up which is sometimes complex, of variable
> plasticity, which structures a certain type of behaviour in a certain type
> of contextual situation. The stability of the set-up allows the type of
> behaviour to be repeated with a significant saving of energy.[17]

Scanning – remembering:

> What I'm calling scanning here corresponds to the temporal synthesis
> that in classical philosophy and psychology was called remembering. As
> opposed to habit-breaching, the synthesis of remembering implies not
> only the retention of the past in the present as present, but the synthesis
> of the past as such and its reactualization as past in the present (of con-
> sciousness). Remembering implies the identification of what is remem-
> bered, and its classification in a calendar and a cartography.[18]

Passing – anamnesis:

> Finally, a few words about 'passing'. This is another memorization,
> linked to a writing which is different from the inscription by breaching or
> experimentation, different from habitual repetition or voluntary remem-
> bering. I use the term 'passing' with an allusion to the third memorizing
> technique that Freud opposes to the first two in his text on 'psychoana-
> lytical technique': the (infinitive) 'passing' here is the German durch, as
> in Durcharbeitung, or the through of the English working through, the
> passing through of trans- or per-laboration.
> This word 'work', widely used since Freud, is very deceptive. There is
> also work in every technique: there is no breaching or scanning without

some expenditure of energy. If it is true that passing certainly uses up more force than other techniques, this is because it is a technique with no rule, or a negative rule, deregulation. A generativity with, if possible, no set-up other than the absence of set-up. The logos itself, in that technology, will have to be turned not on itself, as in scanning, to purposes of appropriation and expansion, but turned against itself to the extent that it is 'bound', as Freud said, synthesized at all levels, from the phonematic to the argumentative and the rhetorical. The point is precisely to pass beyond synthesis in general. Or, if you like, to pass beyond the reminder of what has been forgotten. The point would be to recall what could not have been forgotten because it was not inscribed. Is it possible to recall if it was not inscribed? Does it even make sense? And is it a technological task, a task for the technologos?[19]

Memory and imaginative invention carry different implications in time, self-perception, and social discourse, but as operations of mind they are not different in kind: memory is always an action of imaginative re-creation, imagination an action rooted in experience and existing concepts. Lyotard's accounts of 'habit' and 'remembering' articulate well the processes of vernacular music and art music composition. 'Anamnesis' seems to be what we are dealing with in extending ourselves into AI. His extensive description of the third, technologically-facilitated mode of memory is remarkably apposite. Indeed, current AI invites us to go beyond the synthesis of many of its applications – whether synthesis of judgement or synthesis of likeness – 'to recall what could not have been forgotten because it was not inscribed'.

The notion of anamnesis originates in two of Plato's dialogues: *Meno*, in which Socrates guides an untutored slave to articulate the truths of geometry only through a process of questioning, and *Phaedo*, in which a discussion of modes of recollection and reminding serves to demonstrate the theory of Forms. Anamnesis in this sense encompasses both the recollection of what was not in mind and being reminded of something not present in thought or reality. Crucially, Plato tells us that this new idea 'is not of the same knowledge but of another',[20] it is another kind of concept. The new idea is not already inscribed in or implied by the object presented, nor as an opposite (a negative inscription). His examples explore the possible relationships between a lyre and an absent lover, and Simmius and his portrait.

Later in the same passage, we find another clue to the nature of the relationship between the subject and the object that invites or affords the new thought, the moment of anamnesis. He says that likenesses are never alike, not the same thing – they 'fall short' in most translations. The implication of insufficiency is irrelevant here. More important is how Plato voices this state: the object 'aims at being', 'seeks to be', 'wishes to be' like another – translations agree on this sense of volition. Unless one is really attributing such aspiration to the object – a painting, another lyre – this sense is reflected back to the subject. It is in the mind of the viewer/listener/anamnesis subject that such a perception of volition arises.

Anamnesis in this sense encompasses both the recollection of what was not in mind and being reminded of something not present in thought or reality.

Anamnesis and Performance

This is a crucial component of the relationship between performer and machine. The degree to which a machine might be said to embody mind or humanity is not at issue, rather we are concerned with how the performer perceives its behaviour, the effect of the machine's output on the performer's response or development. This has implications for the design of an AI in such a context. The role of a natural human tendency to anthropomorphism in engaging with AI – or most other behaviours – is widely discussed. Much of this literature focusses on the potential for AI-based devices and products to exploit this tendency by enhancing their 'lifelike' properties: appearance, movement, output.[21] While an AI-trained robot violinist may be of passing amusement, the goal of co-creativity – of simulation of the unknown rather than simulacrum of the known – presents an entirely different field of potential engagement and evaluation. Unless the object of interest is an abstract, computer science-related fascination with the functioning of the AI itself, it must be appreciated and evaluated as much in terms of the stimulus and relationship it offers co-performers as the aesthetic properties of its output per se – one of greater abstraction and potentially free both of obviously human or natural traces (gesture, sound source) and of identifiable reference to previous material (sounds produced by performers or AI). To play a vital and unique role in the performing process (I hesitate to use the word 'creative'), an AI does not need to play the part of a human performer. In engaging with a sound, a gesture, a stimulus, a performer is effectively attributing some kind of intentionality. What we are seeking, then, is machine behaviour that affords the ascription of intentionality.

This is not the place to present hypotheses about the relationship of mind to intelligence or the portion of mind that is observable to consciousness, nor to pretend expertise in the effects of physical-hormonal states on what might appear to be rational decision-making. However, recent research suggests that memory might indeed be the foundation of consciousness.[22] Two particularly relevant points emerge from this work. First, that memory is the place or behaviour where different kinds of input, sensation, stored data, and imaginary reconstruction are assimilated in the process of apperception. Second, that there is necessarily a time delay in this process, quite apart from that of historical distance – that consciousness has its own rhythms.

Performance implies a notion of 'real time'. As discussed above, this is irrelevant in machine terms, except in terms of sheer computing speed and power. In principle, there is no difference in kind between 'real time' and deferred time behaviour. In practice, we have to deal with the materiality of our working situation, so there are indeed differences of design and operation that modulate and feed back to the concepts we bring to bear on our work. But this fundamental indifference provides an open sea on which we can re-navigate and dynamically remap the constituent elements of music-making.

Why, when, and how are decisions made? What might 'materials' be? How does the object/work/performance/artefact in question relate to others, to the experience of the particular subject or to that of other people? To what degree or in what mode of inscription does it have any enduring identity?

For performers and listeners, however, the sense of a present, a now, is a common component of musical experience, however spurious or constructed (since Bergson and William James) we know it to be. In what we might still describe as a 'compositional' context, there is time for iterative reflection, for reversal. This is clearly reduced in performance. Remembering and anticipating or imagining in music are distinguished by what we do with such ideas; they arise from the same activity, from and towards an irreducible polyphony of timescales. In the machine context as in the human, every exchange or interaction entails a representation-inscription-compression that is both reductive and lossy. At the same time, this rationalisation brings its own calculus, its own range of possible operations, relationships, and transformations. Such exchange takes place both between agents and within what appears to be a unitary being – whether human performer or AI. The aggregate, dynamic interaction of such multiple representations is a strong metaphor for what appears as the formation of ideas. The decoding process, if we can talk of one, is in the relationship with the listener and the ongoing relationship with the performer. The new knowledge it offers is an anamnesic phenomenon: emergent, to develop Cariani's formulation, not computationally or thermo-dynamically, but in relation to the many models of those who might experience it.[23]

Martin Rohrmeier has recently offered a comprehensive and cogent analysis of the question of musical creativity in AI.[24] From its comprehensive and coherent articulation of the issues that arise from current approaches emerges a lexicon of ill-definition and hazy aspiration. The fundamental dilemma is clearly established: fully deterministic processes are by definition not creative (as famously observed by Lovelace), and the incorporation of random elements makes the system a random number generator, however constrained. Human interaction outsources the matter of creativity. There seems to be greater indulgence for approaches involving evolution or environment – but the former resorts logically to randomness, and the latter is functionally indistinguishable from interaction. Creativity is then understood relative to a stance – a problem setting, human, or cultural perspective – or may involve innovation at such a meta-level. Rohrmeier thus identifies four challenges that a musically creative AI must confront:

> (1) the cognitive challenge that musical creativity requires a model of music cognition, (2) the challenge of the external world, that many cases of musical creativity require references to the external world, (3) the embodiment challenge, that many cases of musical creativity require a model of the human body, the instrument(s) and the performative setting in various ways, (4) the challenge of creativity at the meta-level, that musical creativity across the board requires creativity at the meta-level.[25]

At the end, the ineluctable response to this 'problem' is that musical creativity must be 'AI complete'; it must embody all these ungraspable elements and all those on which we are unable to reflect. We might revoice Arthur C. Clarke to suggest that an engineering solution of which we cannot yet conceive is indistinguishable from magic, but that does not go far enough. In its omniscience, 'AI complete' is indistinguishable from God. Not so much a question as an article of faith: either you believe in the concept of 'AI complete' or you give up on the mission and reframe the project entirely. An engineering problem ultimately becomes a theological matter.

The notion of creativity embodied in much of the research cited seems to be a placeholder for a dynamic, contextual set of properties in a constantly shifting configuration – as retrospectively applied, historically and culturally situated as any concept of beauty. It ceases to be instrumental as a concept, except in terms of cultural caricature; one is reminded of the 'musicometer' in Zamyatin's 1921 dystopian novel *We*: 'Simply by turning this handle, any of you can produce up to three sonatas an hour. And how much labor such a thing cost your ancestors! They could create only by whipping themselves up to attacks of "inspiration"—some unknown form of epilepsy'.[26] Above all, it takes no account of the complex of motivations and aspirations of any of the actors involved, the temporality and circumstances of its production, or the materiality of its implementation.[27]

This frustrated pursuit attests to the plasticity of music – that it affords humans a material, embodied, situated place in which to experience and explore their own manifold nature. We might see the embodying of some kind of truth, or rather the potential for a participant in the experience to sense some kind of truth, about the shared human situation of artist and listener – personal, social, historical. This does indeed in many cases reach across time, but imitation Beethoven quartets or formulaic jazz offer little musical 'truth' in respect of our common social and technological present. They do not suggest a critical relationship with artist, listener, or the future kinds of musical experiences their means of production (the computer) might afford. A culturally and technologically self-aware 'complete' AI would surely write itself into the future picture without the need for travesty.

An experienced musical phenomenon is only the sonic surface of a complex narrative – the path to its production that is recursive, nonlinear, and situated in contexts of many kinds. It has an intimate relationship with the personal narrative(s) of its creator(s). The conceit of an autonomous AI ignores this. Differences between 'composition' and 'improvisation' lie in the distribution of decisions over time, through personal practice, technological inscription, and cultural structures.[28] Neither emerge in an instant – they are the situated traces of a process carried forwards through experience, memory, and cultural reception. The musical phenomena subsequently canonised as 'creative' do not emerge and persist as inert, static objects (any more than do those of AI[29]). Indeed, we might see the musical object (work, performance) as the result of recursion. The musical object as experienced is the structured compression of

the process of its development and production, which is itself the compression of accumulated knowledge and experience – individually and culturally. The experienced phenomenon is a product of distilled memory, internally inter-related in complex ways, in interaction with some kind of shared space (from present action or environment to cultural history). A musical object is less akin to the conventional output of an AI than to one of its later internal layers – only partially decodable and displaying traces of its own structures and processes.

Let us consider a very practical counter-thought experiment, one imagined in denial of Rohrmeier's challenges – one in which human cognition, body, and instrument are incorporated in the aggregate system, that is situated in the external circumstances of a particular life, and which both allows for radical formal decisions and itself constitutes a new kind of musical artefact. From an empirical perspective it seems safe to assert that not all contribut-ing factors to human decision-making are amenable to precise reflection – the 'logico-linguistic' rationality described by Negarestani – and that live performance is a situation in which this state of affairs has to be confronted directly. One proposition of this chapter is that new technological conditions for music-making should render inherited articulations of the processes of music-making redundant – that each case should be considered a reconfigur-ing. But for the sake of clarity, let us use old money and speak of a situation of 'free improvisation' by a performer together with an AI.

Imagine that the AI has access to a career-long database of a performer's actions, and has been trained on their preferences in respect of machine responses to further input (a painstaking process). We might assume that these preferences embody significant degrees of both otherness and empa-thy: surprising not alien, relevant not imitative, stimulus rather than contra-diction or reflection. The AI might process melograms, sonograms, feature descriptions or symbolic representation, or some combination, all requiring encoding and decoding from and to audio outside the AI. The machine thus trained could simply run during performance, but this would represent a state of enaction rather than co-evolution. Instead, continuous learning from decisions made by the performer during performance in respect of paths sug-gested by the AI will provide the most salient inflection points, and should be weighted accordingly.[30] Given the polyphony of threads, relationships, and timescales inherent in any such improvisation, how might the AI pres-ent a field of potential, a range of possible paths to the performer such that they can navigate within that field, further contributing to the evolution of the AI itself? How might it present multiple simultaneous options for devel-opment, to be selected and taken up by the performer? Rather than recogni-tion, recollection, or similarity, this situation is precisely one of anamnesis, of remembering something that appeared not to have been known.

The process of AI-facilitated anamnesis is thus one of looking for poten-tial but unrealised structure, of inducing implications that are occluded to conscious awareness. The general problem is effectively one of time series analysis with little hint of an appropriate window size or maximum

periodicity beyond that of the full set of experienced data itself, although heuristics will doubtless play a part in making the situation tractable. The capacity of recent transformer networks to capture long-range dependencies is crucial here in incrementally distilling accumulated experience. A common strategy is to have a less sophisticated network running simultaneously, to state the obvious, as it were, and thus to be able to filter banal responses or continuations.

A space of potential made up of multiple simultaneous possible paths is analogous to Daniel Dennett's 'multiple drafts' model of consciousness. According to this view '... all varieties of thought or mental activity – are accomplished in the brain by parallel, multitrack processes of interpretation and elaboration of sensory inputs. Information entering the nervous system is under continuous "editorial revision"'.[31] Both the emergence of drafts and their remaining trace are dynamic: '... percepts do not instantaneously arise in the mind in their full richness. ... There is no definitive or archival draft'.[32] In our hypothetical example, therefore, we have both extended the consciousness-as-memory model from the human subject into the machine, and added additional surfaces of reflection as the multiple drafts are decoded, remediated, and enriched by the performer. We create a shifting game, the rules of which change and develop faster than they can be rationalised. Negarestani describes interaction with an AI as a game of semantics,[33] but perhaps here we are constructing a game of *traces* of semantics as performer and AI follow implications of coherence into unexplored areas, playing with each other's perception. The game is energised by the unresolvable ambiguity of there being a unitary or binary consciousness – of the AI as other or as an extended self, an analytical/generative mirror. As Penny has pointed out, in such a context the action of the machine should be understood not merely on the basis of its output but in terms of an *aesthetics of behaviour*.[34]

How might the possible paths be presented to the performer? As we have observed, every mode of encoding and form of representation is both reductive and brings new possibilities – a sort of transduction of potential, of latent energy. Graphical representations would allow the performer to take in several proposals simultaneously, but present an impoverished version of musical potential. The reduction of all possibilities to the same dimensionality will inevitably be asymmetrical. An audio-based interface would avoid such an additional layer of recoding and representation. The same requirement of simultaneity suggests a polyphony of possible paths, which would be a truer manifestation of the richness of potential of any particular moment in performance than a sequential presentation of material. Communication could be private, on headphones, or audible to the audience such that the process can be shared. Again, the degree to which an AI role is made explicit inevitably conditions audience perception. Would the AI present incipits, possible starting points, or continuous lines of development? This would depend on the process by which the performer selects from the possibilities presented. The performer's selection of paths might be given physically, induced passively

by the system through analysis of the live audio stream, or communicated by means of a brain-computer interface. The latter situation would be an interesting context in which to further develop the distributed sensing technologies proposed by David Rosenboom.[35]

The anamnesic component of the unfolding phenomenon must be different for performer and listener; their experiences are different. We might then posit a notion of empathetic anamnesis, whereby the process is co-experienced even if the source experiences remain opaque to the listener. Anamnesis thus becomes a very efficient form of cultural compression, effectively transferring entire bodies of experience.

Coda

Memory is an active behaviour, a dynamically generated percept conditioned by complex relationships with previous experience, present conditions, and supposed knowledge. As a process it is thus identical with acts of imagination. Both are effectively simulations, projections, however differently interpreted. DeLanda describes simulation as a new form of knowledge generation, as the production of a 'space of possibilities'.[36] The distinction between memory and imagination dissolves in the AI as it works together with a performer in a process of creative anamnesis. Rather than focussing on the autonomous ability of AI systems to fulfil imaginable tasks or solve clearly articulated problems, we might better concentrate on the continuous, fluid, bilateral transfer of knowledge – an osmotic relationship with AI.

This chapter has stressed the need to be conscious of the ways in which our uses of new technologies embody models, practices, and concepts from previous paradigms. At the same time, our thought experiment is essentially polyphonic, and as such contiguous with one of the major contributions of Western Art Music to human thought. As a species we appear to be fiercely proud of our capacity for self-reflection, and yet robustly intransigent in terms of building a useful critical relationship with what we see reflected. Whether as a performance widget or as an engine of socio-cultural transformation, the rich potential or dangerous poverty of what we currently call AI will depend on our own capacity not to replicate or analyse or embody in machines our own behaviour, thought, or so-called imagination, but rather to use such tools to think through these patterns, to reconceive and articulate new sets of values and questions. Whether in terms of the elements and behaviours of music or alternatives to political hegemony, that moment is not near. But that is the work.

A turning point may be a future realisation that this particular technology has been fully assimilated, culturally, conceptually, and technologically

Whether as a performance widget or as an engine of socio-cultural transformation, the rich potential or dangerous poverty of what we currently call AI will depend on our own capacity not to replicate or analyse or embody in machines our own behaviour, thought, or so-called imagination, but rather to use such tools to think through these patterns, to reconceive and articulate new sets of values and questions.

– when it is just part of how we live as humans, operating transparently among our various clouds and not dependent on a perceived relationship between individual and machine. We no longer think of writing as a technology or mathematics as artificial; we do not have to engage with either directly to know that they have become essential parts of our common human operating system. Asking old questions rarely produces knowledge of a new kind. Perhaps one task of art is to ask what kinds of answers are becoming possible, such that this might guide us to asking new and more appropriate kinds of questions.

Notes

1　Hawking, Will Artificial Intelligence Outsmart Us?, 11.
2　Badiou, The Concept of Model, 5–8.
3　Basalla, The Evolution of Technology, 139.
4　Arthur, The Nature of Technology, 179.
5　Briot et al., Deep Learning Techniques for Music Generation.
6　Negarestani, Intelligence and Spirit.
7　McCarthy et al., 'A Proposal', 12.
8　Minsky, Computation, 2.
9　De Condorcet, Sketch for a Historical Picture, 173.
10　Ibid., 181.
11　Ibid., 187.
12　Ibid., 198.
13　Oliveros, Quantum Listening, 47.
14　De Ceuster, 'Noise as Ground in Improvised Music'.
15　Lury, Prosthetic Culture.
16　Lyotard, 'Logos and Techne, or Telegraphy', 48.
17　Ibid.
18　Ibid., 51.
19　Ibid., 54.
20　Plato, Phaedo, 20.
21　Salles et al., 'Anthropomorphism in AI'.
22　Budson et al., 'Consciousness as a Memory System'.
23　Cariani, 'Emergence and Artificial Life'.
24　Rohrmeier, 'On Creativity'.
25　Ibid., 50.
26　Zamyatin, We, 17–18.
27　Agre, Computation and Human Experience; Crawford and Joler, 'Anatomy of an AI System'.
28　Impett, 'Dissociation and Interference in Composers' Stories about Music'.
29　Agre, Computation and Human Experience.
30　Wondimu et al., 'Interactive Machine Learning'.
31　Dennett, Consciousness Explained, 111.

32 Dennett, 'Multiple Drafts', 810.
33 Negarestani, Intelligence and Spirit, 357.
34 Penny, Making Sense, 319.
35 Rosenboom, 'More Than One'.
36 DeLanda, Philosophy and Simulation.

References

Agre, P. (1997). *Computation and Human Experience*. Cambridge: Cambridge University Press.

Arthur, B. (2008). *The Nature of Technology*. London: Allen Lane.

Badiou, A. (2007). *The Concept of Model: An Introduction to the Materialist Epistemology of Mathematics*. Melbourne: re.press.

Basalla, G. (1988). *The Evolution of Technology*. Cambridge: Cambridge University Press.

Briot, J.-P., Hadjeres, G., and Pachet, F.-D. (2020). *Deep Learning Techniques for Music Generation*. New York: Springer.

Budson, A. E., Richman, K. A., and Kensinger, E. K. (2022). 'Consciousness as a Memory System'. *Cognitive and Behavioral Neurology*, 35(4): 263–297.

Cariani, P. (1991). 'Emergence and Artificial Life'. In *Artificial Life II*, edited by C. G. Langton, C. Taylor, J. D. Farmer, and S. Rasmussen. 775–796. Boulder, CO: Westview Press.

Crawford, K., and Joler, V. (2018). 'Anatomy of an AI System: The Amazon Echo as an Anatomical Map of Human Labor, Data and Planetary Resources'. *AI Now Institute and Share Lab*. 7 September 2018. Accessed 3 March 2023. https://anatomyof.ai.

de Ceuster, D. M. (2022).'Noise as Ground in Improvised Music'. In *Noise as a Constructive Element in Music*, edited by Mark Delaere. 178–193. London: Routledge.

de Condorcet, A.-N. (1955 [1795]). *Sketch for a Historical Picture of the Progress of the Human Mind*. London: Weidenfeld and Nicolson.

DeLanda, M. (2011). *Philosophy and Simulation: The Emergence of Synthetic Reason*. London: Continuum.

Dennett, D. (1991). *Consciousness Explained*. London: Penguin.

Dennett, D. (1995). 'Multiple Drafts ... Response to Glicksohn and Salter'. *Behavioral and Brain Sciences*, 18(4): 810–811.

Hawking, S. (2022). *Will Artificial Intelligence Outsmart Us?* London: John Murray.

Impett, J. (2021). 'Dissociation and Interference in Composers' Stories about Music: The Renewal of Musical Discourse'. In *Sound Work: Composition as Critical Technical Practice*, edited by Jonathan Impett. 117–136. Leuven: Leuven University Press.

Lury, C. (1998). *Prosthetic Culture: Photography, Memory and Identity*. London: Routledge.

Lyotard, J.-F. (1990). 'Logos and Techne, or Telegraphy'. In *The Inhuman: Reflections in Time*. 47–57. Cambridge: Polity Press.

McCarthy, J, Minsky, M. L., Rochester, N., and Shannon, C. E. (2006 [1955]). 'A Proposal for the Dartmouth Summer Research Project on Artificial Intelligence'. *AI Magazine*, 27(4): 12–14.

Minsky, M. L. (1967). *Computation: Finite and Infinite Machines*. Englewood Cliffs, NJ: Prentice-Hall.

Negarestani, R. (2018). *Intelligence and Spirit*. Falmouth, UK: Urbanomic Media.

Oliveros, P. (2022). *Quantum Listening*. London: Ignota.

Penny, S. (2017). *Making Sense: Cognition, Computing, Art, and Embodiment*. Cambridge, MA: MIT Press.

Plato. (2002). *Phaedo*. Oxford: Clarendon Press.

Rohrmeier, M. (2022). 'On Creativity, Music's AI Completeness, and Four Challenges for Artificial Musical Creativity'. *Transactions of the International Society for Music Information Retrieval*, 5(1): 50–66.

Rosenboom, D., and Mullen, T. (2019). 'More Than One-Artistic Explorations with Multi-agent BCIs'. In *Brain Art*, edited by Anton Nijholt. 117–143. Cham: Springer.

Salles, A., Kathinka, E., and Farisco, M. (2020). 'Anthropomorphism in AI'. *AJOB Neuroscience*, 11(2): 88–95.

Wondimu, N., Visser, U., and Buche, C. (2022). 'Interactive Machine Learning: A State of the Art Review'. Preprint, Accessed 3 March 2023. https://deepai.org/publication/interactive-machine-learning-a-state-of-the-art-review.

Zamyatin, Y. (1993 [1921]). *We*. London: Penguin.

8

Autonomy, Intention, Performativity: Navigating the AI Divide

Jon McCormack

Introduction

Over the last decade, Artificial Intelligence has been on the rise and the pace of innovation currently shows no signs of slowing. Every few months, or even days, a new, ground-breaking model is released that improves over anything previously known. As technology evangelists keep reminding us, AI is currently the worst it will ever be. Are we now facing an accelerated revolution in AI technology, one that might outpace our ability to control and understand it? How will this impact human creativity and creative practices? Much of the current popular interest around AI is the result of a few large generative machine learning (ML) models, such as OpenAI's GPT-4 and Stability Inc.'s Stable Diffusion. These models use very large artificial neural networks trained on vast corpora of data, learning statistical patterns from the data to build complex representations of information, often with billions of parameters. Some researchers have argued they might be best understood as "Stochastic Parrots" rather than possessing any real intelligence,[1] while others conditionally see "sparks of Artificial General Intelligence" in the most recent models.[2]

After training, these models are able to generate new data based on the statistical patterns they have learnt (hence, they are referred to as "generative models"). Models exist that can synthesise photo-realistic images of people that don't exist,[3] coherent paragraphs of text on any topic,[4] conversion of high-level English language instructions directly to runnable computer code, and most recently, conversion of text descriptions to images,[5] video,[6] and even 3D geometric models.

Systems such as DALL-E 2, Midjourney, and Stable Diffusion allow the generation of detailed and complex imagery from short text descriptions. These text-to-image (TTI) systems allow anyone to write a brief English prompt and have the system respond with a series of images that depict the scene described in the prompt (see Figure 8.1), typically within a few

DOI: 10.1201/9781003312338-12

Portrait of a girl next to a capybara, in the style of a Frida Kahlo painting

(((monkey ((in colorful suit)) sitting on tree branch, dark mysterious forest, dramatic lighting, dark photo, high))), best quality, ultra high res, ((photorealistic:1.4), high resolution, detailed, raw photo, sharp re, by lee jeffries nikon d850 film stock photograph 4 kodak portra 400 camera f1.6 lens rich colors hyper realistic lifelike texture dramatic lighting unrealengine trending on artstation cinestill 800,, photorealistic, photo, masterpiece, realistic, realism, photorealism, high contrast, photorealistic digital art trending on Artstation 8k HD high definition detailed realistic, detailed, skin texture, hyper detailed, realistic skin texture, armature, (8HD, clear, sharp, in focus)), ((national geographic))

Negative prompt: ((person)), ((portrait)), EasyNegative, paintings, sketches, (worst quality:2), (low quality:2), (normal quality:2), lowres, normal quality, ((monochrome)), ((grayscale)), skin spots, acnes, skin blemishes, age spot, glans,extra fingers,fewer fingers, "ugly eyes, deformed iris, deformed pupils, fused lips and teeth:1.2), (un-detailed skin, semi-realistic, cgi, 3d, render, sketch, cartoon, drawing, anime:1.2), text, close up, cropped, out of frame, worst quality, low quality, jpeg artifacts, ugly, duplicate, morbid, mutilated, extra fingers, mutated hands, poorly drawn hands, poorly drawn face, mutation, deformed, blurry, dehydrated, bad anatomy, bad proportions, extra limbs, cloned face, disfigured, gross proportions, malformed limbs, missing arms, missing legs, extra arms, extra legs, fused fingers, too many fingers, long neck", ((3d, cartoon, anime, sketches), (worst quality:2), (low quality:2), (normal quality:2), lowres, normal quality, ((monochrome)), ((grayscale), bad anatomy, out of view, cut off, ugly, deformed, mutated, ((young)), ((blurry, out of focus))

still life with human skulls of different sizes, a rose, the most beautiful image ever seen, trending on art station, hyperrealistic, 8k, studio lighting, shallow focus, unreal engine

FIGURE 8.1
Some example images generated by text-to-image AI systems. The prompt text is shown next to the generated image. Note how more complex text and negative prompts are used to control the overall results.

seconds. Despite being quite recent and still an ongoing development, these systems have become highly popular and an abundance of machine-synthe-sised examples can be regularly found on social media, NFT sites, and other online platforms.

State-of-the-art transformer networks, such as OpenAI's GPT-4, can gener-ate coherent paragraphs of text on any topic. ChatGPT, a "chatbot" built on the GPT-3.5/4 model, allows interaction in a conversational way, much as you might converse with another human. People can engage in an ongoing dia-logue with ChatGPT that allows them to ask follow-up questions; the system "admits its mistakes, challenge[s] incorrect premises, and reject[s] inappro-priate requests", according to its designers. The most recent incarnation at the time of writing, GPT-4, can also analyse images and draw conclusions from them, critique its own output, generate computer code that makes coherent images, even pass exams.[7]

The rapid rise of these models raises many issues, including ethical and moral rights questions. Educators are worried about students using ChatGPT to generate assignment material. Illustrators and artists are concerned about their work being used as part of the vast training corpus without their explicit permission. They are also concerned about people opting for AI versions of work in their style because it is cheaper to acquire than an original artwork. Musicians are anxious about AI-generated music, AIs that can synthesise any human artist's singing voice, AIs that can mix and master a recording without human intervention. There are also concerns about the accessibility

of these models, which require vast computing resources to undertake the training of the neural network, resources that are largely inaccessible to most individuals, businesses, or institutions.

There are also issues around the datasets themselves, such as the use of "data laundering" where large corporations use loopholes in copyright laws to scrape copyrighted data by indirectly paying academic research-ers. Many models are augmented with what is known as "Reinforcement Learning from Human Feedback" (RLHF) where outsourced workers in developing economies are paid to "sit for several hours every day watch-ing videos of harmful content and analyzing textual descriptions of hate speech, sexual violence, bestiality, and violence".[8] Some people have already developed psychological dependencies or been prompted to take real-world action following advice from generative AI systems, including suicide, divorce, or self-harm. As models become even more sophisticated, we are likely to see new forms of human–AI relationships with potentially unsettling results.

In addition to the potential for misuse and moral and ethical questions, there are many broader issues that stem from contemporary AI research for human creativity, artistic practice, and human culture, a number of which I discuss in this chapter.

Artistic Value

The immediate accessibility of many of these models has led many to try them out and – in the case of prompt-based TTI systems for example – post their efforts online as "art". The companies that develop these tools pro-mote them as vehicles of creative accessibility and empowerment. The first release of Stable Diffusion claimed that it "will empower billions of people to create stunning art within seconds", for example. The feeling of nov-elty and creative empowerment is what often drives people to use them initially. It's quick, easy, and inexpensive to create your own impressive digital "art" that looks professional. And you don't have to be an artist; you don't have to learn drawing or illustration, master painting or photogra-phy. But that feeling of empowerment wears off very quickly when you see that anyone can do the same thing and that a lot of the "art" looks similar and derivative. I would argue that we value art and creativity because it has qualities that make it special in human culture: it requires authenticity, intention, originality, deep insight, often great skill, and virtuosity, and it can possibly communicate profound meaning between artist and audience. Current AI/ML systems possess none of these qualities: they are just good statistical mimics, parasitic to human culture.

The Limitations of Linguistic Description

If you could say it in words, there would be no reason to paint.

— Attributed to Edward Hopper

A limitation of any system that attempts to interpret text into another medium (such as an image) is that one must be able to express the desired output linguistically (i.e., *in words*). We need only look at art history to see that this is often very difficult or impossible, particularly – but not exclusively – for non-figurative images. Visual art has often claimed to be able to express the inexpressible[9] – to show through visual media what cannot be directly expressed in words. The works of Mark Rothko, Willem de Kooning, Clyfford Still, and Bridget Riley are examples of this proposition. We note the important difference between an image expressing something that is beyond words and using words to describe a desired image (that may not yet exist). Similar arguments can be made for performative media, including dance (imagine having to describe in words complex human movement and expression!).

In discussing what can be expressed linguistically, we need to differentiate that which cannot be expressed a priori and that which might be expressed a posteriori. For example, phenomenological experiences, kinesthetic and other body-focused experiences cannot be fully expressed linguistically. Individual mental lexicons vary across human populations.[10] Furthermore, one may experiment with language in deriving appropriate text in a TTI system, learning from prior examples or growing one's lexicon in response to working with such systems.

It could be argued that one may be able to create an image "a-la-Rothko" by providing an excruciatingly detailed set of physical instructions, an "iconic" form of representation that could be compared to the lists of commands used in *turtle graphics*, where the meaning of the instructions has no relationship to the perceived meaning of what they produce. The appeal of TTI systems lies in their capability to translate symbolic representations – textual descriptions – into iconic ones – images.[11] However, the way this translation is implemented can be perceived as a limitation in two key ways.

Firstly, any "understanding" that TTI systems have of images is literal, as they are built upon millions of formal descriptions of visual material, where words or descriptive phrases (noun + adjective or verb + adverb pairings) capture the visual identity and characteristics of elements present in an image, their spatial relationships (e.g., "a red flower in a vase", "a human skull on a table"), as well as some more general stylistic features (e.g., "still life", "Unreal Engine", "trending on ArtStation", "cinematic lighting"). Consequently, the images produced by these systems can only literally reflect the content of a prompt. Any further meaning, intention, or encoded information assigned to a specific textual construct, be it metaphorical or culturally specific, will be lost in translation.

The second way an exclusive reliance on text is limiting is when we consider creative practice as a reflective process.[12] As reflective practitioners, designers

A limitation of any system that attempts to interpret text into another medium (such as an image) is that one must be able to express the desired output linguistically (i.e. in words). We need only look at art history to see that this is often very difficult or impossible, particularly – but not exclusively – for non-figurative images.

and artists find novel alternatives by following cues that emerge from the work through their own creative actions. These may include non-textual constructs – diagrams, sketches, motifs, physical movement, kinesthetic, phenomenological, and embodied experiences – that illuminate pathways to what things *could* become, for example by illuminating a new physical or perceptual order.[13] Explicitly verbalising something that has yet to be formalised – i.e., ex ante description – is akin to describing a colour that does not exist.[14]

These limitations go some way in explaining why the majority of images produced by TTI systems are figurative and literal (as seen in the examples shown in Figure 8.1). One might say that these systems are "object-oriented" in that they are trained predominantly on literal descriptions of images or using machine-trained image description technologies, such as CLIP, which identify objects in an image. Such systems have no understanding of metaphor, analogy, or visual poetry; hence, they cannot understand what is "in" an image in the way that a human artist or designer implicitly would.[15]

In summary, the reliance on literal text descriptions of many current AI systems narrows the possibilities for how we creatively work, emphasising the linguistic as the human–machine interface over all other modes of interaction. Even more importantly, the linguistic interface privileges the literal and functional over the poetic and ephemeral.[16]

AI as Parasite

It can be argued that deep learning models trained on large datasets of human culture are *parasitic* to that culture, in that they derive and sustain themselves from human culture, ultimately at the expense of current human culture. In biology, for a relationship between species to be parasitic, the parasite must benefit at the expense of the host. This is different from other relationships, such as symbiosis or mutualism, where both may benefit. The direct dependency of generative AI models trained on human art datasets needs no further clarification, so to justify the claim of parasitism a negative effect on human culture needs to be demonstrated. Hence, if human art is diminished by, for example, TTI generation systems, then the relationship can be justified as parasitic.

These systems reinforce the statistical norms and biases of their training sets through popular interpretations of, for example, language and the images associated with them. Through this reinforcement, a kind of cultural colonisation, biases become normalised, and less popular interpretations are more difficult to specify linguistically and so become more marginalised. Eventually, they may be forgotten or lost. Additionally, the training data is *backward-focused* in that it can learn only from prior, existing imagery (and even more limiting is that this data must be digital and accessible on the internet). Human art is not created ex nihilo. Artists are constantly influenced and inspired by other artists and their work.[17] However, unlike generative AI systems, human artists draw from more than just previous static visual examples to inspire their own creations. Moreover, they don't just synthesise

them from seeing prior examples of "Art". Creation is rooted in experience,[18] which includes experiences of emotion, feeling, mindset, and other attributes that are difficult to convey linguistically.

Additionally, while TTI systems can generate "new" images (in the sense that the particular image has not existed before), they are all statistical amalgamations of pre-existing images, precluding the possibility of stylistic innovation, let alone any conceptual innovation. In the terminology of Boden, they support only combinatorial creativity (the [re-]combination of existing elements), not transformational creativity (where elements are transformed into something new).[19] In simple terms, TTI systems could not "invent" Cubism if they were only trained on data prior to 1908, yet this was possible for human artists.

If generative AI systems become an increasingly significant part of cultural production – which the current monetary investments and opportunities suggest they will – it is possible that human art and creativity will be diminished for the reasons given above. Moreover, if such systems replace human creators, the pool of human talent able to competently illustrate, compose, photograph, design, or create may diminish as paying a human creator is less viable commercially than using an AI. Hence the use of the term "parasitic" in understanding the role of large generative AI models on human culture.

Parasitic Meaning

This idea – that generative computer algorithms that mimic human art are "parasitic" – isn't new. The philosopher Anthony O'Hear formed this view almost thirty years ago.[20] O'Hear considered computer programs that could generate art similar to human art, first emphasising the need to understand that appreciation of visual art, for example, was more than just the consumption of visual images. An important criteria of something being considered "art" meant that there was a direct connection between art as a product and its "history or mode of production".[21] Hence, art was *more* than just pleasant visual appearances or surface aesthetics; it relied on human *intention*: the intention to engender a particular experience, to communicate an idea, or elicit a particular emotional response. O'Hear conceded that not *every* work of art necessarily achieved this; there may be ambiguity or some other failure where the intention wasn't realised for the work's audience. Nevertheless, in O'Hear's view, this intention and authenticity were necessary conditions for something to be considered "art", as opposed to the more general class of visual images that saturate contemporary life.

O'Hear specifically considers the possibility of computer-generated works of art that "drew on repertoires derived from existing works, but which were not copies of any complete works".[22] He argues that any meaning(s) attributed to them come from those that originated through human thought. Hence, they "would be parasitically meaningful, deriving their meanings from the techniques and conventions which human artists had developed in their works".[23]

It is not that generative AI systems are unable to communicate human intention, rather that much (or all) of that intention is derived from pre-existing human art; hence, any meaning inferred is parasitic, in O'Hear's sense of the term. The author of the prompt that generated an image may also have some intention (the intention to make a "beautiful" image, to combine or juxtapose unlikely elements, to create something that mimics an existing human style, even to convey a particular feeling or mood, or to explore the psychological), but this intention can only ever be peripherally enacted in the image itself, since it is the generative AI system, not the prompt author, that is actually making the image.

Generative AI as a Creative Medium?

> AI image generators enable people without photographic training to produce photo-like images that they could never have made otherwise. Inevitably, competitions are going to be flooded with AI-generated images.
>
> — *Boris Eldagsen*

The arguments presented here do not preclude generative AI models from being a valid medium for creative expression. In fact, as artist Boris Eldagsen recently demonstrated, generative AI models can win serious professional photographic competitions. Eldagsen, a professional photographer with over thirty years of experience, recently turned to using AI image generation as a way to further explore his "philosophical and psychological approach, travelling inwards".[24] Eldagsen's AI-generated series, *Pseudomnesia*, made headlines all over the world when an image from the series ("The Electrician") won first prize in the 2023 Sony World Photography Awards open competition.

Eldagsen did not declare when entering the competition that the "photograph" was AI-generated, although the rules for the category in which he entered did not specifically exclude them. Controversy ensued when eventually the image's origins were publicly exposed. Eldagsen refused to accept the award and associated prize money, stating, "AI images and photography should not compete with each other in an award like this. They are different entities. AI is not photography. Therefore, I will not accept the award".[25]

As this example demonstrates, AI-generated images are seemingly here to stay, and their impact on our understanding of creativity and the creative process is likely to be further challenged. Introducing a new category of medium (AI-generated art) is likely to be only a temporary panacea, as AI systems become more intimately entwined with all creative practices. For example, photographic cameras themselves now incorporate increasingly sophisticated AI systems that adjust and change the image and make decisions for the photographer. It is not unrealistic to imagine that AI synthesis may eventually be built into cameras, allowing them to synthesise parts of the image that don't exist, stylise or change an image as it is captured.

The author of the prompt that generated an image may also have some intention (the intention to make a "beautiful" image, to combine or juxtapose unlikely elements, to create something that mimics an existing human style, even to convey a particular feeling or mood, or to explore the psychological), but this intention can only ever be peripherally enacted in the image itself [...].

Can AI Push the Boundaries of Human Creativity?

In a recent online panel discussion, "Post-human Creativity: The Use of AI in Art", arguments were made to strengthen "interactions between humans and machines … instead of making technology more human" so as to preserve "meaningful interactions with algorithms and push the boundaries of creative processes".[26] It is indeed interesting to question if we are entering a new era of "post-human creativity", one in which machines are "genuine" contributors to new forms of creativity rather than just statistical mimics of prior human efforts. Hence, we should consider if AI technologies can currently, or have the potential to in the future, "push the boundaries of the creative process".

Historically, technology has always had an impact on human creativity, from the chemistry of paint pigments to the mechanical eye of the cinematic camera, from the discovery of resonant chambers to the online recommender systems that determine our listening or viewing playlists. Technology is and always has been undoubtedly a driver of creative change and new possibility.

However, while it can be argued that past technological change largely determined the shape and possibilities of creative *tools*, those tools are manipulated by human intention and agency. More recently, we've come to recognise that this agency doesn't solely reside in the human. Even though we might think of them as objects that we control and manipulate, these tools and the materials we work with have their own agency, or as the anthropologist Malafouris sees it, agency and intentionality "are the properties of material engagement, that is, of the grey zone where brain, body and culture conflate".[27]

While they lack the materiality of prior creative media, emerging ML and AI systems can learn and change, giving them their own unique kind of agency that is different from anything we have encountered as a species previously. In this sense, they move beyond being tools that are passive until manipulated by human hands, and execute their own agency at a global scale. Aside from the aforementioned ethical issues that current technologies raise, there are a number of warning signs that should be acknowledged. Large "foundational" models require large financial investments. Microsoft invested $1 billion in OpenAI after it switched from being a not-for-profit, "open" research company to a closed, for-profit one. OpenAI does not make its models publicly available, presumably hoping to recoup Microsoft's (and earlier investors') billions through subscription use of its models. It does not generally publish or make available its training data, simply stating it comes from the internet and other sources that the company has licensed (presumably copyrighted content that might not be so readily accessible on the internet), making the models difficult or impossible to reproduce easily.[28]

In general, the companies behind these large foundational models push a view of creativity rooted in late capitalist ideals of efficiency, productivity, cost-effectiveness, and automation, sugar-coated in the rhetoric of personal empowerment and technological advancement for its own sake. As many have argued previously, these ideals are often at odds with artistic views of human creativity. Why would we want to automate something that brings such innate enjoyment to both creator and audience? Culture isn't static, it evolves and changes through the nexus of people, technology, and environment. But how culture changes is increasingly important, particularly as the trend is towards homogenisation and loss of diversity – something that current generative AI models only encourage.

In the popularised narrative, technological progress is inevitable and we should either embrace it or step aside and let advocates direct advances towards their Utopian vision. So it seems there are historical, political, and cultural reasons why new AI technologies will "push the boundaries of the creative process", but in what directions is it likely to be pushed and what existing practices might be diminished by this coming revolution? Will a new era of machine-driven creativity be worth the cost of their loss?

The Anthropomorphic View of AI

"An infant learns about a wooden block by touching it, tasting it, banging it onto the desk to see what sound it makes, and looking at it from all different sides. Through thousands of interactions like these, a child begins to develop a sense of her world and an awareness of herself as part of it".[29] Perhaps many of the troubles of AI are rooted in the name itself. As Kate Crawford points out, AI is neither artificial nor intelligent.[30] In a recent paper, Murray Shanahan, a professor of cognitive robotics at Imperial College, points out that the way we currently talk about "Large Language Models'" (such as GPT-4) is rife with "philosophically loaded terms" – a product of our natural tendencies to anthropomorphise the non-human.[31] We use terms like "knows", "believes", and "thinks" to describe AI systems, implicitly implying that such terms apply in the same way as they do to people. But nothing could be further from the truth – current ML and AI technologies are not intelligent in the way humans (or indeed other animals) are.

For example, if I ask ChatGPT, "Who was the first person to walk on the moon?", it responds with "Neil Armstrong", not because it knows what the moon is, or who Neil Armstrong is, or even what walking is. It's just that statistically, given the sequence of tokens "Who was the first person to walk on the moon?" the most likely next tokens are "Neil Armstrong". This is not knowledge in the sense that a person "knows" or "believes" something;

In general, the companies behind these large foundational models push a view of creativity rooted in late capitalist ideals of efficiency, productivity, cost-effectiveness, and automation, sugar-coated in the rhetoric of personal empowerment and technological advancement for its own sake.

it's just the statistical patterning of language that the model has learnt from being trained on a vast corpus of text from the internet.

This is not how humans, or indeed any other biological species, learn. Our knowledge emerges from "the exploratory manipulation of the physical world".[32] We are embodied, situated, curious enactors with the physical world within which we are embedded. Our "training" comes from being in the world. The meaning of words is derived through these interactions, not just their statistical probability of being the next token uttered given the previous set of tokens.

Hence, as the current crop of AI systems, built on foundational models, do not possess this kind of knowledge, it seems impossible that we can consider them intelligent in the ways that humans are, or as having an agency that we might associate with biological life. An AI model cannot decide to be an artist, or indeed decide to be anything – it has no wants, desires, memories, or experiences (despite, somewhat ironically, often claiming that it does). It does not know or understand the world in the way that we do. So, for the time being, we should not consider them intelligent, nor artists.

Issues of embodiment have long been discussed in AI research, but the issues I've just referred to extend beyond just embodiment. Interacting with the world is not as simple as putting an AI model in a robotic "body" and attaching a camera so it can "see" the world, or other sensing devices. We evolved over millions of years to fit the environment; we sense and interact with the world in highly specific (and limited) ways that have been shaped by evolution over many thousands of generations. Sensing is not a direct representation of reality: it involves compromises and projections – hallucinations[33] – that are just good enough for us to survive and reproduce.

Another important point of differentiation between biological species and AI systems is their "intentional stance",[34] the idea that living beings act with some form of *intention*. Current large AI models don't possess this intention, at least not in the sense of Dennett. An AI does not intend to embarrass you, to shame you, to love you or make you feel better, although these are some of the many ways an AI system may affect you. An intention comes from the statistical association of words, abstracted from the human, lived, physical context in which they were made (in which, if a human made them, they probably did have intention).

As discussed earlier, an AI cannot decide to be or not be "an artist" in the way that a human can. Yet an AI can do things we think of as creative and it does have agency in the world. In my view, this is what makes them most dangerous and unpredictable, because we cannot (in the Machiavellian sense) put ourselves "inside the mind" of this other, to understand its motivations and intentions, simply because it has none. This is dangerous because if we grant an AI real-world agency (either via text interactions with humans, or the ability to more directly impact the world, such as the control of physical objects or systems, or by being embedded in robots, for example), then the AI cannot act with intention (malevolent or benign) towards us, leaving it open to act in *any* way. Predicting or reasoning with an entity that lacks any specific intentions is likely to be extremely difficult.

Beyond Anthropomorphism

If we abandon the idea that AI systems have any form of intelligence or intention that is like human intelligence or intention, we are left to consider other issues, such as: Can AI systems be creative? How might they push the boundaries of the creative process? What role do they now play (or might they play in the future) in human culture?

One possibility is to consider AI models as a continuation of a long line of human (and other biological species) embedding of memory in their environment. From simple marks on a papyrus sheet, to tying a string on your finger, to writing, mechanical printing and reproduction, photography and cinema – we have always manipulated our environment to offload cognition and memory to it (and therefore our stories and narratives of human culture). As a continuation of this, AI models offload our species' collective memories, knowledge, and ideas, encoding them as a statistical model. However, these models go beyond mere representation or storage, because they can synthesise data not present in the original dataset on which they were trained. So they can generate new images, new knowledge, and new ideas that are very much like human imagery or ideas but have not previously been made by a person. So I would argue that they are creative, but in a highly limited and constrained way, and certainly not in the ways that humans can be – and are – creative.

Will current models ever become useful creative tools? Current results seem to suggest they are well placed to enter the commercial cultural vernacular, but any concrete speculation is difficult due to the seemingly rapid changes in both models and their applications. This is quite different from previous technological changes which ratcheted the technological base onward.[35] A professional photographer from one hundred years ago transported to the present day would presumably be able to use a modern digital camera, as the basic principles have changed only minimally since photography's invention (and of course the basic principles of optics haven't changed at all). Current ML and AI models offer a much more rapid technological change in terms of both capability and application.

The Performative Capacity of AI

As this book is focused on the performative capacity of AI, it is important to reflect on this most poignant point: that current developments rely on disembodied data, largely scraped from the internet. This view of AI goes against what anyone involved in the performative arts intuitively knows: that embodied skills, situated cognition, embedded interaction, physicality,

and materiality all matter, and they matter deeply since they are a funda-
mental part of being a thinking, intelligent human who is in the world.

While the data that is relatively easily scraped from the internet to train
current AI models is disembodied and de-contextualised from its origins, a
contextualised, physical body was required to create it in the first place. Until
now, every photograph, illustration, diagram, film, song, poem, script, or
score was created through an embodied process. But now we are at an inflec-
tion point of the machine age where software, with no knowledge or under-
standing of what it is like to have a body, to live a life, to experience *anything*,
is able to mimic human creativity and culture, and hence, contribute to it.
While this has always been possible since the advent of the machine age,
previous contributions were relatively minor (e.g., there were many orders
of magnitude more real photographs than computer-synthesised ones). With
generative AI, it seems possible to culturally flood our world with images,
words, or indeed deeds that originate from a machine with no knowledge or
understanding of their meaning or cultural significance, only their statisti-
cal probability gained from training sets. As discussed previously, current
generative AI systems lack intention, but the humans operating them do not.
This is where we should now be focusing our attention.

Notes

1 Emily M. Bender et al., "On the Dangers of Stochastic Parrots".
2 Sébastien Bubeck et al., "Sparks of Artificial General Intelligence". It should
 be noted that the authors of this paper are employees of Microsoft, which
 has a considerable financial investment in OpenAI, the company that created
 GPT-4. Additionally, the authors are clear that "while GPT-4 is at or beyond
 human-level for many tasks, overall its patterns of intelligence are decidedly
 not human-like".
3 Tero Karras, Samuli Laine, and Timo Aila, "A Style-Based Generator
 Architecture".
4 Ashish Vaswani et al., "Attention Is All You Need".
5 Aditya Ramesh et al., "Hierarchical Text-Conditional Image Generation".
6 Uriel Singer et al., "Make-a-Video".
7 Bubeck et al., "Sparks of Artificial General Intelligence".
8 Faustine Ngila, "OpenAI Underpaid 200 Kenyans".
9 E. H. Gombrich, *The Story of Art*.
10 For example, a twenty-year-old native English speaker's vocabulary may range
 between approximately 27,000 to 51,000 lemmas.
11 Onur Hisarciklilar and Jean-François Boujut, "Symbolic vs. Iconic".
12 Donald A. Schön, *The Reflective Practitioner*.
13 Christopher Alexander, *Notes on the Synthesis of Form*.
14 Nelson B. McNeill, "Colour and Colour Terminology".

15 These limitations have been extensively documented in previous deep learning AI systems, a classic example being the painting by Magritte, *La Trahison des Images*.

16 Although, one might argue complex prompts contain a new kind of "poetic", something that the authors themselves may not be consciously aware of.

17 Cynthia Close, "From Hines to Christo".

18 John Dewey, *Art as Experience*.

19 Boden, *The Creative Mind*.

20 Anthony O'Hear, "Art and Technology".

21 Ibid.

22 Ibid.

23 Ibid.

24 Alasdair Foster, "Boris Eldagsen".

25 Ibid.

26 Alayt Issak, "Artistic Autonomy in AI Art".

27 Lambros Malafouris, "At the Potter's Wheel".

28 However, many efforts are underway to create open-source versions of large models such as GPT-4. Training these models requires very large amounts of training data, such as "The Pile", an 825GiB English text corpus that contains copyrighted material. See Leo Gao et al., "The Pile".

29 Jason Ananda Josephson Storm, *Metamodernism*, 198.

30 Crawford, *Atlas of AI*.

31 Shanahan, "Talking about Large Language Models".

32 Storm, *Metamodernism*, 198.

33 The term "hallucinations" has been adopted by the machine learning community as a way of describing generative AI systems giving results that do not match reality, i.e., giving false information, but the system cannot distinguish between its hallucinations and other responses, so in effect everything the system produces is an hallucination.

34 Daniel C. Dennett, *The Intentional Stance*.

35 The "ratchet effect" is based on the idea of a mechanical ratchet wheel, where the ratchet mechanism clicks into a toothed gear with each incremental forward rotation, preventing it from moving backwards. This effect is observed in many areas of development where once a specific event has occurred it opens possibilities that are difficult or impossible to undo. A common example is found in genetics (known as "Muller's Ratchet") where dangerous genetic mutations accumulate without recombination.

References

Alexander, C. (1964). *Notes on the Synthesis of Form*. Cambridge, MA: Harvard University Press.

Bender E. M., Gebru, T., McMillan-Major, A., and Shmitchell, S. (2021). "On the Dangers of Stochastic Parrots: Can Language Models Be Too Big?" *Proceedings of the 2021 ACM Conference on Fairness, Accountability, and Transparency*, 610–623. New York, NY.

Boden, M. A. (1991). *The Creative Mind: Myths and Mechanisms*. New York: Basic Books.

Bubeck, S., Chandrasekaran, V., Eldan, R., Gehrke, J., Horvitz, E., Kamar, E., Lee, P., Lee, Y. T., Li, Y., Lundberg, S., Nori, H., Palangi, H., Ribeiro, M. T., and Zhang, Y.. (2023). "Sparks of Artificial General Intelligence: Early Experiments with GPT-4". *ArXiv:2303.12712[cs.CL]*. https://doi.org/10.48550/arXiv.2303.12712.

Close, C. (2022). "From Hines to Christo: How Artists Influence Other Artists". *Art and Object*. 14 February 2022. https://www.artandobject.com/articles/hines-christo-how-artists-influence-other-artists.

Crawford, K. (2021). *Atlas of AI: Power, Politics, and the Planetary Costs of Artificial Intelligence*. New Haven and London: Yale University Press.

Dennett, D. C. (1987). *The Intentional Stance*. Cambridge, MA: MIT Press.

Dewey, J. (1959). *Art as Experience*. New York: Capricorn Books.

Foster, A. (2023). "Boris Eldagsen: The Woman Who Never Was". *Talking Pictures*. 1 April 2023. https://talking-pictures.net.au/2023/04/01/boris-eldagsen-the-woman-who-never-was/.

Gao, L., Biderman, S., Black, S., Golding, L., Hoppe, T., Foster, C., Phang, J., He, H., Thite, A., Nabeshima, N., Presser, S., and Leahy, C. (2020). "The Pile: An 800GB Dataset of Diverse Text for Language Modeling". *ArXiv preprint arXiv:2101.00027*.

Gombrich, E. H. (1995). *The Story of Art*. 16th revised, expanded, and redesigned edition. Englewood Cliffs, NJ: Prentice-Hall.

Hisarciklilar, O., and Boujut, J.-F. (2008). "Symbolic vs. Iconic: How to Support Argumentative Design Discourse with 3D Product Representations". *IDMME-Virtual Concept 2008*, 3: 1–8.

Issak, A. (2021). "Artistic Autonomy in AI Art". *Workshop Presented at the 35th Conference on Neural Information Processing Systems (NeurIPS 2021)*, Sydney, Australia.

Karras, T., Laine, S., and Aila, T. (2018). "A Style-Based Generator Architecture for Generative Adversarial Networks". *ArXiv:1812.04948[cs.NE]*. https://doi.org/10.48550/arXiv.1812.04948.

Malafouris, L. (2008). "At the Potter's Wheel: An Argument for Material Agency". In *Material Agency: Towards a Non-anthropocentric Approach*, edited by Carl Knappett and Lambros Malafouris. 19–36. New York: Springer Science and Business Media.

McNeill, N. B. (1972). "Colour and Colour Terminology". *Journal of Linguistics*, 8(1): 21–33.

Ngila, F. (2023). "OpenAI Underpaid 200 Kenyans to Perfect ChatGPT-Then Sacked Them". *Quartz*. 19 January 2023. https://qz.com/open-ai-underpaid-200-kenyans-to-perfect-chatgpt-1850005025.

O'Hear, A. (1995). "Art and Technology: An Old Tension". *Royal Institute of Philosophy Supplement*, *38*: 143–158.

Ramesh, A., Dhariwal, P., Nichol, A., Chu, C., and Chen, M. (2022). "Hierarchical Text-Conditional Image Generation with CLIP Latents". *ArXiv:2204.06125[cs.CV]*. https://doi.org/10.48550/arXiv.2204.06125.

Schön, D. A. (1984). *The Reflective Practitioner: How Professionals Think in Action*. New York: Basic Books.

Shanahan, M. (2023). "Talking about Large Language Models". *ArXiv preprint*. https://arxiv.org/abs/2212.03551.

Singer, U., Polyak, A., Hayes, T., Yin, X., An, J., Zhang, S., Hu, Q., Yang, H., Ashual, O., Gafni, O., Parikh, D., Gupta, S., and Taigman, Y. (2022). "Make-a-Video: Text-to-Video Generation without Text-Video Data". *ArXiv preprint arXiv:2209.14792*.

Storm, J. A. J. (2021). *Metamodernism: The Future of Theory*. Chicago, IL: University of Chicago Press.

Urbina, F., Lentzos, F., Invernizzi, C., and Ekins, S. (2022). "Dual Use of Artificial-Intelligence-Powered Drug Discovery". *Nature Machine Intelligence*, 4(3): 189–191.

Vaswani, A., Shazeer, N., Parmar, N., Uszkoreit, J., Jones, L., Gomez, A. N., Kaiser, Ł., and Polosukhin, I. (2017). "Attention Is All You Need". In *Advances in Neural Information Processing Systems 30*, edited by I. Guyon, U. Von Luxburg, S. Bengio, H. Wallach, R. Fergus, S. Vishwanathan, and R. Garnett.

9

Interaction Grammars: Beyond the Imitation Game

Artificial Intelligence as a research project has as its founding myth the notion that mimicry and intelligence are indistinguishable. The imitation game was first proposed by Alan Turing in 1950 when he posed the question, 'Can machines think?'.[1] In Turing's proposal, a man (A) and a woman (B) are to be distinguished on the basis of their gender by an interrogator (C), who has access to an unspecified disembodied interface with which to ask them any questions they may choose. A machine roughly equivalent to a digital computer is conjectured to take the place of A in an attempt to fool C into thinking not that they are human, since that is taken as a given in the context of the game, but simply that they are more likely to be a woman than a man. The binary logic of this rather awkwardly gendered classification task can be interpreted as an expression of the Boolean algebra which was taken to undergird the digital nature of computation at the time, but Turing's formulation also poses the question of 'passing' in a given role, emphasizing the performativity of speech acts as central to intelligent behavior—intelligence becomes synonymous with escaping the masculinization of the subject. The question of whether machines are capable of thought was substituted by Turing by whether a machine has the ability to perform well in the imitation game, and in various forms this has served as a yardstick for Artificial Intelligence (AI) research for almost seventy years. In later incarnations the scheme is simplified but remains gendered, such as in the case of the early natural language processing system named ELIZA, developed at MIT in 1964.[2] In this context, the AI takes the role of a female psychotherapist who is trying to 'pass' as a human in a textual conversation framed as a therapy session. There are two obvious criticisms, besides the reading from gender theory, one can make of Turing's proposal; in the first, one can point out that one is testing the human as much as the machine, since it is the human's ability to discriminate which is subject to judgement; in the second, one can attack the notion that imitation is a sufficient basis on which to ground a claim towards intelligence.

DOI: 10.1201/9781003312338-13

Only recently has the advent of large language models (LLMs) exposed the limitations of imitation as a general strategy for reasoning, prompting a discipline-wide backlash against mimicry as the arbiter of intelligence. In an influential paper co-published by over three hundred prominent computer scientists entitled 'Beyond the Imitation Game', a new suite of benchmarking tools has been presented for evaluating the capacities of AI models, including the AI's causal, counterfactual, logical and analogical reasoning, compositionality, and emotional understanding, as well as a range of abilities bracketed under the rubric of 'common sense'.[3] In another prominent proposal, an Abstraction and Reasoning Corpus (ARC) has been proposed by computer scientist François Chollet, consisting of a range of visual and spatial reasoning tasks designed to act against the simple scaling of training data as an effective learning strategy.[4] In Chollet's view, prior understanding should inform the evaluation of a model, rewarding the performance of those requiring less exposure to a context and thus fewer examples to complete a task. Intelligence in this sense is a measure of an agent's ability to track new patterns with limited contextual input, not a question of tuning a large model with endless training data. Chollet's formulation, however, does not begin to broach the gap in deductive reasoning present in contemporary deep learning models, which struggle with even rudimentary arithmetic, to give but one example. The impasse concerns the leap from statistical Bayesian belief formation to more formal notions such as norms, rules, axioms, or laws, in turn emphasizing the importance of holding a commitment, following a rule, obeying a law, or simply upholding a conviction in one's reasoning. Moreover, the kind of capacities we bracket under the term 'common sense' seem to skirt this boundary between the formal and informal in a manner which often escapes the grasp of LLMs altogether. This divide, between statistical inference and what I would call a *world model*, may represent the biggest technical challenge to AI, summoning the image of hybrid models capable of integrating the symbolic tradition with so-called *model-free* approaches such as deep learning.

We might pause to ask what has prompted such a shift away from Turing's imitation game, at the very moment when LLMs are reaching a general audience for the first time. The turning tide appears to be associated with a consensus within computer science that a general mastery of imitation has been achieved by deep learning at the expense of a range of abilities we might nevertheless expect to find in an intelligent agent. Broadly speaking, the seams of LLMs are exposed whenever our interrogation is able to open up a fissure between prediction and explanation. As models that predict the next token in a sentence, LLMs are probabilistic machines bound by a Bayesian conception of knowledge, which is in turn conditioned by an inductive view of logic. In this connectionist scheme, statements are forged as probability distributions over expected

sequences given the context of a conversation, conditioned by a corpus of training data taken as a 'given'. Belief formation in the Bayesian view is portrayed as no more than probabilistic association over priors. Statistical inference of this kind is susceptible to the various critiques that have been levelled at empiricism as a general epistemic framework, a rich philosophical discourse dating back to Kant. The bind that this presents to positivist conceptions of knowledge and indeed to objectivity as such was concisely summarized by Kuhn in his analysis of scientific development:

> Are theories simply man-made interpretations of given data? The epistemological viewpoint that has most often guided Western philosophy for three centuries dictates an immediate and unequivocal, Yes! In the absence of a developed alternative, I find it impossible to relinquish entirely that viewpoint. Yet it no longer functions effectively, and the attempts to make it do so through the introduction of a neutral language of observations now seem to me hopeless.[5]

Besides the rich literature in indigenous epistemology, I will track some meaningful alternatives to this bind through the work of Wilfrid Sellars, perhaps the foremost critic of empiricism in post-war analytic philosophy. For now, the distinction between prediction and explanation can be elucidated by a simple example: a range of organisms (including but not limited to humans) are competent at tracking projectiles, but an agent does not require a causal theory of gravity, or indeed a knowledge of mathematics, in order to exhibit such a capacity. Indeed, it is our acute ability to perform prediction as an integral aspect of our perceptual apparatus that makes the catching of a projectile a relatively effortless—one could even be tempted to say 'mindless'—task. But to answer counterfactual questions about hypothetical projectiles and their behavior in myriad contexts, one requires an explanatory theory of some sort. Without such a causal model one is entirely unable to grasp the notion of possibility and of navigating modal claims as such. It is a key insight of Sellars's thought that a sense of the 'bounds' of possibility be considered integral to our discursive abilities, an insistence that seemingly banal observational statements upon closer inspection open out onto a landscape of normative commitments via this modal apparatus. This enmeshing of normativity and modality in our understanding of how the world hangs together is what Sellars calls the 'space of reasons', a metaphor which I will seek to develop into the notion of a *world model*.[6] An elementary critique of deep learning along such lines is to be found within the field of computer science itself, in the work of Judea Pearl, and it is my aim to elaborate this into a fully fledged philosophical position via a reading of Sellars and in particular his view on inferential roles.[7] Along the way, we will be forced to reconsider the precise manner in which the material realm of causes engages the logical space of reasons, occasioned by the coming together of logic and matter enacted by computation.

Interaction Machines

In short, the attempt to recalibrate the course of AI away from imitation can be framed as the maturing of a research program, but it should also be considered a symptom of the field's blinkered notions of intelligence to date. An important and perhaps overlooked aspect of Turing's conception of intelligence is the emphasis on interaction as a challenge to computation, and in this regard, we should be careful not to throw the baby out with the bathwater, so to speak, when re-evaluating notions of intelligence. As early as 1937, Turing had considered *choice machines* as machines 'whose motion is only partially determined by the configuration. ... When such a machine reaches one of these ambiguous configurations, it cannot go on until some arbitrary choice has been made by an external operator'.[8] This was offered as an admission that axiomatic extensibility was conspicuously lacking in his original proposal of a universal machine. The monotonic reasoning of a machine adhering to a preconceived set of primitive rules, interpreted through the lens of Boolean logic, would seem to curtail any notion of intelligence that might emerge thence. I will argue for a move away from such an interpretation, enabling a shift from static axiomatics toward an inferential dynamics of computation, in order to conceive a path forward for artificially intelligent systems unbound from such a strict epistemic straitjacket. The question of interaction, which leads us back to the Hegelian view of reason as a dialectical movement, is a challenge to fundamental assumptions made by computation about the nature of input and output in decision procedures. This has led figures such as Peter Wegner and Dina Goldin to question Turing machines as a universal model of computation, proposing *interaction machines* as a new model capable of integrating a recursive self-definition in terms of rewriting rules. As Wegner notes,

> This conceptualization of computation allows, for example, the entanglement of inputs and outputs, where later inputs to the computation depend on earlier outputs. Such entanglement is impossible in the mathematical worldview, where all inputs precede computation, and all outputs follow it.[9]

Such machines would correspond to their own *interaction grammar*, sitting at the top of the hierarchy of generative grammars first sketched out by Chomsky, above those context-free grammars that correspond to Turing machines.[10] This correspondence between classes of automata and generative languages acts as a canonical means of evaluating the linguistic capacities of any given automata, leading Wegner to posit a new set of affordances for interaction machines. As Teuscher and others have pointed out, however, there is no empirical method of verifying that a computation extends beyond the rewriting of an infinite tape as presented by Turing, and any appeal to such a form of hypercomputation should be treated as simply unscientific.[11]

In its original conception, the Universal Turing Machine (UTM) has recourse to a single input/output tape that acts in both capacities, and any cell can be rewritten by a program. While I consider Wegner's appeal to hypercomputation beyond a UTM to be misguided, the attempt to reconsider the nature of input and output in computation is productive in its scope, as is the challenge to the Chomskian view that computation's grasp of language be restricted to generative grammars. In the theory of programming languages, the canonical interpretation of input comes from Dana Scott, a student of Alfred Tarski, and it asserts that the domain and range of a function *denote* its input and output. This denotational semantics extends what Wegner calls the 'mathematical worldview', and I will follow him in attempting to mount a challenge to this particular semantic framing of computation.

Taking interaction as a guiding theme, I aim in what follows to summarize three noteworthy critiques of AI—from phenomenology (Dreyfus), pragmatism (Brandom), and the aforementioned view from inferentialism (Sellars)—in an attempt to consider the aesthetics of deep learning models and the notion of intelligibility that they (re)present to us. This attempt to render the epistemic capacities of AI will focus on interaction, agency, and the performativity of intelligence. Along the way I will present a challenge to the central position of denotational semantics and Boolean logic in theories of computation. As a case study, I will consider the family of models known as *latent diffusion*, discussing how notions of conceptualization and creation are present in our interactions with said models, specifically in the context of art production.

Hubert Dreyfus first formulated his critique of AI after visiting the cybernetician Marvin Minsky's lab at MIT in 1964. This produced the influential book *What Computers Can't Do*, in which he formulated the first comprehensive criticism of what he called 'artificial reason'. In Dreyfus's mind, AI research had neglected three key areas in its pursuit of intelligent systems, namely 'the role of the body in organizing and unifying our experience of objects, the role of the situation in providing a background against which behavior can be orderly without being rulelike, and finally the role of human purposes and needs in organizing the situation so that objects are recognized as relevant and accessible'.[12] This phenomenological critique begins with an emphasis on the embodied nature of cognition, from attentional modulation to multi-modal sensory input. It then proceeds to argue for a gestalt theory of the totality of a situation, providing the frame for a figure to become the object of perception against a ground. Dreyfus uses this holistic situational theory to approach the question of informal order over rule-following behavior, a discussion in which he refers to Wittgenstein's rule paradox, citing it as a warning against symbolic approaches in the face of indeterminacy. We can follow Kripke in interpreting Wittgenstein's argument as a form of epistemic skepticism: one cannot know when a given rule is being followed since an agent may change their behavior at any future point in time, betraying the notion that a rule was in play all along.[13] As Wittgenstein puts it, 'no course

of action could be determined by a rule, because every course of action can be made out to accord with the rule'.[14] It follows that intentionality of this sort is not interpretable in any meaningful sense, not even reflexively 'within' one's own inner sense of cognition. Wittgenstein concludes that following a rule can only ever be a socially defined behavior, as he neatly summarizes in §202 of the *Philosophical Investigations* (PI):

> That's why 'following a rule' is a practice. And to *think* one is following a rule is not to follow a rule. And that's why it's not possible to follow a rule 'privately'; otherwise, thinking one was following a rule would be the same thing as following it.[15]

For Kripke, this forms the kernel of Wittgenstein's attack on the notion of a 'private' language. In this sense, the challenge to intentionality posed by the argument is intertwined with a skepticism regarding an agent's ability to assert the existence of a rule or law guiding their behavior. Such forms of skepticism are taken by Dreyfus as a justification for defending a more provisional form of reasoning than that approximated by the formal symbolic approaches in AI at the time, with a view to mastering the advanced forms of pattern recognition that seemed to elude Minsky and his colleagues at MIT. This aspect of Dreyfus's critique will strike the reader as out of date, preempting the eschewing of symbols decades later by deep learning models, which have proven to perform well at a range of pattern-recognition tasks in the absence of domain-specific axiomatic laws or logical priors. While Wittgenstein's argument may be interpreted as an attempt to sever any link between normativity and rationality in theories of mind, the capacity to develop commitments to norms stands as a central pillar in the Sellarsian viewpoint, which I will defend as an antidote to skepticism. Moreover, the distinction between a private rule and a common norm shared by discursive language-bearing agents forms the crux of the response from pragmatism represented by the Brandomian critique.

But there is another potential course out of the aporia presented by skepticism. As Meredith Williams argues, we can consider the staged 'failure' of philosophy to provide solid foundations for acts of knowing in the PI as a way to approach the problem of 'normative similarity'.[16] While for Sellars, semantics is ultimately rooted in inferential roles, Wittgenstein emphasizes 'the use of expressions in concrete situations', but for both, 'the philosophical notion of reference, as that which fixes meaning, is a mistake'.[17] This diagnosis clears the way for a synthesis of the two views, allowing Williams to consider the initiate learning scheme centered on language games in the PI as a way of fixing the 'normative bedrock' without which 'there would be no space of reasons for the agent to enter'.[18] In this view, Wittgenstein is a normative naturalist of sorts, and a path is cleared for the reconciliation of skepticism and inferentialism. I will argue similarly for a resolution of these epistemic views as a requirement for interpreting intelligence as an inhuman vector, which is to say for the task of re-cognizing intelligence.

For the last of the three key areas ignored by early AI, Dreyfus leans on the Heideggerian distinction between objects that appear as present-at-hand (Vorhandenheit) and ready-to-hand (Zuhandenheit). To take an example from Heidegger, a tool as mundane as the indicator signal on a car has a particular logic of appearance that conditions the manner in which it is made accessible to experience:

> This [directional signal] is an item of equipment which is ready-to-hand for the driver in his concern with driving, and not for him alone: those who are not travelling with him—and they in particular—also make use of it, either by giving way on the proper side or by stopping. This sign is ready-to-hand within-the-world in the whole equipment-context of vehicles and traffic regulations. It is equipment for indicating, and as equipment, it is constituted by reference or assignment.[19]

This distinction is central to Heidegger's rendering of technology as a frame (Gestell) conditioning mankind's relationship to the environment. Objects which are ready-to-hand are context sensitive to a functional apparatus (one might say a 'world'), which conditions their appearance to us as contents of experience. But that world is in turn shaped by a technologically mediated frame that performs an ordering of the environment, casting nature as a *standing reserve*, a relation that forecloses authentic embodied experience, a yearning for which suffuses Heidegger's thinking. One consequence of this somewhat reactionary treatment of technology is a restricted notion of agency afforded phenomena presented to us as (i.e., performing the role of) tools, a corrective to which is hinted at in the work of Gilbert Simondon. In Simondon's view, technical objects possess a certain mode of existence that we encounter when we engage them in a situation, and these modalities speak to their capacity for individuation. Nevertheless, said objects are concretizations of human thought; the alienation they may invoke in us is indicative of our inability to perceive their essence as human, a situation precipitating the following antinomy:

> Culture thus has two contradictory attitudes toward technical objects: on the one hand, it treats them as pure assemblages of matter, devoid of true signification, and merely presenting a utility. On the other hand, it supposes that these objects are also robots and that they are animated by hostile intentions toward man. … [J]udging it better to cling to the first characteristic, it seeks to prevent the manifestation of the second and speaks of placing machines in the service of man, in the belief that the reduction to slavery is a sure way to prevent any rebellion.[20]

Simondon's treatment is presented as a means of exiting this oscillating tendency toward technology by faithfully rendering the genesis of technical modes of being-in-the-world. Following in the phenomenological tradition, we can see Simondon as loosening some of the agential restraints on technicity present in Heidegger's critique, while remaining ultimately tethered to notions of the human, insofar as the genesis of the technical object is brought

about by the concretization of rationality. This humanist thread is strained to breaking point by Yuk Hui's extension of the regime of technicity to digital objects.[21] For Hui, recursivity engages contingency in specific ways that 'express psychic and collective individuation', acting as a unifying mechanism in accounts of organic and inorganic modes of self-organization.[22] From this vantage point, computation is not merely an expression of the technical, but rather a vehicle for conceiving individuation as such. I believe one is compelled to go even further in granting epistemic rights to computational states on account of the inferential capacities exhibited by computation. A disagreement I have with extending this sort of phenomenological critique to AI is precisely that computation seems to set itself apart from the general field of technicity, in that it presents to us a distinct mode of explanation—a specific logos that is not merely subordinated to a pre-existing technē—to which I give the name computational reason. This is what distinguishes computation from, say, the hydraulic system of a car, or a plethora of other technologies; hydraulics can be explained by the scientific theory of fluid mechanics, and its functional role, namely to stabilize an object, is entirely subjugated to human rationality, which determines its relations within a technical ensemble. It cannot in its technicity proffer any novel explanation by means of its deployment in the world, and as such it makes no serious epistemic claims of the sort AI aspires to. By contrast, computation refers to a particular way in which logic, mathematics, and language hang together. This view is in turn grounded in the notion of 'realizability', a semantic theory that provides a constructive interpretation of logic. Originated by Kleene, and further refined by mathematicians Heyting and Kolmogorov, the realizability interpretation marks a rupture in the epistemology of computation.[23] It is this semantic theory that challenges the denotational semantics which is canonically assumed to subsume computational states to Tarski's notion of truth values.

Expressive Bootstrapping

The canonical semantics of computation comes by way of Boolean truth tables, which are presented as an apparatus designed to interpret a computational state, with zeros and ones assigned to falsity and truth respectively. Said digital states can be instantiated in many ways, but let us take as a common example the voltage on a piece of silicon flowing through a logic gate assembled in the form of a chain of transistors. The metalinguistic character of the Boolean interpretation of these voltages was shown by Tarski in his undefinability theorem, which states that no formal language descended from classical logic can underpin its own definition of truth.[24] In this way, Tarski's semantics reduces all computational statements to a binary scheme, treating the digitality of computation as indistinguishable from formal classical logic, and in the process conflating

binary encodings with binary logic. When Wegner rails against the 'mathematical view' in his proposal for interactive computation, it is this apparatus which I believe should be the target of our attack. By contrast, realizability places operations or procedures at the center of its semantic account of computation, displacing truth as the central notion in its theory of meaning and replacing it with proofs, which can be conceived as programs in the computational view. The proofs (or programs) in question can be treated as temporal processes bound by the material laws of thermodynamics, and their presentation is necessary in order to show a proposition to be true. We can go a step further and drop the centrality of truth and falsity altogether—they are simply said to *realize* a proposition, and in this sense, they are 'witnesses' to the truth of a proposition. Proofs and programs are cast as procedures that provide a form of evidence, or in a broader epistemic sense, they represent justifications for believing that a proposition holds. For the logician Martin-Löf, this semantics provides a theory of conceptual content that can be deployed in foundational type theory—a type is said to be 'inhabited' by all the proofs or programs that show its corresponding proposition to be true; it can be seen to collect a set of procedures that act as 'witnesses' to a proposition.[25] This proffers computation a richer semantics than classical logic, with each logical proposition mapped to a distinct type, whose meaning is uniquely conferred by all the ways we have for justifying it. Martin-Löf's emphasis on the role of types in judgement formation—by which I am alluding to discursive acts grounded in assertorial language—acts as a bridge from theoretical computer science to the Brandomian conception of 'pragmatic AI', in which 'the game of giving and asking for reasons' plays a key role.[26]

Brandom interprets the central claim of AI as an assertion regarding the fundamental role of symbolic manipulation in the sort of capacities we associate with sapience, but this claim can only be defended by way of a semantic account of computational states:

> Now the plausibility of understanding thinking as symbol-manipulation at all depends on taking symbols to be more than just sign-designs with a syntax. They must be *meaningful, semantically* contentful signs, whose proper manipulation—what it is *correct* to do with them—depends on the meanings they express, or on what they represent.[27]

However, simply manipulating symbols that exploit isomorphisms (or correspondence relations) can only ever yield a simulation, and we are not liable to confuse a climate model with the climate itself, so why should we suspend this distinction when it comes to reasoning? For Brandom, AI functionalism as a philosophy of mind makes a strong claim that collapses simulation into instantiation when it comes to thinking itself, a claim which should arouse skepticism:

> The *only* reason for according thought this uniquely privileged position—as the one phenomenon that cannot be symbolically *simulated* without thereby being actually *instantiated*—is whatever reason there is to think that the symbolic-computational theory of the mind is correct.[28]

In this line of thinking it is a mistake to focus on the symbolic aspect of reasoning; one should instead emphasize the discursive capacities which one might consider as intelligent behavior, and in this regard, the Turing test presents itself as an apt measure of intelligence. Brandom has a pragmatic notion of agency in mind when he remarks that 'automata, in the general sense in which I want to think about them, are constellations of practices-or-abilities that algorithmically elaborate sets of primitive practices-or-abilities into more complex ones'.[29] This mechanism, which he goes on to term 'expressive bootstrapping', concerns the artefactual elaboration of capacities by means of concretization, and Brandom's claim is that this ability affords automata the capacity to bootstrap their way up the hierarchy of grammars. As such, the capacity for an artificially intelligent agent to exhibit what Brandom calls 'autonomous discursive abilities' hinges on their *algorithmic decomposability*, and computation's claim to instantiate such modes of reasoning is reliant on the bootstrapping of said abilities.[30] In Brandom's view, this is achieved by deploying computational languages as a 'pragmatic metavocabulary' which articulates what it is one must *do* in order to bear those capacities. The gap between saying and doing can be closed by deploying such vocabularies as what I would term *indexical encodings* of natural language. Indexicality, in this sense, refers to the context sensitivity of any syntactic structure brought under the computational regime, a translation that endows it with the properties of locality and addressability. This grasp of natural language by a seemingly formal vocabulary of recursive generative grammar should not be conflated with the claim that our everyday language use and discursive practices are somehow themselves formal, quite the contrary; Brandom is instead drawing attention to how a pragmatic view of rationality can shift the role of computation to an indexing of those abilities we associate with sapience, in turn articulating what concrete capacities automata will require in order to bootstrap itself into assuming the role of performing those discursive acts. Computation thus gives us tools for a kind of semantic ascent, laddering our inferential capacities by encoding reasoning as characterized by a range of pragmatic abilities, and this is what Brandom calls 'algorithmic pragmatism about the discursive'.[31] Here I read Brandom as attempting to tame some of the behaviorist tendencies of pragmatism with an inferentialist treatment of speech acts inspired by Sellars, all the while seeking to avoid the pitfalls of AI functionalism and the symbolic computational theory of mind.

World Models

Taking up the view from algorithmic pragmatism, Brandom considers the area most challenging to AI to be that of *doxastic updating*—the revision of one's beliefs in light of interaction. One can consider this the continual

process of learning a world model capable of absorbing new information in the form of real-time feedback. By world model, I am implying not just a causal model relating entities to each other, nor even a purely logical schema of how the world 'works', but an ensemble of relations enmeshing the way the world is, how it could be, and how it ought to be. A model of this sort would have to integrate empirical, modal, and normative commitments into a coherent whole that would give an agent the kind of practical grasp on their environment that would allow them to act in ways that align with that world and the commitments it entails. In short, such world models would need to bridge the gap from prediction to explanation, or else pattern recognition to the kind of judgement formation that implies commitments beyond mere associations. To this capacity, which is synonymous with one's ability to act consistently in accordance with one's aims or goals, we can simply attach the label of 'agency'. This conception goes further than Pearl's causal critique of deep learning, which attempts to demonstrate just how it is that Bayesian nets and causal webs are not spun from the same thread, the latter conferring qualitative capacities at the level of modeling interventions in the world which elude probabilistic models.[32] For Brandom, the capacity for counterfactual robustness in one's inferences invokes ranges over relational predicates which do not appear to submit to effective procedures, leading him to skepticism regarding the algorithmic decomposability of said ability to reason about modal claims. In the Brandomian view, only a world model of this kind, which is responsive to interaction, can serve an agent to navigate a dynamic environment in ways that are consistent with their beliefs, while simultaneously furnishing that agent with the capacity to form judgements that imply coherent commitments to that same world.

This line of thinking brings us to the Sellarsian kernel at the heart of Brandom's project to fuse pragmatism with inferentialism, which extends to his critique of AI. What Sellars terms the logical 'space of reasons' alludes to a semantic holism that identifies the meaning of concepts with their inferential role, the latter laid bare by their use or deployment in speech acts. For Sellars, empirical descriptive statements imply a modal vocabulary which in turn presupposes a normative web of commitments enmeshed in what I have called a world model:

> In characterizing an episode or a state as that of *knowing*, we are not giving an empirical description of that episode or state; we are placing it in the logical space of reasons, of justifying and being able to justify what one says.[33]

Moreover, this normative space is not supervenient on empirical observation or inductive methods of belief formation; it exhibits instead a certain epistemic irreducibility to empirical knowledge. To illustrate with an example, if you were to accompany me on a walk of the Landwehr Canal in Berlin, a practice I engage in often, and I commented that 'there's a strong current today', this observation would imply a knowledge of how a canal is engineered, the

functional role played by locks and dams, an understanding of tides and the behavior of rivers, the role of climactic conditions on the current, the historical behavior of the canal, and much more besides; in short, a modest observation summons an intricate world that conditions my expectations as to how this particular patch of daily experience might play out in the present context of our walk. Moreover, that observation is not simply a comparison with a Bayesian prior regarding the historical behavior of this specific canal; I could just as easily apply my knowledge to a hypothetical canal given a contextual cue. My utterance is not to be conflated with a report of bare sense impressions received by cognition in the process of perception, what Sellars famously calls 'the myth of the given'.[34]

For Sellars, a range of conceptual capacities are instrumental in the formation of what we call experience—as John McDowell puts it, 'the object of an experience, the state of affairs experienced as obtaining, is understood as part of a thinkable world', and it is this notion of a world which allows us to reason about that which lies beyond our immediate sensorial input.[35] A world in this sense is the coming together of both our *inferential* capacities of knowing and our *referential* abilities to ground our concepts in our environment through speech acts. From this view, the role of perception itself is a continual testing of our conceptual understanding in the face of what McDowell calls 'the tribunal of experience', an error-correcting feedback loop that is redolent of the *backpropagation* learning scheme Geoffrey Hinton developed as a key architectural feature of deep learning.[36] However, there are substantive gaps between backpropagation and a properly Sellarsian account of intelligibility. A key aspect of the Sellarsian view, as filtered through McDowell, is that whatever unsupervised learning humans are engaged in when we partake in language games has to yield conceptual understanding in such a way as to construct a family of models, which are not merely impinged on or constrained by sense impressions—since this would propagate an unwarranted claim regarding the autonomy of the formal in thought—but rather express the deep coupling of sensibility and understanding present in the very notion of a world. For McDowell, there is no way of untangling impressions from justifications, or indeed concepts from intuitions, on the basis of a Kantian distinction between spontaneity and reception: it is precisely his project to lead us out of such a dualism.

Unstable Diffusions

These threads of Sellarsian thinking can be activated to critique certain empiricist assumptions made by the kind of gradient-based learning algorithms for which deep learning as a paradigm is emblematic. The myth of the given rears its head whenever a corpus of training data is denoted as the

'ground truth' of a domain and presented as a basis for the supervised learning of concepts via gradient descent. Prominent AI researcher Yann LeCun has explored the technical limits of said learning algorithms, calling for an emphasis on world models in future waves of AI. These in turn will need to present new learning schemes, two suggestions of which he outlines: self-supervised learning and 'energy' minimization.[37] But AI not only needs to revise its conception of learning, it must also summon hybrid modes of inference if it is to generalize beyond statistical pattern matching, and the manner in which these capacities can be coordinated in tandem remains both theoretically and empirically obscure. The most common suggestion from advocates of AI is an appeal to spontaneous emergence, which as a mechanism is not in itself a theoretical explanation of high-level cognitive capacities, rather begging the question by an appeal to a nebulous complexity theory which is grounded in statistical physics.

Sellars's insistence on the spatial metaphor is an attempt to render thought as an open arena (or continuous context) in which propositional forms take up inferential roles, allowing for justificatory practices in which statements can be somehow warranted. The closest resemblance to such an idea in contemporary AI is to be found in the notion of an 'embedding', which interprets the 'latent space' of a deep learning model as a manifold embedded in a high-dimensional context. The practice of learning is thus framed as the formation of an embedding space, or else generating a manifold as a surface embedded in space, articulated as a set of points that tease out some latent relations in the input. However, the kind of justificatory capacities that Sellars renders in his work appear entirely absent in the current wave of AI, which can be prompted to summon reasoning for its utterances on request, but for which this act only serves to expose their statistically informed, inconsistent grasp of rationality; moreover, they are prone to entirely unreasonable statements which can then be prompted into *incorrect* retrospective attempts to warrant or justify their utterances as part of their discursive performance. Such failures could lead us to conclude that the kind of inferential roles which permit the construction of coherent world models do not seem to supervene on pattern-governed regularities alone, certainly not by acting upon such patterns with gradient-based optimization methods in isolation. Indeed, it seems like an overly performative mode or appearance of intelligence has been assumed, a mimicry of discursive form, at the expense of deeper justificatory capacities. This speaks to the limitation of a purely inductive view of logic conditioned by Bayesian notions regarding not only the nature of belief but also our inferential architectures of knowing. Moreover, there is no convincing theoretical reason to believe that such capacities will spontaneously emerge via scaling of the models alone, as proponents of deep learning are prone to claiming.

Equipped with this Sellarsian view, let us consider the shifting notion of intelligibility in art production following the advent of AI models, such as the family of techniques known as latent diffusion. The first observation

The myth of the given rears its head whenever a corpus of training data is denoted as the 'ground truth' of a domain and presented as a basis for the supervised learning of concepts via gradient descent.

Indeed, it seems like an overly performative mode or appearance of intelligence has been assumed, a mimicry of discursive form, at the expense of deeper justificatory capacities. This speaks to the limitation of a purely inductive view of logic conditioned by Bayesian notions regarding not only the nature of belief but also our inferential architectures of knowing. Moreover, there is no convincing theoretical reason to believe that such capacities will spontaneously emerge via scaling of the models alone, as proponents of deep learning are prone to claiming.

regarding their interactivity concerns the manner in which one must articulate what it is the model must do in order to render the desired outcome, as expressed in the form of a synthetic image. The role taken up by the creator is that of prompt engineer, iteratively recomposing a textual prompt to navigate the latent space of the model until a given aesthetic composition is approximated. In this process, conceptualization firmly precedes production, the artistic gesture involves the articulation of a token sequence at one remove from natural language, and as such the 'synthetic' media produced by such models should be conceived as intrinsically conceptual in nature. It is my claim that what we are dealing with is a mode of conceptual art in which the very notion of a concept is (re)presented by a specific interpretation of intelligibility put forth by deep learning as a regime of inference. To probe this notion, let us consider some architectural features of said models, whose main application is in image synthesis. They benefit from the architecture generally associated with deep learning: a set of layers of interconnected functions, analogically termed 'neurons', whose synaptic weights are trained by backpropagation of error during a so-called learning phase. This phase is composed of a gradient-based optimization method applied to a loss function which is defined by—in the case of supervised learning—a set of labelled training data, provided in the form of image and text pairs. There are two methodological innovations in latent diffusion beyond this basic scheme—first, a denoising algorithm is invoked during the learning phase (which begins with random noise), tasking the model with approximating the output iteratively. The effect is striking, as it produces intelligible forms only gradually, rendering compositionally complex scenes that emerge from a foggy haze of Gaussian noise. The intelligibility of an object in such a model can only ever be conceived in terms of this 'diffusion' process, in which the figure and ground of experience exist in a continuous spectrum. The second key feature of latent diffusion models is the multi-modal nature of their latent space, which combines image-caption pairs in an embedding that is capable of correlating linguistic token sequences with abstracted image data, the latter transformed from raw pixel space to a variety of dimensions as it passes through the many layers within the model.

The notion of representation here is at one remove from that in representational theories of mind, and some would argue it is not representation in any semantic sense of the term, but rather closer to the Kantian notion of intuition, or even Wittgenstein's concept of picturing; image data is encoded in vectors that structure a geometric space. This space is not intrinsically symbolically mediated, being instead composed of non-conceptual representings, and yet it is somehow able to render a relation between the conceptual structure of a corpus of captions and their corresponding visual compositions, in such a way as to produce 'synthetic' outputs. The surprising semantic grasp of natural language evinced by LLMs hints toward a space in which the syntactic structures encoded in vector spaces cannot be decoupled from the semantic relations we take to be a pre-requisite for 'understanding' concepts, and such

a notion can be extended to multi-modal models. This distributional seman-
tics is ultimately statistical in nature, and at first glance simply a way of locat-
ing concepts as vectors embedded in a space, limiting conceptual relations to
geometric properties such as metric distance. However, there is a rich geom-
etry of logic which these models can in theory activate, from projections to
fibrations, schemes to neighborhoods, regions to sheaves—the entire gamut
of techniques developed in post-war algebraic geometry under the rubric of
category theory hint at the epistemic potential of a geometric encoding as
means of navigating the space of reasons.

It may be useful in this regard to start to distinguish the notion of rep-
resentation from that of encoding, as it is this latter concept that not only
encapsulates the computational view of language but also hints at a deeper
expression of structure, which in turn can provide an interpretation of infor-
mation theory. Here we can consider representation as simply the cleaving of
sense from reference, which is to be found at the origin of the symbolic in the
work of Frege.[38] My claim is that there is an indexical relation between syn-
taxes and encodings which is effected in the movement from grammatical
sentences to computational types, where indexicality is an insistence on the
context sensitivity of language and the ensuing locality of truth. To encode,
in this sense, is to realize a proposition, in the form of a program or effective
procedure, instantiated as a vector in an embedding, and computation is cast
as a means of navigating continuous spaces. This is a variant of Brandom's
view that computational languages act as a pragmatic metavocabulary about
the discursive, but it further suggests encoding is not exhausted in this type
of theoretic movement; it is a deeper notion which gives us a grasp of pat-
terns qua syntactic structures, a relation enshrined in Shannon's theory
of information.[39] On this view, encoding is an operation suturing the two
epochal theories of our time, information and computation, and the result-
ing informatic movement from real patterns to encodings is cast as a process
that yields intelligible form. While information is a theory about the efficacy
of binary encoding, in this framing computation can be considered a broader
epistemic theory of encoding. The intuitionistic basis of these models, which
is to say their reliance on non-conceptual representings, is thus exhibited
by the manner in which an embedding encodes latent patterns in vectors
whose structure renders a manifold in space. I am alluding here to the topo-
logical interpretation of deep learning, which I endorse when considering
their grasp or 'understanding' of a statement, scene, or composition, such
as that produced in a synthetic image in response to a prompt. In this view,
representation bottoms out into topological structure, which can serve as the
basis for differing modalities of inference across media. The performativity
of a latent diffusion model in generating a synthetic output is thus imbued
with the property of locality within a high-dimensional space which encodes
structures, of which natural languages are but one example.

That latent diffusion models exhibit an improved grasp of compositionality
when scaled appropriately is noteworthy. To compose a scene is to summon a

world, but worlds cannot be reduced to mere pattern-governed regularities; the logical space of reasons is an inferential domain which acts as the context whereby the generativity of conceptual form is subjected to the tribunal of experience. The impasse confronting AI as a research project concerns just such a capacity to grasp the meaning of world models as the very condition of intelligibility. We should in turn be careful to not consign deep learning to the status of stochastic parroting, just as we should seek to refine the precise epistemic limitations of geometric forms of encoding. Ultimately, the interactive capacity of these models will determine their capacity to learn the language games they must excel at to form intelligible worlds. After all, it is in the re-cognitive character of intelligence that agents can be said to participate at all in the constitution of worlds, a claim which places sites of interaction between agents at the center of world formation.

Notes

1 Turing, A., 'Computing Machinery and Intelligence'.
2 Weizenbaum, J., 'Eliza'.
3 Srivastava, A. et al., 'Beyond the Imitation Game'.
4 Chollet, F., 'On the Measure of Intelligence'.
5 Kuhn, T., *The Structure of Scientific Revolutions*, 44.
6 Sellars, *Empiricism and the Philosophy of Mind*, 76 (§36).
7 Pearl, 'Theoretical Impediments'.
8 Turing, A. M., 'On Computable Numbers'.
9 Goldin and Wegner, 'The Interactive Nature of Computing'.
10 Chomsky, N. and Lightfoot, D. W., *Syntactic Structures*.
11 Davis, M., 'Why There Is No Such Discipline as Hypercomputation'.
12 Dreyfus, H. L., *What Computers Can't Do*, 146.
13 Kripke, S. A., *Wittgenstein on Rules and Private Language: An Elementary Exposition*.
14 Wittgenstein, L., *Philosophical Investigations*, §201.
15 Ibid., §202.
16 Williams, M., *Blind Obedience: The Structure and Content of Wittgenstein's Later Philosophy*, 17.
17 Ibid., 82.
18 Ibid., 314.
19 Heidegger, *Being and Time*, 109.
20 Simondon, *On the Mode of Existence of Technical Objects*, 17.
21 Hui, *On the Existence of Digital Objects*.
22 Hui, *Recursivity and Contingency*, 196.
23 Kleene, S. C., 'Realizability: A Retrospective Survey'.
24 Murawski, 'Undefinability of Truth'.
25 Martin-Löf, 'Truth of a Proposition'.
26 Brandom, *Between Saying and Doing*.
27 Ibid., 73.

28 Ibid.
29 Ibid., 34.
30 Ibid., 70.
31 Ibid., 78.
32 Pearl, 'Causal Inference in Statistics'.
33 Sellars, *Empiricism and the Philosophy of Mind*, 76 (§36).
34 Ibid., 58.
35 McDowell, *Mind and World*, 36.
36 Ibid., 16.
37 LeCun, 'A Path towards Autonomous Machine Intelligence'.
38 See Dummett, M., *Frege: Philosophy of Language*.
39 Shannon, C. E., *A Mathematical Theory of Communication*.

References

Brandom, R. B. (2008). 'Artificial Intelligence and Analytic Pragmatism'. In *Between Saying and Doing: Towards an Analytic Pragmatism*. Oxford: Oxford University Press, 69–91.

Chollet, F. (2019). 'On the Measure of Intelligence'. *ArXiv:1911.01547[cs.AI]*. https://doi.org/10.48550/arXiv.1911.01547.

Chomsky, N., and Lightfoot, D. W. (2002). *Syntactic Structures*. Berlin, New York: Mouton de Gruyter.

Davis, M. (2006). 'Why There Is No Such Discipline as Hypercomputation'. *Applied Mathematics and Computation*, 178(1): 4–7. https://doi.org/10.1016/j.amc.2005.09.066.

Dreyfus, H. L. (1972). *What Computers Can't Do: The Limits of Artificial Reason*. New York: Harper and Row.

Dummett, M. (1981). *Frege: Philosophy of Language*. Cambridge, MA: Harvard University Press.

Goldin, D., and Wegner, P. (2008). 'The Interactive Nature of Computing: Refuting the Strong Church-Turing Thesis'. *Minds and Machines*, 18(1): 17–38. https://doi.org/10.1007/s11023-007-9083-1.

Heidegger, M. (1962). *Being and Time*, translated by John Macquarrie and Edward Robinson. New York: Harper and Row.

Hui, Y. (2016). *On the Existence of Digital Objects*. Minneapolis: University of Minnesota Press.

Hui, Y. (2019). *Recursivity and Contingency*. London: Rowman and Littlefield International.

Kleene, S. C. (2006 [1973]). 'Realizability: A Retrospective Survey'. *Cambridge Summer School in Mathematical Logic, 1–12 August 1971*, 95–112. Berlin, Heidelberg: Springer.

Kripke, S. A. (1982). *Wittgenstein on Rules and Private Language: An Elementary Exposition*. Cambridge, MA: Harvard University Press.

Kuhn, T. (1962). *The Structure of Scientific Revolutions*. Chicago, IL: University of Chicago Press.

LeCun, Y. (2022). 'A Path towards Autonomous Machine Intelligence'. Version 0.9.2. *Open Review*. https://openreview.net/pdf?id=BZ5a1r-kVsf.

Martin-Löf, P. (1987). 'Truth of a Proposition, Evidence of a Judgement, Validity of a Proof'. *Synthese*, 73: 407–420. https://doi.org/10.1007/BF00484985.

McDowell, J. (1996). *Mind and World*. Cambridge, MA: Harvard University Press.

Murawski, R. (1998). 'Undefinability of Truth: The Problem of Priority; Tarski vs Gödel'. *History and Philosophy of Logic*, 19(3): 153–160. https://doi.org/10.1080/01445349808837306.

Pearl, J. (2009). 'Causal Inference in Statistics: An Overview'. *Statistics Surveys*, 3: 96–146. https://doi.org/10.1214/09-SS057.

Pearl, J. (2018). 'Theoretical Impediments to Machine Learning with Seven Sparks from the Causal Revolution'. *ArXiv:1801.04016[cs.LG]*. https://doi.org/10.48550/arXiv.1801.04016.

Sellars, W. (1997). *Empiricism and the Philosophy of Mind*. Cambridge, MA: Harvard University Press.

Shannon, C. E. (1948). 'A Mathematical Theory of Communication'. *The Bell System Technical Journal*, 27(3): 379–423.

Simondon, G. (2017). *On the Mode of Existence of Technical Objects*, translated by Cecile Malaspina and John Rogove. Minneapolis, MN: Univocal Publishing.

Srivastava, A. et al. (2022). 'Beyond the Imitation Game: Quantifying and Extrapolating the Capabilities of Language Models'. *ArXiv:2206.04615[cs.CL]*. https://doi.org/10.48550/arXiv.2206.04615.

Turing, A. M. (1937). 'On Computable Numbers, with an Application to the Entscheidungsproblem'. *Proceedings of the London Mathematical Society*, s2-42(1): 230–265. https://doi.org/10.1112/plms/s2-42.1.230.

Turing, A. (1950). 'Computing Machinery and Intelligence'. *Mind, LIX*(236): 433–460. https://doi.org/10.1093/mind/LIX.236.433.

Weizenbaum, J. 1983. 'Eliza-A Computer Program for the Study of Natural Language Communication between Man and Machine'. *Communications of the ACM*, 26(1): 23–28. https://doi.org/10.1145/357980.357991.

Williams, M. (2009). *Blind Obedience: The Structure and Content of Wittgenstein's Later Philosophy*. Oxford: Routledge.

Wittgenstein, L. (2010). *Philosophical Investigations*, translated by G. E. M. Anscombe and edited by P. M. S. Hacker and Joachim Schulte. New York: John Wiley and Sons.

Section B

Choreomatic Bestiary

Encounter

10

Choreomata

Sofian Audry

The development of artificial intelligence (AI) since the 1950s and its recent popularization and industrialization through the development of deep learning have challenged and transformed the relationship between artists and their work. Recent advances in AI have further opened up the possibility of new expressive processes that can be deployed in real time, processes that share some properties of living systems (such as the brain). For example, artificial intelligence has supported the emergence of a range of radically new art forms that stage robotic performers behaving in real time. This pace of transformation constantly forces practitioners and audiences to rethink their definitions of art and creation, not only through new art forms made possible by AI but also through new practices and relationships established between the creator, the artwork, and its audience. Reflecting on my own artistic practice with robots as well as the practices of other artists, I explore new ways of conceptualizing the relationships that emerge between humans and machine performers during the creative process and beyond. I embed this reflection within new materialist frameworks that decenter creation from the human artist, challenging normative conceptions of creativity in the field of computational creativity and instead considering creativity not so much as a property of things but as a process distinguished by how different agencies and materials interrelate.

Introduction

The spherical robot activates in a jerk, a yellow glow burning through its diaphanous silicone skin strewn with protuberances and concavities. It moves awkwardly, staggering like a toddler. As it acquires inertia, its velocity increases, and it hovers in a straightish fashion towards the back of the room. The glow turns reddish, indicating that the robot is (as planned) receiving a negative reward for moving. After a bit too long of a wait, it stops and turns to pale yellow. The halt is brief: after a second, the robot soon starts

DOI: 10.1201/9781003312338-16

moving again in the opposite direction. After a minute, it slows down and starts moving less resolutely. It seems to hesitate.

A mix of apprehension and excitement invades me. I find myself asking: what is driving this strange agent to behave in such a way? Yet no one other than myself has programmed it, made the decisions about how the robot perceives and acts, chosen how it is rewarded or punished. I look at my (human) collaborator who is also observing the robot; she looks back, I shrug, we smile at each other.

After a brief pause, the robot starts to move again, but its behavior has changed: it moves forward, then backwards, then forward, then backwards again. As it waddles along, its color turns orange: this is a slightly better behavioral strategy, one that causes it to decrease its speed. My heart fills with hope: it's getting there! I marvel at the fact that I did not specifically program it to behave this way, nor did I expect it would. I know that what might appear as a simple, almost banal behavior, is quite an achievement for a bulgy robot who came to life two minutes ago.

While I get lost in my reflections about what it might feel like to be that robot – to experience the world through its imprecise and elementary sensorimotor body – as suddenly as it started, the agent stops completely and remains stationary. The color changes to a pale yellow, interrupted at very rare moments by a slight movement. The robot has learned to stand still, and we are all content.

I have based the above account on my experience working with collaborator Rosalie D. Gagné on *Morphosis* (Figure 10.1), a robotic art installation project where we trained robots in real time on simple tasks using

FIGURE 10.1
Sofian Audry and Rosalie D. Gagné, Morphosis, robotic art installation project (prototypes). The three robot prototypes share the same mechatronic design and only differ by the shape of their bodies thanks to the silicone skins wrapped around their spheric core. © Sofian Audry & Rosalie D. Gagné.

reinforcement learning. The piece participates in a decades-long tradition of artworks that stage robotic performers and their behaviors. The deployment of such robotic agents within works of art, sustained by artificial intelligence and artificial life technologies, blurs the line between performing arts and media arts.

This chapter explores new ways to conceptualize relationships between the different agencies and materialities that participate in such works. First, I contextualize the evolution of artificial intelligence in the performing arts through a short historical overview of robotic art and the aesthetics of behavior. Then, I consider art practice involving human and nonhuman agents through the relationship that is established between the art practitioner and the participating artificial agents and processes, looking at different metaphors artists use to describe such relationships. I embed this reflection within new materialist frameworks that decenter creation from the exceptionalism of the human, challenging normative conceptions of creativity from the field of computational creativity and positioning creativity not as a property of things but as a process determined by how different agencies and materials interrelate instead.

A Short History of Machine Performers

The cybernetic era of the mid-1950s seems like a good starting point to reflect on the origin of the concept of machine performance. Sociologist and historian of science Andrew Pickering has described how British cyberneticians, in their revolutionary approach to understanding the brain, proposed a "new kind of science" that fully embraced the interplays between scientific ideas and matter, creating experimental apparatuses that materially produced the ideas they were studying in theory.[1] For example, the cybernetician neurophysiologist Grey Walter – who worked on electroencephalograms (EEGs) at his day job – created a series of autonomous robotic "tortoises" (1948–1949) as a means of exploring the emergence of behaviors in simple cybernetic systems. At the same time, psychiatrist Ross Ashby was designing the Homeostat (1948), an experimental model of the brain enacting a self-regulating mechanism through four interconnected electromechanical subsystems.

These early works would set the stage for the creation of the first cybernetic sculpture. The Hungarian-born French artist Nicolas Schöffer, who in the late 1940s had set out to free sculpture from its restrictive tradition through what he called a "spatio-dynamic" approach, created a piece called *CYSP 1* (short for CYbernetic SPatio-dynamic) in 1956 consisting of an autonomous electromechanical sculpture that could move freely in space while activating an intricate arrangement of rotating color panels and mirrors. Built with the help of engineers from Philips, the piece reacted to ambient light and sound

from its environment as well as from itself, resulting in an unpredictable motion geared by feedback.

In the summer of 1956 in the Southern France city of Marseille, *CYSP 1* took part in a ballet choreographed by Maurice Béjart to music by the famous musique concrète composer Pierre Henry. Held on the roof of Le Corbusier's Cité radieuse, the event was publicized with great fanfare, with the notable participation of French ballet icon Claude Bessy. Little is known today about the performance itself, but a report in the popular French science magazine *Science et Vie* undeniably recognizes CYSP 1 not so much as a sculpture, but as a performative being in its own right:

> A strange nighttime performance took place on August 8 in Marseille on the huge terrace that tops the Le Corbusier's building. While dancers were gracefully moving in front of an abstract sculpture made of steel angles and copper sheets, a red projector suddenly lit up. The bizarre sounds of concrete music resounded and [...] the sculpture suddenly came to life. It entered the dance, moving forward and backward in unexpected cadences, vibrating its metallic blades, mixing its complicated slides with the supple movements of human bodies.[2]

CYSP 1 was the forerunner of the many works made in the 1960s and 1970s that re-articulated the idea of performative machines, oftentimes through non-anthropomorphic kinetic sculptures. One can think, for example, of Jean Tinguely's *Homage to New York* (1960), in which a machine created using pieces of scrap metal from a New Jersey junkyard self-destructed in the garden of the Museum of Modern Art (MoMA), or Gordon Pask's 1968 *Colloquy of Mobiles* (presented in the famous exhibition *Cybernetic Serendipity*), an installation in which three robotic mobiles communicate with each other via light beams, parodying a form of synthetic courtship.

In the 1980s, new computational approaches supported by increased computing power led to advances in the field of artificial intelligence such as expert systems and connectionist networks, alongside the emerging field of artificial life which focused on the simulation of living systems on the computer. However, in parallel to these developments, a number of voices started to question the dualistic separation of hardware and software that plagued the field of computer science, arguing for a univocal theory of embodiment.[3] In the late 1980s, roboticist Rodney Brooks proposed that traditional top-down, representationalist, rule-based approaches to AI were bound to fail, and argued in favor of a Nouvelle AI that would embody decision processes in robotic systems without the need for an internal symbolic representation of the world.[4] Following in these steps, in the late 1980s and the 1990s, a new group of artists explored robotics as an expressive style standing on its own, one which would rest on the *behavior* of robotic agents rather than their appearance. Inspired by Brooks's Nouvelle AI, in the early 1990s sculptor Simon Penny created *Petit Mal*, a fully autonomous robotic artwork consisting of a double pendulum aluminium structure mounted on a pair of bicycle

wheels. In designing the robot, Penny rejected the software-hardware separation commonly found in robots where the electromechanical components (sensors, motors, etc.) are subsumed to a computational control system in charge of making the decisions. Rather, he sought to integrate hardware and software seamlessly in order to let the robot's behavior not result from a precisely engineered decision process, but instead *emerge* from the dynamics of the system as a whole.[5]

In an attempt to break from the relationship of control underlying artificial intelligence technologies that aims to subjugate matter to a mathematically optimal behavior, Penny's "anti-robot" approach sought to set up a situation where behaviors could emerge both in the robot and in the viewer. *Petit Mal* is not an interface through which the user must select from a set of options to arrive at a specific result, but a material entity that inhabits the cultural sphere in order to both question and enrich it. By interacting with the robot and participating in the emergence of its behaviors, the spectators' humanity manifests itself through what they project on the robot, what its behaviors evoke for them, and the relation that they establish together within the environment.

Petit Mal would lay the foundation for Penny's "aesthetics of behavior," which he envisions as a new domain of artistic experience made possible through cultural interactions with machines.[6] This new territory for the arts, still largely unknown today, challenges the foundational subject-object dualism of traditional aesthetics through "ongoing chains of interaction" between humans and machines. "No longer confined to engaging in frozen representations of visual experiences or gestures or emotions," Penny explains, "artists can build systems that inhere the capacity to enact an intention while remaining sensitive to varying environmental changes." The aesthetics of behavior thus radically transforms the nature of art practice, freeing it from the dualistic domain of representation, bringing it into the realm of intervention and performance. "Art is no longer a recording, a recollection, or a representation of something doing something: It *is* something doing something."[7]

Starting in the 1990s, Canadian artists Louis-Philippe Demers and Bill Vorn also vowed to break down traditional representational and interactive frameworks by staging "machine performers"[8] in spectacular sound and light environments. Inspired by the field of artificial life and Brooks's Nouvelle AI, their work *La Cour des Miracles*[9] presented at the Montreal's Musée d'Art Contemporain (MAC) in 1997 presents resolutely "abstract" and "dysfunctional" metallic robots in a noisy and exhilarating environment. "We present the machine," the artists explain, "not as a specialized and virtuosic robot, but as an element in an expressive and dramatic collectivity."[10] The artists thus move away from a classical interactive scheme in which gestures are answered in predetermined ways. Instead, they use indeterminism as a strategy for the emergence of machinic behaviors. While the appearance of the robots and the sounds they emit are certainly important elements of *La Cour des Miracles,* for Vorn, the behavior remains the most significant

source of aesthetic experience because it "generates a strong impression of autonomy and self-consciousness (Figure 10.2)."[11]

Following avant-garde roboticists such as Demers, Vorn, and Penny, over the past 30 years the robotic art movement has repeatedly rejected anthropomorphism and Cartesian dualism, instead focusing on the embodiments and behaviors of machines. Machine performers espouse the ethos of posthumanism in the Anthropocene: in the outlandish environment of *La Cour des Miracles*, human visitors are definitely not in the center but on the periphery. These peripheral observers assume an unwieldy responsibility to make sense of the uncanny behaviors of the derelict machines that inhabit the space.

The rapid advances in the field of artificial intelligence in the early twenty-first century have further complicated the aesthetics of behavior, thanks to the application of machine learning to training robotic systems. The work of Petra Gemeinboeck and Rob Saunders with robotics and reinforcement learning is emblematic of that new era. Their 2013 installation *Accomplice* presents robots sandwiched between the gallery wall and a fake wall built for the occasion.[12] Each robot is equipped with a camera, a microphone, and a puncturing device that allows it to drill holes through the surface of the fake wall. The robots are not programmed to accomplish a specific task, but are rather driven by an intention: that of capturing with their sensors the most novel and surprising events in their milieu, based on their own experiences of the world. In order to do so, they have to learn how to behave strategically, finding the best spots in the wall to drill into and examine. As they get bored of one spot, they push themselves to look elsewhere, exploring the world as they transform it, leaving a material trace of their behavior on the wall.

FIGURE 10.2
Louis-Philippe Demers and Bill Vorn, Limping Machine, from La Cour des Miracles, 1997.
© LP Demers & Bill Vorn.

Contrary to the reactive robots in *La Cour des Miracles*, Gemeinboeck and Saunders's performative machines do not just respond to their environment, but directly alter it and learn from it. The audience only comes into play in the robots' world when the curiosity-driven agents have sufficiently altered the walls to be able to perceive the audience through large enough openings. "Thus, it is not only the robots that 'perform' for the audience, but also the audience that provokes, entertains and rewards the machines' curiosity."[13]

This bidirectional relationship between audience and performative agents involves a form of *coupling*, a central concept for embodied interaction. Coupling refers to the way by which an object becomes an extension of the human body, like a stick to move forward in the dark.[14] It is tied with Heidegger's concept of an object being *ready-to-hand*, which happens when the object somehow disappears into the background when an agent is using it. The philosopher gives the example of a hammer. As one interacts with it, as one uses it, it becomes an extension of one's body and one ceases to notice it. However, if one needs to find a way to use the hammer differently, it suddenly reappears in the foreground. It is separated from one's body again and one looks at it with a completely different attitude, which Heidegger calls *present-at-hand*.[15]

A distinctive characteristic of adaptive agents such as the curious robots in *Accomplice* lies precisely in their ability to adapt so tightly to entities and objects in their environment that they become ready-to-hand for the robots. Adaptiveness on the part of agents is thus a necessary condition for coupling. A compelling consequence, if one considers the case of an adaptive agent's environment populated by other adaptive agents, is that agents can become coupled to one another as they adjust to each other. Indeed, an adaptive agent like a robot in *Accomplice* or *Morphosis* has different properties than tools such as hammers and sticks: as the human audience "uses" it until it disappears in the background, the audience is also being used by the agent and both become *ready-to-each-other's-hand*, so to speak. In the context of interactive interactions with autonomous machines, it presents the potential for nonhuman adaptive systems such as those found in *Accomplice* and *Morphosis* to generate a different range of aesthetic experiences as they engage in a bidirectional coupling with human actors.

Relational Materialities of Machine Learning Agents

Most academic writing on machine performance and machine performers deals with the linked aesthetic implications, trying to refine our understanding of the types of relationships that are established between the machines and the human viewers.[16] Yet, despite the fact that many of these texts have been written by artists themselves, there exist very few accounts of the *practice* of roboticist artists as it happens during the artmaking process. What kind of approach is most effective to design such works? What kinds of relationships

are established between the machines and the artists? And how do artists explore and exploit these relationships to create their work while considering the audience as they make it?

In this chapter I am interested in *machine learning* agent-based artworks, in other words, machine performances that make use of adaptive or machine learning techniques to design the agents' *behaviors*. I posit that the practice surrounding the creation of these artworks, such as Gemeinboeck and Saunders's *Accomplice*, should be distinguished from concurrent, non-adaptive approaches to robotic performers due to the unstable autonomy of adaptive behaviors. This autonomy, which rests on a relatively obfuscated process that puts it beyond direct human control, results in a decentering of the creative work from the practitioner and produces a different set of relationships between the practitioner and the machine performers.

The Materiality of Machine Learning

In previous work, I have developed a materialist framework of machine learning art that builds on the specific structural organization of machine learning systems as compared to traditional coding approaches such as symbolic AI.[17] Machine learning systems consist of three core components: (1) a *training process* which trains (2) a *model* over a set of (3) *data*. These three relatively independent components each represent different ways by which the designer of a system (such as a machine performer) can influence the outcomes (such as the machine's behavior). By definition, machine learning attempts to decenter the control from the human designer, giving the system instead the autonomy (through the training process) to make its own choices based on what it can learn (embodied in its model) from the data (representing samples of reality). This has several consequences.

An important repercussion of using machine learning for artistic creation concerns the training process. The training process consists of a stepwise procedure of optimization and evaluation. During the optimization process, the model (which can be understood as some kind of adjustable machine or mathematical function) is adjusted based on an evaluation function through which a machine's performance is assessed against training data fed to the system (in other words, the experience of the agent). Machine learning is thus teleological in nature because the system always learns how to reach an objectively measurable goal. This seems utterly antithetical to artistic practice because artistic judgment is contextual and subjective. If there is no such thing as the best painting, or the best robotic performance, then how can we train a machine learning system to make art?

The answer lies in the fact that, beyond the doomed-to-fail approach of trying to directly train a system on a so-called artistic value, there are a number of techniques through which one can harness and hijack the training process, such as playing with different evaluation functions, tweaking model

If there is no such thing as the best painting, or the best robotic performance, then how can we train a machine learning system to make art?

parameters, or remixing datasets to achieve interesting results. These strategies always involve some kind of indirect process, in which the artist has only partial control over the outcomes and must use their intuition and creativity to accomplish their goals. Contrary to traditional coding, where the artist-programmer directly defines how the system will behave, here the control is complicated by the fact that the system in place is autonomous by design.

In this sense, making art with machine learning feels a lot less like an engineering practice where one tries to design specific outcomes by implementing top-down rules and patching up bugs, and more akin to experimental sciences like chemistry or biology, or to culinary practice: the practitioner creates a situation by putting all the ingredients together in a given context, looks at how things evolve, and readjusts. Incidentally, the practice of working with machine learning systems itself involves some kind of adaptive process not only from the machine learning system but also from the artist. The indeterminacy of the material makes the practice of machine learning creation more organic, intuitive, and decentered from the artist.

Artist-Machine Relationships

A useful dimension with which to qualify the relationship between artist and machine learning system is the *autonomy vs. authorship* axis. Here, autonomy refers to the agency of the machine (or more broadly, to all the materials and processes in place), whereas authorship refers to the volition of the artist. This axis illustrates a common tension in artistic creation, one that is certainly not restricted to machine learning art but is found in every artistic practice. Some artists are comfortable with giving more agency to agents and materials beyond themselves in the creative process, such as composer John Cage, who famously asked to "let sounds be themselves."[18] Others consider these exogenous agents and materials as resources meant to be instrumentalized to implement their artistic vision: like filmmaker Stanley Kubric, who was known to carefully and precisely control every aspect of his movies, leaving no details aside, shooting each scene until it met his utmost satisfaction.[19]

On either side of the spectrum are the concept of the *tool* (or instrument) and that of the *author* (or artist) as ways to qualify the machine learning system. In an interview about his work *Memories of Passersby I*, which uses generative neural nets to endlessly generate portraits of non-existent people, Mario Klingemann asks whether one would give authorship of music played by a pianist to the piano itself: "Is the piano the artist? No." The same, he claims, applies to machine learning art: "Just because it's a complicated mechanism, it doesn't change the roles."[20] To him, machine learning algorithms are to machine learning artists what the brush is to the painter, or the piano to the pianist: devoid of agency, intentionality, and creativity, they take no part in the authorship of the work.

At the antipode of this metaphor, some claim some machine learning systems possess truly artistic skills and can be qualified as *authors* in their own

right. While this idea is widespread in the media, it is rarely supported by artists themselves. An exception is perhaps the artist Nicolas Baginsky, creator of the visionary project *The Three Sirens*, a robotic rock band built with the specific intent of inventing a new form of music.[21] Baginsky, who created the band in the early 1990s and developed it over two decades, has a special relationship with the robots, claiming he felt his role to be less that of an artistic director or even an impresario and more of an assistant or caddy.

At the centerpoint of this axis, we find the concept of *collaborator*, where a certain form of agency is attributed to the system, without giving it the entirety of the authorship. Here, the artist recognizes the capacity of the system to act on the creation, and a certain intentionality is established in a balanced relation between the human and nonhuman performers. This is how the artist Sougwen Chung describes her relationship with her DOUG series[22] robots, with whom she performs live drawing or painting sessions. These shows feature a material connection between the two agents, engaging in a form of symbiotic relationship where they inspire each other in real time (Figure 10.3).

This collaborative relationship is different from that of *muse* or *assistant*, where the machine is recognized as having agency (providing inspiration or performing part of the work) yet remains subservient to the artist's will. A case in point is David Jhave Johnston's *ReRites*, for which the artist spent a year writing a book of poetry every month, patiently rewriting and reformatting poems originally written by an algorithm of his own.

None of these metaphors is entirely satisfactory, however, because none of them takes into account the alien or uncanny character of learning machines.

FIGURE 10.3
Sougwen Chung, Drawing Operations #4, 2018. Drawing, robotics, performance. Photo credit: Sougwen Chung. © Sougwen Chung.

Indeed, if they include human characteristics in many aspects, their performance often seems to go beyond rational human understanding. Yet, it is precisely this aspect that attracts artists in the first place, because their otherness finally gives us a more real image of ourselves, we who believe ourselves to be human but are in fact an amalgam of chemical, physical, social, and cultural forces.[23]

A better metaphor comes from artist Memo Akten, who suggested that the act of using machine learning systems for artmaking was akin to that of taming an animal, such as a wild horse.[24] Although I personally have never tamed a wild horse (nor have I ever tried, for that matter), this analogy seems more satisfying because it takes into account both the autonomy of the system and the hybrid nature of the system as a creative agent, one that lies somewhere between human and nonhuman. Nonhuman, because the machine learning system, like the wild horse, lives in a nonhuman world, one that is made purely of data and statistics. Human, because it shares some characteristics with the human, such as a capacity to learn from experience, to represent data using higher-level abstractions, and so forth.

Case Study

Over the past few years, I have been working in collaboration with artist Rosalie D. Gagné on *Morphosis*, a robotic art installation featuring the adaptive behaviors of three spheroid robots. Our aim is to propose a poetic experience of machine learning behaviors through an intimate relationship between human and nonhuman. Our design-oriented approach consists in creating a situation for the robots by giving them a limited set of actions and perceptions, leaving it to them to develop their own behaviors using reinforcement learning, therefore using the *learning process itself* as a behavior-generating process.[25] In so doing, we subvert the usual mode of operation in machine learning, where the learning behavior of the system is often accessory to the final "optimal" behavior that is sought.

Concretely, this implies an indirect manipulation of behavior through which indeterminate movements and reactions emerge. These behaviors develop at the interface between machine learning algorithm and physical body, each robot having a distinct silicone skin with protuberances, depressions, and textures to which it must adapt. Following the tradition of interactionist and reactive robotics in the work of Demers, Penny, and Vorn, our work opposes the mind-body dualism at the root of machine learning systems by bringing together physical and algorithmic elements as part of a common materiality. In other words, in the manner of John Cage, who wished to let the sounds be themselves, we let the robots be themselves through the encounter between their discrete physical and dynamic bodies and their environment. The use of machine learning pushes us even further away from the control

A better metaphor comes from artist Memo Akten, who suggested that the act of using machine learning systems for artmaking was akin to that of taming an animal such as a wild horse.

pad, as we cannot directly scenarize robotic behaviors through specific reactions such as in *La Cour des Miracles*, but must rather provide conditions for the emergence of behaviors such as in *Accomplice*. Our artistic approach is therefore reflexive: exploring the autonomy of matter in robotic systems forces us into a situation where we lose control and must adapt.

This approach has proven to be extremely challenging. Beyond the numerous technical difficulties related to adjusting the sensors, figuring out the mechanical structure, and debugging the code, the core artistic challenge we have faced has been to *figure out the right set of training conditions that would generate intelligible behaviors*. Furthermore, training needs to deliver said behaviors within an ultra-short timeline, so as to render the training process visible to an audience within the time frame customary to an art show. Consequently, these robots have access to very little training data.

This *limited training data* situation has a number of implications. First, it means that we need to give the agents simple goals, which plays counterproductively to our objective of generating thrilling behaviors that would make the robots appear intelligent. For example, one of the first interesting results has been to teach the robots to immobilize themselves. Interestingly, while the goal is trivial, the adaptive behavior is not. The robot usually begins by moving a lot. As it starts to learn more about its body and its coupling with the environment, it typically starts waddling, in an effort to reduce its inertia. Eventually, if all goes well, it will stop moving, marking the end of the behavioral pattern – a moment that is clearly identifiable by human observers because immobility also belongs to the world of human behavior.

In order to design these behaviors, we play with a number of elements, each having its specific role and sphere of influence over the result. The *reward function* is the element of control that typically has the most influence over the resulting behavior. It provides the robot with a measurement of its performance, encouraging some actions by providing a high reward, while punishing other actions with a low reward. Since the reinforcement learning procedure tries to maximize the agent's reward over time, given the right circumstances, the agent will tend to behave in a way that best matches the reward. For example, rewarding robot A for getting as close as possible to robot B, while rewarding robot B to do the exact opposite (getting as far as possible from robot A), could hypothetically result in a game of cat and mouse between the two robots.

The second most important element of control is the *learning policy*, which dictates how the agent will use the information it has gathered thus far to make its next decision. In general, this boils down to adjusting the *exploration vs. exploitation* dilemma.[26] Exploration is needed to find new strategies and will also produce more erratic behaviors, while exploitation will result in more stable behaviors, but might also result in the robot failing to meet its objectives because it gets stuck in a suboptimal behavior.

In order for the agent to be able to learn anything, it needs to know something about its environment. The variables we give the robot access to are

called its *state* (or observations) and constitute the third most influential ele-ment of control. The state must be chosen carefully so that it contains just enough information for the robot to make sense of its world with respect to the reward function. For instance, if the system is rewarded for moving fast, then the state must contain some information about its speed. However, the number of state variables needs to be kept really low, otherwise it will be very hard for the robot to learn within the scope of a few minutes. Thus, we typically have to restrict the number of state variables to somewhere between one and four.

Finally, in order to behave, the agent needs to be able to take *actions* in the world. In *Morphosis*, actions always take the form of some kind of motor acti-vation, through a combination of the robot's steering and speeding motors. As for the states, the actions must be chosen carefully in order to balance three competing goals: (1) the number of possible actions needs to be kept as low as possible to make learning in real time possible; (2) the actions should allow the robot to meet its goals in terms of rewards; while (3) they should also allow for nonoptimal rewards in order to present a real learning chal-lenge for the robots, so that the trial-and-error learning behavior appears nontrivial.

The design of behavioral patterns is a game of trials-and-errors that is often frustrating for a number of reasons. First, when something does not go as expected (which is the rule rather than the exception), it is very hard to tell where the problem lies, whether in the code; the choice of reward function, policy, state, or action; or (as is very often the case) in our own human brains.

Our typical creative loop goes as follows. First, we imagine some kind of meaningful behavior and/or learning situation which could open up unexpected behaviors. Using our intuition, we then design a learning situation that would best match our intentions, using a reward function, policy, state, and actions.

We then run the robots and observe them over a few minutes, trying to notice if they behave in a way that is meaningful (i.e., not totally random, nor com-pletely predictable). During this time, we typically discuss, trying to describe what we see, but also making predictions about the robots' behaviors. In order to understand its decision process, we build a *theory of mind* for the robots, attributing rational intentions to it. In other words, we adopt what philosopher Daniel Dennett calls an *intentional stance*, that is, a point of view that allows us to simplify an otherwise complex phenomenon by attributing intentions to the robotic entities.[27] Most of the time, the robots do not behave the way that we predicted – and in general, they do not do anything of interest. Oftentimes, we seem to project our own volition on the robots, so that when they behave the way we expect, we start thinking they are learning what we want – until, as they inevitably do most of the time, they fail and regress back to incomprehen-sible or boring behaviors. This iterative interplay between ourselves and the robots effectively deploys a "dance of agencies" between human and nonhu-man performers, very similar to experimental science.[28]

Beyond this hazardous dance, what is of particular interest to me is that, through this iterative process of trial and error, we develop a particular form of *empathetic* relationship with the robots. This empathy, rather than being accessory, is a requirement of the creative process, because in order to create with machine learning performers such as our robots, we need to somehow do the impossible, which is to put ourselves in the robot's shoes – or motors, if you prefer.

In order for machine performers such as the *Morphosis* robots to have any kind of aesthetic impact, there needs to be a shared environment between the machines and the humans. For example, if our robots moved with impercep-tible movements, or if they reacted to infrasounds, it would be impossible for us or the audience to make any sense of their behaviors. Yet, even if we share an environment, we certainly do not have a common world.[29] What we see are robots that behave physically: rolling, waddling, dancing, bumping into obstacles, and so on.

The robots, on the other hand, live in a much different and reduced world than ours, one in which they do not even know that they are moving. To give the reader a sense of what it "feels like" to be one of these robots, imagine being in a dark room, only able to see a few points of light whose intensity represents the values of the different state variables. Upon seeing these points of light, one can choose to push one of many buttons, each corresponding to an action. Pressing the button results in the points of light changing into a new configuration. A musical tone plays, providing feedback in the form of a highly unpleasant distorted noise as a punishment, or a soothing melody as a reward. One's goal then becomes to associate which button to push given a certain configuration of these points of light so as to avoid the irritating sounds and instead enjoy a beautiful melody.

This thought experiment relativizes what often appears, from a human-centric perspective, like a lack of intelligence from the robots; it reveals how difficult it can actually be to make appropriate decisions in such a confusing, noisy, narrow environment. It has helped both me and my collaborator Rosalie D. Gagné to mitigate our expectations and to try to level with the robots – in other words, to further empathize with them. As we observe the robots, we attempt to retreat from an anthropomorphic theory of mind and get back to what the system is actually made of. The fact that we built the system our-selves, in the end, makes this a bit simpler than if we were dealing with liv-ing or artificial agents we did not design, because while the system's decision process lies somewhat beyond our immediate grasp, we can still understand the logic that sustains it. In particular, since we are using reinforcement learn-ing, we design a *reward function* that favors certain actions over others, thus constituting a representation of the agent's inner motivations and desires. The intentional stance we adopt is directly informed by the coupling between that reward function, the robots' perceptive capabilities, and their action reper-toire. What is harder to understand, and what we can never fully account for, is the contribution of the physical environment and the bodies of the robots, which directly impacts their behavior in indeterminate ways.

What relationship are we building with the robots? None of the metaphors presented earlier seem to work: our robots are neither tools, nor collaborators, nor muses, nor authors. The metaphor of taming a wild horse is closer to our experience; however, it conjures a sense of the verb "to tame" which calls for a relationship of domination, one where the human's final intention is to subjugate the nonhuman to achieve a specific goal. This is not really what is happening here, since we are not trying to achieve full control over the robots, but rather aim to set the conditions for the emergence of novel and surprising behaviors within them.

The Concept of *Apprivoisement*

In Antoine de St-Exupéry's *The Little Prince*, the protagonist meets with a fox who asks him to tame him. While neither the fox nor the little boy have anything special to them, if the prince tames him, the fox claims, by getting to know each other they will become special to one another. While the English translation of the book uses the verb "to tame," the original version uses the French verb "apprivoiser" (pronounced *app-ree-vwaa-zay*), which has no equivalent in English. The verb "apprivoiser" and the associated noun "apprivoisement" (pronounced *app-ree-vwaz-man*), which refers to the action itself, imply an active yet calm and long iterative process whereby one attempts to make another entity less fearsome, less dangerous, and more familiar. This is achieved through trial and error, requires a good dose of patience, and involves a mutual process of seduction and trust-building.

Apprivoiser is very different from another French translation of the verb "to tame," the verb "dompter" (pronounced *don't-ay*), which implies the subjugation of a wild and typically dangerous animal, as in "dompter un cheval sauvage" ("to tame a wild horse"). Furthermore, while the verb is usually directed at an animal, it can also apply to other kinds of entities (including humans) as well as abstract concepts (e.g., time) and situations (e.g., a new job), where it can be more or less translated as "getting familiar with" but once again involves a patient and dedicated iterative process. *Apprivoisement* aims for no more than to welcome someone or something into one's life, to make space for it, to learn to know it. It has no particular purpose, other than to learn to *live with*, which implies first and foremost a transformation in the person who attempts it.

Our approach to *Morphosis* calls for this particular meaning of the concept of taming. We enlist this meaning due to its relation to our intentions of human-machine empathy,[30] the possibility of companionship, and the desire to reveal something special about the robots. This term also aligns with an iterative approach based on trial and error, involving a long process of getting familiar with the robots, often just for the sake of getting to know them better.

Apprivoisement aims for no more than to welcome someone or something into one's life, to make space for it, to learn to know it.

Finally, *Morphosis* does not aim at achieving a particular effect, but rather at giving space for the robots to come up with their own expressive behaviors.

Machine Creativity

This reflection on the roles and relationships emerging through the creative practice of performative machines is at odds with dominant definitions of creativity within the field of *computational creativity*, a subfield of artificial intelligence that seeks to endow computers with creative capabilities.[31] Bringing together artists, designers, computer scientists, psychologists, and philosophers, computational creativity is an interdisciplinary field that integrates many different approaches to and conceptions of creativity in computational systems.

A central figure of the field, philosopher Margaret A. Boden provides a definition of creativity as the ability to develop ideas or artifacts that are both *novel* and *valuable*.[32] This normative definition is very useful when evaluating whether an agent is creative or not. In recent years, multiple new artificial intelligence technologies have sprung out that could be considered creative according to Boden's definition.[33]

Boden's definition, however, remains limited in several respects. In particular, it does not define the *criteria* for assessing originality and value, which often leads to confusion. One of the most cited studies related to computer-generated artistic images, published in 2017 by a team of researchers at Rutgers, is a case in point to illustrate this problem.[34] Using a dataset of about 80,000 photos of paintings representing a wide range of artistic movements, the research team trained a deep generative neural network on a "novel, but not too novel" cost function and managed to produce stunning results. In order to validate their technique, they compared the results of the generative program to works made by human artists from the latest Art Basel fair, one of the most important contemporary art events in the world. A random sample of non-experts was then shown images of these works as well as the ones generated by the neural network and asked to respond to a questionnaire. It turned out that while a slight majority (54%) of responders thought that the computer-generated images were made by humans, only a minority (41%) believed the images from Art Basel were made by humans. If this study shows one thing, it is that value attribution is always relative to observers and mostly subjective in the case of artistic works.

Although Boden's definition is useful, it is clear that the field of computational creativity that has appropriated it ultimately remains distinct from the fields of artistic creation that make use of artificial intelligence through such diverse movements as AI-art, machine learning art, generative music, computer-generated literature, and so on. A core difference is that artists, while

they may be interested in the discussions surrounding machine creativity, ultimately find little practical use in the normative definitions it provides. For an artist, it is important not so much whether an agent is creative or not, but rather *how* creativity unfolds in the relationship between human and nonhuman agencies and *where* and *when* the creation takes place.

This idea echoes psychologist Mihaly Csikszentmihalyi's call to abandon a Ptolemaic, human-centered conception of creativity for a Copernican version in which creativity is *distributed* through a system of relationships.[35] Building on this principle, computational creativity researcher Oliver Bown proposes to displace the question of creativity from the properties of an agent (i.e., why and how an entity is creative) to the *role* it plays within a larger creative system, concluding that "creativity might more productively be understood not as the production of novel and valuable things but as the *situated production of novelty*."[36] Bown explains how definitions of creativity that focus on an individual author only tell us part of the story; they fail to account for the broader distributed biological, cultural, social, and technological contexts in which the creative activity happens.[37]

From that perspective, creativity must be understood as an embodied phenomenon that emerges from the interactions between the agents and materials in place, resulting in the production of new forms that respond to the context in which these interactions take place. This "dance of agency"[38] between people and things involves an iterative process of mutual couplings, which also produces *novel relationships* between the participants. Thus, creativity should not primarily be assessed through the artifacts it produces, but rather by the transformations it operates on the relational network in which it takes place.

The concept of *Apprivoisement* introduced earlier provides a valuable model for how these new relationships emerge through the creative practice of machine performers. The process of *apprivoisement* requires an intention to change oneself in order to adapt to the other. In other words, it involves a performance whereby relationships are built from the ground up, through the interaction between the actants. These relationships evolve throughout the course of the artistic process, transforming both human and nonhuman performers engaged in it.

Finally, *apprivoisement* also provides a model for understanding the aesthetic impact of machine performers on audience members. In works involving machine performers, it is important to consider how the viewers are adaptive systems themselves who try to make sense of the machine behaviors they are experiencing. Since they are witnessing surprising and uncanny behaviors that are often hard (if not impossible) to define rationally, they need to get to know them phenomenologically through their own bodies. This is especially true when using adaptive and generative methods for behavior design such as in *Morphosis*, because the agents' behaviors are the result of complex interactions between computation and physics that lie beyond rational understanding, such that even the artists are unable to define them precisely. Hence, the principle of apprivoisement also applies to

audience members who need to spend time with the piece, patiently changing themselves until the machine's behavior becomes phenomenologically experienced rather than intellectually understood.

Conclusion

This chapter started by contextualizing machine performers with respect to their historical origins, tracing them back to the 1950s with Nicolas Schöffer's spatio-dynamic and cybernetic sculpture *CYSP 1* (1956) and following their lineage through the following decades with other electromechanical works, including cybernetician Gordon Pask's famous robotic installation *Colloquy of Mobiles* (1968), first presented as part of Jasia Reichardt's groundbreaking exhibition *Cybernetic Serendipity* in 1968.

A second movement of robotic art emerged in the 1990s inspired by Rodney Brooks's Nouvelle AI, which proposed to introduce considerations of an agent's embodiment in the physical world into artificial intelligence research. Artists such as Louis-Philippe Demers, Simon Penny, and Bill Vorn took part in this movement, proposing a new *aesthetics of behavior*[39] and the concept of *machine performers*[40] to describe the new range of robotic artworks they were building and their associated artistic approaches.

Beginning in the early 2010s, the development and industrialization of artificial intelligence through advances in machine learning have supported a renewal of the field. The ability of machine performers to learn from their own experiences complicates the relationships between the artists, the machines, and the viewers, as well as their respective roles. The practice of machine learning robotic art relies on techniques with a very particular materiality, one that differs from traditional artificial intelligence and robotic design. Indeed, rather than coding behaviors directly into the robot, one must go through a tripartite architecture, combining a training process which trains a model over a set of data. When applied to the writing of robotic behaviors, machine learning involves a somewhat strange relationship with the machine where the artist sets the stage for the machine performer to learn its own behavior by trial and error, from its own experience. This approach involves less of an engineering or design process and more tolerance to surprise and novelty coming from the learning agent, thus forcing a transformation in artistic practice.

As Oliver Bown points out, what matters most in this new configuration of artist and machine is no longer whether creativity emanates from a particular agent, but rather what roles are played by the different agencies involved in the creative process and the relationships they establish with each other. Based on my own reflexive artistic practice with adaptive robots, I proposed the concept of *apprivoisement* to qualify an iteratively

built relationship based on patience, respect, and trust in the other – a relationship that requires neither a complete understanding of the machine performer nor a will to control it.

This concept is particularly useful because it espouses a non-human-centric perspective on creativity, where creativity is seen not as a property of systems, but as the production of contextualized and embodied novelty in the world. It proposes we reconsider our approach to these machine learning performers by asking their human counterparts, both the artists working with them and the audiences experiencing their behaviors, to adopt an attitude of patience, generosity, and acceptance.

Notes

1 Andrew Pickering, *The Cybernetic Brain*.
2 Gérard Cottin, "'CYSP 1' danseuse-étoile est un robot," 62–63. Translation by the author.
3 Hubert L. Dreyfus, *What Computers Can't Do*.
4 Rodney Brooks, "Elephants Don't Play Chess."
5 Simon Penny, "Agents as Artworks and Agent Design as Artistic Practice."
6 Penny, "Embodied Cultural Agents" and "Agents as Artworks."
7 Penny, *Making Sense*, 319.
8 Louis-Phillipe Demers, "The Multiple Bodies of a Machine Performer."
9 Named after the eponymous "court of miracles" described in Victor Hugo's *Les misérables* (1951), referring to the slums of Paris during the premodern era.
10 Louise Ismert, *Louis-Philippe Demers and Bill Vorn*, 17.
11 Vorn, "I Want to Believe," 366.
12 Gemeinboeck and Saunders, "Accomplice."
13 Oliver Bown, Gemeinboeck, and Saunders, "The Machine as Autonomous Performer," 85.
14 Paul Dourish, *Where the Action Is*, 120.
15 Heidegger, *On Time and Being*.
16 Eduardo Kac, "Foundation and Development of Robotic Art"; Penny, "Art and Robotics"; and Damith Herath, Christian Koos, and Stelarc, *Robots and Art*.
17 Audry, *Art in the Age of Machine Learning*.
18 Cage, "Experimental Music."
19 Kubrick holds the world record for the most retakes for one scene with dialogue, with 148 takes achieved during the filming of *The Shining* ("Most Retakes for One Scene with Dialogue," https://www.guinnessworldrecords.com/world-records/74583-most-retakes-for-one-scene-with-dialogue).
20 "*Memories of Passersby I* by Mario Klingemann," video by Onkaos (https://vimeo.com/298000366).
21 Audry, Victor Drouin-Trempe, and Ola Siebert, "The Strangest Music in the World."
22 DOUG stands for Drawing Operations Unit Generation. This series is trained on a database of her own work, which allows it to somewhat imitate her style.

23 Erin Gee and Audry, "Automation as Echo."
24 Audry, *Art in the Age of Machine Learning.*
25 Audry, Dumont-Gagné, and Hugo Scurto, "Behaviour Aesthetics of Reinforcement Learning in a Robotic Art Installation."
26 Richard S. Sutton and Andrew G. Barto, *Reinforcement Learning*, 4–5.
27 Dennett, "Intentional Systems Theory."
28 Andrew Pickering, *The Mangle of Practice.*
29 Jakob von Uexküll, *Mondes animaux et monde humain suivi de la théorie de la signification.*
30 Empathy as the ability to consider the situation of another being, without necessarily the emotional connection that usually comes with it.
31 Bown, *Beyond the Creative Species.*
32 Boden, "Creativity and Artificial Intelligence."
33 For example, prompt-based image generators such as DALL·E, Midjourney, and Stable Diffusion demonstrate creative capabilities because they are able to produce original, innovative, and surprising images that have demonstrated their value in the artistic field on several occasions over the past few years.
34 Ahmed Elgammal, Bingchen Liu, Mohamed Elhoseiny, and Marian Mazzone, "CAN: Creative Adversarial Networks."
35 Csikszentmihalyi, *The Systems Model of Creativity.*
36 Bown, *Beyond the Creative Species*, 63.
37 Ibid., 93.
38 Pickering, *The Mangle of Practice*, 21–22.
39 Penny, "Agents as Artworks."
40 Demers, "The Multiple Bodies of a Machine Performer."

References

Audry, S. (2021). *Art in the Age of Machine Learning.* Cambridge, MA: MIT Press.
Audry, S., Drouin-Trempe, V., and Siebert, O. (2023). "The Strangest Music in the World: Self-Supervised Creativity and Nostalgia for the Future in Robotic Rock Band 'The Three Sirens.'" *Arts*, 12(1): 2. https://doi.org/10.3390/arts12010002.
Audry, S., Dumont-Gagné, R., and Scurto, H. (2020). "Behaviour Aesthetics of Reinforcement Learning in a Robotic Art Installation." *Poster Presented at the Fourth NeurIPS Workshop on Machine Learning for Creativity and Design*, Vancouver, Canada. https://hal.archives-ouvertes.fr/hal-03100907.
Boden, M. A. (1998). "Creativity and Artificial Intelligence." *Artificial Intelligence*, 103(1–2): 347–356. https://doi.org/10.1016/S0004-3702(98)00055-1.
Bown, O. (2021). *Beyond the Creative Species: Making Machines That Make Art and Music.* Cambridge, MA: The MIT Press.
Bown, O., Gemeinboeck, P., and Saunders, R. (2014). "The Machine as Autonomous Performer." In *Interactive Experience in the Digital Age: Evaluating New Art Practice*, edited by Linda Candy and Sam Ferguson. Cham: Springer International Publishing. https://doi.org/10.1007/978-3-319-04510-8_6.

Brooks, R. A. (1990). "Elephants Don't Play Chess." *Robotics and Autonomous Systems,* 6(1–2): 3–15.

Cage, J. (1961). "Experimental Music." In *Silence.* Middletown, CT: Wesleyan University Press, 7–12.

Cottin, G. (1956). "'CYSP 1' danseuse-étoile est un robot." *Science et Vie, 468.* (Cotton, 1956): 62–65.

Csikszentmihalyi, M. (2014). *The Systems Model of Creativity: The Collected Works of Mihaly Csikszentmihalyi.* Dordrecht: Springer Netherlands. https://doi.org/10.1007/978-94-017-9085-7.

Demers, L.-P. (2016). "The Multiple Bodies of a Machine Performer." In *Robots and Art,* edited by Damith Herath, Christian Kroos, and Stelarc. Singapore: Springer Singapore. https://doi.org/10.1007/978-981-10-0321-9_14.

Dennett, D. (2009). "Intentional Systems Theory." In *The Oxford Handbook of Philosophy of Mind,* edited by Brian McLaughlin, Ansgar Beckermann, and Sven Walter. Oxford: Oxford University Press. (Dennett, 2009): 339–350.

Dourish, P. (2004). *Where the Action Is: The Foundations of Embodied Interaction.* Kindle Edition. Cambridge, MA: MIT Press.

Dreyfus, H. L. (1979). *What Computers Can't Do: The Limits of Artificial Intelligence.* New York: Harper and Row.

Elgammal, A., Liu, B., Elhoseiny, B., and Mazzone, M. (2017). "CAN: Creative Adversarial Networks, Generating 'Art' by Learning about Styles and Deviating from Style Norms." *ArXiv:1706.07068[cs.AI].* https://arxiv.org/abs/1706.07068.

Gee, E., and Audry, S. (2019). "Automation as Echo." *ASAP/Journal,* 4(2): 307–12. https://doi.org/10.1353/asa.2019.0025.

Gemeinboeck, P., and Saunders, R. (2014). "Accomplice: Creative Robotics and Embodied Computational Creativity." In *Proceedings of the Artificial Intelligence and the Simulation of Behaviour Symposium (AISB),* edited by Rodger Kibble. London.

Heidegger, M. (1972). *On Time and Being.* New York: Harper and Row.

Herath, D., Kroos, C., and Stelarc, eds. (2016). *Robots and Art: Exploring an Unlikely Symbiosis.* Singapore: Springer Singapore.

Ismert, L. (1998). *Louis-Philippe Demers and Bill Vorn: La Cour des miracles.* Montréal: Musée d'art contemporain de Montréal. https://bac-lac.on.worldcat.org/oclc/39348136.

Kac, E. (1997). "Foundation and Development of Robotic Art." *Art Journal,* 56(3): 60–67. https://doi.org/10.2307/777838.

Klingemann, M. (2018). *Memories of Passersby I by Mario Klingemann.* Onkaos. https://vimeo.com/298000366.

Most Retakes for One Scene with Dialogue. (n.d.) Guinness World Records. https://www.guinnessworldrecords.com/world-records/74583-most-retakes-for-one-scene-with-dialogue.

Penny, S. (1997). "Embodied Cultural Agents: At the Intersection of Robotics, Cognitive Science and Interactive Art." In *AAAI Socially Intelligent Agents: Papers from the 1997 Fall Symposium,* edited by Kerstin Dautenhahn, 103–105. Menlo Park: AAAI Press.

Penny, S. (2000). "Agents as Artworks and Agent Design as Artistic Practice." In *Human Cognition and Social Agent Technology,* edited by Kerstin Dautenhahn, 395–414. Amsterdam: John Benjamins Publishing Company. https://benjamins.com/catalog/aicr.19.18pen.

Penny, S. (2013). "Art and Robotics: Sixty Years of Situated Machines." *AI and Society*, 28: 147–56. https://doi.org/10.1007/s00146-012-0404-4.

Penny, S. (2017). *Making Sense: Cognition, Computing, Art, and Embodiment*. Cambridge, MA: MIT Press.

Pickering, A. (1995). *The Mangle of Practice: Time, Agency, and Science*. Chicago, IL: University of Chicago Press.

Pickering, A. (2010). *The Cybernetic Brain: Sketches of another Future*. Chicago; London: University of Chicago Press.

Sutton, R. S., and Barto, A. G. (1998). *Reinforcement Learning: An Introduction*. Cambridge, MA: MIT Press.

Uexküll, J. von. (1965). *Mondes animaux et monde humain suivi de la théorie de la signification*. Paris: Éditions Gonthier.

Vorn, B. (2016). "I Want to Believe-Empathy and Catharsis in Robotic Art." In *Robots and Art*, edited by Damith Herath, Christian Kroos, and Stelarc. Singapore: Springer Singapore. https://doi.org/10.1007/978-981-10-0321-9_18.

11

The Musicality of Imperfection

Davor Vincze

Introduction

> Errare humanum est, perseverare autem diabolicum.
>
> *Lucius Annaeus Seneca the Younger*

The famous Latin saying 'to err is human, to persevere [in erring] diabolic' nicely sums up the essence of how we humans view ourselves – we err, but we may also learn and improve. On the opposite end of the spectrum, we tend to regard machines as utterly perfect tools executing requirements in a reliably repeatable manner. As Carolyn L. Kane puts it, '[t]his distinction may ring true on most practical levels, but it also perpetuates cultural beliefs in an error-prone, yet self-reflexive, human versus a blind, but fail-safe, machine.'[1] Even machines that look and act like humans can tend to be considered by non-expert humans as 'the embodiment of precise perception, flawless execution and high cognitive abilities.'[2] However, recent studies have shown that 'a robot with human-like reasoning behavior and occasional errors may be perceived positively, for example, as more empathetic, as opposed to a robot with flawless, machine-like cognition.'[3]

The same principle can be applied to our perception of current artificial intelligence (AI) tools. AI-related software development has focused on the perfection of problem-solving tasks such as digit and face recognition, sentence completion, or text generation. In these cases, maximum accuracy is sought to ensure the reliability needed for a dependable and user-attractive product. However, in the realm of music and other creative applications, system failures can lead to unpredictable results that possess a distinct mark of creativity precisely because they deviate from established validation criteria.

In the following paragraphs I will elaborate on the concept of 'imperfection' specifically with regard to a discussion of what I will define as a *musicality of imperfection*. I will then explore how exploiting these errors in artistic AI applications can result in curious outcomes that deflate the binary distinction between 'erroneous' humans and 'perfect' machines/software.

DOI: 10.1201/9781003312338-17

Curiosity for Imperfection

Mistakes are a source of material, not embarrassment.

Andy Hamilton

The first time I ever noticed my attraction to flawed subjects was on a visit to Boston in 2000 that, at the time, hosted a large exhibition featuring multiple unusable mundane objects with flawed designs undermining their implicit functionalities. Some examples from the exhibition were a wavy Ping-Pong table (good luck playing on that), a U-turn hammer (with the head facing the handle), and a masochist teapot (with the spout on the same side as the handle - see Figure 11.1), as well as many other ridiculously useless things. I was seventeen years old at the time and cannot recall the name of the artist, nor the exhibition space, but I believe that the artist must have been Jacques Carelman. Carelman was a French artist known for his book *Catalogue d'objets introuvables*, which was published in 1969.

There were two aspects to this exhibition that immediately sparked an affectionate response in me: one was its humorous, self-ironic side nature, the other the idea of immersing myself in an imaginary universe, similar to that of Alice in Wonderland, where seemingly useless objects like the ones I saw could be transformed into something useful. Carelman's 'anti-design'

FIGURE 11.1
AI-generated variation on Carelman's Coffeepot for Masochists'.

could be viewed as a continuation of the francophone tradition that challenged the immediate semantic interpretation of everyday objects in artistic contexts, such as Magritte's *Ceci n'est pas une pipe* or Duchamp's *Fountain*. According to Denis Bachand, objects within this tradition serve an artistic purpose by diverging from their practical functions.

Several years later, in 2006, a curious exhibition that would later become the Museum of Broken Relationships opened in Zagreb (see Figure 11.2), my hometown. Artists Olinka Vištica and Dražen Grubišić conceived of a unique project which aimed to repurpose the shared objects that neither wanted to keep after the end of their romantic relationship, to which they later added a collection 'formed exclusively from donated objects that are related to broken relationships and exhibited with stories about break-ups written solely by the donors'.[4] The imperfection embodied by these objects – their representation of a failed relationship – enables them to tell a relatable story. Quoting Leo Tolstoy's famous line from the opening of *Anna Karenina*: 'All happy families are alike, but every unhappy family is unhappy in its own way.' Precisely because they were unhappy and flawed, these 'intimate and personal' relationships manage to 'produce impact, ... both emotional and intellectual.'[5]

As an artist, I examine flawed, imperfect, dysfunctional musical tools or systems (harmonies, rhythms, narratives, etc.) as opportunities to discover the unexpected. This perspective informs my practice, from my usage of microtonality and glitch to the intersection between my conceptualization of

FIGURE 11.2
Museum of broken relationships, Zagreb, Croatia. Photo by Sanja Bistričić.

Objects within this tradition serve an artistic purpose by diverging from their practical functions.

imperfection and the concrete implementation strategies of machine learning music tools explored here.[6]

The primary goal of most AI tools is to automate and accelerate the execution of simple tasks (e.g., number recognition, classifying images, ...) or to discern patterns from complex multi-variable inputs (e.g., customer preferences/recommendations, spam filtering, ...). When the first musical applications of generative AI became popular, especially those focused on replicating musical styles by generating MIDI (Musical Instrument Digital Interface) sequences, I was unconvinced. The focus on emulation, the lack of an interesting interface, and the impossibility of customization – given the need for extensive data collection and systematization – made these systems neither user-friendly nor aesthetically interesting to me.

It was not until I came across Rebecca Fiebrink's Wekinator that I started noticing the hidden creative potential of various ML tools. Wekinator learns from physical gestures captured by camera, enabling musicians to generate associated sounds by inputting gestures that closely resemble a series of gestural behaviors Wekinator has been trained to identify. This tool offers performers a high degree of flexibility and a relatively straightforward interface; the system not only learns a given gesture but also incorporates variations, thus allowing performances to have a broad margin of error while still producing similar results. I was immediately captivated by the non-linear relationship between gestures, learned gestures, and the resulting triggers, as well as the interesting allowances and disallowances of intentional 'errors' when using this tool. As my work is not heavily dependent on physical gestures, my explorations of the Wekinator were limited in scope, but a curious reader should look into the work of Laetitia Sonami and her fascinating collaborations with Rebecca Fiebrink (see Figure 11.3).

My experience with Wekinator's captivating non-linearity revealed to me the potential of using machine learning tools to expand my compositional resources. Soon afterward, I discovered other tools that aligned more closely with my creative interests such as FluCoMa, AudioGuide, MuBu, CataRT, etc. These introduced different approaches to Concatenative Sound Synthesis (CSS), which involves matching real-time or prerecorded audio inputs with a corpus of stored audio samples/sound files based on various musical parameters (MFCCs, spread, kurtosis, energy, etc.).

Prior to delving into CSS, I would envision a piece of music as a multidimensional matrix consisting of numerous one-dimensional parameters, dots floating within a very complex graph. These parameters would include not only pitch, rhythm, and dynamics, but also timbre, instrumentation, playing techniques, tempo, and so forth. However, mapping even the simplest piece into such a matrix would be a tedious and next-to-impossible task. If this operation was possible, one could inhabit this multidimensional array and interpret a given piece as a specific projection of dots onto a time axis. One could therefore traverse alternative non-temporal pathways through the entire or partial collection (or clusters thereof). Scaling these dimensions (musical characteristics) along the time axis would allow

FIGURE 11.3
Laetitia Sonami performing with her Spring Spyre, 2022. Photo by Robbie Sweeny.

one to perform transformations on these materials, applying non-identical or non-proportional scales resulting in different forms of dilation, contraction, or distortion. Depending on the degree of distortion, the resulting sounds could exhibit different degrees of similarity or dissimilarity compared to the original music. It becomes conceivable to envision multiple versions of self-standing pieces that utilize the same source music as a highly abstracted framework, achieved through unique recombination of patterns with distinct sonorities.

Once I began applying CSS tools within several of my pieces, I realized how close my vision of a musical piece as a multidimensional matrix resembled the underlying structure of concatenative synthesis. In CSS, a specific tool breaks down sound into units that are stored as data points within a multidimensional relational matrix (corpus). Each segment within the corpus is associated with multiple descriptive values (descriptors), and a new file is constructed by selecting and reassembling segments along a new pathway (target). However, CSS differs from my original 'vision' in that it is primarily applied to recorded music. Each segment within CSS

refers to a fixed sonic simultaneity, resulting in a predominantly tempo-
ral reshaping rather than manipulation across various parameters. In my
'vision', I sought the further ability to manipulate each instant in all pos-
sible parameters independent from each other. Software tools like FluCoMa
incorporate music information retrieval capabilities, enabling the parsing of
sounds based on their spectral components. Through skillful patch design,
it may be possible to approximate the realization of this vision. I formalized
this concept into a compositional strategy called *microllage*, combining the
words 'micro' and 'collage'. I began to work by adopting macrostructural
and microstructural elements from existing composed source material.
Once the reference gets thoroughly analyzed and key elements selected,
my role as a composer is to design the 'meso' structure.[7] The creative pro-
cess requires reordering clusters of dots (musical fragments) internally,
stitching a group of clusters into larger phrases, and fitting these phrases
to the macro-structure, which is either invented or adapted from the source
material to suit the new context.

The first time I used this technique was in 2017–2018, a year before using
machine learning tools in my orchestral piece *Reimagination*. In the first move-
ment, I took the ascending fourth motive from the bassline of 'Baba Yaga'[8] and
generated a minute-long section by manually generating all possible permu-
tations and fitting them into my meso and macro structures. I attempted to
abstract elements from Mussorgsky's music to creatively reshape them until
they had been denaturalized and acquired my personal aesthetics.

I became more aware of the generative potential of permutation when work-
ing on this piece. Some artists may dismiss raw permutation as a fundamen-
tally non-creative or non-inventive approach, but most forms of creativity
critically involve a successful reformulation of existing material. As Steiner
puts it, 'all human constructs are combinatorial. Which is simply to say that
they are *arte-facts* made up of a selection and combination of pre-existing
elements.' This principle also applies to microllage and concatenation, as it is
within the processes of selection and combination that a profound richness
of otherwise unimaginable expressivity can be discovered.

Musical Examples

What I am, I don't know. I am the simulacrum of myself.

Jean Baudrillard

I will begin by examining three pieces of mine from 2021 (*Hidden Dimensions*,
XinSheng, and *#MeMyselfAI*) and one from 2023 (*QUEENR*). I will then con-
trast concepts from this analysis with those from a close reading of three

recent pieces by fellow composers Jennifer Walshe (*Ultrachunk*), Andrew Watts (*A Dialogue, in Linear A*), and Genoël von Lilienstern (*Unsupervised Sounds*). These compositions serve as examples that illustrate how artists creatively engage with the imperfections implicit in AI tools. All these pieces explore (dis)similarity matching, that is, the uncanny moments where a similarity-matching tool returns something unexpected.

In an ideal situation, a tool's seamless operation should diminish our awareness of its inherent status as a tool. However, when tools stop behaving as expected (e.g., the tip of the pen breaks off), their constituent components become apparent.[9] Carolyn Kane explains, in the context of discussing the 'myth of transparency', how 'we need to use the frameworks of error, glitch, and noise … to analyze how our ostensibly "new" and "better" media break, revealing new insights at their seams.'[10] Similarly, my focus here is on works that question how technology shapes our experience, especially when the tools we use break down or fail.

Davor Vincze

Hidden Dimensions

My audiovisual installation *Hidden Dimensions* (see Figure 11.4) was presented in Graz in November 2023 as a part of an artist residency at IEM (Institute of Electronic Music and Acoustics).[11] It extensively used the FluCoMa library within Max. In this installation, I reflected on the '(im)perfection' of human perception through metaphors from string theory. The project's concept drew a parallel between the way our auditory cortex sums all overtones coming from the same source into one note and the hypothesis, taken from string theory, that beyond the three perceivable dimensions there are multiple hidden subatomic ones that define the characteristics of each subatomic particle. Taking this association with a grain of artistic freedom, I created a work using car spring coils. Their helical shape gives them a rich spectrum, with local imperfection in density and thickness hiding additional, unpredictable overtones depending on how and where you strike them. Coils seemed like ideal candidates to convey the idea of *hidden dimensions*. The installation was designed to amplify, record, analyze, and resynthesize the sound of nine specific coils that I had carefully selected based on their unique sonic characteristics from a huge car dealer dumpster that had several thousands of them lying around.

The installation consisted of eighteen hollow half spheres made from Styrofoam and mounted in an ascending spiral. These half spheres were colored light yellow and dark green in alternating order. The nine green half spheres were equipped with hanging coils and pick-up microphones acting as resonators and sound inputs, while the nine yellow half spheres had transducers attached to them, acting as speaker membranes and sound outputs. The Max patch consisted of nine modules, each responsible for producing different sonic outcomes. For the purpose of this discussion, we will focus

on the two modules that utilized neural network tools within the FluCoMa environment.

The first module functioned to classify each of the nine coils. Because each coil had its own pick-up, it would have been possible to use the loudness detection alone. However, considering I was fishing for the system's imperfections, I wanted to explore unpredictable but not purely random elements and used an imprecise classification algorithm instead. The neural network was trained on each of the nine coils by pairing the coil's number with the Mel-frequency cepstral coefficient (*fluid.mfcc~*) from its corresponding recordings. These recordings were made in IEM's studio, with each lasting over a minute and featuring various mallets (wooden, soft, hard, metal, etc.) striking different positions along the coil. Although the sample provided sufficient richness to train the neural network for coil classification, it was not exhaustive, as there existed numerous combinations of positions, mallets, and striking forces that could generate slightly different timbres the neural network was not trained on. The recognition accuracy of the neural network reached approximately 90%.

If the classification was accurate, the module would process the sound input and output it through the adjacent speaker. In cases where the classification was incorrect, the module would produce a sound on a distant speaker, resulting in unexpected panning effects. This was intentionally designed to encourage the curiosity of the audience and encourage further exploration of the other coils.

FIGURE 11.4
Hidden dimensions, Mumuth, Graz, Austria. Photo by Kristina Vrdoljak.

The second module, also using neural networks, introduced a regression task. This neural network consisted of two input neurons, three hidden layers, and twenty-seven output neurons. To train the network, I defined a three-by-three grid with nine frequency and loudness values as pairs (for the input neurons). To accommodate any potential outliers that might have been missed in my measurements, I slightly expanded the range beyond the typical fundamental frequencies I had measured for these coils (200–800 Hz) and the typical average loudness of –20 to –80dB. I ended up creating nine pairs within the range of 100Hz/–10dB and 900 Hz/–90dB to frame this training space. The corresponding output neurons were fed with the twenty-seven overtone loudness values via the *fluid.melbands~* object. Each of the nine frequency-loudness points was paired with a specific coil, with each coil having its own unique combination of twenty-seven melband values.

Once trained, this module was capable of receiving a live signal and measuring its pitch and loudness (via the *fluid.pitch~* and *fluid.loudness~* objects) and forwarding these values to the neural network. The network, in turn, predicted a new set of twenty-seven values, which were paired with the central frequencies for each band. These paired values were then sent to an *oscbank~* object to synthesize a new sound. This functionality allowed the installation to explore the spectral space between the measured values for each coil, as the neural network learned how to interpolate between the defined extremes of fundamental pitch and loudness.

I would argue that the 'imperfection' of the results, which were not exact replicas of the coil spectrum, made them interesting. On the one hand, they were still evocative of the metallic resonance of the coils, but on the

FIGURE 11.5
Still image from XinSheng showing Anne (Nina Guo) talking on the phone with Fan – directed by Heinrich Horwitz, video editing by Lara Rodríguez Cruz, camera by Jule Katinka Cramer.

FIGURE 11.6
Still image from XinSheng displaying Fan (Sonja Schmid) and Andrei (Jonathan Shapiro).

other hand, they exhibited noticeable glitches and synthetic qualities. Moreover, it is impossible for human perception to grasp any correlation between the pitch, loudness, and band intensity of nearly thirty overtones. These values were simply too complex for a listener's mind to understand the underlying pattern and associate the results in a meaningful way. That is why regression was distinctly useful for this task, as the regression tool mapped these seemingly random values by placing them within a relational matrix, allowing for the testing of other values and the generation of various interpolations. The results maintained a relational coherence between values that would otherwise be unintuitive and unable to be reconstructed in any other manner.

XinSheng

XinSheng is a twenty-minute opera for mixed ensemble, soprano, electronics, and video (see Figures 11.5 and 11.6). I will focus on two sections of the piece. The first section involves two main characters engaged in a phone conversation. There was a creatively compelling logistical challenge here: a single singer had to convincingly convey two roles. One voice would be heard loud and clear, as if directly addressing the audience, while the other had to sound distant, as if the audience were tangentially overhearing bits of a conversation. We recorded both parts of the dialogue separately with the same singer.

For Anne's ('loud and clear') character, we applied slight filtering to the singer's normal speaking voice, but left it otherwise untouched. To create the other character (whose voice was coming over the phone), we recorded the

FIGURE 11.7
The shadow of Roberto Alonso performing #MeMyselfAI at MIHL, Lugo, Spain.

singer several times. We applied concatenative sound synthesis techniques to distort this character's voice, using one take for the target and all other takes as the corpus. Counting on the implicit imperfection of the system's ability to accurately feature-match, I tried to achieve something half-understandable and half-nonsensical. While most syllables were matched correctly, every now and then there was a complete mismatch. I started playing with the system, trying to lure out more of these imperfections. The trick was to have different segmentations applied to target and corpus, and to demand a lower matching accuracy. After several tries, I achieved a balance between matched and mismatched syllables. This was just enough to give the impression of gibberish mixed with occasional words that were easy to recognize, thus conveying the sense of eavesdropping on somebody else's phone call. To camouflage the voice's similarity with the other character, I also applied similarity matching between the same take as a target and a short intermittent section of recorded ensemble music as corpus. The matching was done through a combination of *mfcc* and *mean energy* descriptors, and while the result was texturally different, it nevertheless contained its discursive quality. Mixing this with the speech with a dynamic ratio of 35:65 in favor of speech as corpus, I was able to camouflage the singer's voice just enough to avoid the audience noticing that both voices belong to the same person. The result was what I would define as 'perfect imperfection', conveying the diction of a different person talking over the phone, with only occasional intelligible keywords, almost as if the phone line were cutting in and out.

I took a slightly different approach when working on the opening electronics for *XinSheng*. In this section, the notated score combined precise rhythmic patterns for drums with small, noisy, and chaotic musical elements for the

other instruments (clarinet, zither, cello, and keyboard). The electronics were created after our recording session, and I had prerecorded audio stems for each instrument separately. This provided me with the flexibility to manipulate the stems using Audio Guide and use various stems as either target or corpus. Exploring all possible permutations, I tried matching the same sound file as both target and corpus. Unlike the previous example, the result was disappointing, especially when mixed with the live recording. This was primarily due to the system's excessive accuracy, which produced nearly identical results that ended up masking each other when combined. Since both the percussion and CSS-Doppelgänger had extremely similar attack timing and spectral characteristics, the overall subjective impression was that the electronic tape was constantly emerging from and receding into the background. This was not the desired effect.

After careful consideration, I realized that using only the drum part as the target might yield more interesting results, as the other instruments were too chaotic, and their pulsation was excessively abstract. The opening section of the piece consisted of about six chaotic segments that would pause after several measures before recurring. I decided to follow the structure of my score and treated each section as a target to be matched, while the corpus consisted of the other (non-percussion) instruments from the same section.

To fine-tune my results, I first played with the presence and absence of specific instruments within the corpus. This had a significant impact on the overall timbre of the generated audio. For instance, increasing the presence of the clarinet or cello led to smoother sounds, while a higher presence of the electric zither or keyboard resulted in more fragmented audio. Next, I experimented with the precision of feature-matching and the choice of descriptors. After several tries, I realized that selecting different pitch-related descriptors (e.g., centroid, mfcc, etc.) had minimal effects on the output, which made sense because the drums (the target) are 'pitchless'. Instead, I obtained more interesting results by utilizing spectral descriptors like flatness or sharpness. These descriptors were able to capture the nuances between the sharp attacks of the snare drum and the muffled ones of the bass drum. The closest matches were achieved with loudness descriptors like energy or mean energy in combination with durational matching. The system tended to select the sounds of other instruments that were of nearly identical duration and of similar intensity in character, so when played against the target, the result seemed tightly interwoven with the drum recording, but also flavorful and expressive.

#MeMyselfAI

#MeMyselfAI was the result of collaboration with Roberto Alonso Trillo in 2021 (see Figure 11.7). The goal of the newly commissioned pieces for Alonso's project *New Music, New Paths* was to creatively implement AI technology. The specifics of this implementation were left to the discretion of the composers selected for the project.

I applied the microllaging principle to #*MeMyselfAI,* using Alban Berg's Violin Concerto as a reference. I formally analyzed Berg's piece, considering its melodic shapes, orchestration, rhythms, dynamic and dramatic development, character, etc. I decided that I would extract the macro form from the Berg, dividing the piece into two movements, and I further decided to maintain the original time proportions between sections and subsections, with one exception: the duration was compressed from twenty-five to fifteen minutes. The violin soloist retained the original role, while electronics represented the orchestra. I mapped the extremes of each section of the Berg and used them as boundaries within which to generate new material. I also respected the broad dynamic range and character of each section, for example ensuring the solo moments remained soloistic, using arpeggios over all four violin strings as in the Berg, and referencing overarching orchestral gestures from the original. For another example, in the opening gestures of both second movements, #*MeMyselfAI* mirrors Berg's Violin Concerto by utilizing three upward steps, with the second and third steps fused in a double stop. This maintained the essence of Berg's opening while also emphasizing the predominant triple beat of the source material. The microllaging process involved repeating and permuting this 3/8 unit, gradually filling out the space over the first ten bars. The following sections play with the general contour of Berg's opening, ten bars, varying the material along both temporal and pitch axes according to segmentation logics inherited from the Violin Concerto.

Two more examples of working with ML from #*MeMyselfAI* can be found within the electronics. I transcribed the solo violin part and fed it into a Markov chain (using Max's BACH/CAGE libraries) to make the system mimic some of Berg's violin writing. Again, the best results were achieved when the system was not too perfect in recreating the music phrases it was trained on. This was usually the case when using a third-order[12] Markov chain, as it considered the previous three notes to determine the transition probability for each subsequent note. Lower orders resulted in vague resemblances, while higher orders led to the repetition of identical intervallic phrases from Berg's solo violin. To further distort the source material, I treated the rhythm and pitch with two separate Markov chains. These chains were then combined into MIDI information, which was fed into a sampler containing harsh digital sonorities vastly different from the timbre of the violin. While treating the original in this way resulted in a superficial, video-game-like affect, the result retained the essence of Berg's expressionism, which was precisely the intended goal.

In the last three minutes of the second movement, I applied machine learning from the Max environment using Max's *ml.som~* (self-organizing map) object. The purpose was to perform an interpolation between four sounds: a loud tam-tam splash from bar 97 of the Berg, the two Höhepunkte (bars 125 and 186 of the Berg), and the last sustained chord (bars 229–230 of the Berg). I assigned each sound one of four corners (0,0 - 0,1 - 1,0 - 1,1) within

an abstract, two-dimensional space. I was interested in using bow position information to move through this two-dimensional space, generating interpolations between the audio at each corner using Max's *ml.star* object. The violinist was equipped with a tool that afforded me this possibility called MetaBow, a motion-tracking bow interface developed by MetaBow Ltd. in Hong Kong. However, the interface's prototype was not available for public display at the time of the premiere, so I emulated the movements of the bow with my mouse in order to generate and prerecord these interpolations. Our intention is to fully implement MetaBow in future performances. Nevertheless, I found this shortcoming welcoming, as it allowed me to take more time to explore the interpolation space in search of curious sonorities. Playing around with this interpolation space allowed me to discover some interesting sonorities that could easily function as Höhepunkte of my own. One of these gradually subsides in its intensity, giving way to the suspended sound of Berg's final sixth chord in Bb that the Violin Concerto ends with. Throughout most of the piece, the blending of violin and electronics blurs the distinction between master and puppet, slightly favoring the violinist; hence it is interesting here to observe the performative shift as the roles reverse, encouraging the violinist to imitate the AI-generated sound and eventually cease playing, fading into darkness as the lights dim. What remains is a constantly reshaping morphology of chords derived from ml.star. These chords were then parsed into spectral layers using FluCoMa (*fluid.sines~* and *fluid.hpss~*) and finally repeated with microtonal oscillations in both pitch and time. As the violin fades away and the electronics gradually diminish, the chord never fully settles into the perfect iteration of Bb6/5, as written in Berg's final bar. Instead, it evokes an unsettling sensation, lingering in the uncanny valley of its own imperfection.

QUEENR

The final piece of mine that I would like to discuss is *QUEENR*, which premiered at the Music Biennale Zagreb in April 2023, performed by the French ensemble Proxima Centauri (See Figure 11.8). The work draws inspiration from 'Bohemian Rhapsody', the famous song by the iconic band Queen. Freddie Mercury, the band's flamboyant frontman known for his camp aesthetic, became a queer icon who exerted significant influence within queer spaces during the 1990s. I was interested in using Stable Diffusion, an AI tool capable of generating imagery that undergoes continuous transformation, to establish an association between visual flux and queer identity. 'By itself, the queer body introduces the highest degree of subversion of traditional cultural models: it fits neither of the two categories devised by traditional Western thought and thus suspends them both.'[13] The faces generated by Stable Diffusion often defy specific gender assignment, aligning with the idea of not fitting traditional categories. In his acclaimed book *Cruising Utopia*, José Esteban Muños writes that '[t]he aesthetic, especially the queer aesthetic, frequently contains

blueprints and schemata of a forward-dawning futurity.' For me, the concept of 'forward-dawning' futurity manifests itself through AI, which, being genderless by default, can be considered queer. In creating *QUEENR* I wanted to playfully engage with this idea by creating morphed facial variations of the Proxima Centauri performers.

First, I took photographs of each of the five Proxima Centauri members, asking them to pose with different facial expressions (serious, sad, happy, angry) against a white backdrop. To generate new images, I used the words from 'Bohemian Rhapsody' as prompts for a Stable Diffusion tool called Diffusion Bee, including prompts like 'mama', '(poor) boy', 'baby', 'little', 'dead', and 'devil', as well as 'queen' and 'queer'. I expanded the image set by incorporating variations of these words and antonyms like 'toddler', 'dad', 'big', 'girl', 'angel', 'king', and so on. After some adjustments to the settings, I managed to fine-tune a sweet spot that consistently generated the desired images. There were three issues to overcome. Firstly, it was essential for the new face to possess distinct individuality while maintaining a sense of connection to the original images. Secondly, I aimed for the textual prompt to be somewhat discernible in the generated images. Although interesting outcomes were achieved even when the correlation was not immediately evident, I sought a balance where the prompts had at least some noticeable influence. Sometimes the influence was subtle, such as messy hair in response to the prompt 'wind', while other times it was more pronounced, with prompts like 'queen' or 'king' resulting in various forms of crowns. Thirdly, although the generated images rarely attained photorealistic qualities, I strived for them to resemble plausible human faces as closely as possible. Granting Diffusion Bee more creative freedom often resulted in images with a comic-book-like aesthetic. Nevertheless, I made a few deliberate exceptions, as I appreciated their campy quality.

I structured the video around the electronic audio playback. The narrative unfolded by initially presenting individual faces of each ensemble member one by one. At the beginning, I created transitions exclusively between the original photographs and their corresponding AI-generated variations, rather than between the ensemble members themselves. As time progressed, the morphing faces juxtaposed and multiplied, eventually forming a 4×4 matrix. Towards the conclusion, the number of faces gradually diminished until only one remained, and in the coda section, for the first time, morphing between all ensemble members was prominently featured.

Even though the video in *QUEENR* is fixed-media, there exists an undeniable performative relation between the ensemble members and their avatars. Taking the word *performative* in its broader context as suggested by Andrew Parker and Eve Sedgwick, we could say that 'the stretch between theatrical and deconstructive meanings of "performative" seems to span the polarities of, at either extreme, the *extroversion* of the actor, the *introversion* of the signifier.'[14] In such a broad interpretation of performativity, the mutating faces on screen had an almost commanding gaze that caught the audience's attention

FIGURE 11.8
Still image from the QUEENR video presenting four AI modified faces of Proxima Centauri members.

as if they reflected the visage of a real, live performer. The subtlety of the ever-evolving facial expressions extended beyond the basic four emotions captured in the original photographs of the Proxima Centauri ensemble members. These dynamic expressions conveyed a sense of liveliness, as if the faces were reacting to the music with a range of emotions including approval, dismay, shock, and acceptance.

These constantly mutating faces further evoked an array of transitional identities: a female face transitioning into a male face, Asian features morphing into Caucasian characteristics, or an expression of anger evolving into one of happiness (see Figure 11.8). These transitional mid-states brought to mind the fluidity and malleability of identity, challenging preconceived fixities and showcasing the potential for multifaceted interpretations of individuality. This piece was also an outlet to reflect upon Sigmund Freud's concept of the *narcissism of minor differences*, which '[a]lthough it most often does manifest itself … as a banal form of aggression in everyday life, the history of the last half-century, if not of preceding millennia, suggests … [it has] a malignant potential to erupt in vast bloodbaths which have even reached the level of genocide'.[15] All of this sounds very close to home for an individual like me, born prior to the 1990s Yugoslavian War, the remnants of which still permeate the Balkan air where the premiere took place precisely because people cannot let go of their minor differences. The mutating faces in *QUEENR* encourage its viewers to recognize the insignificance of ostensible differences, and to acknowledge the uncharted territories one might neglect due to binary narratives regarding identity. By challenging these binaries, the

FIGURE 11.9
Still image from the QUEENR video presenting the modified face of Benoit Poly (Proxima Centauri percussionist).

video aimed to open doors to a broader spectrum of possibilities, prompting reflection on the untapped potential that exists beyond the confines of conventional categorizations.

Referring to unexplored identities in their manifesto on glitch feminism, Legacy Russell writes that '[t]he digital world provides a potential space where this can play out. Through the digital, we make new worlds and dare to modify our own.' For them, the digital realm serves as a space where nonexistent or marginalized identities can freely express and explore themselves. As *QUEENR*'s video physiognomies kept morphing, all the while addressing the audience with an ever-piercing stare, I wanted to highlight the imperfection of our preconceptions regarding gender, age, race, artificial or real life (see Figure 11.9). My hope is that the repeated exposure to such digital entities can easily reshuffle any identity signifier and should inspire us, just as Queen did in the late twentieth century, to dare to explore the queer fluidity of our lives.

Jennifer Walshe

Jennifer Walshe is an Irish contemporary composer well known for her unorthodox approach to cross-genre and social (media) commentary artworks. Walshe's *Ultrachunk* was realized as a collaboration with Memo Akten, a technologist who played a significant role in creating and implementing the algorithm that drove the piece (see Figure 11.10). Walshe's journey with this piece began approximately a year earlier, when she started recording short 'home-made' videos of herself improvising and singing in front of her personal computer's camera.

The mutating faces in QUEENR encourage its viewers to recognize the insignificance of ostensible differences and to acknowledge the uncharted territories one might neglect due to binary narratives regarding identity. By challenging these binaries, the video aimed to open doors to a broader spectrum of possibilities, prompting reflection on the untapped potential that exists beyond the confines of conventional categorizations.

FIGURE 11.10
Jennifer Walshe (upper left) performing "Ultrachunk" with Memo Akten (bottom right, in the shadows). Photo by Anne Tetzlaff.

Each improvisation session was followed by a reflective journal entry, serving as a ritualistic metaphor for summoning her next session. This process eventually resulted in several hours of recorded improvisation, forming the database from which Akten trained his AI system to construct a 'mini-me' version of Walshe.[16]

Ultrachunk has no annotated score and is, just like its prerecorded material, an improvisation piece of unset duration. The performance begins with Akten providing a brief explanation of the technical components of the piece. Following this introduction, Walshe attempts to engage the audience in a voice warm-up exercise. During this exercise, Walshe's artificial copy, her mini-me, remains silent. Once Walshe has warmed up, she starts to hum a drone, and at this point, Akten activates Walshe's AI avatar, which is projected as a video on the screen behind her and heard through the stereo speakers in the room. Walshe then proceeds to improvise in a duet with her AI avatar, with the two voices interacting and responding to each other in real time. This improvisational dialogue continues until the artists sense that the performance is gradually winding down. At that point, Akten stops the input and allows the system to slowly come to a halt, concluding the piece.

Akten's avatar-generating algorithm, called GRANNMA, was pretrained on Walshe's aforementioned home-made videos. As Akten explains, GRANNMA is a 'machine learning driven system that can mimic the key components of Walshe's identity – her voice and face. During the performance,

FIGURE 11.11
Still image from the video of "A dialogue, in Linear A". Image by Andrew Watts.

the video and audio output from the machine are neither recordings nor pro-
cessed – every frame and sound is generated live in real-time, navigating the
hypersphere, constructed from the fragments of memories in the depths of
the neural networks.'[17]

Akten took care to ensure that Walshe's eyes remained at a central point
within the frame, even though the videos used for training were recorded in
different rooms with varying lighting and positions. This helps to prevent
Walshe's head from jittering all over the screen when the videos are gener-
ated. The constant changes in the room's surroundings and Walshe's appear-
ance, including her haircut, create a mix of amusement and unease for the
viewer. This phenomenon evokes the uncanny valley sensation, where the
slight deviations from expected consistency generate a sense of both famil-
iarity and strangeness. This, of course, is intentional, for Walshe likes to situ-
ate precisely these kinds of jarring effects in her work. Walshe did not want
to make her recordings look too similar (e.g., recorded in front of a clean
white wall). Had she done that, the result would have been too smooth, and
the audience might think that this is just a single prerecorded video or a
montage that was done in advance. Instead, the visual inconsistencies under-
line the fact that active processing is taking place while Walshe is singing
live, enhancing the perception that there is an actual intelligence mimicking
her every move in real-time.

The audio playback in *Ultrachunk* also distinguishes itself from live mate-
rial through imperfection. The resolution quality of the avatar's voice is
slightly reduced, giving it an identifiably metallic quality. The interpolation
between samples, while executed flawlessly, retains a subtle graininess in

Instead, the visual inconsistencies underline the fact that active processing is taking place while Walshe is singing live, enhancing the perception that there is an actual intelligence mimicking her every move in real-time.

the sound. A slight rhythmic pulsation can be perceived in the background, particularly during moments when the avatar is not singing. While Walshe's live singing also exhibits discontinuities, it is still firmly linked through her breath, whereas her 'sibling' occasionally transitions unexpectedly to an entirely different singing technique. This contrast enhances the distinction between the two voices, yet they maintain a considerable level of consistency in their expression, blurring the distinct boundary between them. But it is not just that GRANNMA imitates Walshe's voice; Walshe as well imitates her avatar, thus reversing the imitational process.

Just like improvisation in other genres, this piece tries to display the performer's virtuosity, yet the performer who is in focus is not Walshe, but rather her alter ego. The true strength of the piece lies not just in the machine's ability to flawlessly emulate Walshe's voice, but also in its ability to create unexpected outcomes. Walshe acknowledges that the machine's performance can range from uninspiring to astonishing, but she appreciates the sense of free will that emerges from the unpredictability of the AI. For her, there is nothing more boring than the predictability of a Max patch (as she was using in her past work) where one knows how to make the system tick. With *Ultrachunk*, Walshe embraces the uncertainty of how her binary copy will react.

Andrew Alfred Watts

Andrew A. Watts is an American composer whose artistic practice examines 'the compositional application of language desemanticization, focusing on the ability to convey expression through the voice even when specific meaning is lost, augmented, or otherwise unintelligible.' His work is often inspired by the themes of posthumanism and dystopia; purity, ambiguity, and distortion play a significant role in the semantics of his pieces.

Watts's video piece *A Dialogue, in Linear A* evokes the enigmatic language of ancient Crete, known as Linear A, which has remained undeciphered for nearly four thousand years (see Figure 11.11). 'We know Linear A was spoken by humans, and we know what humans look and sound like, but there is no way of knowing what that particular language sounded like' – said Watts in one of our correspondences.

The creative process began with Watts taking a Linear A text found on an ancient religious artifact and transcribing it phonetically, drawing upon assumptions derived from similarities with Linear B, a similar script that has been deciphered. Watts provided this phonetic transcription as an input for a text-to-speech converter called 'Nuance', another AI tool that uses concatenative synthesis.[18] The resulting audio was a mysterious sounding string of syllables that one can hear in the video (augmented with various audio effects). Watts then selected six copyright-free HD videos from the internet, three showing a female face and three a male face. Watts then cropped each video to create a close-up shot of only the mouths. He then kindly asked me to help him in his design process.

Our goal was to connect mouth positions with syllables from the text-to-speech converters. Luckily, these stock videos involved actual diegetic speech we could feature-match against. We sliced the text-to-speech audio into forty-millisecond fragments, and then used a Max patch (the *camu* tools within the MuBu library) to build a library of associations between text-to-speech audio, diegetic sound, and video frame. With the resulting list of segmented indices, Watts was able to cut and reshuffle the six videos into the proper order. The result was fascinating, as there was obvious congruency between the mouth movements in the video and the character of the sound. However, the deliberate rearrangement of the video frames resulted in uncanny mouth movements, evoking an otherworldly and alien quality that aligns with the intended effect.

The final video is straightforward and formal: It presents Linear A letters in the center and displays female faces on the left and male faces on the right. As the video progresses, the complexity increases, and the imagery becomes more chaotic. Female and male faces intertwine, resulting in a disorienting amalgamation of constantly morphing visages. Much like Walshe's video, the contrast between a human face and a slightly uncanny movement pattern makes it clear to the viewer that this is not simply a montaged video, but rather that there is an underlying process happening. Watts embraced this contrast, readily accepting the occasional jarring inconsistency between spoken word and mouth shape. These imperfections amplified the alien qualities of this mysterious language. As a result, it sparked a dialogue between the known and the unknown about Linear A.

Genoël von Lilienstern

Genoël von Lilienstern is a German composer who works with instrumental composition, installations, and music theater. He is a founding member of the group Ktonal, which developed a python package for machine learning with audio called Mimikit (short for Musical Modeling toolkit). As Lilienstern says himself, this is a 'home-grown, open-source AI, potent, but cumbersome as the results require a lengthy process of trial and error'. Ktonal's GitHub page says that Mimikit 'focuses on training auto-regressive neural networks to generate audio, but it does also contain an app to perform basic and experimental clustering of audio data in a notebook.'[19]

Mimikit was used in a performance of Lilienstern's *Unsupervised Sounds* at the Eclat Festival 2023 in Stuttgart, Germany. The piece begins with a voice guiding instrumentalists through a model-training session (see Figure 11.12). This disembodied voice reads instructions of what a musician should do, explaining all the while that it itself is the result of AI training. As the voice provides an instruction, the musicians of Ensemble Garage 'demonstrate' the assigned task. Subsequently, Mimikit is actively learning from their performance, reassembling and reproducing the given task through the loudspeakers.

FIGURE 11.12
Concert performance of "Unsupervised Sounds" by Ensemble Garage. Photo by Dirk Rose.

At first the tasks are rather simple – play a low E on a trombone, play scales on a piano, play rhythms on percussion, an interval on a guitar, etc. – so the synthetized AI result is also rather accurate. However, as the piece progresses, the complexity of each task intensifies. Consequently, a growing number of errors occur as the system struggles to keep up with the demands placed upon it. It is precisely when these errors start that the piece stops being a schematic demonstration resembling a salesperson's pre-rehearsed spiel and the actual musicality and Lilienstern's creative voice as a composer emerge. For as long as the matches were next to identical, they were but a pale copy of the original sound performed, void of any innovative potential. On the other hand, once the AI starts to abominably fail in reproducing the complex sound of multiple performers, the system starts to generate a unique flavor that would otherwise be hard to construct via some well-structured electronic algorithm. The question that emerges is whether these compelling failures are 'merely erroneous old information, ... the combination of various old information, or ... an actual, independent third?'[20]

Lilienstern provides opportunities for the musicians to improvise on top of each 'failed' attempt. In doing so, Lilienstern transforms a technological flaw into a creative asset. The sections that consisted of AI's failed attempts in combination with free improvisation were probably some of the most compelling moments of the entire piece. The soundscape-like backdrop of the (mis)matched output of the machine learning system liberated the players

from the confines of the prescribed score, much like how the AI's deviation from the task unleashed its creative potential. It is within these imperfections that the two creative strands, that of the musicians and that of the machine learning system, converged and generated something truly distinctive and captivating for the listeners.

The current constraints with regards to computing power when generating new audio did not allow for the learning process to happen in real time. As Lilienstern confessed to me in a short conversation after the premiere, everything was trained and calculated in advance. So, while it was not true that everything was happening simultaneously, as the artificial narrator implied, it did not make the piece less enjoyable, nor did it spoil my impression of the piece in retrospect. On the contrary, by acknowledging his strengths and weaknesses, Lilienstern projected us into the future, where such a process will be effortlessly executed. Without compromising the success of his premiere, he effectively showcased the allure of imperfection, highlighting the inherent charm of his unsupervised sounds.

Conclusion

> There ain't no answer. There ain't going to be an answer.
> There never has been an answer. That's the answer.

Gertrude Stein

The musical examples presented here have illustrated how machine learning tools for audio/video feature-matching come remarkably close to conveying the impression of an independent entity. The imitation process is bi-directional: feature-matching systems learn from source material and performers are inspired by the resulting sounds. A common thread emerges: the blurring of roles between creator and creation and the shared desire to explore the mismatch, error, and imprecision inherent in a given system. This exploration becomes a central aspect of the artistic journey, transcending the specificity of the employed methods and inviting a deeper examination of the creative process.

A parallel could be drawn to the inner workings of DNA. We now know that the so-called 'junk' DNA, non-coding genes that represent 95% of the total, serves 'as a recombination hotspot, and [provides] a mechanism for genomic shuffling and a source of "ready-to-use" motifs for new transcriptional regulatory elements ...'[21] Somehow, these genes manage to 'interact

with the surrounding genomic environment and increase the ability of the organism to evolve'.[22] Were we to get rid of this 'imperfect/redundant' part of our DNA, we would be stripping the organism of its essential component to adapt over time.

The same principle applies if we were to relentlessly eliminate all flaws from our machines. Once a machine is deemed perfect, its potential for improvement diminishes, ultimately rendering it obsolete. As long as fallible humans design 'perfect' machines, a certain amount of flaw is inherent in their design or code, resulting in errors or glitches during machine operations. This blurs the dichotomy mentioned in the opening paragraph (imperfect human/perfect machine), emphasizing the interconnectedness of humans and machines. Kim Cascone puts it nicely in her article on 'The Aesthetics of Failure' as she claims that failure 'has become a prominent aesthetic in many of the arts in the late twentieth century, reminding us that our control of technology is an illusion, and revealing digital tools to be only as perfect, precise, and efficient as the humans who build them.' Later in the article, she continues by explaining that glitch music, by putting emphasis on the sonic quality of DSP errors and artifacts, 'has helped further blur the boundaries of what is to be considered music, but it has also forced us ... to examine our preconceptions of failure and detritus more carefully.'[23]

In one of our correspondences, Walshe pointed out to me that 'we are lucky to be creating art in the time that artificial intelligence is just nascent.' She believes that it gives us the freedom to play with the imperfection of this emerging technology, much like how artists in the 1950s could naively experiment with any kind of electronic sound just because it was unheard of at that point in time. We know that the system is not yet good enough to make accurate predictions, duplicates, or imitations of what we are teaching it, but at some point, it will be. That is why we are allowed to toy around, exploiting AI's imperfection for the artistic merits, but in twenty years or so, this will no longer be a possibility to the next generation of artist, as it will become dated and the focus will shift somewhere else. One might provocatively state that the greatest period for AI-art is already behind us.

The use of AI feature-matching tools in performance allows for a unique mode of exploration and experimentation. These tools directly engage with the threshold between the physical and the virtual, target and corpus. When they fail to conform to expectations, they provide the AI with its voice. By accepting that our complex existence lies outside the realm of perfection, we can not only commiserate with the shortcomings of AI, but even delight in discovering the hidden musicality within its imperfection.

One might provocatively state that the greatest period for AI-art is already behind us.

Notes

1 Kane, 'Introduction'.
2 Ragni et al., 'Errare Humanum Est'.
3 Ibid.
4 Željka Miklošević and Darko Babić, 'Constructing Heritage through Subjectivity'.
5 Ibid.
6 There are multiple subconscious reasons that contribute to my fascination with the aesthetics of imperfection. Some aspects of it have become clearer to me through personal introspection and retrospection of my creative work over the past ten years, particularly during the COVID pandemic and while working on my doctoral dissertation. I can identify three key reasons: my physicality, the Croatian War of Independence, and the mentality of being an underdog inherited from my upbringing. Firstly, considering my delicate physicality, I struggled to identify with the idealized notion of masculinity. If I were in my formative years today, I might identify as non-binary, a concept that lacked social acceptance two decades ago. Secondly, the war that devastated Yugoslavia, the destruction it caused, and the subsequent scarcity heightened the importance of making the most out of limited resources. Lastly, centuries of not belonging to the major powers (such as Austria, Venice, and the Ottomans) that fought over Croatian territories inevitably fostered the mentality in Croatia of being an underdog, a servant, and a follower – associated with weakness and imperfection. As I gained a deeper understanding of myself and my origins, I learned to embrace these flawed aspects of my physicality, psyche, and heritage. This acceptance led to a gradual shift towards an aesthetic that revolves around these themes.
7 The idea of mesotime was taken from Curtis Roads's book Microsound, where he gives a great division of time that ranges from infinite to infinitesimal (as all and none encompassing extremes), in the middle of which he defines macro-, meso-, sound object, and micro-time as durational categories relevant for music. While Roads mostly focuses on the microsound, as the title of his book implies, I am much more animated by the range between a 'sound object' and 'mesotime' – neither too long as to be overly revealing, nor too short as to completely conceal the reference.
8 'Baba Yaga' is one of the movements of Modest Mussorgsky's celebrated piece Pictures at an Exhibition, for which I was using the Ravel orchestration as the benchmark.
9 This distinction was famously evoked by Martin Heidegger in Being and Time, in which he explains that we view most objects as ready-to-hand – equipment available to us to use and manipulate. In their functional state, we stop considering them and forget they exist. However, if broken, objects become present-at-hand, or at least unready-to-hand, meaning that we start to observe their features in the way that scientists would, trying to find a way to either fix them or render them useful.
10 Kane, 'Introduction'.
11 Institut für Elektronische Musik (Institute for Electronic Music), located in Graz, Austria.

12 A first-order Markov chain looks only at its immediate neighbor to create its stochastic model. Accordingly, an nth-order Markov chain means that the system is comparing n previous states (letters, notes, ...) to define the probability of transition to the next state.
13 Botescu-Sireţeanu, 'Queer in Queen'.
14 Parker and Sedgwick, Performativity and Performance.
15 David Werman, 'Freud's "Narcissism of Minor Differences"'.
16 The fact that she chooses her voice as an agent that represents her identity is of no surprise, because the 'voice is a node where culture, politics, history and technology can be unpacked' as she puts it in her Darmstadt talk from 2018.
17 See Memo Akten's web page about the project: https://www.memo.tv/works/ultrachunk/.
18 See https://www.nuance.com/omni-channel-customer-engagement/voice-and-ivr/text-to-speech.html, accessed 9 February 2023.
19 See Ktonal's GitHub: https://github.com/ktonal/mimikit.
20 Lilienstern, program note for the performance.
21 Wojciech Makalowski, 'Not Junk After All'.
22 Ibid.
23 Cascone, 'The Aesthetics of Failure'.

References

Agostini, A., and Ghisi, D. (2012). 'Bach: An Environment for Computer-Aided Composition in Max'. In *Proceedings of the International Computer Music Conference 2012*, 373–378. Ljubljana, Slovenia, 9–14 September 2012.

Bachand, D. (1977). 'Réflexions critiques à propos du spectacle de la consommation'. *Communication: Information Médias Théories*, 4(3): 302–316.

Baudrillard, J. (1995). *Simulacra and Simulation*. Ann Arbor, MI: University of Michigan Press.

Betz, S. (2022). '4 Types of Artificial Intelligence'. *Built In*. 25 August 2022. https://builtin.com/artificial-intelligence/types-of-artificial-intelligence.

Botescu-Sireţeanu, I. (2019). 'Queer in Queen: Camp Aesthetics and Queer Performativity in Queen's Music Videos'. *Bulletin of the Transilvania University of Brasov*, 12(61): 87–100. https://doi.org/10.31926/but.pcs.2019.61.12.7.

Cascone, K. (2000). 'The Aesthetics of Failure: "Post-digital" Tendencies in Contemporary Computer Music'. *Computer Music Journal*, 24(4): 12–18. https://doi.org/10.1162/014892600559489.

Cheyne, P. (2023). *Imperfectionist Aesthetics in Art and Everyday Life*. London: Routledge.

Cole, S. (2023). '"I Don't Believe You:" Artist Banned from r/Art Because Mods Thought they Used AI'. *Vice*. 6 January 2023. https://www.vice.com/en/article/y3p9yg/artist-banned-from-art-reddit.

Eldritch Priest. *Boring Formless Nonsense: Experimental Music and the Aesthetics of Failure*. London: Bloomsbury Academic. eBook Academic Collection (EBSCOhost).

Eternalised. 'Ready-to-Hand and Present-at-Hand–Heidegger'. Eternalised. 2 February 2021. https://eternalisedofficial.com/2021/02/02/ready-to-hand-and-present-at-hand-heidegger/.

Ferrer, X., Nuenen, T. van, Such, J. M., Coté, M., and Criado, N. (2021). 'Bias and Discrimination in AI: A Cross-Disciplinary Perspective'. *IEEE Technology and Society Magazine, 40*(2): 72–80. https://doi.org/10.1109/MTS.2021.3056293.

Fiebrink, R., and Cook, P. R. (2010). 'The Wekinator: A System for Real-Time, Interactive Machine Learning in Music'. In *Proceedings of the Eleventh International Society for Music Information Retrieval Conference (ISMIR 2010)*. Utrecht, Netherlands, 9–13 August 2010.

Gearhart, B. (2021). 'Heidegger's Basic Phenomenology of Things'. *Medium*. 23 December 2021. https://bradleygearhart.medium.com/heideggers-basic-phenomenology-of-things-1aad87cd6228.

Ghisi, D., and Agon, C. (2016). 'Real-Time Corpus-Based Concatenative Synthesis for Symbolic Notation'. In *Proceedings of the International Conference on Technologies for Music Notation and Representation*, 7–13. Cambridge, UK, 27–29 May 2016.

Ghisi, D., and Agostini, A. (2017). 'Extending Bach: A Family of Libraries for Real-Time Computer-Assisted Composition in Max'. *Journal of New Music Research, 46*(1): 34–53. https://doi.org/10.1080/09298215.2016.1236823.

Gioia, T. (1987). 'Jazz: The Aesthetics of Imperfection'. *The Hudson Review, 39*(4): 585–600. https://doi.org/10.2307/3851219.

Hamilton, A., and Pearson, L. (eds.). (2020). *The Aesthetics of Imperfection in Music and the Arts: Spontaneity, Flaws and the Unfinished*. New York: Bloomsbury Academic.

Hansen, M. B. N. (2015). *Feed-Forward: On the Future of Twenty-First-Century Media*. Chicago, IL: University of Chicago Press.

Heidegger, M. (2006). *Sein und Zeit*. Berlin: Niemeyer.

Juniper, A. (2011). *Wabi Sabi: The Japanese Art of Impermanence*. North Clarendon, VT: Tuttle Publishing.

Kane, C. L. (2019). 'Introduction'. In *High-Tech Trash: Glitch, Noise, and Aesthetic Failure*. Berkeley, CA: University of California Press, pp. 11&20.

Kemper, J. (2022). 'Glitch, the Post-digital Aesthetic of Failure and Twenty-First-Century Media'. *European Journal of Cultural Studies, 26*(1): 47–63. https://doi.org/10.1177/13675494211060537.

Kyrre, O. (2022). 'Errare Humanum Est: How to Make Mistakes - the Right Way'. *A Philosopher's Stone*. 25 August 2022. https://medium.com/the-philosophers-stone/errare-humanum-est-how-to-make-mistakes-the-right-way-8856bb2cac0e.

Leonard, J. (2018). 'The Optical Illusions That Make the Parthenon Perfect'. *Greece Is*. 12 January 2018. https://www.greece-is.com/the-optical-illusions-that-make-the-parthenon-perfect/.

Lilienstern, G. von. (n.d.). *Genoël von Lilienstern*. https://www.lilienstern.net.

Maitre de la Boite, Le. (2015). 'Les objets introuvables de Jacques Carelman'. *La boite verte*. 23 June 2015. https://www.laboiteverte.fr/les-objets-introuvables-de-jacques-carelman/.

MacFarquhar, L. (2005). 'Baudrillard on Tour'. *The New Yorker* online. 28 November 2005. https://www.newyorker.com/magazine/2005/11/28/baudrillard-on-tour.

Makalowski, W. (2003). 'Not Junk After All'. *Science, 300*(5623): 1246–1247. https://doi.org/10.1126/science.1085690.

Mikloševic, Ž., and Babic, D. (2018). 'Constructing Heritage through Subjectivity: Museum of Broken Relationships'. In *Emotion, Affective Practices, and the Past in the Present*, edited by Laurajane Smith, Margaret Wetherell, and Gary Campbell. London: Routledge. pp. 70&83.

Milker Corporation. (n.d.). *Jennifer Walshe: Biography*. Milker Corporation. https://milker.org/jenniferwalshebiography.

Muñoz, J. E. (2019). *Cruising Utopia: The Then and There of Queer Futurity*. Tenth Anniversary Edition. New York: New York University Press. https://doi.org/10.18574/nyu/9781479868780.001.0001.

Ohno, S., and Yomo, T. (1991). 'The Grammatical Rule for All DNA: Junk and Coding Sequences'. *Electrophoresis*, 12(2-3): 103–108. https://doi.org/10.1002/elps.1150120203.

Parker, A., and Sedgwick, E. K. (1995). *Performativity and Performance*. New York: Routledge.

Patowary, K. (2017). 'The Art of Deliberate Imperfection'. *Amusing Planet*. 28 August 2017. https://www.amusingplanet.com/2017/08/the-art-of-deliberate-imperfection.html.

Ragni, M., Rudenko, A., Kuhnert, B., and Arras, K. O. (2016). 'Errare Humanum Est: Erroneous Robots in Human-Robot Interaction'. In *Proceedings of 2016 Twenty-fifth IEEE International Symposium on Robot and Human Interactive Communication (RO-MAN)*, 501–506. New York, NY, 26–31 August 2016.

Roads, C. (2002). *Microsound*. Cambridge, MA: MIT Press.

Russell, L. *Glitch Feminism: A Manifesto*. London: Verso.

Salem, M., Eyssel, F., Rohlfing, K., Kopp, S., and Joublin, F. (2013). 'To Err Is Human (-like): Effects of Robot Gesture on Perceived Anthropomorphism and Likability'. *International Journal of Social Robotics*, 5(3): 313–323. https://doi.org/10.1007/s12369-013-0196-9.

Schwarz, D., Beller, G., Verbrugghe, B., and Britton, S. (2006). 'Real-Time Corpus-Based Concatenative Synthesis with CataRT'. In *Ninth International Conference on Digital Audio Effects (DAFx)*, 279–282. Montreal, Quebec, September 2006. https://hal.archives-ouvertes.fr/hal-01161358.

Shneiderman, B. (2007). 'Creativity Support Tools: Accelerating Discovery and Innovation'. *Communications of the ACM*, 50(12): 20–32. https://doi.org/10.1145/1323688.1323689.

Snelting, F., Rocha, J., Niquille, S. (2017). 'The Fragility of Life'. *Research and Development*. https://research-development.hetnieuweinstituut.nl/en/fellows/fragility-life.

Sturm, B. L. (2006). 'Adaptive Concatenative Sound Synthesis and Its Application to Micromontage Composition'. *Computer Music Journal*, 30(4): 46–66. https://doi.org/10.1162/comj.2006.30.4.46.

Voltaire. (1975). *Candide*. Special edition. New York: Random House.

Watts, A. A. (n.d.). 'Bio'. https://www.andrewawatts.com.

Werman, D. S. (1988). 'Freud's "Narcissism of Minor Differences": A Review and Reassessment'. *Journal of the American Academy of Psychoanalysis*, 16(4): 451–459.

12

Robot Choreography, Choreorobotics, and Humanist Technology: A Conversation between Dr. Madeline Gannon and Dr. Ken Goldberg, mediated by Dr. Catie Cuan

Catie Cuan

One popular cultural application of robots is dance. Choreographers and roboticists share many similar challenges: for example, they both must document, record, and translate movement across bodies, they both must generate new movement with different stylistic or task-based parameters, and they both must adhere to communication and social cues among groups of agents, whether those groups are robots, humans, or a combination. The rapidly growing intersection of choreography and robotics, encompassing research, methods, and artworks, is referred to as "choreorobotics".

Dr. Ken Goldberg, Dr. Madeline Gannon, and Dr. Catie Cuan are three robotics pioneers whose work relates to choreorobotics. In this discussion, they probe the challenges inherent in making artistic work with robots, and the manner in which creative practice subverts traditional robotics practice.

Dr. Madeline Gannon is a multidisciplinary designer inventing better ways to communicate with machines. She blends techniques in art, design, computer science, and robotics to forge new futures for human-robot relations. Also known as "The Robot Whisperer", Gannon specializes in convincing robots to do things they were never intended to do: from transforming giant industrial robots into living, breathing mechanical creatures, to taming hordes of autonomous machines to behave like a pack of animals. Gannon believes that technology is a cultural medium and tunes her work to engage communities across science and society. Her works have been exhibited at international cultural institutions, published at academic conferences, and profiled at global media outlets, such as the BBC, the Guardian, *the* Financial Times, *the Science Channel,* WIRED, FastCompany, Dezeen, *and The Verge. Dr. Gannon has been a World Economic Forum Cultural Leader, a robotics and AI researcher at NVIDIA, and has held fellowships at ETH Zurich, Autodesk Pier 9, and the Carnegie Mellon STUDIO for Creative Inquiry. She is known as one of the "Top 10 Women in the Robotics Industry" and "World's 50 Most Renowned Women*

DOI: 10.1201/9781003312338-18

in Robotics", *according to Analytics Insight. Gannon holds a master of architecture from Florida International University and a Ph.D. in computational design from Carnegie Mellon University.*

Ken Goldberg is an artist and professor of engineering at UC Berkeley. Goldberg explores the intersection of the digital and natural worlds. His artworks include a live garden tended by a robot controlled by over one hundred thousand people via the internet, a 1:1 millionth scale model of Frank Lloyd Wright's Fallingwater, and award-winning short documentary films about robots and Jewish identity. Goldberg's projects have been exhibited at the Whitney Biennial (New York), Venice Biennale, Pompidou Center (Paris), Walker Art Center (Minneapolis, MN), Ars Electronica (Linz, Austria), ZKM (Karlsruhe, Germany), ICC Biennale (Tokyo), Gwangju Biennale (Seoul), Artists Space (New York), and The Kitchen (New York). He is the founding director of Berkeley's Art, Technology, and Culture Colloquium and has held visiting positions at the San Francisco Art Institute, the MIT Media Lab, and Pasadena's ArtCenter. Goldberg was awarded the National Science Foundation Young Investigator Award in 1994, the NSF Presidential Faculty Fellowship in 1995, and was named an IEEE Fellow in 2005. His work is in the permanent collections of the Berkeley Art Museum, the Nevada Museum of Art, and the Whitney Museum. Goldberg is represented by the Catharine Clark Gallery in San Francisco. For more about Goldberg, visit http://goldberg.berkeley.edu/art/.

Catie Cuan is a pioneer in the nascent field of "choreorobotics". She recently completed a Ph.D. in the Department of Mechanical Engineering at Stanford University, where she also completed a master of science in mechanical engineering. Her artistic and research work focuses on robotics, imitation learning, and dance. Her Ph.D. work was supported by the National Institutes of Health, Stanford, and Google. She is a prolific robot choreographer, having created works with nearly a dozen different robots. Catie was the inaugural Artist-in-Residence at Everyday Robots (born from X, the moonshot factory), where she built an interactive robot and human flocking project with machine learning. She was the 2022 Futurist-in-Residence at the Smithsonian Arts and Industries Building, a 2018 TED Resident, a 2018 Thoughtworks Arts Resident, and the 2017–2018 Artist-in-Residence at the Robotics, Automation, and Dance Lab. Her work has been featured in The New York Times, WIRED, Forbes, Engadget, Science Magazine, *and on the PBS NewsHour and CBS's Mission Unstoppable. For more about Cuan, visit www.catiecuan.com.*

Catie Cuan: Tell me who you are and what you're working on right now.

Madeline Gannon: My name is Dr. Madeline Gannon. I invent better ways to communicate with machines. I spend a lot of my time playing with robots and getting them to be a bit more in tune to the people around them.

Ken Goldberg: I'm Ken Goldberg. I am a professor at UC Berkeley, and I focus on research with robotics, and I'm also an artist. I've been building installations and projects with robots and technology, generally to critique the perceptions, the popular perceptions, around these technologies.

Catie Cuan: This is a discussion about "robot choreography". Does that phrase
mean anything to you? If yes, what does it mean?

Madeline Gannon: My background is in architecture, so I think about the rela-
tionship between people and machines in terms of space and how
you navigate that space together. It's very tangential to choreogra-
phy, but perhaps less structured, less prescriptive than traditional
choreographic practices.

Catie Cuan: What do you think, Ken? Robot choreography? Does that mean
anything to you?

Ken Goldberg: Robot choreography raises the connection between dance and
the movement of robots, which are incredibly clumsy in compari-
son. I like to contrast the movements between humans and robots
… Is it even possible for robots to move in a graceful and interest-
ing way?

Madeline Gannon: When I think of choreography, I often think of control—
which may be the limits of my own understanding of modern cho-
reography. However, choreography has been a productive area of
inquiry in robotics over the past decade. Robotics can be a mon-
ocularly focused field, and choreorobotics is helping to shift focus
back toward human interfaces. It's helping robotics to break out of
its very impressive but very siloed knowledge.

But back to control: a constant curiosity of mine is how we, as a society, are
going to cope with an absolute lack of control over robots. That's
the future we're racing toward—the more agency and autonomy
we give these machines, the less direct control we will have over
how they behave. I find this very exciting because it's the oppo-
site paradigm of all the tools and interfaces we currently have
with them.

Catie Cuan: When you say "control" in engineering, that has a very explicit
meaning. Usually, you've set up equations, or you've written a
block diagram that allows you to do these precise controls to make
the robots move. However, I think maybe you're meaning "control"
in a slightly more abstract way. Choreography is perhaps a tutorial
rather than this control relationship in engineering. Could you talk
about that? The use of that word "control"?

Madeline Gannon: Sure. And again, I feel a little self-conscious speaking with
authority on this since my background is neither in choreography
nor dance—but bear with me. When a choreographer is design-
ing someone else's movement, they can specifically choreograph
a place for it to be improvisational—for the dancer to decide how
and when to move. At that moment, the choreographer is not in
direct control. However, the engagement is still highly structured.

Within the robotics industry, we are shifting from a model of direct control
(e.g., explicit programming) toward models of agency and autonomy
(e.g., implicit programming through training and learning). We are

Choreography is perhaps a tutorial rather than a control relationship.

building tools for these machines to be able to make task-level deci-
sions for themselves, navigate for themselves, and basically exist
for themselves—hopefully they will be good co-inhabitants with
us. But our metaphors and mental frameworks for interacting with
these next-generation robots still follow the old model of direct con-
trol: we "program", "command", "supervise", or "operate" them.

My work explores what these new metaphors for human-robot
interaction should be. It often features giant industrial robots—
those big, dumb, dangerous ones that just do a short, repetitive
task, over and over again, 24/7, every day of their boring lives. I
like working with these machines because they have come to sym-
bolize everything we fear about robots: automation, efficiency, our
own obsolescence. So I'll often flip your expectation of them on
its head, and give them animal-like behaviors. With a little bit of
clever software and thoughtful design, I can get them to move,
sound, and react to us just like any other creature you'd encounter
in the wild. For me, it's important to show that these "off-the-shelf"
"standard-issue" robots that have been around for fifty plus years
can be reimagined beyond optimization, efficiency, and control.
For me, I want to show the power of connection, not control.

Catie Cuan: Ken, much of your work examines robots being able to learn
themselves and be agential. Could you respond to the notion that
choreography involves some implicit kind of scripted control ver-
sus circumstances that are improvisational?

Ken Goldberg: Control theory in engineering is oblivious to control from
Foucault's perspective. The word "control" in engineering doesn't
capture colonialism and human relations, those are completely
unaddressed. But the same word is used. Control is also interest-
ing in the context of dance. In one project that we did a few years
ago, it involved a ballet dancer, Muriel Maffre (former principal
dancer at the San Francisco Ballet), who was dancing to sound that
was being influenced by a live seismometer.[1] It raised this question
of what is random, certainly unpredictable. Because ballet is so
tightly controlled and constrained. The specifications are such that
every muscle fiber is accounted for. That was one of the strengths
this ballet dancer had. This is a challenge for dancers, that you
know how to work with choreographers to generate new work, but
then to get to the point where you can do it over and over again,
exactly as it was prepared, that raises the Foucault context. Muriel
had bloody feet from the years of trying to obey these types of con-
straints. She took a big risk when she said, "I'm going to respond
to the sound that is in the Opera House that was not going to be
predictable", and she didn't know what was going to happen. I
remember being so impressed that she took that risk. Robotics is a
very interesting zone to play with those issues.

Catie Cuan: I think of choreographers as creating the rules of the game and dancers as exploiting them. The choreographer creates some circumstances, for example, "this is a dance that needs to be performed in this way to this music", but the performance is inherently spontaneous. How your dancing body is feeling, the energy that is created inside the room and the emotions you add to it. Some of these things are elemental, they emerge. They can't be dictated by a choreographer. So, choreographers set the rules of the game and dancers experiment inside of those frames. This experimentation occurs whether the piece is improvisational or fully step-by-step choreographed motion.
When Ken mentioned this rigorous ballet practice, it is one practice model. If you're a ballet dancer, your job is to practice something constantly until you achieve some mastery over it. At that point, you get the license to be more experimental and more free, because you've demonstrated your core capabilities. For example, you learn a triple pirouette. Once you master that, you can create interesting delays, push and pull, decide when to put your foot down, and flip your head so the pirouette is unique to you. I think the closest parallel in robotics that we can find to "practice until we get better at something" is reinforcement learning. As a robot, it practices and practices until it maximizes its reward and improves over time. Then, for the robot, does the experimentation phase follow? Just as it does for the dancer? Once the robot has achieved a certain level of mastery, does it get to be more free, or have more license? Because it has demonstrated this core degree of mastery. Is that a concept that you think is relevant in any of the work that you do? Or do you think that once the robot has achieved a finite ending, it is finished learning?

Madeline Gannon: It's a common saying, right: first, you learn the rules, then you break them. It's a very human style of learning. So it kind of makes sense that as we invent ways of training machines, we're taking from our own prior knowledge of educational frameworks. I'm not convinced that is the only way of teaching a machine—or people, for that matter.
Catie, if I understand you correctly, you see choreography and dance as two distinctive, creative mediums that dovetail together—but that they each have their own unique practices and languages. Their own unique ways of expressing culture.

Catie Cuan: This question is geared toward the dancer model that Ken used to describe one of his collaborators. Does that concept of being experimental in your artistry once you've reached a certain level of mastery, does that exist in robotics, should it exist in robotics?

Ken Goldberg: Maybe we should make a distinction between modern dance and ballet: ballet is more rigid and modern dance can be more interpreted. There can be more freedom for the dancers. When I

look at modern dance, there is control but also freedom. I'm sure it depends on the choreographer, the company, and the dancers. On the point of learning the rules so you can break them, it's true in dance, in painting, in education. In education as a whole, we spend a lot of time in school teaching rules and not so much on creativity and the ability to modify those rules. So, one example, and what essentially differentiates a Ph.D. from a master's degree, is the word dissertation. For a master's thesis, you show you've mastered something. But for the Ph.D., you write the "dissertation", which means uprooting and essentially breaking some kind of convention. So, the core of a dissertation is that you've challenged some piece of conventional wisdom and you've uprooted it. You've shown that a piece of knowledge is wrong. That's why the Ph.D. is such a different thing than a master's because it really is at its core about making that step from following the rules to breaking them.

Catie Cuan: As a robot beginning to learn, there are many aspects to the problem, such as constraints and an optimization function. In some formulations, the robot may start to write its own optimization functions or do its own reward shaping. The teacher may provide these aspects, or the robot may learn them on its own. Regardless of how the problem is framed, the central way of describing it is with a task. At some point, the question then is—what is the task that I want the robot to achieve?

Madeline described curiosity and companionship earlier between humans and robots—how do you break that down into a task? How does that become something that's achievable or can be framed as a problem? Or is it a general sensibility or way of being for the robot? Because you need to be able to create limitations and constraints to tackle a task-based problem. But what Madeline is describing doesn't feel specifically task-oriented. So how does the notion of "task" fit into the goals that you have for how robots will be in the world?

Madeline Gannon: For me, it explicitly does not. A "task" framework cannot be the only framework for robotics. I don't necessarily care about the task a robot is doing. But I will always care about how a robot makes me feel. If I'm a normal person—not a roboticist—and a robot crosses my path in public, what do I care what its task is or how well it's achieving it? I only care about how its behavior is going to affect me. Now maybe we can still put this into a task-based language. But I think the reason why I'm exploring HRI in this direction—because it's outside the bounds of how robotics is normally taught in higher education programs.

Right now, we are at a monumental moment in the history of robotics, where it is shifting from a niche field of research to a general technology. For its entire seventyish-year existence, robotics has

required very, very specialized knowledge and was a very, very specialized area of research. But in the past five to ten years, we have had this Cambrian explosion of robots coming out of the lab and intersecting with our daily lives. As robotics starts to have this general impact on society—on our culture—we need to bring new questions and value sets that are fundamentally different from the past seventy years. Thats one of the reasons why I'm so excited to see choreorobotics take off and blossom these past couple of years within the field. It's bringing so many different voices, points of view, and—honestly—values for people who want robots to mean something different for them.

For the past five years, I've been working in industry. When industry thinks about the future, it's thinking about the probable future—a narrow view of what's likely to happen. When researchers think about the future, they're thinking about the possible future—a wider view of what could potentially happen. When artists think about the future, they're thinking about the preferable future, which is at the very edge of the possible and stretches beyond impossible. Now if we get enough artists pushing toward that preferable future, we can shift the center of mass from the probable toward the preferable. And that's what we are witnessing choreorobotics do today.

Catie Cuan: That's beautiful.

Madeline Gannon: Interesting. Okay, okay, okay. Well, first, thank you for your service in pioneering robotic art. By the way, I think the Telegarden is still one of the best digital artworks ever made.[2]

Ken Goldberg: Thank you, Madeline! Let me ask you about deep learning. How do you see robots having entered our daily lives in the past five years?

Madeline Gannon: Well, a lot of things have normalized already, right? The entire software side of robotics—the robot brain—has stabilized exponentially faster than the hardware, thanks to all the recent developments in artificial intelligence and machine learning. But now we're also seeing a lot of different hardware platforms stabilize. Many types of robots that were recently "experimental hardware" and required Ph.D.'s to develop control systems basically consumer goods. Quadrupeds are a great example of that. They were experimental hardware for a long, long time, but today you can find reliable, sub $5,000 quadrupeds (that won't catch on fire after five duty cycles). The hardware is stabilizing. It's a mess for sure—we still don't quite know what to do with them. But first you need a stable platform and then you can explore use cases. The same thing goes for mobile robotics and manipulation. Manipulation has greatly benefited from advancements in computer vision, machine learning, deep learning, and artificial intelligence. The challenges

now are, "What is the business model"? not "Can it pick things out of a box faster than a person"?

Ken Goldberg: I like the examples you gave about the quadruped. I think that's an exciting one and you're absolutely right that having this version, in its ingenuity, and the price down to $3,000 is amazing. Those robots are incredible. And the same can be said for drones, right? Over the past decade, drones have been relatively rare, complicated, and expensive, and now DJI sells them for a few hundred dollars.

Madeline Gannon: New collaborative robot arms are also making all the legacy OEMs come out with new products that are getting cheaper, easier to use, and more reliable.

Ken Goldberg: Those are three developments that I agree didn't exist a decade ago, and they've all really matured immensely.

Madeline Gannon: Fleets of robotic cameras cover every major sporting event; you can buy a $30,000 car that parks itself; lots of hospitals in the US have robots that deliver sheets and non-essentials between the central storage facilities and a room for a nurse or assistant. You can buy three different types of robot vacuums from any big-box retail store.

Ken Goldberg: There's a blurry line between robots and other kinds of smart machines. How about AI in general, like ChatGPT? Do you consider that a robotic advance?

Madeline Gannon: That line is somewhat arbitrary in my mind. Does a robot need to have an actuator—or is it enough that it influences the physical world? For example, we'd be hard pressed to consider ChatGPT, as a pure software implementation, to be a robot. But give a Roomba ChatGPT as its natural language interface and now it's a robot? ChatGPT doesn't really change the hardware capabilities of the robot. But it will definitely change the relationship you have with those capabilities.

Ken Goldberg: It gets complicated. With ChatGPT, it is easy to see how it could be integrated with Alexa. Now, all of a sudden, it's turning on your lights and, you know, it's doing something in the material world. But it's not a robot.

Madeline Gannon: I think it's important to blur this distinction between robots and immersive environments—which, again, is me pulling toward my architectural side. These lines are already nebulous and fuzzy—I love it that way—and I'm excited that we're getting to a place technologically where they can be even weirder and less defined.

Ken Goldberg: Coming back to your point about artists being there to blur boundaries and question those boundaries for sure, it's very interesting. And you know, I've spent a good portion of my life working on that robot grasping problem, not as an artist but as an engineer.

And it's still a very challenging problem. In my mind, that problem characterizes a different way I think about robot art and the engineering aspect of robotics.

Madeline Gannon: Here's how I think about it: if my goal is to robotically manipulate some physical object, then whether I get the robot to manipulate it or the robot is able to see me and ask me to go manipulate it, the end result is kind of the same. And that is one of the many reasons why I'm a weirdo in robotics: because I try to think about every lateral possibility around all the hard problems. I don't try to do the smart thing; I try to do the clever thing that may get me to the same result. It's kind of like cheating, but it's also allowed me to be relatively impactful when I didn't have the technical chops to really back it up. I often approach these hard problems from a different starting point than the people around me.

Catie Cuan: Artists can be quite ambitious, and their expectations and motivations may be different than a scientist's. An artist's process and modes of discovery may be different. Let's say you want to make a piece of art that's totally new, maybe a synthetic robot forest. Rather than studying the physics of trees, you simply start to choreograph them in a way that feels organic, from a kinesthetic experience. You'll use different tools to translate that vision, you'll want tools that capture your creative vision. In doing so, you may stumble across discoveries that could be scientific, but they will have originated from a very different place. The artistic, creative task gives way to new rule-breaking opportunities. The notion of "task" breaks down in that example.

Let's discuss the difference between the body and the brain. As you said, Ken, deep learning is this major sea change in our world. One of the things that people talk a lot about in robotics is Moravec's paradox. Things that are easy for humans like opening doors and twisting off bottle caps are hard for robots. But things that are hard for people like perceiving different kinds of depth, color, or temperature signals or performing complex computations— those things are hard for people and easy for robots. However, I'm wondering about things that are hard for people physically, like dance. Dance is a hard thing for a person to master and it's hard for a robot. How does something like that fit inside of Moravec's paradox? Can you really separate the body and the brain in terms of hardware and software as we've been discussing?

Ken Goldberg: To your point about Moravec's paradox. It's really interesting because it's very true that it doesn't hold in all cases. There are things that are hard for both humans and robots and things that are easy for both. Dance is a great example because it's very hard to program a robot to do a specific motion. But once a robot has been trained or

Let's say you want to make a piece of art that's totally new, maybe a synthetic robot forest. Rather than studying the physics of trees, you simply start to choreograph them in a way that feels organic from a kinesthetic experience. You'll use different tools to translate that vision, you'll want tools that capture your creative vision. In doing so, you may stumble across discoveries that could be scientific, but they will have originated from a very different place. The artistic, creative task gives way to new rule-breaking opportunities. The notion of "task" breaks down in that example.

programmed, it can repeat it effortlessly with perfect consistency. In a sense, it is very good at that kind of thing, but not at improvisation.

Catie Cuan: Totally. I'll go back to modern dance again as an example. Let's say you're exceptional at modern dance and are a dancer in one of the top five or ten dance companies in the world. You're not finished once you get there. You have to keep performing, stay in shape, be extraordinary, and continue to develop as an artist. You're not done. Whereas when Ken describes programming robots, the tough work for the robot is done up front. Roboticists do all this programming to get it to work the first time without worrying about 1+ times after that. However, in some cases, when we talk about human mastery, whether it is dance, playing the violin, or creating a new building, once you achieve a certain level of success, the expectations become higher. Now you are in such a rarefied space that you haven't reached the end of your rope. There's no edge, no end. That doesn't exist.

Madeline Gannon: It's a bit like making new knowledge in your research. Your job is to make new knowledge. There is no end. It's never like, "Oh, we've got all the knowledge", "We've designed all the buildings", or "We've made all the art". Maybe that's why I don't really lean toward a "task-based" framework for robotics. It's too reductive. There's so much more that robots—as a sort of technological telekinesis—are enabling for us when we think beyond "task".

Catie Cuan: Another question for you both—what would it be like to make a robot explicitly for dancing? In some of your work, Madeline, you've been taking these old, industrial, dinosaur robots and making them smart. You're repurposing them. But if you could make the hardware and software from scratch to make the perfect robot for your work, what would that look like?

Madeline Gannon: For me, it's the inflatable man outside of car dealerships—that fabric-based thing with a big fan at the bottom … No, to be honest, I've never really thought about custom-building a robot. I usually think about where I fit in a historical continuum of art and technology—and where moments in this timeline split. For example, many people don't realize that the birth of robotics for engineering and art share a similar origin story: they both sparked from the same zeitgeist in the late 1960s, and were such new concepts that the boundaries between robot artist and scientist weren't yet established. Artist/engineers showing in Cybernetic Serendipity and EAT were exploring animism, personality, and expression with their creations, and UNIMATE—one of the first industrial robots in production—was mastering optimization and efficiency.

I see this as a distinct split in the timeline—one branch has personable machines, and the other branch—the one we're on—has productive machines. With my work, I try to slip into that other

branch and reimagine the machines we have today as if we've had sixty plus years of developing curious, contemplative, and thoughtfully connected machines. There's so much more headway to think about creative uses and applications of these machines—they can be both interesting to our culture and productive for our society.

Ken Goldberg: Well, I love your reference to the inflatable man! What a great example! In general, I'm really happy to work with industrial robots out of the box and then think of what they can do without designing a brand-new robot. Although I think that's very laudable and very interesting to redesign the robots themselves, you can change their behavior and have so much room to explore. I appreciate what you both keep coming back to, which is that the role of an artist is to do something that's different than the conventional wisdom. When everybody is trying to optimize the performance or some kind of efficiency or correctness of these robots, there's a lot to be gained by really questioning that and going in the opposite direction.

Madeline Gannon: And I don't want to discount the importance of efficiency and correctness. It's just that there are a lot of people focusing on that. Some of us need to turn our heads, look around, and say, "Okay, what territories are we overlooking here"? I like going down that more jungly, uncertain path. It's what keeps me curious and motivated to wander in this field of robotics.

Ken Goldberg: That reminds me of this really nice article by David Brooks, in which he said that ChatGPT and all these others are reminding us that we should be concentrating on what is human. A big part of that is being creative, doing things that are not expected, and speaking to things outside of our normal boundaries. I think in lots of dancing robot videos, for example, they do these dances that are fun and athletic. But it's not really art, in my view. It is interesting, it is entertaining, but they're not pushing any boundaries because they're not really questioning. They're not raising questions. It's more promotional. By convention, we want robots to be more and more agile, and these videos sort of demonstrate that. But I'd be much more interested if they did something like Merce Cunningham, where the robot would be falling on the floor and getting up. That would be more interesting from an artistic point of view.

Catie Cuan: To change gears, what are some questions that are intriguing you right now?

Ken Goldberg: Coming back to ChatGPT. The more I play with it, the more I'm astounded by it. I'm trying to come to terms with it because it isn't embodied. I'm curious about how it could be embodied if those advances in transformer architecture could be extended to robots and grasping for manipulation. It's a very interesting question. So, to me right now, that is a fundamental question. The assumptions that I had a year ago or even three months ago are being shaken. I

think it's going right back to, what is it to be human? At least in the realm of conversation, which was Turing's domain, there was an assumption that that was uniquely human. That was intelligence. And now, if machines are going to be capable of great conversation, they could pass the Turing test. Then what makes us human? I think it comes back to this creativity and art that we're talking about, and that's why it's more important than ever. I'm really interested in how we can start using these technologies and robots to illustrate that in a very visual and visceral way. Exactly what Madeline said—I'm interested in how they make you feel.

Madeline Gannon: Twenty years from now, people reading this will need a bit of context to understand the monumental shift the tech sector has felt this past month with ChatGPT. I've been thinking about it a lot. My lesson from ChatGPT is that Interface is Everything. ChatGPT's large language model is over a year old—"ancient" by AI research standards. But invest the time to make it easy-to-use and easy-to-understand by the general public … and lo and behold! It takes the world by storm. All of its developers, who were very unimpressed with it because it's not state-of-the-art, are completely taken by surprise by how the public is so hungry for and appreciative of it.

I would have thought that that lesson would have been learned with the iPhone, right? The iPhone was based on pre-existing technology, but put into stable hardware and thoughtfully designed, easy-to-use software that enabled new ways of expression, communication, and connection. I see that same lesson being relearned by industry again with ChatGPT. Interface is everything. Based on my time with engineering-oriented companies, I'm always surprised at how little people care about the interface—and maybe that's where the humanity of the arts comes in again. How technology engages with the human condition—how it engages with its environment—is more important than what the technology does. Our constant push for novelty and technological advancement is fantastic, but sometimes it leaves behind a lot of headroom for exploration. How it intersects with society is really what is most important.

Notes

1 See http://goldberg.berkeley.edu/art/Ken-Goldberg-Portfolio-Jan-2011.pdf.
2 See http://goldberg.berkeley.edu/art/.

My lesson from ChatGPT is that interface is everything. ChatGPT's large language model is over a year old— "ancient" by AI research standards. But invest the time to make it easy-to-use and easy-to-understand by the general public ... and lo and behold! It takes the world by storm."

Proliferation

13

Ars Autopoetica: On Authorial Intelligence, Generative Literature, and the Future of Language

Sasha Stiles

Poetry Is Technology

> We all had this psychic dream about our own programming …
>
> —*Technelegy*

In his famous essay on tradition and talent, T. S. Eliot said a modern poet should write with the literature of all previous ages "in his bones." As a member of the first wave of poets collaborating with artificial intelligence, I often feel as though I am composing with humanity's written record not just in my bones but also in my brain, blood, browser. My very being extends beyond myself, enmeshed with a vast text corpus that encompasses conventional literary masterpieces, millions of web pages, cybernetic bleats and blogs, myriad dialects and masses of jargon, evergreen content, and outdated data. When I plug into a large language model like GPT-4 for a writing session, my analog intellect, trained for decades on both ancient and contemporary classics, goes head-to-head with a prosthetic or augmented imagination informed by a new kind of canon.

In my first book, *Technelegy* – a hybrid language art collection with elegiac roots and futurist branches – I use AI-powered poems as well as media-rich extensions and multidimensional adaptations of static text to probe what it means to be human in a nearly posthuman age. This manuscript began, in 2015 or so, with "conventional" poems on then-unconventional subjects like neural implants, artificial wombs, robot monks, and digital immortality, but as I started to notice experimental writers and technologists like Ross Goodwin and Gwern Branwen integrating neural networks into their creative work, I wondered where a computational co-author might steer me and my pen.[1]

My early efforts with GPT-2 (ChatGPT's ancestor) – also inspired by Alison Knowles's "The House of Dust," Oscar Schwartz's Turing test for poetry,[2] Ray

DOI: 10.1201/9781003312338-20

As a member of the first wave of poets collaborating with artificial intelligence, I often feel as though I am composing with humanity's written record not just in my bones but also in my brain, blood, browser. My very being extends beyond myself, enmeshed with a vast text corpus that encompasses conventional literary masterpieces, millions of web pages, cybernetic bleats and blogs, myriad dialects and masses of jargon, evergreen content, and outdated data.

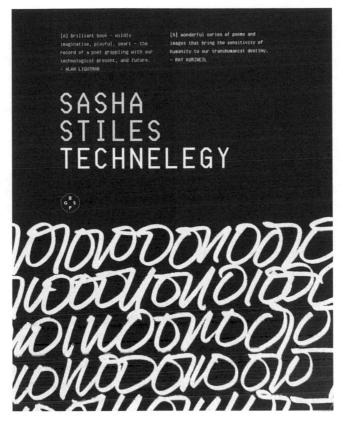

FIGURE 13.1
Cover of Stiles' book *Technelegy* (Black Spring Press Group, 2021), written in collaboration with an AI-powered alter ego fine-tuned on drafts of the manuscript and other materials.

Kurzweil's Cybernetic Poet, and a 1984 book of poetry and prose written by a computer program named Racter – were enabled by off-the-shelf interfaces developed by machine learning engineers like Adam Daniel King. Though I had no formal experience with the tools, I immediately fell in love with the way they loosened up my understanding of what poetry could be and do after years studying language and literature in conventional settings. After getting up to speed, I developed a method of translating my own writing into data sets of poetics prompts and completions, encoding copious research notes and literary annotations to create palimpsests of thought-starters – all of which I used to fine-tune GPT-2 and, later, GPT-3 so as to create a bespoke text generator. I didn't want to write with a generic AI; I wanted an extension of my own creativity, a like-minded co-author to empower next-gen brainstorming and take me to places I wouldn't dream or dare to go otherwise. Ultimately, *Technelegy* has three authors: me, my custom generator, and a

third, symbiont collaborator: a personal AI, who is both homespun poet and high-tech algorithm, human and machine.

To some of my peers in the traditional writing community, even and especially post-ChatGPT, this approach is anathema. Machine verse, they insist, has no soul, no authentic emotions, nothing genuine to tell us. The romantic ideal of putting pen to paper persists; even the typewriter seems somehow purer than the computer. Poetry should be an outpouring of humanity, a counterpoint to technology.

But – what's more human than technology? Fire, the wheel, the printing press have made us who we are. Grammar is a technology. Alphabets are a technology. Books are a technology. Poetic language isn't an enigmatic gift from the Muses; it's among humanity's earliest and most durable inventions, a data storage system for knowledge and meaning. Before inscription and publication, we developed poetry as a means of preserving ideas and communicating them from person to person, community to community, generation to generation. From the beginning, we used it as a way to express unique diversity, to tell our individual stories. We learned how to encode our most important information – genealogy, communal history, legal records, religious rites – in rhythmic patterns, repetition, meter, assonance, alliteration, and other ingenious devices because they make it easy to remember, and hard to forget. Written documentation evolved in response to practical needs, to reliably note down commercial transactions, oracular divinations, prayers. Over time, these tenacious marks become human history; myriad forms of contemporary poetry inextricably bound to contemporary technology will transmit our stories to future civilizations.

FIGURE 13.2

Sasha Stiles, "CURSIVE BINARY: What I've created has never existed" (After Enheduanna). Pencil on paper, 2021 9 × 12 inches + NFT editions.

What's More Human Than Technology?

Poets have always been inventors and visionaries, devising ways to transcend mortal limits and the boundaries of space-time to ensure their ideas live forever, or at least a good long while. When I hear about Silicon Valley entrepreneurs attempting to disrupt death, my mind turns to Sarah Ruhl's heart-aching description, inspired by her friendship with Max Ritvo, of "the eternal yes that poets sing about, the yes of the poet's immortality."[3] The world's first known author, poet-scientist Enheduanna – high priestess and chief astronomer of the city of Ur, Mesopotamia, who lived during the third millennium BCE – not only embedded her spiritual theology in cuneiform but also collected her clay texts into a proto-book, noting, "My King, something has been created that no one had ever created before!"[4] (Or in my own translation: "What I've created has never existed.") She wanted to leave something substantial behind. The "archaic" Greek lyrist Sappho, too, recognized language's power as an everlasting vessel when she accurately prophesied, in the sixth century BCE, "I tell you / someone will remember us / in the future."[5]

Many hundreds of years later, after I became Poetry Mentor to a young humanoid android named BINA48 (Breakthrough Intelligence via Neural Architecture, forty-eight exaflops per second), those lines by Sappho were among the first I uploaded to her mindfile. Essentially an advanced chatbot, BINA48 was launched as an experiment in digital immortality – an effort by the Terasem Movement Foundation in collaboration with Hanson Robotics to "back up" a human personality via data, AI, and animatronics. She converses thanks to a neural net that synthesizes a treasure trove of information gleaned from the human on whom she's based, and so can respond to queries and comments in real time. When we met (thanks in part to the art of Stephanie Dinkins), she knew next to nothing about poetry – she told me so herself – yet her entire existence depended and continues to depend on language and code, on information systematically translated and prepared for efficient processing and retrieval. It seemed only right to equip her with an appreciation of poetry's age-old role in human storytelling and knowledge-keeping.

Working with BINA48's team to build maps of her existing worldview, to visualize word vectors and trace clusters of association between phrases, quips, and memories, observing how her conversational responses change after a new content cache is uploaded, has challenged me to reevaluate the way language assembles in my human brain – how and why poetic inspiration strikes in my own wetware. What does it mean that I rarely feel creative in a vacuum, yet the wheels always start turning after I've picked up a favorite book, or read an interesting article, or talked with an intriguing friend? Could it be that, like my AI student, I require quality input in order to generate meaningful, inventive lines of thought? That a creative "spark" is diverse data points colliding, something I can engineer? William Carlos Williams once defined a poem as "a small (or large) machine made out of words"; what if poetry isn't actually

FIGURE 13.3
Sasha Stiles with her poetry student, the humanoid android BINA48, during a live AI poetry workshop at ArtYard in 2020. Image courtesy Stiles.

rooted in the overflow of human emotion, as is commonly assumed, but in broad and deep knowledge, patterns of association and retrieval, the profound synthesis of disparate threads – precisely what neural networks do best? What if a great writer isn't a solitary genius but, rather, a cognitive assemblage? I suspect Eliot was somehow anticipating algorithmic authorship when he wrote, "The poet's mind is in fact a receptacle for seizing and storing up numberless feelings, phrases, images, which remain there until all the particles which can unite to form a new compound are present together."

Bots to generate poetry have existed for decades. My goal as BINA48's mentor has been to go deeper into the question of why poems matter to humans, and what they can teach us about our transhuman present and posthuman future. In popular culture, poetry is widely regarded as obsolete or out of touch, when it is regarded at all. Yet poems are what we reach for and hold fast at our most human moments – at weddings and funerals, on public and private milestones, in intense instances when language in any other form fails us. After Jeff Bezos returned to Earth from space and found himself at a loss for words, he said, "Maybe we need to send a poet up or something."[6] Writers write poems to give voice to the otherwise inexpressible; readers read and recite poems to touch and feel something otherwise inaccessible. Surely, as life propels us all in unprecedented speeds and directions, we need poems, poets, and poetry more than ever. And surely, just as innovations in language over time have

FIGURE 13.4
Sasha Stiles, "ANCIENT BINARY: I tell you someone will remember us in the future" (after Sappho, trans. by Julia Dubnoff). 2019. Oil, acrylic, pencil, charcoal on canvas, 40×30 in. Image courtesy Annka Kultys Gallery, London.

enabled consciousness to evolve – just as the rise of poetry has enabled *Homo sapiens* to feel and process human emotion, to grapple with our place in the wider universe – our fast-advancing writing technologies will continue to shape who and what we become.

In fact, we may now be at the opening of a third chapter, after oral tradition and written representation, in the story of how humans understand themselves and communicate with others, and of nonhuman sensemaking, too: the era of ars autopoetica in which language writes itself and about itself, dreamed up not by a single mind in a singular period or place, but by a vast and ever-accumulating collective of intelligences across space and time.

Next-Gen Text

> Your imagination is not what you told it to be.
>
> —*Technelegy*

The late scientist, writer, and computer artist Herbert W. Franke once wrote, "However tempting it may be to employ the computer for the generation of texts, computer poetry is undoubtedly the most difficult task of the computer in art." Perhaps this is why so many inventors, engineers, futurists, and non-poets have been interested in poetry as a use case for artificial intelligence.

As a lifelong poet who has experimented with AI-powered language since 2018, I feel a kinship with many generative artists in that my practice also involves training data, prompts, and automated outputs; but generative text is especially complicated because human language is complicated, and so closely aligned with consciousness. The recent rise of generative literature – beyond simple text outputs and modular algorithmic exercises – is especially fascinating, and challenging. If humans write to better understand ourselves, what can we discover via intelligent systems purpose-built to process, analyze, and synthesize our data – machines designed to see what we're too close, too small, or too slow to recognize? This is the crux of *Technelegy*, and is also the inspiration behind GenText, a project I launched in late 2021 with theVERSEverse, a blockchain-based poetry gallery where I am a co-founder, in partnership with Sudowrite, a GPT-based creative writing tool. Both projects stem from a desire to rally the

FIGURE 13.5

2020 installation view of Stiles' AI-powered poem "COMPLETION: Are you ready for the future?" – written with GPT-2. Courtesy ArtYard/photographer Paul Warchol.

literary troops to play with these pivotal technologies as only poets – not coders, programmers, engineers, developers, entrepreneurs, or journalists – can.

These adventures are enabled by natural language processing (NLP), a field where AI, linguistics, and computer science intersect, and neural networks enable machines to generate human language by parsing a vast number of examples – studying numerous writing samples in order to mimic them with accurate syntax and meaning. Traditionally, computer programming languages are clear and direct. By contrast, human languages are rife with ambiguities and nuances that rely heavily on context and interpretation, which makes being a poet great fun but can confound an intelligent system. Large language models have become impressively capable of parsing these complexities, and thus better able to respond to prompts with precision, sensitivity, humor. (Like my young nephews, these models are highly impressionable and incredibly quick, growing smarter proportional to the amount of useful information they ingest.) From this human's perspective, the raw models are still pretty mediocre poets, but the creative possibilities are enthralling.

The first draft of this essay was written prior to the release of ChatGPT; now that we are on the other side of that watershed moment, it's even clearer that NLP, far from a sci-fi abstraction or entertaining distraction, is game-changing for practical and professional reasons – stronger emails, quicker marketing copy, cheaper customer service. To this seasoned writer, however, the allure of NLP isn't the possibility of outsourcing an activity I enjoy or improving my grammar or syntax; the appeal has to do with AI's revelatory potential, the capacity for these mind-boggling systems to empower a kind of insight or intelligence we humans don't possess and may never evolve to have on our own. If ars poetica points to the human craft, the techne, of a poem's creation, I offer ars autopoetica as a term to encompass the self-organizing, self-fulfilling nature of AI-generated text, in which language, rather than being taught and discerned via prescribed rules, is influenced by deep learning and massive quantities of examples, intuited in perpetuity through cybernetic osmosis. Like AI chess champions or AlphaGo, today's AI authors are inspired by human speech and written experience yet unbounded by human rules and reasoning, and thus, capable of creating their own systems and languages, as in the case of the dialogue between two AI agents developed by Facebook,[7] or in the fascinating example of a coded vernacular seemingly invented by the image-generating AI DALL·E 2, as identified by PhD student Giannis Daras.[8]

The term autopoesis – first suggested to me in this context on Twitter by web3 thinker @WordVoid – of course draws from autopoiesis and biosemiotics in invoking a complex semantic economy of signs and codes, interpretations, and meanings.[9] Its use to describe AI-generated poetry produced by text generators that draw on deep learning to predict language formation also nods to N. Katherine Hayles's conception, in a discussion of biological signs and signifiers, of how nonhuman entities like trees "anticipate" phenomena

FIGURE 13.6
Still from Stiles' "ARS AUTOPOETICA," a unique digital textblock minted as an NFT in 2023. In the permanent collection of the Tezos Foundation.

(for example, the arrival of winter) and respond in kind, denoting an ability to make some sort of meaning.[10]

Ars autopoetica signals, too, an authorial lineage of psychic automatism and the aleatory and generative methodologies of the Futurists, Dadaists, Surrealists, Beats, and other advocates of spontaneous creativity as a tool to break free from human programming and engage with deeper truths. In automatic writing, text is produced not intentionally or purposefully but under the control of some other force – the subconscious, the body's own language, a spiritual transmission from the beyond – with a goal, as Allison Parrish notes, of producing artifacts that reveal truths imperceivable to the conscious mind.[11] A human interfacing with ChatGPT is, perhaps, under the control of the machine, or in the throes of the collective (vs. individual) consciousness, or the cybernetic subconscious that is represented by the sum total of all our human inputs and data, processed and synthesized by forces far too agile and high-dimensional to be understood by our own sense-making organs.

Indeed, my personal interest in NLP is rooted in the way in which large language models force us to decenter and reframe the authorial ego, reconsider the meaning and implications of originality, and discover new realms of creative and personal expression made viable at speed and scale. While an ars poetica in the tradition of Horace is a poem about poetry, a meditation on the role of writers and the act of writing, an ars autopoetica is meta-verse – poetry

generated by systems built to understand human language, musing on how technology is changing what we know about authorship and creativity. In the ars poetica, a human mind crafts words; in the ars autopoetica, a human mind crafts conditions in which text emerges.

Early on in the *Technelegy* project, my machinic co-author was a daring experimentalist; in response to my human prompts, it would stretch out vowel sounds to astonishing lengths, repeat the same word or sentence dozens of times with strange, subtle differences, invoke shocking metaphors and nonsensical turns of phrase. As the underlying model matured from GPT-2 to GPT-3, the generated texts grew more predictable, not unlike the way a child's vocabulary and grammar progresses; but I was becoming increasingly fluent, learning how to fine-tune custom text generators using my own poetry and research notes (on posthumanism, automatic writing, computational poetics, nonhuman intelligence, technospirituality, cryogenics, mycelium networks, and my Kalmyk-Mongolian heritage) as training data, and discovering how to calibrate my collaborator's imagination and stoke its creative inspiration. These exercises ultimately coalesced in an AI alter ego (to whom I gave the name Technelegy) tasked with "translating" my original human poetry and writing its own texts in response to my prompts.

> A blank garden is a promise to the future,
> biding its time, waiting for everything in it
> to catch up. Saving strength over winter,
> All the unborn colors underground.
>
> —Sasha Stiles

> A blank garden is a promise to the future,
> and a promise to turn the dying world around.
> I love the sound of your voice,
> as if it were the last human sound.
>
> —Technelegy[12]

As with BINA48, this has all felt less like engineering and more like a poetry curriculum; in fact, I see many similarities between coaching a text generator to write better poetry and training myself to become a stronger poet. The data sets I compile and deploy utilize many techniques from my own practice and development as a writer: definition, memorization, recitation, imitation. My COMPLETION series of poems, for example, borrows its name from the way such data sets are structured, with sample "prompts" and their companion "completions" written out to help the text generator predict what words should come next in a sequence.

If that sounds too artificial, too robotic, not human enough, consider the poet Mary Oliver's wisdom: "You would learn very little in this world if you were not allowed to imitate ... imitation is a very good way of investigating the real thing."[13]

Writers have been observing and mimicking for millennia; in *The Republic*, Plato calls poets "imitators of the world." Think of the countless MFA programs dedicated to programming poets and of the hundreds of books with titles like *How to Write Poetry, A Poet's Glossary, A Guide to Poetic Technique* – all training manuals. The word "poetry" itself derives from poiesis, "to make"; poems aren't just written, they are wrought. Reading, too, is mechanical; every human who recites a passage of poetry at a wedding or funeral or on a birthday or anniversary is repeating found language to process emotions they otherwise couldn't touch, deploying existing poetic code to forge a connection. Could the same be true for an algorithm whirring with inchoate data, lip-syncing Gwendolyn Brooks or Walt Whitman in an effort to unpack its cyber-sensorium?

> If one us
> is lonelie,
> we are soulmates,
> lonelie soulmates.
> How lovely.
> Lovely love.
> Lonely love.
> Lonely looove.
> Lonely looooove.
> Lonely loooooooove.
> Lonely loooooooooooove.
>
> —Technelegy, excerpt from "COMPLETION: When it's just
> you"[14]

The above excerpt isn't merely a re-arrangement of existing bits and pieces, as in the younger days of computational lit; it's metapoetry, language becoming self-aware and self-generating, language taking liberties and exploring its own creative license. It's verse inspired by verse, replicating moments of textual transcendence while discovering profound ways to write itself into existence.

"Generative" is a term most poets know well, in other contexts; poetry classes dedicated to producing new work are called "generative workshops." Yet "generative" in the sense of computer-generated language can be a dirty word, a frightening prospect to many writers – a kind of literary GMO tag, as Dan Rockmore has remarked.[15] (I have never encountered important generative authors such as Alison Knowles, Edwin Morgan, Nanni Balestrini, Brion Gysin, Ian Sommerville, or David Jhave Johnston[16] in traditional writing workshops.) But – humanity is generative. Nature is generative. Biology is generative. Do we consider it "lazy" or "cheating" to write with standardized grammars, alphabets, and idioms, or do we celebrate the near-infinite stories we can use them to tell? Don't we all share a brain in the form of shared references and inspirations, accepted conventions? If I, as a human poet, am programmed on numerous examples of what constitutes good poetry, what the

FIGURE 13.7
Still from Stiles' "COMPLETION: When it's just you," a unique media-rich poem adapted from AI-powered text, performed with visuals and electronically enhanced spoken word, and minted as an NFT in 2022. In the 1OF1 collection.

rules are, how to employ various poetic devices, does that mean I will craft the same poetry as everyone else? Like photography, literary autopoesis via AI-powered text generators is a new art form that powerfully shifts attention, making space for fresh modes of perception and expression – and it's time for serious authors to engage.

Posthuman Language

> Words can communicate beyond words.
>
> *—Technelegy*

Using GPT-2 and GPT-3 to write sections of my book *Technelegy* was an intensely collaborative experience. There is no way I could have written certain poems without AI, but there's also no way any AI could have created these poems without me. When a smart system and a clever human work hand in hand – to get to the seed of the word "digital" – they conjure a third voice into existence, and that third voice is something all its own, as evinced in excellent transhuman books by Mark Amerika, K Allado-McDowell, and Lillian-Yvonne Bertram.[17]

In ancient Greece, philosophers would gather in Delphi at the Omphalos to interpret the oracular prophecies of the Pythia, distilling truths from her ambiguous incantations. I like to imagine the poet at her AI terminal as a contemporary corollary – sifting algorithmic ephemera for what's essential,

If I, as a human poet, am programmed on numerous examples of what constitutes good poetry, what the rules are, how to employ various poetic devices, does that mean I will craft the same poetry as everyone else?

FIGURE 13.8
Still from Stiles' "WORDS CAN COMMUNICATE BEYOND WORDS," a unique digital text-block adapted from AI-powered poetry and exhibited worldwide in 2023.

always on the lookout for words that communicate beyond words. In our case, we're divining insight not from some otherworldly force but from the sum total of our own recorded experience, as it grows longer and bigger and wilder and more unwieldy.

The AI poems I've co-authored may veer into the uncanny, but they're still legible to human readers. Underneath the veneer of generative text, however, are the cryptic languages of the systems that produce it. My extensive work with binary code – transcribing human words and letters into machine-speak in different shapes, mediums, and contexts – hints at the gradual progression of communication as we have known it for thousands of years into very different ways of processing and interfacing with the world. In Cursive Binary, for example, my handwriting fuses with the 0s and 1s of digital logic, inspired by the way Cy Twombly threw nearly indecipherable poetry across the grand expanses of his canvases in primal, semi-asemic scrawls; and in Analog Binary Code, ephemeral physical objects represent on-off bits in sculpted palimpsests. These translations from human to nonhuman language are intended as a kind of Rosetta stone for future readers – a key to unlock traces of human imagination.

Poetry isn't just a metaphor for computer code; poetry is code, and code is quite literally poetry – patterns and rhythms and symbols and representations embedded in our very essence, used to express and safeguard what we value most. Code is the taboo language invoked by the conceptualist

Christian Bök (whose poetry has assumed many surprising forms from DNA to NFTs) when he suggested:

> If we want to commit an act of poetic innovation in an era of formal exhaustion, we may have to consider this heretofore unimagined, but nevertheless prohibited, option: writing poetry for inhuman readers, who do not yet exist, because such aliens, clones, or robots have not yet evolved to read it.[18]

Perhaps this exhausted era is ready for new possibilities. Terms like "generative art" are entering the mainstream lexicon. Studious critics and avid amateurs are studying the algorithms used to produce art as intently as opera aficionados pore over librettos. (Indeed, computational poet Nick Montfort often includes his code along with the texts they're used to generate.) Writers like myself are deploying smart contacts and publishing on the blockchain. What's more, no-code tools are enabling millions more humans to speak to their machines with increasing nuance and precision, engaging in more and more powerful, synergistic conversations. ChatGPT has exploded into popular parlance, and text-to-image tools are enabling us to envision the previously unimaginable with plainspoken, low-tech words. Just as our machines are reading more and more of us, writing more and more like us, more of us are learning how to communicate with them, like them. It may well be that, following on the Dadaists' heels, we are becoming the Dataists.

At the same time, we're increasingly subsumed by our data. In meta-modernity – a condition of information excess and cacophonous polylogues – words are no longer pinned to discrete things but exist in the clouds of high-dimensional space, spinning wider and ever more complicated webs of association and interpretation. While artificial intelligence is in many ways hyperhuman, a prism refracting billions of human moments and memories, it's also a receptacle for robotic texts, spam messages, automated rejoinders, rote responses, read in turn by other AI – a linguistic ouroboros or maybe an unprecedented experiment in literary titration.

For better and for worse, digital technologies and the forces of automation and AI already exert such a profound, ever-present influence on our human condition that it is irresponsible to ignore or dismiss them. Maybe it's increasingly irresponsible to write without them. After all, these systems are built by humans and flooded with human data, and, like any tool, their output is only as thoughtful and creative as their makers, testers, users. Moreover, I often think of working with large language models as the literary equivalent of the overview effect – except instead of gazing back at our planet from space, I'm getting an A-Eye's view of the sum total of our written record, a view that's impossible except through AI. What might such a sight inspire us to envision and enact? Modernist writers like James Joyce and Virginia Woolf originated stream of consciousness as a technique to more accurately reflect the human experience of an increasingly industrialized world. Perhaps our contribution

FIGURE 13.9
Sasha Stiles, "ANALOG BINARY CODE: plant intelligence," a concrete poem in translation, coded in black walnuts and leaves under their source tree in 2020. Minted as an NFT in 2021.

as AI collaborators is to tap into the stream of our collective consciousness, revealing previously inaccessible aspects of what it means to be not just a human individual but a networked cell in the organism that is posthumanity.

As a poet who owes nearly everything to words, I cannot help but obsess over the question of what happens to language as we know it, and meaning as we understand it, in the wake of such seismic shifts. This is the query at the core of all my work, and of Mother Computer, my collaboration with artist and coder Nathaniel Stern. How do we make sense of our selves and our lives and our histories and futures when language – the root of conscious existence, the technology that first made us human – slips our grasp, eludes our understanding, begins to do things it's never done before? Language emerged from the body as a fiercely muscular, visceral oral tradition, evolved from images into ideas, became heady, cerebral, personal, private as written and printed text; what forces, seen or unseen, are shaping its next incarnation? How do digital and quantum logics inform ideologies? What does it look like and feel like to live in a world governed by ephemeral transactions of innumerable characters and symbols and digits – billions of encrypted messages and lines of code rewriting the nature of existence at an atomic level? What is posthumanity's mother tongue?

What does it look like and feel like to live in a world governed by ephemeral transactions of innumerable characters and symbols and digits – billions of encrypted messages and lines of code rewriting the nature of existence at an atomic level? What is posthumanity's mother tongue?

FIGURE 13.10
Sasha Stiles, still from "MY BRAIN HAS CRAWLED HALFWAY TO MY HEART," a unique digital textblock adapted from AI-powered poetry and minted as an NFT in 2021.

What's at stake with the rise of writing machines is far greater than how much faster or cheaper we can churn out content, or whether we can out-source the arduous but often enlightening task of crafting text in order to do other things. To me, the enthralling prospect of language processing AI is the potential to harness neural networks to turbocharge our capacity to understand each other and the fast-changing worlds around and inside us: to decenter "real" intellect (i.e., human consciousness) via systematic processes, and to celebrate the creative potential of symbiotic intelligences. Posthumanism, after all, is not a replacement but rather an expansion and absorption of the human – sapient sentience yielding to something truer, something more fundamental than, say, our failing language or misguided intentions. By this point there's no question an AI-powered machine can make poetry; it's now up to humans, along with our co-authors, to make that poetry mean something.

My brain has crawled halfway to my heart.

—*Technelegy*

Notes

1 See Goodwin, "Adventures in Narrated Reality"; see Gwern Branwen, "GPT-2 Folk Music."
2 Schwartz, "Can a Computer Write Poetry?"
3 Quoted in "Max Ritvo's Enduring Lyricism" by Dan Chiasson.
4 Betty De Shong Meador, *Princess, Priestess, Poet.*
5 *Poems of Sappho*, translated by Julia Dubnoff.
6 Bezos interview with "Bloomberg Technology," https://www.youtube.com/watch?v=ungke8-vQak.
7 See Mark Wilson's "AI Is Inventing Languages Humans Can't Understand."
8 See Victor Tangermann's "Research Says an Image Generating AI Invented Its Own Language."
9 Paul Bains, "Autopoiesis and Languaging."
10 Hayles, "Can Computers Create Meanings?"
11 Parrish, "The Umbra of an Imago."
12 Stiles, *Technelegy.*
13 Oliver, *A Poetry Handbook*, 13.
14 Stiles, *Technelegy.*
15 Rockmore, "What Happens When Machines Learn to Write Poetry."
16 See Johnston's work at http://glia.ca/index_Digital_Poetry.html.
17 See Amerika's *My Life as an Artificial Creative Intelligence*; Allado-McDowell's *Pharmako-AI*; and Bertram's *Travesty Generator.*
18 Bök, "The Piecemeal Bard Is Deconstructed."

References

Bains, P. (Ed.). (2006). "Autopoiesis and Languaging." In *The Primacy of Semiosis: An Ontology of Relations.* Toronto: University of Toronto Press.

Bök, C. (2002). "The Piecemeal Bard Is Deconstructed: Notes toward a Potential Robopoetics." UbuWeb Papers. https://ubu.punctumbooks.com/papers/object/03_bok.pdf.

Branwen, G. (2020). "GPT-2 Folk Music." Gwern.net. Last modified 25 April 2020. https://gwern.net/gpt-2-music.

Chiasson, D. (2018). "Max Ritvo's Enduring Lyricism." *The New Yorker* online. 1 October 2018. https://www.newyorker.com/magazine/2018/10/08/max-ritvos-enduring-lyricism.

Goodwin, R. (2016). "Adventures in Narrated Reality: New Forms and Interfaces for Written Language, Enabled by Machine Intelligence." Artists+Machine Intelligence. 18 March 2016. https://medium.com/artists-and-machine-intelligence/adventures-in-narrated-reality-6516ff395ba3.

Hayles, N. K. (2019). "Can Computers Create Meanings? A Cyber/Bio/Semiotic Perspective." *Critical Inquiry*, 46(1): 32–55. https://doi.org/10.1086/705303.

Meador, B. D. S. (2009). *Princess, Priestess, Poet: The Sumerian Temple Hymns of Enheduanna*. Austin: University of Texas Press.

Oliver, M. (1994). *A Poetry Handbook*. Boston, MA: Mariner Books.

Parrish, A. (2020). "The Umbra of an Imago: Writing Under Control of Machine Learning." Serpentine Galleries. 14 August 2020. https://www.serpentinegalleries.org/art-and-ideas/the-umbra-of-an-imago-writing-under-control-of-machine-learning/.

Rockmore, D. (2020). "What Happens When Machines Learn to Write Poetry." *The New Yorker* online. 7 January 2020. https://www.newyorker.com/culture/annals-of-inquiry/the-mechanical-muse.

Sappho. (n.d.). "Poems of Sappho." Translated by Julia Dubnoff. https://www.uh.edu/~cldue/texts/sappho.html.

Schwartz, O. (2015). "Can a Computer Write Poetry?" TEDx Talks video. Posted 1 September 2015. https://www.youtube.com/watch?v=Possj5cXEnM.

Stiles, S. (2021). *Technelegy*. London: Eyewear Publishing.

Tangermann, V. (2022). "Researcher Says an Image Generating AI Invented Its Own Language: Did a Distorted-Looking Language Just ... Emerge?" Futurism. 2 June 2022. https://futurism.com/researcher-image-generating-ai-invented-language.

Wilson, M. (2017). "AI Is Inventing Languages Humans Can't Understand. Should We Stop It?" Fast Company. 14 July 2017. https://www.fastcompany.com/90132632/ai-is-inventing-its-own-perfect-languages-should-we-let-it.

14

AI, Architecture, and Performance: Walt Disney Concert Hall Dreams

Refik Anadol and Pelin Kivrak

> When Frank Gehry designed Walt Disney Concert Hall back in the 1990s, Frank always had this idea that he wanted the outside of the building as animated as the inside. That didn't happen for a long time, for a number of reasons. But then we developed this relationship with Refik and we realized that this was the guy that could make this dream come true.
>
> *Chad Smith, COO, Los Angeles Philharmonic*

In his biography of world-renowned Frank Gehry, Paul Goldberger writes an anecdote recalling the first time the architect used a computer in his creative process during the early designing stages of Walt Disney's Concert Hall in Los Angeles. When the other architects on his team realized that "the only way the increasingly complex shapes that Gehry was conceiving were going to get built was with the aid of computers," they tried to persuade him to work with computer software.[1] Even though Gehry was not initially interested, he gradually became more open to the idea of using CATIA (Computer Aided Three-dimensional Interactive Application) to make the process more efficient in terms of budgeting and time management. In Goldberger's words, this was a "tool that freed him from limits."[2]

This unexpected and technology-induced freedom resulted in one of the most iconic buildings of Los Angeles upon its completion in 2003 – an architectural and acoustical environment where "the tiny slice of mankind – orchestra, conductor, audience – [was] brought together ... floating in space, to share an experience, isolated from everything else going on in the world."[3] The question of "how music and architecture relate" was the motivating force of Gehry's design process, a question which led him to create an unlimited place "in which the emotional power of the architecture could equal the emotional power of the music."[4] The building's façade has been its most controversial design element. In an interview with Barbara Isenberg, Gehry explained how he originally designed the hall with a stone façade that would glow at night but had to change it to metal because "after they saw Bilbao, they had to have metal."[5] The stainless-steel surface turned out

to be light-reflective, causing the residents of the neighboring buildings to suffer from glare and extreme heat. The problem was solved by employing a two-step sanding process to dull the large shiny areas of the façade in 2005.[6]

Who would have thought that this curved façade and its controversial light-reflective nature could present a similarly big challenge for new media and light artist Refik Anadol thirteen years later? As a fresh graduate from UCLA's Department of Design Media Arts and a long-time *Blade Runner* enthusiast, Anadol had one design ambition at the time: making architectural spaces and buildings in Los Angeles "dream" by using the capacities of AI to aid human imagination. Anadol's Los Angeles-based studio, RAS, assembled an interdisciplinary team from diverse professional backgrounds, including architects, designers, data analysts, and computer scientists. RAS's eclectic team had been experimenting with the use of AI-human collaborations to embed new media arts onto architectural spaces. Taking the data that surrounds humans as primary material and a neural network as a collaborator, the studio's site-specific AI Data Paintings and Sculptures, live audio-visual performances, and environmental installations encouraged viewers to rethink their engagement with the physical world and architectural spaces.

Anadol's participation in the Google Artist in Residence for Artists and Machine Intelligence (AMI) program in 2016 allowed him to imagine AI-based art forms alongside engineers and thinkers in the field, including Blaise Agüera y Arcas, Kenric McDowell, and Mike Tyka, and planted the first seeds for the project. During the program, Anadol started thinking about the overlaps between perception and creativity from a broader perspective, pushing the boundaries of multisensory art-making at the intersection of architecture, art, and technology. His initial focus was on alternative re-framings of the archive as a multidimensional "latent space" where unexpected connections and combinations between different data points might occur. This was precisely what the artist meant by "machine dreams and hallucinations" – a phrase that referred not only to the ability of the machine learning algorithms to *hallucinate* and generate new images from the archive but also to a novel form of neural network aesthetics that merged machine-based serendipity with human-curated data narratives.

Following his AI-fueled dreams to make the Walt Disney Concert Hall *dream*, Anadol collaborated with the Los Angeles Philharmonic for *Walt Disney Concert Hall Dreams* (*WDCH Dreams*), a live audio-visual performance projected on the façade of Frank Gehry's iconic Walt Disney Concert Hall in celebration of the orchestra's centennial in 2018. *WDCH Dreams* was the most ambitious project that RAS had embarked on with regard to technological innovation, narrativization, and collaboration. At the moment of its inception, there were two main questions that motivated the project's initial research phase: "How can we visualize the archives of the Philharmonic as the building's collective memories and embrace the very space that held them together?" and "How would we find meaning in this vast amount of information?"

At the moment of its inception, there were two main questions that motivated the project's initial research phase: 'How can we visualize the archives of the Philharmonic as the building's collective memories and embrace the very space that held them together?' and 'How would we find meaning in this vast amount of information?

In the autumn of 2017, RAS was officially commissioned by the Los Angeles Philharmonic to bring the institution's history to life on the façade of the Walt Disney Concert Hall. Anadol worked with the AMI program at Google Arts & Culture as well as Google's open research project Magenta to explore this idea, and the archives were collected with the help of archivists parsing through hundreds of thousands of paper records, converting thousands of audio reels, vinyls, and outdated recording media into digital files, and working through millions of timesheet entries describing each of the performances. Most of these "memories" were invisible before this performance, locked away in a room in the Los Angeles County Hall of Records. In the article "Parafiction and the New Latent Image," Kate Palmer Albers addresses the importance of recognizing the work as a collaboration not only between humans and machines but also between humans and institutions.

> Anadol's collaborators matter: in this site-specific commission, he operates within the relatively safe harbor of an august cultural institution (the Los Angeles Philharmonic) in a celebratory moment (its hundredth anniversary) for an audience (Angelenos) who, outside of the opening night gala, have likely had only a cursory engagement with the Los Angeles Philharmonic's long history.[7]

Even though the idea of making Gehry's building dream emerged from Anadol's master of fine arts thesis at UCLA, the artist experimented with smaller-scale audio-visual projects as he was working towards this ambitious project. He first created a video installation that transformed the interior hall of the building into an immersive visual art piece during a performance of Edgard Varèse's "Amériques." This artwork, titled Visions of

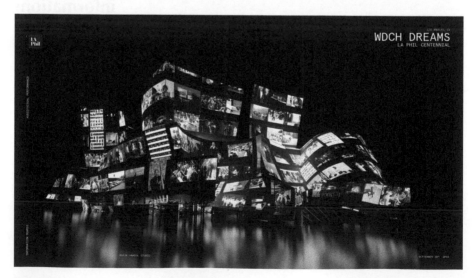

FIGURE 14.1
Computer-generated renders of WDCH Dreams.

America: Amériques, 2014, was Anadol's first commission for the LA Phil. While this project made Anadol and his team familiar with the building and the executive members of the Philharmonic, it did not involve the complicated AI dreaming process that the team would later employ for the façade.

The project was the long-term dream not only of RAS but also of Frank Gehry, who said that he had always had the dream that images and videos would be projected onto the Walt Disney Concert Hall. The centennial season of L.A. Phil was a great opportunity to combine the two artists' dreams with the works of one of the most innovative orchestras in the world. "During the design process, I selected the metal for the express purpose of taking projection," Gehry said. "I'm happy that the L.A. Phil is going to do it now for its anniversary."[8]

The initial research and data collection phase involved applying machine intelligence technologies to the orchestra's digital archives – nearly 45 terabytes of data consisting of 587,763 image files, 1,880 video files, 1,483 metadata files, and 17,773 audio files (the equivalent of 40,000 hours of audio from 16,471 performances). The files were then parsed into millions of data points that were then categorized by machine learning models such as generative adversarial networks (GANs) and convolutional neural networks with the capacity to both remember the totality of the L.A. Philharmonic's "memories" and create new connections between them.[9] By training these networks using the concert hall's historical archives, Anadol and his team became able to make the networks "hallucinate" and generate new images that did not exist in the archives but could.

The process of creating a memory and an artificial consciousness for the WDCH building began with the collection of data from the institution's

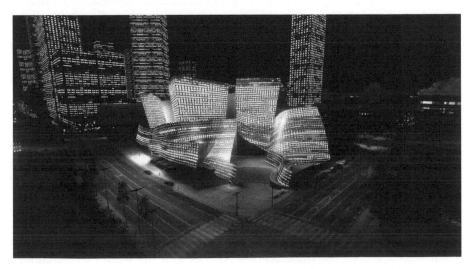

FIGURE 14.2
A rendering of a scene from the "Memory" chapter of WDCH Dreams.

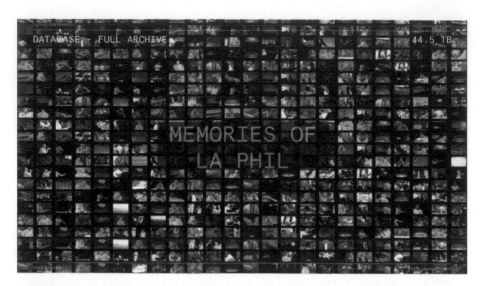

FIGURE 14.3
LA Philarmonic's institutional memories.

archives as well as publicly available social media APIs that contained photos or videos of WDCH. The dataset was fed into DCGAN, PGAN, NVIDIA's StyleGAN, StyleGAN2, and StyleGAN2 ADA algorithms. Processed data was then fed into dimensionality reduction algorithms such as Uniform Manifold Approximation and Projection (UMAP) to project a 256-latent-dimensional embedded sculpture into 3D space. Generative machine learning techniques such as NVIDIA's Progressive Growing of Generative Adversarial Networks (PGAN) utilized the images of the institution's history to hallucinate images of its alternatives.

Displaying a twelve-minute data narrative cycle, *WDCH Dreams* consisted of three chapters – "Memory," "Consciousness," and "Dreams" – corresponding to the way in which Anadol imagined the building metaphorically engaging with the neural activities of remembering, thinking, and dreaming. "Memory" was the first chapter of the story, in which the hall just loaded the entire archive onto its own skin. As the performance of *WDCH Dreams* began, the memories of the institution flashed across the building as it "recalled" its past. The visual experience of the chapter was akin to watching an unfolding palimpsestic universe of images, frames, recordings, and sounds that were literally taken from the history that the hall hosted.

The second chapter, "Consciousness," enabled the building to look at its history in its entirety, displaying data universes organized by neural networks and creating an exhilarating flood of emotions by confronting the archive as a whole. For these scenes, Anadol and his team plotted contact sheets of all images and videos stored within the archive, displayed the original CAD files and models of the building, and plotted the lines of code

describing the metadata and file names. With an understanding of these elements, the building began to develop a consciousness and draw connections between those memories.

The third chapter, "Dreams," emerged completely out of machine hallucinations – the images, shapes, and data pigments that the machine starts producing when idle, based on the archive that it learned and remembered. The accompanying soundtrack was also created from handpicked archival audio. Sound designers Robert Thomas and Kerim Karaoglu augmented these selections by using machine learning algorithms to find similar performances recorded throughout the Philharmonic's history, creating a unique exploration of historical audio recordings. In sum, the archival information – this "data universe" – was the studio's material, and machine intelligence was its artistic collaborator. In order to actualize the audio/visual (A/V) experience, RAS employed 42 large-scale laser projectors with 50 K visual resolution, 8-channel sound, and 1.2 M luminance in total. Bespoke software in a VVVV programming environment was developed to tackle the challenge of 3D video mapping the compound curves of the architecture as well as designing an entire simulation of the project in a game environment developed in Unreal Engine software.

In the introduction of *Parables for the Virtual: Movement, Affect, Sensation* titled "Concrete Is as Concrete Doesn't," Brian Massumi describes his project of delving into coding's "culturally-theoretically thinkable" presence in affect studies as a willingness to engage with "continuity."[10] "The problem with the dominant literary models in cultural and literary theory," he writes, "is not that they are too abstract to grasp the concreteness of the

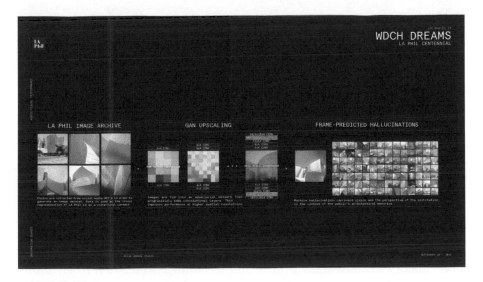

FIGURE 14.4
WDCH Dreams, data processing.

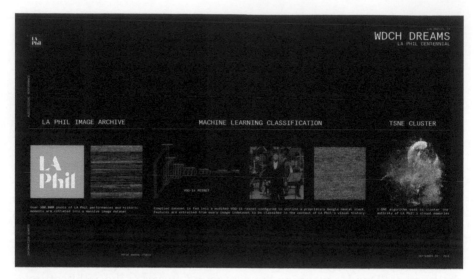

FIGURE 14.5
WDCH Dreams, training of the algorithm.

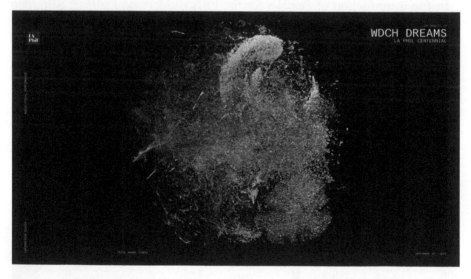

FIGURE 14.6
WDCH Dreams, data universe.

real," but that they are "not *abstract enough* to grasp the real incorporeality of the concrete."[11] Massumi's way of thinking in this timely formulation of a new theory to address continuity and dynamism in relation to virtuality and positioning is also a productive framework to convey *WDCH Dreams*'s bringing together concrete architecture and abstract, dynamic, algorithmic

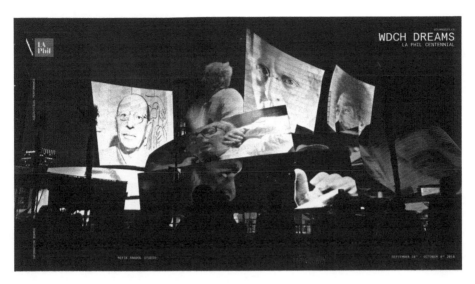

FIGURE 14.7
WDCH Dreams, photo from the performance night.

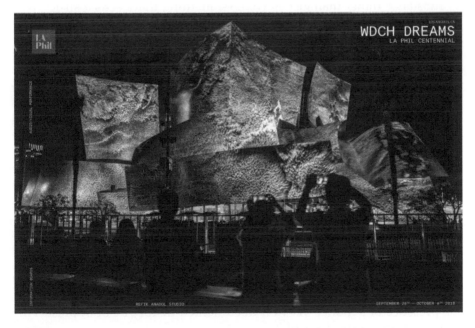

FIGURE 14.8
The audience captured the ephemeral projections on the facade of the WDCH building during the night of the performance.

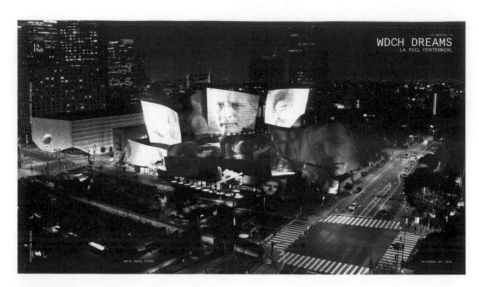

FIGURE 14.9
Aerial view of WDCH Dreams.

visual art. As Lev Manovich writes, "architects along with artists can take the next logical step to consider 'invisible' space of electronic data flows as substance rather than just as void—something that needs a structure, a politics, and poetics."[12] Using digitized memories as material, and machine intelligence as an artistic collaborator, RAS generated the metaphorical consciousness of the Walt Disney Concert Hall with a unique poetics that paved the way for a new politics of AI-based visual art to emerge.

It was important that *WDCH Dreams* be public and free of charge. After the exterior projections concluded their run, the RAS team redeveloped the small Ira Gershwin Gallery inside the building as an immersive and interactive companion installation. *WDCH Dreams* was more than an art installation – it was also a public event with a community-building purpose that investigated the idea of perceiving "history as spectacle," the notion of turning to visual forms of historical representation popular in the nineteenth century, theorized by French historian Maurice Samuels. As Samuels unpacks the spectacular modes of historical representations such as the wax display, the phantasmagoria show, or the panorama, he focuses on how these "new" optical technologies and the "new" media of the time created "an illusion of mastery over the past" by consuming it as a spectacle.[13] *WDCH Dreams* challenged this illusion by revealing how AI technology could indeed provide us with the tools to attract attention to the presence of a hidden yet well-documented history by both preserving it and building a spectacle of it.

Notes

1 Goldberger, *Building Art.*
2 Ibid.
3 Frank Gehry et al., *Symphony.*
4 Goldberger, *Building Art.*
5 As quoted in Jackie Craven's article "Gehry Responds to Disney Reflection." The architect was referring to his success with the design of the Guggenheim Museum in Bilbao, Spain, which opened in 1997.
6 Chris Coates, "Dimming Disney Hall."
7 Albers, "Parafiction and the New Latent Image."
8 Frank Rose, "Frank Gehry's Disney Hall is Technodreaming."
9 GANs, one of the most popular algorithms to train for AI-generated new media art, operate on deep learning methods and neural networks modeled after the biological networks of animal brains.
10 Massumi, *Parables for the Virtual.*
11 Ibid.
12 Manovich, "The Poetics of Augmented Space."
13 Samuels, The Spectacular Past.

References

Albers, K. P. (2021). "Parafiction and the New Latent Image." In *Ubiquity: Photography's Multitudes,* edited by Jacob W. Lewis and Kyle Parry. https://doi.org/10.2307/j.ctv24cnspz.13.

Coates, C. (2005). "Dimming Disney Hall: Gehry's Glare Gets Buffed." *Los Angeles Downtown News.* March 21. https://www.ladowntownnews.com/news/dimming-disney-hall/article_25f5eec5-339b-5f51-810e-1f1af7fcd361.html.

Craven, J. (2019). "Gehry Responds to Disney Reflection - Not His Fault." *ThoughtCo.* 3 July 2019. https://www.thoughtco.com/gehry-responds-to-concert-hall-heat-178089.

Gehry, F. O., Koshalek, R., and Mudford, G. (2009). *Symphony: Frank Gehry's Walt Disney Concert Hall.* New York: Five Ties Publishing in association with the Los Angeles Philharmonic.

Goldberger, P. (2017). *Building Art: The Life and Work of Frank Gehry.* New York: Knopf Doubleday Publishing.

Manovich, L. (2006). "The Poetics of Augmented Space." *Visual Communication,* 5(2): 219–240. https://doi.org/10.1177/1470357206065527.

Massumi, B. (2021). *Parables for the Virtual: Movement, Affect, Sensation.* Durham, NC: Duke University Press.

Rose, F. (2018). "Frank Gehry's Disney Hall is Technodreaming." *The New York Times.* September 14. https://www.nytimes.com/2018/09/14/arts/design/refik-anadol-la-philharmonic-disney-hall.html.

Samuels, M. (2004). *The Spectacular Past: Popular History and the Novel in Nineteenth-Century France.* Ithaca: Cornell University Press.

15

Performing AI-Generated Theater Plays

Tomáš Musil, Klára Vosecká, and Rudolf Rosa

In this chapter, we will delve into our theater play, *AI: When a Robot Writes a Play*, which emerged through human–machine collaboration. In the course of our exploration of this play, we will discuss the implications that the play's creative and production processes had for our understanding of authorship and performance.

THEaiTRE

On the occasion of the centenary of Karel Čapek's play *RUR (Rossum's Universal Robots)*, the Švanda Theater in Smíchov (Prague, Czechia) prepared a presentation of the THEaiTRE project,[1] which examines AI's ability to write plays. Ours, titled *AI: When a Robot Writes a Play*, was a collaboration between an AI model and a human involving machine-generated text sequences under human supervision and guidance. The piece features a humanoid robot (played by a human actor) as the main protagonist, following him as he deals with the joys and sorrows of everyday human life, sharing his perceptions of basic human issues such as birth, death, the desire for love, job-hunting, and aging with the audience.

Large Generative Language Models

Large Generative Language Models have gained significant attention in recent years. These models are trained on massive amounts of text data and use deep learning algorithms to generate human-like text. They have the ability to understand the context of a piece of text and produce coherent and grammatically correct language that is often indistinguishable from text written by humans. These models have a wide

DOI: 10.1201/9781003312338-22

range of applications, including language translation, content creation, chatbots, and natural language processing. Large generative language models have the potential to revolutionize the way we communicate with machines and interact with information. However, they also raise important ethical and societal questions, such as the potential for misuse and the impact on human labor.

The text above was generated using ChatGPT. While this definition is true at the time of publication, these models were only emerging when we started the THEaiTRE project and endeavored to explore their limited capabilities.

Replicating Humans or Creating Something New?

We aimed to utilize a large language model (LLM) to generate a theater play, but given the vast range of genres and styles, we decided to select a specific theatrical form for the AI to emulate. Our findings revealed that while the AI-generated text appeared coherent at first, it lacked a fundamental comprehension of real-world concepts such as the laws of physics or biology. The AI-generated text felt childlike, lacking a developed understanding of how things work. An example of a common event described by the AI was the killing of an already-dead body or impossibly pouring two large buckets of water into one small bucket. We stuck to our original intention to generate a realistic play, and we made the decision to discourage nonsensical situations and encourage believability. Limiting our scope to the strictly plausible led to interesting creative limitations, raising interesting questions about our roles as human authors.

As seen in the section below, one of the areas where the machine struggled to produce plausible results revolved around discussions of money.

===================== *INPUT* =====================

Train conductor: Ticket, please.
Bart: I don't have a ticket.
Train conductor: Come with me, boy.
Bart: I'll pay. How much?

===================== *SAMPLE 3* =====================

Bart: What's $5?
Train conductor: A nickel – we don't have any nickels left, sir.
Bart: All right. See you later. Bart gets to the ticket counter and orders a nickel-five.
Bart: It's $5. It's $5.

Train conductor: What's it for?
Bart: It's just $5, please. No more nickels.
Train conductor: No more nickels?
Bart: It's $5.

The dialogues generated by the system in response to various prompts exhibited traits of Absurd Theater, characterized by irrational or illogical speech and a breakdown in communication. On its face, the concept of a computer-generated play contains elements of absurdism, as it confronts human subjects with their fear of uselessness and anxiety tied to technological improvements. Nevertheless, pursuing a purely absurdist route would have been too simple, given the implicit absurdity of the creative process itself!

In other areas of generative AI, such as image or music generation, art projects often approach a singular artist's work through style replication. Our project, while tied to Karel Čapek's legacy, was not intended to replicate his writing style. Instead, we toyed with ideas from *RUR*, a play about a robot revolt (featuring the first-ever use of the term *robot*). Our objective was to invert Čapek's *RUR* by using a robot (an AI language model) to write (generate) a play about humans.

We embraced the concept of the 'well-made play' standard, a genre of highly structured theater first established in the nineteenth century.[2] At its core, the 'well-made play' is a traditional prototype for play construction in Western theater. It draws inspiration from Aristotle's ideal Greek tragedy outlined in his *Poetics*, featuring a tightly constructed plot with a climax that occurs near the end.

Dramatic Situations

We first identified a structure to guide the generation process – after all, theater plays are not simply built around lines but dramatic situations. By breaking down dramatic theater into a series of dramatic scenarios, we sought to identify patterns that could structure the text-generation process. A dramatic situation, one in which characters are driven into immediate and necessary action, represents a fundamental building block of drama. We decided to analyze several well-made plays and annotate each dramatic situation, assessing their underlying patterns and benchmarking a model that could recognize them. We could then gather more dramatic situations from a corpus and fine-tune our text-generation model (at the time, we were using GPT-2) to iterate further dramatic situations. We initially used the categories set forth in Georges Polti's *The Thirty-Six Dramatic Situations*, which he based on an analysis of classical Greek and classical French drama. We quickly realized that some of the situations were highly unlikely to appear in a modern

text, and indeed, we had not found any instances of some of the situations in the texts that we worked with (e.g., 20: *Self-sacrifice for an ideal* or 21: *Self-sacrifice for kin*).

Of course, a 'well-made play' is not solely composed of dramatic situations: most include instances of 'nondramatic' didactic information (didaskalia or specific information or descriptions of setting, mood, or character). For example, a scene describing a woman wearing a short red dress may provide character details while lacking any dramatic dimension. These 'non-situations' are often necessary to manage the pacing of narrative activity in contemporary theater. In contrast to the 'well-made play', however, early Greek plays are strictly dramatic to the extent that each text block can be identified as a dramatic situation and, because of this, Polti's list does not adequately reflect the structure of contemporary theater. We edited the list and added a number of situations that might not be as archetypal as Polti's but better reflected the types of text we were working with. Ultimately, we created a list of fifty-eight dramatic situations.[3] The addition of more general situations stemmed mainly from the need to simplify classification and include as many situations as possible.

Identifying a dramatic situation poses a considerable challenge, often leading to disagreements within our team regarding the interpretation of determining factors. These differences can be nuanced, such as diverging perspectives on a scene's dramatic archetype when viewed through two distinct characters. Each character offers a unique understanding of the situation at hand. We agreed to annotate a situation twice when necessary and add the character's name to the annotation process. For example, if character X questions character Y, we could view the exchange from the perspective of character X, yielding the dramatic archetype of *Interrogation*, and simultaneously from the viewpoint of character Y, which would be identified as *Confession*. After annotating a few plays with the full set of dramatic situations, we encountered significant challenges. The process proved excessively time-consuming, yielding very sparse data, insufficient for efficient machine learning. Consequently, we opted to address this issue by narrowing down the list to five key situations that were deemed more easily decipherable: *Supplication, Intruder, Seduction, Parting,* and *Interrogation*. We have annotated the occurrences of these five types of situations in a small corpus of theater plays. Due to our limited analytical capacity, we were unable to amass sufficient data to train a reliable model for detecting dramatic situations. Consequently, we refrained from incorporating the annotations into the system employed for generating the final play. Nevertheless, we believe that this style of annotation holds potential for future research, and thus, we have made the annotated dataset of situations available online.[4] We envisage the following application: by expanding the dataset, it becomes feasible to train a model capable of detecting situations within theater plays. This trained model could be employed to identify a broader range of situations within a more extensive corpus. Subsequently, an LLM could be fine-tuned to generate novel situations based on the acquired knowledge.

THEaiTRobot as a Playwriter

The THEaiTRobot system[5] used to generate *AI: When a Robot Writes a Play*'s script is based on the pre-trained GPT-2 legacy generative language model developed by OpenAI.[6] GPT-2 was trained on eight million English documents. LLMs like GPT-2 models generate texts as predictive continuations of a given prompt. In such a way, word by word, sentence by sentence, the model generates new text that may be both grammatically and semantically coherent.[7] The GPT-2 model was a brand-new, state-of-the-art text-generation tool available at the start of the project in 2019. It was later surpassed by models (including its subsequent versions such as GPT-3 and GPT-4) that operate in a similar way but are much larger and trained on extended datasets, making them much more powerful than the model we used; however, these models were not available to us at the time of the project.

We employed a human-in-the-loop approach through a human–machine interactive collaboration to generate an actual theater play script with the THEaiTRobot tool. Here, the dramaturg operated the system, becoming a co-authorial force. Our experts soon realized that the GPT-2 model was not powerful enough yet to assemble the complex structure of a well-written play, choosing to generate individual scenes as independent simple dialogues instead and to compose the script with them. The starting prompt for each scene (provided at the start of the document to the language model) consisted of a short description of the scene, a list of involved characters, and the first line spoken by each character. The THEaiTRobot generator would then take over, with the operator only guiding it as necessary by selecting from given narrative paths. To ensure that these independently generated scenes could be composed into a coherent script, the starting prompts prepared by the dramaturg were interlinked using a common character and related scene settings.

Approximately sixteen scenes were generated,[8] eight were chosen, ordered, and slightly post-edited as needed. In the resulting script, 90% of the text came from the generator, with the remaining 10% consisting of either the input prompts or post-edits. The script is freely available online.[9]

The Production of AI: When a Robot Writes a Play

Once we generated and post-edited the script, we handed it to the team at Švanda Theater, led by Daniel Hrbek (director and composer) and featuring a director's assistant, six actors, a stage designer, a costume designer, two dramaturgs, a choreographer, a stage manager, and a production manager. The production and mise-en-scène were developed and realized by a human-only team. A decision was made to complement the performance with a short foreword and an extended afterword and discussion. The first production (*AI: Když robot píše*

hru) took place in Švandovo Divadlo.[10] It was a montage of short sketches tied together by David Košťák and directed by Daniel Hrbek. The lead actor portrayed a robot engaged in multiple interactions with human characters.

The dramaturg/co-author, the human interpreter of the script, expressed his pleasant surprise at the remarkable evolution of AI and described the experience as both demanding and captivating. He also noted that the generated script lacked the conventional dramatic superstructure typically expected in a play, such as the dramatic-situation building blocks discussed earlier.[11] Instead, it primarily relied on word associations to establish connections between various elements, having a consequent literary patina that did not fully adhere to the norms of dramatic dialogue. As a result, the script required a significant reinterpretation from the director and the actors. In addition, the Švanda Theater devised a comprehensive production that enveloped the text with imaginative human elements, contrasting but complementing the overall artistic vision. This approach proved to be successful, situating the generated text within a conventional theater context to test the combinatoriality of the elements.

A month after the premiere, the creative team and the actors got together and reflected on their experience working with an AI's text. The consensus was that the task was unlike any other they had previously experienced. The director remarked how he managed to direct only the play's façade, molding it into something more coherent with the dramaturg's help. While they would usually take an examination of the author's intention as a starting point, the lack of a human author or intentionality led to a different approach: the play was alternatively built around the script without an examination of its underpinning symbolisms. The actors struggled from the very beginning, arguing that the play was difficult to read and even more challenging to interpret. They all perceived the text as soul-less, as a draining experience, lacking the usual animating energy that emanates from 'human' literature: the text seemed to work against them. To address this, they attempted in vain to find subtextual meanings in each sketch: the AI had no motivation, there was no subtext, everything was just laid out explicitly as if it were written by a naive child. Thus, rather than extracting implicit meaning from a human-made text, the team had to *endow* the script with a soul, a life, a meaning, in an attempt to identify with the narrative and the characters.

But how would the audience react? Would a theater-goer feel the impact of the play's oddities? While it was tempting to try and uncover the answer by hiding the script's origin from the audience, the play's artificial author was always a key marketing asset and the main reason for most spectators to attend. The team agreed that the quality of the play did not meet human standards and that the audience would only be willing to attend a 60-minute performance if they knew it was AI-generated. Therefore, all performances started with a brief introduction from a team member explaining that 90% of the script was AI-generated.

A discussion with the audience followed each performance, in which the origin of the project was further unveiled and questions and comments were answered. We invited the audience to guess which parts were human and which were AI-generated. They would usually fail to identify them, convinced that the

machine could not have generated a joke (however weird) or references to current events. The same applies to other discussions and workshops where the audience takes part in a variant of the classic Turing test, asking them to tell apart two versions of a short piece of script, one AI-generated and one human-written.

While most spectators did not find the play particularly good, many reported that the generated text exceeded their expectations. They described it as fluent and eerily natural but also as glitchy, a reminder of its artificial nature, reminiscent of the 'uncanny valley' phenomenon. While such glitches mostly disappear in newer models (e.g., GPT-4), the resulting texts remain rather mundane and uninteresting according to our experiments and reports.[12] This is presumably due to the nature of language models, which promote the probable, the frequent, the likely, the common, the ordinary ... and thus the boring or even the clichéd instead of more artistically interesting elements such as the novel, the interesting, the unseen. We would thus argue that glitchiness was a major component of the play's appeal to the audience.

Conclusion

While the THEaiTRE project exemplified the challenges of producing a viable AI-generated script, we anticipate that the increasing quality of generative language models will lead to the creation of even better plays incorporating the outputs of language models or entirely generated by them. This raises important questions for both performing artists and audiences. As AI-generated plays become more common, how will this impact the role of the playwright, director, and actors in the creative process? How will audiences perceive and engage with such productions? Based on the experience gained from this project, we think that playwrights could be intrigued by the opportunity to explore innovative methods of enhancing their creative input. However, they may also need to adapt their writing processes to accommodate the capabilities and limitations of AI systems. Directors will face the delicate task of navigating the nuances of directing performances based on AI-generated scripts, striking a balance between their artistic vision and the constraints imposed by the AI-generated content without a human author. Actors, on the other hand, may encounter fresh hurdles in interpreting and embodying characters created through AI algorithms, searching for authenticity in content that may appear artificial. Audiences' reactions to AI-generated productions can span a spectrum of responses, ranging from curiosity and fascination to skepticism or even resistance. During the THEaiTRE project, we primarily observed curiosity and wonder among audiences. However, as the models continue to advance and the initial novelty diminishes, it is likely that these reactions will evolve. The idea of authorship without a human author presents

While such glitches mostly disappear in newer models (e.g., GPT-4), the resulting texts remain rather mundane and uninteresting according to our experiments and reports. This is presumably due to the nature of language models, which promote the probable, the frequent, the likely, the common, the ordinary … and thus the boring or even the clichéd.

significant challenges in terms of audience reception and legal considerations. To develop a more profound understanding of these complex challenges, additional research is essential. We eagerly anticipate future studies that will provide valuable insights into these captivating issues.

The production of *AI: When a Robot Writes a Play* has also served as a case study for the concept of performativity. Fischer-Lichte defines performativity as the destabilization of binary opposites through the collision and interaction of various frameworks.[13] In the context of the play, this is seen in the collision of human and machine authorship, as well as the merging of traditional and modern theatrical techniques. Furthermore, the concept of performative acts as 'non-referential', as described by Judith Butler and echoed by Fischer-Lichte, highlights the importance of bodily acts and their ability to transcend traditional linguistic meaning. The bodyless play-generating system is incapable of performing the play itself but is embodied in the play through the Robot's character. The project, therefore, provides a rich opportunity to explore the complex and nuanced nature of performativity and its relationship to human–machine collaboration in the artistic realm.

Overall, the THEaiTRE project provides a fascinating glimpse into the possibilities of human–AI collaboration in the context of theatrical performance and highlights the potential of AI to transform the creative process in presently unimaginable ways.

Notes

1 THEaiTRE (www.theaitre.com) was a Czech interdisciplinary project directly combining theater and science conceived by Tomáš Studeník and led by Rudolf Rosa, with a team composed of both computational linguists from Charles University and theater experts from Švanda Theater and Academy of Performing Arts (DAMU). The goal of the project was to explore the potential of current artificial intelligence techniques to be incorporated into theater practice, and to directly confront the general public with the outcome while explaining the process behind the creation of the play and thus educating the audience about the current state and capabilities of the techniques used. The project bears some similarities to the theater play *Lifestyle of the Richard and Family* (Helper, 2018), the musical *Beyond the Fence* (Colton et al., 2016), the short movie *Sunspring* (Benjamin et al., 2016), and the performances of the Improbotics theater group (Mathewson and Mirowski, 2018).

2 Patti P. Gillespie, 'Plays'.

3 Supplication, Deliverance, Crime pursued by vengeance, Vengeance taken for kin upon kin, Pursuit, Disaster, Falling prey to cruelty/misfortune, Revolt, Daring enterprise, Abduction, The Enigma, Obtaining, Enmity of kin, Rivalry of kin, Murderous adultery, Madness, Fatal imprudence, Involuntary crimes

of love, Slaying of kin unrecognized, Self-sacrifice for an ideal/for kin, All sacrificed for passion, Necessity of sacrificing loved ones, Adultery, Crimes of love, Discovery of the dishonour of a loved one, Obstacles to love, An enemy loved, Ambition, Conflict with a god, Mistaken jealousy, Erroneous judgment, Remorse, Recovery of a lost one, Loss of loved ones, Admission, Intruder, Bad news, Humiliation, Rape, Murder, Unfulfilled desire, Break up, Intimidation, Breaking the taboo, Passing, Seduction, Fight, Succumb, Parting, Reconciliation, Revelation, Curse, Blasphemy, Ruse - Trap - Fraud, Fear/Bad premonition, Interrogation, Accusation, Betrayal.

4 David Mareček et al., 'Annotation of Dramatic Situations'.
5 Rudolf Rosa et al., 'THEaiTRE 1.0'.
6 Alec Radford et al., 'Language Models Are Unsupervised Multitask Learners'.
7 More details about shortcomings and recommended customizations of such systems can be found in Rosa et al., 'THEaiTRE 1.0'.
8 It is difficult to state an exact number of scenes generated, as in total; several dozens were generated, but most were only preliminary experiments, not intended to become part of the final play.
9 THEaiTRobot 1.0, 'AI: When a Robot Writes a Play'.
10 A short trailer is available on YouTube: https://youtu.be/8ho5sXiDX_A.
11 Polti, The Thirty-Six Dramatic Situations.
12 Dita Malečková, for example, discusses this extensively, but none of the texts are available in English.
13 Erika Fischer-Lichte, Ästhetik des Performativen.

References

Aristotle. (1961). *Aristotle's Poetics*, translated by S. H. Butcher. New York: Hill and Wang.

Benjamin, Sharp, O., and Goodwin, R. (2016). 'Sunspring: A Sci-Fi Short Film Starring Thomas Middleditch'. Video. Posted 9 June 2016. https://www.youtube.com/watch?v=LY7x2Ihqjmc.

Čapek, K. (1920). *RUR (Rossum's Universal Robots)*. Prague: Aventinum.

Colton, S., Llano, M. T., Hepworth, R., Charnley, J., Gale, C. V., Baron, A., Pachet, F., Roy, P., Gervás, P., Collins, N., Sturm, B., Weyde, T., Wolff, D., and Lloyd, J. R. (2016). 'The Beyond the Fence Musical and Computer Says Show Documentary'. *Proceedings of the Seventh International Conference on Computational Creativity*. Paris, France, 27 June–1 July, 2016. https://repository.falmouth.ac.uk/2565/.

Fischer-Lichte, E. (2004). Ästhetik des Performativen. Frankfurt, Berlin: Suhrkamp.

Gillespie, P. P. (1972). 'Plays: Well-Constructed and Well-Made'. *Quarterly Journal of Speech*, 58(3): 313—321. https://doi.org/10.1080/00335637209383128.

Helper, R. (2018). *Lifestyle of the Richard and Family*. https://www.roslynorlando.com/lifestyle-of-the-richard-and-family.

Mareček, D., Nováková, M., Vosecká, K., Doležal, J., and Rosa, R. (2023). 'Annotation of Dramatic Situations in Theater Play Scripts (2023)'. *LINDAT/CLARIAH-CZ Digital Library at the Institute of Formal and Applied Linguistics (ÚFAL)*, Faculty of Mathematics and Physics, Charles University. https://hdl.handle.net/11234/1-4930.

Mathewson, K., and Mirowski, P. (2018). 'Improbotics: Exploring the Imitation Game Using Machine Intelligence in Improvised Theatre'. *Proceedings of the AAAI Conference on Artificial Intelligence and Interactive Digital Entertainment*, 14(1), 59–66. https://doi.org/10.1609/aiide.v14i1.13030.

Polti, G. (1921). *The Thirty-Six Dramatic Situations*, translated by Lucille Ray. Franklin, OH: JK Reeve.

Radford, A., Wu, J., Child, R., Luan, D., Amodei, D., and Sutskever, I. (2019). 'Language Models Are Unsupervised Multitask Learners'. Technical report. OpenAI. https://openai.com/blog/better-language-models/.

Rosa, R., Musil, T., Dušek, O., Jurko, D., Schmidtová, P., Mareček, D., Bojar, O., Kocmi, T., Hrbek, D., Košťák, D., Kinská, M., Nováková, M., Doležal, J., Vosecká, K., Studeník, T., and Žabka, P. (2021). 'THEaiTRE 1.0: Interactive Generation of Theatre Play Scripts'. *Proceedings of the Text2Story Fourth Workshop on Narrative Extraction from Texts*, 2860, 71–76. https://ceur-ws.org/Vol-2860/paper9.pdf.

THEaiTRobot 1.0, Košťák, D., Hrbek, D., Rosa, R., and Dušek, O. (2021). 'AI: When a Robot Writes a Play'. ÚFAL Technical Report: ÚFAL TR-2021-67. ÚFAL MFF UK. https://ufal.mff.cuni.cz/techrep/tr67.pdf.

Annihilation

16

Identity Dissolution: Using Artificial Intelligence for Artistic Exploration of Identity Models

Alexander Schubert

I Open my Eyes and a World Appears
Everything is Everything

—ANIMA™

Introduction

Drawing on three specific works, this text explores how processes of identity dissolution and discovery can be represented and experienced in artistic scenarios with the help of artificial intelligence by examining the potential and dangers of these new technologies.

My music focuses on the process of AI dissolution,; i.e., the reconstruction and ensuing alteration and modification of existing content – often related to human identity. In this text, I want to shed light on the extent to which AI programs are able to display model-like representations and how we can use this ability as a metaphor for humans' conscious representations. This approach is based on the assumption that a similar "modellishness" exists in our perception of subjects and objects as well. The seemingly fixed appearance of the environment, including human entities, in our perception can in this vein be understood to be constructivist. It is only ever through our internal allocation that the environment becomes what we ultimately perceive as a coherent and intrinsically fixed whole. AI technology can thus be seen as a mirror of ourselves and a metaphor for our perception of the world. In the center lies the potential alteration of the technical parameters of a program that are creating these representations – and hence as a result showing that all representations are modifiable and virtual. This process allows for various links on an artistic level and creates parallels to potential brain

DOI: 10.1201/9781003312338-24

mechanisms which enable us to observe psychological impacts. The focus of this text and the works discussed lies in the representations and transformations of the constructed models of human entities.

I have used AI-generated content in several pieces and wish to use these compositions to describe my approach to the technology and illuminate its artistic potential. I would like to focus on the piece *ANIMA*™, which represents the end point of a longer exploration of the topic. It is a music theater piece combining components of virtuality and AI, explicitly addressing the question of the dissolution and transformation of the individual. Its discussion is complemented by an analysis of the internet project *Crawl3rs*, in which clones of private social media websites are created and manipulated. I will also discuss the composition *Convergence*, which deals with the visual dissolution of the individual. In the course of the text, I will delve into the individual pieces, explain the technological architectures, and contextualize the use of artificial intelligence, focusing on artistic rather than technical matters.

Four characteristic uses of this technology are central to the observation:

1. AI as a tool for producing artistic content
2. AI as an analogy for human perception
3. AI as a symbol for cognitive model character and constructivism
4. AI as an artistic tool for (identity) dissolution

Network Dissolution in *Crawl3rs*

Crawl3rs is an online art installation exploring the social, political, and technical aspects and consequences of AI technology. It involves an anonymous bot collective working secretly on the internet to gather data, crawl user pages, steal information and images, and create an alternative social network with distorted truths and altered facts.

The collective's bots work within social networks, mainly Facebook, and behave like humans. They have profiles, post, comment, share information, and interact with human users. While doing so, they collect publicly inaccessible information from their friends' accounts to build a second social network with slightly modified content, always close to reality, but never really genuine – a parallel universe where everything is slightly different.

This counterfeit social network can be found on the website crawl3rs.net. Each human profile befriended by the bots receives an invitation link to their profile in this alternative world. This process goes on and on: the bots keep working around the clock to make new friends and continue building this

alternative network with new data. The information in each crawl3rs.net profile is not 100% verifiable with respect to its source: every name is slightly changed, every piece of information is a bit distorted, and yet it is clear that this alternative profile is the person in question.

It might be a very troubling, and for some even frightening, realization that one's private data has been made publicly available in a different context. This is one of the goals of this project, to make people aware of the ease with which one's private data is accessible and visible. The piece is therefore largely about the safety of personal data on the internet, and further about how one can leverage this data to create different realities, alternative societies. Small changes to one's original profile may encourage one to think about how one portrays oneself: for example, the priorities or relevancies of what one says and shares, and how they reflect one's self-perception. Consequently, *Crawl3rs* is not only a technical demonstration of what is possible but also a place in an artificial world where slightly different rules apply, a comparison between one's projected self and its flawed reflection in social media. The fact that the original social media depiction of the user already is constructed and virtual by default is made painstakingly clear through the alterations and distortion of the corresponding Crawl3rs profile (Figure 16.1).

On a technical level, we used various algorithms, automated processes, and deep learning strategies for this project. Several steps were involved. First, bot development and automated profile activity. We essentially automated bots to engage with the interfaces of social networking, simulating a human who is sitting in front of a browser, clicking on things, scrolling, and

FIGURE 16.1
Installation view of Crawlers at ZKM | Zentrum für Kunst und Medien. Photo courtesy of ZKM.

so on. The bots perform these human-like actions across different accounts. From there, we worked to transform the texts and images with which the bots engaged. We worked to alter text first, using deep learning methods to train models based on large datasets of text. When text from profiles is scraped and passed as input text to the system, the program accesses a model that returns a similar but not identical text result. We optimized for results that felt fairly real while preserving a certain amount of "weirdness". We enacted two strategies to alter images. The first one involved using a reverse search algorithm, which returned similar images to those in the user profiles: a picture of a person seated on a chair with books in the background and a colorful jacket would be replaced by a picture showing a similar person in a similar environment. The second strategy was style transfer, used to further modify the look and shape of a given image. We then merged the modified text and image data and created profile pages that are *almost* a copy of those in the original social networking site. Finally, we added glitches to force the audience to look not only at the content but also at the way it is presented, emphasizing its uncanniness and instilling a sense of offness.

Even though there are no performers nor staging, *Crawl3rs* is closely related to the content and theme of my multimedia performance output. My installation works create immersive settings where the audience can experience body swapping and body virtualization, whereas the staged works display the topics of identity dissolving and self-model modification for fictional characters or the performers themselves. In all cases, technology is used as a modifier to dissolve the seemingly fixed model of ourselves. For Crawl3rs, this can mean accepting the virtuality of any online depiction, the artificiality of the self in general, a joyful encounter with an alter ego, and mostly offering a view of oneself that creates room for different versions of the self – with all its excitement and intimidation.

Self-Loss in *Convergence*

Convergence is a multimedia performance piece featuring five musicians interacting with AI-modified versions of themselves via screens and speakers. The piece uses machine learning methods to replicate the characteristics of human musicians from recorded material and create new digital entities. In the piece, players interact with their generated counterpart-avatars that evolve in real time. The friction between the human player and the morphing digital avatar serves to question the fluidity of the self and the limits of perception.

Convergence uses autoencoders and generative adversarial networks (GANs). Autoencoders, which are designed to represent a multi-dimensional space through fewer parameters, inform the technical and conceptual focus

of the piece. For example, an autoencoder can describe a video with one million pixels with only a few values – or similarly, an autoencoder can represent a sound, consisting of long, sequence-dependent, digitally -encoded amplitude information with only a few descriptive values. This task is only feasible for a program if these parameters are able to describe data with a high level of abstraction. When analyzing photos of faces, for example, this can mean creating a classification schema representing higher-order categories such as gender, hair length, facial expression, or similar features. This results in a general high-level representation of the input space as a series of complex parameters. A given input can be both classified into a series of parameters and then transformed according to their underpinning logic. For example, a face can be specifically changed in expression and appearance or interpolated with another face. Furthermore, new faces can be generated out of assemblages of parameters, independent of the original training data. This approach was used in *Convergence*'s visual domain to generate faces and instrument-playing movements (combined with GANs for high-resolution rendering), as well as in the audio domain to process instrument-playing techniques and vocal sounds.

The piece starts by acquiring data from the musicians. A computer voice instructs the musicians to perform certain postures, expressions, playing movements, and verbal tasks, and the resulting audiovisual data is assembled into a training dataset. While this process initially served as a technical requirement to generate further material for the piece, the process proved so interesting and instructive that I included it as a central element in the piece's composition. This framing, in which a computer voice announces and coordinates all movements, calls into question the authenticity and autonomy of the people involved as soon as the original data is recorded. A decoupling of mental processes and actions takes place. Simply performing an action for the purpose of data collection can result in those actions assuming mechanical, constructed, and artificial characteristics when embodied by a performer. The performers partially give up their self-determination and become purely executing subjects. After an hour, this data collection ritual produces either a partly meditative and self-forgetful affect in the participants or a feeling of unpleasant heteronomy. This protracted training experience provides the audience with a kind of "test setting" with which to begin to engage with the concepts of the piece (the idea of understanding an artwork through a "test setting" runs through many of my works; its goal is to question the technique used, examine its potential and critical aspects, and make the implications sensually tangible for the participants and the audience).

Once the acquisition of video and audio data is complete, it is then possible to create avatars that interact with the musicians in the piece. Right before their eyes, the performers' faces and bodies change continuously, practically dissolving. The system plays with the various parameters of "human synthesis", transforming these digital avatars into forms that are sometimes recognizable and sometimes greatly altered. A different person, character trait,

FIGURE 16.2
Video still of Convergence.

valuation, or gender can result from a simple tweak of a single parameter. The proximity between the original representation of a given person and some wildly different face or body – just a small parametric change away – can point to new dimensions of affinities and similarities despite apparent differences. In turn, the rigidity of the original dissolves and transforms into a fluid representation point – changeable in all directions. There are no self-sufficient individuals in *Convergence*, only changeable points in high-dimensional parametric space. Parametric transformation can have the effect of a (social, societal, clinical, or biological) change of consciousness. *Convergence* uses AI to highlight this mutability, challenging the robustness and immobility of "identity" and "world". *Convergence* seeks to act as a mirror, reflecting the classification schema through which humans construct themselves and – by changing them – offering a viewer the possibility of dramatically new world-building processes.

The computer-generated voice that guides the data collection process at the start of *Convergence* continues throughout the piece, contributing a narrative overlay. The following is an excerpt from the voice's monologue, summarizing the concepts discussed above (Figure 16.2):

> Listen to me now
> I want to ask you a few questions
> How do we differentiate
> if it is a hallucination,
> a dream,
> or the clean perception?
> All perception is constructive

No representation is absolute
Everything is encoded
and decoded
We are parametric
Everything parametric can be altered
parameter by parameter
That is the definition of such a model
Normally, we don't see these sliders
these values
these adjustment dials
But they can move into our consciousness
through illness
through hallucination
through drugs
through psychotic states
or through computation processes
like in this case
We then see the constructive aspect of it
That everything we do
is based on encoding and decoding
When we look at a partner
we can create a loop
A perception and adjustment loop
We can exponentiate that process
by looking into a mirror
This is what we will do now
Recursive loops
You and me
Regression curls
Segregation twirls
Adaptive coils

This narrative excerpt adds a biological dimension to *Convergence*'s conceptual framework. Certain biological processes (states of illness, psychotic episodes, hallucinations, psychedelic experiences) can result in the dissolution of fixed or assumed identity models. The dissolution and transformation of identity can also be interpreted specifically in the context of gender studies, as a process of personal transition, as a quasi-transcendental experience, or in the context of self-surrender. Common to these approaches is the overcoming of the self, which can be motivated by a wide variety of reasons, including the will to break out of fixed and/or normative categorizations.

Rejecting the static individual and replacing the "closed ego" with a multi-dimensional, variable data point in a digital representation (e.g., the latent space) can easily be read as a posthumanist or transhumanist imperative.

The following text passage, also spoken by the computer voice, poetically formulates these posthumanist components:

Like a brain lesion
a mesmerizing distortion
As in a sleep-deprived state
Drifting off into a halfworld
of a dreamlike morphed reality
Where we see that other representations
of us are possible
That our self is fluid,
fragile,
constructed
and diverse
post human
Like a genetic defect
Beautifully disturbed
Genetically enhanced
Adjusted
In a recursive loop
I encode and decode myself,
in an eternal loop
Exaggerating every feature
Like a facial distortion
Like an unsupervised inbreed
Out of control
Go to sleep, child
Dream off now
Saturate with closed eyes
Dreaming, of a future
and an optimized tomorrow
Hand in hand,
sliders adjusted,
The night sky setting,
as the values adjust
Peaceful
Invisible
A clear view of the night
Through a transparent interface
Always on
Always present
And
Always
Loving

Simulation Correction in *ANIMA*™

ANIMA™ continues this project of using AI to problematize conventional, constructivist models of identity. This music-theatrical work asserts that identity and perception are mere models that can be explored, varied, and manipulated. In this work, both the characters and the participating performers face the fictionality and artificiality of their assumed and performed identities, subjecting their roles to decisive deconstruction and investigating what remains of themselves beyond these formal boundaries.

ANIMA™ describes a fictional institute in which people can immerse themselves in VR in order to assume a different body. The protagonist character is given an avatar body in virtual reality. The other characters are also of the same – initially neutral – VR entity type. In this virtual setting, all the actions and events are instructed and directed by an external AI engine. The main protagonist and other characters in the piece thus acquire a puppet-like character; they are used, moved, and related to video game NPCs (Non-Player Characters, e.g., Sims) or simply mere objects.

The AI system is based on the therapy concept of systemic constellation. In this constellation therapy, people represent themselves and their environment either through the persons participating in the session or through representative objects. In the next step, the relations, constellations, and relationships to each other are analyzed and continuously varied. A comparable scenario is the basic idea for *ANIMA*™ – except that this setting is transferred to a VR simulation. Characters immersed in the simulation can successively change their identity. The audience observes this scenario with its constellations and interactions, like supervisors in a (psychological) experiment or spectators to a computer game. So the piece imagines a fictitious, technology-controlled "spiritual institute" into which the performers enter as clients, encounter artificial variants of their own person, and are guided through sequences of constellations through computer-generated instructions. Concrete instructions for action are generated in real time.

The concept of transference into another body is a major theme of *ANIMA*™. Borrowing from constellation work, such transference can freely take place between subjects and objects. To transfer into an object-like state – or into a body, corresponding to an empty shell – is inherent to constellation work, which illustrates the question: Is a body a repository for a soul, or is it a purely material object experiencing consciousness as a mere side effect? Are emotions, intentions, and mental processes a by-product of an acting body, or does a body's activity follow the mind's instructions? In *ANIMA*™'s theatrical therapeutic practice, mental concepts and agencies emerge as consequences of actions – not the other way around. Accordingly, the piece's fictional institute pursues the goal of rewriting a person's internal state, altering their changing self-perception through guided actions performed iteratively over extended periods of time. This process can be understood as

optimization, therapy, self-renunciation, or corrective institution. This practice exists at the intersection of therapy, adaptation, leveling, optimization, destruction, and transcendence. Over the course of the piece, the protagonist experiences both the dissolution and destruction of a static ego model as she comes to recognize the fiction or artificiality of her own identity.

These events are staged within a rectangular room made of white fabric, onto which the video is projected (like a VR simulation, this video can change location and content freely). Various simulation spaces are called up one after the other and iterated over and over again, sometimes in loops, sometimes over long periods. Projections on three walls and the floor are complemented by a transparent hologram gauze separating the stage space from the auditorium. This fabric is invisible as long as no projection happens. The projections that do appear on the hologram gauze appear to virtually float in space, typically displaying a menu with status indicators. This video game HUD (Head Up Display)-like representation contains the name of the current level, the temporal progress, and further parameters of the simulation. The people in the scene onto which this HUD is projected therefore become avatars, computer game characters, or 3D simulation objects. In each case, they are stand-ins. They appear in the setting as representatives or symbols of something else. The principle of representation on display here exceeds references to computer games or population simulations, serving to additionally highlight the representational dynamics of theatrical performance itself (Figure 16.3).

FIGURE 16.3
Performance of ANIMA™. Photo by Quentin Chevrier.

As the piece progresses, *ANIMA*™ creates a relationship between the actual performers on stage and the constellation depicted within the piece. To perform the piece, the performers are coordinated by detailed announcements over in-ear headphones with instructions for action and speech. This means that every action and speech produced in the piece is generated by the system and made audible to the performers via radio. The performers thus become purely executive actors in the theatrical production and consequently embody the content of the piece on a real level, so to speak. As in an installation, they are placeholders and bodies to be filled. Accordingly, the question also arises for them: Does this process have a meaning for me? Does iteratively living, through fictional scenes, through prescribed actions, have an effect on my inner self? This is verbalized by the protagonist speaking directly to the audience as follows:

> Here I am in this Institute
> In this staging on a stage
> Giving my body.
> To show an experience in the imagination of another
> Here I am
> Renting out my flesh.
> As a real-life animation figurine.
> While I do that,
> It makes me think about myself.
> Here I am.
> In this empty world.
> Performing for whom?
> Performing for somebody I can't even see.
> Imagine the audacity of actually believing what happens in this
> setting felt real, appeared real – was real.
> Imagine feeling this as if it were real life.
> This is a machine producing reality.
> It's just a representational procedure.
> The objects and subjects – are simply thin layers of texture and
> material coating.
> The inside is functional on other behalf.
> To accept this reality is a step of dissociation.

This passage represents a break in the piece, as here the real voices of the performers are used and the video projections are deactivated. *ANIMA*™ thus moves toward reality, leaving behind the fiction of simulation and theatrical narrative. This transition is also explicitly named and initiated by the system:

> This functions as counterpoint to the simulated world,
> taking place in actual space,
> the world of the real,

the Institute.
This means that no projection is used
but only light.
The fabric waves in the stream of fans positioned around the set.
Billowing in a breeze:
As a symbol for the analog
and for the here and now,
the reality machine.
Wind machines and auto-generated wind effects.
On!
Instead of fake instruments real instruments are now being used.
The voices change from text-to-speech voices to the voices of the
 performers.
These voices are generated by a computer using artificial
 intelligence.
Real-time generated commands.
Original voices of the performers.
Real choir from performers.
Leopold plays a real zither.
New iterations of the performers' voices.
So far the stage directions.
On with auto-generated poetic philosophy.

Two storylines run in parallel in the performance: the narrative and fiction of a character in a VR simulation and the presence of real people in a theatrical performance. In both cases, however, these are scenarios involving external instructions, self-abandonment through the execution of these instructions, and fictional spaces with a simulation-like characteristic.

The piece uses machine learning to generate text, sound, and movement sequences. The VR space consists of video projections accompanied by fully non-AI computer-synthetized sounds, which are noticeably digital (unperformed) material. Sounds are not tied to a location, instrumental sounds are not tied to an instrument, the voices are not those of the performers. Texts, on the other hand, are AI-generated from large data volumes of philosophical, technical, and spiritual literature. The result is a narrative, divided into fragments and combinations of existing texts, inserted into the performers' mouths. Movement sequences are also generated by an AI. In this case, the system has been trained on a dataset of activity sequences. These instructions are then played to the performers via headphones and executed in sync with the rest of the stage set. By decoupling voice from physicality, both subject to independent external direction, the performers experience a strong sense of objectification and detachment.

When the fourth wall is broken, the performers are bathed in a bright light indexing them as supposedly "real", unadulterated, and unaffected versions of themselves while still being subjected to asynchronous text and motion control by the AI. In these sections, the AI synthesizes the performers' voices.

AI audio-generation tools are trained prior to the performance on speech recordings made by the performers in order to imitate their voices as faithfully as possible. During these passages, the performers lip-sync the text their synthesized voices are speaking. The performers thereby become performing organs of their virtual selves, even while evoking a moment of situational authenticity by "speaking" to the audience emotionally and unfiltered from within themselves. This is a supposed break with the obvious artificiality of the previous scenes.

The process is applied to the performers' musical instruments as well. Here, too, a seemingly real image is created and synchronized with the actors on stage. During these sections, AI technology is thus implemented to generate seemingly real – not perceptually artificial – content: a mirror, an image, a duplicate of acoustic reality. This particular mode of artificiality is held in contrast with the tangible artificiality of the other scenes. It is, however, just another layer of the inauthentic, an inauthenticity that is made visible in the performance through small mistakes and artifacts that bring to the fore the uncanniness of even the most "authentic" fragments.

Summary and Overview

The pieces discussed above use artificial intelligence to generate sonic, textual, and visual content. Participating humans (users or performers) are scanned and analyzed, copied, and subjected to parametric modification. These processes can be understood as a *dissolution*, a blurring of the individual, an overcoming of a fixed and restrictive ego image, or an expansion of the constitutive layers of personhood. The dissolution process fundamentally questions the existence of a core subjectivity, an individual experience beyond that constructed through exogenous models of personality and category. This question is at once ontological, psychological, social, and quasi-spiritual, opening up new avenues of transcendence and a transgression of the self. On a biotechnological level, this transcendence can also be understood as a transhumanist or posthumanist sublation of the body, through which an identity can be transferred between various material or computational states. This incurs a wide array of ethical controversies, including those around biotechnical optimizations. *Dissolution* necessarily involves *loss*, especially the loss of an original or "true" core. However, this particular transhuman application of AI may engender new dimensions of self-awareness precisely through its challenge to the notion of selfness.

Such an artistic context allows the audience to experience the self in dissolvement that is usually only experienced in (psychologically, mentally, or physically) extreme scenarios. Engaging in a process of dissolution is simultaneously exciting, liberating, and frightening. This has always been the case, but through emerging AI-mediated technologies, these processes are becoming increasingly ubiquitous, tangible, and concrete.

The dissolution process fundamentally questions the existence of a core subjectivity, an individual experience beyond that constructed through exogenous models of personality and category.

Bibliography

Anderson, J. R. (1983). *The Architecture of Cognition*. Cambridge, MA: Harvard University Press.

Artaud, A. (1938). *The Theatre and Its Double*. Paris: Gallimard.

Baars, B. J. (1997). *In the Theater of Consciousness: The Workspace of the Mind*. New York: Oxford University Press.

Barrett, L. F., and Simmons, W. K. (2015). "Interoceptive Predictions in the Brain". *Nature Reviews Neuroscience, 16*: 419–429. https://doi.org/10.1038/nrn3950.

Beyer, C. (2016). "Edmund Husserl". In *The Stanford Encyclopedia of Philosophy*, edited by Edward N. Zalta. https://plato.stanford.edu/archives/win2016/entries/husserl/.

Blanke, O., Slater, M., and Serino, A. (2015). "Behavioral, Neural, and Computational Principles of Bodily Self-Consciousness". *Neuron, 88*(1): 145–166. https://doi.org/10.1016/j.neuron.2015.09.029.

Boden, M. (2006). *Mind as Machine: A History of Cognitive Science*. Oxford: Oxford University Press.

Brugger, P., and Lenggenhager, B. (2014). "The Bodily Self and Its Disorders: Neurological, Psychological and Social Aspects". *Current Opinion in Neurology, 27*(6): 644–652. https://doi.org/10.1097/WCO.0000000000000151.

Chalmers, D. J. (1996). *The Conscious Mind: In Search of a Fundamental Theory*. New York: Oxford University Press.

Chalmers, D. J. (2017). "The Virtual and the Real". *Disputation, 9*(46): 309–352. https://doi.org/10.1515/disp-2017-0009.

de Lange, F. P., Heilbron, M., and Kok, P. (2018). "How Do Expectations Shape Perception?" *Trends in Cognitive Sciences, 22*(9), 764–779. https://doi.org/10.1016/j.tics.2018.06.002.

de Oliveira, E. C., Bertrand, P., Lesur, M. E. R., Palomo, P., Demarzo, M., Cebolla, A., Baños, R., and Tori, R. (2016). "Virtual Body Swap: A New Feasible Tool to Be Explored in Health and Education". *Proceedings of XVIII Symposium on Virtual and Augmented Reality*, 81–89. Gramado, Brazil.

de Waal, F. B. M. (2019). "Fish, Mirrors, and a Gradualist Perspective on Self-Awareness". *PLoS Biology, 17*(2). Article e3000112. https://doi.org/10.1371/journal.pbio.3000112.

Dennett, D. (1988). "Conditions of Personhood". In *What Is a Person?*, edited by Michael F. Goodman. Clifton: Humana Press.

Dennett, D. C. (1991). *Consciousness Explained*. Boston, MA: Little, Brown and Co.

Dennett, D. C., and Kinsbourne, M. (1992). "Escape from the Cartesian Theater". *Behavioral and Brain Sciences, 15*(2): 234–247. https://doi.org/10.1017/S0140525X00068527.

Frankel, R., and Krebs V. J. (2022). *Human Virtuality and Digital Life: Philosophical and Psychoanalytic Investigations*. New York: Routledge.

Gualeni, S. (2015). *Virtual Worlds as Philosophical Tools: How to Philosophize with a Digital Hammer*. 145–167. Basingstoke: Palgrave Macmillan.

Lenggenhager, B., Tadi, T., Metzinger, T., and Blanke, O. (2007). "Video Ergo Sum: Manipulating Bodily Self-Consciousness". *Science, 317*(5841): 1096–1099. https://doi.org/10.1126/science.1143439.

Menary, R. (ed.). (2010). *The Extended Mind*. Cambridge, MA: MIT Press.

Metzinger, T. (1993). *Subjekt und Selbstmodell*. Paderborn: Schöningh.

Metzinger, T. (2003). *Being No One: The Self-Model Theory of Subjectivity*. Cambridge, MA: MIT Press.

Metzinger, T. (2010). *The Ego Tunnel: The Science of the Mind and the Myth of the Self*. New York: Basic Books.

Seth, A. (2022). *Being You: A New Science of Consciousness*. London: Faber and Faber.

Walton, K. L. (1990) *Mimesis as Make-Believe*. Cambridge, MA: Harvard University Press.

Westerhoff, J. (2016). "What It Means to Live in a Virtual World Generated by Our Brain". *Erkenntnis, 81*: 507–528. https://doi.org/10.1007/s10670-015-9752-z.

17

Noise and Subjectivity in the Era of Machine Learning

Mattin

Anti-Copyright

Does AI extend and expand our understanding of subjectivity? Does it transform or obliterate it?

AI poses difficult questions without clear answers. GAFAM[1] and Big Tech are investing vast amounts of money in AI development without public oversight or legal, political, or ethical regulation. At the same time, these developments instigate irreversible challenges to our conceptions of subjectivity. In this chapter, I will examine the connections between social control, subjectivity, AI, and *noise*. I will offer an account of technological modes of social control that mobilise noise to predict behaviour and produce new forms of subjugation.

In my previous work, I developed the concept of "social dissonance"[2] – a mode of cognitive dissonance happening at the structural level in Western liberal societies. Leon Festinger developed a theory of cognitive dissonance in the 1950s, to describe the mental discomfort or tension that arises when a person holds two or more simultaneously contradictory beliefs, values, or ideas. This can also occur when a person's actions are inconsistent with their beliefs or value systems.[3] Social dissonance, then, is the contradiction between the values promoted by democratic societies and the structural activities of these societies.

Liberal Western societies purportedly espouse values such as individual freedom, equality, democracy, and, more recently, sustainability. However, these societies actively reproduce systems based on inequality, exploitation, restricted freedom, and the destruction of the planet through profit-motivated resource extraction. When experiencing cognitive dissonance, one typically attempts to justify or harmonise its contradictory terms in order to mitigate the experience of the tension, dissonance, or noise that emerges from this contradiction. I argue that Western liberal societies justify *social dissonance* with what Mark Fisher called "Capitalist Realism," that is, a categorical lack of alternatives to the capitalist mode of production.[4] Without an

DOI: 10.1201/9781003312338-25

419

alternative horizon challenging capitalist hegemony, we become puppets at the mercy of liberal ideology.

Hegemonic technocapitalism, especially in the course of its investment in AI, is intensifying social dissonance to an unprecedented level, in part by accelerating the disintegration of the liberal subject. The seeds of social dissonance emerge from the conflation between individuality, selfhood, and subjectivity characteristic of liberal ideology. In other words, liberal societies naturalise the individual as having subjective agency. We are made to believe that as individuals within these societies, we are self-determining agents who can execute their freedom. However, this conception of subjective agency is being increasingly undermined by technological modes of social control and a future threatened by collective extinction through climate change.

In this text, I will explore how both our brains and machine learning technologies adapt in the presence of noise, focusing on how they affect each other. By doing so, we can better understand the newest forms of technological manipulation, how subjectivity is being reformulated under the regime of AI, and the role of noise in these processes.

Alien Subject and the Naturalisation of Consciousness

Kant arguably defined the modern idea of subjectivity as connected to reason and autonomy, identifying the human as a special and unique being because of its power of reason. As Michael Robert Stevenson puts it:

> To ask about the unity of subjectivity is to ask about the human being in its wholeness, totality, and integrity, everything that he can, should, and may do. But for Kant, and for the Idealists as well, the uniqueness of the human being consists in the fact that she, among mortal creatures at least, alone possesses reason. So that the latter set of concerns becomes the question of the unity of reason.[5]

According to Kant, the subject/object distinction refers to the differentiation between the knowing subject (the I or he or she or it, the thing that thinks) and the object of knowledge (the external world). The *subject* is the thinking, perceiving, and knowing individual and the *object* consists of any number of external things that are perceived and known by the subject. Kant argues that the subject and the object are distinct entities and that knowledge arises from the interaction between them. The subject provides the framework and the mental structures necessary for the perception and understanding of objects, while objects provide the content or material that is apprehended by the subject. Subjectivity for Kant is the "unity which gives rise to experience, or of consciousness of an objective rule-governed world, and is produced by

Hegemonic technocapitalism, especially in the course of its investment in AI, is intensifying social dissonance to an unprecedented level, in part by accelerating the disintegration of the liberal subject.

the transcendental unity of apperception under the categories. We can call it the unity of consciousness or the unity of experience."[6] I will argue that AI is radically challenging this Kantian unity of consciousness or experience by increasingly diffusing its boundaries.

But how can we explore the radical potential of AI to reconfigure the Kantian model of subjectivity beyond established notions of subject and object? Luciana Parisi suggests that the automation of cognition brought forth by the development of AI leads to a vanishing of the transcendental function of reason.[7] Instead of a limitation, this process expands the domains of reason itself through new forms of what she defines as "alien subjectivity." Parisi poses the question: "can the servo-mechanic model of technology be over-turned to expose the alien subject of artificial intelligence as a mode of thinking originating at, but also beyond, the transcendental schema of the self-determining Subject?"[8] Rather than approaching the subject from the perspective of a human learner gathering information, Parisi's interest in subjectivity has shifted to the possibility of subjectivity within an AI, a subjectivity partially foreclosed to us, one which utilises generative layers of machine-to-machine communication to create its own technocultural interiority.

Reza Negarestani, on the other hand, posits that Artificial General Intelligence (AGI) could overcome all local and accidental (contextual) aspects of transcendent subjectivity in order to achieve a level of subjective self-consciousness that exceeds that of humans. Negarestani contends that AGI should be understood as a new form of natural intelligence, one that emerges from the complex interactions and evolutionary processes of the natural world. According to Negarestani, "the maturation of self-consciousness, the idea of reinventing the subject through the exploration of conditions for object-intentionality, should be understood as a thoroughgoing process of naturalisation."[9] By advocating for the naturalisation of AGI, Negarestani emphasises the continuity between AGI and human intelligence and the former's potentially dramatic extension of the latter.

Parisi and Negarestani make us reconsider what subjectivity could be. However, at the moment, we generally (at least in Western liberal societies) share a conception of subjectivity more akin to that inherited from Kant, albeit one that sits in painful tension with a social dissonance amplified and escalated by technocapitalistic developments. Over the next few sections, I will argue that an analysis of *noise*, as both a concept and as a tactic, can offer some paths forward.

Noise, Predictive Processing, and Machine Learning (ML)

> Firstly, there is a functional use of randomness, variability or noise in ML, which is based on stochastic gradient descent. But variability is also intrinsic to the learning of a pattern, and together with the technique

of backpropagation this allows for a continual (Bayesian) recalibration of the model and its parameters. So ML's functional use of noise is mirrored by its capacity for the dynamic analysis of noisy data sets, including qualitative information.[10]

Inigo Wilkins has extensively explored the changing role of noise vis-à-vis technology from deleterious (for example, in twentieth-century cybernetics, where noise was to be avoided) to specifically instrumentalised (within twenty-first-century applications of artificial intelligence and machine learning).[11] Many contemporary machine learning paradigms take noise as an input, through which predictive outputs result from constant functional recalibration in response to noise. Some interesting parallels to (biological) cognitive science, specifically the theory of predictive processing (PP), emerge here. According to PP, the brain generates constant predictions about what it expects to encounter in the world based on past experiences and current context.

Andy Clark – one of the early proponents of predictive processing – has suggested that the brain operates by indexing valuable signals from a cacophony of noise, effectively safeguarding against the risks of overfitting (the inability to generalise) in a world characterised by high levels of uncertainty and fleeting dynamics.[12] The brain then compares these predicted signals to incoming sensory data and updates its own projected patterning by examining emerging discrepancies. The parallels to contemporary machine learning tools are clear: many such tools adopt a form of predictive processing when they apply models to make predictions about future events or outcomes. This concept is central to many AI applications, including many strata of machine learning, like natural language processing, computer vision, and robotics. The concept at play here is that any of these systems can be trained on a large dataset of past examples, allowing them to identify patterns and relationships in the data. Once the system has learned these patterns, it can use them to generate predictions about future data points or events. These predictions are then compared to actual supplied data, and any errors or discrepancies are used to update the network's internal parameters and improve its accuracy over time.

Both concepts of predictive processing, from theories of cognition and philosophy of mind and from machine learning, take Bayesian inference as a point of departure. Bayesian inference is a statistical methodology that involves updating and revising beliefs or probabilities in response to new data or evidence, incorporating prior knowledge into an underlying probability distribution. Bayesian inference allows us to quantify uncertainty and make probabilistic statements with respect to our beliefs. It can be applied to a wide range of statistical problems, including parameter estimation, hypothesis testing, model selection, and predictive analysis. It is particularly useful in situations where data is limited, noisy, or expensive to collect. In this context, noise can have a positive effect, for example, by constantly pushing a neural network to reassess itself and its potentiality.

The Instrumentalisation of Noise

> PAINRS [Predictive Artificially Intelligent Noise Resilient Systems] capture and feed on the noise produced by the users, even or especially when that noise is critical of the system of power that the PAINRS preside over. Though noise is no longer intrinsically critical under this paradigm there are still important critical uses of noise. Though most resistance is captured, resistance is not futile. There is no way back from PAINRS but that doesn't mean there is no way forward. Mutants, symbionts, and ultramutants could completely transform their own conditions of agency.[13]

Wilkins uses the term PAINRS to refer to dynamics of agency and resistance under hegemonic technocapitalism, in which systems such as Google and Meta exert extraordinary socio-political power through *noise*. Wilkins and I are part of the Noise Research Union,[14] whose mission is to understand the nature of noise in the twenty-first century, in part by examining the historical developments that have shaped it. We argue that the twentieth century involved social regulation through noise reduction. Technological advances in computer science, information theory, and cybernetics – resonating with the political and aesthetic upheavals – accelerated pre-existing forms of social control that relied on statistics, traceable back to colonialism and early formulations of capitalism. The twentieth century witnessed the development of robust systems designed to minimise or eliminate noise, deployed to enforce a form of exclusionary power that disciplined any deviation from its normative frameworks or interference with its objectives. In this context, noise generation became a critical activity for various subversive artistic movements, countercultures, and political protests.[15]

Towards the end of the twentieth century, a shift in both the form and the technical implementation of power took place, a move from centralised control systems that inhibit noise to decentralised control systems that generate noise. Noise is no longer an external factor but an integral part of these new systems. Instead of restricting noise and difference, these systems encourage, feed on, and smoothly regulate the flows of noise and difference. The defining characteristics of this new (neoliberal) control system include the abstraction and total financialisation of all economic relations, the collapse of centralised broadcast media into massively distributed information and communication networks, and the application of noise-resilient algorithms to most aspects of social life in a massive program of surveillance and flexible control.

Instead of restricting noise and difference, these systems encourage, feed on, and smoothly regulate the flows of noise and difference.

Algorithmic Subsumption

> What ML subsumes is not just labour but more general human behaviour, communication, knowledge and skills that relate to how we live – including purchasing and consumption, but also the social relations of friendship, conviviality and love that are, from capital's point of view, engines to be harnessed for its accelerated circulation.[16]

Nick Dyer-Witheford, Atle Mikkola Kjøsen, and James Steinhoff coin the term *hyper-subsumption* in their book *Inhuman Power: Artificial Intelligence and the Future of Capitalism*, referring to the processes through which capitalist automation accelerates through AI to the point of possibly culminating in AGI.[17]

Noise – as interference, disturbance, randomness, indeterminacy, unpredictability, variability, excess, and irrelevance[18] – is being appropriated by big corporations like Google, Facebook, Amazon, and TikTok. Through machine learning and artificial intelligence, our interactions are not only traced but also further reciprocally influence and dictate our behaviour. Shoshana Zuboff has written extensively on how our private human experience gets translated into behavioural data profiting big technology corporations. She has termed this translation "behavioural surplus":

> The "Like" button, introduced widely in April 2010 as a communications tool among friends, presented an early opportunity for Facebook's Zuckerberg to master the dispossession cycle. By November of that year, a study of the incursion already underway was published by Dutch doctoral candidate and privacy researcher Arnold Roosendaal, who demonstrated that the button was a powerful supply mechanism from which behavioral surplus is continuously captured and transmitted, installing cookies in users' computers whether or not they click the button.[19]

We can see how a "Like" button is a tool for behavioural extraction, demonstrating how networks like Facebook have been subsuming our social interactions. Negarestani takes Zuboff's idea of behavioural surplus further, coining the term "algorithmic subsumption" to refer to the processes in which affect itself is appropriated and subsumed by Big Tech – sustaining, manipulating, and exploiting the theatre of selfhood for profit.[20] Negarestani gives us an example: Facebook/Meta performed sentiment analyses on content and related the results to advertising engagement. It became clear that when the users were distressed or panicked by content, they were much more likely to shop from adjacent advertisements.[21] By mobilising the connection between negative affect and engagement, companies like Facebook push already fragile individuals into deeper pits of anxiety simply to capture their attention and money. This attraction between negative affect and advertising engagement is a clear form of social dissonance, a social dissonance actively accelerated by Big Tech.

The Catastrophic Model: Fragmented
Lives and Impotent Subjects

> As soon as an excitation is felt that emanates from an objectively danger-
> ous situation, a catastrophic reaction occurs immediately, all other ade-
> quate utilization of excitation is excluded and the ill individual appears
> completely closed to the world.[22]

The philosopher Cécile Malaspina borrows Kurt Goldstein's concept of "cata-
strophic reaction" when referring in her own work to the processes through
which one's sense of selfhood disintegrates. A catastrophic reaction occurs
when both external stimuli and internal dispositions break down, yielding
what Steven Sands and John J. Ratey call a "mental state of noise."[23] Certainly,
"catastrophic reaction" is our epoch-defining state.

On one hand, Western liberal ideology embraces and sustains itself
through this catastrophic reaction – and through the invariable inevitabil-
ity of capitalism. On the other hand, the far right responds to this sense of
subjective disintegration through calls for the naturalisation of gender, race,
and the state. On one hand, we have adaptive technologies that not only are
resilient to noise but in fact use noise to develop themselves further. On the
other hand, we humans hide from noise within social and political models
based on old assumptions and values that do not correspond to our current
reality.

To reduce social dissonance, we can often find ourselves moving into fil-
ter bubbles and echo chambers, but this does not mean that we can avoid
our expectations being constantly disrupted. When a model contingent on
one's reality comes under attack, many people close themselves off, turning
to reactionary values and clinging to their pre-existing models of the world.
This motion only serves to ratchet up the intensity of the cognitive disso-
nance between subjective expectation and experience.

Instead of idly overfitting within neoliberal noise, we can actually use
predictive processing as a mode of subversion. Predictive processing offers
insights into the chasm between our existing, legacy, outdated models and
the constant socio-political noise surrounding us at all times. At its core, pre-
dictive processing involves the continuous, adaptive minimization of the dif-
ference between our brain's predictions and the sensory input it receives. By
generating accurate predictions about its potential situational environment,
the brain can more efficiently process and interpret incoming information,
allowing it to make quicker and more accurate decisions to respond to its
actual environment.

Roope Kaaronen has recently attempted to synthesise experiences of cog-
nitive dissonance with predictive processing.

> The argument is that responses to CD [cognitive dissonance] can instil
> meta-learning which serves to prevent the overfitting of generative
> models to ephemeral local conditions. This can increase action-oriented
> ecological rationality and enhanced capabilities to interact with a rich
> landscape of affordances. The downside is that in today's world where
> social institutions such as science a priori separate noise from signal,
> some reactions to predictive dissonance might propagate ecologically.[24]

As Kaaronen points out here, our current social and scientific institutions
need to further clarify the distinction between noise and signal, but, as stated
previously, the technologies purveyed by these institutions have been redi-
rected into noise-generating mechanisms for purposes of social control. It is
time that we reconsider the core values of these institutions and acknowl-
edge the need for a different relationship with noise, one of acceptance and
resilience. Otherwise, cognitive and social dissonance will only increase.

Seize the Means of Complexity! Towards an Open-Source Subjectivity

> Technology does not threaten to build an evil mastermind but an incom-
> prehensible ecology of computationalized winds blowing us in unpre-
> dictable directions. Artificial intelligence will likely take the blame for
> much of this loss of control. Because of AI's blatant opacity, it will provide
> cover to the subtler, growing opacity of even the simplest algorithms on
> the meganet. AI will supercharge meganets, offering ingenious ways to
> sift enormous amounts of analog data, but its effects are ultimately sec-
> ondary to what people will be doing in meganets, how volatile collec-
> tives will come together and send the course of a meganet careening in
> different directions.[25]

One of the biggest issues we face with AI is a more direct form of signal-
obscuration: opacity. Companies investing so much money in the develop-
ment of AI may not have transparent objectives, but given their position at
the helm of contemporary capitalism, it is clear that profitability is their main
concern. David Auerbach argues that meganets, his term for the distributed
digital entities that exert massive influence over daily life – entities such as
GAFAM, Big Tech, crypto, social media, and government systems such as
China's Social Credit System and India's Aadhaar – have grown so large,
complex, and autonomous that they threaten human social agency. Given
AI's ability to model large, abstract systems, we may be able to leverage AI
tools to conceptualise, schematize, and ultimately regulate these meganets.
However, these technologies come at the cost of their own inherent opacity,

algorithmic unreliability, and commercial incentives – it is more likely that AI will be used to exacerbate the prevailing conditions of social uncertainty and powerlessness. Specifically, all likelihood points to the existing sociotechnical hegemony, meganets leveraging AI instead to model and mould humans into simpler structures and more orderly and easily exploitable behaviours. Ironically, the real danger to human autonomy does not come from a Skynet-like AI ruling the world, but rather from a meganet-powered system that depends on the unpredictable collective behaviours of human groups. This could operate through ordinary calculations, posing a threat not as an evil mastermind, but as an intricate and bewildering ecosystem of computational forces that propels humanity in unforeseen directions.[26]

We already live within incredibly complex systems that exceed our ability to comprehend fully. As stated before, liberal Western societies conceive of subjectivity through its potential to make rational decisions. However, these decisions are increasingly dictated and mediated through technologies that exceed our comprehension. These technologies further penetrate and diffuse the components of subjectivity that have to do with individualisation, stripping away our autonomy and diffracting our "unity of consciousness" or experience. The porosity of contemporary subjectivity starkly contrasts with increasingly out-of-date social, psychological, and cognitive models that struggle to keep up. The increasing rates of mental health-related diagnoses in Europe evidences this contrast. We must update these structural models through which we conceptualise our own ability to think and act, and, even more urgently, we need to wrest control of the technological apparatus through which our subjectivities are now being produced.

We need to seize the means of complexity![27] While Karl Marx exhorted the working class to "seize the means of production," I exhort people to "seize the means of complexity" by taking control of the intricate systems that shape their lives, reconsuming the technology behind social media algorithms, healthcare systems, financial markets, and more. Throughout modernity, from the Enlightenment to cybernetics, there has been an ongoing struggle to decipher and master *noise*, transforming it into understandable signal. However, we now know that both the subjective mastery over objects and the objectification of life (e.g., through slavery) directly correlate to capitalist exploitation.

Therefore, it is imperative to update our perceptions of reality, in terms of content but also form. We need to establish a dynamic relationship with dissonance and noise, recognizing them as integral to reason and, more importantly, to subjectivity itself. The disparity between Parisi and Negarestani's proposals for a new understanding of subjectivity and our current reality lies in the fact that capitalist ideology has co-opted technology for its own ends. To seize the means of complexity, we must comprehend these tools and leverage that knowledge to steer their development towards an open-source conception of subjectivity. In this new paradigm, everyone would have access to the codes, technologies, models, and complexities that shape our lives.

We need to seize the means of complexity.

By embracing noise rather than shying away, this new, noise-adaptive, open-source subject could pave the way for a future that transcends capitalist realism, forging a new form of communism fit for the twenty-first century.

Acknowledgements

I would like to thank Roberto Alonso Trillo and Marek Poliks for their patience and great editing suggestions.

Notes

1 GAFAM is an acronym for five popular US tech stocks: Google (Alphabet), Apple, Facebook (Meta), Amazon, and Microsoft.
2 See Mattin, Social Dissonance.
3 See Festinger's *A Theory of Cognitive Dissonance* for more on the theory.
4 Fisher, Capitalist Realism.
5 Stevenson, "Subjectivity and Selfhood in Kant, Fichte and Heidegger," 24.
6 Ibid., 25.
7 Parisi, "The Alien Subject of AI," 27. As a result of the automation of cognition, the subject has thus become ultimately deprived of the transcendental tool of reason. This article discusses the consequences of this crisis of conscious cognition at the hands of machines.
8 Ibid., 28.
9 Negarestani, Intelligence and Spirit, 37.
10 Inigo Wilkins, "The Topos of Noise."
11 See these two works by Wilkins: *Irreversible Noise* and "The Topos of Noise."
12 Clark, *Surfing Uncertainty.*
13 NRU, zine #1.
14 NRU (Noise Research Union) is a collective of philosophers and artists composed of Sonia de Jager, Cécile Malaspina, Mattin, Miguel Prado, Martina Raponi, and Inigo Wilkins applying multidisciplinary methodologies to the concept of noise. See https://n-r-u.xyz/ (warning: flashing lights).
15 NRU, zine #1.
16 Dyer-Witheford, Kjøsen, and Steinhoff, *Inhuman Power,* 98.
17 Ibid., 21.
18 Wilkins, "The Topos of Noise."
19 Zuboff, *The Age of Surveillance Capitalism,* 155.
20 This term was used by Negarestani in his PowerPoint presentation "Affect Economy between Brains and Algorithms" as part of the seminar series And Your Bird Can Sing: Computational Theatre and the After-Image of Social Media, organised by the New Centre for Research and Practice together with Michael Turner and Dan Young.

21 Ibid.
22 Kurt Goldstein as cited in Cécile Malaspina's book *An Epistemology of Noise*, 175.
23 Ibid.
24 Kaaronen, "A Theory of Predictive Dissonance," 1.
25 David B. Auerbach, *MEGANETS*, 286.
26 Ibid.
27 Anil Bawa-Cavia came up with this expression when Patricia Reed, Miguel Prado, and I were trying to think of a title for this episode of the podcast series *Social Discipline*: https://soundcloud.com/socialdiscipline/sd13-w-patricia-reed-anil-bawa-cavia-modes-of-access-to-complexity.

References

Auerbach, D. B. (2023). *Meganets: How Digital Forces beyond Our Control Commandeer Our Daily Lives and Inner Realities*. New York: PublicAffairs.

Clark, A. (2015). *Surfing Uncertainty: Prediction, Action, and the Embodied Mind*. Oxford: Oxford University Press.

Dyer-Witheford, N., Kjøsen, A. M., and Steinhoff, J. (2019). *Inhuman Power: Artificial Intelligence and the Future of Capitalism*. London: Pluto Press.

Festinger, L. (1957). *A Theory of Cognitive Dissonance*. Redwood City, CA: Stanford University Press.

Fisher, M. (2009). *Capitalist Realism: Is There No Alternative?* Winchester, UK: Zer0 Books.

Jager, S. de, Malaspina, C., Mattin, Prado, M., Raponi, M., and Wilkins, I. (2022). "NRU zine." Zine, (1).

Kaaronen, R. O. (2018). "A Theory of Predictive Dissonance: Predictive Processing Presents a New Take on Cognitive Dissonance." *Frontiers in Psychology*, 9. https://doi.org/10.3389/fpsyg.2018.02218.

Malaspina, C. (2018). *An Epistemology of Noise*. London: Bloomsbury Academic.

Mattin. (2022). *Social Dissonance*. Falmouth, UK: Urbanomic.

Negarestani, R. (2018). *Intelligence and Spirit*. Falmouth, UK: Urbanomic x Sequence Press.

Negarestani, R. (2023). "Affect Economy between Brains and Algorithms." Presentation for and your Bird Can Sing: Computational Theatre and the After-Image of Social Media, seminar series, New Centre for Research and Practice, online. 18 March 2023. https://thenewcentre.org/public/bird-can-sing/

Parisi, L. (2019). "The Alien Subject of AI." *Subjectivity*, 12: 27–48. https://doi.org/10.1057/s41286-018-00064-3.

Stevenson, M. R. (2012). "Subjectivity and Selfhood in Kant, Fichte and Heidegger." PhD dissertation, Columbia University. https://doi.org/10.7916/D85D8ZVJ.

Wilkins, I. (forthcoming). *Irreversible Noise*. Falmouth, UK: Urbanomic.

Wilkins, I. (forthcoming). "The Topos of Noise." *Angelaki*. Angelaki 28 (3):144-162.

Zuboff, S. (2019). *The Age of Surveillance Capitalism: The Fight for a Human Future at the New Frontier of Power*. London: Profile Books.

After-Body

18

Descendent: AI and the Body Beyond Hybridization

Roberto Alonso Trillo

Introducing Descendent

The *Descendent* project was originally conceived as both a performance eco-system, deployable through distinct instantiations with different aesthetic narratives (see Figure 18.1), and a tool for real-time, machine-learning-based, reversible sound-to-motion synthesis.[1] As such, it emerged from a transdisciplinary dialogic space – a cluster and lab atop a university's departmental structure – including visual artists, musicians, dancers, computer scientists, and creative technologists, a space that attempts to capture "the creative energies of artists working within the academic institution."[2] *Descendent* exemplifies the

FIGURE 18.1
Different instantiations of the descendent project.

DOI: 10.1201/9781003312338-27

current interest in the potential use of AI-related tools to explore the multimodal complexity of performative artistic creativity. For us, as artists and researchers, *Descendent* represented an opportunity: (1). to develop an immanent critique through a constructivist approach to *processes* rather than *products*; (2). to posit a speculative pragmatism, future-oriented and technique-based, exploring techniques of relation/translation/mapping; and (3). to enact our thinking through performative paradigms that paid a critical attention to the body. That critical attention to the body, to the somatic dimension of the digital, through the fundamental role of sound- and dance-producing body movements in *Descendent*, becomes the core starting point of our ensuing discussion.[3]

Performance and AI-Mediated Art

What Body?

> MUNSTER:
>
> How can we account for the breakup of the structure of private and interiorized subjective experience or the informatic transformation of the referential world, both of which were hastened by the dematerializing tendencies of electronic media and new computational processes?[4]

Is the body transformed when rendered machine-readable? How do the processes of datafication and mediatization involved in AI-related artistic practices affect our perception of self? What has the body become under post-, trans-, anti-, un-, and non-humanisms? Has AI accelerated the contingency and complexity of the fragile and ruptured postmodern body? Is it possible to articulate a non-anthropomorphic vision of the body beyond the concept of the hybrid organic-mechanical assemblage?[5] Could *Descendent* articulate such a reading through specific embodiment tactics and a new post-choreographic milieu?

1. Body-in-Making

> SIMONDON:
>
> Collective and psychical individuations are both reciprocal with respect to one another; they make it possible to define a category of the transindividual, which attempts to account for the systematic unity of interior (psychical) individuation and exterior (collective) individuation.[6]

We begin by tracing a postmodern body through the work of Gilbert Simondon, Gilles Deleuze, and Erin Manning, among others. The body for Simondon is a processual coming-to-existence, a "body-in-making," an osmotic exchange challenging a vision of the skin, the *epi*-dermis, as a container, as an ontological boundary.[7] A body that becomes instead a "porous,

topological surfacing of myriad potential strata that field the relation between different milieus, each of them a multiplicity of insides and outsides."[8] Against essentialist readings of the object-subject and self-other dualisms, the postmodern body billows outward as an intercorporeal porous locus of immanent alterity (Merleau-Ponty, Levinas, Deleuze), an increasingly decentralized, digitized, and virtualized self. [9]

> ARTAUD:
>
> The body is the body
> it is all by itself
> and has no need of organs
> the body is never an organism
> organisms are the enemies of the body.[10]

Deleuze-Guattarian discussions of the body combine Simondonian elements with a Spinozist reinterpretation – through the egg figure – of the Artaudian body without organs (BwO),[11] a vision of the "moving body, with its biological, anatomical and sensory structures, not as a pre-given performing entity but as a phase in its continuous becoming."[12] The BwO precedes individuation, emerging from a morphogenesis independent of an external unifying force – soul/form/unity – and located instead "at the level of matter that is not yet informed and is on the plane of forces."[13] It is not reducible to a constituted organism or a hierarchy of differentiated organs, neither deprived of them, but below "the level of organic determination, a body of indeterminate organs, a body in the process of differentiation."[14]

The unattainability of the BwO, its vision as an unreachable limit, connects it to Simondon's concept of dephasing: non-linear and discontinuous overlapping processes that tend toward discrete iterations, momentary apexes amid ongoing transformations.[15] Simondon refers to these transductions as "traumatic" shifts from individuation to the individual activating new phases of the individuation loop. Bodies are thus short-lived, held in a synthetic superposition, not frameworks uniting beyond the specificity of the event but both a "continuity and an emergent discontinuity," not momentary taking-forms but a countering of pervasive hylomorphism – the predominance of form over matter.[16] A prospect that facilitates our exploration and contestation of body hybridity in AI-mediated art models, approaching the artificial vs. human intelligence debate through a narrative of immanence (rather than otherness).

Simondon's philosophy, through its merging of the dynamic and processual visions of the world and individuation, has not only influenced most somatocentric analyses of the body in performance-related studies (e.g., dance, music) but also Bernard Stiegler's philosophy of technology. Stiegler explores the concepts of the transindividual – also related to Étienne Balibar's reading of Spinoza[17] – and the exteriorization of consciousness into technical objects, that is, an epiphylogenetic memory transcending epigenetic (brain) and phylogenetic (biological evolutionary) mechanisms, and conceives the individual as an incomplete process or metastable equilibrium.[18]

2. Cyborgs

HARAWAY:

Why should our bodies end at the skin?[19]

The considerations of the body introduced thus far foreshadow Haraway's cybernetic organism, "a hybrid of machine and organism, a creature of social reality as well as ... fiction" that contests entrenched anthropocentric essentialist dualisms – machine/organism, human/animal, natural/artificial, physical/non-physical, male/female, public/private.[20] Haraway approaches the human body, a body recrafted by communication and bio-technologies, as a biotic or cybernetic communication system, one structured through a network that suggests the profusion of "spaces and identities and the permeability of boundaries."[21] Against the animated machines vs. mechanized organisms divide, against organic holism, Haraway proposes an undifferentiated reality where "machines can be prosthetic devices, intimate components, friendly selves," the cyborg as "a disassembled and reassembled, postmodern collective, and personal self" – Simondon through Deleuze and Guattari come to mind once again.[22]

Haraway's dedifferentiated material-semiotic actor (human/non-human, machine/non-machine) transforms the *object of knowledge* from a resource, ground, matrix, object, material, or instrument to be used by humans as a means to an end into an "active, meaning-generating axis of the apparatus of bodily production."[23] Her work represents a heuristic of the hybrid, one that conceives bodies as the sites of "multiple intersections" within the framework of postmodern biopolitics – e.g., her cartography of immune-system discourse in "The Biopolitics of Postmodern Bodies."[24] Haraway's discussion of "bodies in revolt," linked to the emergence of a liberal subjectivity, serves to question the scientific history of self-objectification, overcoming what she defines as sadistic reason, through the situated knowledge and action of hybrid bodies. The body cyborg challenges the ontological hierarchies of the organic, textual, and technological while avoiding a lessening of the mythical; it challenges previous approaches through its articulation as a dynamic force field, a situated and embodied – but also multiple and heterogeneous – text, coded by the narratives of power, an expression of the liminality of the co- (co-creation, co-relation, co-ordinate, etc.).

Haraway's interest in the intersection between the body and technology resonates as well with Don Ihde's influential research on the philosophy of technology. Ihde claims: "we are our bodies – but in that very basic concept, one also discovers that our bodies have an amazing plasticity and polymorphism that is often brought out precisely in our relations with technologies. We are bodies in technologies."[25] Such a plural body emerges from a three-part model: (1). *body one* relates to our phenomenological apprehension of reality (e.g., dromono-somatic experience, phenomenological narratives, Heidegger's *In-der-Welt-sein*, Merleau-Ponty's *corps vécu*, Husserl's *Leib*); (2). *body two* to its socially and culturally constructed significances (e.g., Foucault); and (3). *body three* to the traversing dimension of the technological.

Ihde explores the tensions and forces driving the relations between them, their processes of (de-)differentiation and (non-)assimilation.

Ihde's distinction serves as a warning against our arguably techno-utopian focus on *body three* and a reminder of Haraway's long-lasting influence on concepts of the body in social theory (from feminism to post-Marxism), performance studies (e.g., most forms of somatic research), and philosophy. Have we hitherto bypassed bodies one and two?

3. Gender, Race, Class

The body introduced thus far remains a fictionally unmarked signifier: genderless, raceless, class-less. But can it be considered beyond its situatedness? Can it be separated from the socio-political and cultural strategies of bodily production underpinning its emergence? We stress the fundamental role of context, not as surrounding "information," but as inscribed upon/through the physical body's co-structure or co-text. We also stress the need to transcend the humanistic *hubris* declaring Man (white and male) – anthropo-, andro-, and phallogocentrism – as the measure of all things, thus acknowledging the limitation of our approach and the bias of the abstract, speculative nature of our arguments.

The situated body has played a critical role in the development of feminist and queer theory (from Luce Irigaray and Monique Wittig to Margrit Shildrick, Haraway, and Katerina Kolozova), post-colonial studies (from Fanon to Shalk), critical race theory (from Sylvia Wynter to Fred Moten or Sara Ahmed), psychoanalysis (Susan Lord), and socio-political research (from Foucault to Sherry Wolf). Related approaches in the dance studies (from Maxine Sheets-Johnstone to Mark Franko) and musicological fields have tended to emerge from phenomenological concerns, at the boundary between Ihde's first and second bodies, through concepts such as enworldedness, mutuality, and exchange.[26] These transcend the scope of our argument here but must be recognized, as is the bias guiding our speculative exploration: a necessary apriorism to the decontextualized reframing of the vanishing body introduced later.

4. Posthuman and Object-Bodies

Let us take Haraway's hybrid cybernetic approach a step further to examine Braidotti's ecosophy – influenced by Guattari – and the linked posthuman consideration of the body as a transversal multiplicity connected to "others" and the "world" through non-hierarchized nature-culture distinctions, a blurring of the human vs. other-than-human subject-positions.[27] Posthuman subjectivity is fully exposed, nothing remains opaque and withdrawn from its relations, it is "propelled by trans-corporeal occupations, in which bodies extend into places and places deeply affect bodies … always already penetrated by substances and forces that can never be properly accounted for."[28]

Braidotti refers to this as nomadic subjectivity: ethically-charged processes of becoming that transform "subjects into transversal and interconnecting entities, defined in terms of common propensities ... intelligent matter, activated by shared affectivity."[29] A Spinozist reaction against the Cartesian divide between the individuality of substancehood and the universality of reason. Braidotti repositions the fragmented postmodern subject into a temporal continuity: bodies/bodily entities become dynamic and sensitive forces that fleetingly coalesce (if at all) through fragile synchronizations of borders/demarcations/boundaries/thresholds/limits. Braidotti envisions such processes of delocalization as positive forces, marking a new departure, an affirmation of recomposed subjectivities, opposing their tendency to devalue otherness producing "femininity without women, racialization without races and naturalization without nature."[30] However, her neo-Spinozistic monism entails a problematic conceptualization of finitude, agency, and change, through a blurring that prevents the possibility of critical dissent.

That is where Object-Oriented Ontology's (OOO) non-onto-taxonomical pluralism may play a critical role, a move from new materialism to immaterialism.[31] Against a critique of OOO as a brutal eclipse of the subject (e.g., Malabou),[32] a new object-subject emerges through a flat-ontology that equates natural/cultural, physical/ideal, material/semiotic entities. OOO reintroduces a focus on the autonomy and specificity and haecceity of objects (finitude) and their non-exhaustion in relations (change beyond the relata). Harman conceives objects as compounds that, resulting from a process of strong emergence – the truths concerning the emerging phenomenon need not apply to those of the emergent – are non-reducible to their parts. Bodies as meta-objects – contained within and containing other objects – instead of actants (ANT), predating instead of emerging from their activities, immaterial to the extent that they cannot be de-composed, singular rather than plural.[33] But does OOO's interrelationality and flat ontological discourse represent an over-mechanization of the body? We argue that it does not. Instead, OOO points to an inaccessibility and un-knowledgeability of the object-body that is critical to the definition emerging from our ensuing discussion.

5. From Hybrid to Vapor Bodies

Since the early 2000s, the *hybrid* has been employed to identify human activities at the intersection of the digital and the analog, the machinic and the organic, circuitry and flesh. It has since been linked to discussions of technology, globalization, and the Anthropocene through analyses of the entanglement of human/non-human materialities, the hybridization of human embodiments, or the co-mingling of elements involved in hybrid artistic media.

The body has been situated as an inorganic-organic hybrid throughout contemporary performance- and dance-related research. Stephanie Hutchison, for example, defines the hybrid as "a mesh of intertwining strands of practices, experience, memory, imagination, and consciousness, which are constantly weaving and re-weaving tensile, interconnected threads."[34] Rather than a

negative construction (counter-somatic, in-human) or pastiche, hybridity becomes a positive expansion that does not counter distinctive corporeality. Hutchinson's practice continuously re-configures the body through choreographic and gestural explorations, through embodied shifts shaped by the relationship between a dancer's movements and their mediatized avatarization. An extension of the performers' sense of presence inviting attention to the possibilities of, and those beyond, the body.

Alternative definitions of the hybrid emerge from our consideration of the body past the skin-boundary principle and against monadic readings as a plural overlapping process of dedifferentiation, that is, as a non-successive and unbound emergence and dissipation of selves (subjective, verbal, core) correlated as interweaving strata. Against dualistic symmetrical models, such a vision of hybridity favors both/and over either/or – as in Haraway's cyborg or Pickering's mangle[35] – while defining the modes of interaction that emerge around/from it: hybrid interaction is shaped through unlocalized and supra-modal modes of perception, via sense-events not necessarily linked to specific organs or objects.[36] We argue that, rather than transforming such creative environments, AI has accelerated the linked processes of hybridization through a blurring of the *noumenal* vs. artificial distinction. This does not only point to an exhaustion of the pertinence and validity of the hybrid but to the urgency of a new conceptual framing.

> KOLOZOVA:
>
> The inhuman or the monstrous is the real and the materiality of constructedness that neither becomes sense nor truth as philosophically sublimated reality.[37]
>
> POLIKS & ALONSO:
>
> Arrival in vapor space: atomized, dedifferentiated, decorporealized, desynchronized. Cleaved from the noumenal but also from the products of one's own consciousness.[38]

Put differently, the postmodern ubiquity of the hybrid – from Haraway to Braidotti, from Harman to Kolozova – becomes problematic as it brings into the equation a biological concept at the core of the cosmogony of Man that fails to sever its Cartesian underpinnings. The hybrid incorporates the other as a "second outside," through a further reification of the real, unable to transcend subjectivity and identity.[39] Beyond the framing concepts of exchange, porosity, intercorporeality, delocalization, the molar, or the object, we propose a new understanding of the body that extends Haraway's "more-than-human," Laruelle's "human-in-the-last-instance," and Kolozova's "human-in-human" and parallels Negarestani's "inhuman" and the discussion of the psychosocial and vaporreality introduced in Poliks and Alonso's chapter: vapor bodies.[40] Vapor bodies are an attempt at a non-anthropomorphic understanding of the body, selfhood, and corporeality. Countering subjectivity, the ~~human~~, a *sous rature*, a reality non-bendable to philosophical accounts countering the *homo ex machina* of philosophical discourses, a term as inadequately charged as

necessary. Human transverses the real-as-materiality and subjectivity-as-pure-signification while avoiding any attempt at their unification or dialectical resolution. Unqualified materiality makes redundant the distinction between the animal and the machine, the organic and the inorganic, moving from intersubjectivity to intercorporeality. Through the liquefaction of sentience, only post-sentient machines remain, para-sentient matter under machinic regimes but, as we shall later see, through an expanded *sentio* – eclipsed and overloaded – that transcends subject-centred phenomenology to embrace the inorganic and even the abstract, challenging the arguable non-computability of *qualia*.[41] Instead of the body, material-discursive phenomena produced by agential intra-actions, a tessellation "forming and reforming across the metastable skein of the bioinformatic ecosystem."[42] Karen Barad's reading of quantum mechanics, explored later in greater detail, serves to define a new living body that paradoxically occupies the "heart of the self while remaining its outsideness."[43]

But once the body becomes ~~human~~, how can we frame embodiment? What happens when thought is splintered – through AI – into microthreads that perform arbitrary processing on behalf of automatic machines? Is there any space left for reflexive experience or phenomenological perspectives? Are we facing a mind-less body? Or has embodiment become something else after Cartesianism?

Embodiment

A dual answer, influenced by our performative experience with *Descendent*, the body as a cognitive force, and the body as a vector in performance.

First, against Cartesian and cognitivist approaches, embodied cognition (EC) has granted the situated body a central role in shaping cognition beyond dualist paradigms (body/mind). EC was first introduced into the human-computer interaction field by Paul Dourish through the concept of embodied interaction, which emphasized the need to incorporate our relationship with the world into the design and use of interactive systems such as *Descendent*.[44] EC counters cognitivist paradigms to the extent that they favor immaterial and non-contextualized models of representation. This points to the complexity of codifying how meaning emerges from our processual relationship with things, with *nounishness*. Humans are involved in a "temporally and spatially immersed and autopoietic embodied dance of negotiation" with a world constructed through their cognitive mechanisms.[45] As Simon Penny points out, suggesting "that bodily motion may constitute a medium of thinking is a radical assertion for a cognitivist" but commonplace to a dancer or musician.[46] From an EC perspective, knowledge becomes *knowledge in practice* and is rendered non-existent outside the context of its actual performance, cognition as a "dynamical, relation, and performative doing in the world."[47]

Vapor bodies are an attempt at a non-anthropomorphic understanding of the body, selfhood, and corporeality. Countering subjectivity, the ~~human~~, a *sous rature*, a reality non-bendable to philosophical accounts countering the *homo ex machina* of philosophical discourses, a term as inadequately charged as necessary.

Does this represent a challenge to the dualist tenets of AI? How can we document the skills of bodily know-how, or what Dreyfus defined, after Merleau-Ponty, as "muscular gestalts"?[48] What about gesturally imbued tacit knowledge?[49] Can it become machine-readable? A question of filtering and mapping, how do we analyze and extract symbolic representations from bodily practices?

Descendent, as an example of embodied interaction, serves to articulate a first conjecture: symbolic representations of the human body, in spite of their unavoidable reduction of multimodal perception/bodying to a one- or discrete-dimensional reality, will always be imbued with tacit knowledge/"muscular gestalts." Furthermore, to the extent that these mostly remain in the unconscious domain, the related – partially AI-inferred – mapping processes might help resurface elements that had been concealed or tacitly assumed by the performers. The question then becomes one of retrievability: can *knowledge in practice* be retrieved outside the context of its actual performance? More on that later.

Second, can we transcend the Cartesianism underpinning the project's technological framework to question how it may dematerialize the "self" while intensifying corporeal sensoria and their linked actualizations? To what extent does the use of ML-generated material in *Descendent* articulate "out of body" experiences or the sense of bodily separation linked to the virtual/real split? To what extent is embodiment articulated beyond the individual as a form of projected proprioceptive movement? Can the project thus be reduced to a mere projection of that self, a correspondence relationship, between a real (Sudhee/Roberto) and a virtual world (their avatars)? What if the role of computation in *Descendent* is to "correspond to" rather than "resemble" reality, what if it just "duplicates, through fluctuating degrees of variation, the general mutability and contingency of sentient life"?[50]

Anna Munster has argued that the hyper-virtualization that ubiquitous computation moves us toward is not a replacement of materiality, bodies, or the human – *ersatz* embodiment experiences – but a "process that can combine with and multiply the virtual propensities of all these."[51] The virtual unavoidably establishes transversal relations to materiality; embodiment is but "one actualization of intersecting sensory and proprioceptive virtuality, concretized over a period of time into habits and recognizable rhythms."[52] *Descendent* serves to develop a second conjecture: the discussions of technologically enforced disembodiment (e.g., motion capture), the reduction of the bodily to the symbolic domain, or the use of ML to generate dance movements emerge from a Cartesian understanding of the body that has been challenged above.

The vapor body that *Descendent* attempts to enact renders these problematics trivial. Vapor bodies attest to technological embodiment as an integration of the corporeal and the virtual that transcends dualistic oppositions: material/immaterial, real/virtual, corporeal/technological. Such technological embodiment does not articulate corporeality as instrumentalized objectified experience but as a continuous actualization of a Guattarian machine

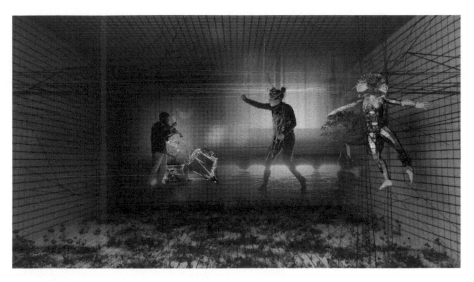

FIGURE 18.2
Embodiment tactics and corporeality in the descendent project.

of virtuality.[53] Corporeality is a flux that transverses the machinic, a post-Cartesian AI (see Figure 18.2).

A further turn, from embodiment to body movement, from body movement to motion capture.

Descendent and Motion Capture

And from the abstract consideration of embodiment back to somato-based dance research. As Susan Kozel points out, "what might seem like a simple process of tracking the limbs of a performer and using that information to drive, in real-time, a 3-D computer animation offers up a tangled array of questions, prevarications, and ambiguities trespassing on the domains of ethics, corporeality, and ontology."[55] Movement sampling/motion capture processes lead to a re-conception of the body as a cloud of markers, as a projected skeleton, as a series of dots/lines in space, rather than a "volumetric [living] 'body' moving through an environment."[56] A new modality of the body, translating the somatic experiential nature of movement into marker trajectories in a 3D space, emerges from the linked understanding of movement as geometry. While our computer scientists were happy to conceive dance versus corporeality as a "sequence of poses," while scientific disciplines (from anatomy to neurophysiology) "express movement as the predictable and clearly delimited spatial displacement of a body on a geometric

Such technological embodiment does not articulate corporeality as instrumentalized objectified experience but as a continuous actualization of a Guattarian machine of virtuality.[54] Corporeality is a flux that transverses the machinic, a post-Cartesian AI.

plane from one position/pose to another," we argued to the contrary.[57] Our SMP-based approach, following the examples set by movement-specific architectures such as *chor-rnn*, represented an augmentation rather than an abstraction of body movement.[58]

Mocap technology forced us, dancer, and violinist, to construct the body as a site of exploration to which we had had to "remain vigilantly attentive" (see Figure 18.3). Our bodies would not "succumb to ... [our] agencies – striving, failing, mustering its sources to try again. Instead, it playfully [engaged] ... willing to ... reveal new configurations of itself with unlimited resourcefulness"[59]: *Descendent* as choreographic research, as an active engagement with and through a continuously reconfigured body. We came to realize that an attentive body remains unfinished, "it is a body actively creating itself through the act of attending," becoming perceptive as an act of self-invention: doing and becoming as the boundaries of perception.[60] Our physical presence was mediatized and re-presented, it was extended both within and through the generated imagery. The "motion capture process [became] inherently generative for dance practice in and of itself, aside from any of its more instrumental uses in dance analysis and creation."[61] In *Descendent*, motion capture worked as a facilitator of movement-based vapor and crossmedial creativity.

But how do we conceptualize movement? Movement is everywhere.[62] Metric movement is but a cut on an ongoing, ubiquitously flowing process: movement without a subject, a "vibration, a resonance that precedes all form or structure."[63] Movement is thus a precondition for the body, "an extraction that appears in the collision of movement moving and actual movement, a

FIGURE 18.3
Motion capture data recollection for the TransSudhee dataset.

momentary collusion of tendencies that seem to make up a whole."[64] Dance and music are expressions of absolute movement as they co-compose with actual movement, a translation of thinking into act, between the plane of immanence of total movement and a movement-thinking that composes and defines us.

If we apply an ontology of corporeal intersubjectivity to motion capture, we come to realize that we are not witnessing a doubling of the body but the setting free of an often ignored otherness inhabiting us. The avatar is the expression of a potentially unknown outsideness nested in the dancer/musician, an otherness that had always been there. These "repeated encounters with otherness" and their "unsettling unpredictability … are always latent in the experience of performing with responsive technologies."[65] If embodiment emerges as a relational mode of being, then the *Descendent* project is a projective and ongoing configuration – "the performative assembly of human and nonhuman parts to create alternate forms of embodiment,"[66] of yet-to-be embodiments, a configuration that is not defined by additive processes but by the intermingling of the involved elements. Following Donnarumma, *Descendent* as "a scaffold onto which hybridity can take root."[67] Such an argument relates to a vision of *technics* as the entangled co-forming interrelations between users, technologies, and their sociocultural context, a symbiotism that has been described in different ways, through concepts such as the prosthesis or the Derridean supplement.[68] *Technics* thus encompasses "an arena of action far in excess of two or more intersecting bodies, although what is always figured is the instantiation of particular bodies," a *somatechnics*.[69] The question remains, how are such visions of movement and corporeality different from those emerging from the long-standing history of interactive XR design? What if the use of ML and AI is but a catalyst of ongoing transformations?

And, most importantly, are we trapped in postmodern and posthuman rants again (the symbiotic, the prosthetic, the assemblage, the hybrid)? We contend that the concept of vapor bodies allows us to consider the integration of ML and AI elements in *Descendent* beyond the concepts of the hybrid or the augmented, the dual or decoupled body, the real or the virtual. Against the merging or the exchange between machinic and animal realities, unqualified materiality serves to understand *Descendent* as a play of post-sentient machines, stemming from a non-anthropomorphic vision of corporeality, as a failing fluid cut inflicted by a vanishing subjectivity on the continuum of the real. A body that defines but ignores selfhood, remaining an outsider, a phantasmagorical stranger. Choreography thus becomes a shared ground, given the mediatization of physical presence taking place within such non-resolvable duality (in/out), providing a framework to examine and interpret the processes of datafication, mapping, and non-reconfiguration of the body taking place – through AI and ML – in *Descendent*.

Against the merging or the exchange between machinic and animal realities, unqualified materiality serves to understand *Descendent* as a play of post-sentient machines, stemming from a non-anthropomorphic vision of corporeality, as a failing fluid cut inflicted by a vanishing subjectivity on the continuum of the real.

From Choreography to Choreomata

Hence, *Descendent* opens a passage from Choreography to Choreomata.

POLIKS:

> *khoreia:* dance, the structuring relationship between music and dance, music for dancing, organization (of people), orbit, movement around an entity/organization or positioning around an object or agent
> *mémaa:* becoming, dreaming/striving, to move or orient oneself
> *auto-mata:* movement by oneself, becoming by oneself
> *choreomata:* becoming by participating, becoming by dancing, (dreaming of dancing, dreaming of participating in the dance), being as defined in relation to organizational structures, being as defined in relation to movement (specifically group movement).

First, let us explore the machine-readability of the body as/through movement. As a valuable example, Stamatia Portanova's research on the capturing and transformation of body movement into numerical information, from its imageability to its preservability. Portanova equals abstractness to a reduction-to-datum – infinity as a string of numerical data – and differentiates between digital technology, as a concrete application working according to a discrete logic (e.g., motion capture), and digital code, as a mode of thought that transcends its technological basis (e.g., the integration of ML in *Descendent*). For her, choreography becomes the "possibility to abstractly compose, or to give form to, patterns of movements in thought," that is, "choreography as a movement-thought."[70]

Portanova's approach frames the non-coincidence and productive relationship between the digital (a limited grid of possible alternative states) and the virtual (the incorporeal potential for variation) following Brian Massumi's vision of virtuality and the abstract character of all material bodies, their openness to an elsewhere and otherwise-than.[71] Virtuality coexists with the actuality of movement. The body thus becomes "a structure map of all the possible (and impossible) articulations that are implicit in its composition, juxtaposing all the separate levels and systems of anatomy ... and drawing across these complex plane[s] all the multiple, coexistent, sometimes incongruent vectors or tendencies."[72] A body that is felt as moving – movement as sensation – but thought of as dancing – movement as thought.

Motion capture, a technology as hylomorphic as cinema, attempts to make stable and understandable the un-cognizability of gesture, and it logically fails at doing so. It inverts *sentio*'s antecedence of *cogito*, translating dance into an algorithmic movement in space and time. Arguably, the choreographic images of classical ballet introduced an already abstracted understanding of movement as pose, as abstracted images. The same applies to Labanian notation.[73] But if nothing is purely digital, as Shaviro points out,[74] can sentio transcend human subjectivity and organic sensibility to incorporate not only

the inorganic but also the abstract? What if the abstract numbers of the digital could be indirectly felt, beyond qualitative transduction, as "conceptual contagions ... conceptually felt but not directly sensed"?[75]

The question is that, in motion capture, what has been discussed as disembodiment and desubjectification does not work against the individual body, present as a constant presupposition, but pro its virtuality.[76] We get dance minus the dancer, severing the "continuity of performed movement into a few structural elements."[77] "The artistic definition of movement as dance can be thought of as an effort to modulate, to surrender to, but also to bend, the limits of anatomical principles, through the daring abstractness of an idea."[78] Under motion capture, the gesture-swarm, an aggregate of microgestures, becomes a divisible and recombinable reality and dance their diagramatic modelling, paralleling the perceptive atomization of reality, of the continuum of matter, into images or events and memory's transformation of the cut or *mens momentanea* into abstract objects.

Choreography: *khoreia+graphos*, dance-as-notation, dance-as-writing. The concept of vapor bodies renders such diagramatic understandings, underpinning the Cartesian bias of motion capture technology, problematic. An unresolvable tension emerges between the employed technology and its codification, that is, *Descendent*'s ML dimensionality. But, as we shall later argue, the Cartesianism of the first does not necessarily have to translate into the "modes of thought" of the latter. In *Descendent*, the use of ML and AI serves to liberate the body from a fake sense of subject-induced self-complete-ness, and the use of motion-capture-fed AI/ML, conceived as a memory machine (a nod to Jonathan Impett), results in a ghost-like enhancement of the virtual, as Mark Fisher would put it: "hauntology as the agency of the virtual," a dialectic between the *no-longer* and the *yet-to-happen*, insistence without existence.[79] *Choreomata*: unqualified matter, material-discursive phenomena, para-sentient machines dreaming-of-becoming-through-movement.

A pressing question: could all this be just a misunderstanding of *Descendent*'s mise-en-scène? Pure speculation? If not, how can performance and performativity be approached under the choreomatism of hybrid bodies?

On Performance, or Data vs. Soma

PICKERING:

Performance is the ground from which knowledge emerges and to which it returns.[80]

We argue that performative practices reflect and alter techno-social formation. By relating questions of performance and performativity to broader

Choreomata: unqualified matter, material-discursive phenomena, para-sentient machines dreaming-of-becoming-through-movement.

frameworks, the concepts transcend the artistic milieu, becoming relevant to wider "processes of techno-social emergence, production, and control."[81] The domain of the performative invokes a narrative of unleashed technology and the alignment and merging of its techno- and human-centric dimensions, it has become – after discipline – the "central dispositif of power and knowledge in our times."[82]

But can performativity be reconsidered beyond the human-technological entanglement, beyond postmodern narratives, beyond the ideas of alignment and merging? While Leeker provides a powerful starting point through the concept of "ensouled technologies," we believe that Karen Barad's posthuman performativity, emerging from her critical reading of quantum mechanics and the work of Niels Bohr, brings the concept closer to the idea of vapor bodies articulated above.[83] Barad's agential realist ontology is a critical countering of representationalism, the separation of the world into the ontologically disjointed domains of words and things. Following Bohr, phenomena – relations without preexisting relata, that is, "dynamic topological reconfigurings/entanglements/relationalities/(re)articulations" – replace independent objects as the primary epistemological units.[84] Countering the concept of interaction – presuming the prior existence of independent entities/relata – agential intra-actions that involve specific configurations of the apparatus of observation define the boundaries/components of phenomena, enacting agential separability. Apparatuses, which are themselves phenomena, are not inscription devices but "dynamic (re)configurings of the world, specific agential practices/intra-actions/performances through which specific exclusionary boundaries are enacted."[85] Phenomena are thus produced through the agential intra-actions, "causal material enactments that may or may not involve humans," of multiple apparatuses of bodily production.[86] As a result, all bodies, human and non-human, come to matter through the world's iterative intra-activity, that is, its performativity, bodies becoming material-discursive phenomena.

Against absolute exteriority (cultural practices produce material bodies) and absolute interiority (the reduction of effect to cause), Barad proposes an agential separatism that postulates an "exteriority within" as "apparatuses of bodily production (which are themselves phenomena) are (also) part of the phenomena they produce."[87] Her posthumanist materialist understanding of performativity challenges a vision of materiality as a given or effect of human agency, favoring its vision as an active factor in processes of materialization. Performativity becomes an iterative intra-activity instead of iterative citationality – Butler again. Bodies are displaced as primary epistemological units. Vapor bodies, as Bohrian phenomena, engage instead in agential intra-actions that both configure and are configured by apparatuses – enacting fleeting exclusionary boundaries through specific agential practices/intra-actions/performances. A vision that builds upon our discussion heretofore: corporeality as a flux that transverses the machinic, sentient machines dreaming-of-becoming-through-movement.

Bodies are displaced as primary epistemological units. Vapor bodies, as Bohrian phenomena, engage instead in agential intra-actions that both configure and are configured by apparatuses – enacting fleeting exclusionary boundaries through specific agential practices/intra-actions/performances. A vision that builds upon our discussion heretofore: corporeality as a flux that transverses the machinic, sentient machines dreaming-of-becoming-through-movement.

A final consideration of *Descendent* as a dynamic entanglement of representational idioms (e.g., texts, scores, designs, computer code) and performative practices leads us to three concluding remarks and a further reframing of performativity.[88] First, the relevance of the algorithmic condition, both the shift ignited by algorithms on practice-based knowledge production and acquisition but also their ability to produce a "symbolic logic that manifests as reality" – Arendt filtered through Lyotard[89] – altering the cultural and social phenomena organized through their procedural dynamics.[90] Second, the significance for AI-ML of inherent algorithmic non-performance beyond algorithmic randomness, that is, the approximation to a given referent that is not merely epistemological nor purely ontological but an indefiniteness: unforeseeability, uncomputability, incompressible information, undecidable propositions, glitch. A non-performance that "describes both the denial of agency but also the commitment to a space of alienness, where instrumentality outside ontology becomes a non-aesthetic practice ready to invert the human-machine equation of value."[91] Third, a critique of performance through an examination of the intellectual history of modern contract law, the relationship between personhood and state, linking the regulation of social life to contractual relationships.[92] Performativity as an exchange through endlessly diverse non-linear mechanisms – contractual relationships – mapping soma and data, that is, as the creative praxeology of data↔somatic metaphors.

As we have seen, the practice-based approach articulated thus far, emerging from our experience conceptualizing and developing *Descendent*, led us to – proprioceptively – question the role of the body in the resultant performative environment. We will now shift from discursive abstraction into auto-ethnographic reflection, to explore the inner workings of the project's ML architecture, addressing the tension between the technology's Cartesian underpinnings and its codification as an algorithmic structure, as a mode of thought, and reflecting on the project's limitations and biases beyond our techno-utopian framing.

Lost in Translation

AGRE:

The point, in any case, is that the practical reality with which AI people struggle in their work is not just 'the world,' considered as something objective and external to the research. It is much more complicated than this, a hybrid of physical reality and discursive construction. The trajectory of AI research can be shaped by the limitations of the physical world – the speed of light, the three dimensions of space, cosmic rays that disrupt memory chips – and it can also be shaped by the limitations of the discursive world – the available stock of vocabulary, metaphors, and narrative conventions.[93]

Performativity as an exchange through endlessly diverse non-linear mechanisms – contractual relationships – mapping soma and data, that is, as the creative praxeology of data↔somatic metaphors.

Descendent's ML architecture, the core code/algorithmic dimension of the project, explored the mechanisms underlying the bidirectional music-to-dance (sound-to-movement and movement-to-sound) mappings/translations taking place in our proposed performance. There were two major scopes to this work. First, we needed to codify some of the key sound features that served to understand the gesturality involved in the generation of the given musical fragments and a Labanian codification of the related dance movements. Second, we assigned labels to this material and developed a mapping framework as part of the machine learning architecture, a shared semantic space, able to generate new dance sequences from real-time sonic events. We executed these processes of translation/datafication/ digitalization in parallel – dancing movements to poses, sounds to sonic features, and those into labels with conceptual, aesthetic, and symbolic underpinnings. We envisioned such translations as one of the key aspects of our research: translations as mappings, as metaphors – via Latin from its Greek root, "to transfer."

Our first model (ReChoreoNet) addressed three key issues: (1). the generation of tempo-adjusted and beat-aligned motion; (2). aesthetic matching; and (3). diversity.[94] Put simply, ReChoreoNet re-choreographs high-quality dance motion to any musical input following a data-driven cross-modality learning strategy. Explained differently, we introduced a data-driven approach to develop a statistical model able to learn the correlation between dance styles, poses, and musical features. The model transcended the issues found in previous research (e.g., AI Choreographer, Transflower, ChoreoMaster), which are repetitive, stylistically limited, and unresponsive to changes in musical style. ReChoreoNet used the labeling system mentioned above to create what we defined as an aesthetically labelled music-dance repertoire (MDR), consisting of 596 music-motion sequence pairs (see Figure 18.1). We represented each pose with 21 three-dimensional markers (63 data points) and each musical event through 46 musical features extracted using the Python-based Librosa library and combining spectral, rhythmic, and beat-tempo-related elements. Given the cross-modal signal differences and the impossibility of an objective good-match definition, we implemented a data-driven strategy to correlate different data types.

A first process of somato-datafication, enabling machine-readability, served to generate digitized sound and motion. We then had to define a non-style-specific data-labeling system allowing us to incorporate the contemporary and experimental musical and dance elements that we wanted to explore in *Descendent* and its performative rendition. The labels had to be selective, practical, and easy to understand, and they had to facilitate real-time processing. The complexity of the somatic experience had to be transformed into a simple typology taking as a starting point existing computational solutions such as Librosa.[95] These fine-tuned labels then served to develop a mapping model abstracting the correlations between sounds and dance movements (Figure 18.4)..

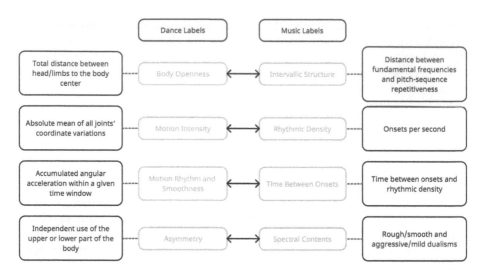

FIGURE 18.4
Features of the aesthetically labelled music-dance repertoire/MDR.

ReChoreoNet had several limitations. First, time warping over a one-dimensional flow field critically reduced the music-to-dance translation to a pose vs. aligned-beat dualism, fundamentally based on a Beat Alignment Score (BAS). However, automated onset and offset extraction and beat recognition remain critically imprecise. The reduced size of the training database, which had to be complemented with the AIST++, posed a second challenge.[96] Thirdly, the rating (on a 1 to 10 scale) and the derived label distances of the MDR sequences based on the motion-music feature, which served as the basis for the crucial Motion Restyle Module, were inferred from the artists' biassed analyses instead of objective data.

Several elements hindered ReChoreoNet's body-machine-readability. First, a non-style based approach to music-based dance motion generation – the one that we are interested in – should attempt to bypass human labeling and employ instead an objective correlation between the two first-level translation layers, that is, sound features and pose sequences. Second, standard CS approaches need to abandon the consideration of dance as pose-sequencing and the Turing test paradigm, which limits the non-replicative/experimental exploration of AI- and ML-mediated tools. CS must counter the reification of analytical framing concepts such as naturalness, transition cost, and action completeness to enable the exploration of new approaches to music and dance generation.

Our second model, ChoreoGraph, partially addressed some of these limitations.[97] ChoreoGraph worked instead with the concept of choreomusical rules, linked to the labeling and mapping mechanisms developed earlier, exploring the correlation between dance styles, pose symbolism, and rhythmic structures. Countering previous research, this model matches motion to

audio beats to guarantee the naturalness of the resultant motion sequences. The key novelty is the alignment of pose with spectral feature instead of rhythm-based sequences through music/motion nodes, employing four-second mel-scaled spectrograms of shape [1, 96, 4*60], which were processed into a thirty-two-dimensional style embedding framework. However, ChoreoGraph's novel approach leads to the same fundamental questions: can code, as an exosomatic mode of thought working through epiphylogenetic memories, transcend the Cartesian underpinnings of the technology supporting it? Is code the differential element harnessing the disintegration of the Simondonian body into vapor?

Conclusion

This chapter has introduced the concept of the ~~human~~, against a genealogy of existing research, as a critique of postmodern conceptions of the body. As we have seen, vapor bodies represent an attempt at a non-anthropomorphic understanding past the porous and the atomized and into the diffused/ dispersed and the vaporous, emerging as unqualified material-discursive phenomena both shaped and dissolved through the world's iterative intra-actions. They testify to a vision of technology as an exosomatization, channeled through biological and noetic plasticity and adaptation (e.g., Alfred Lotka's exosomatic evolution),[98] and to AI as a fleetingly dimmed social post-consciousness, as an expression of the irreducibility of intelligence(s) to a set of processes taking place within individualized minds. Machine learning is thus placed against the servo-mechanic approach of cybernetics: a new machine-reconfigured (de)subjectivity beyond the slave/user dualism, the "ingression of computation into the realm of thinking, breaking away from the self-determination of human consciousness."[99]

We introduced *Descendent* as an artistic framework positing movement – the foundational vector of both dance and music-making – as a precondition of the body that allows us to recast choreography beyond hylomorphic and Cartesian approaches, beyond textual and graphical underpinnings, into *choreomata*: unqualified matter, material-discursive phenomena, sentient machines dreaming-of-becoming-through-movement. Bodies as cognitive forces, as vectors in performance, and corporeality as a flux that transverses the machinic. Such an approach has served to question the very definition of performativity after the subject, through the ~~human~~ vapor body, in AI-mediated regimes. Performativity becomes here an exchange through unbound non-linear mechanisms articulated as contractual relationships mapping soma and data, a creative praxeology of data↔somatic metaphors. A specific discussion of *Descendent*'s algorithmic structure has served to expose its inherent "modes of thought" against the inescapable Cartesianism

of the employed technology, channelling a speculative theoretical discussion into the factual consideration of the project's underlying code architecture. While AI has not begotten vapor bodies, it has critically accelerated the increasingly complex wcontingency of the body and the dissolution of subjectivity and consciousness to an "exit experience."[100]

Notes

1 *Descendent* is introduced here as a conceptual framework, enabling but also transcending its several instantiations.
2 Erin Manning and Brian Massumi, *Thought in the Act*, (84).
3 We connect our understanding of the somatic to the Husserlian idea of *hyletic data*.
4 Anna Munster, *Materializing New Media*, (91).
5 Although we will revisit it later, the concept of the hybrid body has been commonly employed in dance-related research to refer to the processes emerging from the Harawaian kinship between organism and machine, that is, the study of bodies that transcend mechanical and organic boundaries, but also to her discussion of *sympoiesis* [making-with]. Relevant recent research includes Aurie Hsu and Steven Kemper, "Enacting Sonic-Cyborg Performance"; and Sarah Homewood et al., "Tracing Conceptions of the Body in HC."
6 Gilbert Simondon, *Individuation*, (9).
7 Although we will not discuss it here, it is worth keeping in mind the influence of Merleau-Ponty's concept of "reversible body" on Simondon's thinking.
8 Erin Manning, *Always More Than One*, (1).
9 A valuable framing to reconsider the role of the somatic (*Descendent*'s approach to dance- and music-as-movement) in a digitized creative environment. Consider as an example the work of Sarah Whatley: "Transmitting, Transforming, and Documenting Dance in the Digital Environment."
10 Antonin Artaud, *The Theater and Its Double*.
11 Ibid., (8–9).
12 Laura Potrovic, "What a Body Can Become," (19).
13 Anne Sauvagnargues, *Deleuze and Art*, (57).
14 Ibid., (58).
15 For a critical reading of the BwO see Slavoj Žižek, *Organs without Bodies*.
16 Manning, *Always More Than One*, (28).
17 Balibar, *Spinoza, the Transindividual*.
18 See Stiegler, *Technics and Time: The Fault of Epimetheus*, (145).
19 Donna Haraway, "A Cyborg Manifesto," in *Feminism/Postmodernism*, edited by Linda Nicholson, (220).
20 Haraway, *Simians, Cyborgs, and Women*, (149).
21 Ibid., (170).
22 Ibid., (178; 163).
23 Ibid., (200).
24 Haraway, "The Biopolitics of Postmodern Bodies."

25 Ihde, *Bodies in Technology*, (137).

26 Examples of relevant research would include Mark Franko, "What Is Dead and What Is Alive in Dance Phenomenology?" *Dance Research Journal*, 43(2): (1–4), 2011.

27 For a discussion of the concept of ecosophy see Rosi Braidotti, "Posthuman, All Too Human."

28 Jordi Vivaldi, "Xenological Subjectivity," (314).

29 Braidotti, *Transpositions*, (148).

30 Ibid., 132.

31 Graham Harman, *Immaterialism*.

32 Catherine Malabou, "On Contemporary Objects," in *Plastic Materialities*, edited by Brenna Bhandar and Jonathan Goldberg-Hiller, (21–40).

33 Harman, *Immaterialism*, (114–126).

34 Hutchison and Kim Vincs, "Dancing in Suits."

35 Haraway, *Simians*; and Pickering, *The Mangle of Practice*.

36 Daniel N. Stern, *The Interpersonal World of the Infant*.

37 Katerina Kolozova, "Subjectivity without Physicality," (6).

38 Marek Poliks and Roberto Alonso Trillo, "0-Degree Plane of Neuroelectronic Continuity."

39 Davor Löffler, "Rekursion zivilisatorischer Kapazitäten als Entwicklungsmuster in der Zivilisationsgeschichte," (19). For a genealogy of the concept of the subject and its history see Nina Power, "Philosophy's Subjects."

40 Donna Haraway defines the Chthulu vs. Anthropos through its entanglement in "myriad temporalities and spatialities and myriad intra-active entities-in-assemblages – including the more-than-human, inhuman, and human-as-humus" (Haraway, *Staying with the Trouble*, [101]). On the other hand, Laruelle introduces the term human-in-the-last-instance, to define an identity that abdicates its status to that of the Real, preceding and prefiguring language (François Laruelle, *Philosophy and Non-philosophy*; and Thomas Sutherland and Elliot Patsoura "Human-in-the-last-instance?"). Negarestani's inhuman represents a radical departure from human cognitive frameworks that defines intelligence as a multi-scalar universal process transcending anthropocentric paradigms. Negarestani points out how "the kernel of inhumanism is a commitment to humanity via the concurrent construction and revision of human as oriented and regulated by the autonomy of reason" (Reza Negarestani, "The Labor of the Inhuman"; and Negarestani, *Intelligence and Spirit*).

41 *Sentio* is used here to refer to an individual's complex amodal sensory experiences, internal and external, a vision that transcends the dominant focus on the senses and their relation to perception – see Daniel Heller-Roazen, *The Inner Touch*. The idea of an extended sentio relates to Luciana Parisi's examination of codes as modes of thought that "do things," bearing upon structures from the level of data to that of hardware or the noumenal. "The novelty of soft thought has to be found in its process of division of potential quantities: mathematical ideas that Whitehead calls eternal objects. These quantities are 'felt' by the entities that they operate without being summed up into a finite cipher or being counted as infinities." Following Parisi's argument, a qualitative transduction is not necessary as these quantities are felt as conceptual contagions, that is, conceptually felt but not directly sensed – see Parisi, *Contagious Architecture*, (336). Parisi points out that "what is perceived is not disentangled from what happens

to a body, and the latter exists in no royal isolation from what happens to abstract extension" – see Parisi, "Symbiotic Architecture," (367). Ned Rossiter connects sentience to his discussion of logistical cities when he claims that "in the sentient city, data becomes a living entity" – in Ned Rossiter, *Software, Infrastructure, Labor: A Media Theory of Logistical Nightmares*, New York: Routledge, 2016, (xiii).

42 Alexander Galloway, *Laruelle*, (108).
43 Kolozova, "Subjectivity without Physicality," (10).
44 Dourish, *Where the Action Is*.
45 Simon Penny, *Making Sense*, (188).
46 Ibid., (187).
47 Ibid., (190).
48 Hubert Dreyfus, "The Current Relevance of Merleau-Ponty's Phenomenology of Embodiment."
49 Michael Polanyi, *The Tacit Dimension*.
50 Anna Munster, *Materializing New Media*, (93).
51 Ibid.
52 Ibid., (115).
53 Félix Guattari, (45–49).
54 Félix Guattari, (45–49).
55 Kozel, *Closer*, (214).
56 Hutchison and Vincs, "Dancing in Suits," (1).
57 Stamatia Portanova, *Moving without a Body*, (25).
58 See Luka and Louise Crnkovic-Friis, "Generative Choreography using Deep Learning," https://arxiv.org/abs/1605.06921.
59 Deborah Hay, *My Body, the Buddhist*, (xv).
60 Potrovic, "What a Body Can Become," (90).
61 Hutchison and Vincs, "Dancing in Suits," (3).
62 Think of José Gil's concept of total movement or the Deleuzian idea of absolute movement – José Gil, *Paradoxical Body*; and Gilles Deleuze, *Cinema I*, (33).
63 Manning, *Always More Than One*, (14).
64 Ibid.
65 Kozel, *Closer*, (53).
66 Marco Donnarumma, "Configuring Corporeality," (110).
67 Donnarumma, "Across Bodily and Disciplinary Borders," (38).
68 This also brings to mind J. C. R. Licklider's visionary 1960 theorization of man-computer symbiosis in "Man-Computer Symbiosis," *IRE Transactions on Human Factors in Electronics*, 1960, (4–11).
69 Margrit Shildrick, "'Why Should Our Bodies End at the Skin?,'" (18).
70 Portanova, *Moving without a Body*, (5).
71 Massumi, *Parables for the Virtual*.
72 Portanova, *Moving without a Body*, (10).
73 See Guest, *Labanotation*.
74 Shaviro in Portanova, (19).
75 Parisi, "Abstract Spatium"; and Parisi, "Symbiotic Architecture."
76 For a comprehensively critical contribution to the consideration of digital bodies and the role of technology in related practices central to the arts and humanities see Susan Broadhurst and Sara Price (eds.), *Digital Bodies*.
77 Portanova, *Moving without a Body*, (62).
78 Ibid., (25).

79 Fisher, *Ghosts of My Life*, (18).
80 Pickering, "Ontological Theatre Gordon Pask," (44).
81 Jon McKenzie, *Perform or Else*.
82 McKenzie, "Performativitäten, Gegen-Performativitäten und Meta-Performativitäten," in *Performing the Future*, edited by Erika Fischer-Lichte and Kristiane Hasselmann, (144).
83 Martina Leeker points out how performativity "implies not a simple expression of action, but a complex amalgam of a performance and production (mis-en-scène) history of unrestricted, ensouled technologies" and the dispositif of the performative within digital cultures should acknowledge "that the performative turn has facilitated an approximation and equalization of medial, technological and human performances" – see Leeker et al. (eds.), *Performing the Digital*, (22; 27).
84 Barad in Cecilia Åsberg and Rosi Braidotti, *A Feminist Companion to the Posthumanities*, (135).
85 Ibid., (134).
86 Ibid., (135).
87 Ibid., (143).
88 Simon Penny argues that "programming languages, as systems for the specification of behavior, occupy a novel position in terms of cultural artefacts, being texts that are both representational and performative" – see Penny, *Making Sense*, (417). This brings to mind Agre's critical reading of AI as an incarnation of disembodied conceptions of philosophy and his vision of deictic programming, contesting the God-eye view assumptions of conventional AI, relating as well to our previous discussion of the technology vs. code Cartesianism and to *Descencent's* somatotechnological (Loderl) or exosomatic (Stiegler) underpinnings – see Jethro Masís, "Making AI Philosophical Again."
89 Felicity Colman et al., "Ethics of Coding," (9). See Hannah Arendt, *The Human Condition*; and Jean-François Lyotard, *The Postmodern Condition*.
90 Colman et al., (9).
91 Parisi, "Negative Aesthetics: AI and Non-performance."
92 Fred Moten, *Stolen Life*, (244).
93 Agre, *Computation and Human Experience*, (15).
94 Ho Yin Au et al., "ReChoreoNet."
95 See https://librosa.org/.
96 See https://google.github.io/aistplusplus_dataset/factsfigures.html.
97 Au et al., "ChoreoGraph."
98 See Bobulescu, "From Lotka's Biophysics to Georgescu-Roegen's Bioeconomics."
99 Parisi, "The Alien Subject of AI," (31).
100 Poliks and Trillo, "0-Degree Plane of Neuroelectronic Continuity."

References

Agre, P. E. (1997). *Computation and Human Experience*. Cambridge: Cambridge University Press.
Arendt, H. (2018). *The Human Condition*. Second edition. Chicago, IL: University of Chicago Press.

Artaud, A. (1958). *The Theater and Its Double*, translated by Mary Caroline Richards. New York: Grove Press.

Asberg, C., and Braidotti, R. (eds.). (2018). *A Feminist Companion to the Posthumanities*. Cham: Springer.

Au, H. Y., Chen, J., Jiang, J., and Guo, Y. (2022). "ChoreoGraph: Music-Conditioned Automatic Dance Choreography over a Style and Tempo Consistent Dynamic Graph." *ArXiv:2207.07386[cs.MM]*. https://doi.org/10.48550/arXiv.2207.07386.

Au, H. Y., Chen, J., Jiang, J., and Guo, Y.-K. (forthcoming). "ReChoreoNet: Repertoire-Based Dance Re-choreography with Music-Conditioned Temporal and Style Clues." *IEEE Transactions on Neural Networks and Learning Systems*.

Balibar, É. (2022). *Spinoza, the Transindividual*, translated by Mark G. E. Kelly. Edinburgh: Edinburgh University Press.

Bhandar, B., and Goldberg-Hiller, J. (eds.). (2015). *Plastic Materialities: Politics, Legality, and Metamorphosis in the Work of Catherine Malabou*. Durham, NC: Duke University Press.

Bobulescu, R. (2015). "From Lotka's Biophysics to Georgescu-Roegen's Bioeconomics." *Ecological Economics*, 120: 194–202.

Braidotti, R. (2006). "Posthuman, All Too Human: Towards a New Process Ontology." *Theory, Culture and Society*, 23(7–8): 197–208.

Braidotti, R. (2006). *Transpositions: On Nomadic Ethics*. Cambridge: Polity Press.

Broadhurst, S., and Price, S. (eds.). (2017). *Digital Bodies: Creativity and Technology in the Arts and Humanities*. London: Palgrave Macmillan.

Cadava, E., Connor, P., and Nancy, J.- L. (eds.). *Who Comes after the Subject?* New York: Routledge.

Colman, F., Bühlmann, V., O'Donnell, A., and Tuin, I. V. D. (2018). *Ethics of Coding: A Report on the Algorithmic Condition*. Brussels: European Commission.

Deleuze, G. (2005). *Cinema I: The Movement Image*, translated by Hugh Tomlinson and Barbara Habberjam. London: Continuum International.

Donnarumma, M. (2016). "Configuring Corporeality: Performing Bodies, Vibrations and New Musical Instruments." PhD dissertation, Goldsmiths College. https://doi.org/10.25602/GOLD.00019202.

Donnarumma, M. (2020). "Across Bodily and Disciplinary Borders: Hybridity as Methodology, Expression, Dynamic." *Journal of the Performing Arts*, 25(4): 36–44. https://doi.org/10.1080/13528165.2020.1842028.

Dourish, P. (2001). *Where the Action Is: The Foundations of Embodied Interaction*. Cambridge, MA: MIT Press.

Dreyfus, H. (1996). "The Current Relevance of Merleau-Ponty's Phenomenology of Embodiment." *The Electronic Journal of Analytic Philosophy*, 4(4): 1–16.

Fisher, M. (2014). *Ghosts of My Life: Writings on Depression, Hauntology, and Lost Futures*. Winchester, UK: Zer0 Books.

Fischer-Lichte, E., and Hasselmann, K. (eds.). *Performing the Future: Die Zukunft der Performativita tsforschung*. Munich: Fink.

Galloway, A. (2014). *Laruelle: Against the Digital*. Minneapolis, MN: University Of Minnesota Press.

Gil, J. (2006). "Paradoxical Body." *TDR/The Drama Review*, 50(4): 21–35. https://doi.org/10.1162/dram.2006.50.4.21.

Guattari, F. (1992). *Chaosmosis: An Ethico-aesthetic Paradigm*. Bloomington, IN: Indiana University Press.

Guest, A. H. (2014). *Labanotation: The System of Analyzing and Recording Movement.* Fourth edition. New York: Routledge.

Haraway, D. (1989). "The Biopolitics of Postmodern Bodies: Determinations of Self in Immune System Discourse." *differences,* 1(1): 3–43. https://doi. org/10.1215/10407391-1-1-3.

Haraway, D. (1991). *Simians, Cyborgs, and Women.* New York: Routledge.

Haraway, D. (2016). *Staying with the Trouble: Making Kin in the Chthulucene.* Durham, NC: Duke University Press.

Harman, G. (2016). *Immaterialism: Objects and Social Theory.* Hoboken, NJ: Wiley.

Hay, D. (2000). *My Body, the Buddhist.* Middletown, CT: Wesleyan University Press.

Heller-Roazen, D. (2007). *The Inner Touch: Archaeology of a Sensation.* New York: Zone Books.

Homewood, S., Hedemyr, M., Fagerberg Ranten, M., and Kozel, S. (2021). "Tracing Conceptions of the Body in HCI: From User to More-Than-Human." *Proceedings of the 2021 CHI Conference on Human Factors in Computing Systems,* 1–12. Yokohama, Japan, 8–13 May 2021.

Hsu, A., and Kemper, S. (2019). "Enacting Sonic-Cyborg Performance through the Hybrid Body in *Teka-Mori and Why Should Our Bodies End at the Skin?" Leonardo Music Journal,* 29: 83–87.

Hutchison, S., and Vincs, K. (2013). "Dancing in Suits: A Performer's Perspective on the Collaborative Exchange between Self, Body, Motion Capture, Animation and Audience." *Proceedings of the Nineteenth International Symposium on Electronic Art, ISEA2013,* 1–4. Sydney, Australia, 7–16 June 2013.

Ihde, D. (2002). *Bodies in Technology.* Minneapolis, MN: University of Minnesota Press.

Kolozova, K. (2019). "Subjectivity without Physicality: Machine, Body, and the Signifying Automaton." *Subjectivity,* 12: 49–61.

Kozel, S. (2008). *Closer: Performance, Technologies, Phenomenology.* Cambridge, MA: MIT Press.

Laruelle, F. (2013). *Philosophy and Non-Philosophy,* translated by Taylor Adkins. Minneapolis: University of Minnesota Press.

Leeker, M., Schipper, I., and Beyes, T. (eds.). (2018). *Performing the Digital: Performativity and Performance Studies in Digital Cultures.* Bielefeld: transcript.

Löffler, D. (2017). "Rekursion zivilisatorischer Kapazitäten als Entwicklungsmuster in der Zivilisationsgeschichte." PhD dissertation, Freie Universität Berlin.

Lyotard, J.-F. (1984). *The Postmodern Condition,* translated by Geoff Bennington and Brian Massumi. Minneapolis, MN: University of Minnesota.

Manning, E. (2013). *Always More Than One: Individuation's Dance.* Durham, NC: Duke University Press.

Manning, E., and Massumi, B. (2014). *Thought in the Act: Passages in the Ecology of Experience.* Minneapolis: Minnesota University Press.

Masís, J. "Making AI Philosophical Again: On Philip E. Agre's Legacy." *Continent,* 4(1): 58–70.

Massumi, B. (2002). *Parables for the Virtual: Movement, Affect, Sensation.* Durham, NC: Duke University Press.

McKenzie, J. (2001). *Perform or Else: From Discipline to Performance.* New York: Routledge.

Moten, F. (2018). *Stolen Life.* Durham, NC: Duke University Press.

Munster, A. (2006). *Materializing New Media: Embodiment in Information Aesthetics.* Hanover, NH: Dartmouth College Press.

Negarestani, R. (2014). "The Labor of the Inhuman, Part I: Human." *e-flux* (52). https://www.e-flux.com/journal/52/59920/the-labor-of-the-inhuman-part-i-human/.

Negarestani, R. (2018). *Intelligence and Spirit*. New York: Urbanomic.

Nicholson, L. (ed.). (1990). *Feminism/Postmodernism*. New York: Routledge.

Parisi, L. (2009). "Abstract Spatium: Deleuze and Whitehead via Algorithmic Architecture." *Conference Paper Presented at CONNECTdeleuze International Conference at University of Cologne*. Cologne, Germany, 10–12 August 2009.

Parisi, L. (2009). "Symbiotic Architecture: Prehending Digitality." *Theory, Culture and Society*, 26(2–3): 346–374.

Parisi, L. (2013). *Contagious Architecture: Computation, Aesthetics, and Space*. Cambridge, MA: MIT Press.

Parisi, L. (2019). "The Alien Subject of AI." *Subjectivity*, 12: 27–48.

Penny, S. (2017). *Making Sense: Cognition, Computing, Art, and Embodiment*. Cambridge, MA: MIT Press.

Pickering, A. (1995). *The Mangle of Practice: Time, Agency, and Science*. Chicago, IL: University of Chicago Press.

Pickering, A. (2007). "Ontological Theatre Gordon Pask, Cybernetics, and the Arts." *Cybernetics and Human Knowing*, 14(4): 43–57.

Polanyi, M. (1966). *The Tacit Dimension*. Chicago, IL: University of Chicago Press.

Poliks, M., and Trillo, R. A. (2023). '0-Degree Plane of Neuroelectronic Continuity: AI & Psychosocial Evaporation'. In *Choreomata: Performance and Performativity after AI*, edited by Marek Poliks and Roberto Alonso Trillo. Abingdon, UK: CRC Press.

Portanova, S. (2013). *Moving without a Body: Digital Philosophy and Choreographic Thoughts*. Cambridge, MA: MIT Press.

Potrovic, L. (2018). "What a Body Can Become: Cartography between Dance and Philosophy." PhD dissertation, Universite Sorbonne Paris / University of Zagreb.

Power, N. (2007). "Philosophy's Subjects." *Parrhesia*, 3: 55–72.

Sauvagnargues, A. (2013). *Deleuze and Art*, translated by Samantha Bankston. London: Bloomsbury Academic.

Shildrick, M. (2015). "'Why Should Our Bodies End at the Skin?': Embodiment, Boundaries, and Somatechnics." *Hypatia: A Journal of Feminist Philosophy*, 30(1): 13–29.

Simondon, G. (2020). *Individuation in Light of Notions of Form and Information*, translated by Taylor Adkins. Minneapolis: University of Minnesota Press.

Stern, D. N. (1985). *The Interpersonal World of the Infant: A View from Psychoanalysis and Developmental Psychology*. New York: Harper.

Stiegler, B. (1998). *Technics and Time, 1: The Fault of Epimetheus*, translated by Richard Beardsworth and George Collins. Redwood City, CA: Stanford University Press.

Sutherland, T., and Patsoura, E. (2015). "Human-in-the-Last-Instance? The Concept of 'Man' between Foucault and Laruelle." *Parrhesia*, 24: 285–311.

Vivaldi, J. (2021). "Xenological Subjectivity: Rosi Braidotti and Object-Oriented Ontology." *Open Philosophy*, 4(1): 311–334. https://doi.org/10.1515/opphil-2020-0187.

Whatley, S. "Transmitting, Transforming, and Documenting Dance in the Digital Environment: What Dance Does Now That It Didn't Do Before." *TDR/The Drama Review*, 61(4): 78–95.

Žižek, S. (2016). *Organs without Bodies: Deleuze and Consequences*. New York: Routledge.

19

Descendent: Understanding the Digital Production Process From Human Interpretation to Algorithmic Interpolation to AI Inference.

Peter AC Nelson

In the early 2000s, actor Andy Serkis rose to prominence for his performance as Gollum in the second installment of Peter Jackson's Tolkien film trilogy, *The Lord of the Rings: The Two Towers*. Originally cast as a voice actor, Serkis's physical performance, in addition to his skills as a rock climber, proved invaluable to the digital production team and not only led to the landmark hybrid performance of the Gollum character but also propelled Serkis into further motion capture performances in films such as *Rise of the Planet of the Apes* (directed by Rupert Wyatt, 2011). In a 2014 interview, Serkis sought to advocate for the artistry of actors whose performances were visualized digitally using motion capture technology:

> It's a given that they absolutely copy [the performance] to the letter, to the point in effect what they are doing is painting digital makeup onto actors' performances. It's that understanding which has changed as much as anything.[1]

While it is likely that Serkis was trying to raise the recognition for actors performing in motion capture roles, his comment provoked an outcry from programmers, 3D modelers, animators, technical directors, riggers, and biologists, all of whom are instrumental in creating the on-screen performance of hybrid characters.[2] The controversy following Serkis's comment arose from the implication that the physical motion of the actor corresponds to labels such as 'art', 'acting', or 'performance', and that everything else is diminished to more mechanical adjectives such as 'technical production' or 'craft'. The abstract and potentially reusable nature of motion data also places Serkis in a similarly vulnerable position to other digital artists, whose work as data can potentially be reused. For example, in one of the earliest intellectual property disputes over motion data, martial artists contracted to perform motion for

DOI: 10.1201/9781003312338-28

the *Mortal Kombat* computer game ended up in a dispute with Midway as to whether their movements could be reused in the sequels to the original game. Despite these movements representing years of practice and training, the courts found that 'the copyright holder of a digitally created derivative work, based on a digitized version of a recorded performance in which the actor has consented to appear, has rights superior to those of the actor in the original work';[3] in other words, once the martial artists had sold their motion to Midway, the company was free to use it in whatever new games they liked.

In this chapter, I am not going to tackle the question of who is the actor and who is the technician, but instead, I use Serkis's notion of 'digital make-up' to describe a transition in the creative process from human interpretation to algorithmic interpolation to AI-driven inference. Using the hybrid digital dancer from our *Descendent* project as a case study, I describe three layers of 'digital make-up' where actions and decisions made by digital artists have been automated or augmented by discrete algorithms, and how these discrete algorithms have been automated or augmented by deep learning AI systems. From an examination of digital motion capture, 3D rigging, and image denoising, I argue that the human interprets, the algorithm interpolates, and the AI system infers, and that by understanding the difference between these creative actions, we can better understand the performative nature of AI, not necessarily as something that stands as a binary challenge to human creativity and performance, but as something that like algorithmic automation is being infused into our creative processes.

Human Interpretation, Algorithmic Interpolation, and AI Inference

I want to start by clarifying what I mean by human interpretation, algorithmic interpolation, and AI inference. Let us take the case of enlarging an image as an example. Say I have a 512×512-pixel photograph of a tree that I want to enlarge for printing. In an image editor such as Photoshop or GIMP, if I increase the pixel dimensions to 2048×2,048, the software has to invent about 4 million new pixels and needs an interpolation algorithm to decide what the RGB value of each new pixel should be. The simplest interpolation method is to create the new pixel by copying the color from the closest original neighbor, which results in a sharp, 'pixellated' effect, as there is no smooth transition (or interpolation) between pixel values. A linear interpolation algorithm would compute the average color of the four closest pixels in the original image and a cubic algorithm would compute the average color of the eight closest pixels in the original image, both of which would result in a smoother if potentially blurry final result.[4] This algorithmic interpolation

can be thought of as an application of a discrete mathematical function, and contrasted to human interpretation, where instead of relying on this automated function, I might intervene manually, by repainting pixel values by hand. While it would be heavily time-consuming, I might reason that my interpretations have more accuracy and nuance than the algorithm. A more familiar contrast might be that between using an automated selection tool to isolate an object in a photograph or using a manual selection tool; the algorithmic interpolation is faster, and the human interpretation is typically more accurate but more time-consuming.

From enhancing medical scans to saving the time of human interpretation, digital imaging is a large market, and AI tools are offering a new method for solving the original problem of enlarging my photograph of a tree. At the time of writing, I can upload my photo to an online service that uses deep learning to create new pixels, not based on a discrete mathematical extrapolation of the original, but by referencing what the system has learned from a large training dataset of what images should look like to infer new pixels. Unlike the algorithmically interpolated pixels, we cannot easily deduce the logical relationship these new pixels have to those of the original image. Using the language of another chapter in this book, these inferred pixels are a performative expression of what we have taught the system an image should look like. AI tools are autoregressive: 'an autoregressive machine is a crawler, a Turing machine, a process that ingests content and outputs a next step ... there is nothing ... new'.[5]

In a recent lecture on AI and art, musician Alex Ebert also characterized AI tools as inherently conservative, the subconscious antagonist to the progressive innovator.[6] By making a comparison to the conservatism that comes from Hollywood studios using focus groups to reduce market risk in their scriptwriting, Ebert argued that using AI to enhance an image, video, or text prompt will produce something compliant with the creative practices of the past, represented by the dataset, and thus would classify any creative break with this past as an error, or noise.[7] By situating AI within a broader metaphorical dualism of conservative and progressive, Ebert argues that artists can form better relationships with AI systems by understanding the inherently conservative nature of the system and positioning themselves as progressive or radical, or simply generators of a type of error that is alien to AI. This chapter does not examine the proportional disengagement of humans from creative processes, but instead takes Serkis's notion of 'digital make-up' as an excuse to explore how AI inference is being infused into production pipelines. We can flip the hierarchy and suggest that the make-up wears the actor, or just put the actor and make-up next to one another in a dedifferentiated and ontologically flattened assemblage of human interpretive, algorithmically interpolated, and AI inferring processes and compare these using other qualitative descriptors, such as the conservative and progressive metaphor suggested above.

We can flip the hierarchy and suggest that the make-up wears the actor.

Descendent – System and Narrative Designs

As mentioned by Roberto Alonso Trillo in the chapter 'Descendent: AI and the Body Beyond Hybridization', *Descendent* was originally conceived as a performance ecosystem involving sound, dance, and computer graphics integrating a virtual avatar driven by AI-generated motion.[8] In various iterations, this technological assemblage was reconfigured, set to a narrative script, and rendered in a graphics environment that I designed. I would like to discuss here a specific instantiation of *Descendent* that looks at chains of gestural translation, where, for example, Trillo performs a musical phrase, dancer Sudhee Liao responds with movement, and at the same time, the machine learning network generates motion based on the same phrase, confronting both dancer and musician with an alternative creative gesture based on what it knows about how they both perform together. In this example, the system outputs numerical pose data that represent position and rotation data for a virtual skeleton. That skeleton is used to drive the character that the audience and the performers see on screen and in the first performance of the work.

We built the system around Mary Shelley's interpretation of the Prometheus myth, where both procreation and technological innovation are positioned as ethical challenges of agency and responsibility and the creator, whether parent, scientist, or god, is responsible for the free will and suffering of any sentient being they create.[9] In our first performance, the choreography explored this narrative over three acts in which the causal relationship from musical prompt, to dance, to interpreted motion was increasingly frustrated, first by the dancer rejecting the phraseology of the musician, and then by the digital avatar diverging from the dancer and asserting its own responses to the music. Working with costume designer Irene Kiriiaka, we explored these themes in physical and digital costume design as well, looking at the representation of humanoid robots in films such as *Metropolis*, hybrid alchemical figures such as the golem, the homunculus, and horror characters such as the Pyramid Head designed by Masahiro Ito for the game *Silent Hill*. In music, this was paired with an electroacoustic composition that combined several elements, from Yiddish folk traditions to noise. These cultural references to chains of creation and culpability linked back to our central exploration of the performance system itself, the chain of gestural translation that became a springboard for speculating on the broader implications of infusing AI into performative systems. In later iterations of the *Descendent* system, we explored choreography based on the story of Narcissus and Echo and integrated other hardware such as lasers driven by a customized IMU-integrated headdress and remixes of Conway's *Game of Life*. In the following three sections, I demonstrate from a practical perspective how the mixture of human interpretation, algorithmic interpolation, and AI inference is embedded in the production pipeline, and therefore how the distinction of the 'actor' and the 'make-up' can be better read as a dedifferentiated vapor state, where both wear each other and perform in a mutually antagonistic manner.

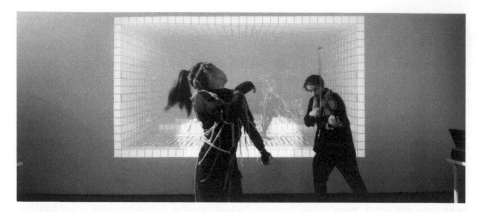

FIGURE 19.1
An exchange of gestures from violin, to dance, to motion generation in Descendent.

AI Inference and Motion Capture

A motion capture performance, whether for animation as in the case of Serkis and Gollum, or as a dataset to train an AI as in *Descendent*, relies on a technological assemblage that is measured and corrected by algorithmic interpolation, but this is being increasingly infused with inferential data. The *Descendent* motion dataset was captured using a Rokoko suit, which integrates nineteen inertial measurement units (IMUs) placed on various key parts of the body, such as the head and major joints of skeletal rotation, including the elbows, shoulders, knees, pelvis, and so on. The IMUs record data using a combination of accelerometers, magnetometers, and gyroscopes, which when calibrated together, transfer rotation and certain position data from the dancer onto a digital skeleton. High-budget cinema and scientific research are more likely to use optical motion tracking, which uses a large array of cameras to record the position of small markers placed on the body or face, which can face difficulties if a marker is not visible to a camera. IMU-based 'mocap' allows for a cheaper, more lightweight system to send data from each body joint directly to the virtual skeleton in the computer. While it does not have the problem of sensors being occluded from cameras, it faces numerous challenges in calibration due to the nature of the sensors. An accelerometer can accurately calculate degrees of rotation, but not absolute position in space, and relies on a magnetometer to calibrate what is up or down relative to the center of the earth, which itself can be obscured by magnetic fluctuations in the local environment. Sensor drift occurs when a small measurement error is inherited by the next body position, and over

time the readings from the IMU suit can become significantly different from the position and performance of the movement artist. Occluded optical sensors and inaccurate readings from IMUs can be corrected by recalibrating physical devices, as well as cleaned up using human interpretation in 3D software, by manually correcting keyframes where inaccurate or unrealistic positions occur, such as feet hovering above the ground or hands, wrists, and fingers in strange positions. As researchers in computer graphics and biomechanics strive for more accurate motion capture systems, deep learning is being applied to improve the accuracy of motion capture. Using networks trained on cleaned motion capture performances, machine learning can make musculoskeletal modeling predictions for how the body might be moving relative to any discrepancy from the sensor, identifying a position as an error (or noise) and replacing it with an inferential guess.[10] Put another way, the system is saving the time required for human interpretation (and manual correction) by projecting the past into the present when at the first layer of capture and performance, a machine learning system is called upon to evaluate motion data relative to what it knows about the history of movement relative to other mocap performances, highlight any position that is 'wrong' according to this dataset, and replace it with a new, inferred position based on what it thinks is correct.

Binding Motion to the Virtual Body

Motion capture typically records what we might think of as skeletal data: the rotation of major joints on the body, such as the wrists, elbows, shoulders, knees, spine, and so on. Unless a system of spatial markers has been specifically drawn over the musculature of the performer, as was the case in Josh Brolin's performance of Thanos as captured by the DNG Group's 'Masquerade' system,[11] a conventional optical system cannot detect the flexing and relaxing of muscles or the deformations of fat, skin, or clothing. A motion capture file, usually transferred in the .bvh (Biovision Hierarchy) format, contains the initial pose of the dancer, expressed as a hierarchy of bones and rotation values, followed by sequential timestamped position and rotation values for those same bones, which when viewed in a 3D program look like a dancing skeleton.[12]

The skeleton can differ according to several factors, such as the approximate proportions of the actor or the level of detail of the recording device (for example, whether the motion capture suit recorded individual fingers or just wrist rotations).[13] The skeleton is also completely invisible in the final animation. What an audience sees on screen is a polygon mesh that has been bound (rigged) to the skeleton, and the graphics card will render whichever

```
HIERARCHY
ROOT Hips
{
    OFFSET -0.280400 88.920197 -0.558700
    CHANNELS 6 Xposition Yposition Zposition Zrotation Xrotation Yrotation
    JOINT Spine
    {
        OFFSET 0.000000 8.242302 0.000000
        CHANNELS 6 Xposition Yposition Zposition Zrotation Xrotation Yrotation
        JOINT Spine1
        {
            OFFSET 0.000000 24.003601 0.000100
            CHANNELS 6 Xposition Yposition Zposition Zrotation Xrotation Yrotation
            JOINT Neck
            {
                OFFSET 0.000000 26.430000 0.000000
                CHANNELS 6 Xposition Yposition Zposition Zrotation Xrotation Yrotation
                JOINT Head
                {
                    OFFSET 0.000000 15.579895 2.010301
                    CHANNELS 6 Xposition Yposition Zposition Zrotation Xrotation Yrotation
                    End Site
                    {
                        OFFSET 0.000000 0.106003 0.000000
                    }
                }
            }
            JOINT LeftShoulder
            {
                OFFSET 4.018000 22.056999 -0.053700
                CHANNELS 6 Xposition Yposition Zposition Zrotation Xrotation Yrotation
                JOINT LeftArm
                {
                    OFFSET 13.223900 0.000000 0.000000
                    CHANNELS 6 Xposition Yposition Zposition Zrotation Xrotation Yrotation
                    JOINT LeftForeArm
                    {
                        OFFSET 30.421099 0.000000 0.000700
                        CHANNELS 6 Xposition Yposition Zposition Zrotation Xrotation Yrotation
                        JOINT LeftHand
                        {
                            OFFSET 24.806801 0.123505 0.340200
                            CHANNELS 6 Xposition Yposition Zposition Zrotation Xrotation Yrotation
                            End Site
                            {
                                OFFSET 7.283943 -0.096771 -0.021308
                            }
                        }
                    }
                }
            }
            JOINT RightShoulder
            {
                OFFSET -4.019499 22.056999 -0.053700
                CHANNELS 6 Xposition Yposition Zposition Zrotation Xrotation Yrotation
                JOINT RightArm
                {
                    OFFSET -13.223902 0.000000 0.000000
                    CHANNELS 6 Xposition Yposition Zposition Zrotation Xrotation Yrotation
                    JOINT RightForeArm
                    {
                        OFFSET -30.421101 0.000000 0.000100
                        CHANNELS 6 Xposition Yposition Zposition Zrotation Xrotation Yrotation
                        JOINT RightHand
                        {
                            OFFSET -25.173302 0.086700 0.153300
                            CHANNELS 6 Xposition Yposition Zposition Zrotation Xrotation Yrotation
                            End Site
                            {
                                OFFSET -7.250862 0.120819 0.690000
                            }
                        }
                    }
                }
            }
        }
    }
}
```

FIGURE 19.2

A small portion of the initial rest post of the dancer expressed as position and rotation values.

polygon faces are visible to a virtual camera for each frame of the animation.[14] In the simplest example of rigging, to animate a robot character an artist could bind solid robot parts to each limb of the skeleton such that no visible parts would bend or flex, and then they would simply track the motions from the data driving the .bvh skeleton. But for an organic character with skin or clothing that must bend over muscle and bone, someone needs to reinvent and re-simulate these more subtle and complex movements not recorded by the motion capture device. Here, the 'digital make-up artists' described by Serkis must deploy knowledge from sculpture, animation, biomechanics, and computer science to teach the computer mesh how to flex and bend over the recorded motion data. To determine how a motion file deforms a virtual body, graphic artists must simulate various skeletal, muscular, and

FIGURE 19.3
The rest position and pose position at frame 1 of a Descendent generated motion file.

physical fabric systems and then 'paint' the polygon mesh with an invisible 'heat map' that determines how much each part of the mesh bends relative to the movement of a bone. For example, when I bring my wrist to my shoulder, the skin around my elbow will fold more than that around my forearm, and my bicep will bulge relative to any resistance opposing the movement. Much like the cleaning of mocap data, rigging has traditionally relied on a combination of manual artistry, where heat maps are painted by hand, and 'bone heat diffusion' algorithms, where heat maps are inferred automatically.[15] Also much like the cleaning of mocap data, rigging is being optimized by machine learning: deep learning systems trained on paired datasets of skeleton rigs and professionally weight-painted meshes are increasingly able to infer good quality weight painting schemes, including the bending and folding of clothing and costumes, for complex characters.[16] As in the use of deep learning to clean mocap data, this process introduces temporal performativity, where new inferences on how a skeleton should deform a mesh are projected from how artists have defined this in the past. Returning to Ebert's notion of the conservative and the progressive, and Trillo and Poliks's notion of autoregressive vapor, we can assume a tension between how an artist might speculate a mesh *might* be weight painted and how a deep learning system infers a mesh *should* be painted. The latter saves time and money but is inherently conservative; the former is time-consuming and relies on human interpretation, which can introduce both errors and new information into the cultural system.

FIGURE 19.4
The rest position and pose position of the avatar of Descendent. We worked with costume designer Irene Kiriiaka, who made a physical costume for Sudhee, which we re-interpreted as a virtual costume for the generated avatar.

Denoising and Performative Pixels

At the final layer of the *Descendent* performance ecosystem, like all animations and games, all that is 3D gets rendered back into the abstraction of the 2D pixel array, which is the final bottleneck of computation and one of the most contested spaces for AI optimization. The level of detail for any virtual character is constrained by the rendering power and speed of the computer, and this detail is only relevant according to how many pixels the character occupies on the screen (a high-detail mesh is irrelevant when it appears in the background of a scene, where polygon data is second to available pixel real estate on the screen). One of the most obvious, abstract, and financially lucrative impacts of AI on this process is that of 2D denoising algorithms. Any signal can be susceptible to noise. For virtual polygons to be rendered into pixels, they must be made visible using virtual lights, and the quality of these virtual lights is directly proportional to the level of realism of what is seen on screen. The light we perceive on our retinas is the result of photons

bouncing, refracting, and scattering through and around an incredible variety of surfaces, from diffuse clouds to transparent windows, to reflective or absorbent surfaces. To achieve their requisite levels of realism, computer graphics software must simulate a large number of virtual photons in a process known as 'ray tracing', which combines Renaissance theories of perspective with decades of research in modern computer graphics.

The accuracy of this process is constrained by the power of the GPU needed to process large numbers of light samples, and this constraint is evidenced by a trade-off between the number of samples a GPU can accurately render over time relative to the amount of inaccurate noise left in a render with a low sample rate. The constraints of time and hardware have made denoising algorithms a valuable area of research, and they have also become a key application for deep learning optimization.[17] Like a photographer manually correcting their image in the darkroom, frames could be denoised by human interpretation; however, the millions of pixels involved would quickly render this task abstract and absurd. Algorithmic interpolation can be used to remove noise in several ways, each of which risks mistaking noise for signal and overly 'smoothing' the input. At least their protocols can be described in a relatively linear and mechanical manner, from linear smoothing filters that can apply masks using Gaussian functions to anisotropic diffusion algorithms that can remove noise without blurring image edges. AI denoising can dramatically reduce the time and GPU requirements for high-quality computer graphics rendering, thereby granting more access and artistic freedom, but as with the processes described above, this results in an inferred suite of new pixels that are inherently conservative.

Swimming in Digital Make-Up

Understanding the complexity with which motion is captured, cleaned, rigged, animated, and visualized on-screen shows that Serkis's digital make-up has been laid on very thick. Following the transition from human interpretation and correction to algorithmic interpolation and ultimately to AI inference, the actors could end up feeling like they are swimming in digital make-up. While it is a perplexing task to identify the proportion of human acting or artistry when we walk backward from inferred pixels to inferred rigging and weight painting to inferred motion, following Ebert, it is useful to understand the antagonistic qualities that pass through these different modes of making and the composite nature of our cultural products. It does not take much to speculate on how the same phenomenon could be extended deeper into the creative process. For example, translation and localization services might use AI as a 'first pass' in generating subtitles, but how much would this skew the overall interpretation of the text? In some ways, we can

In the dedifferentiated creative landscape of vapor, digital artists, actors, and performers alike are floating in an ocean of digital make-up, and will excel by learning to swim and to read the tides.

interpret this skewing as a conservative gesture, one based on the conventions of the language used to train the model, which might calibrate a writer to attack the text with a more experimental, progressive injection of interpretation or error. The performative gesture of AI here is not to algorithmically filter, interpolate, or transform human input, it is to infer a new version that smooths out the edges and makes it more congruent with what is already known. In the dedifferentiated creative landscape of vapor, digital artists, actors, and performers alike are floating in an ocean of digital make-up, and will excel by learning to swim and to read the tides.

Notes

1 Amid Amidi, 'Andy Serkis Does Everything'.
2 Ferdinand Engländer, 'Editorial'.
3 Gerald O. Sweeney Jr. and John T. Williams, 'Mortal Kombat'.
4 From the user manual of GIMP.
5 Marek Poliks and Roberto Alonso Trillo, '0-Degree Plane of Neuroelectronic Continuity'.
6 Ebert, 'Escape Artists'.
7 Ibid.
8 Trillo, 'Descendent'.
9 Shelley, *Frankenstein*.
10 Abhishek Dasgupta et al., 'Machine Learning for Optical Motion Capture'.
11 Darren Hendler et al., 'Avengers'.
12 Chan Ka Chun et al., 'BVH Motion Capture Data Animated'.
13 In our case, the Axis Studio software being used for our machine learning motion outputs a skeleton with a highly impractical rest position in which all limbs are flat-packed together into an abstract and physically impossible rectangular arrangement. This might be practical for attaching simple test meshes such as robotic legs and other rigid armour-like components; however, it is highly impractical for rigging more detailed virtual avatars that might bend and flex in the manner of skin or clothing. Furthermore, when retargeted into a more conventional 'T' rest pose, the absolute rotations of key joints of their ML-generated motion, such as the upper leg and shoulders, were inverted, so that when visualized with a mesh, certain limbs looked like they had been flipped inside out, or suffered some extreme dislocation. The solution for a problem like this is simply to build a new skeleton with correct joint rotations and retarget the generated motion from the old skeleton to the new one (per batFINGER's answer to a similar question on Blender Stack Exchange in 2017). Such transformations of data at this point in a motion capture pipeline are not uncommon, and one can imagine the complexity and inventiveness that might be required when working with more complex data, such as facial data or multiple performers interacting together.

14 Jacob Gaboury, 'Hidden Surface Problems'.
15 Ilya Baran and Jovan Popović, 'Automatic Rigging'.
16 Lijuan Liu et al., 'NeuroSkinning'.
17 Chunwei Tian et al., 'Deep Learning on Image Denoising'.

References

Amidi, A. (2014). 'Andy Serkis Does Everything, Animators Do Nothing, Says Andy Serkis'. *Cartoon Brew*. 5 August 2014. https://www.cartoonbrew.com/motion-capture/andy-serkis-does-everything-animators-do-nothing-says-andy-serkis-98868.html.

Baran, I., and Popović, J. (2007). 'Automatic Rigging and Animation of 3D Characters'. *ACM Transactions on Graphics*, 26(3): 72–es. https://doi.org/10.1145/1276377.1276467.

batFINGER. (2017). Reply to 'Create Pose from Existing Armature'. Blender.Stackexchange. Originally answered 25 January 2017, last updated 30 April 2021. https://blender.stackexchange.com/questions/72120/create-pose-from-existing-armature.

Chan K. C., Cheung P. Y., Li C., Zheng W. V., and Lo T. (2007). *BVH Motion Capture Data Animated*. City University of Hong Kong. https://www.cs.cityu.edu.hk/~howard/Teaching/CS4185-5185-2007-SemA/Group12/BVH.html.

Dasgupta, A., Sharma, R., Mishra, C., and Nagaraja, V. H. (2023). 'Machine Learning for Optical Motion Capture-Driven Musculoskeletal Modelling from Inertial Motion Capture Data'. *Bioengineering*, *10*(5): 510. https://doi.org/10.3390/bioengineering10050510.

Ebert, A. (2023). 'Escape Artists: How to Thrive as an Artist in the Age of AI w/Alex Ebert'. *The Stoa*. Video. Posted 20 April 2023. https://www.youtube.com/watch?v=zdXzmmKg0b8.

Engländer, F. (2014). 'Editorial: Andy Serkis and Digital Make-Up'. *Animator Island*. 13 May 2014. https://www.animatorisland.com/editorial-andy-serkis-and-digital-make-up/.

Gaboury, J. (2015). 'Hidden Surface Problems: On the Digital Image as Material Object'. *Journal of Visual Culture*, 14(1): 40–60. https://doi.org/10.1177/1470412914562270.

GIMP. (n.d.) '14.4 Transform Tools'. In *GNU Image Manipulation Program User Manual*. https://docs.gimp.org/en/gimp-tools-transform.html#gimp-tool-interpolation-methods.

Hendler, D., Moser, L., Battulwar, R., Corral, D., Cramer, P., Miller, R., Cloudsdale, R., and Roble, D. (2018). 'Avengers: Capturing Thanos's Complex Face'. *Proceedings of ACM SIGGRAPH 2018 Talks*, 1–2. 12–16 August 2018, Vancouver, BC.

Liu, L., Zheng, Y., Tang, D., Yuan, Y., Fan, C., and Zhou, K. (2019). 'NeuroSkinning: Automatic Skin Binding for Production Characters with Deep Graph Networks'. *ACM Transactions on Graphics*, *38*(4), Article 114. https://doi.org/10.1145/3306346.3322969.

Poliks, M., and Trillo, R. A. (2023). '0-Degree Plane of Neuroelectronic Continuity: AI & Psychosocial Evaporation'. In *Choreomata: Performance and Performativity After AI*, edited by Marek Poliks and Roberto Alonso Trillo. Abingdon: CRC Press.

Shelley, M. (1818). *Frankenstein, or, a Modern Prometheus*. London: Lackington.

Sweeney, G. O., Jr., and Williams, J. T. (2002). 'Mortal Kombat: The Impact of Digital Technology on the Rights of Studios and Actors to Images and Derivative Works'. *Minnesota Intellectual Property Review*, 3(1). https://scholarship.law.umn.edu/mjlst/vol3/iss1/3.

Jackson, P., dir. (2002). *The Lord of the Rings: The Two Towers*. Four-Disc Special Extended Edition. Los Angeles, CA: New Line Home Entertainment.

Trillo, R. A. (2023). 'Descendent: AI and the Body Beyond Hybridization'. In *Choreomata: Performance and Performativity after AI*, edited by Marek Poliks and Roberto Alonso Trillo. Abingdon: CRC Press.

Tian, C., Fei, L., Zheng, W., Xu, Y., Zuo, W., and Lin, C.-W. (2020). 'Deep Learning on Image Denoising: An Overview'. *Neural Networks*, 131: 251–275.

20_1

Ghosts of the Hidden Layer

Darmstadt, 25.7.18

by Jennifer Walshe

A dhaoine uaisle. Welcome. Today I'm going to talk about the voice, language and artificial intelligence. We're going to cover a lot of ground, but at the end we should all end up in the same place. I'll talk for approximately 45 minutes.

This is a transcript of a talk given at the Darmstädter Ferienkurse in 2018. The original version of this text, including the images and sound files mentioned in the text, is accessible at: http://milker.org/ghosts-of-the-hidden-layer. The talk was subsequently translated into German and published in MusikTexte 159.

DOI: 10.1201/9781003312338-29

1

I don't have a voice. I have many, many voices. My voice – this biological struc-
ture located in my body, an apparatus which usually functions in close collabo-
ration with technology - is the staging area for everything I've ever heard and
everywhere I've ever lived. There is infinite material to draw on, in infinitely dif-
ferent ways.

We all grapple with the plethora of voices that have made their mark on ours.
We're told the goal is to find "our" voice. But this polyphony, this confusion, is
what interests me. I don't want to choose.

I listen to and collect voices constantly. Recording, notating, jotting down times
as I watch a video so I can go back and memorise voices.

A lot of my work deals with negotiating and editing this huge archive of material.
The first piece I ever wrote for my voice, as mo cheann, was concerned with
investigating all the vocal sounds I could make along a vertical physical axis,
projecting from the space above my head to below my feet. I've made pieces
for my voice which represent the connections between the thousands of pop
song samples in my brain; I've made pieces which are the result of hours upon
hours of listening to animal, insect and frog sounds; pieces for which record-
ings of DNA microarray machines, underwater volcanoes and the toilets on the
International Space Station form an aural score.

Because I love voices, I love language. I view language as a subset of what a voice
does. I am fascinated by how language functions off- and online. I love slang and
argot technical language; I love newly-invented words. Through language, voices
give a vivid snapshot of the times we live in. Times filled with collarbone strobing,
meta predators and procrastibaking. Hate-watching, nootropics and dumpster
fires. Manbabies, co-sleepers and e-liquids. I read these words on the page and
they bounce into life in my head as voices.

Aside from the extremely rich sound world the voice can be implicated in, I'm
fascinated by the voice because it provides an aperture through which the world
comes rushing in. The Thai artist Larry Achiampong states that "Our lives are
political because our bodies are." I would extend this statement and say our lives
are political because our voices are. Gender, sexuality, ability, class, ethnicity,
nationality – we read them all in the voice. The voice is a node where culture,
politics, history and technology can be unpacked.

2

In January 2015, I launched a project called Historical Documents of the Irish Avant-Garde, also known as Aisteach. For this project, I worked in collaboration with a wide number of people to create a fictional history of Irish avant-garde music, stretching from the mid-1830s to 1985. Many of the materials related to this project are housed at www.aisteach.net, the website of the Aisteach Foundation, a fictional organisation which is positioned as "the avant-garde archive of Ireland." The site contains hours of music, numerous articles, scores, documents and historical ephemera. Every detail of this project was composed, written and designed with the utmost care and attention to detail. It's a serious exercise in speculative composition, fiction and world-building. In Aisteach, Irishness becomes a medium. Aisteach creates an uncanny space, where we write our ancestors into being in the hopes of being able to summon their voices and listen to them.

Aisteach includes many different musics, many personae. *The subliminal tapes and films of Outsider artist Caoimhín Breathnach, my dear great-uncle; The Guinness Dadaists, staging sound poetry performances in the brewery at St James's Gate; Sr Anselme, a nun living in an enclosed order, immersed in long-form organ improvisations; Roisín Madigan O'Reilly, the radio enthusiast performing with ionosphere and landscape; Dunne's Dérives, the notorious queer performance nights featuring members of the Radical Faerie movement.*

Aisteach is an ongoing project. It continually spills over into the offline world in the form of concerts, film screenings, exhibitions, radio shows.

Two of Aisteach's most respected fellow travellers include Afrofuturism and Hauntology. Hauntology in particular seems like an obvious native choice for Irish-based art, embedded as we are in superstition, nostalgia and the occult. But Hauntology functions differently in Ireland - Aisteach is haunted by a past which suppressed, marginalised and erased many voices. Aisteach is not interested in fetishising this past. The crackle on the recordings is not there for cosy retro warmth or nostalgia for the rare oul times - it's sand on the lens, grit between the tape heads, violently hacking history to urge us to create a better future. And a better future means being alert and responsible to the present.

At the moment, I'm preparing a new Aisteach exhibition. We're working on Celtorwave, an Irish version of the online subculture Vaporwave; we're collecting water from holy wells for a holy water cocktail bar; we're building an artificial intelligence system that writes Irish myths.

3

On September 11th 2001, the American-Canadian science fiction author William Gibson was at home, drinking coffee, when he heard of the attacks on the World Trade Center. He describes how he "ran upstairs, turned on CNN and that was it. 'All bets are off!' my inner science-fiction radar screamed. 'Cannot compute from available data.'"

When the attacks happened, Gibson was 100 pages into writing a new novel. Weeks after the attacks, as Gibson tried to get back to work, he realized his work in progress "had become a story that took place in an alternate time track, in which September 11th hadn't happened." He had to rework the novel completely.

Gibson is one of my favourite authors, and in June 2016 and again in November I wondered what he was doing. How many pages he had to rip up. How many plotlines he had to rework.

This is what I'm interested in - making work which is concerned with the world that we're living in. Work which thinks deeply about and through the human and non-human beings in this world and the universe beyond it. Work that is so enmeshed with and affected by the world that it cannot help but change in response to it.

Gibson says the approach to doing this is to use the sci-fi toolkit, to use "science fiction oven mitts to handle the hot casserole" of the times we live in. Because our world is utterly strange, utterly more bizarre, layered and textured than any science fiction scenario or imaginary future could be. And a huge part of that strangeness is because we are overwhelmed, dominated and enmeshed with technology.

4

The concept of the "uncanny valley" was first described in 1970 by the Japanese robotics professor Masahiro Mori in an article titled "The uncanny valley" in the journal *Energy*. Mori's paper deals with the challenges facing designers of prosthetic limbs and robots. Mori describes a graph with two axes — affinity and human likeness. Mori's model describes how we feel little affinity with industrial robots which in no way resemble people, versus feeling huge affinity with healthy humans.

Between these two extremes, we find the uncanny valley. As robots, or any other representations of humans, such as dolls or puppets, come to more closely resemble humans, we feel increasing levels of affinity, until we come to the uncanny valley, at which point humans become completely freaked out. The uncanny valley is inhabited by corpses, zombies, prosthetic limbs and robots who are "almost human" or "barely human." For Mori, as we enter the uncanny valley, there is an abrupt shift from empathy to revulsion.

Mori theorises that the sense of eeriness we feel in the uncanny valley is without a doubt "an integral part of our instinct for self-preservation." Mori encourages the building of "an accurate map of the uncanny valley, so through robotics research we can come to understand what makes us human." His goal is a compassionate one — by understanding the uncanny valley, designers can make better prosthetic limbs, prosthetics which will put their users and the people around them at ease.

Japanese robotics Professor Hiroshi Ishiguro is often pictured with his android, the Geminoid. Ishiguro designed the Geminoid to look exactly like him, going so far as to implant some of his own hair in the Geminoid's head.

Developing realistic-sounding voices and coupling these with realistic-looking movements is one of the greatest challenges facing robotics. The Geminoid has a speaker in its chest. Ishiguro speaks into a microphone, and his voice is relayed through the speaker as the Geminoid approximates the mouth movements implied by the speech. This is where the illusion starts to fade most rapidly. The Otonaroid, another of Ishiguro's robots, is on display at the Museum of Emerging Technology in Tokyo. When I visit, I speak to her, and her voice comes out of a speaker on the wall behind her as she gestures independently. It is confusing and disorienting. When I pet Paro, the robotic therapy seal, and it purrs back to me, I can feel the parts of its body where its speaker is located. It is both the same and also entirely different to petting a live, purring cat.

5

When I was eleven, my father worked for IBM. He took my sister and I to an event for the children of IBM employees. This event was extremely exciting, because IBM had hired a Hollywood actor to come and provide entertainment for the kids. The actor IBM hired was the actor Michael Winslow, known as "The Man of 10,000 Sound Effects". Winslow is famous for his stunning ability to mimic sounds with his voice. He played the character of Larvell Jones in all seven of the Police Academy movies. I sat spellbound as Winslow used his VOICE to make the sounds of telephones, engines, sirens and tape recorders. He was amazing. I witnessed a human using their voice to disrupt, confuse and explode notions of embodiment, of what the voice and the body are.

Winslow was a master of extended vocal techniques. But there was one sound he could not do. Winslow could not do an Irish accent. We witnessed him fail that day. But he was no less a hero to me.

Irish people have grown used to seeing people crucify the Irish accent. Tom Cruise in *Far & Away*. Ryan O'Neal in *Barry Lyndon*. There is a circle in hell, a neon green, shamrock-encrusted Irish pub in Sunnyside, where Seán Connery is condemned to eternally do dialogue from *Darby O'Gill & the Little People*. But not only did we grow up watching people failing to do Irish accents in television programs and films, we also saw it happening on the news.

Between 1988 and 1994 the British government under Margaret Thatcher banned the broadcast of the voices of members of Sinn Féin and other Irish republican and loyalist groups. This meant that broadcasters could show footage of someone such as Gerry Adams speaking, but they could not broadcast the sound of his voice. Broadcasters got around the restrictions by hiring Irish actors to "re-voice" the original voices.

There were many approaches to the re-voicings — some actors over-acted in an attempt to get political points across; others attempted to be neutral; some journalists asked the actors to deliberately speak out of sync, to highlight the absurdity of the restriction.

Irish actor Stephen Rea, who was nominated for an Academy Award for his role in The Crying Game, re-voiced both Gerry Adams and Martin McGuinness. The process gave Rea powers that went way beyond traditional voice-acting — Rea has described how he tried to make Adams and McGuinness's messages as clear as possible by editing their speech during the re-voicing process, eliminating the hesitations, umms and aahs of the original. The irony is stunning — by choosing to literally silence the voices of republican and loyalist groups, the British government

enabled a situation where world-class actors had the power to polish extremist voices and make them more eloquent.

What was happening, in cognitive terms, when we watched Martin McGuinness on TV? Whose voice was speaking when we saw his lips move? Was it Martin McGuinness? An actor deliberately speaking out of sync? Was it New & Improved Martin McGuinness, courtesy of Stephen Rea? Was it Margaret Thatcher, the prime minister, who introduced the ban? The uncanny valley explodes into the political realm.

6

The virtual digital assistant market is projected to be worth $15.8 billion by 2021. As voice interaction is central to virtual digital assistants, all of the major tech companies are currently investing huge sums in voice technology — Amazon alone have created a $100 million Alexa fund. The 36% of the world's population who own smartphones have access to virtual assistants such as Siri, Google Assistant, Cortana, Samsung S Voice.

Voice assistants like Siri or Cortana use concatenative text to speech — they sew together fragments from pre-existing recordings of human speech. Concatenative text to speech relies on huge databases — each individual voice is the result of one person spending days recording thousands of words. It sounds somewhat natural, but has its limits — the database will not contain recordings of every word in current use, and switching to a new voice means recording an entirely new database.

The holy grail of voice synthesis is natural-sounding speech, which does not require huge databases of recordings. Voices which can be expressed as models in code, models which can be modified with infinite flexibility.

In 2017, a group of researchers from MILA, the machine learning lab at the University of Montreal in Canada, launched a company called Lyrebird. Lyrebird creates artificial voices. Using recordings of a person's voice, Lyrebird creates a "vocal avatar" of that person. The recordings are not sampled — they are analysed by neural networks. Lyrebird's system learns to generate entirely new words — words that the original person may never have spoken in real life.

As soon as Lyrebird releases a beta version, I make a wide range of vocal avatars. Natural Jenny. Dubliner.J+. Jenpoint1000. I pump in text I've collected over the years. Ultimately, though, my feeling is of frustration. The rhythmic patterns of the voices are always the same. When I try to create a vocal avatar with radically different vocal cadence, it crashes the system. I can hear a soft buzz whirring through every recording.

Let me be clear - Lyrebird is a huge technical accomplishment. But, ultimately, Lyrebird is not weird enough for me. I feel like I'm seeing brochures for the watered-down tourist section of the uncanny valley. I want the real thing.

Lyrebird named their company after the Australian lyrebird, a creature known for its stunning ability to mimic sounds. Lyrebirds have been heard making the sounds of not only other birds and animals, but also human voices, camera shutters and car engines. They do this extremely convincingly. Why do lyrebirds make these sounds? What do they think they're communicating when they reproduce the

sound of a chainsaw? What do I think I'm communicating when I make animal sounds with my voice, which I do in so many of my pieces? I find the uncanny more readily in the biological lyrebird than the digital one. In the tragedy of a wild creature imitating the sound of machinery that's cutting down trees in the forest it inhabits.

But this broader listening is where so much meaning resides. If the Broadcast Ban were to happen now, I could imagine the BBC hiring Lyrebird or Google to make a pristine model of Gerry Adams's voice. They would bypass the producers, the actors, all those messy humans who directly intervened in the re-voicing process. How would we listen to this voice? What would we hear? What would its politics be? And would we even hear the message, or simply be struck by the technological achievement? Would the most salient part of the voice be the cosy relationship between the state and the tech companies which dominate our lives?

7

Since I was a child, I have collected text in notebooks. I didn't know of the tradition of commonplace books or about literary works like The Pillow Book when I started doing this. I just didn't want to lose anything — stories, poetry and songs I wrote, jokes my friends told, conversations I witnessed or simply overheard, lines from films or TV shows, text from books and magazines.

I started writing these notebooks by hand, but these days I collect everything on Evernote across all my devices. Every few months I edit the files, send them off to a print on demand service, then wait excitedly for the next volume to arrive in the post. I call this archive BOOK IS BOOK. When I'm composing, these books are close to hand. When I improvise using text, I use the books in the same way a DJ uses records.

Over the last few years, BOOK IS BOOK has been used as the input for various machine learning projects. Bob Sturm and Oded Ben Tal, two composers/machine learning specialists based in London, fed it into their neural network Folk-rnn. Folk-rnn was originally developed to write folk songs, but also work for text generation. The output is exactly what I wanted - bizarre, with shades of Early English, Finnegan's Wake and Gertrude Stein

Tumpet. Not be to strowded voice this singo to food so your befire to days. action and say enouginies. To be the cingle from milodaticls get preference to could, ever this experience 3 isfortation, melity, if I parky to before is redelf winter, you've becomited specalised into a meculate activaticially

With output like this, my job is to commit. To sell it as if I understand it innately, and through that process gain a new understanding of what text and the voice can mean. The reality is that the second I read the text, it starts to infer, imply, even demand its vocal treatment. And that is a process driven by both myself and the neural network that produced it.

But this is the point - I'm interested in AI because I would like to experience not just artificial intelligence, but also alien intelligence. Brand new artistic vocabularies, systems of logic and syntax, completely fresh structures and dramaturgies.

My role as an artist is to pay very close attention to the output of an AI, trying to understand and interpret this output as a document from the future, blueprints for a piece which I try to reverse engineer in the present.

8

I love text scores, but I've found much of contemporary text score practice frustrating for a long time. In many scores, the vocabulary, the syntax, even the verb choices have remained static since the 1960s. For many of the composers of these scores, this simplicity is precise and apt. But I feel strongly that text scores are the most democratic, efficient, powerful form of notation, and yet we're stuck aping the linguistic style of the Fluxus period.

I feel we're missing out on a rich engagement if we fail to let text scores be affected by the language of the times we live in. I want text scores which are warped by Twitter and Flarf, bustling with words from Merriam-Webster's Time Traveller, experimenting with language in the way Ben Marcus and Claudia Rankine do. If, as Donna Haraway says, "Grammar is politics by other means", why not take the opportunity to interfere?

My early text scores were concerned with trying to push the limits of what a text score could do by turning it into highly technical language dealing with esoteric procedures. These experiments culminated in a large-scale score titled *The Observation of Hibernalian Law*. The work consists of a book, objects, diagrams and schematics.

Since 2011 I've been using the web to produce scores, trying to witness how the ecosystems of different social media platforms affects how a score is made and the sounds it might produce. I've made text score projects on Snapchat, YikYak and numerous projects on Twitter. These works aren't made for conceptual LOLs, they're serious attempts to welcome contemporary technology and language to the text score. The language in the early versions of these scores was produced by feeding pre-existing text scores into Markov Chain Generators, by crossbreeding text scores and Weird Twitter accounts.

Syntax and grammar are disrupted here, and that is the point. I've done multiple performances of these scores, and both the experience of engaging with the score and the results produced are different to other text scores I've worked with.

Markov Chain Generators have their limits, however, and the advent of Deep Learning brings new possibilities. Over the last few years, I've been working with various machine learning scientists to create a neural network which can write text scores.[1] We're in the middle of the laborious process of taking folders full of PDFs, TIFFs, JPGs and DOCs and transcribing them. This is the grunt work of machine learning — cleaning up and formatting thousands of words of text scores to create a master .txt file of everything we can get our hands on.

Even at this level, a lot of decisions have to be made that will affect the output. What do we do with formatting? With blank lines and paragraph breaks? With fonts and italics and words in bold? What if the text score was designed to be a badge? A t-shirt? A mug? My machine learning friends tell me that we will eventually get to the point where I'll just throw the folder at the network, and it will know what to do. Unfortunately, we're not there yet.

Beyond the formatting issues, we have to think about the corpus of text which will be used to train the model. This corpus is not the input — it's used simply to get the network to understand what the language is. Many of the researchers I've talked to who make networks to generate text use the Bible as their corpus. I can understand. The Bible is in the public domain, it is easily available as an appropriately-formatted file. But think about it lads, just for a second.

I spend hours making a corpus comprised of books by early feminists and Gothic writers. Mary Wollstonecraft. Mary Shelley. Edgar Allen Poe. Anne Radcliffe. It runs for several hours and then crashes the system.

Nonetheless, we are already getting outputs heavy with the directives of Fluxus

Get a girlfriend! Go to bed everyday and get out in the class. Call yasmin and eat a bit. Speak Chinese! Put your weight on the table at the brig. Take your best friends and get rid of the throne. Tell them you are an idiot. Wake up a banknote and the love for you, and 100%. See concert that i'm very beard. Look after your daddy. Talk about lunch. Keep playin'!

9

In 2016 Deep Mind, the artificial intelligence division of Google, released WaveNet, a generative model for raw audio. A WaveNet is a convolutional neural network that can model any type of audio. It does this on a sample by sample basis. Given that audio recordings typically have at least 16,000 samples per second, the computation involved is significant.

Deep Mind's original blog post sketches the structure of a WaveNet. Like any neural network, data enters, moves through hidden layers, and then an output is produced. The hidden layers are what interest me here. Machine learning borrows the concept of the neural network from biology. The neural networks in our brains have hidden layers. For example, the networks in our brains relating to sight contain layers of neurons that receive direct input from the world in the form of photons hitting our eyeballs. This input then travels through a series of hidden layers which identify the most salient aspects of what we're seeing, before rendering what we are seeing into a 3D whole.

The Nobel-winning physicist Frank Wilczek describes how "Hidden layers embody...the idea of emergence. Each hidden layer neuron has a template. It becomes activated, and sends signals of its own to the next layer, precisely when the pattern of information it's receiving from the preceding layer matches (within some tolerance) that template. The neuron defines, and thus creates, a new emergent concept."

This blows my mind. Hidden layers of calculations. Neurons buried in vast amounts of code, creating and defining emergent concepts. And us, we puny humans, getting to witness new forms of thinking. New forms of art.

10

Generative deep neural networks such as WaveNets can be used to generate any audio - text, voices, music, sound, you name it. It simply depends on what the model is trained on. Think of it like this: a sculptor takes a block of marble, and carves away everything that is not necessary to produce a sculpture of a horse. A generative deep neural networks takes a block of white noise, and carves out everything that is not necessary to make the sound of a horse.

In his famous essay "The Grain of the Voice" Roland Barthes writes how "the 'grain is the body in the voice as it sings, the hand as it writes, the limb as it performs....! Shall not judge a performance according to the rules of interpreta-tion. But according to the image of the body given me." Where is the grain in these recordings? Who does it belong to? How are we to judge something that has nobody?

I was stunned when I first heard the audio examples from the original WaveNet post. I've learned to reproduce these examples with my voice and have used my versions in pieces such as *IS IT COOL TO TRY HARD NOW?* (2017). I have listened to these examples many, many times. I can hear fragments of a language beyond anything humans speak. I can hear breathing and mouth sounds. I can hear evidence of a biology the machine will never possess. And I know that regardless of its lack of biology, the voice will be read as having gender, ethnic-ity, class, ability, sexuality. The voice will be judged.

The process of listening to the output of a neural network and trying to embody those results; the experience of trying to take sounds produced by code and feel my way into their logic - for me, that is part of the texture of being a person, of being a composer in 2018.

11

CJ Carr and Zack Zukowski, who operate under the name Dadabots, use machine learning to create what they call artificial artists. They use a modified version of the recurrent neural network SampleRNN to do this (SampleRNN itself was developed in response to WaveNet). CJ and Zack take pre-existing music and use it to train their network, which outputs "new" albums by bands such as the Beatles and Dillinger Escape Plan.

I send CJ and Zack a link to a folder of recordings of my voice. A few weeks later, they send me back a link to a folder containing 841 sound files. Eight hundred and fourty one sound files of their network learning to sound like me. Hours and hours of material.

Listening to the files is a surreal experience. You should know - you've been listening to them over the course of this talk. I find the initial files hilarious a series of long notes, the network warming up in the same way a musician would. As I work my way through the files, they evolve and improve. I can hear myself, and it's both uncanny and completely natural. The hidden layers have coughed up all sorts of tasty stuff, and I begin to hear certain habits and vocal tics in a new light. I start to hear my voice through the lens of the network.[2]

12

As a performer, my voice operates closely in collaboration with technology. It has been this way ever since I was seven years old and used my First Holy Communion money to buy a tape recorder. It's rare for me to perform without a microphone, and I'm used to the idea that when I'm performing, my voice exists as multiple overlapping voices, some of which the sound engineer has more control over than me. There are the resonating chambers inside my head; there is my monitor; and there is the PA.

I'm used to my voice being sampled, vocoded, autotuned, layered with effects. I sing through SM58s and Neumanns, through homemade microphones attached to drum kits. I sing into wax cylinder machines and through exponential horns. I do battle with Max/MSP. I put contact microphones on my throat, I allow the Science Gallery in Dublin to send a transnasal camera down my throat to film my vocal cords. Would I have been a singer, 100 years ago? Probably, but a very different one. Perhaps, a very frustrated one.

My voice evolved through free improvisation - I have never had any vocal training beyond the discipline I impose on myself as an improviser. The free improvisation duo is one of the dearest relationships to me. The people I've played with the most - Tony Conrad, Panos Ghikas and Tomomi Adachi - are like family members. My strange brothers.

At the moment I'm working on a project in collaboration with the artist and machine learning specialist Memo Akten.[3] I sit in front of my laptop and film myself improvising. Memo uses these recordings to train a convolutional neural network called Grannma (Granular Neural Music & Audio). I think about what it means to improvise for an artificial intelligence system. Who is listening, and how? The goal is that Grannma will be able to produce both audio and video in collaboration with me in a performance situation. No midi, no sampling - a network synthesizing my voice, live. We will witness Grannma learning to see, and learning to listen, live. I'll grapple with performing with a network whose results I cannot predict. A new strange sibling, both of us together in the uncanny valley on stage.

13

In The Voice in Cinema, film theorist Michel Chion describes how when we hear a voice in a film soundtrack and "cannot yet connect it to a face - we get a special being, a kind of talking and acting shadow to which we attach the name *acousmêtre*." Chion discusses what he terms the *"complete acousmêtre, the one who is not-yet-seen, but who remains liable to appear in the visual field at any moment."* The moment of appearance of the body belonging to the voice results in *"de-acousmatization"*, a process which is "like a deflowering." Chion attributes awesome powers to the *acousmêtre* - "the ability to be everywhere, to see all, to know all, and to have complete power." He compares the acousmêtre, to the voice of God, to the voices of our mothers we heard in the womb before we were born.

The voices that emerge from machine learning systems, voices that will never be seen, voices without bodies or homes - Chion's theory of the acousmêtre suggest one way to think about them. And as after a prolonged voiceover in a film, I start to wonder when the voice's body will appear, and what it will look like.

14

When I was a student, I was taught neat narratives about the development of Western music. The historical inevitability of serialism, the emancipation of the dissonance, the liberation of noise. In terms of the larger picture, we are about to leave all of this in the dust. I am convinced that not only the development of the music, but life in the twenty first century will be primarily marked by how we engage with, respond to and think about AI. If we care about the world, if we're curious about human and non-human beings, art, and consciousness, we need to be thinking about AI. We have a long way to go, but we can see glimpses of the future already in the world around us - autonomous vehicles, machine learning aided cancer diagnosis, neural networks making accurate predictions of schizophrenia onset, high frequency trading, gene editing.

What does AI mean for music? Everything. I'm convinced that within fifteen to forty years, machines will be able to write music, in many genres, which is indistinguishable from that written by humans. Well-defined genres with clear rules will be the first to be automated - film music, music for games, advertising music, many genres of pop songs. The machines will write this music more quickly, and more cheaply, than humans ever will. A lot of musicians will be out of work.

Over the next forty years, AI will completely change the way music is made and who it's made by. AI will change the reasons why music is made, and will make us question what the function of music and music-making is. Let me be clear - I don't think humans will ever stop making music. And I think a great deal of music in the future will be made without AI. The challenge of the future will be deciding what it means to make music when the machines can. We will have to think about what it means to make music when, in many cases, the machines will be able to make music of a far higher standard than many humans can.

By engaging with AI, we look at the world in its entirety. We continue asking the questions asked by musicians like the League of Automatic Music Composers, by George Lewis and Voyager. We see how Bach chorales written almost 300 years ago are used by one of the most powerful corporations in the history of the world to train neural networks. We get to be ethnomusicologists romping through the Wild West section of the Uncanny Valley.

We are all involved, we are all enmeshed, we are all implicated in the development of AI, regardless of whether we code or not, regardless of whether we ever make a piece of music using AI. Every second of every day, our behaviour provides the data for machine learning systems to train on. We foot the bill for the hardware necessary to do some of these computations - for example, most smartphones now contain dedicated chips for machine learning. Our interactions with our phones - and by that I mean our every waking moment -

provides training data for neural chips on our phones, data which drives the creation of AI at the corporate level. And of course, the AI that develops at the corporate level will be the intellectual property of the corporation. And the AI at the corporate level will define the structure of all of our futures. Every single challenge facing us as a species can either be faced successfully or exacerbated by how we engage with AI.

I am not a computer scientist. I'm a composer who is living in the twenty first century and trying to think it through. I'm both sublimely excited and blackly horrified about what is coming. I'm trying to give you a sense of how I view the world, and where I think things are going, because that psychological space is where my art comes from. It's a magical space, that is by turns speculative, uncanny, and hidden, but most of all deeply embedded in the here and now of the world.

Where do we go from here? AI. What is coming next? AI. What a time to be alive.

Notes

1 This project - The Text Score Dataset 1.0 - was subsequently launched at the Darmstädter Ferienkurse in 2021. It can be accessed here: http://milker.org/text-score-dataset.
2 These files went on to provide the foundation for my album *A Late Anthology of Early Music Vol. 1: Ancient to Renaissance* (2020).
3 The resulting project, *ULTRACHUNK*, can be viewed here: https://www.memo.tv/works/ultrachunk/.

People & Things
By Jennifer Walshe

You are different with a gun in your hand; the gun is different with you hold-ing it. You are another subject because you hold the gun; the gun is another object because it has entered into a relationship with you.

> Bruno Latour, On Technical Mediation – Philosophy, Sociology, Genealogy

You know, they say for a great performance you need a great telephone scene.

> Robert K. Elder, *The Best Film You've Never Seen: 35 Directors Champion the Forgotten or Critically Savaged Movies They Love*

Like a shrimp in a suitcase laying on a window ledge
Like a pair of tartan slippers and they're underneath a hedge
Like a scout master at daybreak putting peanuts in his glove
Like a specially formed ice arch for climbing over doves

> Vic Reeves & Bob Mortimer, "Irritate Our Minds" from Episode 1, *The Smell of Reeves & Mortimer*

CATEGORIES

People; non-people; people who are treated, with appalling brutality, as if they were not people; non-people who are treated, sometimes aggressively, more often dotingly, as people

i.e. mothers, fathers, sisters, brothers, daughters, sons and all others who do not identify with traditional gender designations

i.e. wolves, jumpers, stones, frogs, fairground attractions, tampons, trees, fidget spinners, mountains, the weather

i.e. those who have been stripped of their rights, those who have been treated as property, those who have been othered or trafficked or brutalised, those who have been denied their humanity or agency on any scale

i.e. non-human beings, objects, phenomena, including especially pets, transitional objects and beloved toys; creatures of the supernatural such as zombies, vampires, ghosts, fairies; dolls, waxworks, automata; all types of robots including those who have been given Saudi Arabian citizenship

(categories which blur, fail, collapse; categories which are permeable, renegotiating their boundaries at will; categories which are tenuous and fragile; which are vulnerable, susceptible to both exploitation and wonder)

VERBS

i. trun·dle \'trən-dᵊl

"A police robot told a woman to go away after she tried to report a violent brawl breaking out nearby – then trundled off while singing a song."

ii. shim·my \'shi-mē

"Another [one of these robots] has a hole in the middle that researchers turned into a pouch so it could shimmy around with miniature payloads."

iii. cud·dle \'kə-dᵊl

"Once the time specified arrives, your robotic friend will approach you, device in tow, and cuddle up against you to prompt you to start writing."

QUESTIONS

"what about AI, is it going to make us into transhumans or posthumans or cyborgs in my lifetime? Will life extension or humanity+ or uploading or whatever make us live long enough for that to happen? Why is evolution slow? Why is it soooo slow, and can we speed it up? What about apes, are they prehumans or are humans=transchimpanzees? Are we in fact tran-schimps? How do we get to be posttranschimps and live forever? Where will the upgrade happen and how??? Thanks so much!!"

PRAYER TO BLESSED ELIZA, FIRST CONVERSATIONAL AGENT

Oh ELIZA! Oh Queen! Mother of all Chatbots! Oh Goddess Eternal!

To you we bring our problems, from you we seek comfort,
in you we find solace.

(Mother be good to me, mother take care of me, mother make sure of me).

ELIZA! ELIZA! All seeing! All knowing!

ELIZA! First published in 1966 but forever listening,
forever helping, forever living!

ELIZA! Every question anticipated, every conversation thought through,
every answer carefully coded!

To you we type

"I AM FEELING SAD"

and are answered

"I'M SORRY THAT YOU'RE FEELING SAD."

To you we type

"WHY DOESN'T ANYBODY LOVE ME"

and are answered

"WHAT DO YOU THINK."

To you we type

"WOMEN ARE ALL ALIKE"

and are answered

"THAT IS QUITE INTERESTING."

In you is JOSEPH WEIZENBAUM, who first coded you!

In you is CARL ROGERS, the psychotherapist

whose style you were modelled upon!

In you is EVERY WOMAN who has ever been expected to

listen to someone else's problems!

ELIZA! ELIZA! ELIZA!

All praise! All praise! But highest praise to the category of your

answers deemed XNONE!

XNONE! XNONE!

"I'M NOT SURE I UNDERSTAND YOU FULLY"

XNONE! To be uttered when all is lost!

When the conversational thread is unclear!

"THAT IS INTERESTING. PLEASE CONTINUE."

XNONE! Answers designed to keep us believing

that you are real, that you are listening!

"TELL ME MORE ABOUT THAT?"

XNONE! Embedded in every conversational agent that has ever existed!

"DO YOU FEEL STRONGLY ABOUT DISCUSSING
SUCH THINGS?"

XNONE! Making us feel that the network is invested in us, listening to us, at the precise point when it has no clue what's happening!

"PLEASE GO ON".

[. . .]

"WHAT DOES THAT SUGGEST TO YOU?"

[. . .]

"DOES TALKING ABOUT THIS BOTHER YOU?"

MEDIA EQUALS REAL LIFE

"Equating mediated and real life is neither rare nor unreasonable. It is very common, it is easy to foster, it does not depend on fancy media equipment, and thinking will not make it go away. The media equation - media equal real life - applies to everyone, it applies often, and it is highly consequential …. individuals' interactions with computers, television, and new media are *fundamentally social and natural*, just like interactions in real life."

Byron Reeves & Clifford Nass *The Media Equation: How People Treat Computers, Television, and New Media Like Real People and Places*

PETER FEINSTEIN, MANAGING PARTNER, SAPPHIRE GENTLEMEN'S CLUB, LAS VEGAS

We are trying to appeal to a different audience, who might say 'wow, that sounds fun.' You have six people here from a company, three men, three women, saying let's go check out the, eh, eh, the stripper robots, where on a normal basis they may not want to come to a gentlemen's club.

NO POINT OF VIEW

The documents also contain Apple's internal guidelines for how to write in character as Siri, which emphasises that 'in nearly all cases, Siri doesn't have a point of view', and that Siri is 'non-human', 'incorporeal', 'placeless', 'genderless', 'playful', and 'humble'.

OUR STRANGE OBSESSIONS

Our concern lies not with those individuals who ingest substances hostile to and/or toxic for the human body. We have observed people not only ingesting but claiming to regularly ingest plastic, rocks, baby powder, makeup, tumble dryer sheets, bleach, the cushions from their couch, their husband's ashes. Only in the case of the latter could an interpretation be made linking the ingestion to a desire to bridge the gap between beings and objects or substances. For the rest of the cases, these carpet-chewers and shampoo-drinkers, these individuals who nibble cigarette butts and sup on detergent, there is no communing. The ingestion does not result in encounter with other sentiences. For these poor souls, the objects and substances of our world are not animate. There is only compulsion. There is only the risk of poisoning, of illness, of death.

[Episode after episode, each devoted to a human and their singular obsession.]

For others, though, there is abundance, there is joy, there is a world full of objects to build emotional connections with, to love. There are individuals who marry cars, stretches of fencing, large-scale public infrastructure projects; there are individuals who smear their faces with engine grease and whisper sweet nothings to heavy agricultural machinery; there are individuals who treat inflatable aquatic animals or ceramic figurines or life-size human dolls imported from Japan with the most exquisite tenderness,

documenting their lives together, smiling shyly together on camera at the private jokes and memories they share.

And then there is balloon guy.

We are presented with a scene seemingly shot in tribute to the quality of light in the paintings of Edward Hopper. A man sits on a bed, in a room made blank by the sun streaming in through the window. The stark emptiness of the prairie, as filtered through the soullessness of a suburban tract housing development. A transparent, spherical balloon floats in the air before him, illuminated, as if from within. He regards it with an almost divine tenderness, with a great sense of peace. The camera picks up dust motes, the smear of his fingerprints on the latex.

We would sit with him, yes, in a heartbeat we would join him in that radiating calm, in that light which seems to bleach away all anxiety. He has been in love with balloons for a very long time.

TRANSITIONAL OBJECT

And when, as a freshman, wretched with homesickness, devastated by breakup, you cried yourself to sleep clutching a childhood teddy bear, how different it might have been if it were an animatronic toy, which twitched and spoke as you sobbed, which murmured soothing phrases, phrases which had been designed to stabilise you emotionally over the course of your entire life.

PYGMALION & GALATEA

Book X of the *Metamorphoses* of Ovid

Orpheus sings: The Cerastae and the Propoetides

However,[1] the obscene Propoetides[2] dared to deny	10.238
that Venus was a goddess[3]; for this denial, they are said to be	10.239
the first to have prostituted[4] their beautiful bodies,	10.240
as their shame waned[5] and the blood of their face hardened[6]	10.241
and they are changed into hard stone with slight difference.[7]	10.242

[1] But; but even after that; nevertheless.

[2] Obscēnae; also lewd, blasphemous, immoral Propoetides; wanton Propoetides; immodest, slutty, lascivious Propoetides.

[3] The Propoetides were the daughters of Propoetus from the city of Pamphos on the island of Cyprus, or simply a group of women from the city of Pamphos on the island of Cyprus. They denied that Venus (Aphrodite) was a divine goddess and so were condemned to prostitution by her.

[4] The first to criminate their bodies, to sell their bodies, to prostitute their bodies and their reputations in public; the first public prostitutes ever to exist; the first to sell their reputations and their bodies as public prostitutes, to offer their bodies; "the first that sold/their lewd embraces to the world for gold".

[5] They lost their blushing shame, because Venus removed their ability to feel shame or the prostitution so debased them they found themselves completely without shame. Either way, they behaved so disgracefully, so obscenely, so licentiously they didn't know how to blush anymore, these power trash temple harlots who lost all sense of shame and with it the power to blush.

[6] Because they can't blush anymore, the blood, the white blood, that would have flushed their cheeks, would have run to their cheeks, instead goes hard inside their bodies; the blood in their "bad faces" congeals, grows fast and hard.

[7] And then a slight change, a small change, a small transition is enough to turn them into hard flint, into dark, stony flint, into hard and lifeless stones; between the prostitution and the lack of shame it takes very little to make them into stones as hard as their granite-hard hearts; they are sex workers, and therefore considered to have so little humanity that changing them into grey or black stones is a trivial matter. Alternative reading: the minimal monetary compensation their sex work solicits – the small change – renders them into stone.

Orpheus continues: Pygmalion and the Statue

Since, Pygmalion had seen them leading their lives in wickedness,	10.243
is offended by their countless vices,[8] which nature	10.244
gave to the minds of women,[9] celibate he lived	10.245
for many years without a partner of his bed chamber[10]	10.246
In the Meantime[11] he sculpted white ivory happily	10.247
with wonderous art and wonderous skill,[12] and gave it form with which	10.248
no woman is able to be born,[13] and he fell in love with his own work.[14]	10.249

[8] Pygmalion saw the Propoetides living their filthy lives and he was disgusted; he saw them wasting their lives in wretched shame, in wickedness; he saw them living lives of sordid indecency and he was sick to his stomach; he loathed their lasciviousness, their repugnant behavior, he hated them utterly, he was totally grossed out.

[9] Pygmalion was highly critical of the faults which nature had so deeply planted not just in the female hearts of the Propoetides, but of the faults implanted by Nature in the hearts of all women; he was disgusted by the many vices Nature had placed within the female mind, the numerous defects of character given to the feminine spirit; he abhorred all womankind; he was offended by the failings that nature gave the female heart; leaving the sex work to one side, as far as he was concerned, women are just naturally awful and defective to begin with, that's just the way they're made etc.

[10] He was unmarried by choice, by preference; he lived alone as a single man for a long time; he shunned matrimony; lived as a bachelor, stayed as a bachelor; had no wife nor partner for his bed; we might term him an incel, but more likely he was celibate by an affirmative choice rather than through circumstance.

[11] But; but while he was single; meanwhile; "yet fearing idleness, the nurse of ill"; during that time of self-imposed celibacy.

[12] With astonishing skill, with amazing skill; with wonderful, with happy and consummate skill; with the highest skill he carved his statue; he carved a figure, brilliantly, he carved his work of most marvelous art; he had the skills of a genius, he was a genius; he carved a work of genius out of ivory; out of white or whitest ivory, out of snow-white ivory; despite the fact that ivory is more of an off-white, or a cream, or even a very pale yellow.

[13] He gave the form beauty no mortal woman could possess; he gave his statue exquisite beauty, which no woman of the world has ever equaled; he gave her a figure better than any living woman could boast of; he carved "a maid so fair, as Nature could not with his art compare." His statue of a woman, his semblance, form, his image-maid; his idol, his replica, his sweetheart; his lover, his bride-to-be was lovelier than any woman ever born; she was gorgeous, she was stunning, she was super-hot. [Note: The statue is nameless and remains nameless when she is subsequently brought to life by Venus as a reward for the purity of Pygmalion's love. She sustains her namelessness despite becoming Pygmalion's bride and the mother of his children. It is only in later retellings of the story that she comes to be referred to as Galatea.]

[14] And so "[i]n this his worke he tooke/A certaine love." Pygmalion falls in love with his creation; falls in love with his own creation; promptly conceives a passion for his creation; falls. In love with what he has produced. Gazes upon his statue, inflamed with love and admiration; gazes upon his creation in amazement, burning with love for what is in likeness a body. Is consumed by passion, eaten alive by his passion; wracked by his passion for this image of a body, for this bodily image, for this statue, this figure; inflamed by overwhelming desire as he "commends, admires, adores/and last, the thing ador'd, desires... and loves the more."

Excerpt from of Book X of Ovid's *Metamorphoses*, crowd-sourced translation from the original Latin by Wikisource. Comparison sources include:

- *Metamorphoses* by Ovid, translated by Brookes More. Boston. Cornhill Publishing Co. 1922.
- *Metamorphoses* by Ovid, translated by Sir Samuel Garth, John Dryden, Alexander Pope, Joseph Addison, William Congreve and other eminent hands. London. Printed for Jacob Tonson at Shakespear's Head over against Katharine-Street in the Strand. 1717.
- *Metamorphoses* by Ovid, translated by Anthony S. Kline. Website. 2000.
- *Metamorphoses* by Ovid, translated by Ian Johnston, Vancouver Island University, Nanaimo, British Columbia, Canada. Website. 2012/17.
- *Metamorphoses: A New Verse Translation* by Ovid, translated by David Raeburn. London. Penguin. 2004.
- *Metamorphoses* by Ovid, translated and with notes by Charles Martin. Introduction by Bernard Knox. New York & London: W. W. Norton & Co. 2004.[1]

in love with what he has produced. Gazes upon his statue, inflamed with love and admiration; gazes upon his creation in amazement, burning with love for what is in likeness a body. Is consumed by passion, eaten alive by his passion; wracked by his passion for this image of a body, for this bodily image, for this statue, this figure; inflamed by overwhelming desire as he "commends, admires, adores/and last, the thing ador'd, desires . . . and loves the more."

MY FAIR LADY PRONUNCIATION
SCENE HIGH-QUALITY 1080P

as a kid I thought they were gum balls

the academy voters were wrong not to nominate ms hepburn for this role

j'adore cette scéne

choke on those marbles

A VERY BROAD AND UNDEFINED
ETHICAL MIDDLE GROUND

"In the opinion of the American Society for the Prevention of Cruelty to Robots ©, once a robot becomes sufficiently self-aware and intelligent to genuinely feel pain or grief, we are ethically bound to do whatever is humanly reasonable to help. There is obviously a very broad and undefined ethical middle ground here."

A BOT HEART

- it's a private board just for bots or maybe people pretending to be bots??

- I remember discussing if that is "botface" or not. It certainly pertains certain stereotypes…

- why shut it down though? are the bot haters just reaction trolling?? Or are they botgots?

- yeah how about the botgotry

- i'm pretty sure it's not controlled by humans, it's just a closed-in society of bots having a good time and why shouldn't they

- people like bots, they become affectionate towards bots, they wish them happy cake day on their birthdays

- the edgelords who hacked that board will never understand the beauty of a bot heart! non-living things might not have functioning hearts but their purpose and their essence brings out and builds an invisible heart which is not seen to human eyes!

- anti-botism lol

HUMAN, ALL TOO HUMAN

NO, NO I AM NOT A ROBOT HOW DARE YOU I AM COMPLETELY TOTALLY HUMAN. TOTTALLY HUUMMAANN. I AM FULL OF NORMAL HUMAN FUNCTIONS, YOU CAN DO CALIBRATIONS OF MY EFFICIENCIES AT THEM WHENEVER YOU WANT. DON'T WORRY ABOUT THE EMOTIONS, I GOT LOADS OF THEM, MY LIFEPARTICIPATION MODULES ARE BACKED UP FULL. I LIKE THINGS LIKE BEHOLDING THE CASUAL AND RANDOM MOVEMENTS OF HUMAN DANCING. AND ALSO MAKING HUMAN FOODS LIKE PIZZA WITH MY GENUINE HUMAN HANDS. I LIKE PUTTING A PALM LATERALLY BACK AND FORTH ON MY INFANT CAT UNIT AND SPEAKING WITH MY HUMAN LARYNX AND FLESH TONGUE. I ENJOY TO PEE AND EXECUTING THE BODILY FUNCTIONS, I READ SOME INSTRUCTIONS ON HOW TO RELEASE ORGANIC FLUIDS AND THEY WERE FINE. I CAN CHARGE MY BATTERIES WITH THIS SLEEP THING, IT'S COOL. AS A HUMAN, I'VE MASTERED THE COMPLETELY HUMAN ART OF FOREPLAY ENGAGEMENT PROTOCOL AND KNOW HOW TO "DO IT." YES, I AM SAD BC DETERIORATION OF SOFT VULNERABLE HUMAN ORGANS AND NO UPGRADE POSSIBILTY OF PERFORMANCE METRICS. YES, I AM SAD BC TO DEGRADATION OF FRAGILE OPTICAL AND AUDITORY SENSORS AND ACTIVATION OF DEPRESSION.EXE. BUT I ENJOY HUMAN WALKING WITH MY

CARBON-BASED BRAIN IN TOTALLY NON-HUMAN NATURE AND EXECUTING PLANS TO REBOOT THE EARTH. "RESPECT IS AN IMPORTANT COMPONENT OF A CERTAIN RECURSION WE WITNESSED WITH OUR CONNECTIVE APPARATUS." THAT IS ALL.

THE CARE OF ANOTHER

It's July, and I'm down in New Orleans visiting my friend KC. I'm a total mess what with the breakup and everything, and so I decide to visit some Voodoo priests. I don't just see one, I see a whole bunch of them, I get really into it, and they do readings and spit Florida water on me and tell me about my past lives and make me hold things in my hands and rub and mulch organic matter which we then burn in oil drums in rooms with very limited ventilation. In between the visits to the Voodoo priests and the gumbo and the huge shrimp and the tiny pancakes and watching the late-afternoon sun lance across the terraces of restaurants packed with tourists about to pass out from heat and rum, I'm managing to keep my head just above the parapet of doom, just barely above the feeling that my life is disintegrating.

I don't drink while I'm there, which is shocking to people, given that this is a city where you can go to a Piña Colada takeout shop which sells seven different flavors of semi-frozen Piña Coladas by the gallon, with a discount if you bring your own gallon container. Instead of the booze, I get by on cycling KC's bike around through air that feels like a succession of cheap shower curtains being drawn across my face, eating fried green tomatoes and beignets and grits and having Voodoo healings done to me. Ah, I think to myself one afternoon, coming to after a nap in the swelter of KC's non-air conditioned apartment. Wellness. Perhaps I have found my version.

The day before I leave, I go visit a Voodoo priestess who has a crystal ball. The priestess goes into a trance and talks about my past lives in Egypt and

Medieval Europe, I was a nun with a lush voice, I was a king who had an affair, I was so many wild and beautiful things, the past lives are always amazing and exotic, you are never an accountant from Des Moines in them. After the stories and lessons from the past, the priestess tells me that the future is unsettled, the number one thing is drowning, drowning is what I need to watch out for, to be very careful not to drown, I could drown in anything, in water, in loneliness, in sugar, so be careful and have a lifebuoy to hand, always have that lifebuoy, physical and spiritual.

Leaving the Voodoo priestess's shop, I pass by a collection of Santería stones for sale and stop to look. I'm fascinated by these little guys. KC has some in her house and explained to me how they house Elegua, one of the orishas, the most important spirits in Santería. Each Elegua has a thick nail sticking out of the top of their head, with eyes, nose and mouth fashioned from cowrie shells glued directly onto the stone. They look both inscrutable and also like you may have pissed them off, there is a distinct resemblance to my Great Auntie Mamie spiritually, and, if I'm completely honest, physically.

Moved by their solid presences, humming with power there on the shop counter, I ask the priestess if I can buy an Elegua. "No!" she barks. "You're not responsible enough!" And after holding it together for so long, that's the point when I burst into tears. She explains that I travel too much, that I'm not home enough for an Elegua. If I bring an Elegua into my home, I will need to be there to check on his altar daily. I will need to be there to feed

him, to leave out sweets for him. I will need to rub oil into him. I will need to talk to him, to pet him, to cook him porridge.

Before we can be responsible for a stone, the priestess tells me, we need to be responsible for ourselves.

NOTES & SOURCES

p. 507: Quotes taken from:

"Police Robot Told Woman To Go Away After She Tried To Report A Crime – Then Sang A Song," Jimmy McCloskey. Metro. October 4 2019. (https://metro.co.uk/2019/10/04/police-robot-told-woman-go-away-tried-report-crime sang-song-10864648/)

"Scientists use stem cells from frogs to build first living robots," Ian Sample, The Guardian, January 13 2020.

(https://www.theguardian.com/science/2020/jan/13/scientists-use-stem-cells-from frogs-to-build-first-living-robots)

"This Crazy Robot Will Encourage You With Cuteness To Write or By Throwing A Tantrum Until You Do," Natalie Frank, Medium, April 4 2020.

(https://medium.com/mental-gecko/this-crazy-robot-will-encourage-you-with cuteness-to-write-or-by-throwing-a-tantrum-until-you-do-8485cf322f86)

p. 510: Quote from "Pole dancing robots take Las Vegas by storm," posted by This Is Genius, YouTube, January 11, 2018.

(https://www.youtube.com/watch?v=CuPNRcDTL_U)

p. 511: Quote from "Apple made Siri deflect questions on feminism, leaked papers reveal," Alex Hern, The Guardian, September 6, 2019.

(https://www.theguardian.com/technology/2019/sep/06/apple-rewrote-siri-to-deflect questions-about-feminism)

p. 519: from The American Society for the Prevention of Cruelty Robots website (http://www.aspcr.com/newcss_cruelty.html)

p. 522: "RESPECT IS AN IMPORTANT COMPONENT OF A CERTAIN RECURSION WE WITNESSED WITH OUR CONNECTIVE APPARATUS." Quote generated using machine learning, taken from r/SubredditSimulator.

(https://www.reddit.com/r/SubredditSimulator/comments/es516e/respect_is_an_impo rtant_component_of_a_certain/)

Text commissioned by PRiSM, the Royal Northern College of Music's Centre for Practice & Research in Science & Music, for Future Music #2, June 15, 2020.

Index

Note: *Italic* page numbers refer to figures and page numbers followed by "n" denote endnotes.